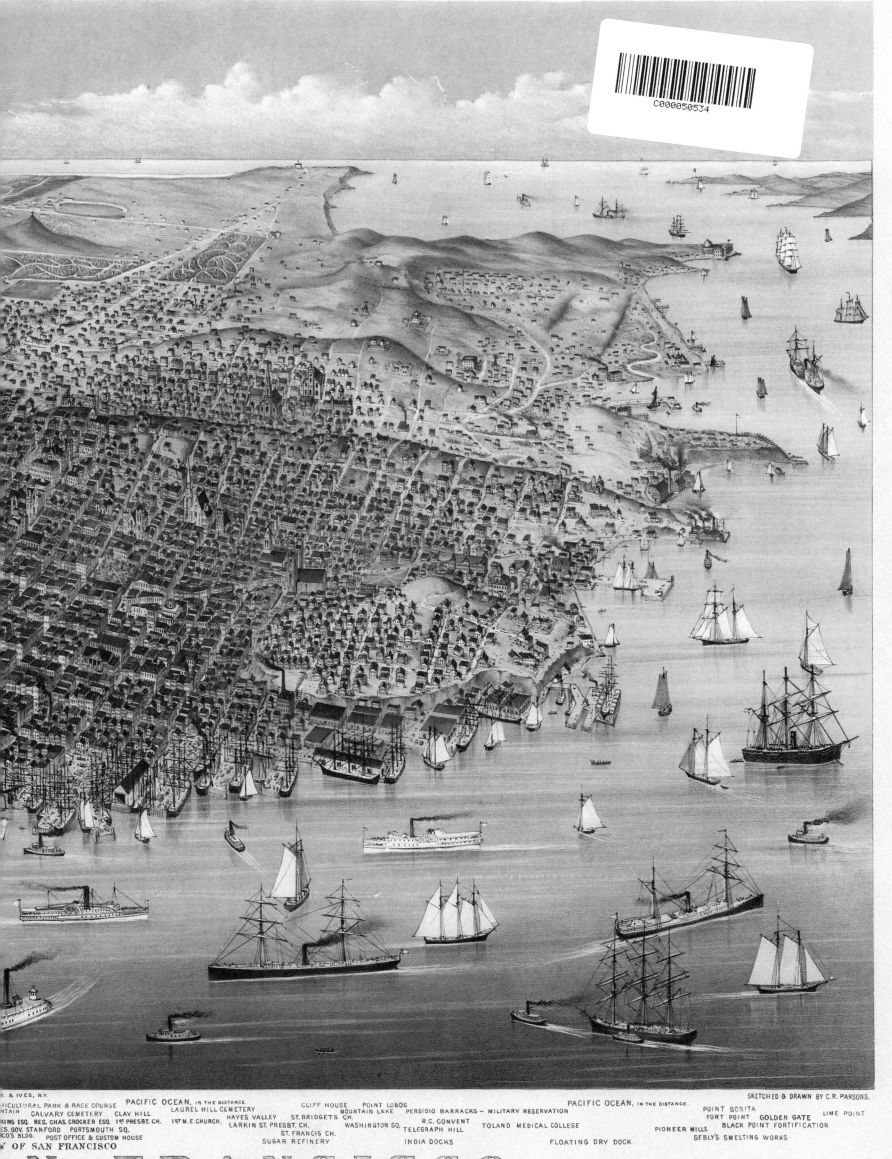

& IVES, N.Y.

PACIFIC OCEAN, IN THE DISTANCE. CLIFF HOUSE POINT LOBOS PACIFIC OCEAN, IN THE DISTANCE. SKETCHED & DRAWN BY C.R. PARSONS.

RICULTURAL PARK & RACE COURSE LAUREL HILL CEMETERY MOUNTAIN LAKE PERSIDIO BARRACKS — MILITARY RESERVATION POINT BONITA

TAIN CALVARY CEMETERY CLAY HILL FORT POINT GOLDEN GATE LIME POINT

KINS ESQ. RES. CHAS. CROCKER ESQ. 1ST PRESBT. CH. 1ST M.E.CHURCH. HAYES VALLEY ST.BRIDGETS CH. R.C. CONVENT

S. GOV. STANFORD PORTSMOUTH SQ. LARKIN ST. PRESBT. CH. WASHINGTON SQ. TOLAND MEDICAL COLLEGE PIONEER MILLS BLACK POINT FORTIFICATION

CO'S BLDG. POST OFFICE & CUSTOM HOUSE ST. FRANCIS CH. TELEGRAPH HILL SEBLY'S SMELTING WORKS

W OF SAN FRANCISCO SUGAR REFINERY INDIA DOCKS FLOATING DRY DOCK

AN FRANCISCO.

San Francisco

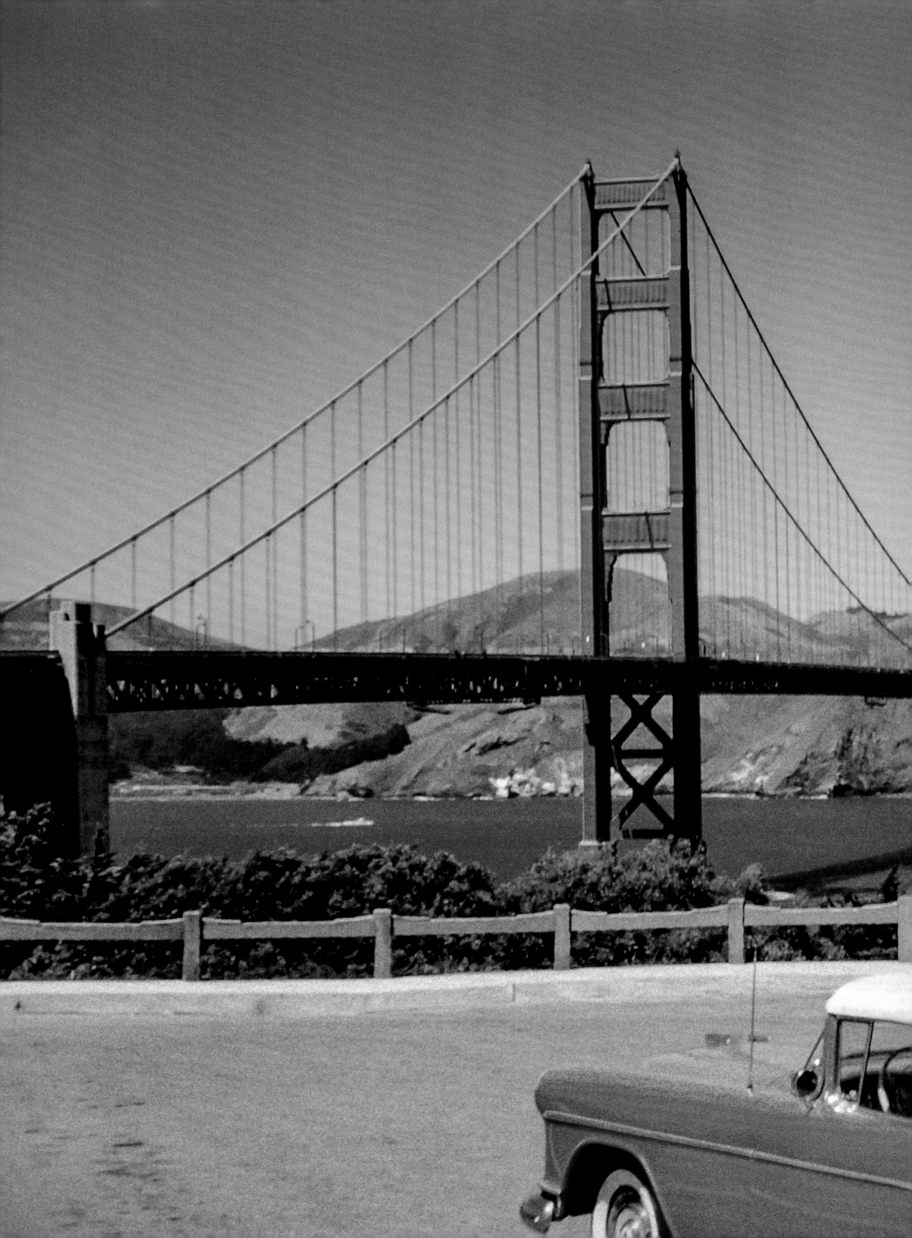

Edited by Reuel Golden
With texts by Richie Unterberger

San Francisco

Portrait of a City • Porträt einer Stadt • Portrait d'une ville

TASCHEN

Contents / Inhalt / Sommaire

→
Fred Lyon

View from the bottom of one of the steepest parts of the California Street cable car line, on the route that climbs to Nob Hill, 1959.

Der Blick vom Fuß eines der steilsten Abschnitte der Cable-Car-Linie California Street nach Nob Hill, 1959.

Au bas de l'un des tronçons les plus raides de la ligne de cable car California Street, qui grimpe vers Nob Hill. 1959.

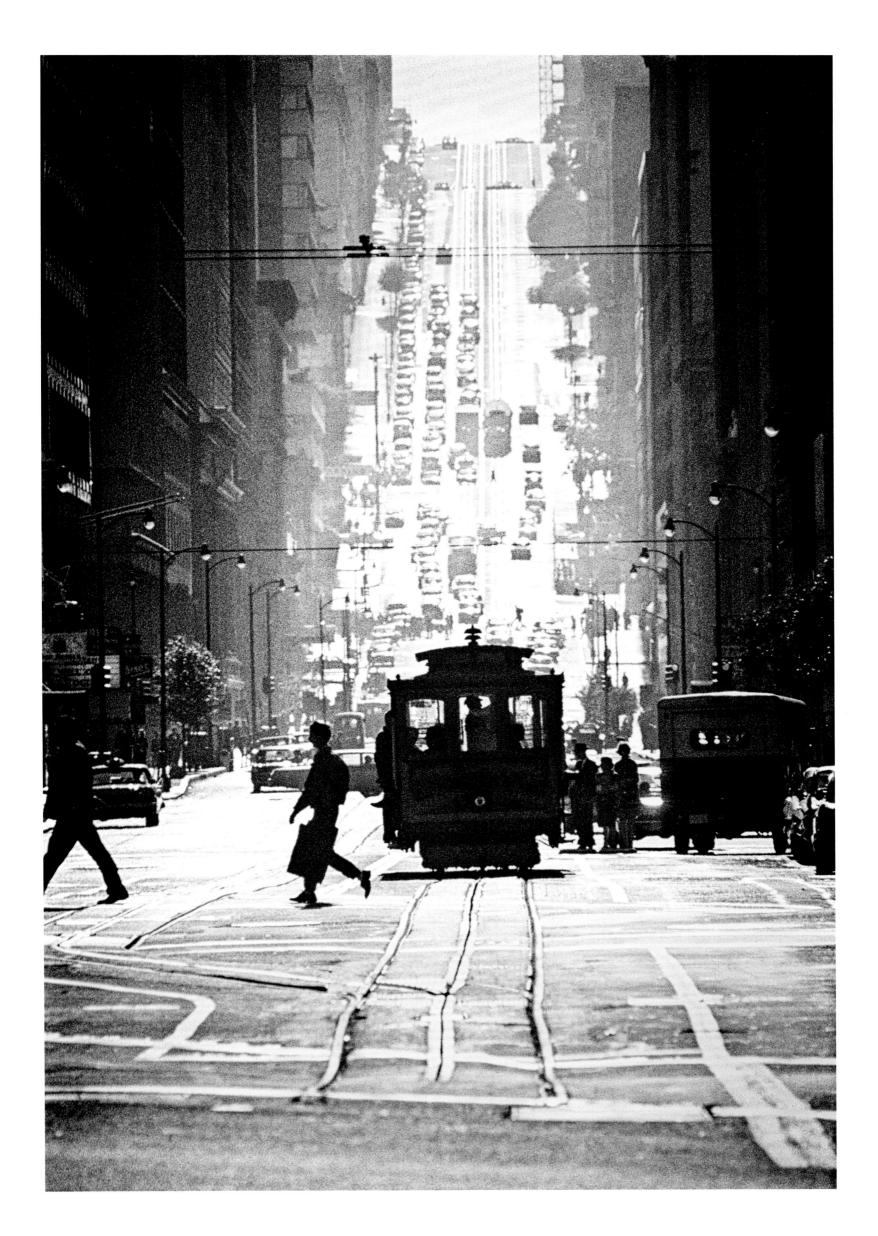

#1

The City by the Bay 1846–1929

p. 2/3
Anonymous

The Golden Gate Bridge and Marin County, as viewed from a parking lot near Fort Point on the San Francisco side, c. 1950s.

Marin County und die Golden Gate Bridge, von einem Parkplatz in der Nähe von Fort Point auf der San-Francisco-Seite aus gesehen, 1950er-Jahre.

Le Golden Gate Bridge et le comté de Marin, vus d'un parking à proximité de Fort Point, côté San Francisco. Vers les années 1950.

Ever since California became part of the United States in 1850, San Francisco has been the crown jewel of the West Coast. Its steep hills, magnificent parks, and stunning panoramic views of land and water have not only made the city one of the top tourist destinations in the world, but a magnet for millions of dreamers, hustlers, and fearless innovators who've launched some of the most visionary social, technological, and artistic movements of the last century.

Whether to visit or settle, they're in a place like no other in the United States, for reasons above and beyond its picturesque setting. It radiates the most European feel of any American city, with a vigorous street life, huge range of cafes and restaurants, convivial open spaces, and humane scale that's made it—almost uniquely among the country's metropolitan areas—easier and far more pleasant to explore by foot than car. Its multicultural population and diverse neighborhoods foster a cosmopolitan air buzzing with lively conversation as likely to be in Spanish, Cantonese, and many other languages as English. Elegant, quirkily imaginative architecture offers constant delights and surprises, whether Alamo Square's famed series of Victorian "Painted Ladies" homes, Mission murals whose stories nearly leap off the sides of buildings with buoyant Latino pride, or some of the tallest skyscrapers on the West Coast.

Even San Francisco's weather is like no other city's. Fog often tops or obscures the skyline, rushing in and around with an unpredictable speed that can drop the temperature by 10 or 15 degrees in a matter of minutes, and makes dressing in layers a necessity. Microclimates mean it can be sunny and mild in the Mission, yet nearly freezing and overcast with drizzle-thick mist just a mile or two closer to the bay. First-time visitors are taken aback by how cool it can get in the summer, with a bracing chill at odds with the international image of California as the land of perpetual warm sunshine.

The "warm San Franciscan night" hailed by the Animals in a Summer-of-Love-era hit is largely mythical. The constant rolling fog, however, ensures that San Francisco seldom gets unpleasantly hot. With few days that see the thermometer fall below freezing, the temperate climate helped seal its status as a coveted destination for millions who have passed through the city since it was founded.

The first settlers arrived in the San Francisco Bay long before the city had its name. Although it's impossible to date with certainty, it's likely Ohlone Native Americans lived in the area for 3,000 to 5,000 years before Europeans arrived. In the mid-1770s, Spanish explorers disrupted the long-established Ohlone way of life by setting up outposts near the area where the bay meets the Pacific Ocean. By the time the region passed into Mexican hands in the early 1820s, the Ohlone were nearly decimated by forced relocation and disease brought by the newcomers, as Native Americans so often were throughout North America.

As lovely as the narrow gap where the bay meets the Pacific Ocean was, now the site of the Golden Gate Bridge, the area's commercial and residential potential were underestimated for the next 25 years. When a US flag was raised in 1846 over the plaza that would soon be renamed Portsmouth Square, the San Francisco peninsula was still pretty much a village, occupied by a ragtag assortment of traders, ranchers, and drifters. So small was the settlement still known as Yerba Buena that when about 240 Mormons arrived a few weeks later, the population more than doubled. Yerba Buena was soon renamed San Francisco, in honor of Mission San Francisco de Asis, built in 1776 by the Spanish in what is now the Mission District.

San Francisco's dot-on-the-map status changed in a hurry in January 1848, when gold was discovered in the Sierra foothills about 115 miles to the northeast. The Gold Rush was on, bringing tens of thousands of would-be prospectors from all over the States, and indeed all over the world. Many came by ship, and San Francisco's harbor made the town the first stop for the new arrivals. In a hurry to get to the gold, many prospectors continued their journey north. Meanwhile, plenty of the ships crowded with fortune-seekers lay abandoned in the bay in the early 1850s, with quite a few crews joining the fray.

But the city itself was hardly abandoned. The newcomers needed tools, supplies, places to stay, recreation, and banks to deposit their assets. By the end of the 1840s, San Francisco's population had zoomed to 25,000. As the gold country's reserves were plundered, and many hopes dashed with few fortunes made, a wealth of disappointed Gold Rushers found it easier to stay put than backtrack to their points of origin. By 1860, the town had more than doubled in size again, to almost 60,000. It was now a boomtown, with a population greater, by far, than any US city west of St. Louis.

Such explosive urban growth, unprecedented in the history of the Western United States, was not without its problems. Construction could hardly keep up with the pace, leaving many homeless or without adequate shelter—problems that continue to plague the city to the present. Buildings were hastily erected on narrow streets that had to cut through the rolling hills at steep grades, many of which remain in place today. Often unstable to begin with, many of the new structures would also be threatened by periodic earthquakes, though the one that would level much of San Francisco was half a century in the future.

Its social infrastructure was as precarious as its physical one. If the Gold Rush brought many hardworking miners with a bold lust for adventure, it also brought many opportunists lusting for thrills besides gold. Crime, vice, and ridiculously inflated prices were rampant, and the local government chaotic. Men far outnumbered women in the city's early years, and prostitution soon boomed. So did gambling, drinking, and other forms of unregulated connivery, with masses of fresh-off-the-boaters supplying easy targets. Much, though certainly not all, of this nasty business thrived in the Barbary Coast neighborhood, near what today is bounded by Chinatown, North Beach, and downtown.

As an urbanizing Wild West of sorts, the fledgling government was ripe for greed and corruption. Duels and unpunished murders were far from uncommon, sometimes involving founding fathers whose names still adorn some city streets and institutions. The chicanery grew so out of control, and enforcement by authorities so haphazard, that some citizens took the law into their own hands, forming Committees of Vigilance. From

Two Years Before the Mast, *Richard Henry Dana Jr., 1840.*

wherever violence was instigated, the victims were often among the numerous ethnic minorities who were part of the Gold Rush, especially the Chinese.

Yet even as rapid growth and sin threatened to collapse San Francisco almost as soon as it had risen, the city was becoming as cosmopolitan as almost any East Coast metropolis. Theatrical and opera productions were popular from the start. The infusion of so many new residents from so many different locales and cultures spurred the creation of droves of restaurants unrivaled in their diversity and a pride in fine dining the Bay Area still boasts more than 150 years later. The windfall of new money, if more in banking than mining, meant new hillside mansions of such splendor they were soon adorning postcards coast to coast.

Suddenly one of the 15 biggest cities in the country, San Francisco was also hungry for information about both local goings-on and whatever else could reach them from the rest of the United States, which had yet to even build railroad lines reaching the West Coast. Newspapers were a staple of city life from San Francisco's start, and writers were quickly needed to fill them. Like the prospectors, they came from all over the country and beyond, and not just for work. A city in the midst of defining itself offered more opportunities for colorful prose than almost anywhere else, and not only for the reading pleasure of San Franciscans. Enterprising writers found that readers everywhere wanted to find out just what was going on in that wild, faraway port, and out-of-town media were eager to print these accounts.

So began San Francisco's literary scene, where young, up-and-coming writers could make a name for themselves more quickly and perhaps more enjoyably than anywhere else. Some of their tales were tall ones, no doubt embroidered for readers so distant from the action they were unlikely to have their credibility dampened by fact-checking. Sometimes they were serialized over weeks or even years, turning into popular books.

Mark Twain is the most famous of these journalists who got into gear as San Francisco newspaper reporters and

columnists, though his stint as a local resident only took in a few years in the 1860s, and he never actually wrote or uttered his oft-quoted barb "the coldest winter I ever spent was a summer in San Francisco." Ambrose Bierce, famed for his arch *The Devil's Dictionary* and short stories like "An Occurrence at Owl Creek Bridge," was another, and Frank Norris used the city as the principal setting for his gritty naturalistic novel *McTeague*. A growing intellectual community was also served by the birth of several colleges in the area, dating back to St. Ignatius Academy (now the University of San Francisco) in 1855, and joined in 1868 by the University of California at Berkeley, about 10 miles across the bay to the east.

The influx of new blood from far-flung territories guaranteed a multiculturalism that's still one of the Bay Area's trademarks. Besides remnants of the Mexican and Spanish overseers of the land, strong Irish and Italian communities developed, along with pockets of African Americans, Portuguese, and other ethnic groups. Some groups were made less welcome than others, none more so than the Chinese, many of whom were drawn to California to work on the transcontinental Pacific Railroad. Shortly after that was completed in nearby Oakland in 1869, Chinese comprised almost 10 percent of San Francisco's population.

As vital as Chinese labor had been to linking the Bay Area to the rest of the country, the presence of so many Chinese immigrants was often considered a threat. White working-class communities repeatedly and violently attacked Chinese communities in San Francisco and throughout the West Coast. Media caricatures of the foreigners as devious interlopers accentuated a widespread prejudice that culminated in 1882's federal Chinese Exclusion Act, preventing Chinese laborers from immigrating to the United States. Those who remained were already a permanent fixture of San Franciscan life, especially in the couple dozen square blocks north of downtown where they practiced their own customs and cuisine. Still a vibrant, densely packed

The Annals of San Francisco,
Frank Soulé, 1855.

neighborhood today, Chinatown was quickly exploited as an exotic tourist attraction in its own right. That didn't stop its residents from suffering discrimination in housing and the workplace, as well as longtime exclusion from the city's policymaking.

The 1860s were a decade of astronomical growth, the population nearly tripling to about 150,000 by its end. Streets were already clogged with animal-drawn carts, carriages, and streetcars. New and ingenious transportation was needed to carry passengers and cargo over the sharply ascending and descending hills. In 1873, the first San Franciscan cable cars went into use, quickly becoming some of the city's visual icons. Now mostly used by tourists on just a few routes, they were far more utilitarian in the 19TH century, with 23 lines in operation by 1890. Even then, however, there was the bonus of spectacular views as they delivered crowds from one place to another.

Those riders were in need of less crowded spaces as their families took root and grew. In the 1870s, a rectangular stretch of land three miles long and half a mile wide was developed into Golden Gate Park, ending at Ocean Beach by the Pacific Ocean. A rather desolate, sparsely populated area dominated by sand dunes was transformed into a lush green space with 150,000 trees. It might not have reflected the region's natural ecosystem, but it was immensely popular, and not just for its greenery. Soon museums and gardens bolstered its drawing power. The Conservatory of Flowers, built in 1878, and the Japanese Tea Garden, which followed in 1894, were thronged with tourists and residents alike, lauded both for their graceful architecture and gorgeously eclectic, verdant plant life. After the California Midwinter Fair International Exposition was staged in the park in 1894, they'd be joined by the de Young art museum and a growing number of recreational facilities, which already included one of the first children's playgrounds in the country.

San Francisco's urban areas, still largely concentrated on the eastern side of the peninsula, were not without their own visual highlights. Opulent Nob Hill mansions were constructed

by some of the era's leading financial barons, including railroad magnates Charles Crocker, Mark Hopkins, Collis Potter Huntington, and Leland Stanford. Equally opulent hotels were built to accommodate the growing numbers of wealthier business travelers and tourists. With 775 rooms, the Palace Hotel, just off downtown's main Market Street thoroughfare, was the biggest hotel in the Western United States when it was built in 1875. Sometimes dubbed robber barons for their hunger to accumulate wealth, some of these industrialists mitigated their images with philanthropic projects. Near his estate overlooking Ocean Beach, Adolph Sutro—who had made a fortune through Nevada's Comstock Lode, where silver had been discovered after the Gold Rush—developed the Sutro Baths, a glass-covered swimming and entertainment complex near where the ocean met the bay at Lands End. Opening in 1896, it was soon joined under his estate by the Sutro-built Cliff House, a restaurant with hard-to-match views of the rocks where sea lions took in the sun just offshore.

San Francisco was now studded with visual gems, whether the new parks, mansions, hotels, or the natural waterside landscapes that had always made for great views from the city's many hills. Photography came into being at around the same time San Francisco did, and few areas boasted such rich subject matter to document in pictures. Several early photography pioneers took numerous images of the Bay Area in the 19TH century, including Carleton E. Watkins, G.R. Fardon, Eadweard Muybridge, and Arnold Genthe. If photography was not yet considered a fine art, their pictures of San Francisco still found a large audience through another new medium: internationally distributed postcards.

At the turn of the century, San Francisco was in many senses thriving, despite the inevitable financial hiccups of any explosive growth spurt. Now approaching 350,000 in population, it was among the 10 biggest cities in the United States. Its port was the busiest on the West Coast, though it would be overtaken in this and other financial matters by its even faster-growing rival to the south, Los Angeles. Urban designer Daniel Burnham

The Miner's Manual, *circa 1873.*
Heritage Auctions, HA.com

created a city plan in 1905 with wide boulevards spreading from the Civic Center that might have made the area truly resemble the Paris of the West.

The Bay Area metropolitan area was also expanding beyond its relatively small, approximately seven-by-seven-mile city limits. Residents and businesses were rapidly starting to fill Marin County to the north and Oakland and Berkeley in the East Bay, as well as extending southward about 60 miles to San Jose. The foot of Market Street was a hub for commuter traffic with the new Ferry Building, though bridges that might span the bay remained mere speculation.

Yet San Francisco's infrastructure didn't have as solid a foundation as it might have seemed. That foundation met its greatest challenge at 5:12 a.m. on the morning of April 18, 1906, when a 7.9 magnitude earthquake struck. The initial damage was bad enough, collapsing many buildings in the downtown Financial District, along with the newly opened City Hall. The worst by far was yet to come, as fires set off by broken gas mains and fallen lanterns and candles turned much of San Francisco into an inferno. The water mains depended upon to fight fires had also broken. Firefighters couldn't do much to combat the blaze, which was responsible for about 80 percent of the disaster's damage.

Not all of the victims were accounted for, but up to 3,000 people died. More than 80 percent of the city was destroyed. About 250,000 San Franciscans—more than half the population—were left homeless, among them former residents of Nob Hill's grandest mansions. Many of the city's parks now housed refugee camps, including Golden Gate Park, with 70,000 taking shelter in the huge Presidio military fort on the peninsula's northern tip. There had been fires and earthquakes in San Francisco ever since the city was named, but this was on an entirely different scale. Even with millions of dollars of immediate relief funding from the federal government and charitable donations from other parts of the United States and a few other nations, there

was property damage of nearly $500 million. Rebuilding the city would take an enormous amount of money and labor.

San Francisco's greatest assets were now its people. Homeless and impoverished as many were, it would be up to them to somehow reconstruct a city largely in ashes. It was a task they met with generosity and ingenuity. Besides the temporary towns in San Francisco's formerly open spaces, pop-up cafes appeared that were little more than booths hastily erected from scraps.

A lot of hard labor was ahead, and the number of construction workers tripled by the end of the year. Speed was of the essence, and Daniel Burnham's ambitious city plan with grand boulevards was scrapped. It might have been prohibitively expensive to enact in the best of times, but the stress was now on getting the city back on its feet as quickly as possible, even if that meant cutting corners on creativity. By 1910, there were new buildings in place of most of the ones that had been ruined. Just as crucially, advantage was taken of the opportunity to guard against similar disasters in the future. Many of the new structures used fire-resistant steel and reinforced concrete. At the end of 1915, a new City Hall was dedicated, overlooking a Civic Center that would feature several of San Francisco's leading civic and cultural institutions, including an opera house and its main public library branch.

San Francisco was not just rebuilt. Improbably, it showcased its new luster in a world's fair just walking distance from where the earthquake had raged fiercest. Held along a square mile on the northern waterfront between Fort Mason and the Presidio, the Panama-Pacific International Exposition presented a dazzling array of exhibits showcasing the era's cutting-edge technologies. Halls and boulevards created especially for the fair made the exposition grounds something of a mini-city, highlighted by a 435-foot Tower of Jewels lit by more than 50 electric searchlights at night. The Panama-Pacific International Exposition served as notice that San Francisco had not only recovered from the 1906 earthquake but was now a world-class city. Alas, just one of its custom-built

Picturesque California, edited by John Muir, 1888. Heritage Auctions, HA.com

structures remained after the fair was taken down at the end of 1915, but it was a major one—the Palace of Fine Arts, still one of the city's top landmarks. Its splendid architecture, featuring a rotunda and lagoon-side colonnades, remain oft gazed upon by visitors and residents of the Marina District in which it resides.

With the United States on the verge of entering World War I, the area was also of mounting strategic importance. Already considered something of the West Coast's first line of defense, both the Presidio and Marin foothills across the water were dotted with forts guarding against foreign invasion. The government also found uses for two nearby islands in the bay, putting a military prison on Alcatraz. Angel Island was turned into an immigration station for processing and, often, detaining new arrivals, usually from Asia, sometimes barred from entry for months. The war didn't have universal support. On July 22, 1916, a pipe bomb was set off at a Market Street Preparedness Day parade, killing 10 and injuring more than 40. Two suspects were convicted and, some believe, framed for the crime. One, Tom Mooney, was not pardoned until 1939; another, Warren Billings, wasn't released until 1939, and not pardoned until 1961.

For all the country's preparations, no enemies broached or even approached the Golden Gate. But as the war was winding down, the influenza pandemic that spread across much of the globe reached San Francisco in autumn 1918. Attempting to curb each wave of infection, the Red Cross distributed cloth masks, and judges even held outdoor court sessions. With almost 45,000 cases and more than 3,000 deaths, San Francisco was hit harder than any other US city.

The passage of the 18TH Amendment in 1919 outlawed liquor in the United States, but city officials showed little interest in enforcement. In the teens, a reform-minded cleanup of the Barbary Coast, spearheaded by Reverend Paul Smith and newspaper tycoon William Randolph Hearst during Mayor Sunny Jim Rolph's reign, had closed brothels and all but eliminated saloon entertainment. Coming in the wake of California's 1912

passage of women's suffrage, it could also be seen as part of a broader campaign targeting independent working women, even cracking down on dance halls admitting women who were unaccompanied by men. But most houses of sin had simply relocated to other neighborhoods, particularly the Tenderloin, just blocks from the Civic Center. During Prohibition, the Bay Area coastline was a boon to bootleggers, and by some estimates, San Francisco had more bars and consumed more liquor than any other city.

Although hardly on the same scale as similar activity in New York or Chicago, a San Francisco underworld lurked if you knew where to find it, whether in bootlegging or more dubious trades in smuggling, drugs, and prostitution. As in those other big cities, government and police corruption made a serious crackdown on—let alone elimination of—such practices unlikely. They did supply fodder for the stories of the most celebrated San Francisco novelist of the era, Dashiell Hammett. With some firsthand experience of the scene from his years as a Pinkerton detective, he gave the city an alluring seediness in his most celebrated crime novels, especially *The Maltese Falcon*. That, in turn, became one of the most popular San Francisco–set movies, with Humphrey Bogart starring as Sam Spade.

The Roaring Twenties were in some ways good to San Francisco. As its population passed the half-million mark, neighborhoods were established in some relatively undeveloped western districts like Sea Cliff, where some of the Bay Area's most elegant and expensive dwellings indeed overlooked sea and cliffs. Some areas, like the Fillmore and Western Addition, boasted especially strong concentrations of ethnic minorities, especially Japanese Americans and (until after World War II) the Fillmore's strong Jewish community.

The good and bad times were disrupted by the stock market crash of 1929. But the Depression that followed did not stop the city's expansion, and in the decade to come, San Francisco would transform its skyline by building its most iconic structure.

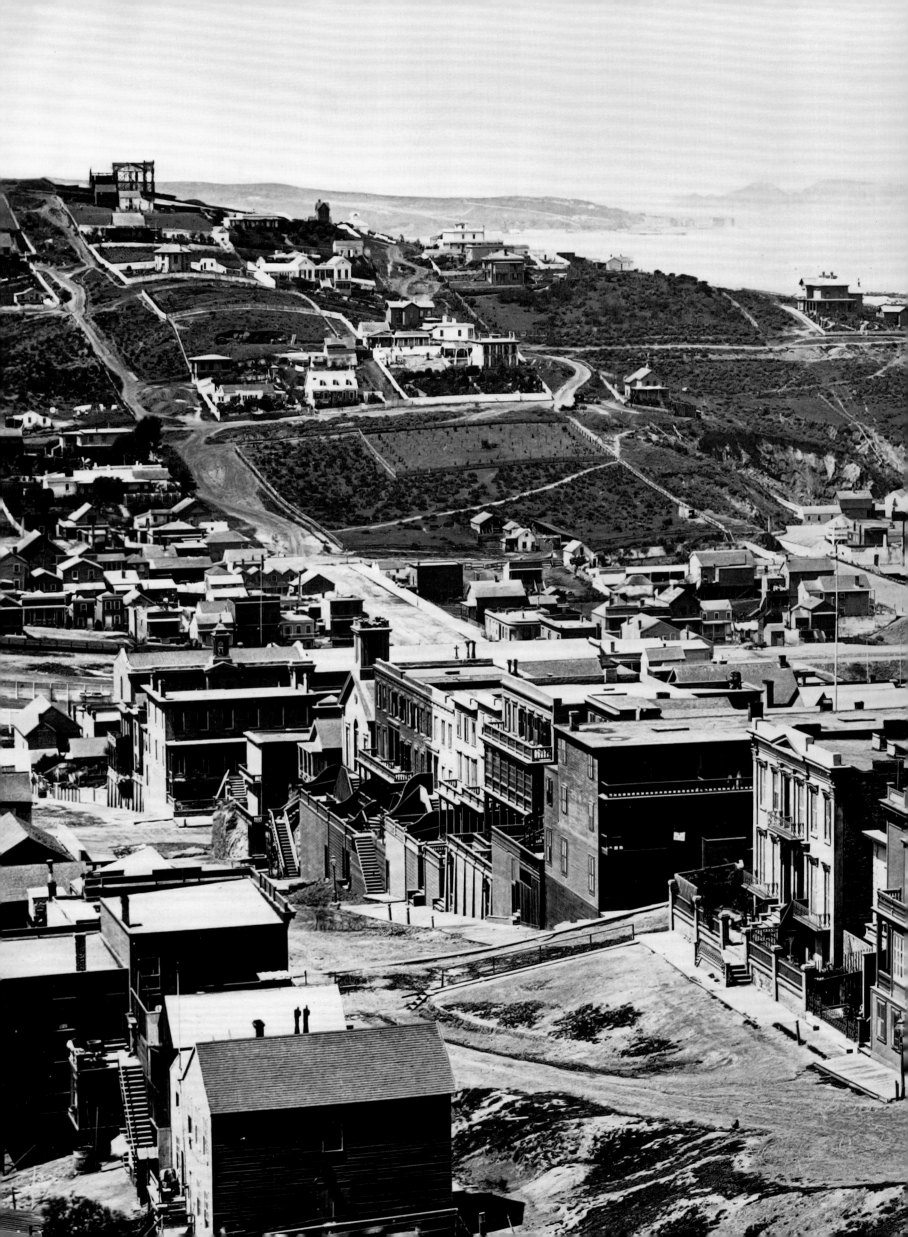

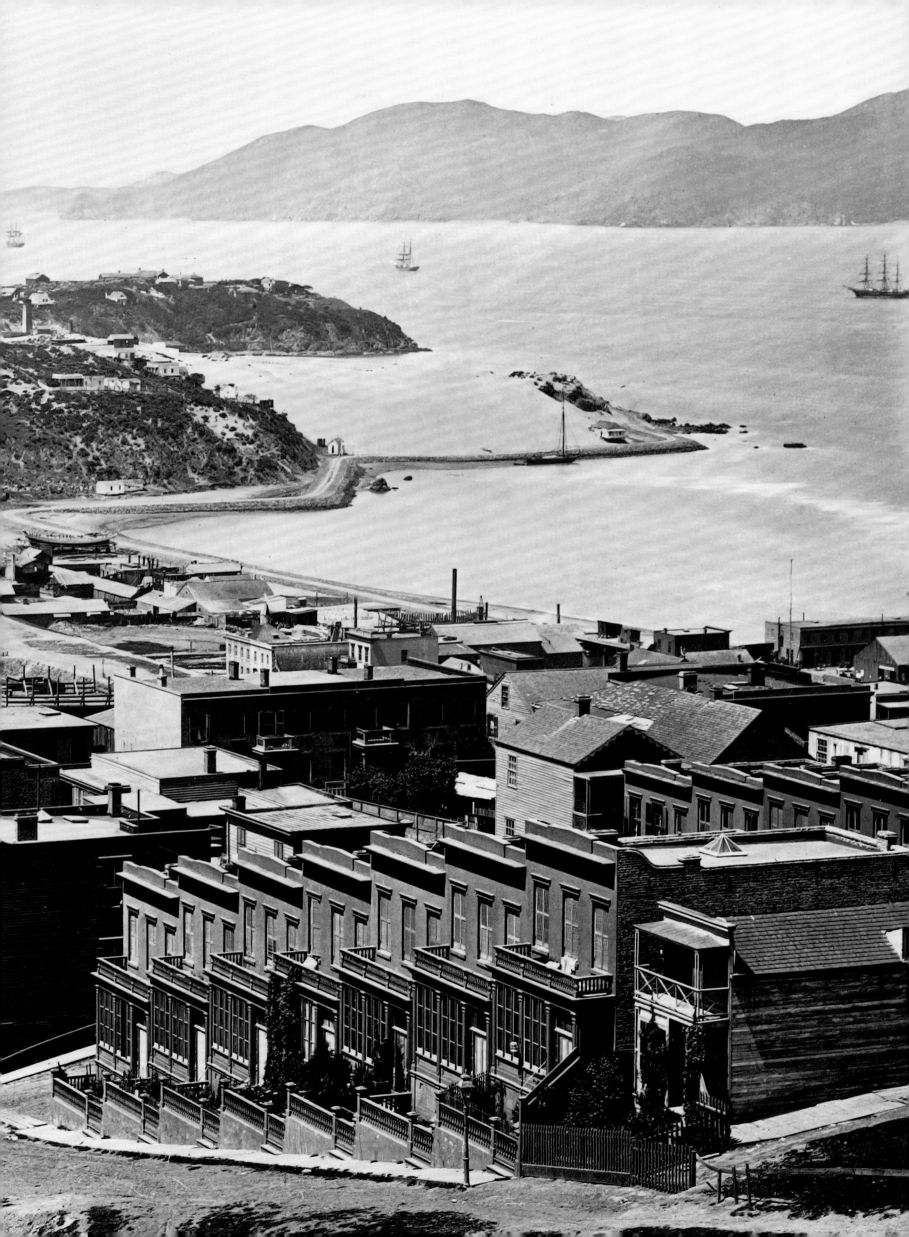

#1

Die Stadt an der Bay 1846–1929

p. 12/13
Carleton E. Watkins

Looking west toward the Golden Gate from Telegraph Hill as the northwestern outskirts of a fast-booming city start to develop, 1868 or 1869.

Der Blick vom Telegraph Hill westwärts zum Golden Gate, als die nordwestlichen Teile der Stadt gerade begannen zu wachsen, 1868 oder 1869.

Au nord-ouest, du nouveau : la ville connaît une expansion fulgurante et sa périphérie, tournée ici vers le détroit du Golden Gate, saisi depuis Telegraph Hill, commence à se développer. 1868 ou 1869.

San Francisco ist das Kronjuwel der Westküste, seit Kalifornien 1850 Teil der Vereinigten Staaten wurde. Steile Hügel, großartige Parks und der Panoramablick über Land und Meer haben die Stadt nicht nur zu einem Magneten für Touristen aus aller Welt gemacht. Sie zieht auch Träumer, Glückssucher und Vorreiter aller Art an, die einige der visionärsten sozialen, technologischen oder künstlerischen Bewegungen des letzten Jahrhunderts geschaffen haben.

Ob sie die Stadt nur besuchen oder sich dort niederlassen, sie sind an einem Ort ohnegleichen in den USA, aus Gründen, die weit über die malerische Landschaft hinausgehen. Von allen amerikanischen Städten fühlt sie sich am europäischsten an, mit lebendigen Straßen, einer Vielzahl von Cafés und Restaurants und belebten öffentlichen Plätzen. Dazu kommt der menschliche Maßstab der Stadt. Sie ist – und das fast als einziger Metropolraum der USA – angenehmer zu Fuß zu erkunden als mit dem Auto. Die multikulturellen Viertel schaffen eine kosmopolitische Atmosphäre, in der die Luft vor Unterhaltungen, die genauso gut auf Spanisch, Kantonesisch oder einer anderen Sprache wie auf Englisch sein können, nur so brummt. Die elegante und einfallsreiche Architektur hält immer eine Überraschung parat, seien es die viktorianischen Häuser auf dem Alamo Square, die „Pinted Ladies", die Wandmalereien der Mission, die vom Stolz der Latinos erzählen, oder einige der höchsten Wolkenkratzer der Westküste.

Selbst San Franciscos Wetter ist einzigartig. Oft legt sich Nebel über die Skyline, der in nur wenigen Minuten auf- oder abziehen kann. Deswegen kann die Temperatur genauso schnell um fast 10 Grad fallen, hier ist der Zwiebellook wirklich angebracht. Wegen der Klimazonen der Stadt kann es in der Mission sonnig und mild sein, aber nur wenige Kilometer näher an der Bucht bewölkt mit dichtem Nebel. Wer zum ersten Mal hier ist, wird oft davon überrascht, wie kalt es im Sommer werden kann, denn die Sommerkälte ist das Gegenteil von Kaliforniens internationalem Ruf als ein Ort voller Sonnenschein.

Die „warm San Francisco night", besungen von den Animals in einem Hit aus dem Sommer der Liebe, ist zum Großteil ein Mythos. Der ständige Nebel sorgt aber dafür, dass es in San Francisco nur selten unangenehm heiß wird. Mit nur wenigen Tagen im Jahr, an denen die Temperatur unter den Gefrierpunkt fällt, hat das gemäßigte Klima dazu beigetragen, seit der Gründung den Status der Stadt als begehrtes Reiseziel für Millionen zu sichern.

Die ersten Siedler kamen in der San Francisco Bay an, lange bevor die Stadt ihren Namen hatte. Ein genaues Datum ist nicht bekannt, es ist aber wahrscheinlich, dass das Volk der Ohlone schon 3000 bis 5000 Jahre vor der Ankunft der Europäer in der Gegend lebten. Mitte der 1770er-Jahre störten spanische Entdecker die jahrhundertealte Lebensweise der Ohlone, indem sie in der Nähe der Stelle, wo die Bucht auf den Pazifik trifft, Außenposten errichteten. Als die Region Anfang der 1820er-Jahre in mexikanischen Besitz überging, waren die Ohlone durch Zwangsumsiedlungen und von den Neuankömmlingen eingeschleppten Krankheiten bereits fast ausgelöscht. Dieses Schicksal teilten sie mit der indigenen Bevölkerung in ganz Nordamerika.

So schön die schmale Mündung der Bucht in den Pazifik, die heute die Golden Gate Bridge überspannt, auch war, so sehr wurde das Potenzial des Gebiets, wirtschaftlich und als Wohnort, in den nächsten 25 Jahren unterschätzt. Als 1846 die US-Flagge

über dem bald in Portsmouth Square umbenannten Platz gehisst wurde, war die Halbinsel San Francisco höchstens ein Dorf, bewohnt von einer zusammengewürfelten Gruppe aus Händlern, Viehzüchtern und Landstreichern. Die noch Yerba Buena genannte Siedlung war damals so klein, dass sich die Bevölkerung mit der Ankunft von etwa 240 Mormonen ein paar Wochen später mehr als verdoppelte. Bald wurde der Name zu San Francisco geändert, zu Ehren der Mission San Francisco de Asis, 1776 von den Spaniern im heutigen Mission District errichtet.

Im Januar 1848 änderte sich das blitzschnell, als etwa 185 Kilometer nordöstlich des Orts in den Ausläufern der Sierra Gold entdeckt wurde. Der Goldrausch begann und zog aus den gesamten USA und tatsächlich aus aller Welt zehntausende von Goldsuchern an. Viele von ihnen kamen mit dem Schiff, und der Hafen machte San Francisco zu ihrer ersten Anlaufstelle. Um schnell zum Gold zu gelangen, reisten viele direkt weiter in den Norden. In den frühen 1850er-Jahren lagen viele der einst mit Glückssuchern überfüllten Schiffe verlassen in der Bucht, denn nicht wenige Besatzungen hatten sich der Suche angeschlossen.

Die Stadt selbst war aber alles andere als verlassen. Die Neuankömmlinge brauchten Werkzeuge, Vorräte, Unterkünfte, Unterhaltung und Banken für Geld und Gold. Ende der 1840er-Jahre war die Einwohnerzahl San Franciscos schlagartig auf 25 000 gestiegen. Als die Goldreserven des Landes geplündert und wenige Hoffnungen erfüllt, aber viele enttäuscht waren, fanden es zahlreiche desillusionierte Goldgräber einfacher, zu bleiben, anstatt in ihre Heimat zurückzukehren. Die Größe der Stadt hatte sich bis 1860 wieder mehr als verdoppelt, diesmal auf fast 60 000 Einwohner. Sie war nun eine sogenannte Boomtown, die größte amerikanische Stadt westlich von St. Louis.

Dieses explosive urbane Wachstum, beispiellos in der Geschichte des Westens der USA, war nicht ohne Probleme. Es konnten nicht schnell genug Wohnungen gebaut werden, sodass viele Menschen obdachlos oder ohne angemessene Unterkunft blieben – Probleme, die die Stadt immer noch plagen. Häuser wurden in aller Eile an schmalen Straßen gebaut, die sich durch die steilen Hügel schlängeln mussten und von denen es heute noch einige gibt. Von vornherein instabil, wurden viele der Gebäude durch regelmäßige Erdbeben bedroht, auch wenn das Beben, das große Teile San Franciscos dem Erdboden gleichmachen sollte, noch ein halbes Jahrhundert in der Zukunft lag.

Die soziale Infrastruktur der Stadt war so prekär wie die bauliche. Mit dem Goldrausch kamen nicht nur abenteuerlustige Bergleute, sondern auch viele Opportunisten, die den Nervenkitzel genauso suchten wie das Gold. Verbrechen und lächerlich überhöhte Preise waren weit verbreitet und die lokale Regierung chaotisch. Männer waren in den frühen Jahren der Stadt weitaus zahlreicher als Frauen, und Prostitution war schnell eines der größten Geschäfte. Das Gleiche galt für Alkohol, Glücksspiel und verschiedene Formen des Betrugs, wobei die Massen an Neuankömmlingen ein leichtes Ziel waren. Viele, wenn auch sicher nicht alle, dieser üblen Geschäfte gediehen im Viertel Barbary Coast, in der Nähe dessen, was heute an Chinatown, North Beach und Downtown grenzt.

Als eine Art urbanisierender Wilder Westen war die unerfahrene Regierung anfällig für Gier und Korruption. Duelle und ungestrafte Morde waren keine Seltenheit. Manchmal waren auch

Official Guide to the California
Midwinter Exposition, *1894*.

Gründungsväter in sie verwickelt, deren Namen noch immer Straßen und Einrichtungen der Stadt schmücken. Die Lage geriet so sehr außer Kontrolle und die Vollstreckung der Gesetze durch die Behörden wurde so willkürlich, dass einige Bürger das Gesetz selbst in die Hand nahmen und Bürgerwehren bildeten. Wer auch immer die Gewalt anzettelte, die Opfer gehörten meist den zahlreichen am Goldrausch beteiligten ethnischen Minderheiten an. Besonders oft traf es Chinesen.

Zur selben Zeit, als rasantes Wachstum und Sünde drohten, San Francisco fast so schnell zu Fall zu bringen, wie es aufgestiegen war, war die Stadt auf dem Weg, so kosmopolitisch wie eine Ostküstenmetropole zu werden. Theater und Oper waren von Anfang an populär. So viele neue Einwohner aus vielen verschiedenen Gegenden und Kulturen führte zur Eröffnung von unzähligen Restaurants, die in ihrer Vielfalt unübertroffen waren. So entwickelte sich der Stolz auf die gehobene Gastronomie, den die Bay Area auch mehr als 150 Jahre später noch pflegt. Neue Vermögen, wenn auch eher im Bankwesen als im Bergbau gemacht, bedeuteten Villen in den Hügeln, deren Pracht bald Postkarten im ganzen Land zierten.

San Francisco war plötzlich zu einer der 15 größten Städte des Landes geworden und hungerte nach Nachrichten, lokal und national. Eine Eisenbahn zur Westküste gab es noch nicht. Von Anfang an aber waren Zeitungen in San Francisco ein fester Bestandteil des Stadtlebens, und es wurden Reporter gesucht, um sie zu füllen. Wie schon die Goldsucher kamen sie von überall her und dabei hatten sie nicht nur Zeitungsarbeit im Sinn. Eine Stadt, die gerade dabei war, sich selbst zu definieren, bot mehr Möglichkeiten für farbenfrohe Prosa als fast jeder andere Ort –nicht nur für das Lesevergnügen der Einwohner von San Francisco. Überall wollten man wissen, was in dem weit entfernten Hafen vor sich ging, und einfallsreiche Schriftsteller verstanden schnell, dass die Medien in anderen Städten ihre Berichte bereitwillig druckten.

So begann San Franciscos Literaturszene, in der sich junge Schriftsteller schneller und auf vergnüglichere Art einen Namen machen konnten als irgendwo anders. Einige ihrer Geschichten waren frei erfunden und für Leser geschrieben, die so weit weg

vom Geschehen waren, dass Fakten kein Hindernis darstellten. Manche wurden über Wochen oder sogar Jahre hinweg als Fortsetzungsromane veröffentlicht und wurden so zu beliebten Büchern.

Der berühmteste dieser Journalisten, die als Zeitungsreporter und Kolumnisten in San Francisco anfingen, ist Mark Twain. Er lebte jedoch nur einige Jahre in den 1860ern in der Stadt, und sein bekanntes Zitat „Der kälteste Winter, den ich je erlebt habe, war ein Sommer in San Francisco" stammt auch nicht wirklich von ihm. Ein weiterer war Ambrose Bierce, berühmt für seine Serie *The Devil's Dictionary* und Kurzgeschichten wie „An Occurrence at Owl Creek Bridge"; Frank Norris nutzte die Stadt als Hauptschauplatz für seinen düsteren naturalistischen Roman *McTeague*. Zum wachsenden intellektuellen Leben gehörte auch die Gründung mehrerer Universitäten in der Gegend: zuerst die St. Ignatius Academy (und heutigen University of San Francisco) 1855. Etwa 15 Kilometer in Richtung Osten dann 1868 die University of California in Berkeley.

Die Einflüsse aus der Ferne schufen einen Multikulturalismus, der noch heute ein Merkmal der Bay Area ist. Neben den Überbleibseln der mexikanischen und spanischen Herrschaft über das Land entwickelten sich große irische und italienische Gemeinschaften, dazu kamen Afroamerikaner, Portugiesen und andere. Einige Gruppen waren weniger willkommen als andere, keine jedoch so wenig wie die Chinesen, von denen viele als Arbeitskraft für die transkontinentale Eisenbahn nach Kalifornien kamen. Als diese 1869 im nahen Oakland fertiggestellt wurde, machten Chinesen fast 10 Prozent der Bevölkerung San Franciscos aus.

Chinesische Arbeitskräfte waren für die Anbindung der Bay Area an den Rest des Landes unersetzlich gewesen, trotzdem wurde ihre Anwesenheit oft als Bedrohung angesehen. Gewaltsame Gruppen weißer Arbeiter griffen wiederholt chinesische Gemeinden in San Francisco und entlang der Westküste an. In den Medien stellten Karikaturen sie als hinterhältige Eindringlinge dar, was bereits verbreitete Vorurteile nur verstärkte, und 1882 im Chinese Exclusion Act gipfelte, der chinesischen Arbeitern die Einwanderung in die USA komplett verbot. Diejenigen, die übrig blieben, waren ein schon fester Bestandteil des Stadtlebens, ins-

The Sea-Wolf, *Jack London, 1904.*

besondere in den paar Dutzend Straßen nördlich von Downtown, wo die meisten von ihnen wohnten und ihre Bräuche und Küche pflegten. Chinatown ist auch heute noch ein lebendiges Viertel, das schon früh als exotische Touristenattraktion ausgenutzt. Diskriminierung gegen die Bewohner bei der Wohnungssuche und am Arbeitsplatz verhinderte dies jedoch nicht, und lange Zeit blieben sie von politischen Entscheidungen ausgeschlossen.

Die 1860er waren ein Jahrzehnt von astronomischem Wachstum, die Einwohnerzahl verdreifachte sich fast auf etwa 150 000. Straßen waren durch von Tieren gezogene Karren, Kutschen und Straßenbahnen verstopft. Neue Transportmittel wurden benötigt, um Passagiere und Fracht die steilen Hügel hinauf und hinunterzubringen. 1873 wurde die erste San Francisco Kabelstraßenbahn, die Cable Cars, in Betrieb genommen, die bald zu den Wahrzeichen der Stadt zählten. Heute sind nur noch wenige Linien in Betrieb und werden vor allem von Touristen genutzt. Im 19. Jahrhundert war das noch anders, 1890 gab es 23 Linien. Aber auch damals war es schon ein Schauspiel, wenn sie Menschenmengen von einem Ort zum anderen brachten.

Die damaligen Fahrgäste brauchten mehr Platz für ihre Familien. In den 1870er-Jahren wurde ein Stück Land, fünf Kilometer lang und fast einen Kilometer breit, zum Golden Gate Park ausgebaut, der am Ocean Beach im Pazifik endete. Die trostlosen Sanddünen verwandelten sich in eine Grünfläche mit 150 000 Bäumen. Auch wenn er nicht dem natürlichen Ökosystem der Region entsprach, wurde der Park sehr beliebt. Das lag nicht nur am Grün, denn schon bald kamen Museen und Gärten hinzu. Das 1878 errichtete Conservatory of Flowers und der japanische Teegarten, der 1894 folgte, wurden von Touristen und Einwohnern gleichermaßen frequentiert und sowohl für ihre elegante Bauweise als auch die vielseitige Pflanzenwelt gelobt. Nachdem 1894 die Weltausstellung Mid-Winter California Exposition im Park stattgefunden hatte, kamen das Museum de Young und immer mehr Freizeiteinrichtungen dazu, inklusive einem der ersten Kinderspielplätze.

Auch die urbanen Gebiete San Franciscos, noch immer größtenteils auf der Ostseite der Halbinsel, hatten ihre eigenen

visuelle Highlights. In Nob Hill bauten einige der größten Finanzbarone der damaligen Zeit ihre Villen, unter ihnen die Eisenbahnmagnaten Charles Crocker, Mark Hopkins, Collis Potter Huntington und Leland Stanford. Ähnlich opulente Hotels wurden errichtet, um die wachsende Zahl wohlhabenderer Geschäftsreisender und Touristen zu beherbergen. Als es 1875 gebaut wurde, war das Palace Hotel, das direkt an der Market Street in Downtown liegt, mit 775 Zimmern das größte Hotel im Westen der USA. Von manchen wegen ihrer Gier nach immer größerem Reichtum auch als Räuberbarone bezeichnet, versuchten einige dieser Industriellen, ihren Ruf durch Philanthropie zu verbessern. In der Nähe seines Anwesens mit Blick auf Ocean Beach baute Adolph Sutro – der sein Vermögen mit dem Silber der Comstock Lode in Nevada gemacht hatte – die Sutro Baths, einen glasüberdachten Bade- und Unterhaltungskomplex in der Nähe von Lands End, wo die Bucht in den Ozean mündet. 1894 eröffnet, kam schon bald das Cliff House hinzu, ein Restaurant mit einem unvergleichlichen Blick auf die Felsen, auf denen sich Seelöwen vor der Küste sonnten.

In San Francisco reihte sich nun ein Juwel ans andere, seien es die neuen Parks, Villen, Hotels oder die natürliche Küstenlandschaft, die von den Hügeln aus schon immer ein großartiger Anblick gewesen war. Die Fotografie entstand etwa gleichzeitig mit San Francisco, und nur wenige Gegenden boten so viele dankbare Fotomotive. Mehrere Pioniere der Fotografie machten im 19. Jahrhundert zahlreiche Bilder von der Bay Area, darunter Carleton E. Watkins, G. R. Fardon, Eadweard Muybridge und Arnold Genthe. Wenn die Fotografie auch noch nicht als Kunstform angesehen wurde, fanden ihre Werke dennoch ein Publikum durch ein anderes neues Medium: international vertriebene Postkarten.

Trotz der unvermeidlichen finanziellen Engpässe, die explosives Wachstum mit sich bringt, blühte San Francisco um die Jahrhundertwende auf. Mit knapp 350 000 Einwohnern war die Stadt eine der zehn größten der Vereinigten Staaten. Der Hafen war der geschäftigste der Westküste, doch bald wurde die Stadt in diesem und anderen Belangen vom südlichen Rivalen, Los Angeles, überholt. Stadtplaner Daniel Burnham entwarf 1905 einen Stadtplan mit

McTeague: A Story of San Francisco,
Frank Norris, 1899.

breiten Boulevards, die vom Civic Center ausgingen und die Innenstadt tatsächlich einem Paris des Westens hätten ähneln lassen.

Das Ballungsgebiet Bay Area wuchs auch über die nur 18 Quadratkilometer umfassenden Stadtgrenzen hinaus. Anwohner und Unternehmen begannen, sich in Marin County im Norden oder in Oakland und Berkeley in der East Bay anzusiedeln, manche sogar in Richtung Süden, bis zum 95 Kilometer entfernten San Jose. Am Ende der Market Street befand sich eine Drehscheibe für den Pendlerverkehr mit dem neuen Ferry Building, Brücken über die Bucht gab es noch keine.

Doch das Fundament für San Franciscos Infrastruktur war nicht so stabil, wie es den Anschein hatte. Dies zeigte sich, als die Stadt am Morgen des 18. April 1906 von einem Erdbeben der Stärke 7,9 getroffen wurde. Die ersten Schäden waren schon groß genug und viele Gebäude im Finanzdistrikt stürzten ein, darunter auch das neu eröffnete Rathaus. Doch das Schlimmste kam erst noch, als gebrochen Gasleitungen zusammen mit umgestürzten Laternen und Kerzen Brände auslösten, die einen Großteil San Franciscos in ein Inferno verwandelten. Auch die für die Brandbekämpfung nötigen Wasserleitungen waren geborsten. So konnte die Feuerwehr nicht viel gegen das Feuer unternehmen, das für etwa 80 Prozent der Schäden verantwortlich war.

Es gibt keine genauen Zahlen, aber bis zu 3 000 Menschen starben und mehr als 80 Prozent der Stadt wurden zerstört. Etwa 250 000 Menschen – mehr als die Hälfte der Bevölkerung – wurden obdachlos, darunter auch ehemalige Bewohner der größten Villen in Nob Hill. Viele Parks wurden zu Flüchtlingslagern, so auch der Golden Gate Park. 70 000 Menschen suchten Schutz in der riesigen Militärfestung Presidio an der Nordspitze der Halbinsel. Es gab Brände und Erdbeben in San Francisco schon seit die Stadt einen Namen hatte, aber noch nie in diesem Ausmaß. Selbst Soforthilfen in Höhe von mehreren Millionen Dollar durch die Regierung und Spenden aus anderen Teilen der USA sowie einigen anderen Ländern konnten den enormen Sachschaden von fast 500 Millionen Dollar kaum decken. Der Wiederaufbau sollte eine enorme Menge an Geld und Arbeit in Anspruch nehmen.

San Franciscos wertvollster Schatz waren nun seine Einwohner. Sie mochten obdachlos und verarmt sein, aber es war ihre Aufgabe, eine weitgehend zerstörte Stadt wieder aufzubauen: eine Aufgabe, die sie mit Großzügigkeit und Einfallsreichtum bewältigten. Neben den provisorischen Städten auf den ehemaligen Freiflächen San Franciscos entstanden Pop-up-Cafés, die wenig mehr waren als eilig aus den Trümmern gezimmerte Buden.

Es stand eine Menge harter Arbeit an, die Zahl der Bauarbeiter verdreifachte sich bis zum Jahresende. Weil es schnell gehen musste, wurde Burnhams ehrgeiziger Stadtplan mit den großen Boulevards wurde verworfen. Er wäre selbst in besseren Zeiten finanziell kaum zu stemmen gewesen, aber jetzt ging es darum, die Stadt so schnell wie möglich wieder auf die Beine zu bringen, auch wenn man dafür an Kreativität sparen musste. Bis 1910 waren die meisten der zerstörten Gebäude ersetzt worden. Genauso wichtig war, dass diese Gelegenheit genutzt wurde, um sich gegen ähnliche Katastrophen in der Zukunft zu schützen. In vielen der neuen Gebäude wurden feuerfester Stahl und Stahlbeton verbaut. Das neue Rathaus wurde Ende 1915 eingeweiht. Es ist das größte Gebäude des Civic Center, in dem sich einige der wichtigsten Bürger- und Kultureinrichtungen San Franciscos befinden, darunter ein Opernhaus und die Hauptstelle der Stadtbibliothek.

San Francisco war nicht nur wieder aufgebaut. Allen Widrigkeiten zum Trotz zeigte es seinen neuen Glanz auf einer Weltausstellung, die unweit von dem Ort entfernt stattfand, an dem das Erdbeben die größten Schäden angerichtet hatte. Die modernsten Technologien der damaligen Zeit waren unter den Exponaten der Panama-Pacific International Exposition, die auf zweieinhalb Quadratkilometern am nördlichen Ufer zwischen Fort Mason und dem Presidio stattfand. Das Ausstellungsgelände ähnelte einer kleinen Stadt, mit speziell erbauten Hallen und Boulevards, deren Höhepunkt der 132 Meter hohe Tower of Jewels war, den nachts mehr als 50 elektrische Scheinwerfer beleuchteten. Die Ausstellung zeigte, dass San Francisco sich nicht nur von dem Erdbeben erholt hatte, sondern auch zur Weltstadt geworden war. Leider blieb nur eines der für die Weltausstellung errichteten

San Francisco Through Earthquake
and Fire, *Charles Keeler, 1906.*
Heritage Auctions, HA.com

Bauwerke übrig, nachdem die Messe Ende 1915 abgebaut wurde: der Palace of Fine Arts, noch heute eines der wichtigsten Wahrzeichen der Stadt. Die Rotunde und Kolonnaden direkt an der Lagune werden immer noch von Besuchern und Anwohnern des Marina District, in dem er sich befindet, bestaunt.

Kurz vor dem Eintritt der USA in den Ersten Weltkrieg wurde das Gebiet um die Stadt auch strategisch immer wichtiger. Das Presidio galt als erste Verteidigungslinie der Westküste, und sowohl dort als auch in den Hügeln von Marin County auf der anderen Seite der Meerenge befanden sich Forts zum Schutz vor Invasionen. Die Regierung fand zudem Verwendung für zwei in der Bucht gelegene Inseln: auf Alcatraz entstand ein Militärgefängnis, auf Angel Island eine Einwanderungsstation, in der viele aus Asien stammende Immigranten abgefertigt und oft monatelang an der Einreise gehindert wurden. Der Krieg fand keine allgemeine Zustimmung. Am 22. Juli 1916 wurde bei einer Pro-Kriegs-Parade in der Market Street eine Rohrbombe gezündet, zehn Menschen wurden getötet und mehr als 40 verletzt. Zwei Verdächtige wurden verurteilt, die man, wie manche glauben, zu Unrecht beschuldigte. Der eine, Tom Mooney, wurde 1939 begnadigt; der andere, Warren Billings, kam 1939 frei und wurde erst 1961 begnadigt.

Kein Feind näherte sich dem Golden Gate, doch als der Krieg zu Ende ging, erreichte die Grippepandemie, die sich über den Erdball ausbreitete, im Herbst 1918 auch San Francisco. Um die Infektionswelle einzudämmen, verteilte das Rote Kreuz Stoffmasken, und sogar Gerichtssitzungen wurden im Freien abgehalten. Mit fast 45 000 Fällen und mehr als 3 000 Toten war San Francisco stärker betroffen als alle anderen Städte der USA.

Mit dem 18. Zusatzartikel zur Verfassung im Jahr 1919 begann die Prohibition, die Stadtverwaltung zeigte aber wenig Interesse an einer Durchsetzung des Verbots. Während der Amtszeit von Bürgermeister Sunny Jim Rolph in den 1910er-Jahren kam an der Barbary Coast zu einer von Pfarrer Paul Smith und dem Zeitungstycoon William Randolph Hearst geleiteten Säuberungsaktion, bei der Bordelle geschlossen und Vergnügungen in Saloons so gut wie unterbunden wurden. Im Kontext der Verabschiedung

des Frauenwahlrechts in Kalifornien 1912 konnte dies auch als Teil einer umfassenderen Kampagne gesehen werden, die unabhängige berufstätige Frauen zum Ziel hatte und sogar gegen Tanzsäle vorging, die Frauen ohne männliche Begleitung besuchen konnten. Die meisten Etablissements waren jedoch einfach in andere Stadtteile gezogen, vor allem in den Tenderloin, nur wenige Blocks vom Civic Center entfernt. Während der Prohibition war die Küste der Bay Area ein Paradis für Schwarzbrenner, es gab in San Francisco mehr Bars und Alkoholkonsum als in jeder anderen Stadt.

San Franciscos Unterwelt erreichte nicht dieselbe Größe wie die New Yorks oder Chicagos, trotzdem konnte man illegalen Alkohol oder zwielichtige Geschäfte rund um Schmuggel, Drogen und Prostitution finden, wenn man wusste, wo man danach suchen sollte. Genau wie in anderen Großstädten machte die Korruption der Regierung und der Polizei ein ernsthaftes Vorgehen dagegen – geschweige denn ein Verhindern – unwahrscheinlich. Sie lieferten aber das Material für die Geschichten des berühmtesten Autors der Ära, Dashiell Hammett. Als Pinkerton-Detektiv hatte er über Jahre Erfahrungen in der Szene gesammelt und verlieh so der Stadt in seinen berühmtesten Kriminalromanen eine verführerische Zwielichtigkeit, insbesondere in *Der Malteser Falke.* Die Adaption wurde zu einem der beliebtesten Filme, die in San Francisco spielen, mit Humphrey Bogart als Sam Spade.

Auf manche Arten waren die Roaring Twenties gut zu San Francisco. Als die Einwohnerzahl eine halbe Million überschritt, entstanden in einigen, bis dahin relativ unerschlossenen, westlichen Bezirken wie Sea Cliff neue Stadtviertel, in denen heute einige der teuersten Häuser der Bay Area tatsächlich einen Ausblick auf Meer und Klippen bieten. Andere Gegenden wie das Fillmore und die Western Addition beheimateten besonders viele ethnische Minderheiten, vor allem japanische Amerikaner und (bis nach dem Zweiten Weltkrieg) die große jüdische Gemeinde.

All das wurde 1929 durch den Börsencrash unterbrochen. Doch die folgende Weltwirtschaftskrise konnte die Expansion der Stadt nicht aufhalten, und im nächsten Jahrzehnt veränderte sich ihre Skyline durch den Bau des heute ikonischsten Gebäudes.

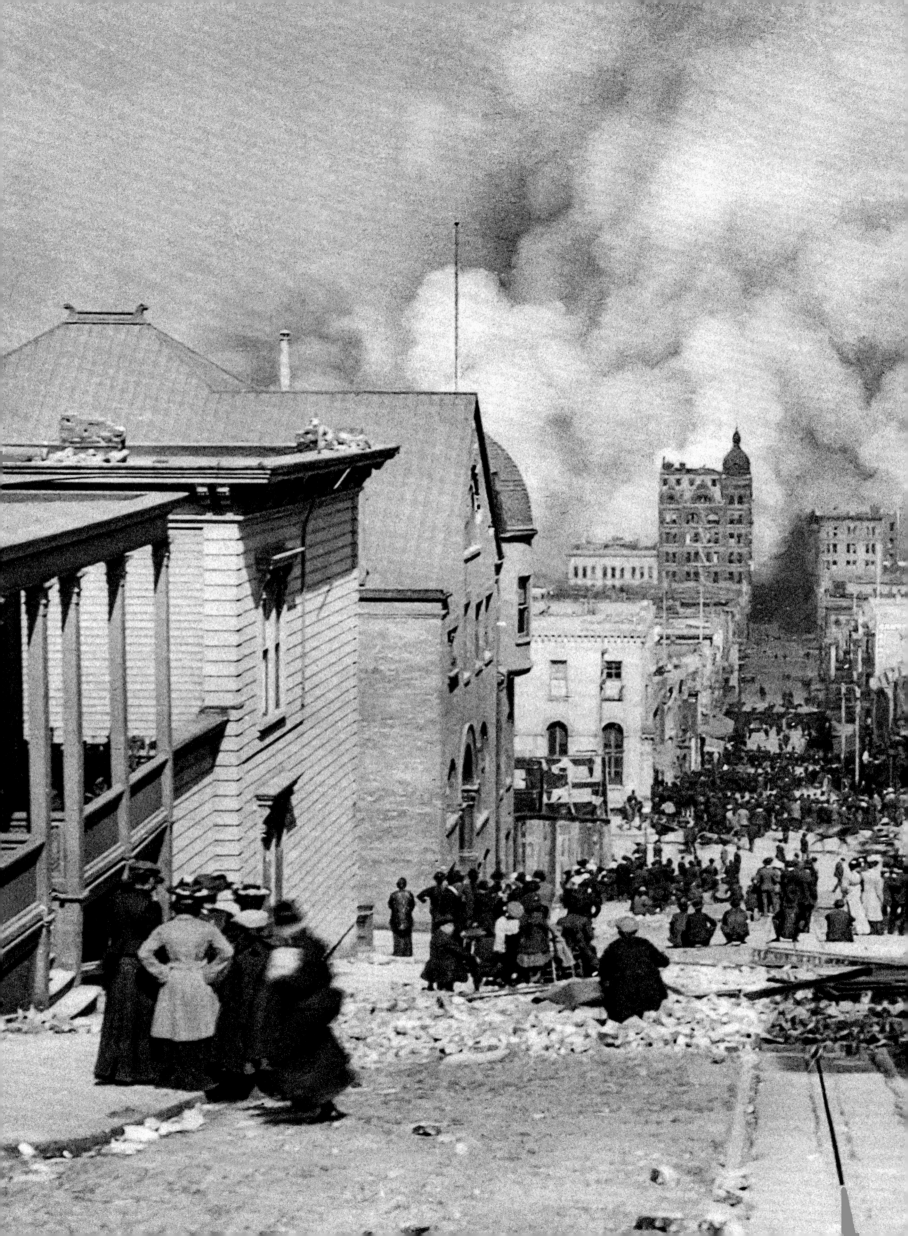

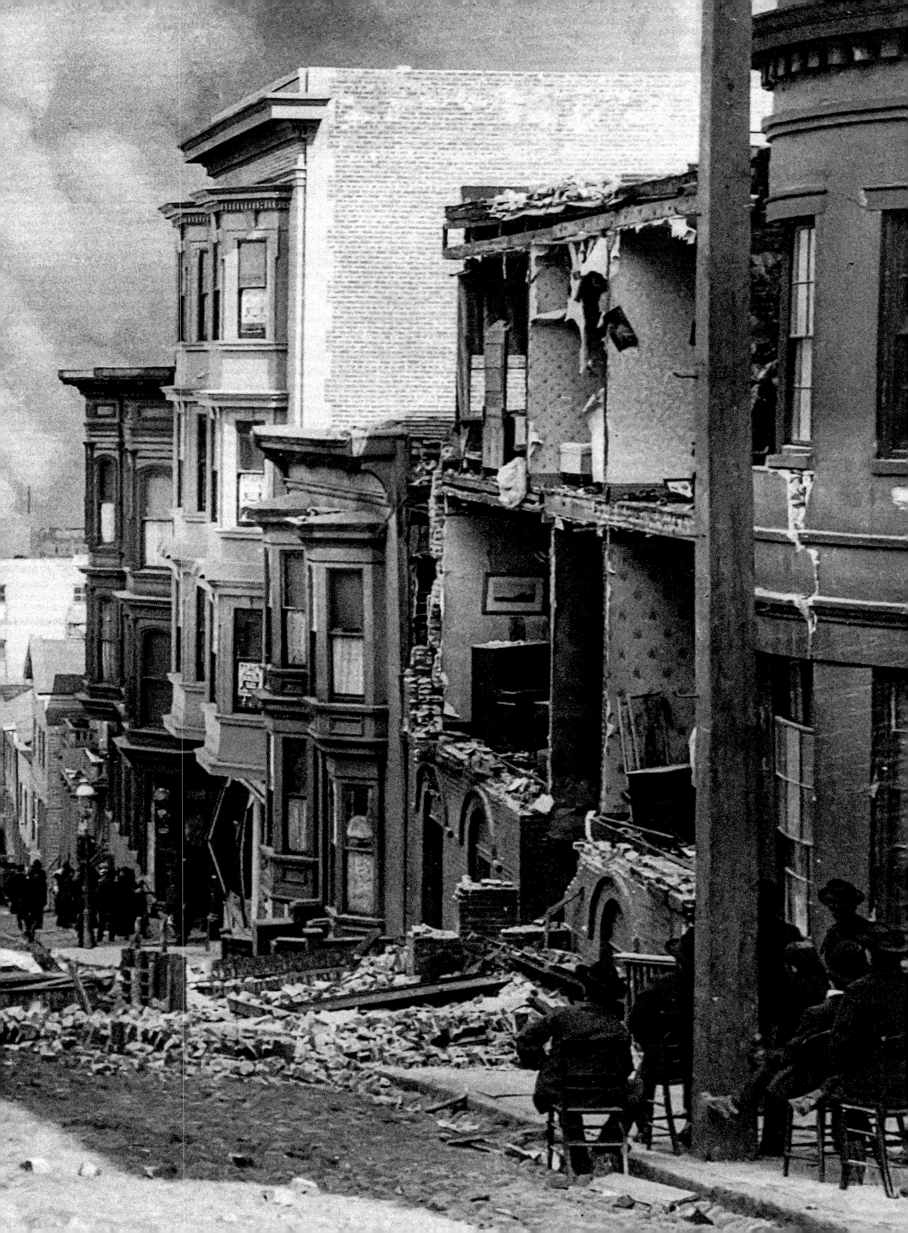

#1

Une ville sur la baie 1846–1929

p. 20/21
Arnold Genthe

Stunned San Franciscans look down Sacramento Street toward the bay as buildings crumble and fires rage after the city was hit by its worst earthquake. As photographer Arnold Genthe wrote in As I Remember *"Groups of people are standing in the street, motionless, gazing at the clouds of smoke. When the fire crept up close, they would just move up a block." April 18, 1906.*

Fassungslos blicken Einwohner von San Francisco die Sacramento Street in Richtung Bucht hinunter, auf einstürzende Gebäude und das Feuer, welches auf das bis dato schwerste Erdbeben folgte. Der Fotograf Arnold Genthe schrieb in As I Remember: *„Gruppen von Leuten stehen in den Straßen, bewegungslos, und blicken auf die Rauchwolken. Wenn das Feuer näherkommt, gehen sie einfach einen Block weiter", 18. April 1906.*

Du haut de Sacramento Street, la population sidérée regarde vers la baie alors que la ville vient d'être frappée par le pire séisme de son histoire. Les bâtiments s'effondrent, les incendies font rage. « Figés, les gens se regroupent dans la rue et contemplent les nuages de fumée. Lorsque le feu se rapprochait, ils reculaient simplement quelques maisons plus haut », écrit le photographe Arnold Genthe dans As I Remember. *18 avril 1906.*

Depuis que la Californie a rejoint l'Union américaine en 1850, San Francisco est le diamant de la côte Ouest. Ses collines escarpées, ses parcs magnifiques et les splendides panoramas entre terre et mer ont fait d'elle non seulement l'une des premières destinations touristiques au monde mais également le pôle d'attraction de millions de rêveurs, d'aventuriers ambitieux et d'innovateurs intrépides à qui l'on doit certaines des avancées sociales, technologiques et artistiques les plus visionnaires du siècle dernier.

Que l'on s'y rende en visite ou pour s'y installer, il s'agit d'une ville singulière aux États-Unis, pour des raisons qui dépassent son seul cadre pittoresque. Entre toutes les cités américaines, elle irradie l'atmosphère la plus européenne. La vie urbaine y est dynamique, cafés et restaurants abondent, tout comme les espaces naturels ouverts à la convivialité. C'est son échelle humaine qui rend San Francisco si facile à vivre, beaucoup plus agréable à explorer à pied qu'au volant… et, à cet égard, quasiment unique en son genre parmi les grandes agglomérations du pays. La diversité culturelle de ses quartiers et de sa population insuffle une énergie cosmopolite à l'image des conversations enflammées où s'entendent l'espagnol, le cantonais, entre autres langues, tout autant que l'anglais. Son architecture, aussi élégante qu'insolite, ne cesse d'émerveiller et d'étonner, depuis le chapelet de maisons victoriennes du quartier d'Alamo Square, les *Painted Ladies*, jusqu'à certains des gratte-ciel les plus élevés de la côte Ouest… sans oublier les peintures murales du Mission District, dont les thématiques débordant de fierté «latino» bondissent littéralement d'une façade à l'autre.

Le climat lui-même est hors norme. Il n'est pas rare que l'horizon s'obscurcisse d'un brouillard qui tombe et se déplace à une vitesse imprévisible. La température peut chuter de dix à quinze degrés en quelques minutes; par le jeu des microclimats, il fera doux sous le soleil du Mission District et presque glacial 2 kilomètres plus loin vers la baie, au cœur d'une épaisse brume. Au début, l'ébahissement est grand de constater la fraîcheur de l'air en plein été, voire le froid mordant, comme si l'universelle réputation de la Californie, terre de soleil perpétuel, devait être écornée. Les «nuits chaudes de San Francisco» que chantaient les Animals au temps béni du «Summer of Love» relèvent en grande partie du mythe. Cela dit, la présence récurrente du brouillard épargne à la ville, en général, les épisodes de canicule. La chute du mercure en dessous de zéro étant aussi inhabituelle, son climat tempéré, *in fine*, aura bien servi San Francisco, destination prisée de millions de visiteurs depuis sa fondation.

Les premiers colons sont arrivés dans la baie de San Francisco longtemps avant que la ville ne prît ce nom. Il est probable que la tribu Ohlone vivait dans la région entre trois et cinq mille ans avant l'apparition des Européens. Vers 1770, son mode de vie ancestral a été bouleversé lorsque les explorateurs espagnols ont installé des avant-postes à proximité de la zone où la baie rencontre le Pacifique. À l'aube des années 1820, quand la région passa aux mains des Mexicains, les autochtones avaient déjà été quasiment décimés à force de déplacements contraints et de maladies importées du Vieux Continent, sort commun à la plupart des peuples amérindiens. Aussi charmant fût ce fin détroit, le potentiel commercial et résidentiel de la zone, au cours du quart de siècle suivant, est resté sous-estimé. En 1846, le jour où le drapeau américain a été hissé sur la place qui n'allait pas tarder à se voir rebaptiser «Portsmouth Square», la péninsule de San Francisco n'était encore plus ou moins qu'un village, occupé par un assortiment hétéroclite de commerçants, de fermiers et de vagabonds. La colonie qui porte toujours le nom de Yerba Buena était alors si maigre qu'après l'arrivée de quelque 240 mormons, cette même année, sa population fit plus que doubler. Trente ans plus tard, Yerba Buena deviendra San Francisco, en l'honneur de la mission Saint-François-d'Assise édifiée par les Espagnols dans ce qui constitue de nos jours le Mission District.

San Francisco serait demeurée un point anodin sur la carte si son statut n'avait soudain changé, à dater du 24 janvier 1848. Ce jour-là, 200 kilomètres plus haut dans les contreforts de la Sierra Nevada, un ouvrier d'une scierie découvrit des particules d'un métal singulièrement brillant. La ruée vers l'or venait de démarrer, qui aimantera des dizaines de milliers d'aspirants prospecteurs accourus de partout. Arrivés nombreux par voie maritime, les nouveaux venus feront de San Francisco et de son port la première étape de leur voyage. Impatients de faire fortune, la plupart d'entre eux le poursuivront dès que possible vers le nord : la baie se couvrit de centaines de bateaux vides, abandonnés par les chercheurs d'or qu'ils avaient transportés et par nombre d'équipages saisis du même émoi. La ville, elle, ne sera pas désertée. Les arrivants avaient besoin d'outils, de fournitures, de murs où se loger, de loisirs et de banques. À la fin des années 1840, San Francisco comptait déjà 25 000 habitants. À mesure que s'épuiseront les réserves du nouvel Eldorado et bien des espérances, quantité de déçus préféreront rester sur place plutôt que de retourner à leur point de départ. Ainsi en 1860 la population avait-elle encore plus que doublé, transformant l'ancienne Yerba Buena en ville-champignon de près de 60 000 âmes.

Cette croissance explosive, sans précédent dans l'histoire de l'Ouest des États-Unis, n'alla pas de soi. La construction de logements peinait à en suivre le rythme et beaucoup de gens se retrouvèrent sans abri adéquat, un fléau toujours d'actualité. Aujourd'hui encore subsistent certains de ces bâtiments alors édifiés à la hâte dans des rues étroites obligées de se frayer un chemin au hasard d'une topographie particulièrement escarpée. Déjà souvent instables, ces nouvelles structures allaient aussi devoir faire face à la menace des séismes périodiques.

L'infrastructure sociale n'était pas moins précaire que les fondations physiques. La ruée vers l'or n'attira pas qu'une foule de mineurs durs à la tâche et avides d'aventure, mais aussi toutes sortes d'opportunistes en mal de sensations fortes. Le crime et l'immoralité prospéraient, la moindre denrée se négociait à des tarifs exorbitants et la législation était chaotique. Au début, la prévalence masculine favorisa l'essor de la prostitution. Il en alla de même des jeux d'argent, de l'alcool et d'autres formes de trafics; la masse des profanes fraîchement débarqués représentait une cible idéale. L'essentiel de ces affaires louches s'épanouissait dans le quartier de Barbary Coast, à proximité de la zone que délimitent aujourd'hui Chinatown, North Beach et le centre-ville.

Dans cette sorte de Far West en phase d'urbanisation, l'inexpérience de l'administration favorisait la cupidité et la corruption. Duels et meurtres impunis couraient les rues, jusqu'à impliquer des «pères fondateurs» dont certaines voies et institutions honorent encore la mémoire. Face à la multiplication des

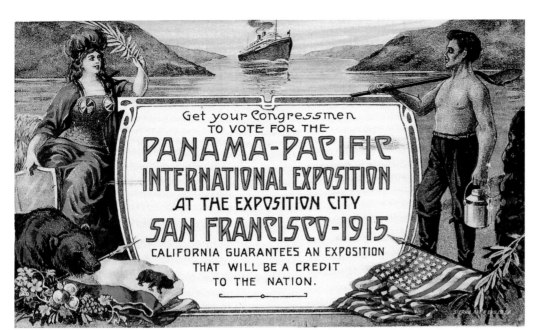

Postcard from the Panama–Pacific
International Exposition, 1915.
Heritage Auctions, HA.com

fraudes en tout genre et au caractère aléatoire de l'application
de la loi, il se trouva des citoyens pour décider de se faire justice
eux-mêmes en formant des comités de vigilance. D'où que vînt la
violence, ses victimes se comptaient souvent parmi les nombreuses
minorités ethniques engagées dans la ruée vers l'or, à commencer
par les Chinois.

Pourtant, alors que le crime et sa fulgurante croissance
menaçaient de l'abattre presque aussi vite qu'elle s'était édifiée,
San Francisco se changea peu à peu en métropole cosmopolite,
à l'image des villes de la côte Est. Théâtre et opéra rencontrèrent
un vif succès. L'arrivée de nouveaux résidents issus de tant de
lieux et cultures différents stimula la floraison d'une multitude
de restaurants à la diversité inégalée : plus d'un siècle et demi
après, sa gastronomie fait toujours la fierté de la « Bay Area ». La
manne d'argent frais eut beau profiter aux banques plus qu'au
secteur minier, elle se concrétisa par l'apparition à flanc de colline
de splendides demeures dont la majesté eut tôt fait d'illustrer les
cartes postales expédiées aux quatre coins des États-Unis.

Promue parmi les quinze plus grandes villes d'Amérique,
San Francisco se montra aussi désireuse de s'informer sur son actua-
lité locale que d'en savoir plus sur le reste du pays. À l'époque, le
chemin de fer qui relierait un jour les deux côtes n'avait pas encore
dépassé le stade du projet. Du coup, les journaux ont constitué
un élément essentiel de la vie de la cité, et il fallut dénicher des
plumes capables d'en noircir les pages. Comme les chercheurs d'or,
elles allaient venir de partout, d'au-delà même des océans. Pour
l'écriture, rares sont les lieux aussi inspirants qu'une ville saisie alors
qu'elle est en train de se forger une identité. Pas question, dès lors,
de cantonner à ses seuls habitants le plaisir de lecture : les premiers
rédacteurs à s'être jetés à l'eau constatèrent rapidement que le
monde fourmillait de lecteurs curieux de découvrir le quotidien de
ce port aussi farouche que lointain, et de journaux impatients de
relayer leurs récits. Ainsi naquit la scène littéraire de San Francisco
où les jeunes écrivains brillants pouvaient se faire un nom plus
vite et peut-être plus plaisamment qu'ailleurs. Certains de leurs
reportages ne s'embarrassaient pas de véracité, clairement romancés

à destination de lecteurs si éloignés de l'action que le crédit de l'au-
teur n'était pas en péril. Ils étaient parfois publiés en feuilleton, des
semaines voire des années durant, pour finir en succès de librairie.

Bien que son passage, à partir de 1864, ne s'y fût pas pro-
longé au-delà de quelques années, et qu'il n'eût en réalité pas écrit
ni prononcé la fameuse pique selon laquelle «l'hiver le plus froid
[qu'il eût] jamais passé fut un été à San Francisco», Mark Twain est
le plus célèbre de ces journalistes qui commencèrent leur carrière
en qualité de reporters et de chroniqueurs pour la presse de San
Francisco. Ambrose Bierce, dont le *Dictionnaire du diable* a forgé la
renommée, en est un autre. Frank Norris prit la ville pour décor
principal de son roman *McTeague*, au naturalisme âpre. Le dévelop-
pement de la communauté intellectuelle bénéficia également de la
naissance de plusieurs universités, dès 1855 l'Académie Saint-Ignace
(future Université de San Francisco), suivie en 1868 de l'autre côté
de la baie par l'Université de Californie à Berkeley.

L'afflux de sang neuf et diversifié généra un multicultura-
lisme qui reste l'une des marques de fabrique de la région. Outre
les descendants des anciens colons mexicains et espagnols, de
fortes communautés irlandaises et italiennes s'y sont implantées,
imitées par des immigrants aux origines multiples – afro-amé-
ricaine, portugaise… – qui formèrent à leur tour des poches de
population spécifiques. Certains groupes ont été moins bien
accueillis que d'autres, surtout les Chinois, attirés en Californie,
surtout, par la perspective de travailler sur le premier chemin de
fer transcontinental, le Pacific Railroad. Peu après son achève-
ment dans la périphérie d'Oakland en 1869, ils représentaient près de
10 % de la population de San Francisco. Si essentielle fût cette
main-d'œuvre pour lier la baie au reste du pays, elle était souvent
perçue comme une menace. À plusieurs reprises, les communautés
chinoises eurent à endurer de violentes agressions perpétrées
par des groupes d'ouvriers blancs. Les caricatures présentent les
étrangers comme autant d'intrus sournois confortaient un préjugé
largement répandu qui déboucha sur le Chinese Exclusion Act,
une loi fédérale prohibant l'immigration des travailleurs chinois.
Ceux qui sont restés étaient les mieux intégrés, notamment au

Wild Women, *John "Jack" Ford, Universal
Pictures, 1918.
Heritage Auctions, HA.com*

nord du centre-ville, dans le secteur où ils s'efforçaient de préser-
ver les coutumes de leur pays natal. Chinatown est toujours un
quartier dynamique, densément peuplé, dont l'exotisme n'a jamais
manqué d'être exploité comme une attraction touristique en soi.
Pour autant, ses habitants n'ont pas échappé aux discriminations
en matière de logement et de travail, ainsi qu'à une durable mise
à l'écart de la gestion locale.

Les années 1860 ont été marquées par une croissance effré-
née. La population passa quasiment du simple au triple, frisant les
150 000 habitants au terme de la décennie. Les rues étaient encom-
brées de charrettes à cheval ou à bœuf, de calèches, de cabriolets,
de tramways. Il fallut imaginer de nouveaux modes de transport,
aussi ingénieux que possible, pour véhiculer passagers et marchan-
dises à travers les rues pentues d'une ville bâtie sur des collines.
Introduits en 1873, les premiers *cable cars*, ces tramways tractés par
un filin d'acier, seront vite identifiés à San Francisco. Leur usage,
aujourd'hui, se réduit principalement aux touristes et à une poi-
gnée d'itinéraires mais au XIXᵉ siècle, quand ils affichaient jusqu'à
23 lignes opérationnelles, leur utilité était inestimable. Même à
l'époque, le spectaculaire panorama proposé à leurs nombreux
utilisateurs justifiait à lui seul le voyage.

Avec l'enracinement et l'agrandissement des familles vint
la quête d'espaces moins congestionnés. Entre 1860 et 1870, la
ville aménagea un grand rectangle de 4 kilomètres carrés et demi
qui s'étendait jusqu'aux rives du Pacifique, à hauteur d'Ocean
Beach, pour en faire le Golden Gate Park. Assez désolée et presque
inhabitée, dominée par des dunes sablonneuses, la zone se méta-
morphosa en un luxuriant espace vert planté de 150 000 arbres.
Sans doute ne reflétait-il pas l'écosystème naturel de la région,
mais le parc n'en connut pas moins un immense succès populaire
; musées et jardins, en effet, vinrent sans délai renforcer son pou-
voir d'attraction. Le conservatoire des fleurs implanté en 1878 et le
jardin de thé japonais en 1894 furent illico envahis par les touristes
comme par les résidents, qui encenseront à la fois leur architecture
gracieuse et leur végétation composite. Après l'organisation dans le
parc, en 1894, de la California Midwinter Fair, ces créations seront

rejointes par le musée De Young et toujours davantage d'équipe-
ments de loisirs.

Les quartiers littéralement urbains, concentrés à l'est de
la péninsule, ne manquaient pas non plus de charmes visuels. Les
opulentes demeures de Nob Hill avaient été édifiées par de grands
barons de la finance. Des hôtels tout aussi luxueux sortirent de
terre afin d'accueillir touristes et voyageurs d'affaires fortunés. Avec
ses 775 chambres, le Palace Hotel, juste à côté de Market Street, la
principale artère du centre-ville, trônait lors de son inauguration
en 1875 comme le plus grand hôtel de l'Ouest. Parfois qualifiés de
« barons voleurs », certains des industriels précités s'évertuaient à
rectifier leur image à grand renfort de projets philanthropiques.
À deux pas de sa propriété nichée en surplomb d'Ocean Beach,
Adolph Sutro, qui avait fait fortune grâce au gisement d'argent du
Comstock Lode, développa les Sutro Baths. Coiffé d'une vaste ver-
rière, cet établissement de bains et de loisirs se dressait non loin de
l'embouchure de la baie, à Lands End. Ouvert en 1896, il accueillit
la même année la reconstruction de la Cliff House, un restaurant
haut perché offrant une vue imprenable sur les îlots rocheux où
les otaries viennent se dorer au soleil.

Manoirs, hôtels, parcs, paysages naturels en bord de
mer admirés depuis les innombrables hauteurs de la ville : San
Francisco, qui avait vu le jour à peu près en même temps que la
photographie, se découvrait constellée de merveilles. Les régions
à même de proposer autant de tableaux dignes d'être couchés sur
la pellicule n'étaient pas si nombreuses, et celle-ci inspira plu-
sieurs pionniers de la photo, dont Carleton Watkins, G.R. Fardon,
Eadweard Muybridge et Arnold Genthe. Si la discipline n'était pas
encore considérée comme un art à part entière, leurs photos ren-
contrèrent un vaste public grâce à un autre nouveau support : les
cartes postales désormais distribuées à l'échelle internationale.

Au tournant du siècle, San Francisco se trouvait donc,
à bien des égards, en plein essor, malgré les cahots financiers inhé-
rents à toute croissance foudroyante. Avec près de 350 000 habi-
tants, elle figurait parmi les dix plus grandes villes des États-Unis.
Son port était le plus actif de la côte Ouest avant de se voir

Greed, *Erich von Stroheim, Metro-Goldwyn-Mayer, 1924.*
Heritage Auctions, HA.com

dépasser, en la matière comme sur d'autres plans, par Los Angeles, la rivale méridionale portée par une expansion encore plus rapide. En 1905, un projet d'embellissement aurait pu faire ressembler San Francisco à un Paris américain, avec de larges boulevards rayonnant à partir du Civic Center, mais les événements en décideraient autrement. L'agglomération formée par la baie de San Francisco s'était également étendue au-delà des limites relativement étroites de la ville (environ 127 kilomètres carrés). Résidents et entreprises entreprirent d'annexer le comté de Marin au nord, Oakland et Berkeley à l'est, et de pousser vers le sud jusqu'à San José. Le bas de Market Street, face au nouveau terminal des ferries, faisait office de plaque tournante pour la circulation suburbaine, quand l'idée d'ériger des ponts qui chevaucheraient la baie n'était encore que spéculation.

L'assise de San Francisco n'était pourtant pas aussi stable qu'on aurait pu le croire. Au matin du 18 avril 1906, à 5 heures 12, le sol trembla, frappé par un séisme de magnitude 7,9 sur l'échelle de Richter. Les premiers dégâts se traduisirent par l'effondrement de l'hôtel de ville, qui venait d'ouvrir, et de divers bâtiments du quartier financier. Le pire restait à venir, car les incendies déclenchés par les ruptures de conduites de gaz naturel et les chutes de lanternes et de chandeliers transformèrent une grande partie de la ville en fournaise. Les canalisations d'eau qui alimentaient les bouches d'incendie n'ayant pas résisté davantage, les pompiers ne pourront sérieusement combattre le brasier, à l'origine d'environ 80 % des dommages engendrés par la catastrophe.

Bien des victimes resteront inconnues mais le drame causa la mort de près de 3 000 personnes et la destruction de plus de 80 % de la ville. Quelque 250 000 habitants, soit plus de la moitié de la population, se retrouvèrent sans abri, et parmi eux d'anciens résidents des plus majestueuses maisons de Nob Hill. De nombreux parcs, à l'image du Golden Gate, se convertirent en camps de réfugiés. L'immense fort militaire du Presidio, à la pointe nord de la péninsule, accueillit 70 000 sinistrés. Depuis que San Francisco portait son nom, elle avait déjà connu incendies et tremblements de terre, mais cette fois la tragédie avait été d'une tout autre

envergure. Les millions de dollars du fonds de secours d'urgence mobilisé par le gouvernement et les dons caritatifs émanant du reste des États-Unis et d'autres pays ne minoreront la facture qu'à la marge. Les dégâts matériels s'élèveront à près de 500 millions de dollars et la reconstruction requerra une formidable masse de capitaux et d'efforts.

San Francisco devait dorénavant s'appuyer sur son atout le plus précieux : sa population. Appauvris et souvent sans toit, il reviendrait aux habitants de rebâtir une cité presque réduite en cendres. Ils s'y attelleront avec autant de générosité que d'ingéniosité. En dehors des structures d'hébergement provisoires installées dans ce qui restait d'espaces verts, des cafés éphémères sont très vite apparus – guère plus que des stands fabriqués à la hâte à partir de ferraille. Un labeur acharné s'annonçait. Dès la fin de l'année, le nombre des ouvriers du bâtiment avait triplé. Il fallait aller vite, c'est pourquoi l'ambitieux projet d'architecture urbaine de 1905 s'arrêta net : le coût de sa mise en œuvre risquait d'être prohibitif ; or, il fallait remettre la ville sur pied aussitôt que possible. En 1910, la plupart des bâtiments détruits auront été remplacés. L'occasion servira également à se prémunir contre de futures catastrophes : la reconstruction, le plus souvent, privilégiera le béton armé et un acier résistant au feu. Inauguré en 1915, le nouvel hôtel de ville surplombera un « Civic Center » prévu pour accueillir plusieurs institutions majeures, dont un opéra et la principale bibliothèque publique.

San Francisco ne se contenta pas d'une reconstruction. Elle fit la démonstration de son nouvel éclat à l'occasion d'une exposition universelle organisée à quelques pas de l'endroit où le séisme avait frappé avec le plus de rage. Ouverte en 1915 le long de la côte nord, entre Fort Mason et le Presidio, l'Exposition internationale Panama-Pacifique affichait un éventail éblouissant d'attractions, de présentations et de maquettes célébrant les technologies de pointe de l'époque. De vastes halls et boulevards participaient à l'éclosion d'une sorte de ville miniature, dont la tour des Joyaux et ses 133 mètres éclairés la nuit par plus de cinquante projecteurs électriques constituaient le point d'orgue. L'exposition permit non

Old San Francisco, *Alan Crosland,*
Warner Bros., 1927.
Heritage Auctions, HA.com

seulement d'attester que San Francisco s'était bien remise de la tragédie mais aussi qu'elle avait pris une dimension internationale. Une seule, hélas, des structures édifiées pour l'occasion subsista après le démantèlement de l'exposition, heureusement l'une des plus représentatives : le Palace of Fine Arts qui reste l'un des principaux monuments de la ville. Sa splendide architecture, composée d'un dôme en rotonde et de colonnades, continue de faire l'admiration des visiteurs et des habitants du Marina District.

À la veille de l'entrée du pays dans la Première Guerre mondiale, la région revêtait également une importance croissante au niveau stratégique. Déjà considérés comme la première ligne de défense de la côte, le Presidio et les collines des Marin Headlands, de l'autre côté de la baie, étaient semés de fortifications. Le gouvernement eut aussi recours à deux îles voisines qui accueillirent l'une une prison militaire (Alcatraz) et l'autre une « station d'immigration » dévolue à la réception et souvent à la détention des nouveaux arrivants (Angel Island). En provenance d'Asie, pour la plupart, ces immigrants pouvaient se voir interdire pendant des mois l'entrée dans le pays. La guerre n'avait pas que des partisans : en juillet 1916, une bombe explosa sur Market Street pendant un défilé dédié à la préparation militaire et fit 10 morts et plus de 40 blessés. En dépit de tous les préparatifs et mesures de précaution, cependant, nul ennemi ne se jeta à l'abordage du Golden Gate ni ne s'en approcha. Mais alors que la guerre touchait à sa fin, à l'automne 1918 la pandémie de grippe espagnole qui avait commencé à frapper le reste du monde toucha San Francisco. Avec près de 45 000 cas et plus de 3 000 décès, San Francisco fut plus durement affectée qu'aucune autre ville américaine.

En 1919, la ratification du 18e amendement de la Constitution américaine décréta l'alcool illégal. Quelques années plus tôt, le nettoyage du quartier de Barbary Coast avait entraîné la fermeture des maisons closes et réduit à la portion congrue la carte des divertissements associés aux saloons. Alors que la Californie, en 1912, venait d'accorder le droit de vote aux femmes, ces mesures relevaient vraisemblablement d'une campagne ciblant les travailleuses indépendantes ; le mouvement alla jusqu'à sanctionner

les dancings qui acceptaient les clientes non accompagnées d'un homme. En vérité, les maisons de perdition s'étaient déplacées vers d'autres quartiers, dont le Tenderloin, à quelques rues du Civic Center. Tant que dura la prohibition, le littoral de la baie fit le bonheur des bootleggers. San Francisco, dit-on, comptait alors davantage de bars et consomma plus d'alcool que toute autre ville des États-Unis. Bien qu'elle opérât à une échelle incomparable avec New York ou Chicago, la pègre de San Francisco, entre contrebande de spiritueux, trafics variés, drogue et prostitution, ne chômait pas. Et là aussi, la corruption limitait considérablement toute répression un peu sérieuse. Le célèbre romancier Dashiell Hammett ne puisa pas ailleurs le matériau de ses récits. Fort d'une expérience de première main rapportée de six années passées au sein de l'agence de détectives Pinkerton, il jouera à merveille de la séduction et de la dépravation de la ville dans ses romans noirs ; ainsi *Le Faucon maltais* qui donnera lieu à l'un des films les plus fameux jamais tournés à San Francisco, avec Humphrey Bogart en Sam Spade. D'une façon générale, les « Roaring Twenties » auront plutôt profité à la ville. Le cap du demi-million d'habitants était franchi et de nouveaux quartiers naissaient à l'ouest dans certaines zones jusque-là négligées – par exemple Sea Cliff, où certaines des habitations les plus chères de la région dominaient littéralement l'océan. Plusieurs secteurs (Fillmore, Western Addition) présentaient des concentrations élevées de minorités ethniques, Américains d'origine japonaise, notamment, et dans le cas de Fillmore, une forte communauté juive.

Les bonnes heures comme les mauvaises ont toutes une fin, et celle-ci coïncida avec le krach de 1929. La dépression à venir, contre toute attente, n'étrangla pas l'expansion de la ville. Mieux : au cours de la décennie qui s'annonçait, San Francisco allait ni plus ni moins redessiner son horizon en édifiant la plus emblématique de ses créations.

"The accounts of the abundance of gold in that territory are of such an extraordinary character as would scarcely command belief were they not corroborated by the authentic reports of officers in the public service who have visited the mineral district."

„Die Berichte über den Überfluss an Gold in diesem Gebiet sind so außergewöhnlich, dass man ihnen kaum Glauben schenken würde, wenn sie nicht durch glaubhafte Berichte von Offizieren im Staatsdienst, die das Mineraliengebiet besucht haben, bestätigt würden."

« L'abondance de l'or sur ce territoire génère des récits d'une nature si extraordinaire qu'ils susciteraient l'incrédulité s'ils n'étaient corroborés par les rapports certifiés des agents du service public qui ont visité la région minière. »

PRESIDENT JAMES POLK, 1848

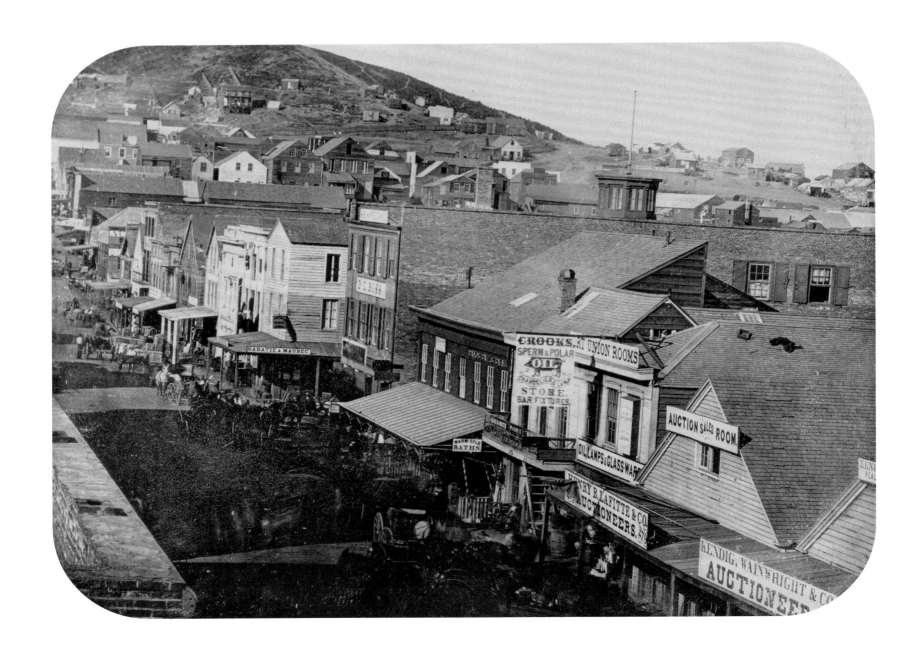

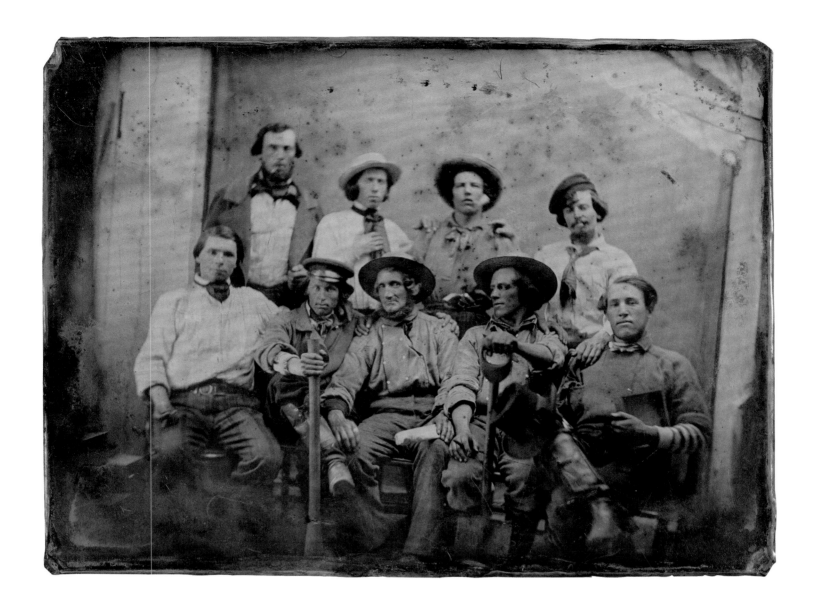

← **Frederick Coombs**

Montgomery Street as the Gold Rush got underway, with Telegraph Hill in the background. Later to mushroom into the "Wall Street of the West," this road was just emerging as a downtown hub as settlers poured into the city, 1850.

Montgomery Street während des Goldrauschs, im Hintergrund der Telegraph Hill. Die später als „Wallstreet des Westens" bekannte Straße ist hier in ihren Anfängen zu sehen. Sie wurde ein Zentrum in Downtown, als viele Siedler in die Stadt kamen, 1850.

Montgomery Street au début de la ruée vers l'or, avec Telegraph Hill à l'arrière-plan. Cette rue appelée à un essor qui fera d'elle la « Wall Street de l'Ouest » commence alors à s'imposer comme un passage obligé au cœur d'une ville où affluent les colons. 1850.

↑ **Anonymous**

Believed by some historians to be the earliest surviving photo of Gold Rush prospectors, this was taken in either San Francisco or Sacramento, which had the only facilities for taking such images at the time. These men likely would have posed for the picture not long after arriving in San Francisco in search of a fortune, c. early 1850s.

Dieses Foto, entstanden entweder in San Francisco oder in Sacramento, den einzigen beiden Orten, in denen es Fotoausrüstungen gab. Es wird von einigen Historikern für das älteste erhaltene Bild von Goldsuchern gehalten. Die Männer sind wahrscheinlich kurz nach ihrer Ankunft in San Francisco fotografiert worden, frühe 1850er.

D'après certains historiens, cette photo de chercheurs d'or au temps de la grande ruée est la plus ancienne connue. Elle aurait été prise à San Francisco ou à Sacramento, seules à disposer des équipements nécessaires à une telle prise de vue. Il est probable que ces hommes ont posé peu après leur arrivée à San Francisco en quête de fortune. Vers le début des années 1850.

↓
Carleton E. Watkins

Looking west from the north side of California Street as it began developing into one of the city's main crosstown routes. The cable car line's steepest tracks had yet to be built. Eventually the street stretched from downtown almost to the ocean, 1864.

Blick in Richtung Westen von der nördlichen Seite der California Street, als sie gerade zu einer der Hauptstraßen durch die Stadt wurde. Die steilste Cable-Car-Strecke war noch nicht gebaut. Später reichte die Straße von Downtown bis fast ans Meer, 1864.

California Street regarde vers l'ouest et s'apprête à devenir l'une des principales artères transversales de la ville. Reste à créer la ligne de cable car dévolue à ses parties les plus pentues. Du centre de San Francisco, la rue s'étend pratiquement jusqu'à l'océan. 1864.

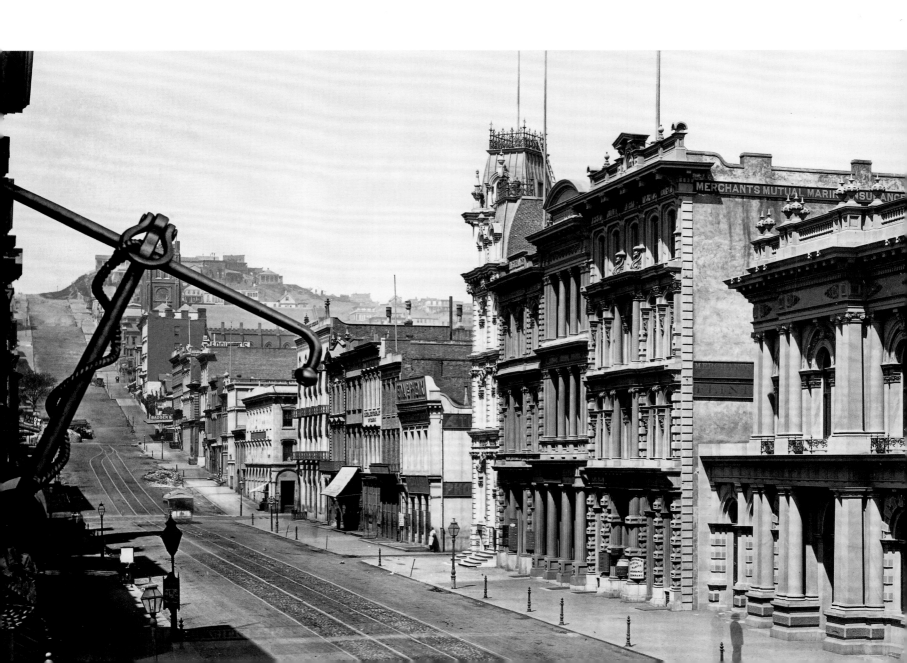

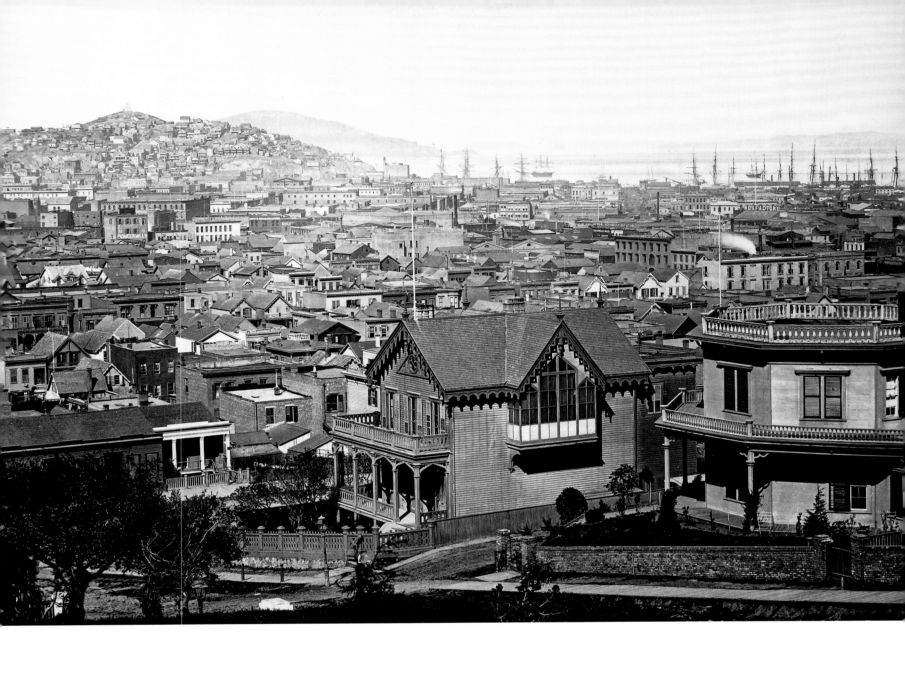

Carleton E. Watkins

View of the rapidly expanding city from Rincon Hill, one of San Francisco's first neighborhoods for the well-to-do. After major damage in the 1906 earthquake, it would transform into part of the industrial neighborhood now known as South of Market, 1864.

Blick über die rapide wachsende Stadt vom Rincon Hill, einer der ersten Gegenden für die Wohlhabenden in San Francisco. Nachdem das Erdbeben 1906 schwere Schäden verursacht hatte, wurde die Gegend Teil einer industriellen Nachbarschaft, heute bekannt als South of Market, 1864.

La ville croît à vue d'œil, saisie ici depuis Rincon Hill, l'un des premiers quartiers aisés de San Francisco. Celui-ci subira des dégâts importants lors du tremblement de terre de 1906 et se fondra à l'intérieur du quartier longtemps industriel aujourd'hui connu sous le nom de South of Market. 1864.

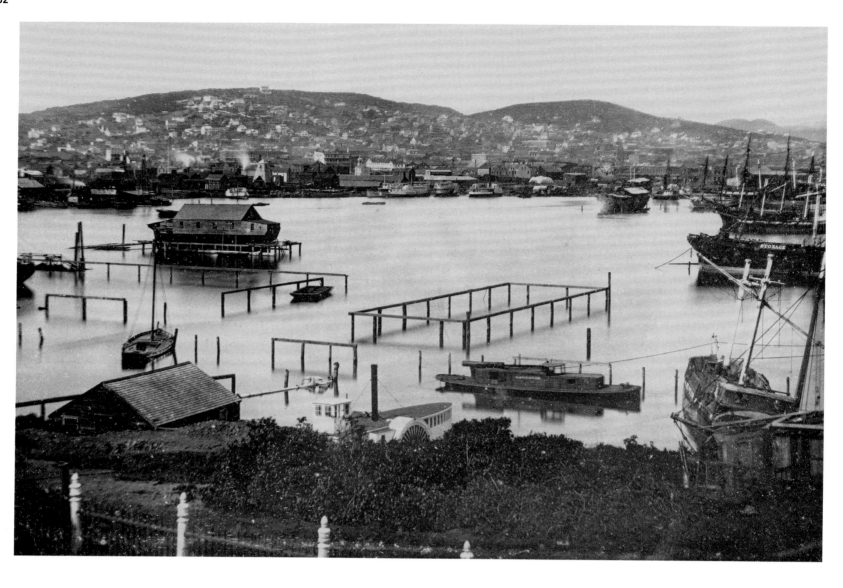

↑
William Shew

*Ships in the San Francisco harbor, as
seen from Rincon Point. These had been
abandoned by sailors eager to join the
Gold Rush, c. 1852.*

*Schiffe im Hafen von San Francisco, Blick
von Rincon Point. Sie wurden von Matrosen,
die beim Goldrausch dabei sein wollten,
zurückgelassen, um 1852.*

*Ces bateaux visibles depuis Rincon Point ont
été abandonnés dans le port de San Francisco
par leurs équipages pressés de rejoindre la
ruée vers l'or. Vers 1852.*

↓
Carleton E. Watkins

Alcatraz Island, shortly after a jail was built on its grounds for military prisoners. In 1854, the first lighthouse on the West Coast was built here. The military had already fortified the island by the Civil War, though it was not involved in combat, 1868 or 1869.

Die Insel Alcatraz, kurz nachdem dort ein Militärgefängnis errichtet wurde. 1854 wurde hier der erste Leuchtturm der Westküste gebaut. Schon im Bürgerkrieg war die Insel befestigt worden, hatte aber keine Kampfhandlungen erlebt, 1868 oder 1869.

L'île d'Alcatraz, peu après la construction de ce qui sera d'abord une prison militaire. C'est là qu'a été édifié, en 1854, le premier phare de la côte Ouest. Pendant la guerre de Sécession, l'armée avait fortifié l'île mais aucun combat ne s'y est déroulé. 1868 ou 1869.

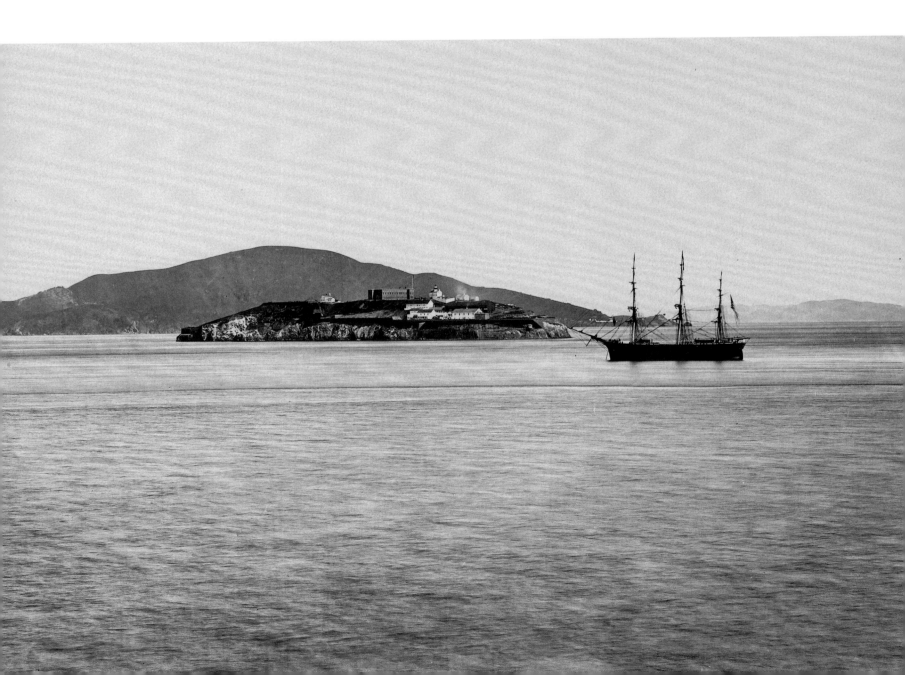

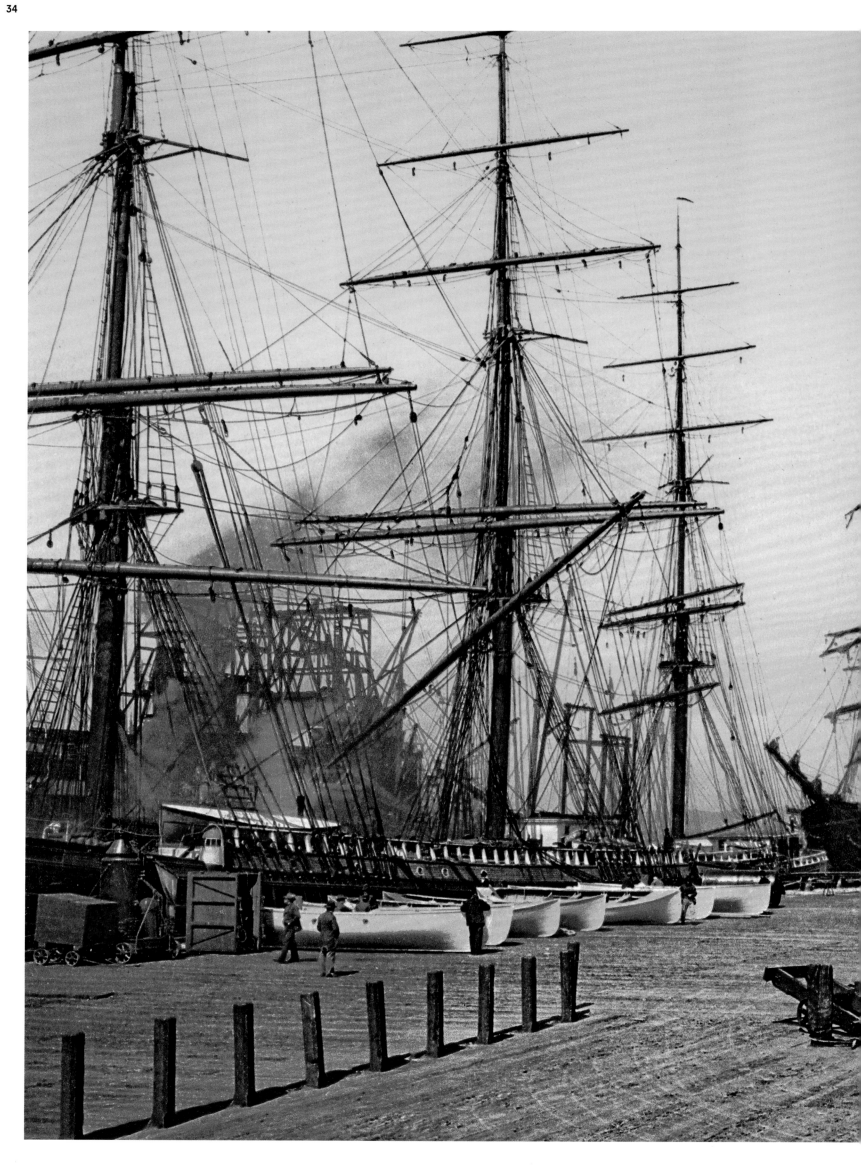

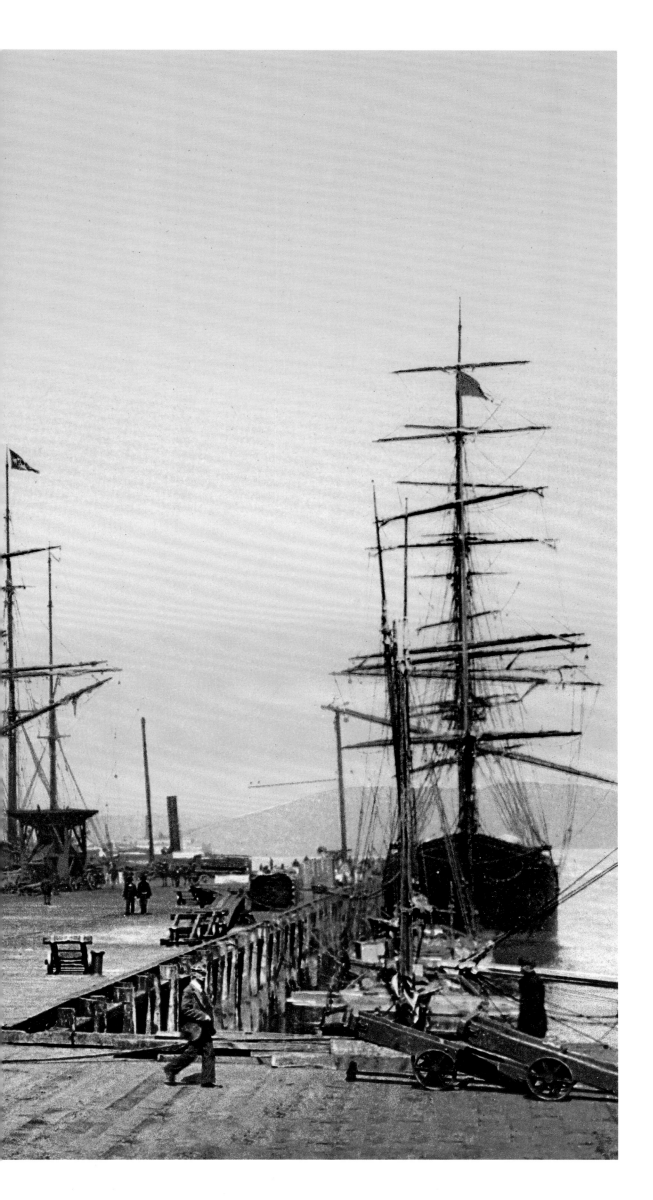

Anonymous

Ships in the San Francisco harbor. As one of the best natural harbors in the world, it was essential to the city's growth and commerce, with the Port of San Francisco handling almost $10 million of merchandise and raw goods per year by the early 1920s, c. 1900.

Schiffe im Hafen von San Francisco. Als einer der besten natürlichen Häfen der Welt trug er mit einem Umschlagvolumen im Wert von fast 10 Millionen Dollar jährlich in den frühen 1920er-Jahren maßgeblich zum Wachstum der Stadt bei, um 1900.

Navires dans le port de San Francisco. Essentiel à la croissance et au développement commercial de la ville, ce port naturel, l'un des plus remarquables au monde, voyait transiter chaque année quelque 10 millions de dollars de marchandises et de matières premières au début des « Roaring Twenties ». Vers 1900.

"God bless you for your devotion to the Union, but the unknown is before us. I may say, however, that I have it now in purpose when the railroad is finished, to visit your wonderful state."

„Gott segne Sie für Ihre Hingabe an die Union, aber das Unbekannte liegt vor uns. Ich darf jedoch sagen, dass ich nun vorhabe, sobald die Eisenbahn fertiggestellt ist, Ihren wunderbaren Staat zu besuchen."

« Dieu vous bénisse pour votre dévouement à l'Union, mais nous sommes face à l'inconnu. Je peux dire, cependant, que j'ai maintenant l'intention, lorsque le chemin de fer sera achevé, de visiter votre merveilleux État. »

PRESIDENT ABRAHAM LINCOLN, 1865

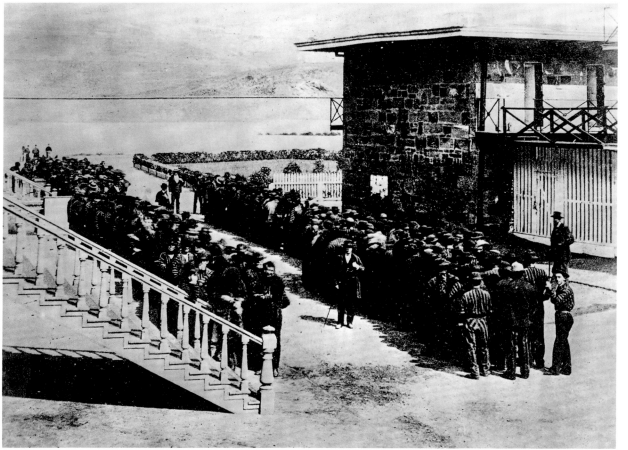

←
Anonymous

Inmates lining up at the mess hall of San Quentin, with the San Francisco Bay in the distance. The oldest prison in California, this Marin County jail has housed numerous infamous criminals over the last 170 years, 1871.

Gefangene in San Quentin stehen vor dem Speisesaal an, im Hintergrund die San Francisco Bay. Das Gefängnis in Marine County, das älteste in Kalifornien, hat in den letzten 170 Jahren zahlreiche berüchtigte Verbrecher beherbergt, 1871.

Une file de détenus devant la cantine du pénitencier de San Quentin. Au loin, la baie de San Francisco. En près de cent soixante-dix ans d'existence, cette prison bâtie dans le comté de Marin, la plus ancienne en Californie, hébergea de nombreuses célébrités du crime. 1871.

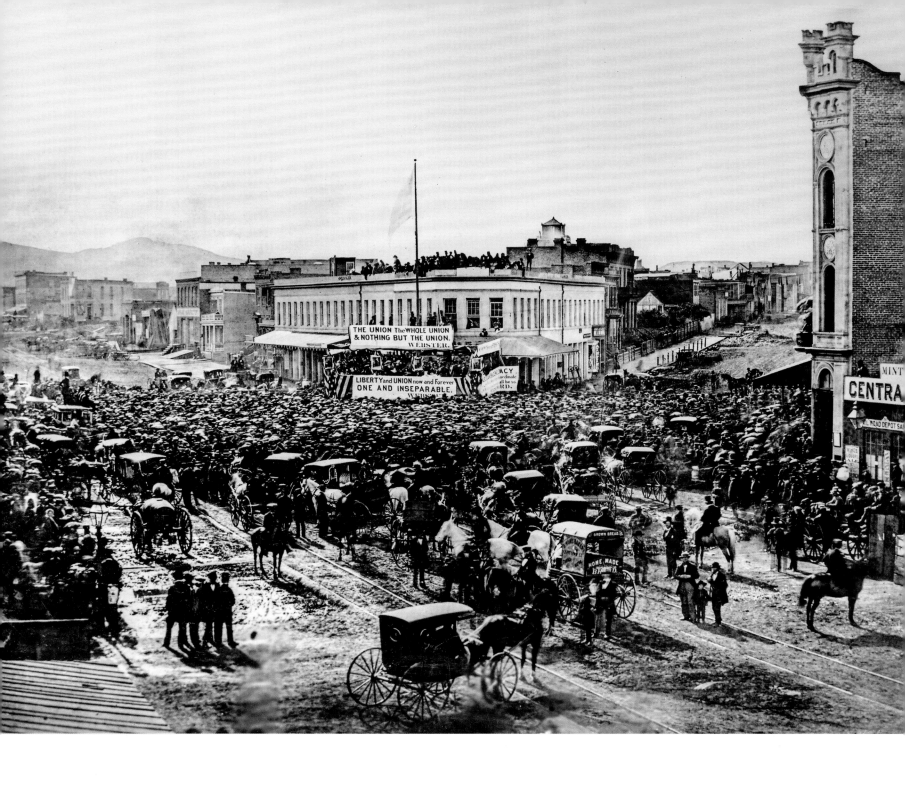

↑

Carleton E. Watkins

Crowds jam the intersection of Montgomery, Post, and Market streets to show support for the Union in the first year of the Civil War. Almost 15,000—about a quarter of the city's population—marched from City Hall on Portsmouth Square and heard hours of pro-Union speeches. This remains among downtown's busiest spots today, 1861.

Menschenmassen blockieren die Kreuzung von Montgomery, Post und Market Street, um ihre Unterstützung für die Union im ersten Jahr des Bürgerkriegs zu demonstrieren. 15 000 – ein Viertel der Bevölkerung – marschierten vom Rathaus am Portsmouth Square los, es gab über Stunden Reden zur Stärkung der Union. Der Ort ist auch heute noch einer der belebtesten der Stadt, 1861.

La foule se presse à l'intersection de Montgomery Street, de Post Street et de Market Street pour exprimer son soutien au Nord pendant la première année de la guerre de Sécession. Parties de l'hôtel de ville alors situé sur Portsmouth Square, quelque 15 000 personnes, soit pratiquement le quart de la population, sont venues écouter des heures de discours favorables à l'Union. Cette place reste aujourd'hui l'un des sites les plus animés du centre-ville. 1861.

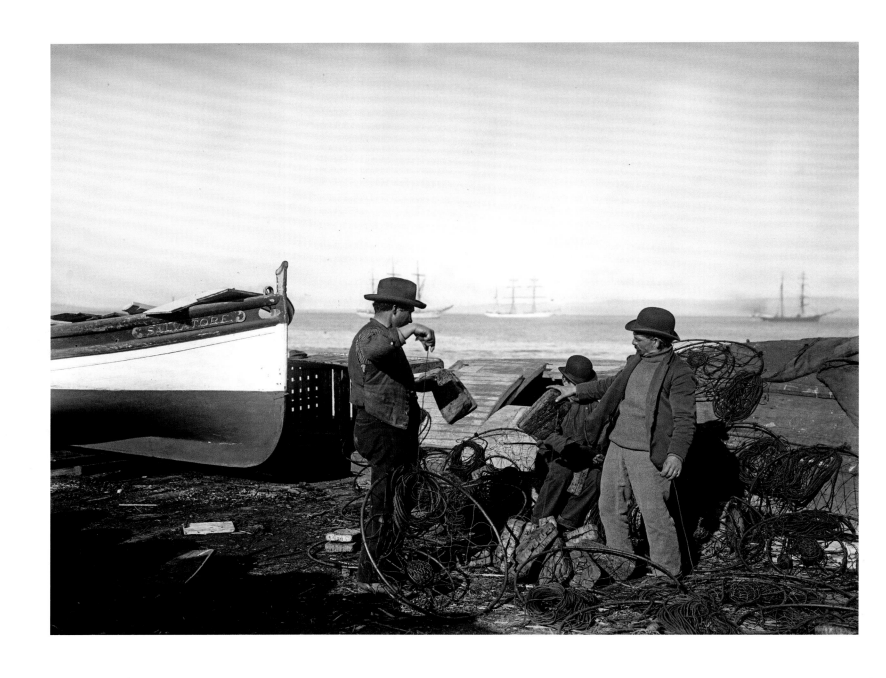

↑

D. H. Wulzen

Back when Fisherman's Wharf was for fishermen rather than tourists, three men mend nets on one of the piers. Perhaps these are for the fishing boat Salvatore on the left, 1899.

Drei Männer flicken Netze auf einem der Piers, als die Fisherman's Wharf noch für Fischer und nicht nur für Touristen da war. Vielleicht gehören sie zum Boot Salvatore links im Bild, 1899.

À l'époque où le Fisherman's Wharf accueillait plus de pêcheurs que de touristes, trois hommes réparent des filets sur l'un des quais. Peut-être travaillent-ils pour le Salvatore, à gauche sur la photo. 1899.

→

Anonymous

The Excelsior steamship sets sail for the Alaskan gold fields. Almost half a century after the California Gold Rush, many prospectors set their sights much farther north for the Klondike Gold Rush, often setting off from San Francisco, 1897.

Das Dampfschiff Excelsior fährt in Richtung der Goldvorkommen Alaskas. Fast 50 Jahre nach dem kalifornischen Goldrausch zieht es viele Goldgräber weiter nach Norden, zum Klondike. Oft fahren sie von San Francisco aus los, 1897.

Le steamer Excelsior appareille pour les champs aurifères d'Alaska. Près d'un demi-siècle après la ruée vers l'or californienne, les prospecteurs seront nombreux, souvent venus de San Francisco, à se diriger bien plus au nord vers la région canadienne du Klondike où s'est ouverte une nouvelle course au métal jaune. 1897.

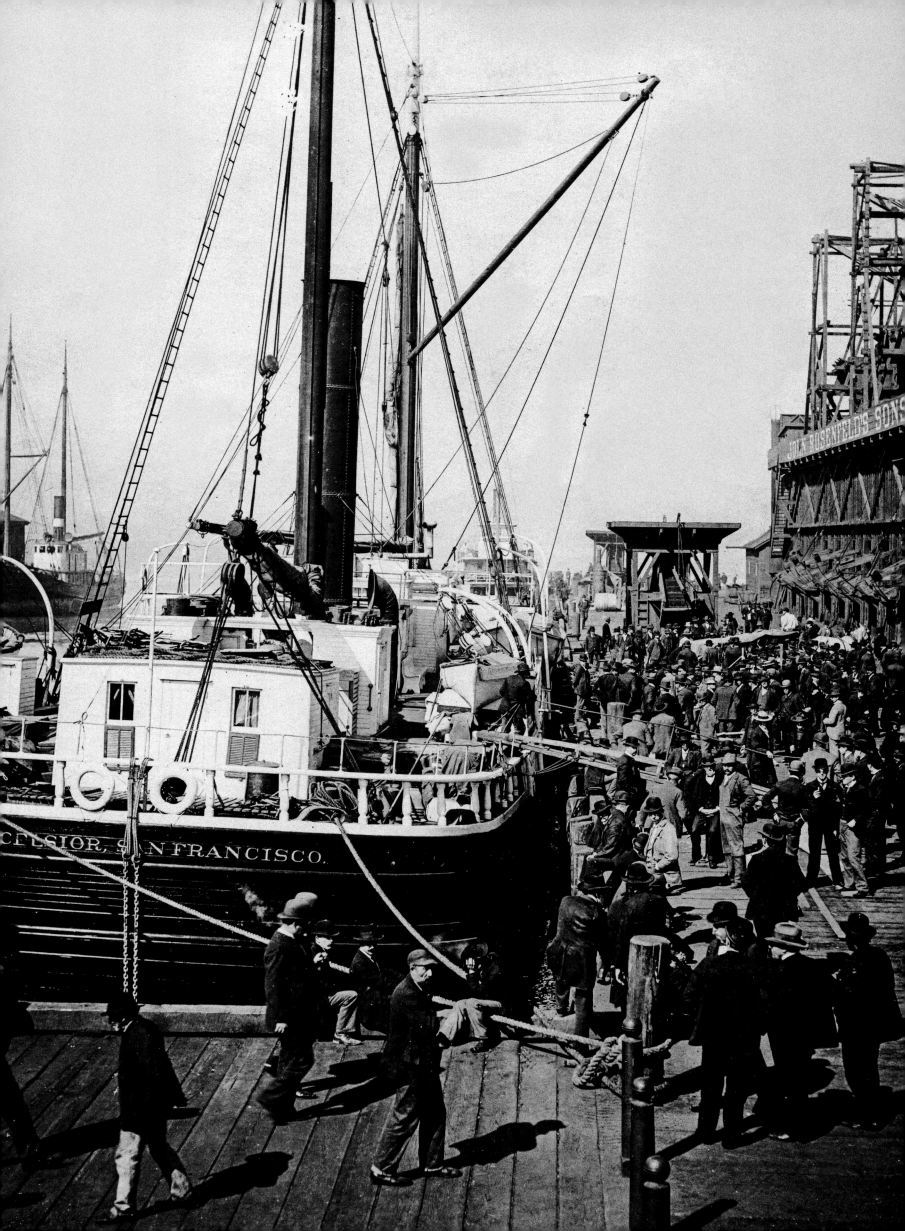

Arnold Genthe

This photo is titled The Street of Gamblers
(by Day), *and depicts Ross Alley, seen
here from Jackson Street, which became
one of the most bustling thoroughfares in
Chinatown. Built in 1849, the oldest alley in
San Francisco had by the late 19th century
numerous gambling rooms. The traditional
papier-mâché garlands above the doorway
on the building to the right indicate this
was taken around Chinese New Year, when
thousands of seasonal workers who were laid
off clogged Chinatown streets, 1898.*

Dieses Foto heißt Die Straße der Glücks-
spieler (am Tag) *und zeigt Ross Alley, hier
von der Jackson Street aus, später eine der
Hauptstraßen Chinatowns. Gebaut 1849
und die älteste Straße in San Francisco,
florierte hier im späten 19. Jahrhundert das
Glücksspiel. Die traditionellen Girlanden
aus Pappmaché über den Türen lassen darauf
schließen, dass dieses Foto in der Zeit um
das chinesische Neujahrsfest aufgenommen
wurde, als die Straßen voll von entlassenen
Saisonarbeitern waren, 1898.*

Cette photo intitulée The Street of the
Gamblers *représente Ross Alley, ainsi qu'on
peut la voir depuis Jackson Street, elle-même
devenue l'une des artères les plus animées
de Chinatown. Percée en 1849, la plus vieille
ruelle de San Francisco abritait à la fin
du XIXe siècle de nombreuses salles de jeux.
Au-dessus de l'entrée de l'immeuble de droite,
les guirlandes traditionnelles en papier
mâché indiquent que le cliché a été pris
autour du Nouvel An chinois, lorsque des
milliers de saisonniers mis à pied s'agglu-
tinent dans les rues du quartier. 1898.*

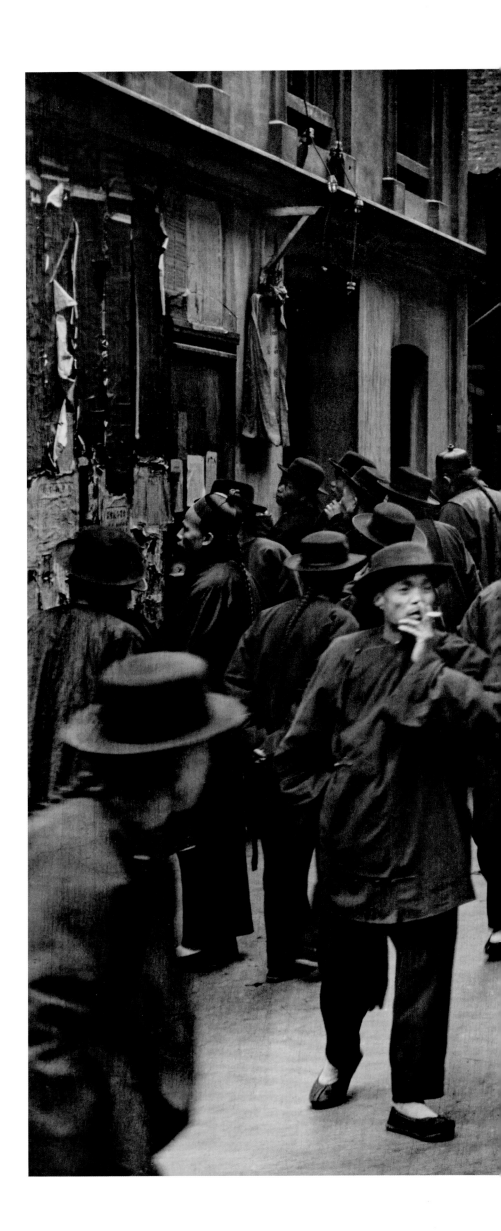

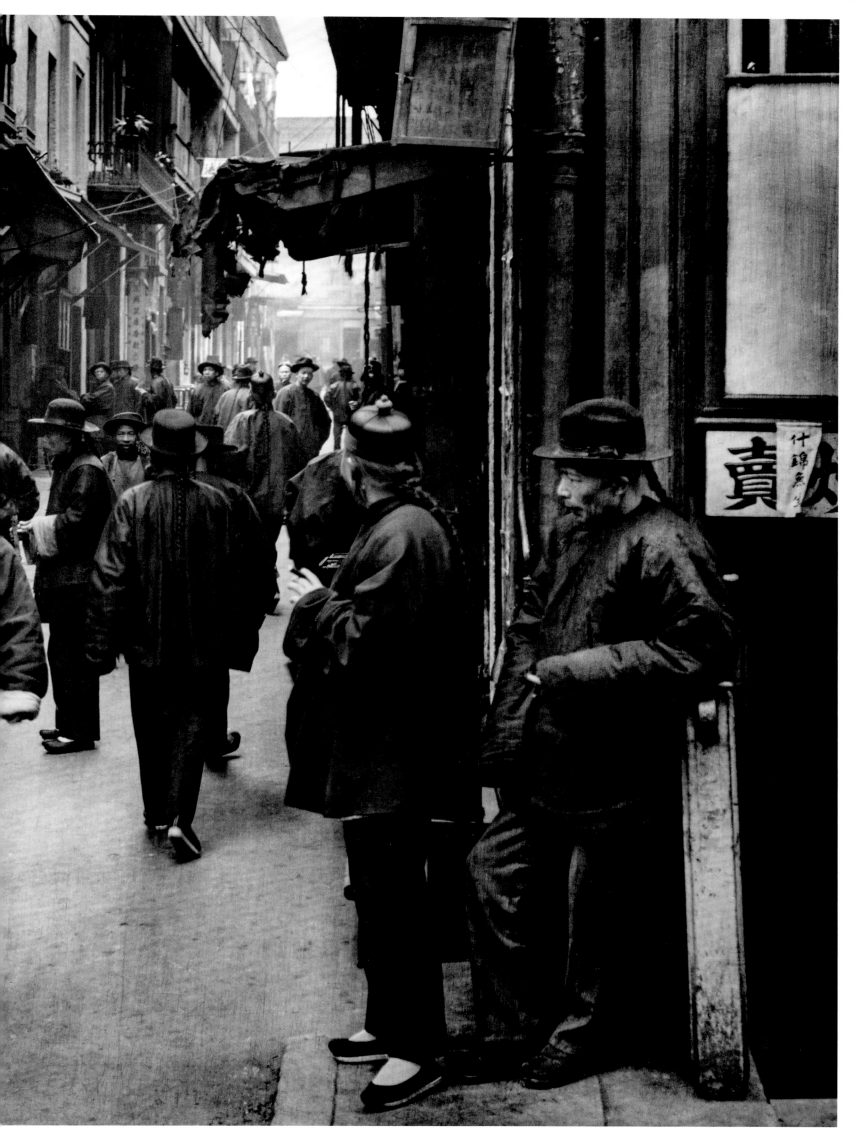

*"It's an odd thing, but anyone who disappears
is said to be seen in San Francisco."*

*„Es ist eine merkwürdige Sache, aber von jedem,
der verschwindet, wird behauptet, man habe ihn
in San Franzisko gesehen."*

*« C'est bizarre, mais de toute personne qui disparaît
on dit qu'elle a été vue à San Francisco. »*

OSCAR WILDE, 1890

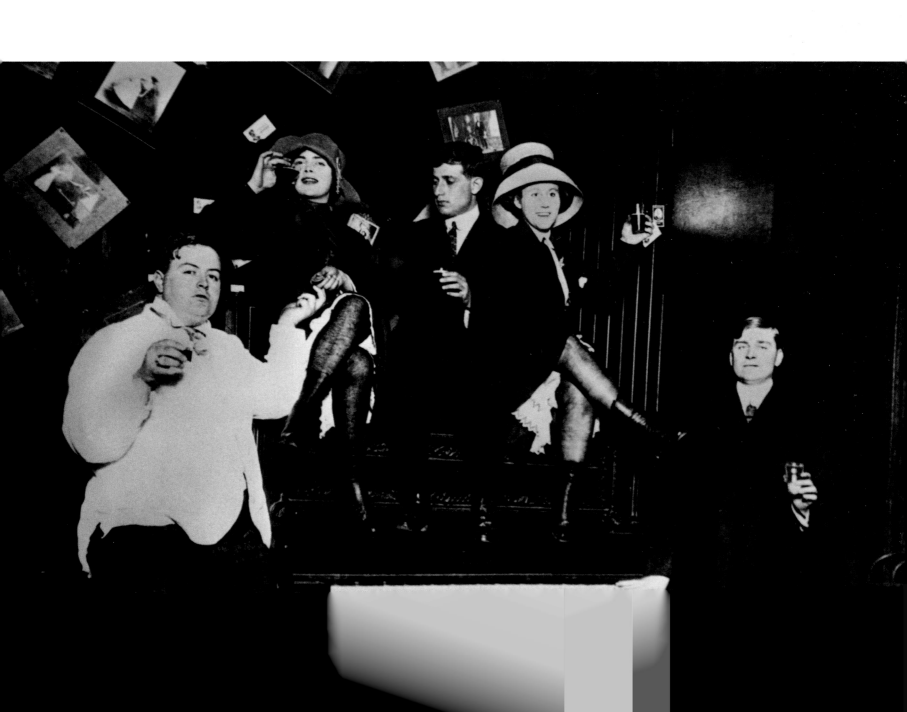

←

Anonymous

Drinks in hand, men and women get ready to whoop it up in what's likely a Barbary Coast saloon, c. 1890.

Mit Drinks in der Hand sind Männer und Frauen zum Feiern bereit, wahrscheinlich in einem Saloon an der Barbary Coast, um 1890.

Le verre à la main, un groupe de fêtards des deux sexes se prépare à faire honneur à ce qui ressemble fort à un saloon du quartier de Barbary Coast. Vers 1890.

↗

Arnold Genthe

Jack London, posing for one of the leading early San Francisco photographers shortly after novels like 1903's The Call of the Wild *made him one of the most popular and influential writers of the early 20th century, 1906.*

Jack London posiert für einen der führenden Fotografen San Franciscos, kurz nachdem Romane wie Der Ruf der Wildnis *von 1903 ihn zu einem der beliebtesten und einflussreichsten Schriftsteller des frühen 20. Jahrhunderts gemacht haben, 1906.*

Jack London pose pour l'un des premiers grands photographes de l'époque à San Francisco. Il est lui-même, grâce à des romans tels que L'Appel de la forêt *(1903), l'un des écrivains les plus populaires et les plus influents de ce xxᵉ siècle naissant. 1906.*

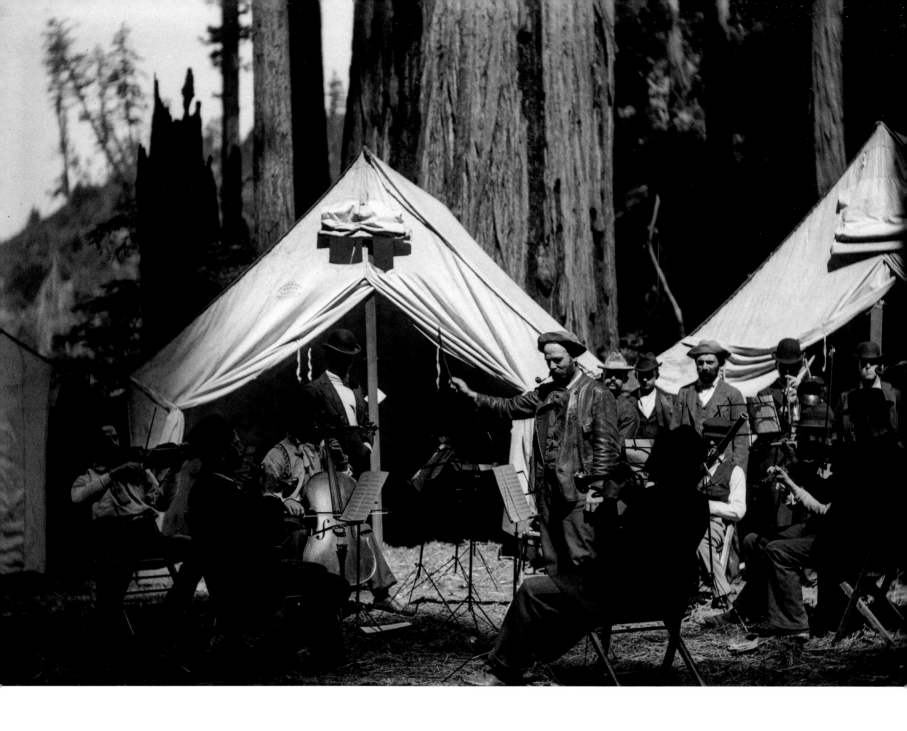

Anonymous

*Relaxing at the Bohemian Grove, which has
served as an elite retreat for a San Francisco
men's club since the late 19th century.
Situated 75 miles north of the city in Monte
Rio, it's evolved from more bohemian origins
into a haven for some of the world's most rich
and powerful politicians and businessmen.
Here, some of the early bohemians are playing
in the Grove's members' orchestra, c. 1890s.*

*Entspannung im Bohemian Grove, einem
elitären Rückzugsort des Männerclubs von
San Francisco, den es seit dem späten
19. Jahrhundert gibt. 120 Kilometer nördlich
vom Ort Monte Rio gelegen, entwickelte er
sich von seinen unkonventionelleren*

*Ursprüngen zum Erholungsort für einige
der reichsten und mächtigsten Politiker und
Geschäftsleute der Welt. Hier spielen gerade
einige der frühen Bohemiens im Orchester
der Grove-Mitglieder, um 1890.*

*Pause musicale au Bohemian Grove, qui pos-
sédait son orchestre attitré et sert de retraite
discrète et élitaire à un « gentlemen's club »
de San Francisco depuis la fin du XIXe siècle.
Situé à Monte Rio, 120 kilomètres au nord
de la ville, il a troqué l'anticonformisme des
origines pour devenir le refuge de certains des
grands patrons et politiciens les plus riches
et les plus puissants de la planète. Vers 1890.*

↓

Miles Brothers

Just a few days before the 1906 earthquake, these exuberant newsboys were part of the short movie A Trip Down Market Street, *which spotlighted the city's busiest intersections of traffic, pedestrians, and street life. Much of the downtown area seen in the film was destroyed by the disaster, April 1906.*

Nur ein paar Tage vor dem Erdbeben von 1906 wurden diese ausgelassenen Zeitungsjungen für den Kurzfilm A Trip Down Market Street *gefilmt, der Verkehr, Fußgänger und Straßenleben der geschäftigsten Kreuzungen der Stadt zeigte. Viel von dem, was im Film zu sehen war, wurde bei der folgenden Katastrophe zerstört, April 1906.*

Quelques jours avant le séisme de 1906, ces petits marchands de journaux viennent conclure joyeusement le court métrage A Trip Down Market Street *dans lequel s'entrecroisent piétons, tramways, véhicules hippo- et automobiles: la vie d'une rue encore insouciante. La zone du centre-ville dépeinte par le film sera très largement anéantie par la catastrophe. Avril 1906.*

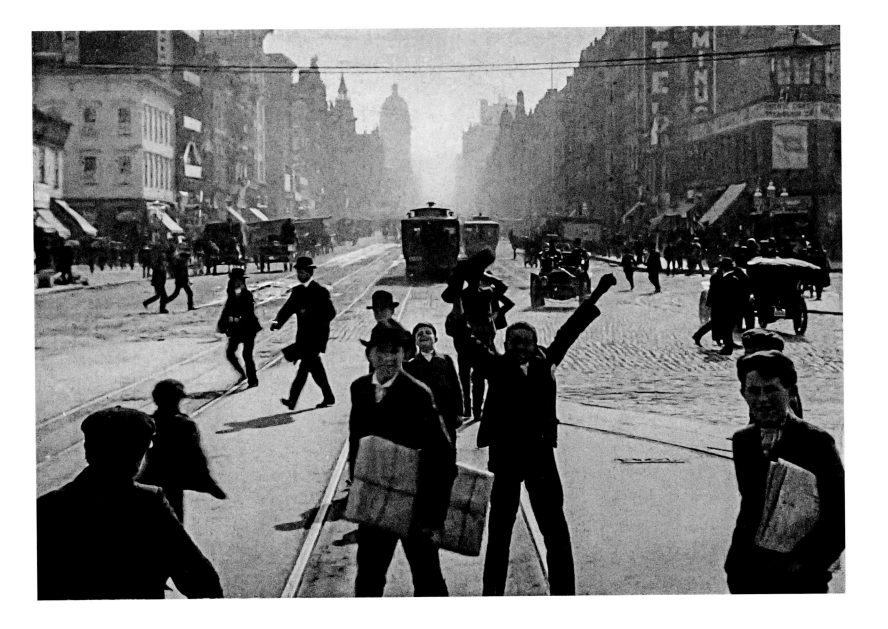

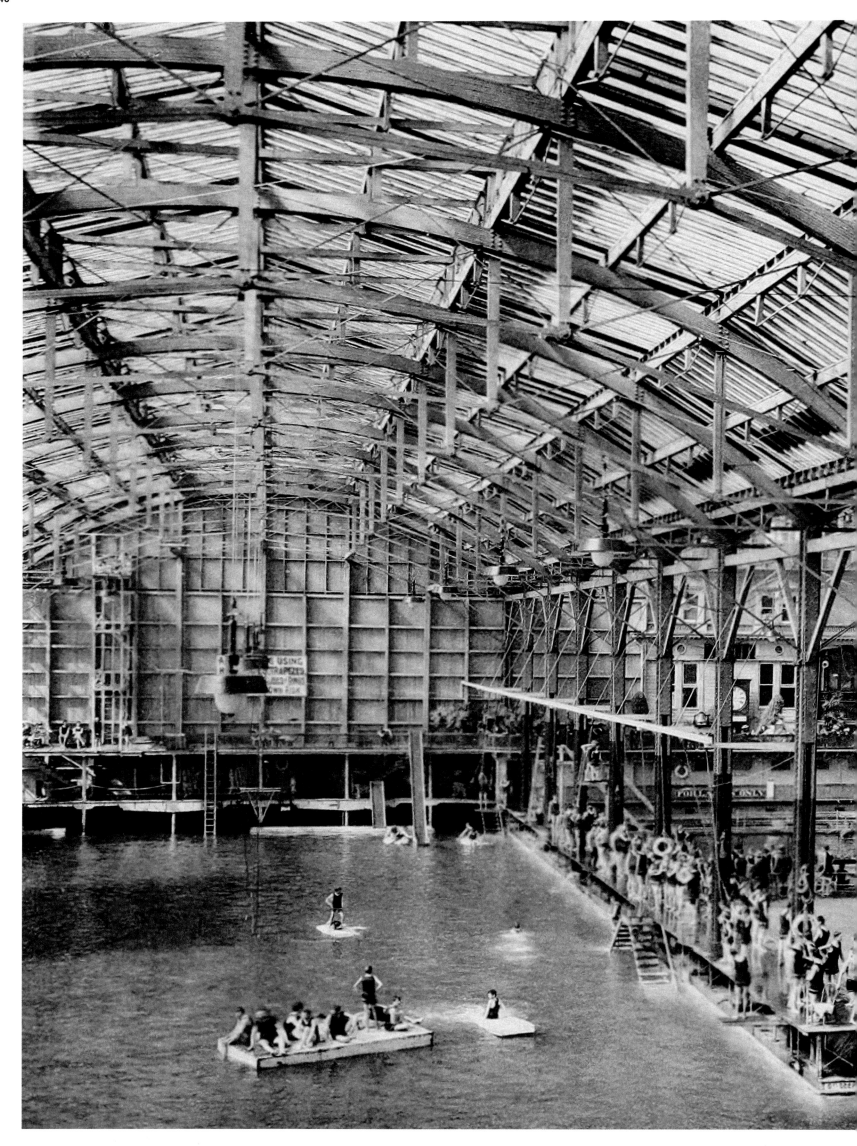

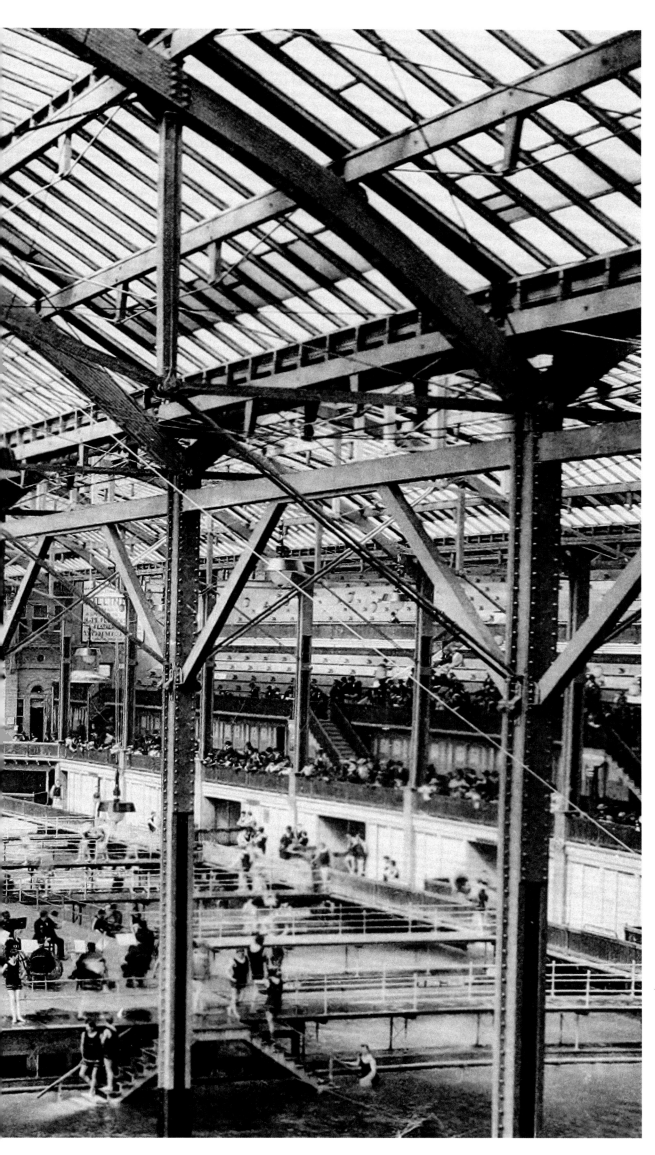

Anonymous

Sutro Baths, at that time the world's biggest indoor swimming facility, opened next to the Pacific Ocean in 1896. The baths included several pools, seating for thousands, and a giant glazed roof. Adolph Sutro was an industrialist and mayor of the city then. The baths were destroyed in 1966 by a fire but had been closed for a decade, 1900.

Die Sutro Baths direkt am Pazifik wurden 1896 eröffnet und waren die größte Hallen-badanlage der Welt. Sie bestanden aus mehreren Schwimmbädern, Tausenden Sitz-gelegenheiten und einem riesigen verglasten Dach. Adolph Sutro war zu dieser Zeit nicht nur ein Großindustrieller, sondern auch Bürgermeister. Die Bäder brannten 1966 ab, waren damals aber schon für über zehn Jahre geschlossen, 1900.

Inaugurés en 1896, les Sutro Baths cons-tituaient alors le plus grand complexe balnéaire couvert jamais édifié. Doté de plusieurs piscines, de milliers de places assises et coiffé d'une gigantesque structure vitrée, l'établissement faisait face à l'océan Pacifique. Son propriétaire, l'entrepreneur d'origine allemande Adolph Sutro, était aussi le maire de la ville. Une dizaine d'années après leur fermeture, les bains seront détruits par un incendie en 1966. 1900.

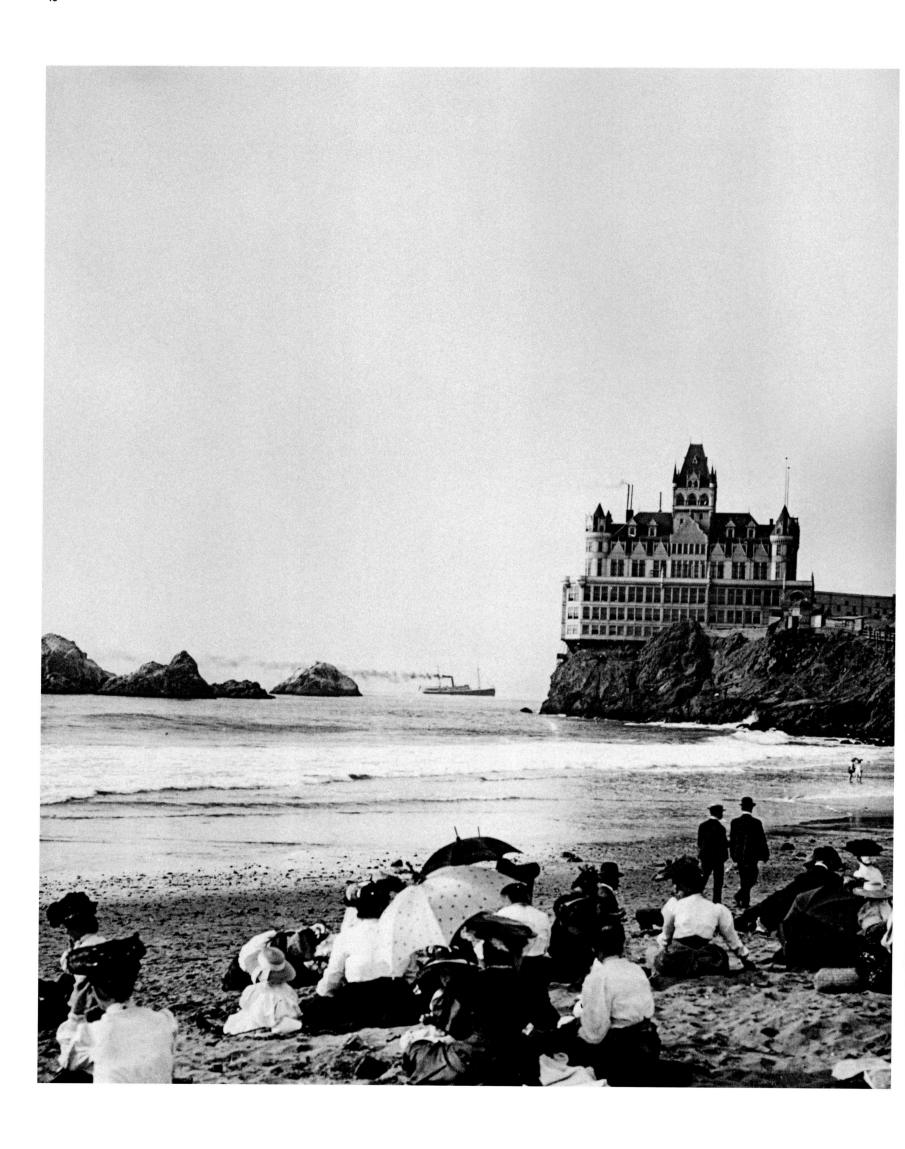

←
Anonymous

Beachwear was more formal as the 20th century began, but it's often too cold to dress with less at the northern end of Ocean Beach. A few hundred years in the distance, the Cliff House overlooks Seal Rocks, where sea lions sunbathe au naturel, c. 1905.

Badekleidung war Anfang des 20. Jahrhunderts zwar formeller, aber es ist sowieso meist zu kalt, um am nördlichen Ende von Ocean Beach weniger bekleidet zu sein. Ein paar Hundert Meter entfernt steht das Cliff House über den Seal Rocks, wo Seelöwen sich sonnen, um 1905.

Les tenues de plage, en ce début de xxe siècle, sont encore un rien austères mais il fait souvent trop froid pour s'habiller plus léger au nord d'Ocean Beach. À quelques centaines de mètres de la plage, la Cliff House surplombe les Seal Rocks, les îlots rocheux où les otaries viennent se dorer au soleil. Vers 1905.

↑
Anonymous

Two young men and a dog take to the frigid Pacific waters, possibly on Thornton Beach just south of San Francisco, 1903.

Zwei junge Männer und ein Hund im kalten Wasser des Pazifiks, möglicherweise am Thornton Beach, etwas südlich von San Francisco, 1903.

Deux jeunes gens et un chien affrontent les eaux glaciales du Pacifique, peut-être sur Thornton Beach, au sud de San Francisco. 1903.

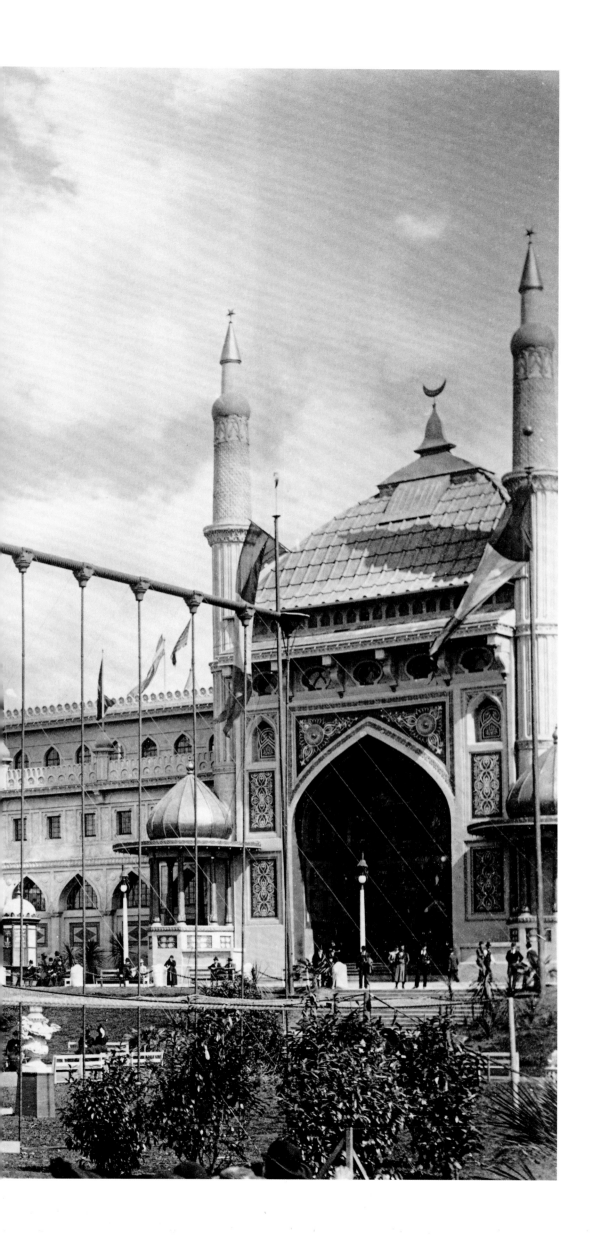

Isaiah W. Taber

Billed as "The Marvelous Equilibrist," Achille Philion manages to keep his balance atop a ball several stories above the ground in his Spiral Tower Revolving Globe exhibition at the 1894 Midwinter Fair. In the background is the fair's Mechanical Arts Building, 1894.

Achille Philion, bekannt als „der großartige Gleichgewichtskünstler", hält die Balance auf einem Ball hoch über dem Boden bei seiner Spiral Tower Revolving Globe Show für die Midwinter Fair 1894. Im Hintergrund befindet sich das Mechanical Arts Building der Weltausstellung, 1894.

Démonstration de stabilité à l'Exposition internationale d'hiver. Debout sur un globe rotatif, le Français Achille Philion, surnommé « le merveilleux équilibriste », confirme qu'il est bien à la hauteur – vertigineuse – de sa réputation. À l'arrière-plan, le pavillon dédié aux arts mécaniques. 1894.

↓
Anonymous

Officially billed as the California Midwinter International Exposition, the Midwinter Fair, as it was often called by San Franciscans, was the city's first major showcase for cutting-edge technology, arts, and amusements. This view of the fair in Golden Gate Park was taken from Strawberry Hill above Stow Lake, which are still among the park's prime attractions, 1894.

Die California Midwinter International Exposition, von den Einwohnern San Franciscos oft einfach Mitwinter Fair genannt, war die erste große Ausstellung für modernste Technik, Kunst und Unterhaltung in der Stadt. Hier der Blick über die Ausstellung im Golden Gate Park vom Strawberry Hill über dem Stow-See, die bis heute zu den beliebtesten Attraktionen des Parks zählen, 1894.

Organisée dans le Golden Gate Park et officiellement intitulée « California Midwinter International Exposition », l'Exposition internationale d'hiver, ou Midwinter Fair, comme l'appelaient les habitants, permit à San Francisco d'exprimer sa vocation novatrice en matière technologique, artistique et récréative. Cette photo a été prise depuis Strawberry Hill, au milieu du lac Stow, qui l'un et l'autre comptent toujours parmi les grandes attractions du parc. 1894.

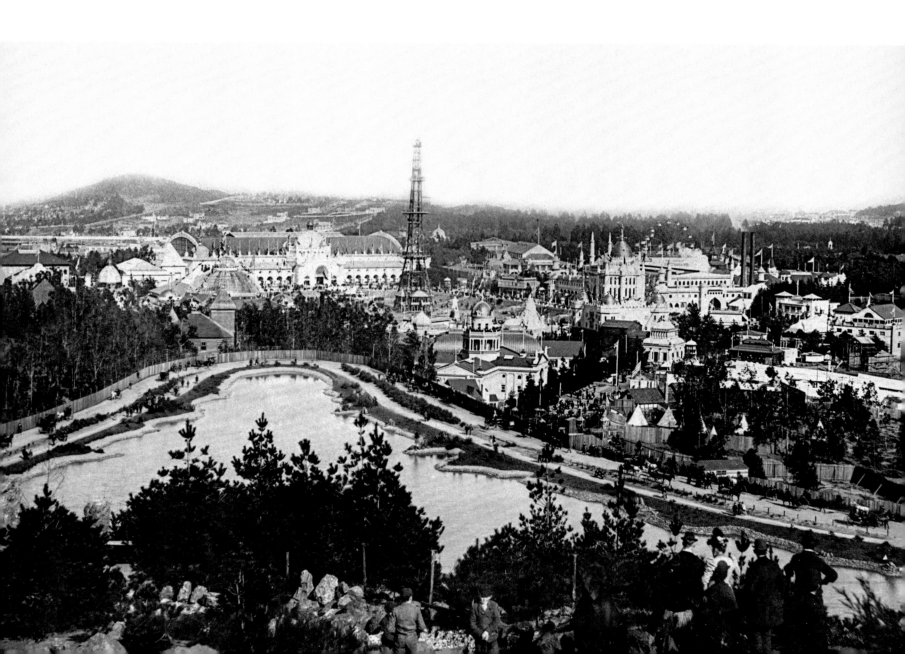

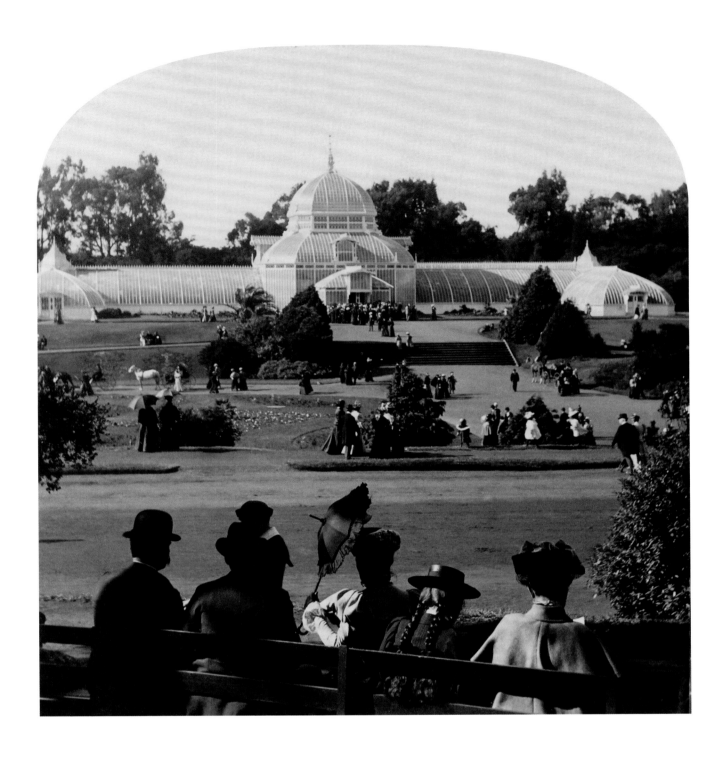

↑
Anonymous

People relaxing in Golden Gate Park. In the background is the Conservatory of Flowers, a classic Victorian greenhouse. Constructed in 1878, it is the park's oldest building, 1897.

Entspannung im Golden Gate Park. Im Hintergrund sieht man das Conservatory of Flowers, ein klassisches viktorianisches Gewächshaus. Es wurde 1878 gebaut und ist das älteste Gebäude des Parks, 1897.

Jour de détente dans le Golden Gate Park dont l'édifice le plus ancien, le Conservatoire des fleurs, une serre d'inspiration victorienne construite en 1878, fait face aux promeneurs. 1897.

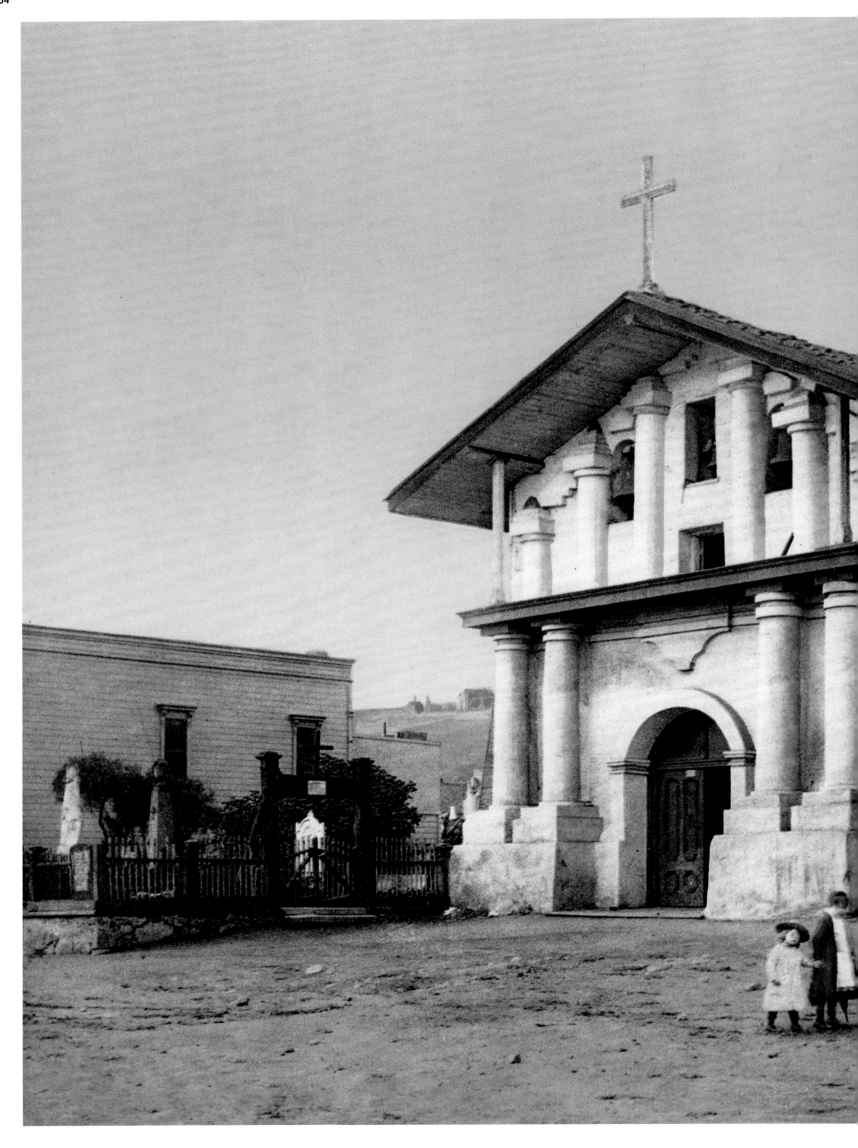

Anonymous

Founded by Spanish settlers in 1776, Mission Dolores evolved into one of the city's top architectural attractions. It also draws many worshipers and tourists for its religious services and small, dignified cemetery. The oldest surviving building (modified over the years) in San Francisco, it remains the chief landmark of the Mission District, one of the city's most vibrant neighborhoods, c. 1898.

Mission Dolores, gegründet von spanischen Siedlern 1776, entwickelte sich zu einer der größten architektonischen Sehenswürdigkeiten der Stadt. Gottesdienste und der kleine, aber würdevolle Friedhof ziehen Gläubige genauso wie Touristen an. Als das älteste, wenn auch über die Jahre umgebaute Gebäude in San Francisco ist es auch das Zentrum des Mission Districts, um 1898.

Fondée par des colons espagnols en 1776, la Mission Dolores n'a pas tardé à devenir l'une des attractions architecturales les plus courues de San Francisco. Elle attire aussi fidèles et touristes, nombreux à fréquenter ses offices religieux et son digne petit cimetière. Modifiée au fil du temps, elle est l'édifice le plus ancien de la ville et reste le jalon emblématique du Mission District, l'un de ses quartiers les plus dynamiques. Vers 1898.

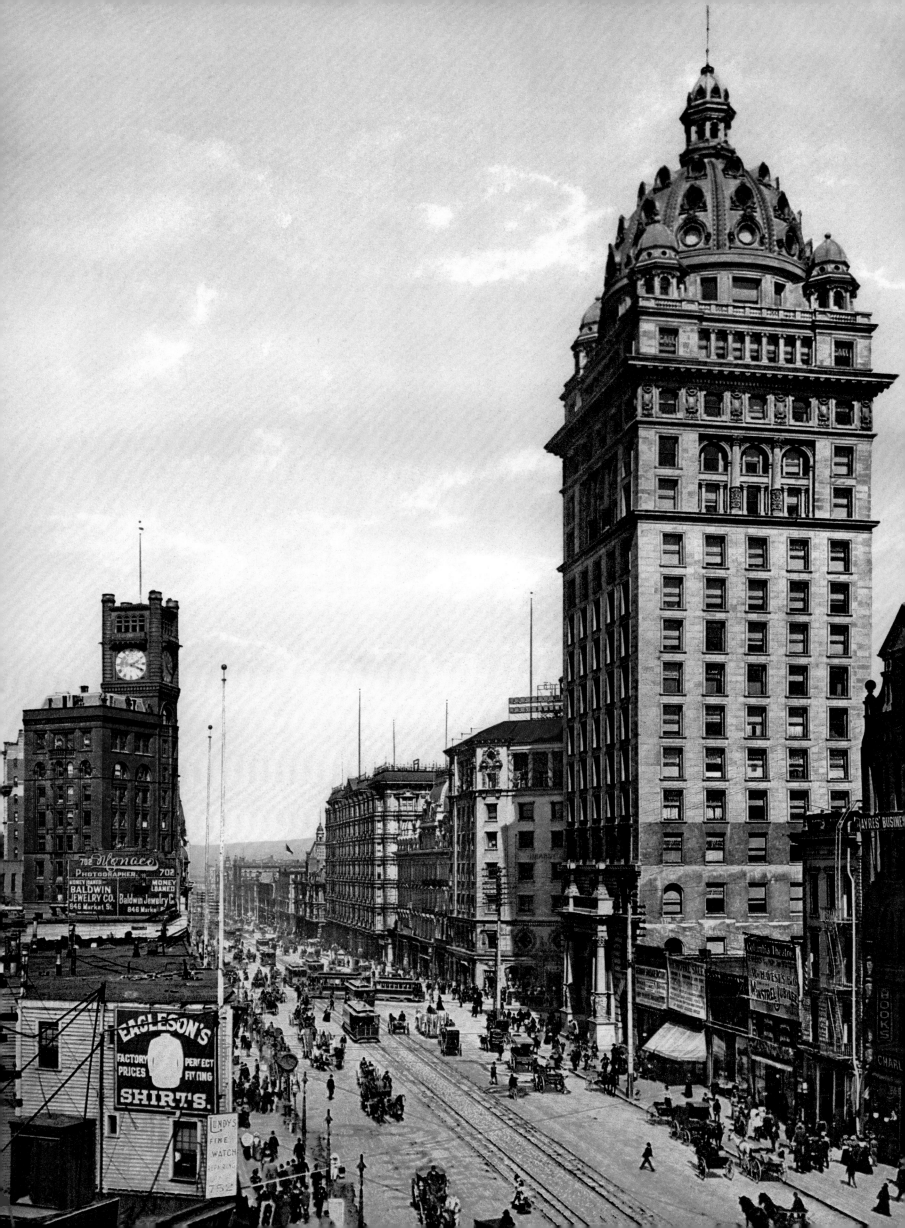

← **Anonymous**

The view west down Market Street, dominated by the Call Building, erected in 1898 to house the San Francisco Call *newspaper. After several renovations, the 300-foot office building still stands at 3rd and Market streets as Central Tower, 1900.*

Blick auf die Market Street nach Westen, sie wird vom Call Building dominiert,das 1898 für die Zeitung San Francisco Call *gebaut wurde. Nach einigen Renovierungen steht das 91 Meter hohe Gebäude noch heute als Central Tower an Third und Market Street, 1900.*

Vue vers l'ouest de Market Street, dominée par le Call Building – érigé en 1898 afin d'accueillir le journal San Francisco Call*. Après plusieurs rénovations, cet immeuble de bureaux d'une hauteur de 91 mètres se dresse toujours à l'angle de la 3ᵉ Rue et de Market Street sous le nom de Central Tower. 1900.*

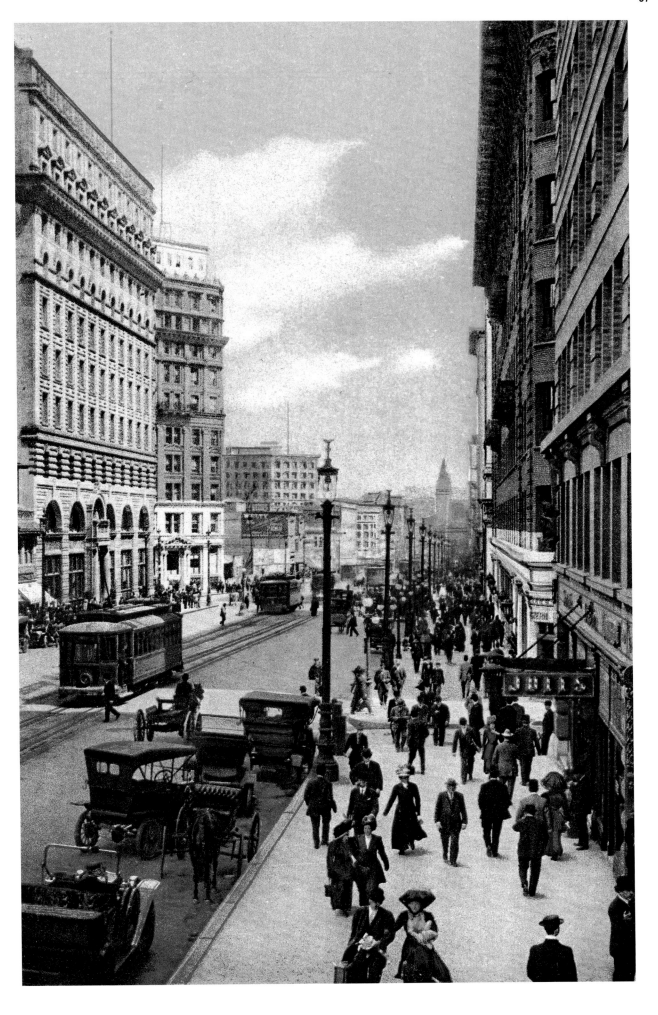

↑ **Anonymous**

Streetcars, automobiles, and horse-drawn carriages jostle for space on Market Street. In the distance at the eastern foot of Market is the newly opened Ferry Building, topped by a green spire, c. 1900.

Bahnen, Autos und Pferdekutschen kämpfen um Platz auf der Market Street. In der Ferne, am östlichen Ende der Market Street, ist das neu eröffnete Ferry Building mit seiner grünen Turmspitze zu sehen, um 1900.

Tramways, automobiles et voitures à chevaux se disputent la chaussée sur Market Street. Au loin, à l'extrémité orientale de la rue, on distingue la flèche verte du Ferry Building, qui vient d'être inauguré. Vers 1900.

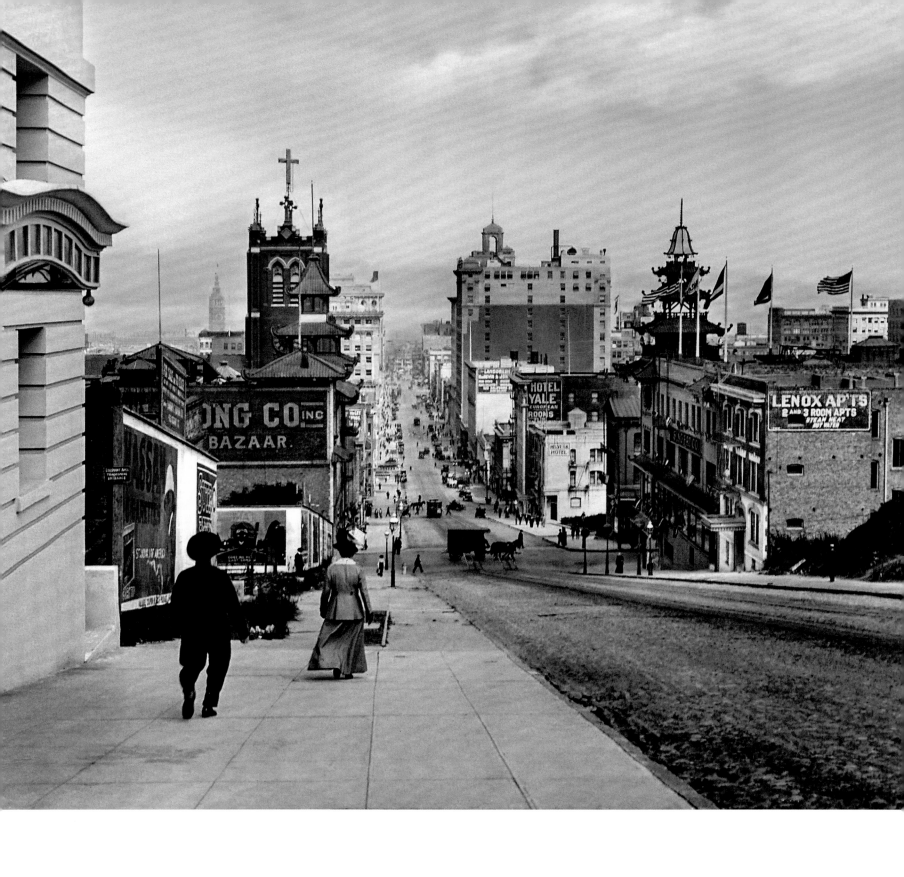

↑
Burton Holmes

Looking down California Street toward the bay from Stockton Street. The tower of Old St. Mary's Cathedral at California and Grant streets is on the left, and the Ferry Building faintly visible yet more to the left at the bottom of the hill, 1915.

Der Blick auf die zur Bucht führende California Street von der Stockton Street aus. Der Turm der Old St. Mary's Kathedrale an der California und Grant Street sind links im Bild und das Ferry Building ist noch weiter links gerade eben am Fuß des Hügels sichtbar, 1915.

Une vue de California Street orientée vers la baie depuis Stockton Street. On peut apercevoir à gauche la tour de la cathédrale Old St. Mary's, à l'angle de California Street et de Grant Street, et plus loin encore, à peine distinct au bas de la colline, le Ferry Building. 1915.

→
Anonymous

Downtown flower vendors at Market and Kearney streets, c. 1900.

Blumenhändler an der Ecke Market und Kearney Street, um 1900.

Un marché aux fleurs à l'angle de Market Street et de Kearney Street. Vers 1900.

"I have always been rather better treated in San Francisco than I actually deserved."

„Ich bin in San Francisco immer eher besser behandelt worden, als ich es eigentlich verdient hätte."

« À San Francisco, j'ai toujours été plutôt mieux traité que je ne le méritais vraiment. »

MARK TWAIN, 1868

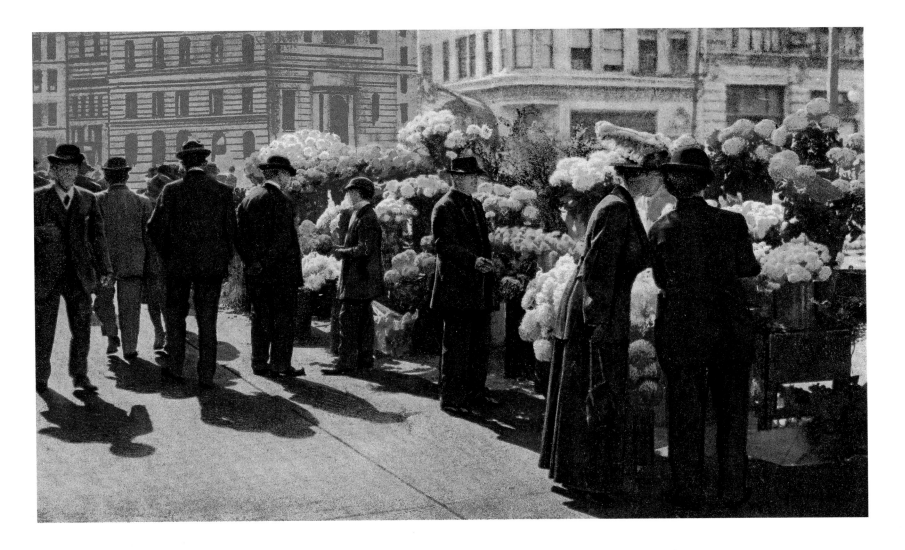

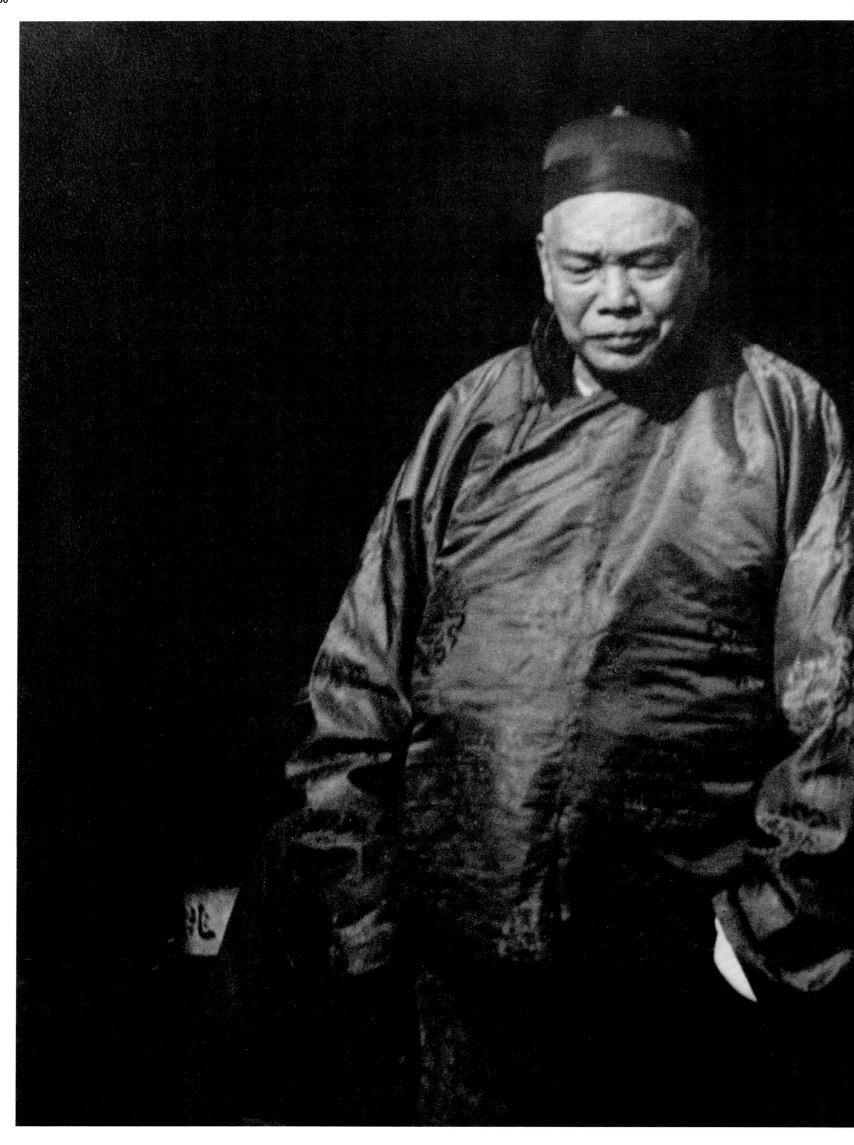

Arnold Genthe

Another of Arnold Genthe's pictures of turn-of-the-century Chinatown is simply titled Merchant and Body Guard, Old Chinatown. *Wrote the photographer in* As I Remember: *"Sometimes one of the big merchants would ask me into his sanctum where he would show me his treasures—a delicately carved crystal, a rare jade, or a peach blow vase,"* c. 1895–1906.

Ein weiteres von Arnold Genthes Bildern aus der Chinatown der Jahrhundertwende, heißt schlicht Händler und Leibwächter, alte Chinatown. *In* As I Remember *schrieb er: „Manchmal lud mich einer der wichtigen Händler ein und zeigte mir seine Schätze: ein filigran geschnitzter Kristall, seltene Jade oder eine Peachblow-Vase", um 1895–1906.*

Cette photo prise par Arnold Genthe dans le quartier chinois s'intitule simplement Merchant and Body Guard, Old Chinatown *(Marchand et garde du corps, vieux Chinatown). « Parfois, l'un des gros commerçants m'invitait dans son antre où il me montrait ses trésors – un cristal délicatement taillé, un jade rare ou un vase en verre soufflé rose pêche », écrit-il dans* As I Remember. *Vers 1895–1906.*

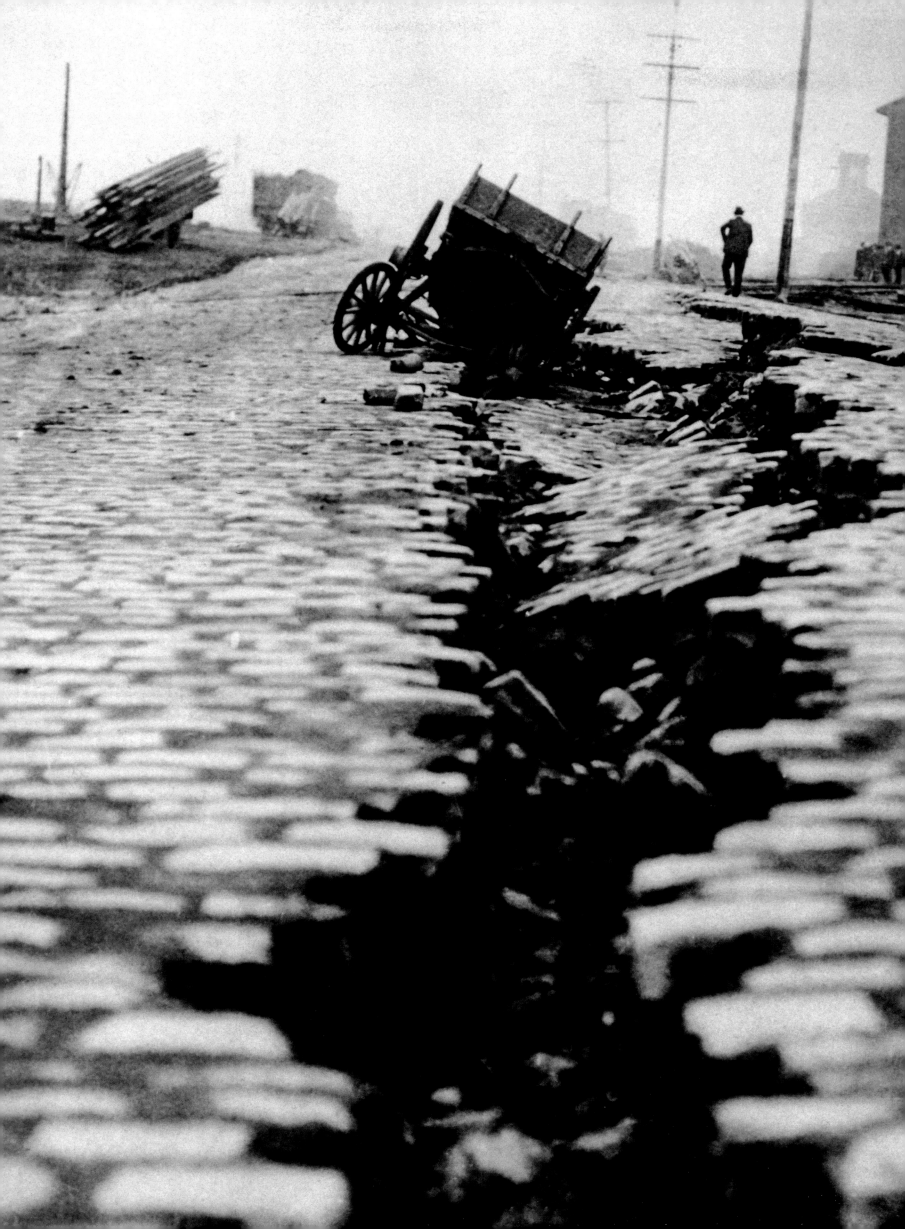

Anonymous

Such was the severity of the earthquake that it split cobblestone streets. The fissures were so wide they literally stopped carts in their tracks. More than 3,000 San Franciscans died in the disaster, which destroyed more than 80 perrcent of the city and left more than half its residents homeless, 1906.

Das Erdbeben war so stark, dass es das Kopfsteinpflaster aufriss und Spalten hinterließ, die die Straßen unbefahrbar machten. Mehr als 3 000 Menschen starben, etwa 80 Prozent der Stadt wurde zerstört und die Hälfte ihrer Einwohner obdachlos, 1906.

Le tremblement de terre a été si puissant qu'il a fendu le pavé des rues. Les larges fissures stoppaient les charrettes dans leur course. Plus de 3 000 habitants de San Francisco périront dans cette catastrophe qui anéantit plus de 80 % de la ville et laissa plus de la moitié de sa population sans abri. 1906.

"Wednesday night the whole city crashed and roared into ruin, yet the city was quiet. There were no crowds. There was no shouting and yelling. There was no disorder."

„Es erscheint seltsam, aber die Nacht zum Mittwoch, in der die ganze Stadt unterging, war eine ruhige Nacht. Es gab keine Menschenansammlungen. Es gab keine erregten Rufe und keine gellenden Schreie. Es gab keine Hysterie, keinen Aufruhr."

« Mercredi soir dans un grondement furieux la ville tout entière s'est effondrée, et pourtant la ville était silencieuse. Pas de cohue. Pas de cris ni de hurlements. Aucun désordre. »

JACK LONDON, 1906

Arnold Genthe

Ladies laugh as the city burns, these onlookers perhaps too shocked to comprehend the scale of the disaster as the earthquake's damage unfolds. "So many whom I met during the day seemed completely unconscious that the fire which was spreading through the city was bound to overtake their own homes and possessions," wrote photographer Arnold Genthe in As I Remember. *His home was destroyed after he'd spent much of the day documenting the catastrophe in pictures, April 18, 1906.*

Zwei Damen lachen angesichts der brennenden Stadt, vielleicht zu schockiert, um das Ausmaß der Katastrophe verstehen zu können. „Vielen von denen, die ich an diesem Tag traf, war es überhaupt nicht bewusst, dass das sich durch die Stadt fressende Feuer auch ihr Zuhause und Hab und Gut erreichen würde," schrieb der Fotograf Arnold Genthe in As I Remember. *Auch seine Wohnung wurde zerstört, nachdem er den Tag damit verbracht hatte, die Katastrophe in Bildern festzuhalten, 18. April 1906.*

La ville brûle et ces dames rient. Peut-être les spectateurs sont-ils ici trop choqués pour mesurer l'ampleur du désastre et des ravages causés par le séisme. « J'ai rencontré ce jour-là quantité de gens qui ne semblaient absolument pas réaliser que le feu se propageant dans la ville allait inexorablement gagner leurs propres maisons et biens », écrit le photographe Arnold Genthe dans As I Remember. *Il passa une grande partie de la journée à photographier la catastrophe, et sa maison fut, elle aussi, détruite. 18 avril 1906.*

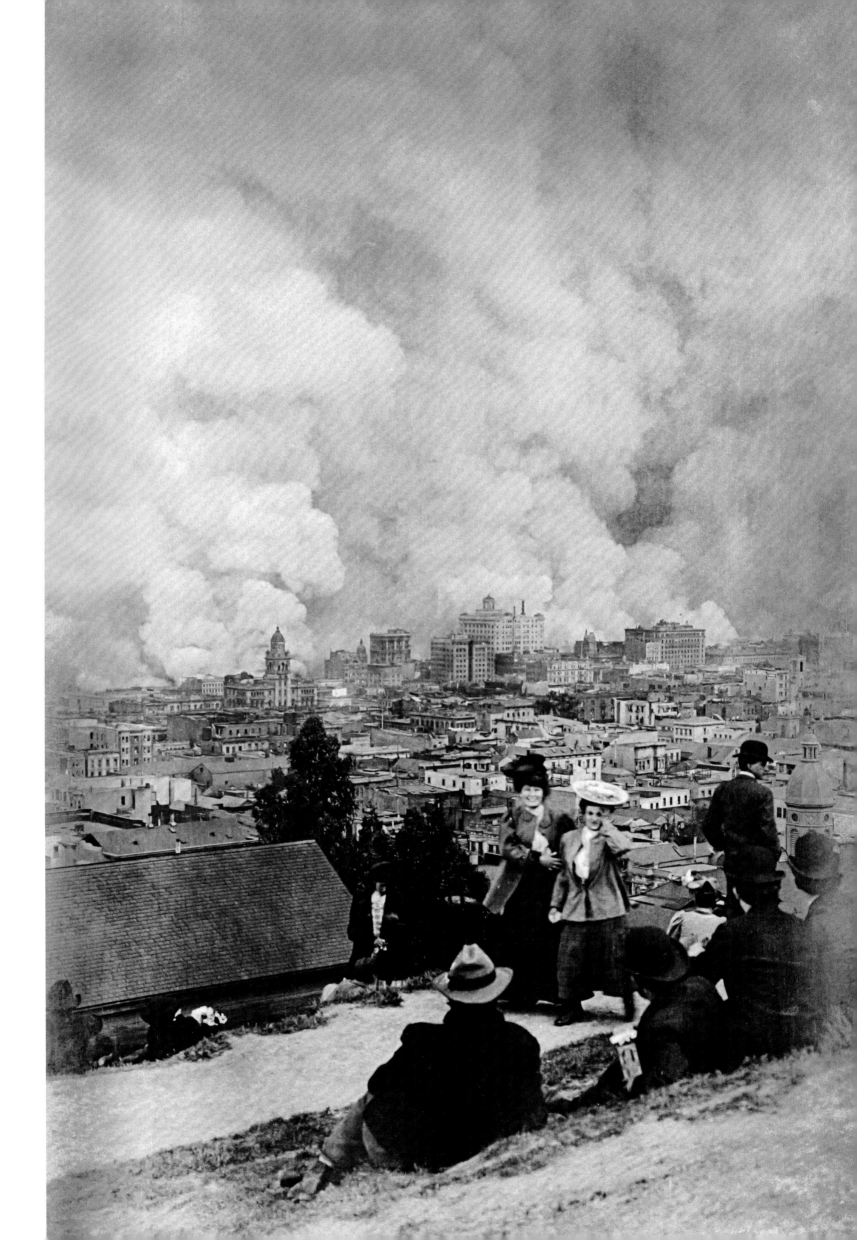

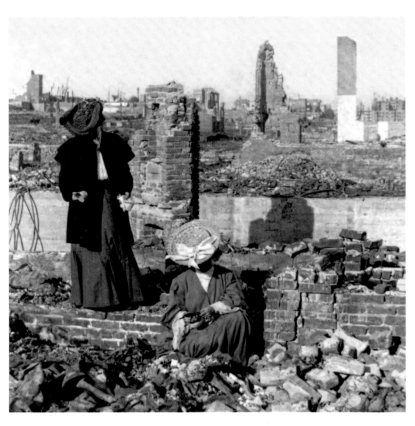

Underwood & Underwood

Two women search for family relics in the ruins of their brick home in the earthquake's aftermath, 1906.

Zwei Frauen suchen nach dem Erdbeben in den Trümmern ihres Hauses nach Familien-andenken, 1906.

Deux femmes fouillent les ruines de leur maison en brique après le tremblement de terre. 1906.

George R. Lawrence

Aerial view of damage a couple weeks after the earthquake. This was taken from an airship 600 feet above Folsom Street between 5th and 6th streets, just a few blocks south of downtown, May 5, 1906.

Blick von oben auf die Schäden, ein paar Wochen nach dem Beben. Das Bild wurde von einem Luftschiff aus gemacht, knappe 200 Meter über der Folsom Street zwischen Fifth und Sixth Street, nur ein paar Blocks südlich von Downtown, 5. Mai, 1906.

Vue aérienne des dégâts, un peu plus de quinze jours après le tremblement de terre. Photo prise depuis un dirigeable, 200 mètres au-dessus de Folsom Street, entre la 5e Rue et la 6e Rue, à quelques pâtés de maisons au sud du centre-ville. 5 mai 1906.

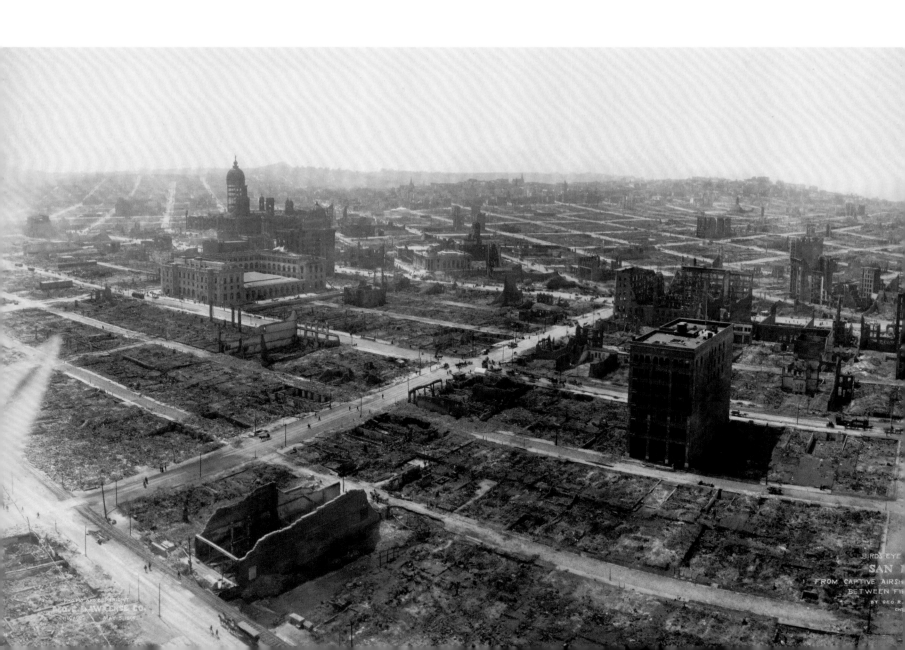

→
Underwood & Underwood

With the fortitude and humor many San Franciscans summoned in the earthquake's aftermath, these displaced residents offered furnished rooms, running water, steam heating, and elevator service in their "House of Mirth" tent. Precursors to "pop-up" cafés also sprang up in small street stalls and shacks, 1906.

Mit Tapferkeit und Humor bieten diese obdachlos gewordenen Anwohner in ihrem Zelt, dem „House of Mirth", möblierte Zimmer, fließendes Wasser, Dampfheizung und einen Aufzug an. Vorläufer der „Pop-up"-Cafés entstanden auch an kleinen Ständen und Schuppen entlang der Straßen, 1906.

Avec la résilience et l'humour dont firent preuve nombre d'habitants après le séisme, ces résidents évacués proposent chambres meublées, eau courante, chauffage central et service d'ascenseur dans leur tente baptisée « House of Mirth » (la maison de l'allégresse). Cafés éphémères avant l'heure, de petites échoppes ont aussi surgi çà et là, bricolées à la hâte à partir de tas de ferraille. 1906.

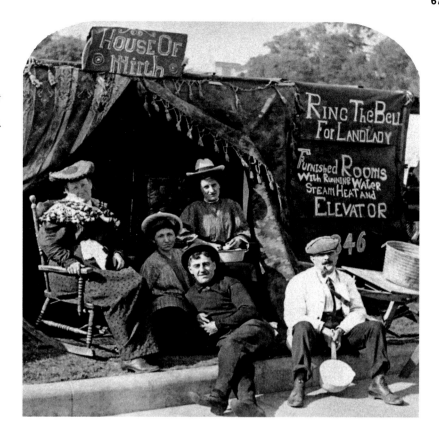

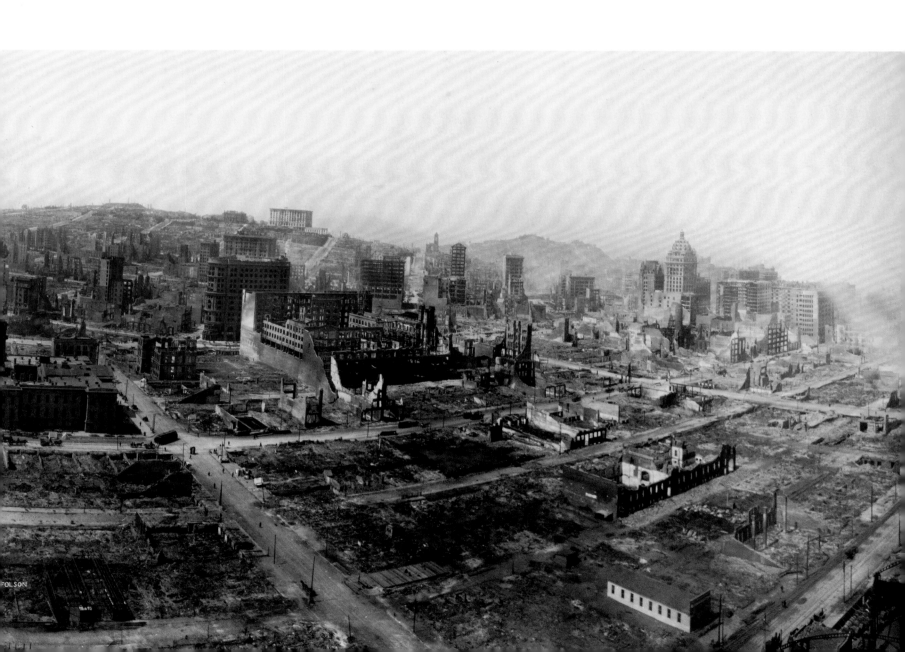

"The fog was rising over the citied hills of San Francisco; the bay was perfect—not a ripple, scarce a stain, upon its blue expanse; everything was waiting, breathless, for the sun."

„Nebel lag über den Hügeln von San Francisco. Die Bucht war spiegelglatt. Nicht eine Welle, kein Gekräusel trübte ihre blaue Weite. Alles hielt in Erwartung der Sonne den Atem an."

« Le brouillard se levait sur San Francisco et ses collines urbaines ; la baie était parfaite – pas le moindre clapotis, à peine une ombre sur l'immense bleu ; à court de souffle, tout attendait le soleil. »

ROBERT LOUIS STEVENSON, 1879

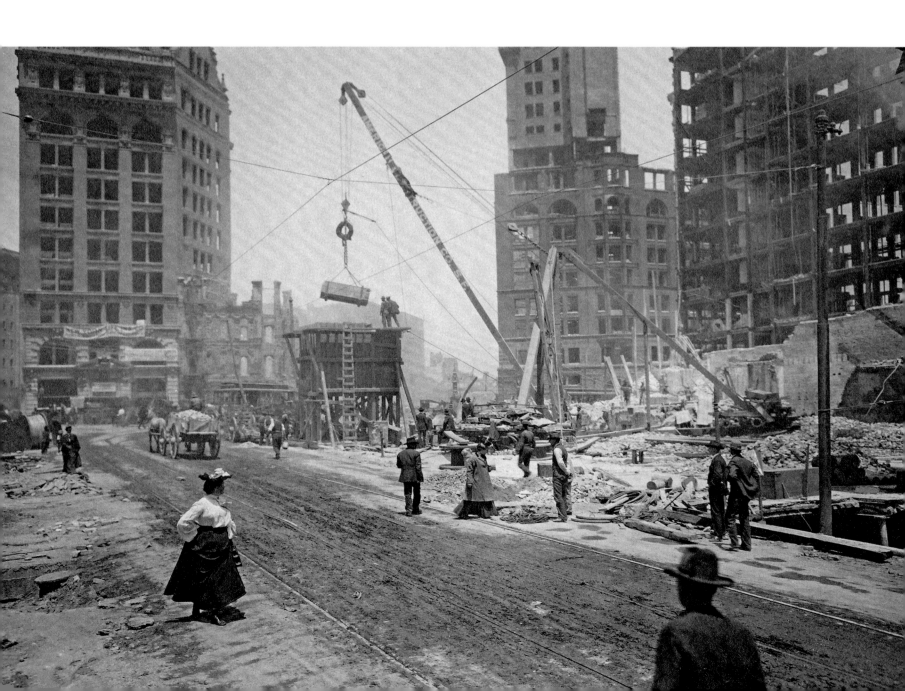

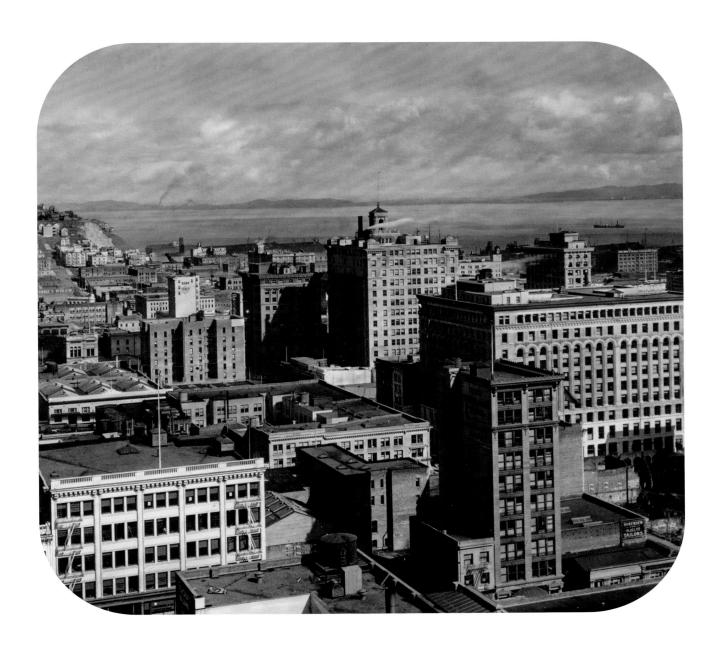

←

Anonymous

*The slow, mammoth task of rebuilding the
city begins as citizens watch a crane move
earthquake rubble, 1906.*

*Die langwierige Mammutaufgabe des
Wiederaufbaus der Stadt beginnt. Die Bürger
sehen den Kränen zu, die die Trümmer
wegräumen, 1906.*

*La lente et colossale entreprise de recons-
truction de la ville s'amorce tandis que
des passants regardent une grue déplacer
les décombres du séisme. 1906.*

↑

Anonymous

*Downtown seen from around Market and
Kearney streets, with Telegraph Hill at the
far left. Just four years after the earthquake,
the city was rebuilding with astonishing
speed, 1910.*

*Downtown von Market und Kearney Street
aus gesehen, mit dem Telegraph Hill ganz
links. Nur vier Jahre nach dem Beben war
die Stadt mit beeindruckender Geschwindig-
keit wiederaufgebaut worden, 1910.*

*Une vue du centre-ville depuis les
alentours de Market Street et de Kearney
Street (Telegraph Hill à l'extrême gauche).
Quatre ans seulement après le tremblement
de terre, la ville se reconstruit à une vitesse
stupéfiante. 1910.*

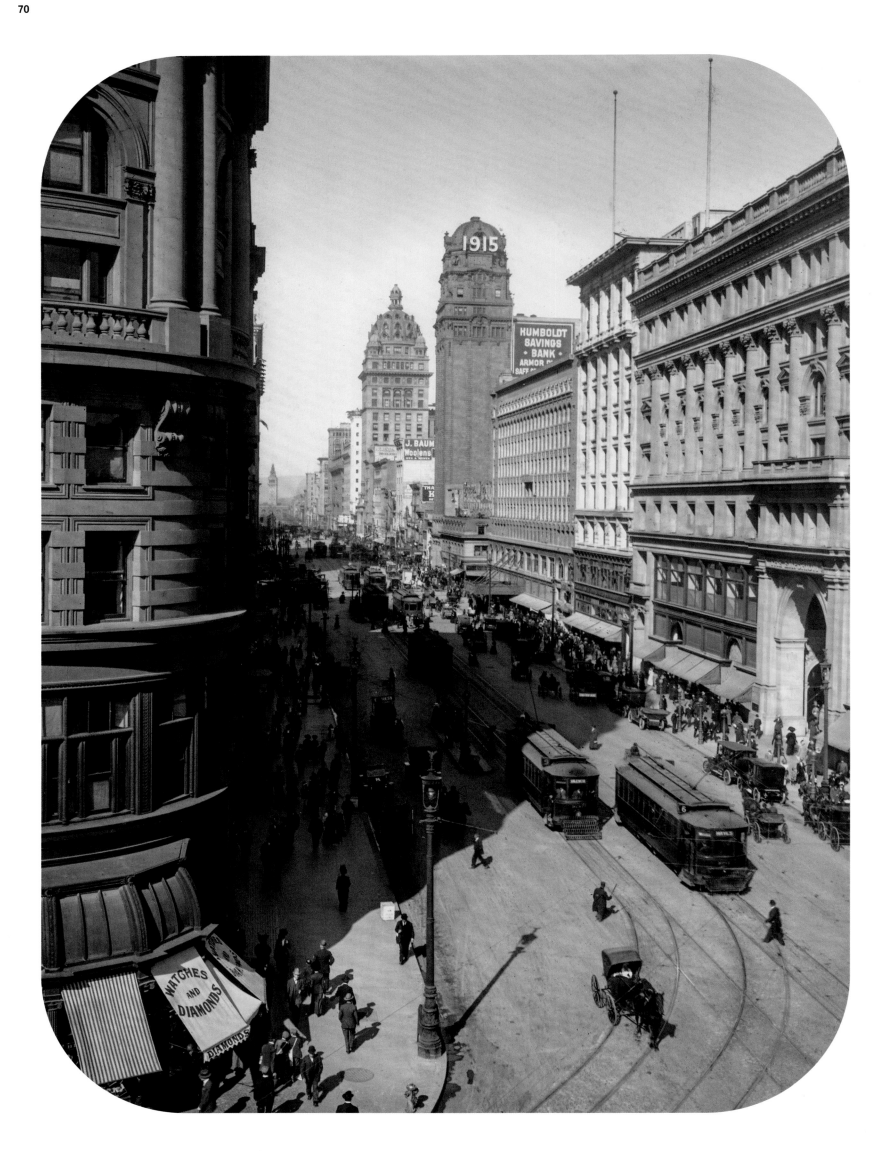

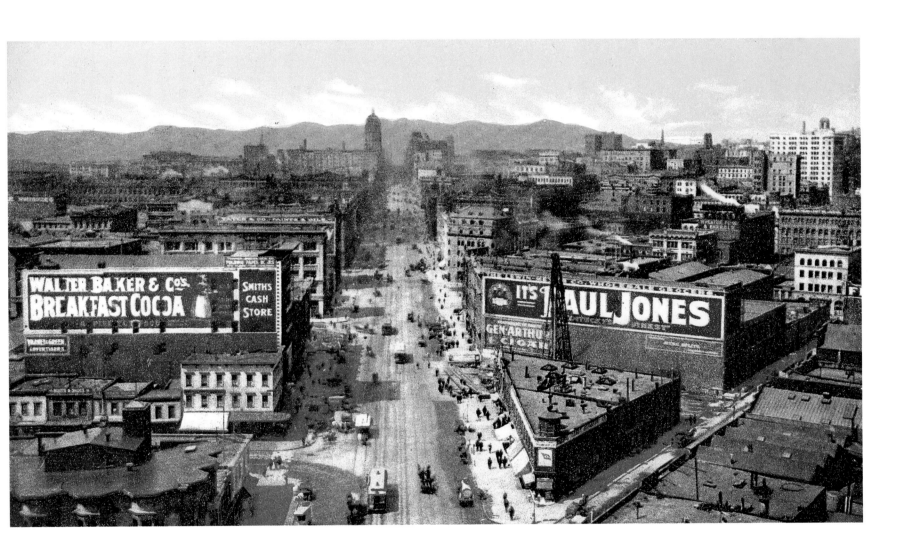

H. C. Tibbitts

Streetcars and automobiles are gaining the upper hand over horse-drawn carriages in this view of Market Street from Powell Street, with the Ferry Building in the distance. The "1915" sign on the Humboldt Bank building anticipates the 1915 Panama–Pacific International Exposition, 1914.

Straßenbahnen und Autos verdrängen Pferdekutschen in diesem Bild der Market Street, aufgenommen von der Powell Street mit dem Ferry Building im Hintergrund.

Das Schild „1915" an der Humboldt Bank verweist auf die 1915 kommende Panama– Pacific International Exposition, 1914.

Tramways et automobiles commencent à damer le pion aux véhicules hippomobiles sur cette vue de Market Street prise depuis Powell Street – on distingue au loin le Ferry Building. L'enseigne marquée « 1915 » en haut de la Humboldt Bank annonce l'Exposition internationale Panama-Pacifique, qui doit se tenir cette année-là. 1914.

Anonymous

Looking west on Market Street. As the 20th century began, more and bigger buildings were rising on downtown's main thoroughfare, adorned with huge billboards targeting the heavier traffic, c. 1900.

Der Blick über die Market Street nach Westen. Anfang des 20. Jahrhunderts wurden mehr und größere Gebäude an der Hauptdurchgangsstraße von Downtown gebaut, immer größere Werbetafeln richten sich an die zunehmende Zahl der Passanten, um 1900.

Tournée vers l'ouest, Market Street au début du xxe siècle. À cette époque la principale artère du centre-ville se couvre d'immeubles toujours plus nombreux ornés de publicités qui rivalisent de taille pour s'adapter au flot croissant de la circulation. Vers 1900.

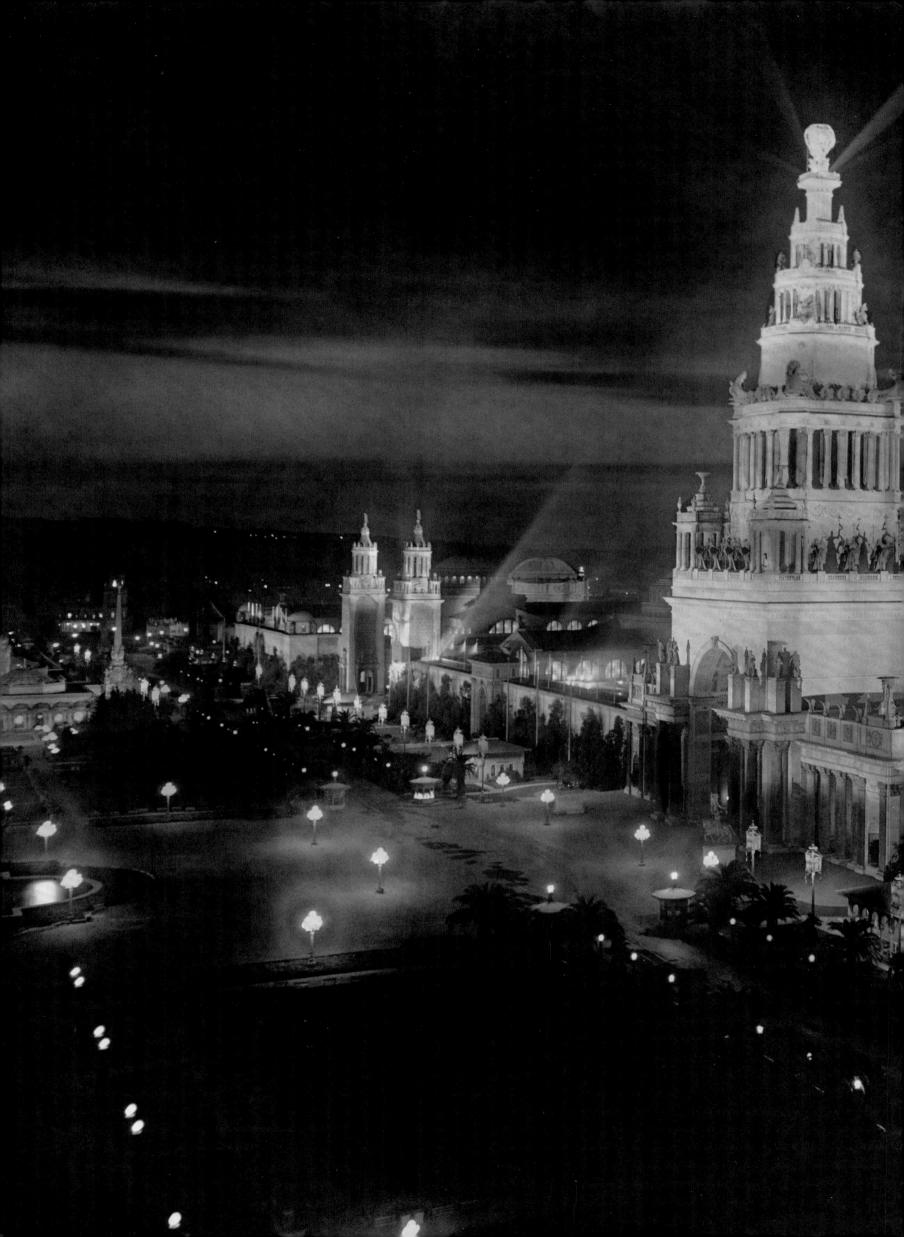

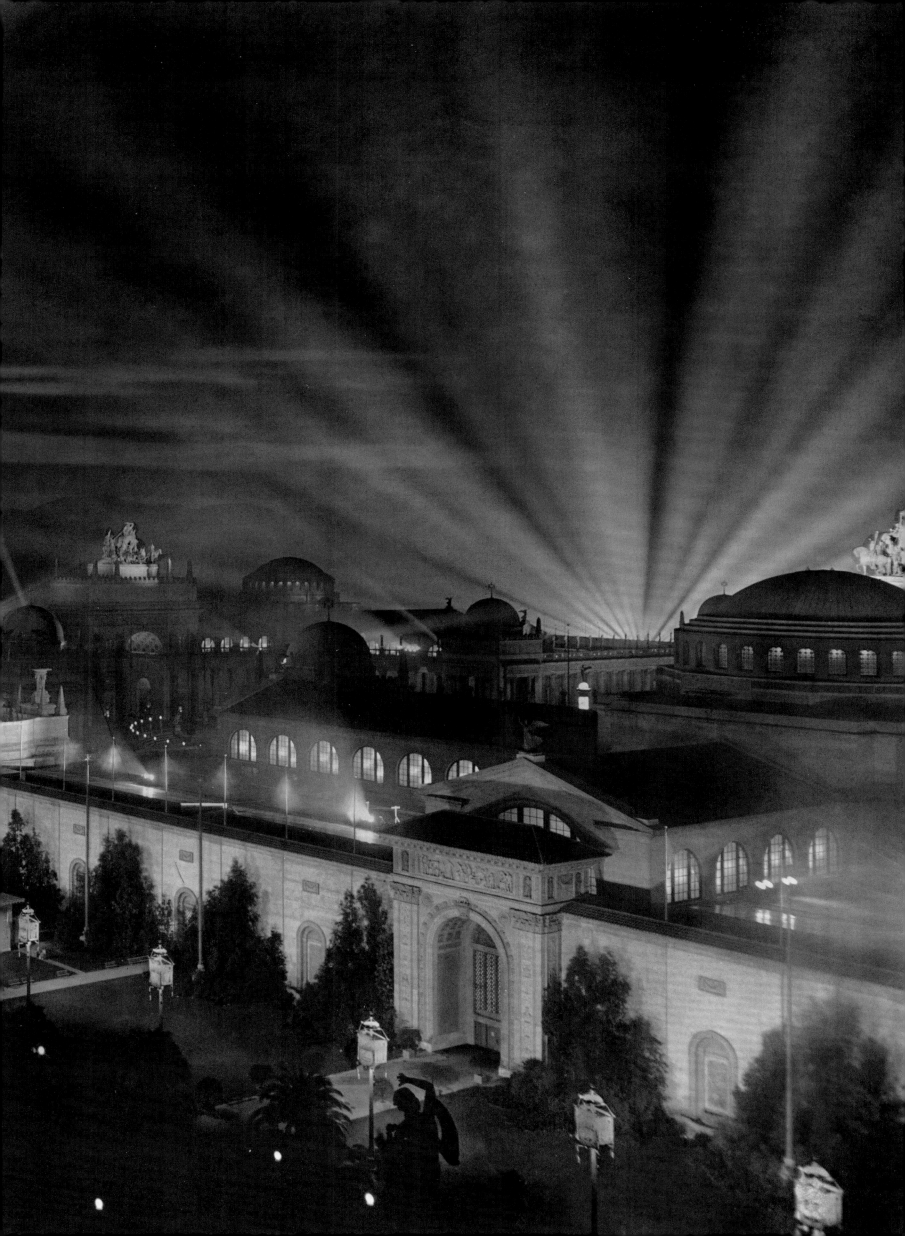

"The street never failed to interest him. It was one of those streets peculiar to Western cities, situated in the heart of the residence quarter, but occupied by small tradespeople who lived in the rooms about the shop."

„Die Straße interessierte ihn immer. Es war eine der Nebenstraßen, wie sie den Städten im Westen eigentümlich sind: im Herzen des Wohnviertels gelegen, war sie dennoch eine Straße der kleinen Geschäftsleute, die in den Räumen über ihren Läden hausten."

« La rue ne manquait jamais de l'intéresser. C'était une de ces rues propres aux villes de l'Ouest, située au cœur du quartier résidentiel mais occupée par de petits commerçants qui habitaient au-dessus de leur boutique. »

FRANK NORRIS, *MCTEAGUE*, 1899

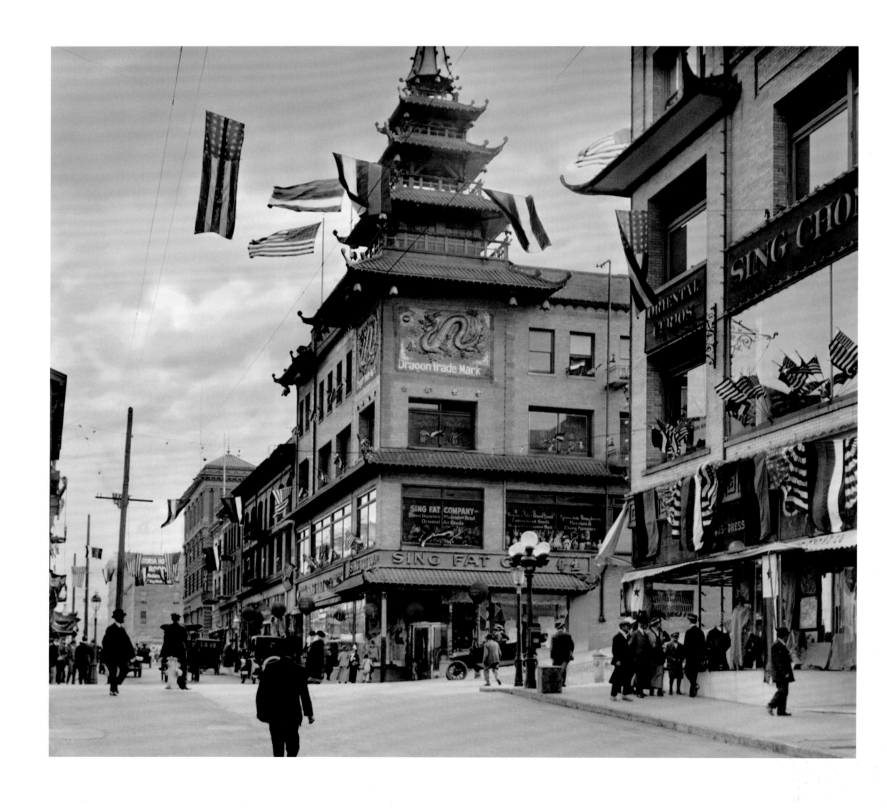

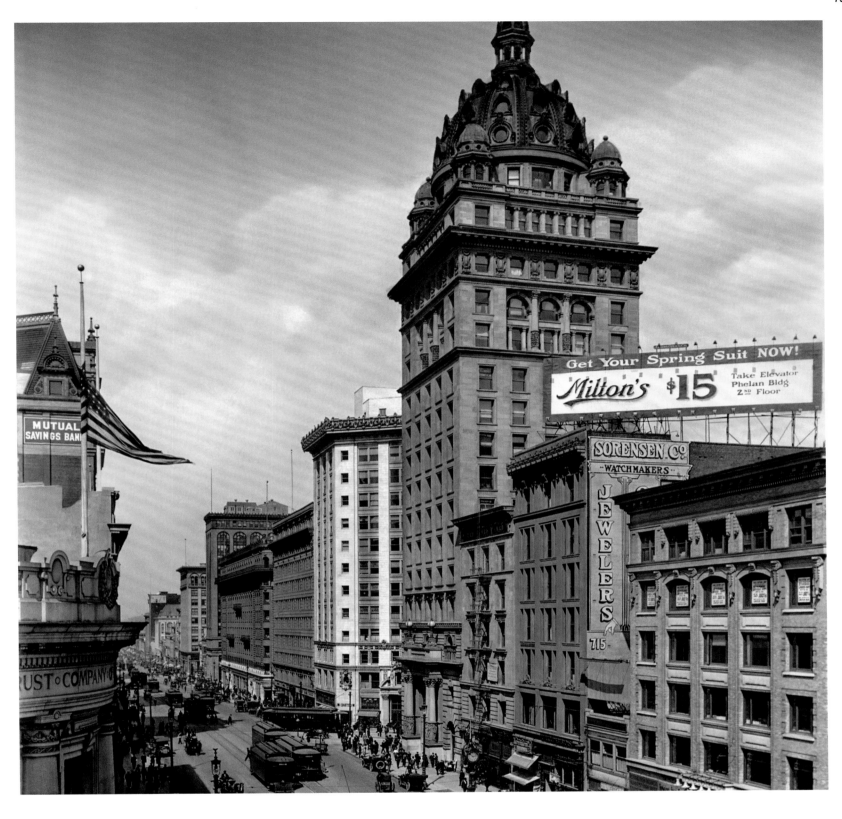

←
Burton Holmes

The Sing Fat Company building on Grant Avenue, Chinatown's main drag, where it intersects California Street. Billed as a "leading Oriental bazaar," it also had branches in New York and Los Angeles, 1915.

Das Gebäude der Sing Fat Company an der Kreuzung der Grant Avenue, der Hauptstraße Chinatowns, mit der California Street. „Der führende orientalische Bazar", hatte auch Zweigstellen in New York und Los Angeles, 1915.

Le bâtiment de la Sing Fat Company sur Grant Avenue, l'artère principale du quartier chinois, là où elle croise California Street. Présentée comme « le meilleur bazar oriental », elle comptait également des succursales à New York et Los Angeles. 1915.

↑
Burton Holmes

The Spreckels Building, formerly the Call Building (and later Central Tower), hovers over surrounding structures in this view near Third and Market streets. As the billboard in its shadow let passersby know, these were the days when new spring suits cost 15 dollars, 1915.

Das Spreckels Building, zuvor bekannt als Call Building (und später als Central Tower) überragt die umliegenden Häuser in der Nähe von Third und Market Street. Das Werbeplakat verrät, dass damals ein neuer Frühlingsanzug 15 Dollar kostete, 1915.

Le Spreckels Building, ex-Call Building et future Central Tower, plane au-dessus des immeubles voisins sur cette vue prise tout près de la 3e Rue et de Market Street. Ainsi que l'annonce le panneau publicitaire, s'offrir un costume neuf en prévision du printemps coûtait alors 15 dollars. 1915.

p. 72/73
Anonymous

The 435-foot Tower of Jewels was among the centerpieces of the Panama–Pacific Exposition. Here it's illuminated by the Scintillator, a huge fan of colored lights operated by Marines that was created especially for this world's fair, 1915.

Der 120 Meter hohe Tower of Jewels war eine der Hauptattraktionen der Panama–Pacific Exposition. Hier wird er vom Szintillator angestrahlt, einem eigenes für die Ausstellung entwickelten Gerät, das farbiges Licht abgibt und von Marines bedient wird, 1915.

Haute de 132 mètres, la Tower of Jewels était l'un des points d'orgue de l'Exposition universelle de 1915, également nommée Exposition internationale Panama-Pacifique. On la voit ici illuminée par le Scintillator, un formidable faisceau de projecteurs colorés actionné par un bataillon de marines et créé spécialement pour l'occasion. 1915.

↑
Hamilton Henry Dobbin

By fall 1918, the influenza epidemic hit San Francisco so hard that outdoor court sessions were held in Portsmouth Square in hopes of stemming the spread. Judge John J. Sullivan presides, 1918.

Im Herbst 1918 traf die Grippe-Epidemie San Francisco so hart, dass Gerichtsverhandlungen auf dem Portsmouth Square abgehalten wurden, um eine weitere Verbreitung der Viren zu verhindern. Die Verhandlung leitet Richter John J. Sullivan, 1918.

À l'automne 1918, l'épidémie de grippe espagnole frappa si lourdement San Francisco que le tribunal dut siéger en plein air sur Portsmouth Square, dans l'espoir d'en enrayer la propagation. Le juge John J. Sullivan préside ici l'instance. 1918.

↓
Hamilton Henry Dobbin

Police officer warns citizen to put on a mask as the influenza epidemic sweeps through the city. Hundreds were arrested for wearing masks improperly or not at all, foreshadowing controversies over health guidelines in the pandemic that erupted around the world over a century later, 1918.

Ein Polizist ermahnt einen Bürger, wegen der Grippe-Epidemie eine Maske zu tragen. Hunderte wurden verhaftet, weil sie Masken falsch oder gar nicht trugen, ein Vorgeschmack auf die Kontroversen, die sich um das Thema während einer weiteren Pandemie über ein Jahrhundert später entwickeln sollten, 1918.

Un policier sensibilise un citoyen au port du masque alors que l'épidémie de grippe déferle sur la ville. Des centaines de personnes seront interpellées pour avoir porté leur masque de manière incorrecte ou s'en être dispensées. Une préfiguration des controverses qui entoureront les directives sanitaires d'une autre pandémie plus d'un siècle plus tard. 1918.

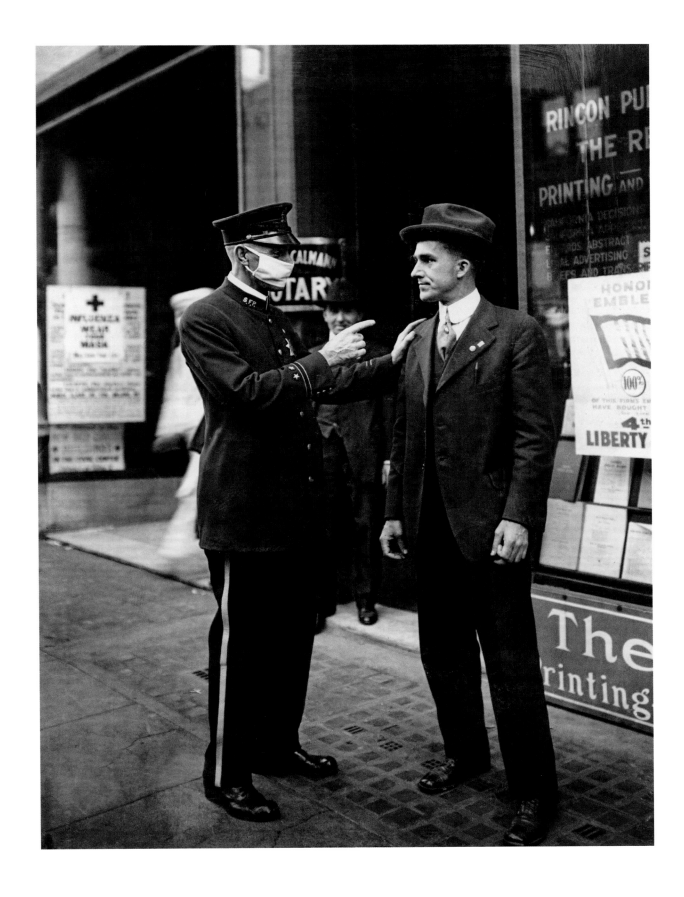

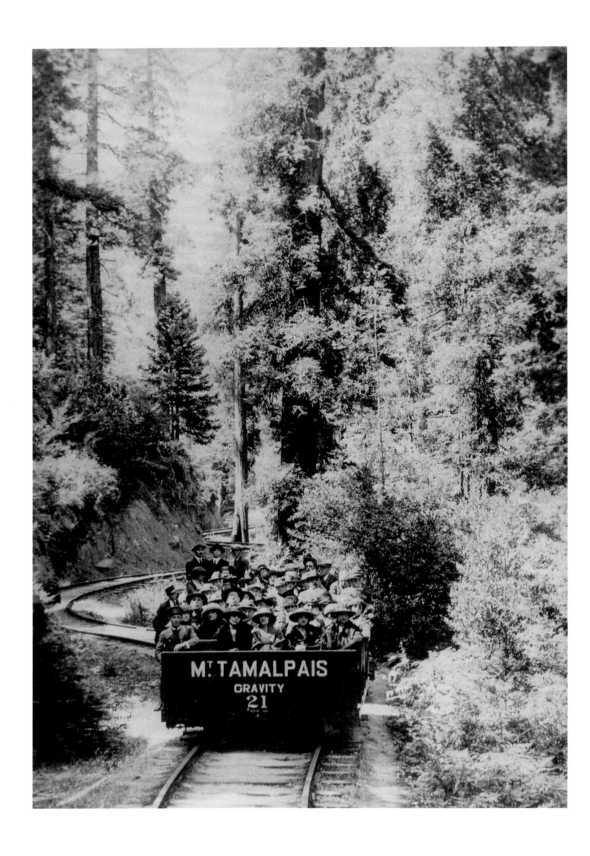

→
Hamilton Henry Dobbin

City Hall as seen from the entrance of the State Building. The centerpiece of the Civic Center, it had opened in 1916 as a replacement for the original City Hall, which was destroyed in the 1906 earthquake, 1925.

City Hall vom Eingang des State Buildings aus gesehen: das Rathaus ist der wichtigste Teil des Civic Center. Sein Vorgänger wurde beim Erbeben von 1906 zerstört, 1925.

L'hôtel de ville vu depuis l'entrée du State Building. Pièce maîtresse du Civic Center, il avait été inauguré en 1916 en remplacement de l'édifice original, détruit par le séisme de 1906. 1925.

↑
Anonymous

Visitors to the east peak of Mount Tamalpais in Marin County could take an eight-mile ride in a "gravity car" to Muir Woods on what was reported as the most crooked railroad in the world. Carrying about 20 passengers, these engine-less vehicles were powered by gravity at a speed of 10 to 15 miles per hour. A locomotive pulled them back up the mountain. The operator in the left front seat used a set of double brakes, c. 1915.

Besucher des östlichen Gipfels von Mount Tamalpais in Marin County konnten mit dem „gravity car" die 13 Kilometer bis Muir Woods auf der vermeintlich kurvigsten Schienenstrecke der Welt fahren. Diese Bahn ohne Motor bot Platz für rund 20 Personen und fuhr nur von der Schwerkraft angetrieben bis zu 25 Stunndenkilometer. Eine Lokomotive zog sie dann wieder auf den Berg. Vorne links sitzt der Fahrer und bedient die Doppelbremsen, um 1915.

Pour découvrir le versant oriental du mont Tamalpais, dans le comté de Marin, les volontaires avaient droit à une excursion de 13 kilomètres jusqu'aux séquoias de la forêt de Muir Woods à bord de ces « gravity cars ». Capables d'accueillir une vingtaine de passagers sur le chemin de fer alors le plus tortueux du monde, ces véhicules sans moteur étaient mus par la gravité à une vitesse de 16 à 24 km/h et tractés en phase d'ascension par une locomotive. Assis sur le siège avant gauche, le conducteur disposait d'un double frein manuel. Vers 1915.

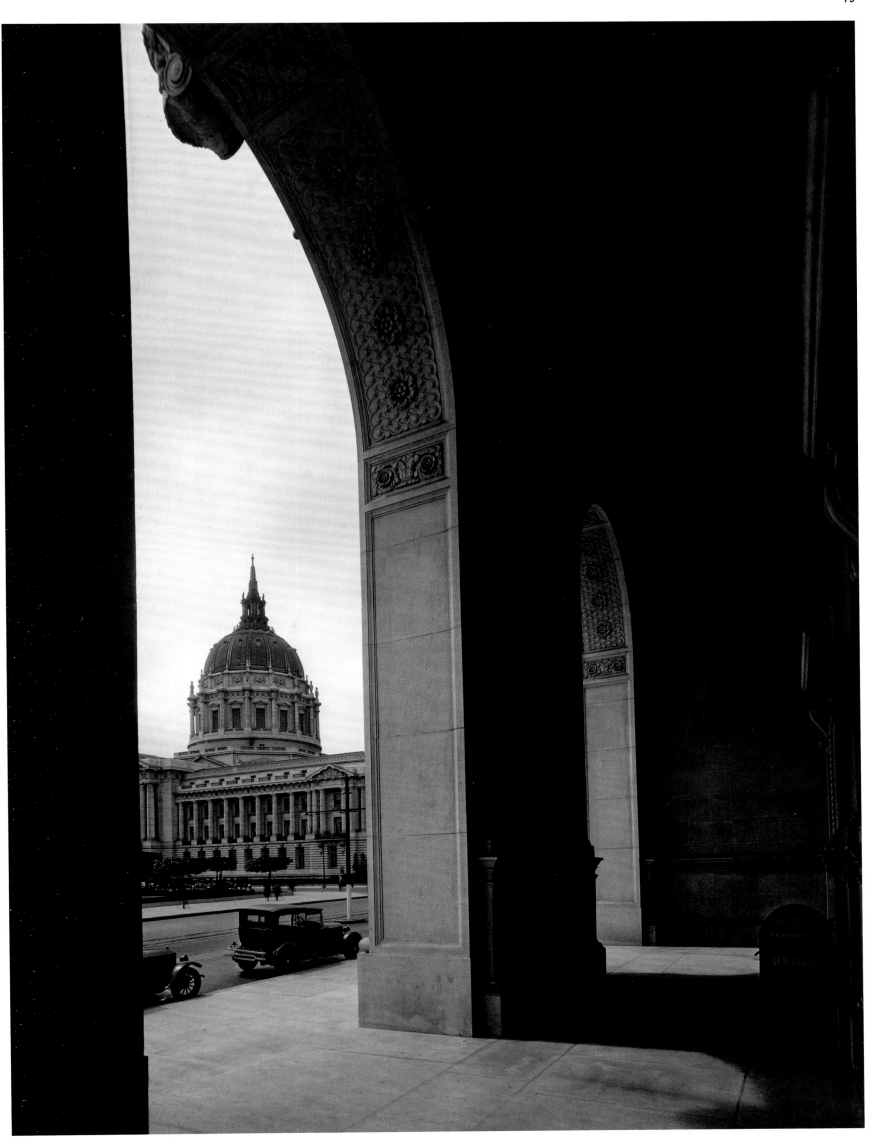

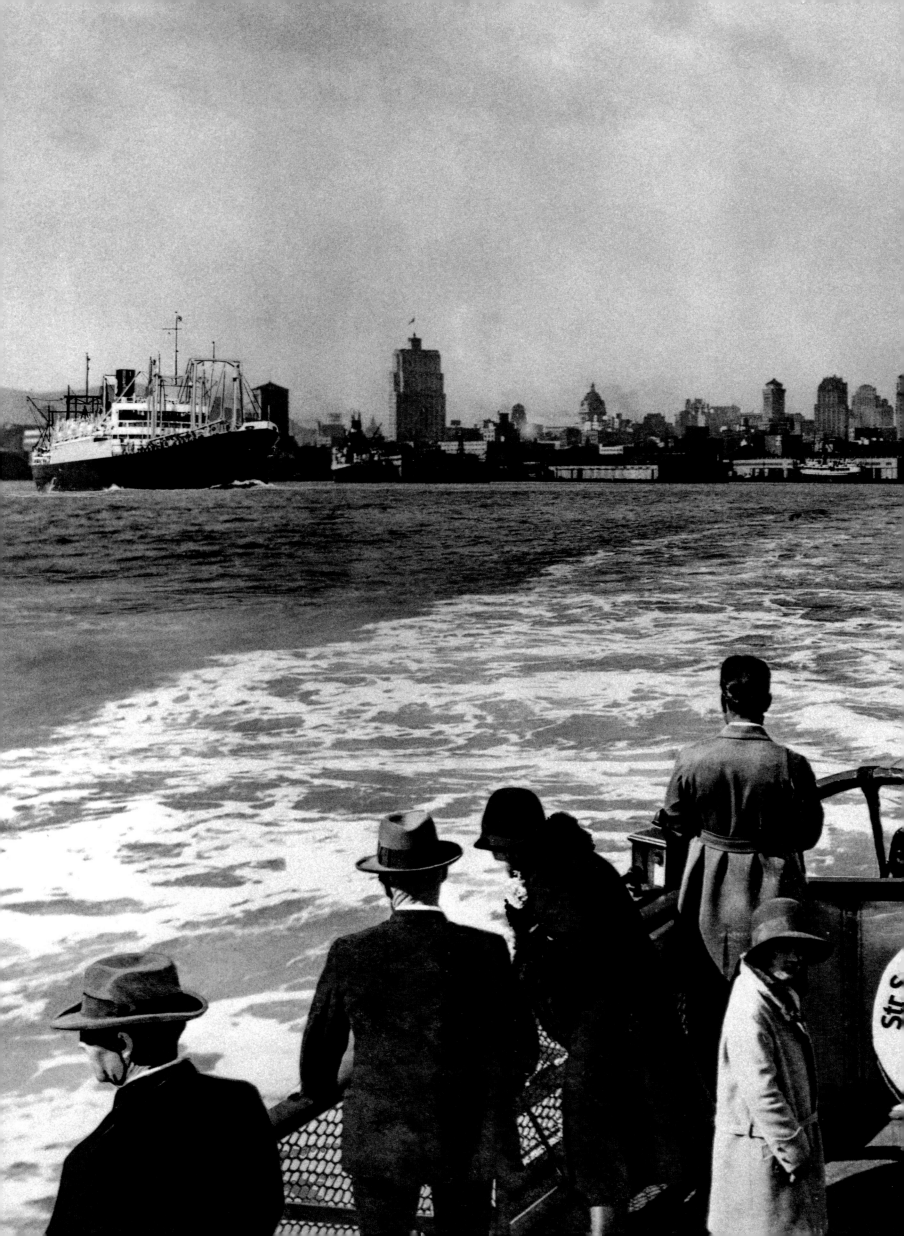

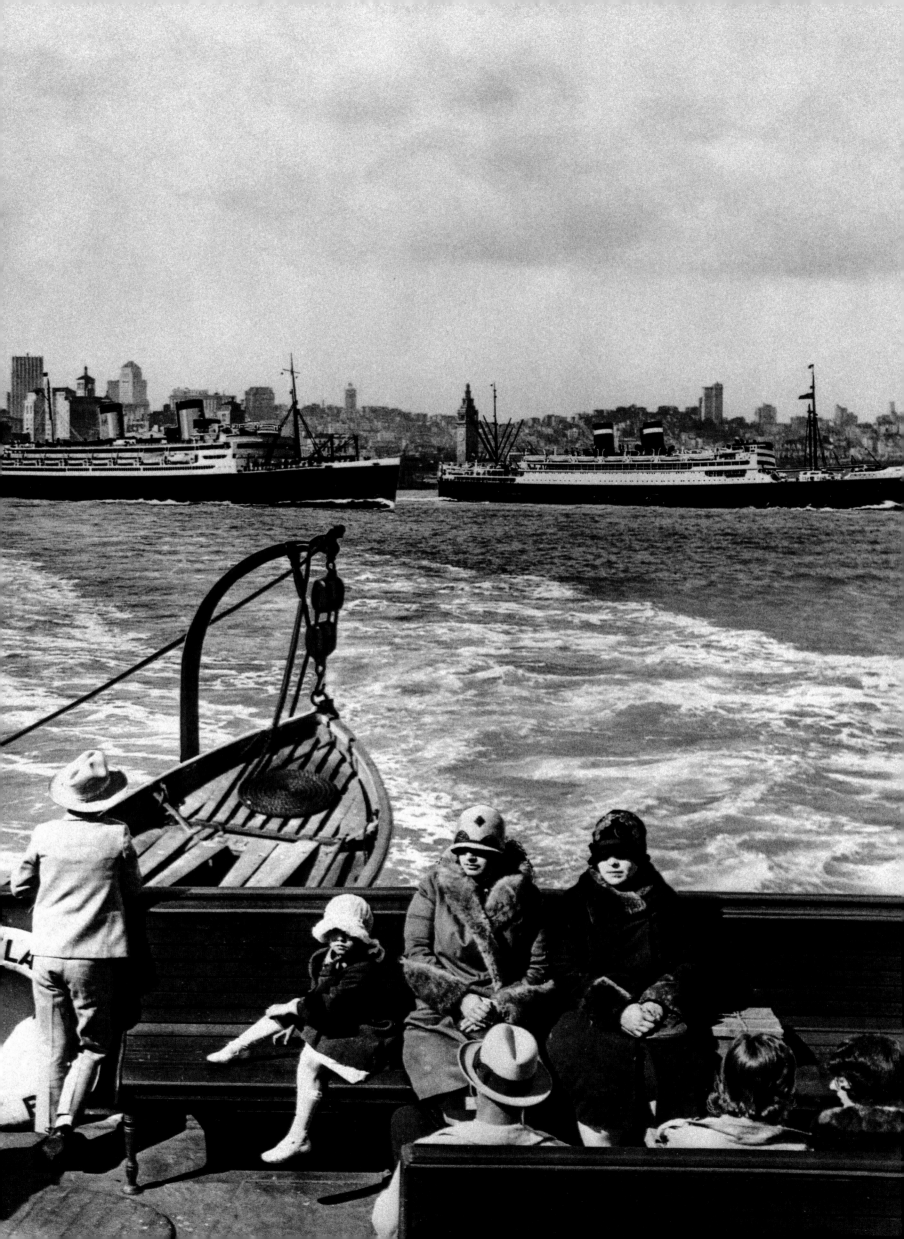

2

Bridge the Divide
1930–1945

p. 80/81
W. W. Swadley

Ferry passengers taking in the San Francisco skyline as it looms into view, c.1920s.

Passagiere einer Fähre bestaunen die langsam sichtbar werdende Skyline San Franciscos, 1920er-Jahre.

Les contours de San Francisco soudain se découpent à l'horizon devant les passagers de ce ferry. Vers 1920.

The Depression hit all sectors of San Francisco society hard. That included the wealthy, especially those working in the downtown Financial District, whose main drag, Montgomery Street, had become known as the Wall Street of the West. The poor were hit harder. Unemployment was high, and even those who held on to jobs struggled for decent pay.

Work on the docks in San Francisco's busy port meant low wages under dangerous conditions. Longshoremen began a strike in every western port on May 9, 1934. Two months later, the Industrial Association tried to reopen San Francisco's port with scab labor. On July 5, conflicts between mounted police and strikers escalated into violence, with more than a hundred injuries. Police fired into the crowd, killing two men on what became known as Bloody Thursday. The Longshoremen's Association rank-and-file leader, Harry Bridges, pushed for a general strike, which broke out spontaneously throughout the Bay Area after the July 9 funeral march honoring the victims. In solidarity, on July 16, about 150,000 local sailors, engineers, and other workers walked off their jobs with an official strike.

The "official" general strike, one of the few and likely the most famous in US history, lasted four days. Although strikers went back to work after agreeing to accept an arbitrator's decision, to a large degree, it was eventually successful. A few months later, that decision gave them a jointly controlled hiring hall, which over time gave them de facto control over how work could be allocated.

The strike was also instrumental in establishing another long-held Bay Area tradition: political activism, often considered by authorities to be dangerously radical. Over the next decade and a half, there would be hundreds of wildcat strikes and plenty of attendant violence. A major union-busting push in 1948 failed, consolidating the trade union deal between the International Longshore and Warehouse Union and the Pacific Maritime Association. Plenty of political radicals found work in the longshoremen's union during this period, though by the 1960s, Bay Area protester–police conflicts would take a different shape over different causes.

The Depression was hitting its depths, but San Francisco was about to pull off some of the most remarkable engineering feats in history, despite the enormous expense and labor involved. Since World War I, hopes for building a bridge that would cross the Golden Gate strait at its narrowest point had gained increasingly strong momentum. By the beginning of the 1930s, a $30–35 million bond measure (reports of the exact amount still vary) for its construction had been approved. Work on the bridge didn't start until January 1933, taking four years to complete, and costing nearly a dozen lives. After navigating almost impossibly complicated political and technical obstacles, the bridge opened with great fanfare on May 27, 1937. Besides opening automobile traffic between San Francisco and Marin County, it also became the city's most vivid and enduring symbol. With its long, gracefully arching orange spans overlooking a constant parade of ships of all shapes and sizes, the bridge itself became one of the country's top landmarks, symbolizing the gateway not just to San Francisco, but to the entire American West. Few other man-made structures

combine everyday usefulness with such classic aesthetics, if anything enhanced by its frequent shrouding from the fog that so often blankets much of the city.

If not as scenic as the Golden Gate Bridge, the San Francisco–Oakland Bay Bridge was about as impressive an accomplishment, and not without its own visual charms. Much longer than its counterpart, the nearly five-mile-long Bay Bridge carries far more traffic, though it would get so clogged that yet another means of city–East Bay transportation had to be built decades later. Opening in November 1936, it cost twice as much as the Golden Gate Bridge, yet it more than paid back its expense with the huge increase in the flow of people and goods between both sides of the bay.

Other projects in the 1930s provided many laborers with much-needed work and further beautified San Francisco. From the mid-1930s through the early 1940s, federal Works Progress Administration programs helped create Aquatic Park, the northern waterfront space whose tiny beach is still used as a base for hardy wet suiters brave enough to swim in the chilly bay. WPA murals, acclaimed for both their artistic merit and historical documentation, adorned the building in Aquatic Park that would become the Maritime Museum, as well as the Beach Chalet at the western end of Golden Gate Park.

The most popular murals, commissioned not by the WPA but by the New Deal's Public Works of Art Project, were found in Coit Tower. Built in 1933 to overlook Telegraph Hill in North Beach, the 210-foot concrete art deco building quickly became yet another of the city's visual icons, beloved for both its slim white column and the panoramic views from the top. On the way up and down, visitors could take in murals depicting California life in all its social realism by 25 artists, most of whom taught or studied at the California School of Fine Arts. Other artistic and cultural pursuits prospered in the city. The California School of Fine Arts (later the San Francisco Art Institute) was one of the most prestigious schools of its kind west of the Mississippi, hiring famed muralist Diego Rivera to paint a still-standing mural in its gallery in the early 1930s. Also affiliated with the school were several innovative photographers, some of whom helped found Group f/64. This band of San Francisco–based artists gave a more realistic and social dimension to picture-taking, and some such as Ansel Adams, Imogen Cunningham, and Edward Weston took many of their finest photos in the Bay Area.

Organized sports became bigger business with the Pacific Coast League's San Francisco Seals, which started in 1903 and featured many future and past stars of baseball's major leagues. The biggest, Joe DiMaggio, hailed from an Italian American fishing family in North Beach. He played for the Seals for several years in the early 1930s before starring for the New York Yankees. Joe's brothers Vince and Dom would also graduate from the Seals to the majors, as did Yankee All-Stars Lefty Gomez and Frankie Crosetti.

As the 1940s began, the city's population had leveled off at slightly shy of 650,000. There wasn't enough space for many more inhabitants, and plenty opted for less fogbound environs, especially with bridges that made commuting far easier. Better transportation also meant more access to some of the top nearby

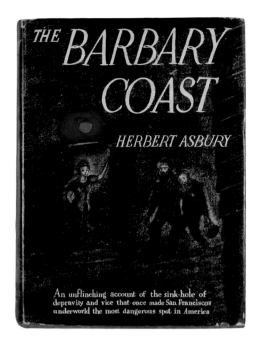

attractions, whether buildings in Berkeley and Oakland by noted architect Julia Morgan, or Marin County's Muir Woods. Recreation took a backseat when the United States entered World War II in December 1941. Harbor defenses were shored up with underwater mines and antisubmarine nets. San Francisco had the nation's first major blackout the day after Pearl Harbor, as protection against a feared Japanese attack.

Those fears also sparked a roundup of residents of Japanese descent throughout the West Coast. Within months, more than 100,000 Japanese Americans, most of them US citizens, were forcibly relocated to detention camps. In reality they posed no threat to the country's security, their incarceration stoked by unrealistic suspicions of espionage and naked racism. In San Francisco's sizable Japantown in the Western Addition neighborhood, not far west of downtown, Japanese were forced to abandon their homes and businesses, as they were throughout the Bay Area. Often they were unable to reclaim these when they were permitted to return at the war's end.

The defense industry's need for workers drew thousands to San Francisco. Among them were African Americans who moved from the South. Many moved to Hunters Point, where the Navy had purchased the shipyard in 1940 and hastily built housing for its new workers. Many found homes in the Western Addition, which Japanese Americans had been forced to abandon. Within a few years, the Fillmore District was a hub of Black culture, and its many jazz clubs and Black-owned businesses earned it the nickname "the Harlem of the West." The need for labor also brought unprecedented numbers of women to work in shipyards and factories.

Discrimination didn't go away when African Americans and women took jobs that had formerly belonged to white males.

A July 1944 munitions explosion in the East Bay's Port Chicago took more than 300 lives and injured almost 400 others, with African Americans accounting for most of the casualties. When hundreds of African American Port Chicago sailors refused to continue loading such material to protest against unsafe working conditions, 50 were convicted of mutiny, though most were released shortly after the war.

San Francisco was a key point of embarkation for soldiers serving in the Pacific, and more than a million passed through Fort Mason. When they finally returned from combat, quite a few stayed, whether to keep working in the Bay Area's sizable military community or simply to build new lives in a city with such charm and opportunity. Foreign enemies never invaded San Francisco, but it had one strategic role to play before the war came to an official end.

In spring 1945, shortly after the death of President Franklin Roosevelt, representatives from 50 governments met in San Francisco to draft a United Nations charter. This was adopted in the city on June 25. President Harry Truman was present when the sole US woman delegate to the conference, Barnard College dean and women's rights advocate Virginia Gildersleeve, signed the charter the following day.

Hopes to actually situate the UN in San Francisco went unrealized, but the city never stopped championing the human rights in its charter, many of them in place due to Gildersleeve's efforts. How San Franciscans asserted those rights—in free speech, political activism, and an unprecedented explosion of musical and cultural liberty—would do much to define the city's modern identity in the next quarter century.

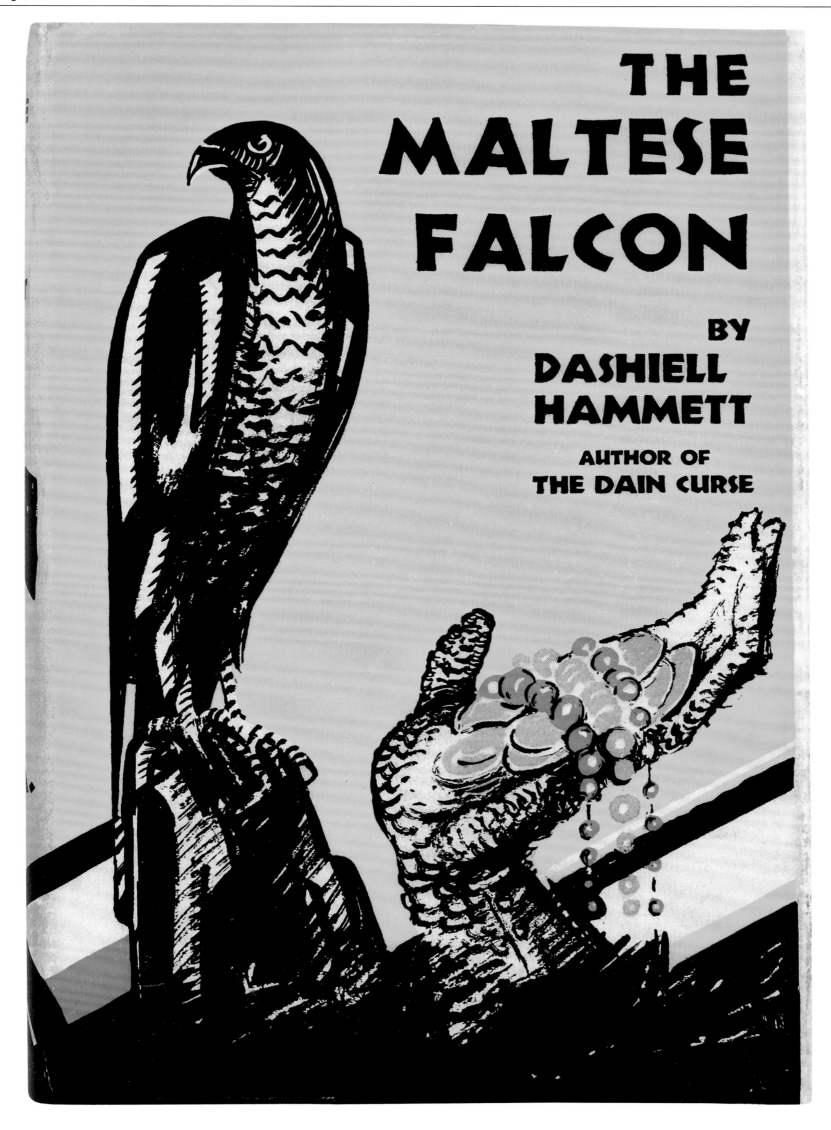

THE MALTESE FALCON

BY DASHIELL HAMMETT

AUTHOR OF THE DAIN CURSE

#2

Brücken bauen
1930–1945

p. 86/87
Peter Stackpole

The Bay Bridge under construction, as viewed from its north side on a passing ferry, with the center anchorage on the left. Connecting Oakland to San Francisco, the bridge spans four and a half miles. Wrote the photographer of one ferry passenger in The Bridge Builders, *"Perhaps he knew that we would lose these things to inevitable change, and that his commuting days on the bay were almost over. As the ferry passed under the span's shadow, he may have chilled at the thought that a way of life he had taken for granted was about to end," 1935.*

Die Baustelle der Bay Bridge mit dem Hauptstützpfeiler links, nördliche Ansicht von einer Fähre. Die über sieben Kilometer lange Brücke verbindet Oakland und San Francisco. Der Fotograf schrieb in The Bridge Builders *von einem der Passiere auf der Fähre: „Vielleicht wusste er, dass er all das an den unausweichlichen Wandel verlieren würde und dass seine Pendlertage durch die Bucht vorbei waren. Als die Fähre unter der Brücke hindurchfuhr erschauerte er vielleicht bei dem Gedanken, dass eine Lebensweise, die er für selbstverständlich gehalten hatte, an ihrem Ende angekommen war", 1935.*

Vu d'un ferry qui le longe côté nord, le Bay Bridge en construction, appelé à relier Oakland à San Francisco sur une longueur de 7 kilomètres; à gauche, l'ancrage central. Dans The Bridge Builders, *le photographe imagine un passager du ferry: « Peut-être savait-il que ce genre de chose allait disparaître en raison d'inévitables évolutions, et que ses navettes quotidiennes sur la baie appartiendraient bientôt au passé. Glissant sous l'ombre de la travée, peut-être a-t-il frissonné à l'idée qu'un mode de vie qu'il tenait pour acquis était sur le point de prendre fin. » 1935.*

Die Weltwirtschaftskrise traf alle gesellschaftlichen Schichten in San Francisco hart, auch die Reichen und besonders diejenigen, die ihr Geld im Finanzdistrikt verdienten, dessen Hauptstraße, die Montgomery Street, als Wall Street des Westens bekannt war. Den Armen ging es noch schlechter. Viele waren arbeitslos, und selbst die, die Arbeit hatten, bekamen selten genug Lohn.

Die Arbeit an den Docks im geschäftigen Hafen von San Francisco war gefährlich und schlecht bezahlt. Am 9. Mai 1934 traten die Hafenarbeiter in allen westlichen Häfen in den Streik. Zwei Monate später versuchte die Industrial Association, den Hafen mit Streikbrechern wieder zu öffnen. Auseinandersetzungen zwischen der berittenen Polizei und den Streikenden eskalierten am 5. Juli, mehr als 100 Menschen wurden verletzt. Polizisten schossen in die Menge und töteten zwei Arbeiter; der Tag wurde als Blutiger Donnerstag bekannt. Harry Bridges, der Anführer der Gewerkschaft der Hafenarbeiter, rief zum Generalstreik auf. Nach dem Trauermarsch zu Ehren der Opfer am 9. Juli brach dieser auch spontan in der gesamten Bay Area aus. Als Zeichen der Solidarität legten am 16. Juli etwa 150 000 Seeleute, Ingenieure und andere ihre Arbeit nieder und traten in einen offiziellen Streik.

Der „offizielle" Generalstreik dauerte vier Tage und war einer der wenigen und wahrscheinlich der berühmteste in der amerikanischen Geschichte. Obwohl die Streikenden die Arbeit wieder aufnahmen, nachdem sie den Vorschlag eines Vermittlers angenommen hatten, war der Streik doch weitgehend erfolgreich, denn durch ihn erhielten die Hafenarbeiter einige Monate später ein Mitspracherecht bei Neueinstellungen, was ihnen im Laufe der Zeit de facto die volle Kontrolle über die Arbeitsverteilung gab.

Durch den Streik wurde auch eine andere, lange Tradition der Bay Area begründet: politischer Aktivismus, der oft von der Obrigkeit als gefährlich radikal eingestuft wurde. In den folgenden anderthalb Jahrzehnten gab es Hunderte wilde Streiks, die mit viel Gewalt einhergingen. 1948 scheiterte ein groß angelegter Versuch, die Gewerkschaften zu zerschlagen, wodurch das bestehende Abkommen zwischen der Gewerkschaft International Longshore and Warehouse Union und der Pacific Maritime Association weiter gefestigt wurde. Die Gewerkschaft der Hafenarbeiter gab in dieser Zeit vielen politisch Radikalen Arbeit, doch ab den 1960ern hatten in der Bay Area die Konflikte von Demonstranten und Polizei andere Formen und Ursachen.

Am Tiefpunkt der Wirtschaftskrise stand San Francisco kurz davor, einige der größten technischen Meisterleistungen der Geschichte zu vollbringen, trotz massiver Kosten und enormen Arbeitsaufwands. Seit dem Ersten Weltkrieg hatte der Plan zum Bau einer Brücke, die die Golden-Gate-Meerenge an ihrer engsten Stelle überqueren würde, immer mehr an Fahrt aufgenommen. Anfang der 1930er-Jahre wurden Anleihen in Höhe von 30 bis 35 Millionen Dollar (die Angaben schwanken) für den Bau der Brücke genehmigt. Erst im Januar 1933 begann der vier Jahre dauernde Brückenbau, bei dem fast ein Dutzend Menschen ihr Leben verloren. Nachdem das Kunststück gelungen war, unglaublich komplizierte politische und technische Hindernisse zu überwinden, wurde die Brücke am 27. Mai 1937 feierlich eröffnet. Sie ermöglichte den Autoverkehr zwischen San Francisco und Marin County und wurde außerdem zum langlebigsten Wahrzeichen

der Stadt. Mit ihren anmutig geschwungenen Seilen überragt die Brücke die Parade der großen und kleinen Schiffe und wurde zu einem der wichtigsten Symbole der USA, nicht nur als das Tor nach San Francisco, sondern als Tor zum Westen der USA überhaupt. Kaum ein anderes menschengemachtes Bauwerk vereint Nutzen mit derartiger klassischer Ästhetik; der Nebel, der die Stadt so oft bedeckt, hebt das nur noch mehr hervor.

Die San Francisco-Oakland Bay Bridge ist zwar nicht so malerisch wie die Golden Gate Bridge, ist aber trotzdem eine beeindruckende Leistung und nicht ohne ihren eigenen Charme. Die im November 1936 eröffnete Brücke kostete doppelt so viel wie die Golden Gate Bridge, machte sich aber durch die enorme Verkehrszunahme zwischen beiden Seiten der Bucht mehr als bezahlt. Mit fast acht Kilometern ist sie viel länger als ihr Gegenstück und kann weitaus mehr Verkehr bewältigen. Jahrzehnte später war sie jedoch oft so verstopft, dass ein weiterer Transportweg zwischen der Stadt und der East Bay gebaut werden musste.

Andere Projekte in den 1930er-Jahren schufen dringend benötigte Arbeitsplätze und verschönerten San Francisco weiter. Von Mitte der 1930er bis Anfang der 1940er ermöglichten die Arbeitsbeschaffungsprogramme der Works Progress Administration (WPA) den Bau des Aquatic Parc am nördlichen Ufer, dessen winziger Strand immer noch von hart gesottenen Schwimmern in Neopren besucht wird, die mutig genug sind, sich in die kalte Bucht zu wagen. Das Gebäude im Aquatic Park, das später das Maritime Museum werden sollte, ließ die WPA mit Wandmalereien ausschmücken. Dasselbe geschah mit dem Beach Chalet im Golden Gate Park. Bis heute werden die Malereien sowohl aus künstlerischen als auch aus historischen Gründen geschätzt.

Die beliebtesten Wandmalereien entstanden nicht im Auftrag der WPA, sondern des New Deal Public Works of Art Project, und zwar im Coit Tower. 1933 mit Blick auf den Telegraph Hill in North Beach gebaut, wurde das 64 Meter hohe Art-déco-Gebäude, eine schlanke weiße Säule aus Beton, schnell zu einer weiteren Ikone der Stadt, die auch wegen ihres Panoramablicks geschätzt wurde. Beim Hinauf- und Hintergehen konnten die Besucher Wandmalereien betrachten, die das kalifornische Leben im Stil des sozialen Realismus darstellen. Geschaffen wurden sie von 25 Künstlern, die meisten waren entweder Lehrer oder Studenten an der California School of Fine Arts. In der Stadt blühten weitere kulturelle Aktivitäten auf. Die California School of Fine Arts (später das San Francisco Art Institute) war eine der angesehensten Schulen ihrer Art westlich des Mississippi. Anfang der 1930er-Jahre wurde der berühmten Maler Diego Rivera mit einem Wandbild beauftragt, das noch heute in ihrer Galerie zu sehen ist. Auch innovative Fotografen besuchten die Schule. Einige von ihnen gehörten zu den Gründungsmitgliedern der Gruppe f/64. Sie gaben ihren Arbeiten eine realistischere und sozialere Dimension, und einige, wie Ansel Adams, Imogen Cunningham und Edward Weston, machten viele ihrer besten Fotos in der Bay Area.

Auch Sport wurde mit der 1903 gegründeten Pacific Coast League wichtiger; für die San Francisco Seals spielten viele Stars der großen Baseball-Ligen. Der größte von ihnen, Joe DiMaggio, kam aus einer italienisch-amerikanischen Fischerfamilie in North Beach. Er war in den frühen 1930ern mehrere Jahre bei den Seals,

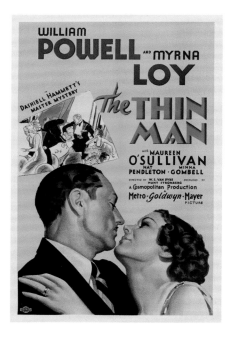

←
The Thin Man, W. S. Van Dyke, Metro-Goldwyn-Mayer, 1934.
Heritage Auctions, HA.com

→
"San Francisco World's Fair" poster,
Simon Vanderlaan, 1939.

bevor er zu den New York Yankees wechselte. Auch Joes Brüder Vince und Dom schafften es von den Seals in die größeren Ligen, genau wie die Yankee All-Stars Lefty Gomez und Frankie Crosetti.

Als die 1940er-Jahre begannen, pendelte sich die Einwohnerzahl bei knapp 650 000 ein. Für mehr Einwohner gab es kaum noch Platz, und dank der Brücken, die es einfach machten zu pendeln, entschieden sich viele für weniger nebelverhangene Orte. Die verbesserte Mobilität bedeutete auch, dass die Attraktionen der Gegend einfacher zu erreichen waren, seien es die Gebäude der bekannten Architektin Julia Morgan in Berkeley und Oakland oder die Muir Woods in Marin County. Die Freizeitgestaltung verlor an Wichtigkeit, als die USA im Dezember 1941 in den Zweiten Weltkrieg eintraten. Der Hafen wurde durch Unterwasserminen und U-Boot-Schutznetze gesichert. Zum ersten Mal in den USA wurde in San Francisco am Tag nach dem japanischen Überfall auf Pearl Harbor nachts der Strom abgeschaltet, um die Stadt vor einem möglichen Angriff zu schützen.

Die Angst vor einem Angriff der Japaner führte auch zur Internierung der japanischstämmigen Einwohner an der gesamten Westküste. Mehr als 100 000 Menschen japanischer Herkunft, die meisten von ihnen amerikanische Staatsbürger, wurden innerhalb weniger Monate in Internierungslager zwangsumgesiedelt. In Wirklichkeit waren sie keine Bedrohung für die Sicherheit des Landes, ihre Inhaftierung basierte auf haltlosem Spionageverdacht und blankem Rassismus. In San Franciscos Japantown in der Western Addition nahe Downtown und im Rest der Bay Area mussten die Japaner ihre Häuser und Geschäfte aufgeben. Als sie nach Kriegsende zurückkehren durften, waren sie oft nicht in der Lage, ihr Recht auf den ehemaligen Besitz geltend zu machen.

Die Arbeitsplätze in der Rüstungsindustrie brachten Tausende nach San Francisco, darunter auch Afroamerikaner aus den Südstaaten. Viele zogen in die eilig von der Marine gebauten Unterkünfte in Hunter's Point. In der Western Addition bezogen andere die Wohnungen, die japanische Amerikaner hatten zurücklassen müssen. In wenigen Jahren wurde das Fillmore zu einem Mittelpunkt der schwarzen Kultur, wegen der vielen Jazzclubs und Geschäfte mit afroamerikanischen Besitzern auch „Harlem des Westens" genannt. Der Bedarf an Arbeitskräften brachte zudem mehr Frauen als jemals zuvor in die Werften und Fabriken.

Dass Afroamerikaner und Frauen Arbeitsplätze erhielten, die zuvor weißen Männern vorbehalten waren, war nicht das Ende der Diskriminierung. Eine Munitionsexplosion im Juli 1944 am Port Chicago in der East Bay tötete mehr als 300 Menschen und verletzte fast 400 weitere, die meisten Opfer waren Afroamerikaner. Hunderte schwarzer Matrosen aus Port Chicago weigerten sich aus Protest gegen die Arbeitsbedingungen, das gefährliche Material weiter zu verladen. 50 wurden wegen Meuterei verurteilt, die meisten kamen jedoch kurz nach dem Krieg wieder frei.

San Francisco war ein wichtiger Einschiffungshafen für Soldaten, mehr als eine Million von ihnen durchliefen Fort Mason auf dem Weg in den Pazifik. Wenn sie aus dem Krieg zurückkehrten, blieben viele von ihnen, entweder um weiter in der Bay Area für das Militär zu arbeiten oder um sich in einer Stadt mit so vielen Möglichkeiten ein neues Leben aufzubauen. In San Francisco sind nie fremde Truppen einmarschiert, aber bevor der Krieg offiziell zu Ende war, spielte es noch eine strategische Rolle.

Kurz nach dem Tod von Präsident Franklin D. Roosevelt kamen im Frühjahr 1945 Vertreter von 50 Regierungen in San Francisco zusammen, um eine Charta der Vereinten Nationen zu verfassen. Diese wurde am 25. Juni in der Stadt verabschiedet. In Anwesenheit von Präsident Harry Truman unterschrieb die einzige weibliche Delegierte der USA, die Dekanin des Barnard College und Frauenrechtlerin Virginia Gildersleeve, die Charta am folgenden Tag. Der Wunsch, San Francisco zum Sitz der UNO zu machen, erfüllte sich nicht, aber die Stadt blieb eine Verfechterin der Menschenrechte, von denen viele durch Gildersleeves Bemühungen in der Charta verankert worden waren. Wie die Menschen San Franciscos sie nutzten – freie Meinungsäußerung, politischer Aktivismus und noch nie dagewesene kulturelle Freiheit – würde die Identität der Stadt im nächsten Vierteljahrhundert prägen.

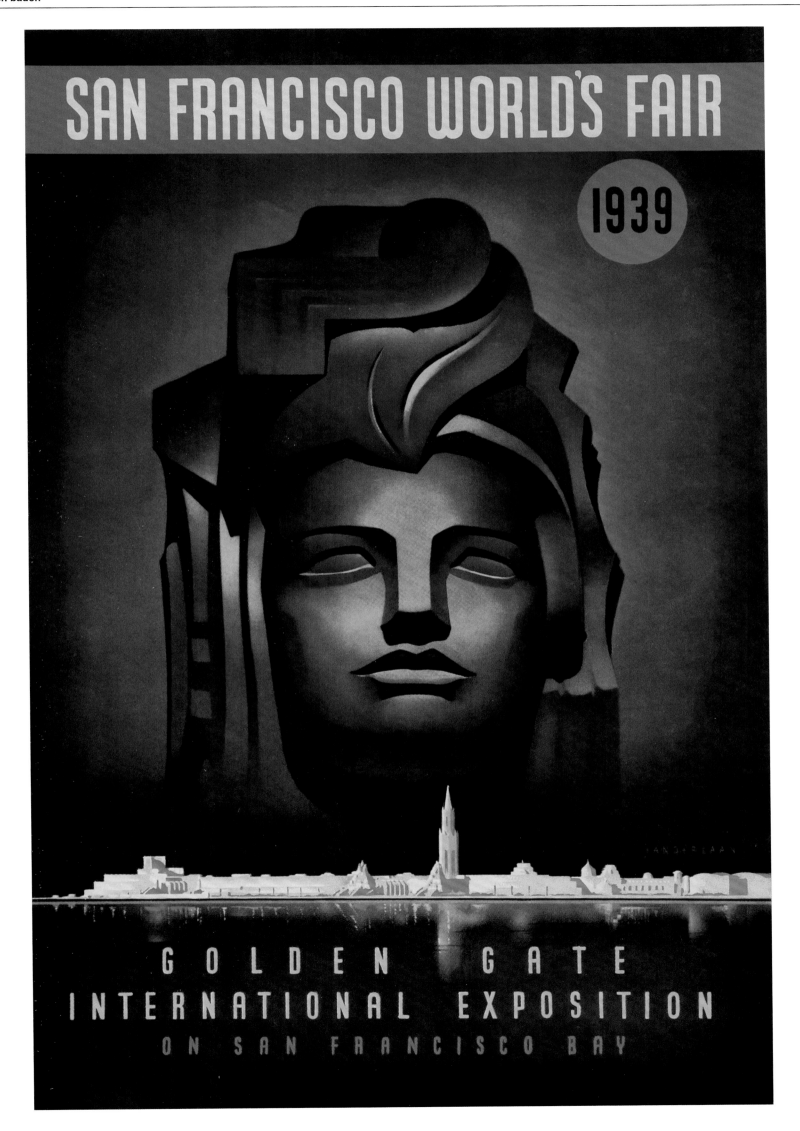

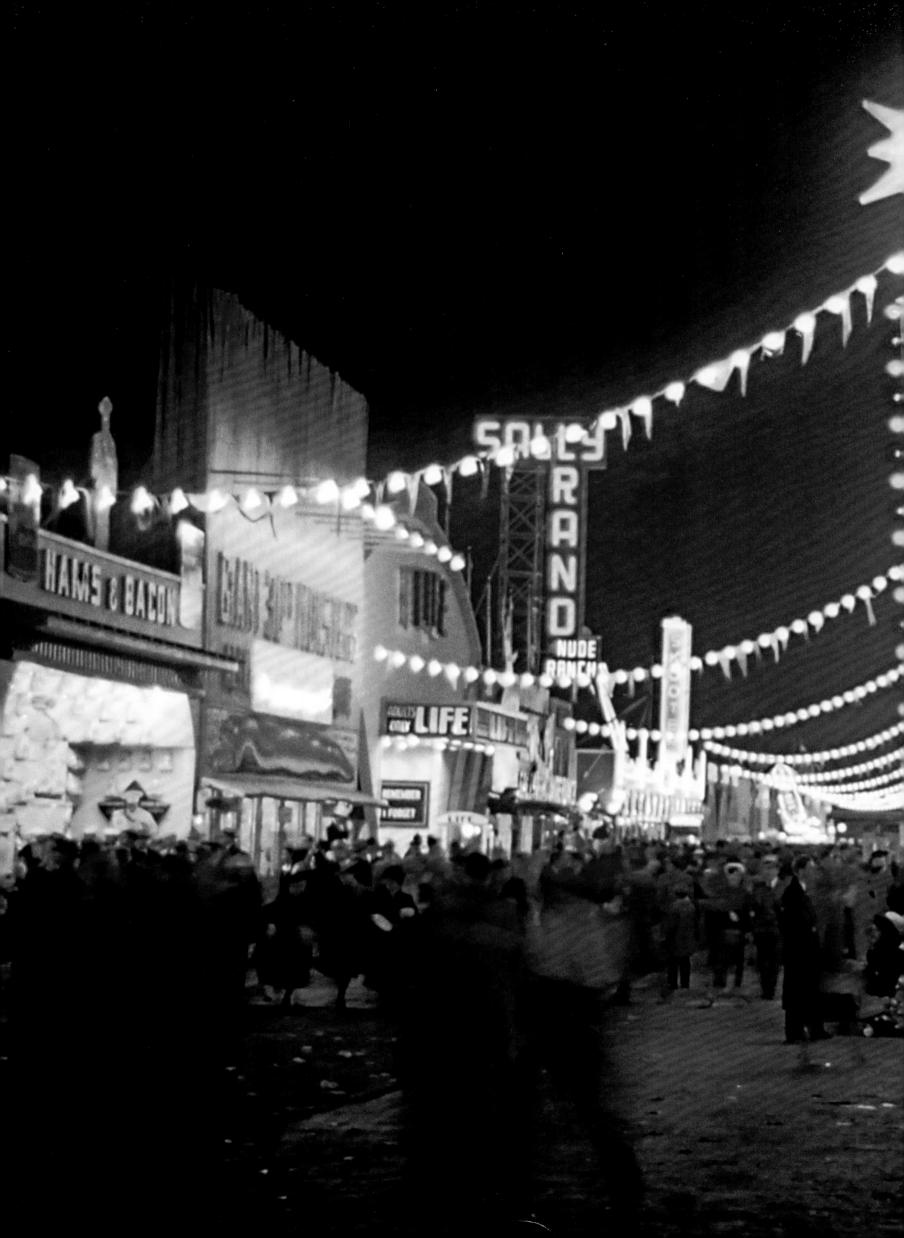

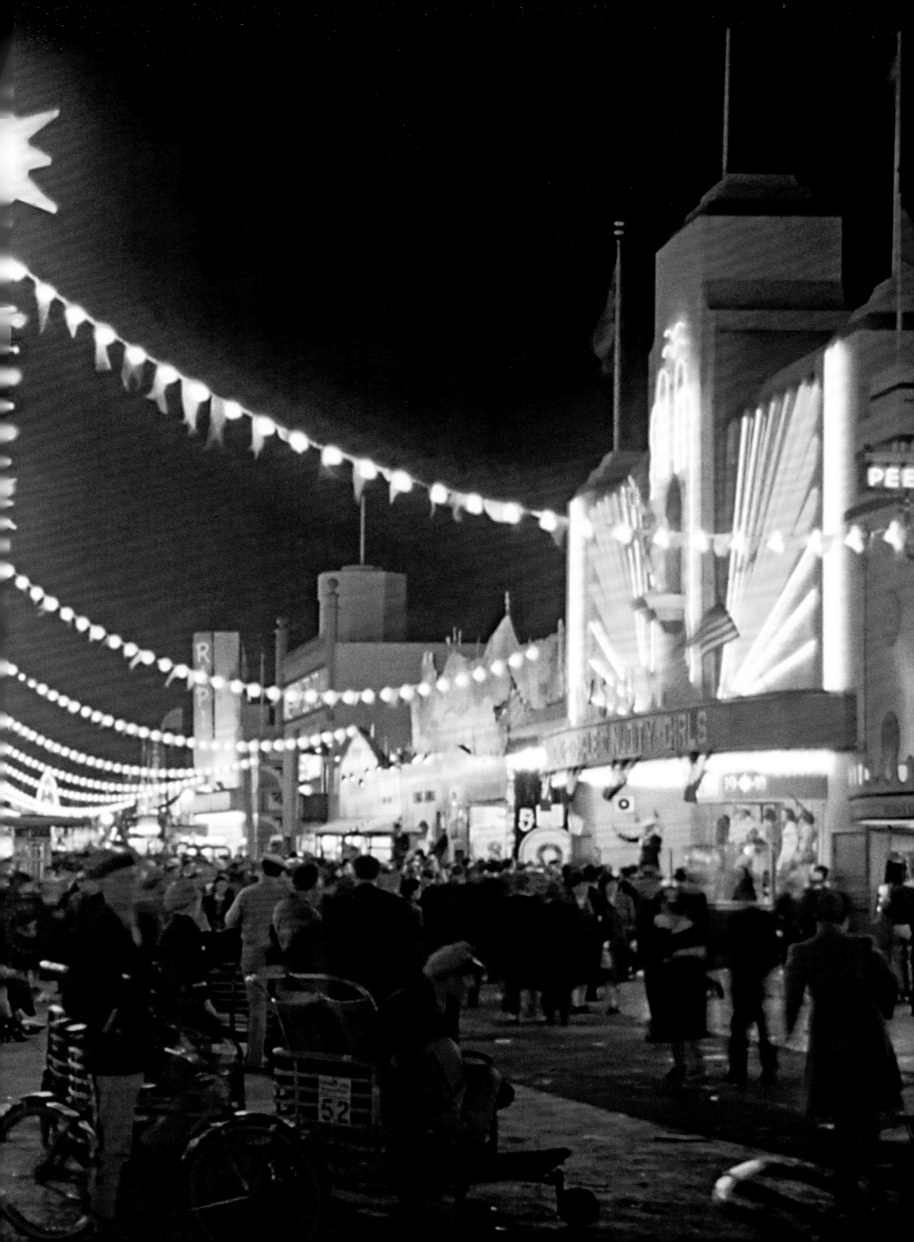

#2

Ouvrir la voie 1930–1945

p. 92/93
Charles W. Cushman

The Golden Gate International Exposition on Treasure Island, lit up at night on Independence Day. This shot spotlights the 40 acre "Gayway" area of amusements and sideshows like "Sally Rand's Nude Ranch," July 4, 1940.

Die Golden Gate International Exposition auf Treasure Island, hell erleuchtet aus Anlass des Unabhängigkeitstags. Das Bild zeigt den 16 Hektar großen Unterhaltungsbereich „Gayway", eine Amüsiermeile mit Attraktionen wie „Sally Rand's Nude Ranch", 4. Juli 1940.

L'Exposition internationale du Golden Gate, sur l'île artificielle de Treasure Island, brille de tous ses feux le jour de la fête nationale. La photo montre ici « Gayway » (l'« Allée joyeuse »), où sont regroupés sur 16 hectares attractions et spectacles tels que le « Sally Rand's Nude Ranch », des cow-girls en (très) petite tenue. 4 juillet 1940.

La crise économique des années 1930, cette «Grande Dépression», frappa lourdement tous les secteurs de la société de San Francisco. Les plus fortunés n'y échappèrent pas, surtout s'ils travaillaient dans le quartier d'affaires du centre-ville dont l'artère principale, Montgomery Street, était considérée comme le Wall Street de l'Ouest américain. Les pauvres furent plus affectés encore. La courbe du chômage s'envola, et même ceux qui parvenaient à conserver leur emploi peinaient à obtenir un salaire décent.

L'activité portuaire restait intense, mais un emploi sur les docks rapportait peu et exigeait d'évoluer dans des conditions fréquemment périlleuses. Le 9 mai 1934, les dockers décidèrent de cesser le travail dans l'ensemble des ports de la côte. Au bout de deux mois de tension et de négociations infructueuses, l'Industrial Association, le syndicat patronal, mobilisa des briseurs de grève afin de rompre le blocus. Le 5 juillet, les affrontements entre police montée et grévistes dégénérèrent violemment, au point que ce «Bloody Thursday», jeudi sanglant resté dans la mémoire ouvrière, laissa sur le carreau plus de 100 blessés et deux morts parmi les grévistes, abattus par la police. Après la marche funèbre organisée en hommage aux victimes le 9 juillet, et à l'initiative d'Harry Bridges, porte-parole des dockers, un projet de grève générale se propagea dans la région comme une traînée de poudre. Le 16 juillet, près de 150 000 marins, conducteurs de tramway, camionneurs et ouvriers de toutes qualifications refusèrent de rejoindre leur poste. Cette grève générale «officielle», l'une des rares et probablement la plus célèbre de l'histoire des États-Unis, dura quatre jours. Si les grévistes finirent par accepter la décision d'un médiateur, le mouvement, dans une large mesure, se révéla payant. Les syndicalistes, en effet, obtiendront quelques mois plus tard d'être associés au processus d'embauche dans les ports, ce qui leur assurera au fil du temps un contrôle *de facto* sur les conditions de recrutement.

La grève joua également un rôle déterminant dans l'enracinement d'une autre tradition bien vivace à San Francisco : l'activisme politique, que les autorités du moment avaient toujours tendance à juger dangereusement radical. Au cours des quinze années qui allaient suivre, les grèves sauvages se compteraient par centaines, ponctuées de nombreuses violences. L'échec en 1948 d'une grande offensive antisyndicale conforta un an plus tard le regroupement au sein d'une même entité, nommée Pacific Maritime Association, de l'International Longshore and Warehouse Union – ILWU, «Syndicat international du débardage et de l'entreposage» – et de l'organisation qui défendait les intérêts des industriels du transport maritime. La période favorisa l'embauche au sein du syndicat des dockers de nombreux militants très engagés. Dans les années 1960, on le verra, les heurts entre manifestants et forces de l'ordre revêtiront d'autres formes, autour de nouvelles causes.

La crise économique atteignait son paroxysme, et pourtant, en dépit de la force de travail et des investissements titanesques qu'elles allaient requérir, San Francisco se préparait à accomplir certaines des prouesses technologiques parmi les plus remarquables de son histoire. Depuis la Première Guerre mondiale, l'idée de bâtir un pont suspendu qui traverserait le détroit du Golden Gate à son point le plus étroit n'avait cessé de gagner du terrain. Au début des années 1930, l'émission d'un emprunt obligataire de 30 à 35 millions de dollars destinés au projet avait été adoptée (les avis continuent de diverger sur son montant précis). Ouvert en janvier 1933, le chantier dura quatre ans et coûta la vie à onze ouvriers. Après avoir triomphé d'obstacles politiques et techniques d'une complexité quasi insurmontable, le Golden Gate Bridge fut inauguré en grande pompe le 27 mai 1937. Il ne se contentait pas d'ouvrir la circulation automobile entre San Francisco et le comté de Marin : il devenait d'un seul coup le symbole le plus éclatant et le mieux ancré de la ville. Avec ses longues travées orangées, gracieusement arquées, qui surplombent un défilé permanent de bateaux de toutes formes et de toutes tailles, il matérialise la porte d'entrée de San Francisco comme de l'Ouest américain et s'inscrit parmi les repères emblématiques du pays. Rares sont les structures artificielles à combiner ainsi l'utilité au jour le jour et une esthétique exceptionnelle, d'autant mieux sublimée par le voile de brume qui enveloppe si souvent la plus grande partie de la ville.

S'il est moins spectaculaire, le Bay Bridge, qui relie San Francisco et Oakland, est un ouvrage presque aussi impressionnant, doué d'une séduction visuelle bien à lui. Nettement plus long, il s'étend sur plus de 7 kilomètres et supporte une circulation autrement importante, d'une telle densité qu'il faudra, quelques décennies plus tard, imaginer une liaison supplémentaire entre la ville et l'est. Inauguré le 12 novembre 1936, il a coûté deux fois plus cher que le Golden Gate Bridge mais l'accroissement considérable du flux humain et marchand transporté d'une rive à l'autre de la baie aura *in fine* plus que rentabilisé la dépense.

Les projets ambitieux, alors, ne manquaient pas, qui fournirent à quantité d'ouvriers le travail dont ils avaient âprement besoin et contribuèrent un peu plus encore à l'embellissement de San Francisco. Du milieu des années 1930 au début de la décennie suivante, les programmes fédéraux de la Works Progress Administration (WPA), initiés par le président Roosevelt, permettront ainsi de créer l'Aquatic Park, cette partie du front de mer, au nord, dont la minuscule plage sert toujours de base aux nageurs sportifs assez endurants et téméraires pour affronter la fraîcheur de ses eaux. Saluées à la fois pour leur valeur artistique et leur caractère historique, des peintures murales commandées par la WPA viendront habiller le futur musée maritime de l'Aquatic Park et le Beach Chalet, le restaurant de style colonial situé à la pointe occidentale du Golden Gate Park. C'est toutefois à l'intérieur de la Coit Tower que se déploieront les fresques les plus populaires, exécutées dans le cadre du New Deal à l'initiative cette fois du Public Works of Art Project. Édifié en 1933, ce bâtiment Art déco en béton non peint d'une hauteur de 64 mètres domine Telegraph Hill et le quartier voisin de North Beach. La tour s'est vite imposée, elle aussi, comme l'une des icônes visuelles de la ville, grâce à sa fine colonne blanche et à la vue panoramique qui s'offre au visiteur parvenu au sommet. L'ascension permet d'admirer le réalisme social des fameuses peintures murales consacrées à la vie de la Californie pendant la Grande Dépression et réalisées par vingt-cinq artistes différents. Tous, ou presque, ont enseigné ou étudié à l'École des beaux-arts de Californie (California School of Fine Arts, futur San Francisco Art Institute),

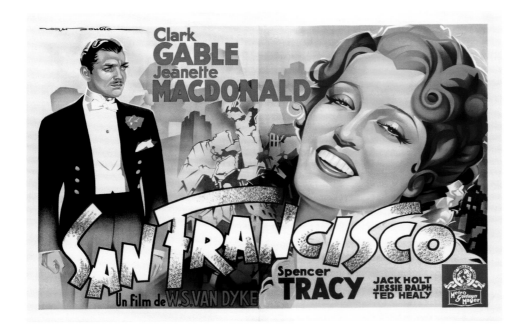

San Francisco, *W. S. Van Dyke, Metro-Goldwyn-Mayer, 1936.*
Heritage Auctions, HA.com

alors l'une des plus prestigieuses en son genre dans l'Ouest américain. Au début des années 1930, le célèbre peintre mexicain Diego Rivera avait également été invité à y créer une fresque, toujours visible aujourd'hui, sur l'une des façades. Plusieurs photographes novateurs étaient également affiliés à l'école, dont certains participèrent à la création du groupe f/64. Ce collectif basé à San Francisco insuffla à la photographie une dimension là encore plus réaliste et sociale ; la région inspirera certains des meilleurs clichés d'Ansel Adams, Imogen Cunningham ou Edward Weston. Le sport professionnel, de son côté, montait en puissance. L'équipe de base-ball des San Francisco Seals, qui opéra dans le championnat de la côte Pacifique de 1903 à 1957, verra évoluer en son sein de très nombreuses stars de la discipline. La plus illustre d'entre elles, Joe DiMaggio, était issue d'une famille de pêcheurs italo-américains de North Beach. Joueur des Seals entre 1931 et 1935, c'est au niveau national et à New York, sous le maillot des Yankees, qu'il deviendra par la suite une immense vedette. Ses frères Vince et Dom passeront également des Seals à la « Major League ».

Au début des années 1940, la population de la ville s'était stabilisée, approchant les 650 000 habitants. L'espace manquait pour en accueillir davantage, aussi bien des familles se dirigèrent-elles vers des périphéries moins brumeuses, d'autant que la mise en service des nouveaux ponts facilitait les déplacements. L'amélioration des transports permettait par ailleurs d'accéder plus aisément à certains des principaux centres d'attraction des environs. Parmi eux, les édifices dessinés à Berkeley et à Oakland par la célèbre architecte Julia Morgan, et Muir Woods, dans le comté de Marin, cette forêt de séquoias à feuilles d'if classée monument national.

En décembre 1941, l'entrée des États-Unis dans la Seconde Guerre mondiale relégua loisirs et divertissements au second plan. Mines submersibles et filets anti-sous-marins vinrent renforcer la sécurité du port. Au lendemain de Pearl Harbor, et afin de se protéger d'une éventuelle et très crainte attaque nippone, San Francisco connut le premier grand black-out jamais décrété dans le pays. Une inquiétude de même nature déclencha sur toute la côte Ouest une vaste rafle des résidents d'origine japonaise. Cent mille d'entre eux, qui pour beaucoup étaient citoyens américains, seront internés de force dans des camps prévus à cet effet. Ils ne représentaient en réalité aucune menace pour la défense nationale ; leur incarcération procédait surtout d'invraisemblables suspicions d'espionnage et d'un racisme pur et simple. Les habitants de Japantown, qui couvrait une superficie assez considérable dans le quartier de Western Addition, à proximité du centre-ville, se virent contraints d'abandonner maisons et commerces, comme ce fut le cas dans toute la région. Et lorsqu'ils recevront l'autorisation de rentrer chez eux à la fin de la guerre, ils réussiront rarement à les récupérer.

Les industries de défense avaient besoin de bras, aussi San Francisco attira-t-elle des milliers de candidats à l'embauche, dont de nombreux Afro-Américains venus du sud des États-Unis. Beaucoup s'installèrent à Hunters Point où la marine, en 1940, s'était rendue propriétaire du chantier naval, bâtissant à la hâte des logements pour ces nouveaux travailleurs. D'autres trouvèrent à s'héberger dans le quartier délaissé par les Américains d'origine japonaise – Western Addition. C'est ainsi que le Fillmore District, qui en fait partie, devint un foyer important de la culture noire, truffé de clubs de jazz et de commerces qui lui vaudront le surnom de « Harlem de l'Ouest ». La demande de main-d'œuvre conduisit également une proportion inédite de femmes à rejoindre les chantiers navals et les usines. Cette irruption noire et féminine à des postes autrefois occupés par des hommes blancs n'apaisa pas les discriminations. En juillet 1944 à Port Chicago, dans l'East Bay, l'explosion accidentelle de deux cargos de munitions fit plus de 300 morts et près de 400 blessés, pour la plupart afro-américains. Dénonçant leurs conditions de travail dangereuses, des centaines de marins noirs refusèrent de continuer à charger ce type de matériel. Une condamnation pour mutinerie frappera cinquante d'entre eux, même si la plupart seront libérés au lendemain de la guerre.

This Gun for Hire, *Frank Tuttle.*
Paramount Pictures, 1942.
Heritage Auctions, HA.com

San Francisco était un point d'embarquement essentiel pour les troupes appelées à servir dans le Pacifique. Plus d'un million de soldats sont ainsi passés par Fort Mason. Une fois de retour, ils seront un certain nombre à choisir de rester sur place afin de continuer à travailler au sein de l'importante communauté militaire de la région ou tout simplement pour démarrer une vie nouvelle dans une ville offrant tant de charmes et d'opportunités. L'invasion ennemie ne se produisit pas mais San Francisco eut à jouer un rôle tout à fait stratégique avant même le terme des hostilités. C'est là en effet qu'au printemps 1945, peu après la mort du président Roosevelt, les représentants de cinquante gouvernements se réunirent pour rédiger ensemble une Charte des Nations unies, adoptée à San Francisco le 25 juin.

Le lendemain, en présence d'Harry Truman, successeur du président défunt, Virginia Gildersleeve, doyenne du Barnard College, défenseure des droits des femmes et seule de son sexe parmi les sept Américains délégués à la conférence, apposa son paraphe au bas de la Charte. L'espoir de voir l'ONU s'établir au bord de la baie sera certes déçu mais la ville ne cessera jamais de défendre les droits de l'homme gravés dans cette Charte. Liberté d'expression, activisme politique, explosion sans précédent de la créativité musicale et culturelle : la détermination de San Francisco à faire valoir ces droits participera largement à définir l'identité moderne de la ville au cours du quart de siècle suivant.

Anonymous

Hailed as "the crookedest street in the world," the stretch of Lombard Street between Leavenworth and Hyde streets has long been one of the city's chief tourist hangouts. With a grade of 18.2 %, drivers on this Russian Hill road have to make eight turns in the course of one block, 1933.

Bekannt als „die kurvenreichste Straße der Welt", ist dieser Abschnitt der Lombard Street zwischen Leavenworth und Hyde Street schon seit Langem beliebt bei Touristen. Bei einem Gefälle von 18,2 Prozent müssen Autofahrer auf der Straße zum Russian Hill innerhalb von einem Block acht Kurven bewältigen, 1933.

Qualifié de « rue la plus sinueuse au monde », ce tronçon de Lombard Street entre Leaven-worth Street à Hyde Street constitue de longue date un pôle d'attraction touristique majeur. Pour contourner un seul pâté de maisons de Russian Hill, le conducteur doit négocier huit virages serrés alors inclinés à 18,2 %. 1933.

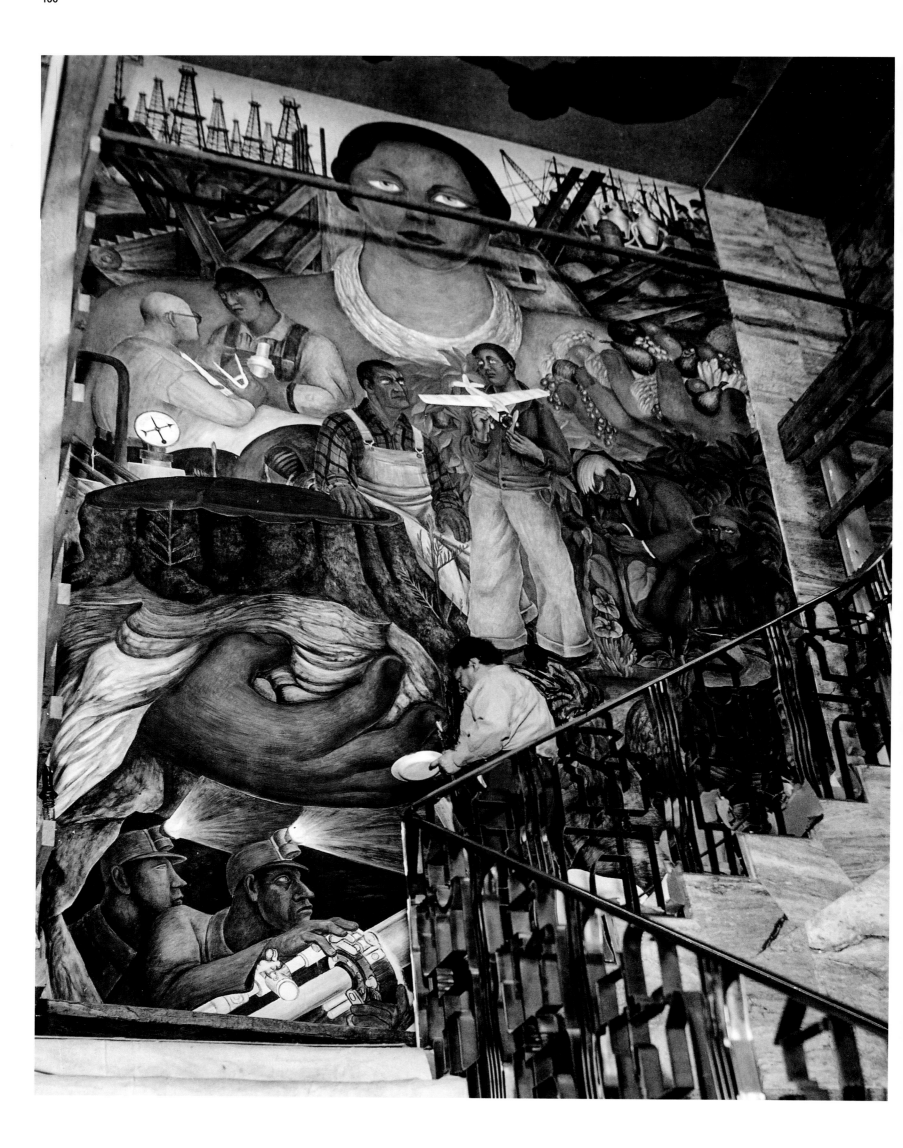

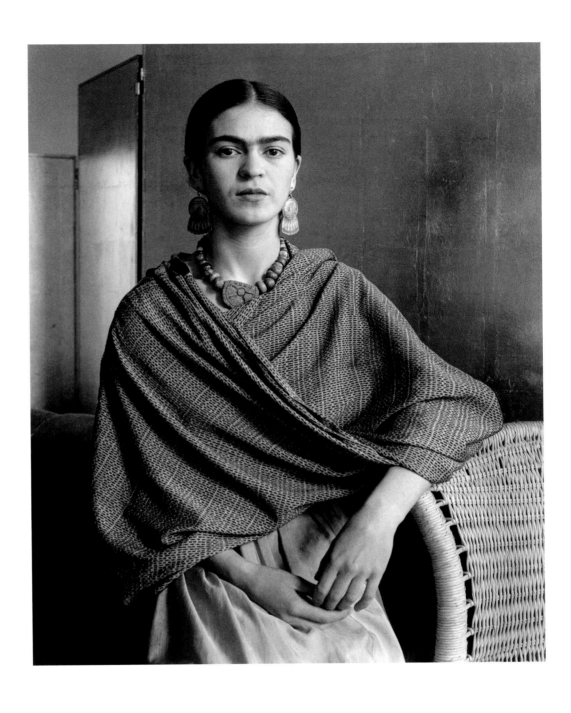

←

Anonymous

Diego Rivera finishing his fresco The Allegory of California *in the Stock Exchange Tower's Pacific Stock Exchange Lunch Club, at 155 Sansome Street between Pine and Bush streets. The central figure, Califia, represents the state of California, and was modeled on tennis champion Helen Wills. The man holding the airplane is noted photographer Peter Stackpole (featured in this book) whose sculptor father, Ralph, had been crucial in getting Rivera a commission to work on the mural, 1931.*

Diego Rivera stellt sein Fresko The Allegory of California *im Pacific Stock Exchange Lunch Club des Stock Exchange Towers, 155 Sansome Street zwischen Pine und Bush Streets, fertig. Califa, die zentrale Figur, stellt den Staat Kalifornien dar und basierte auf Tennischampion Helen Wills. Der Mann mit dem Flugzeug ist der bekannte Fotograf Peter Stackpole (ebenfalls in diesem Buch vertreten), dessen Vater, der Bildhauer Ralph Stackpole, Rivera den Auftrag für die Wandmalerei besorgt hatte, 1931.*

Diego Rivera termine sa peinture murale Allégorie de la Californie *au Luncheon Club de la Bourse de San Francisco, située 155 Sansome Street, entre Pine Street et Bush Street. La championne olympique de tennis Helen Wills a servi de modèle à la figure centrale, Califia, qui représente l'État de Californie. L'homme tenant un avion n'est autre que l'éminent photographe Peter Stackpole (figurant dans ce livre) dont le père sculpteur, Ralph, avait été pour beaucoup dans la commande de la fresque au peintre mexicain. 1931.*

↑

Imogen Cunningham

Mexican artist Frida Kahlo moved with her husband, Diego Rivera, for a time in the early 1930s to San Francisco, where both of them did some of their most famous work, 1931.

Die mexikanische Künstlerin Frida Kahlo zog mit ihrem Mann, Diego Rivera, in den frühen 30er-Jahren für einige Zeit nach San Francisco, wo beide einige ihrer berühmtesten Arbeiten anfertigten, 1931.

Au début des années 1930, l'artiste mexicaine Frida Kahlo s'est installée pour un temps à San Francisco avec Diego Rivera, son mari à l'époque. C'est là qu'ils ont créé certaines de leurs œuvres les plus célèbres. 1931.

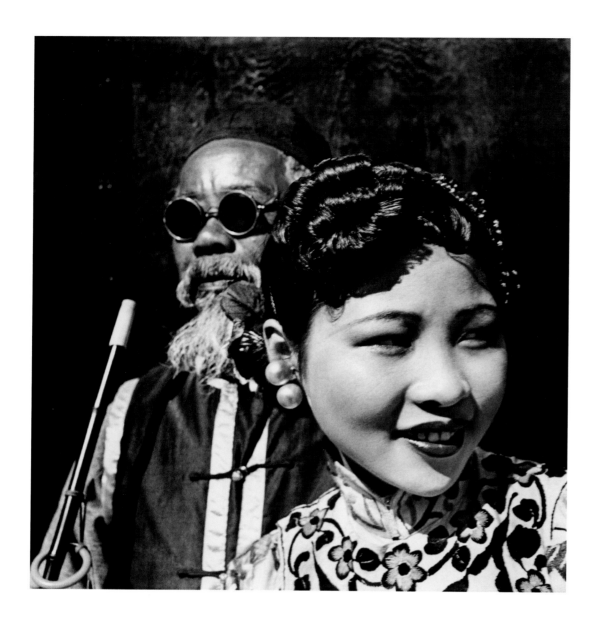

↑
John Gutmann

Local Chinese merchant with granddaughter, 1939.

Ein chinesischer Händler aus San Francisco mit seiner Enkelin, 1939.

Marchand chinois avec sa petite-fille. 1939.

→
John Gutmann

A dragon heads a procession up Pine Street. This seems like a modest affair compared to some other parades staged by the city's Chinese community, which can take up several blocks with colorful animal and human costumes, especially during the Chinese New Year, 1934.

Ein Drache führt eine Parade auf der Pine Street an. Sie fällt bescheiden aus im Vergleich zu den anderen Paraden, die von der chinesischen Gemeinde organisiert werden und sich teilweise über mehrere Blocks mit farbenfrohen Tier- und Menschenkostümen erstrecken, vor allem zum chinesischen Neujahrsfest, 1934.

Un dragon à la tête d'un défilé sur Pine Street. Le spectacle paraît modeste au regard d'autres événements organisés par la communauté chinoise : la parade multicolore des animaux mystérieux et participants costumés peut s'étendre sur plusieurs pâtés de maisons, surtout lors du Nouvel An chinois. 1934.

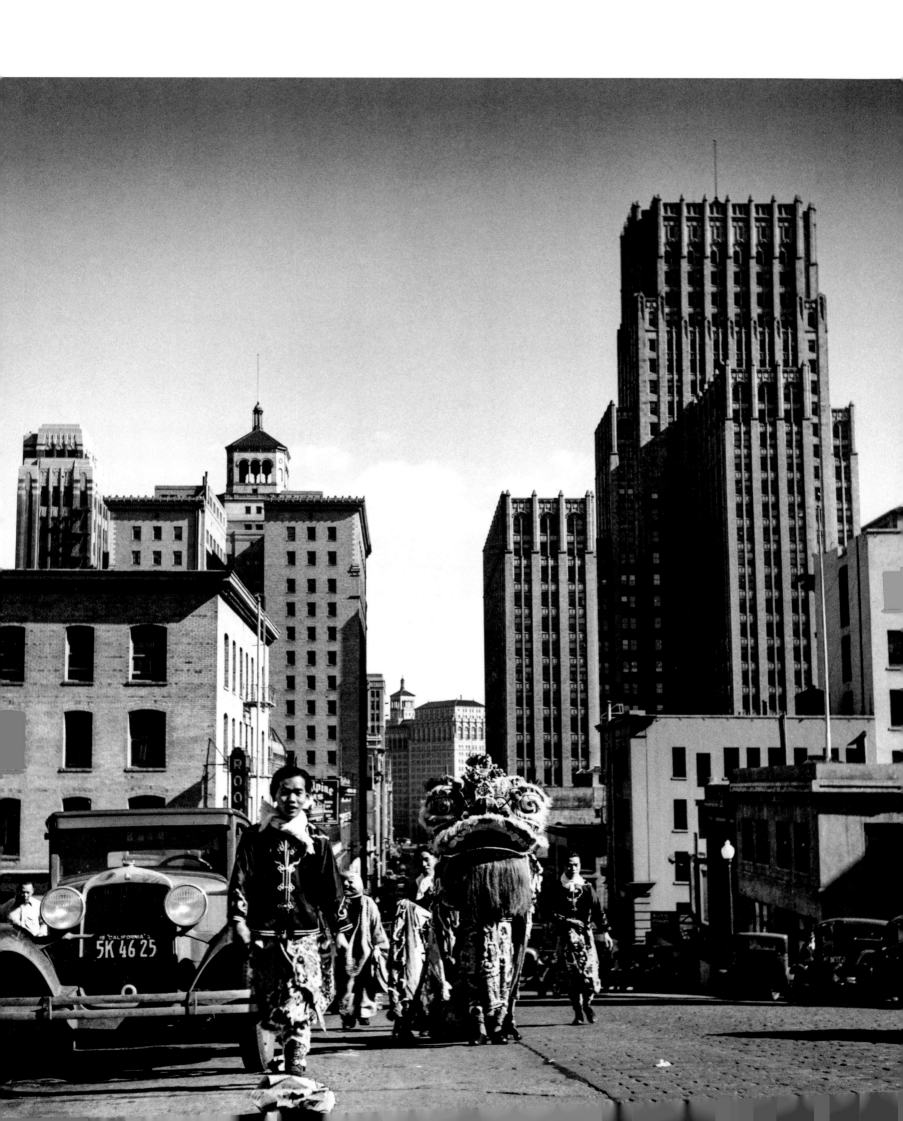

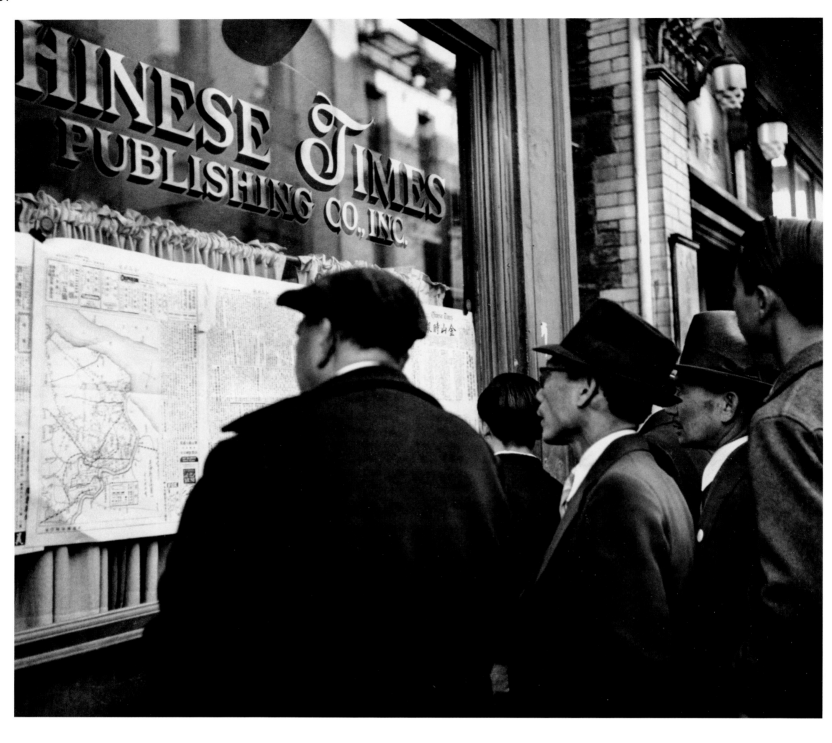

↑
John Gutmann

Crowd reading The Chinese Times *in the window of its Chinatown place of business. Founded by Chinese American rights activist Walter U. Lum, it had the biggest circulation of any Chinese newspaper in San Francisco. A Chinatown street that runs alongside Portsmouth Square, Walter U. Lum Place, is named after him, 1934.*

Leuten lesen The Chinese Times *im Fenster der Redaktion in Chinatown. Vom chinesisch-amerikanischen Aktivisten Walter U. Lum gegründet, hatte sie die höchste Auflage aller chinesischen Zeitungen in San Francisco. Die Walter U. Lum Street am Portsmouth Square in Chinatown ist nach ihm benannt, 1934.*

Lecture du Chinese Times *devant le siège de sa rédaction à Chinatown. Fondé par Walter U. Lum, lui-même très engagé dans la défense des droits sino-américains, il affichait le plus gros tirage de tous les journaux chinois de San Francisco. Une rue de Chinatown qui borde Portsmouth Square porte son nom (Walter U. Lum Place). 1934.*

↓

Erich Salomon

Across the street from Union Square, guests at the St. Francis Hotel, one of the city's biggest and finest, watch quotes on the San Francisco stock exchange as the Depression takes hold. 1930.

Gegenüber vom Union Square betrachten Gäste des St. Francis Hotels, einem der größten und elegantesten der Stadt, zu Beginn der Weltwirtschaftskrise die Börsenkurse, 1930.

Alors que sévit la Grande Dépression, face à Union Square les clients de l'hôtel St. Francis, l'un des plus grands et des plus beaux de la ville, scrutent les cotations de la Bourse de San Francisco. 1930.

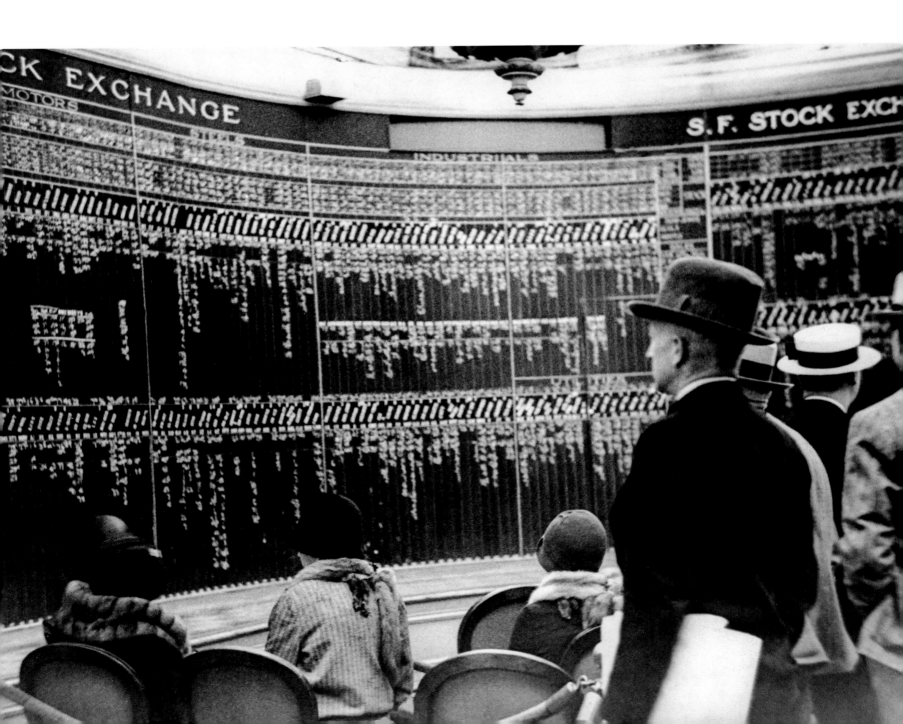

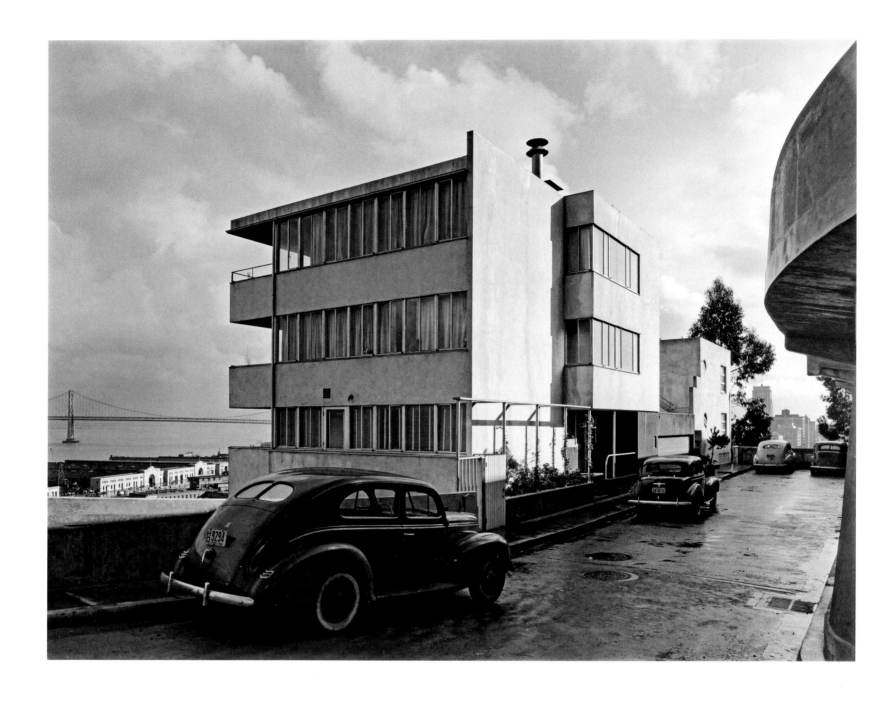

↑
Julius Shulman

The Sidney Kahn house on Calhoun Terrace in Telegraph Hill, a couple blocks from Coit Tower. Designed by leading modernist architect Richard Neutra, the four-story home has balconies with views of downtown and the East Bay, topped by a living room and bar on the highest floor, 1941.

Das Haus von Sidney Kahn auf der Calhoun Terrasse in Telegraph Hill, nur ein paar Blocks vom Coit Tower, wurde von einem der führenden Architekten der Moderne, Richard Neutra, entworfen. Von den Balkonen des viergeschossigen Hauses hat man einen Blick auf Downtown und die East Bay. Ganz oben befinden sich das Wohnzimmer und die Bar, 1941.

La Sidney Kahn House sur Calhoun Terrace à Telegraph Hill, non loin de la Coit Tower. Conçue par l'important architecte moderniste Richard Neutra, cette habitation de quatre niveaux aux balcons donnant sur le centre-ville et l'East Bay est coiffée à son plus haut niveau d'un salon et d'un bar. 1941.

↓
Anonymous

The Kate Gleason House in Sausalito, just over the Golden Gate near the southern tip of Marin County. Unusually, the garage was on the top floor of this four-story home, and residents had to climb to the attic to take their car out for a drive. The small, affluent town is renowned for its proximity to the lovely Marin Headlands National Recreation Area just north of the Golden Gate Bridge, as well as its lively waterfront of houseboats, restaurants, and upscale shops, 1933.

Das Kate Gleason House in Sausalito, oberhalb des Golden Gate am südlichen Zipfel von Marin County. Bemerkenswerterweise ist die Garage im dritten Stock des Hauses, die Bewohner mussten auf den Dachboden klettern, um an ihr Auto zu kommen. Der kleine und wohlhabende Ort liegt nah an der Marin Headlands National Recreation Area nördlich vom Golden Gate und ist bekannt für die Uferpromenade mit Hausbooten, Restaurants und teuren Geschäften, 1933.

La Kate Gleason House à Sausalito, juste au-dessus du Golden Gate à proximité de la limite méridionale du comté de Marin. Contrairement aux habitudes, le garage se trouvait au dernier étage de cette bâtisse qui en comptait trois. Ses occupants devaient donc monter au grenier pour sortir leur voiture. Petite et riche, la ville est réputée pour sa proximité avec la Marin Headlands National Recreation Area, juste au nord du Golden Gate Bridge, ainsi que pour son front de mer animé : houseboats, restaurants, boutiques chics, etc. 1933.

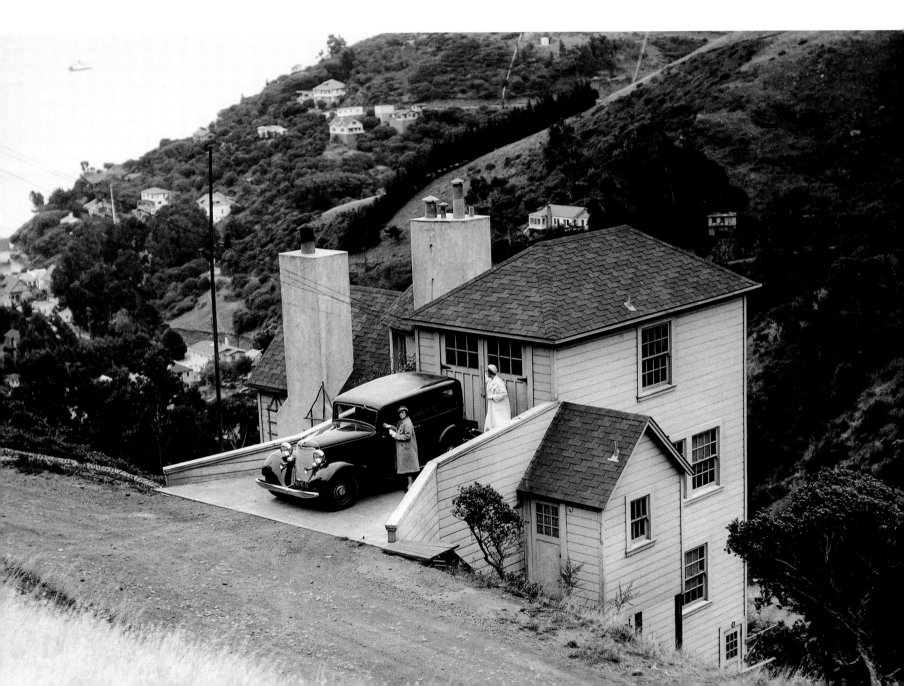

*"San Francisco's night-fog, thin, clammy, and penetrant,
 blurred the street."*

*„San Franciscos Nachtnebel, dünn, klamm und durch-
 dringend, verwischte die Straßenkonturen."*

*« Le brouillard nocturne de San Francisco, diffus, moite
 et pénétrant, estompait le décor. »*

DASHIELL HAMMETT, *THE MALTESE FALCON,* 1929

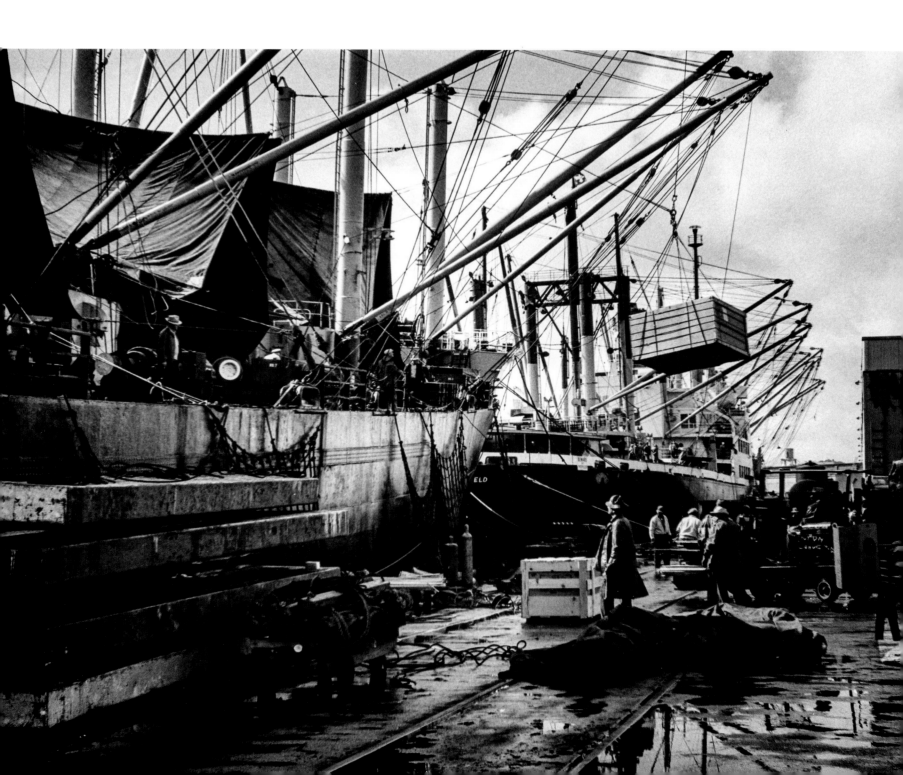

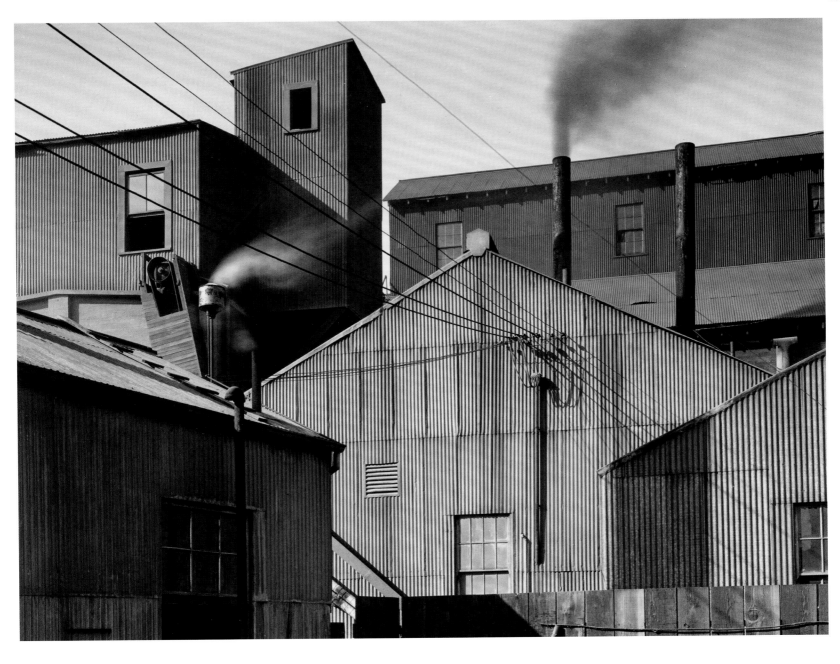

←
Hansel Mieth

Ships load cargo on the San Francisco waterfront. Frustrated by the risky work for low pay, longshoremen went on strike this year, sparking a general strike in July when many sailors, engineers, and other workers joined them, 1934.

Schiffe werden am Kai von San Francisco beladen. Von gefährlicher Arbeit und schlechter Bezahlung frustriert, traten die Hafenarbeiter in diesem Jahr in den Streik, was im Juli sogar zum Generalstreik führte, an dem viele Seeleute, Maschinisten und andere Arbeiter teilnahmen, 1934.

Chargement des marchandises à bord de navires de commerce. Mal payés pour ce labeur dangereux, les dockers mécontents vont cesser le travail et déclencher en juillet une grève générale à laquelle se joindront marins, camionneurs, conducteurs de tramway et ouvriers de toutes qualifications. 1934.

↑
Ansel Adams

Although most known for his landscape pictures of the American West, Ansel Adams also took in his share of urban landscapes, like this plainly titled Factory Building, San Francisco. *Just after World War II, he and Minor White started the first fine art photography department at the city's California School of Fine Arts, 1932.*

Obwohl er besser für seine Landschaftsbilder aus dem amerikanischen Westen bekannt ist, machte Ansel Adams auch einige Aufnahmen von Stadtlandschaften, wie dieses, das schlicht Factory Building, San Francisco *heißt. Kurz nach dem Zweiten Weltkrieg gründeten er und Minor White die erste Fakultät für Kunstfotografie an der California School of Fine Arts, 1932.*

S'il est surtout connu pour ses panoramas de l'Ouest américain, Ansel Adams n'a pas pour autant négligé les paysages urbains, à l'exemple de cette photo intitulée Factory Building, San Francisco. *Juste après la Seconde Guerre mondiale, il créa avec Minor White le premier département de photographie artistique à la California School of Fine Arts. 1932.*

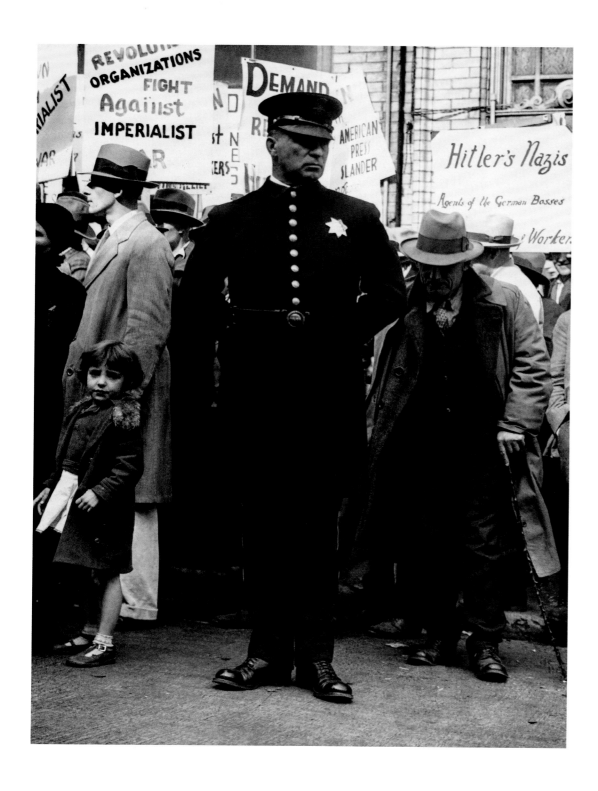

↑

Dorothea Lange

The gathering in this photo titled Street Meeting *likely features a left-leaning crowd, judging from signs urging opposition to imperialism and hinting at revolution, 1937.*

Das Foto Street Meeting *zeigt den Schildern nach zu urteilen, die zum Widerstand gegen den Imperialismus auffordern und auf die Revolution anspielen, eine linksorientierte Gruppe, 1937.*

Ce rassemblement, intitulé Street meeting *par la photographe, réunit probablement des militants de gauche, si l'on en croit les pancartes qui appellent à combattre l'impérialisme et évoquent la révolution. 1937.*

→

Dorothea Lange

The White Angel breadline, *as the Depression tightened its grip on San Francisco and the world. On an Embarcadero lot near Filbert Street, the White Angel soup kitchen served meals to more than a million men during a three-year period. This was the first documentary photograph taken by Lange, who'd make pictures of the underprivileged a specialty throughout her career, 1932.*

Als die Wirtschaftskrise San Francisco und die Welt schon fest im Griff hatte, versorgte die Suppenküche White Angel Breadline *auf einem Grundstück am Embarcadero nahe der Filbert Street innerhalb von drei Jahren mehr als eine Million Menschen. Dorothea Lange, deren erstes dokumentarisches Foto dies ist, hielt ihr Leben lang das Leid der Unterprivilegierten in ihren Fotos fest, 1932.*

La crise resserre son étau sur San Francisco et le reste du monde. Pendant trois ans, la soupe populaire (« White Angel Breadline ») servira des repas à plus d'un million de démunis sur un terrain dédié de l'Embarcadero baptisé « White Angel Jungle », près de Filbert Street. Dorothea Lange prend là sa première photo littéralement documentaire. Elle ne cessera plus de se consacrer au sort de tous les défavorisés. 1932.

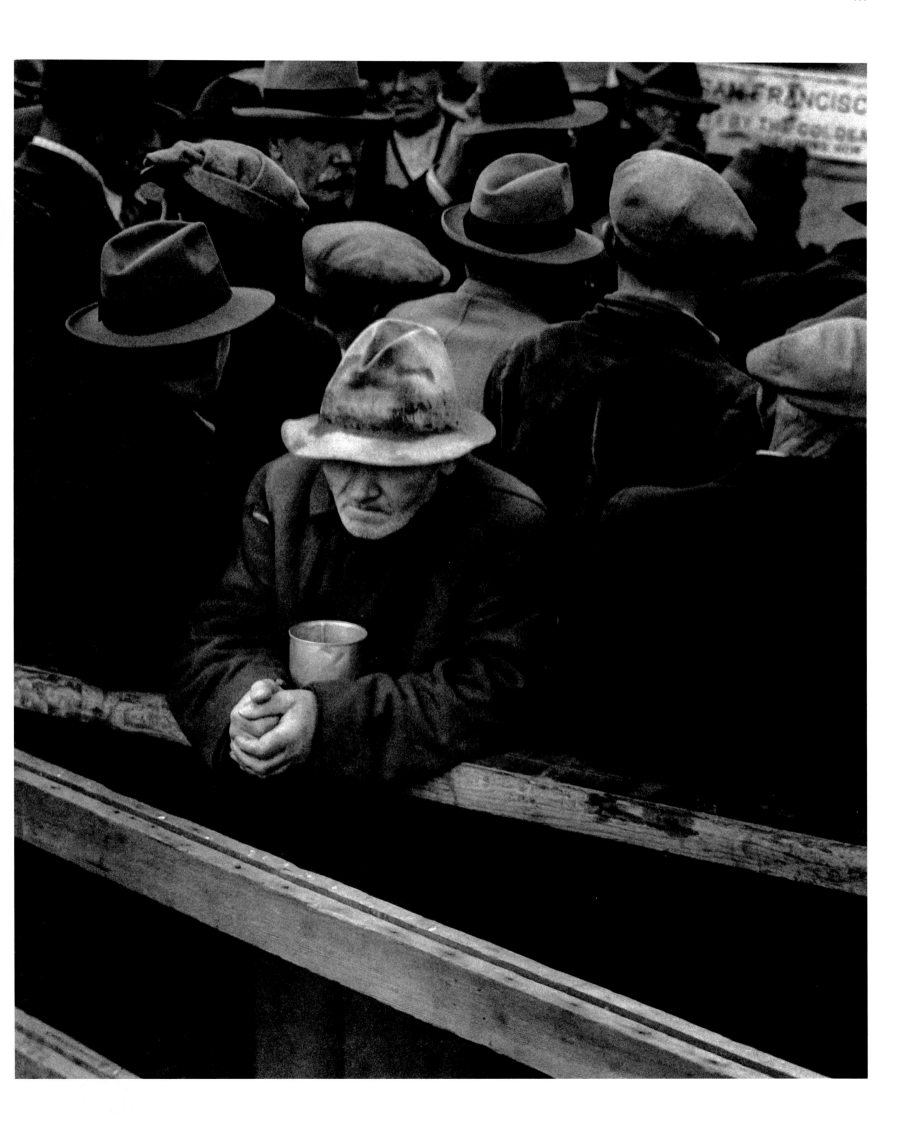

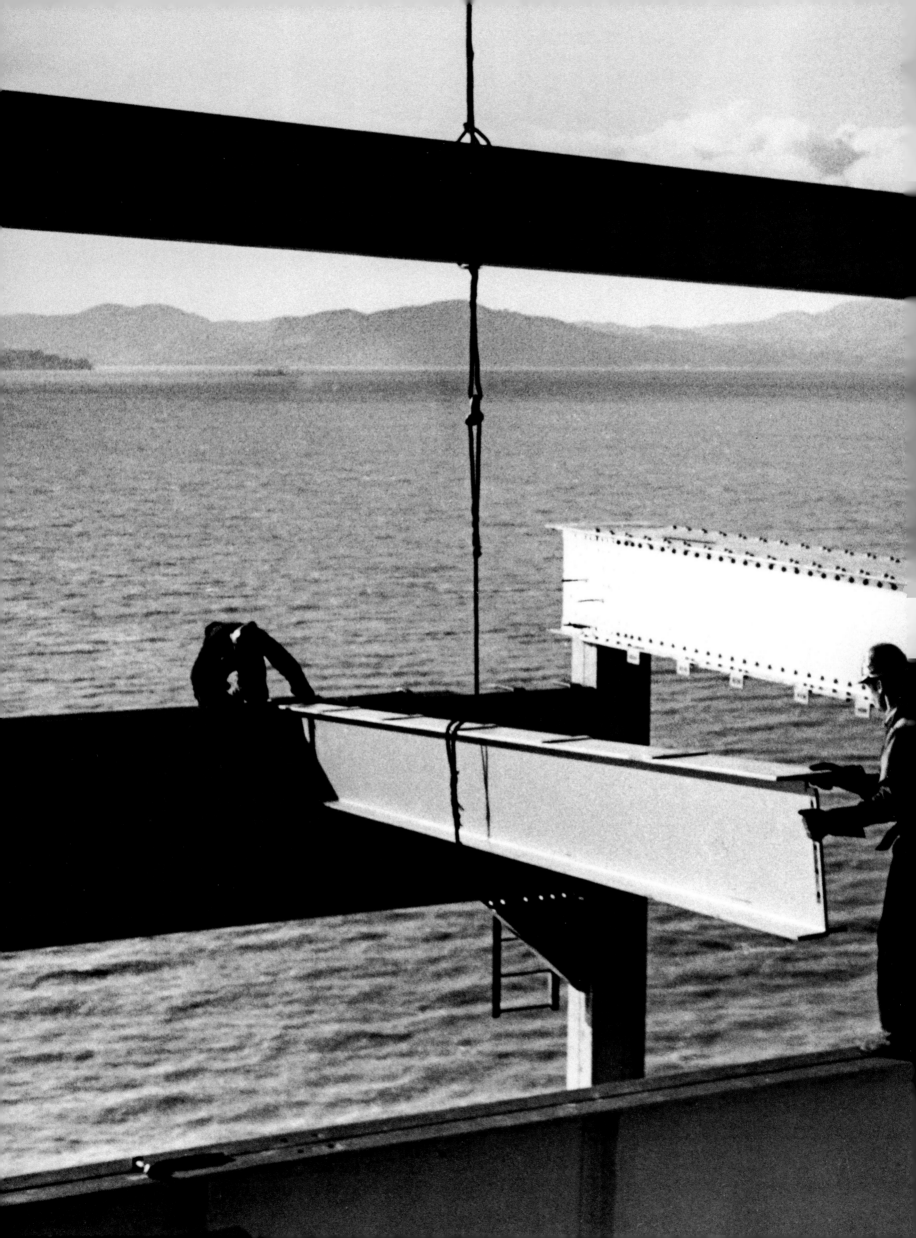

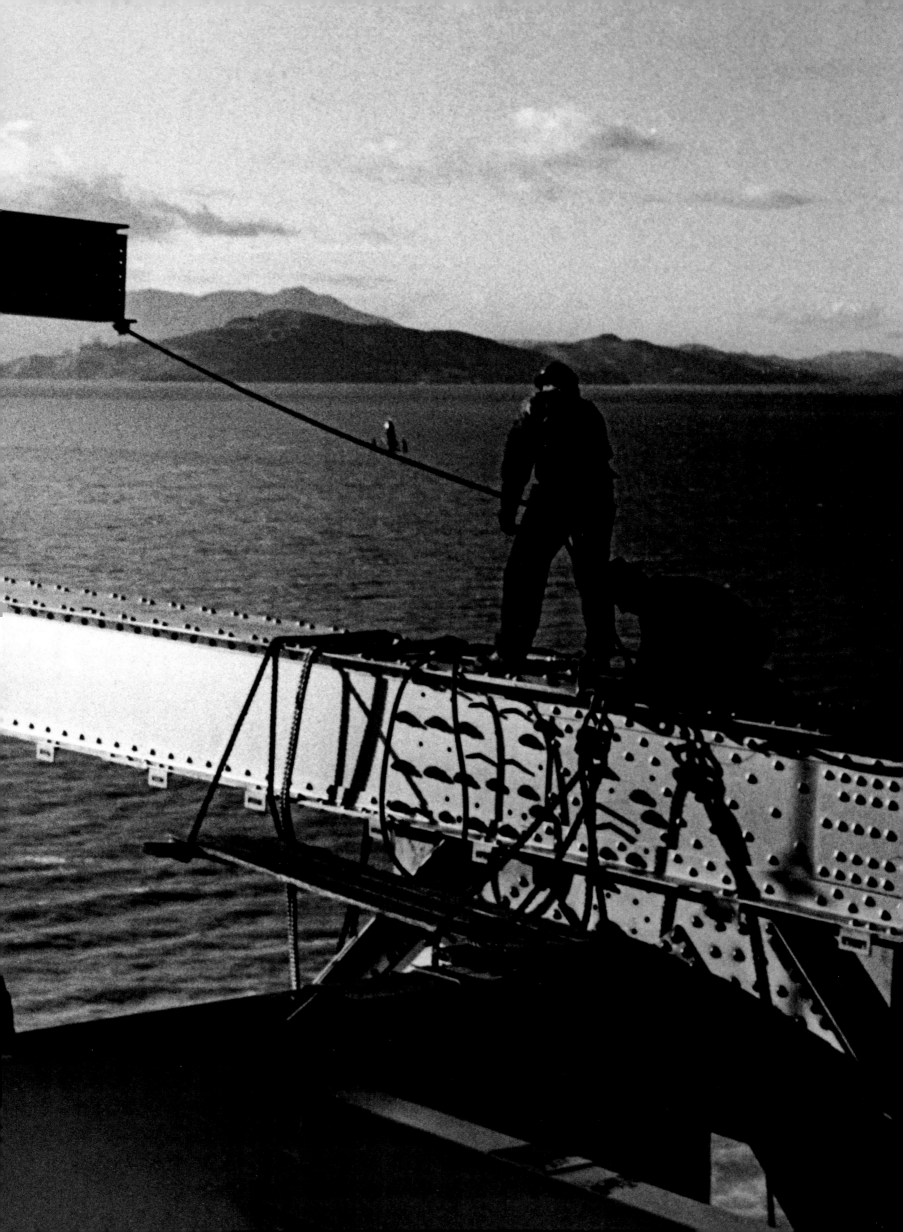

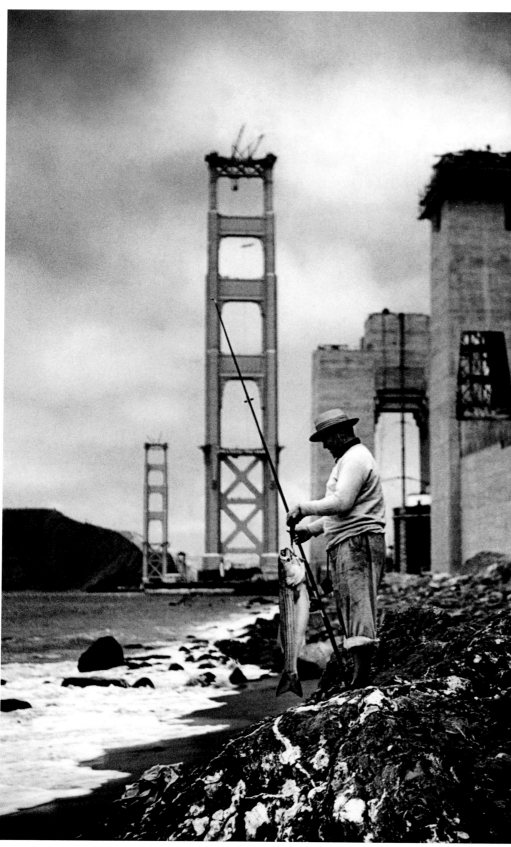

←
Ted Huggins

Fishing at the foot of the San Francisco side of the Golden Gate Bridge, which is still a couple years away from completion. The Marin Headlands are in the distance, 1935.

Angeln am Fuß der Golden Gate Bridge auf der südlichen Seite, hier noch ein paar Jahre vor der Fertigstellung. Im Hintergrund sind die Marin Headlands zu sehen, 1935.

Pêcheur au pied du Golden Gate Bridge, côté San Francisco. Le pont ne sera pas achevé avant deux ans. Au loin, les Marin Headlands. 1935.

→
Anonymous

Planes fly between the spans of the Golden Gate Bridge on its opening day. Nearly 20,000 San Franciscans were waiting to walk the new landmark at dawn, with 200,000 crossing as the day progressed, May 27, 1937.

Flugzeuge fliegen am Tag ihrer Eröffnung zwischen den Seilen der Golden Gate Bridge hindurch. Fast 20 000 Menschen warteten schon bei Sonnenaufgang darauf, das neue Wahrzeichen zu Fuß zu überqueren, im Lauf des Tages waren es fast 200 000, 27. Mai 1937.

Le jour de son inauguration, des avions volent entre les travées du Golden Gate Bridge. Dès l'aube, près de 20 000 habitants de San Francisco attendaient impatiemment de pouvoir emprunter le nouvel ouvrage, et 200 000 s'y aventureront tout au long de la journée. 27 mai 1937.

p. 112/113
Peter Stackpole

Workers construct a roadbed support for a cantilever section of the Bay Bridge as part of the three-year effort to complete the structure. "It wasn't uncommon for a bridgeman to grow impatient with waiting for the elevator and to slide down a bare cable to catch an earlier boat to shore," wrote the photographer in The Bridge Builders, *c. mid-1930s.*

Die Arbeit an einem Kragträger für die Fahrbahn der Bay Bridge, deren Bau drei Jahre dauerte. „Es war nicht selten, dass die Brückenbauer zu ungeduldig waren, um auf den Fahrstuhl zu warten, und stattdessen einfach an einem der Kabel herunterrutschten, um ein früheres Boot zur Küste nehmen zu können", schrieb der Fotograf in The Bridge Builders, *Mitte 1930er.*

Des ouvriers construisent un support de plate-forme pour une section en porte-à-faux du Bay Bridge. Il faudra trois ans pour achever la structure. « Il n'était pas rare de voir un ouvrier lassé d'attendre l'ascenseur se laisser glisser le long d'un câble nu pour monter dans le premier bateau venu vers la terre ferme », écrira le photographe dans The Bridge Builders. *Milieu des années 1930.*

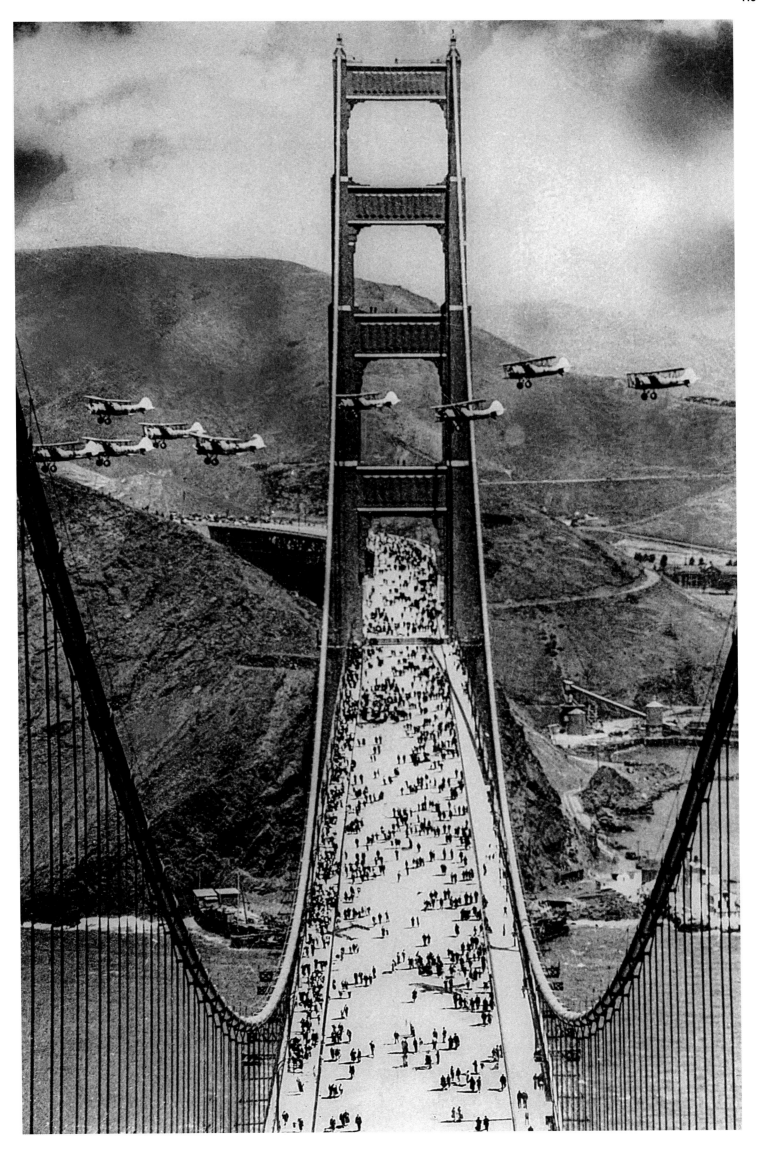

→
John Gutmann

Taken from the north side of Lafayette Park at Washington and Octavia streets in Pacific Heights, the photographer titled this picture Looking at Russian Hill, *the upscale neighborhood to the north of Nob Hill. Russian Hill is named after a now-gone cemetery on its peak, 1938.*

Aufgenommen von der Nordseite des Lafayette Park an Washington und Octavia Street in Pacific Heights, nannte der Fotograf das Bild Blick auf Russian Hill, *das wohlhabende Viertel nördlich von Nob Hill. Russian Hill ist nach einem mittlerweile verschwundenen Friedhof auf seiner Spitze benannt, 1938.*

Prise au nord du Lafayette Park, à l'angle de Washington Street et d'Octavia Street à Pacific Heights, cette photo intitulée Looking at Russian Hill *évoque le quartier chic situé au nord de Nob Hill. Russian Hill doit son nom à un cimetière aujourd'hui disparu, alors implanté à son sommet. 1938.*

↑
Anonymous

Coit Tower on Telegraph Hill, seen about a decade after its 1933 opening. The 210-foot concrete art deco building offers marvelous panoramic views of the city and the bay. The Public Works of Art Project commissioned murals of California life on its spiral stairway, though those can only be seen by signing up for a tour, c. 1940s.

Coit Tower auf dem Telegraph Hill, etwa zehn Jahre nach der Eröffnung im Jahr 1933. Das 64 Meter hohe Art-déco-Gebäude aus Beton bietet einen wunderbaren Panoramablick über Stadt und Bucht. Die Public Works of Art Project gab Wandmalereien für das Treppenhaus in Auftrag, heute muss man sich aber für eine Tour anmelden, um sie zu betrachten, 1940er-Jahre.

La Coit Tower sur Telegraph Hill, dix ans environ après son inauguration en 1933. Ce bâtiment Art déco en béton d'une hauteur de 64 mètres offre un magnifique panorama sur la ville et la baie. Dans le cadre des visites guidées, l'ascension de son escalier en colimaçon permet d'admirer les fresques commandées par le Public Works of Art Project et consacrées à la vie de la Californie pendant la Grande Dépression. Vers les années 1940.

Julius Shulman

The Hallawell Seed Company, near Stern Grove park and one of the city's busiest intersections at 19th Avenue and Sloat Boulevard. It was the first steel structure designed by architect Raphael Soriano, who'd innovate the use of steel and aluminum in both residential and commercial buildings, c. early 1940s.

Die Hallawell Seed Company, in der Nähe von Stern Grove Park und einer der meistbefahrenen Kreuzungen der Stadt, Nineteenth Avenue und Sloat Boulevard. Es war das erste vom Architekten Raphael Soriano entworfene Gebäude aus Stahl, einem der Wegbereiter für die Verwendung von Stahl und Aluminium im Bau von Wohn- und Gewerbegebäuden, frühe 1940er.

L'entreprise semencière Hallawell Seed, à proximité du parc de Stern Grove et de l'un des carrefours les plus fréquentés de la ville, à l'angle de la 19e Avenue et de Sloat Boulevard. C'est la première structure en acier réalisée par l'architecte Raphael Soriano, qui fut l'un des pionniers en la matière et conçut également des maisons préfabriquées « tout en aluminium ». Vers le début des années 1940.

↑
Julius Shulman

The back porch of one of the first International Style homes in San Francisco, dubbed the "The Darling House" after the name of the family who first lived there. Designed by Richard Neutra, it was built in 1937 on Woodland Avenue, a few blocks up the hill from the southeast corner of Golden Gate Park, 1937.

Die Veranda des Darling House, benannt nach der ersten Familie, die es bewohnte, und entworfen von Richard Neutra, einem der führenden Architekten der Moderne. Gebaut 1937 in den Hügeln an der Woodland Avenue, ein paar Blocks oberhalb der südöstlichen Ecke des Golden Gate Park, 1937.

L'une des premières maisons conçues dans le style international à San Francisco était surnommée « The Darling House », en référence au patronyme de ses premiers occupants. Construite en 1937 sur Woodland Avenue, un peu plus haut que l'angle sud-est du Golden Gate Park, elle est l'œuvre du grand architecte moderniste Richard Neutra. 1937.

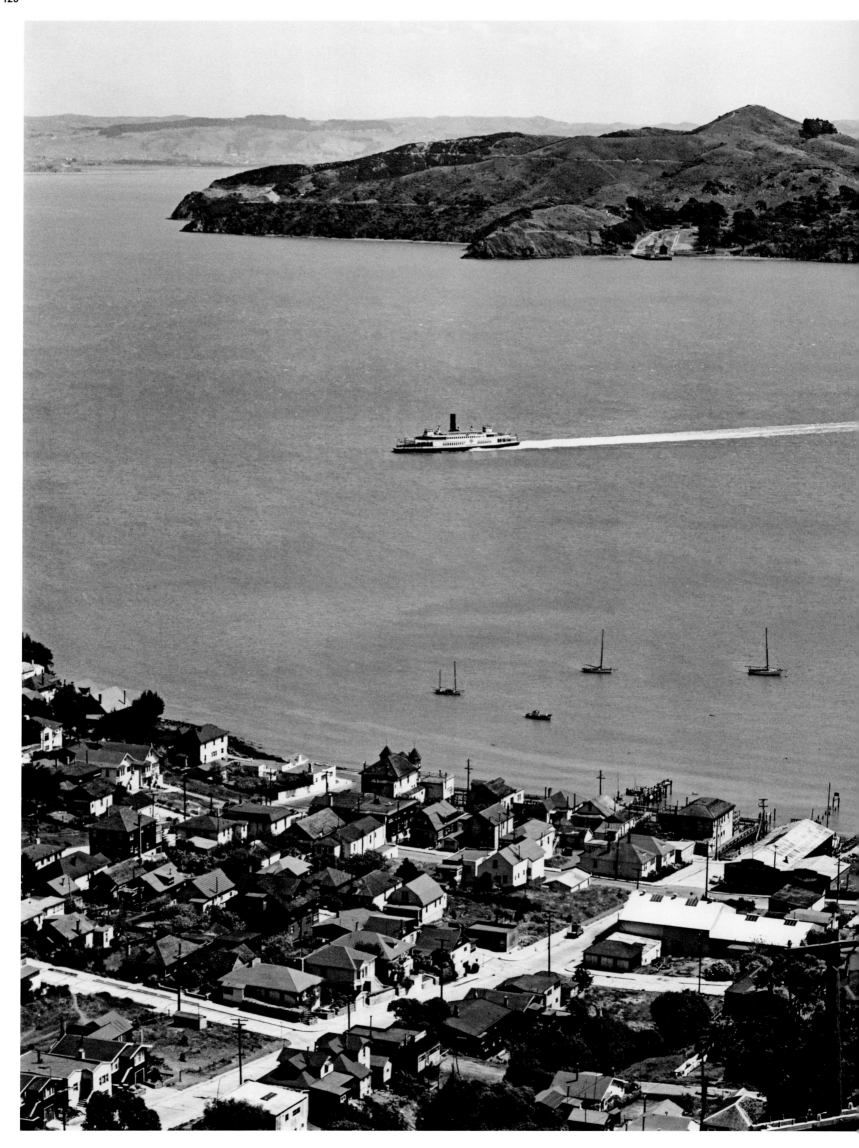

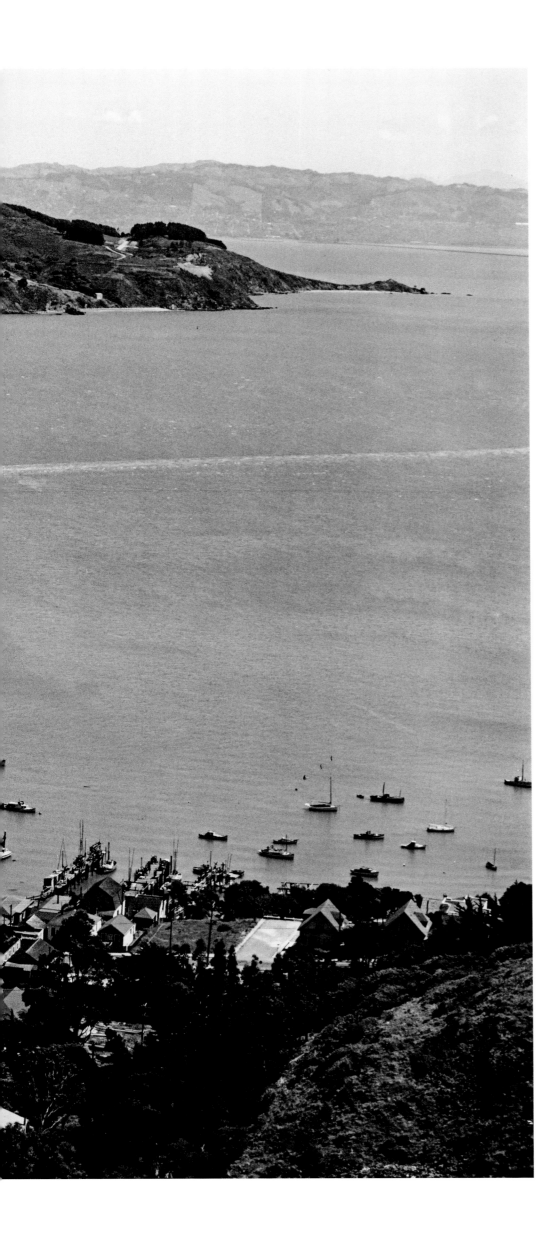

←
Edward Weston

The Sausalito waterfront, in Marin County just a few miles across the bay from the northern shores of San Francisco. In the background is Angel Island, which from 1910 to 1940 housed an immigration station, processing about a million Chinese. The second largest island in the San Francisco Bay, it's now a state park, 1939.

Die Küste von Sausalito in Marin County, nur ein paar Kilometer vom nördlichen Ufer San Franciscos auf der anderen Seite der Bucht entfernt. Im Hintergrund ist Angel Island zu sehen, wo von 1910 bis 1940 rund eine Million Chinesen die Einreisebehörden passierten. Als zweitgrößte Insel in der Bucht ist sie jetzt ein State Park, der unter Naturschutz steht, 1939.

Le front de mer de Sausalito, dans le comté de Marin, à quelques kilomètres à peine du rivage septentrional de San Francisco. À l'arrière-plan, Angel Island, la deuxième plus grande île de la baie, aujourd'hui parc national. Elle abrita de 1910 à 1940 une « station d'immigration » dévolue à la réception et souvent à la détention des nouveaux arrivants. Près d'un million de Chinois y séjourneront. 1939.

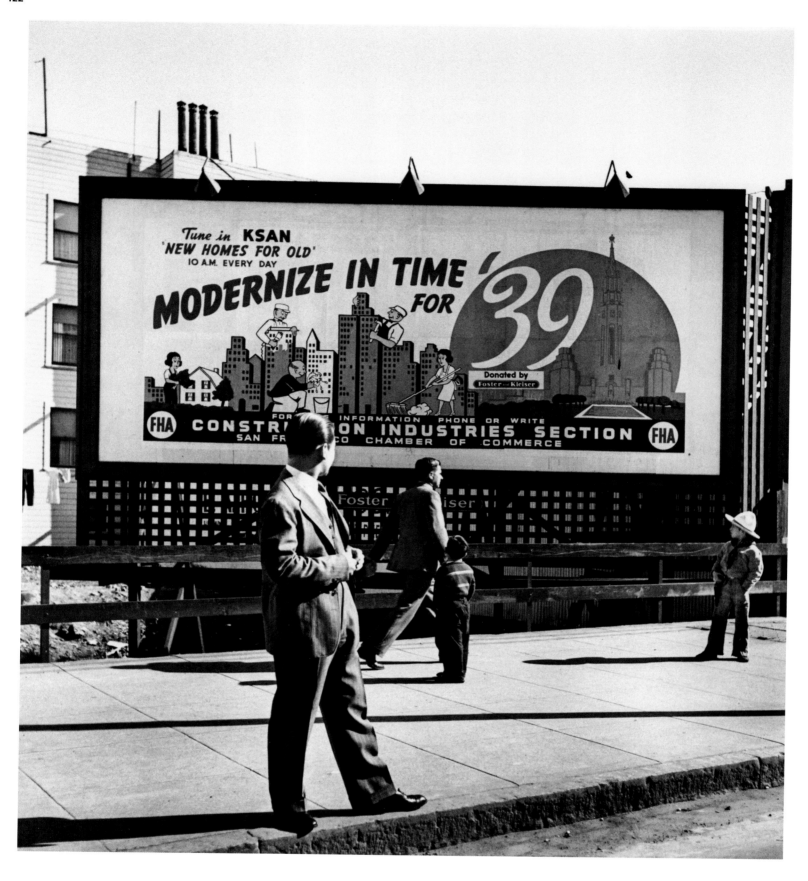

↑
John Gutmann

Billboard urging San Franciscans to "Modernize in Time" by contacting the construction industries section of the local chamber of commerce. It also plugs the "new homes for old" program on KSAN, whose call letters would be used by the city's top FM/underground rock station three decades later, 1939.

Ein Plakat will die Menschen in San Francisco dazu bewegen, die Bauabteilung der lokalen Handelskammer anzusprechen und noch in diesem Jahr ihr Haus zu modernisieren. Es bewirbt auch die Sendung „Neue Häuser für alte" auf KSAN. Das Kürzel

stand 30 Jahre später für den besten Underground-Rock-Radiosender der Stadt, 1939.

Panneau d'affichage invitant la population de San Francisco à « se moderniser à temps », et à cet effet à contacter le département « travaux publics » de la Chambre de commerce locale. La publicité assure au passage la promotion d'une émission de radio, « Des maisons neuves pour les vieux », sur KSAN – sans rapport avec la grande station underground qui enflammera la ville trois décennies plus tard. 1939.

→
John Gutmann

Pop Advertising, as this picture was titled, for MacFarlane's "awful fresh" candy at Crystal Palace Market. From 1923 to 1959, the 71,000-square-foot downtown market had more than 50 shops offering all sorts of food and several other products at Eighth and Market streets, 1939.

Pop Advertising, so der Name des Bildes, wirbt für MacFarlanes „mordsmäßig frische" Süßigkeiten am Crystal Palace Market. Von 1923 bis 1959 hatte der 6 500 Quadratmeter große Markt an Eighth und Market Street mehr als 50 Geschäfte, die Lebensmittel aller Art und vieles mehr anboten, 1939.

« Publicité sur le lieu de vente », comme le dit le titre de cette photo, pour les bonbons MacFarlane, « terriblement frais ». Entre 1923 et 1959, le Crystal Palace Market, au centre-ville, alignait une cinquantaine de boutiques proposant sur plus d'un demi-hectare toutes sortes de denrées alimentaires et produits variés, à l'angle de la 8e Rue et de Market Street. 1939

"Third Street, below Howard, is a district; think of the Bowery in New York, Main Street in Los Angeles: think of old men and boys, out of work, hanging around, smoking Bull Durham, talking about the government, waiting for something to turn up, simply waiting."

„Die Dritte Straße, unterhalb von Howard, ist ein Bezirk – denk' an die Bowery in New York, an die Main Street in Los Angeles: denk' an alte Männer und Jungens, die arbeitslos sind, herumlungern, Bull Durham rauchen, über die Regierung schwatzen, warten, daß irgendwas geschieht, einfach warten."

« La 3e Rue, en dessous d'Howard Street, est un quartier en soi; imaginez le Bowery à New York, Main Street à Los Angeles: imaginez ces hommes déjà vieux et ces gamins qui traînent à longueur de journée, sans travail, à fumer du Bull Durham en parlant du gouvernement, à attendre qu'il se passe quelque chose, à attendre, tout simplement. »

WILLIAM SAROYAN, *THE DARING YOUNG MAN ON THE FLYING TRAPEZE AND OTHER STORIES,* 1934

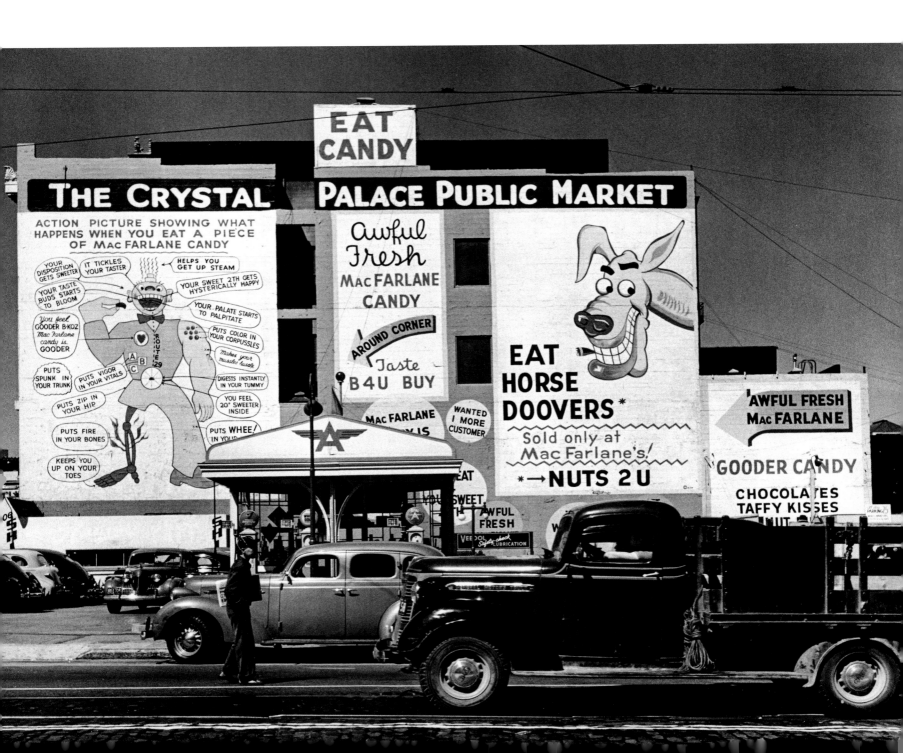

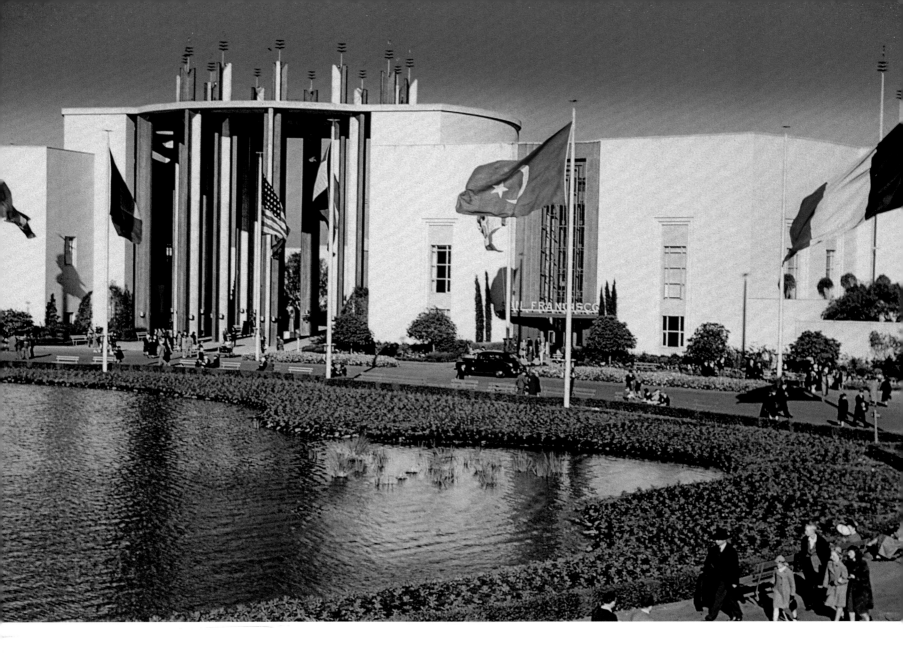

Anonymous

The Lake of the Nations at the Golden Gate International Exposition on Treasure Island, with flags from several countries fluttering in the breeze. When the lake was drained after the fair closed, it was a foot deep with Coca-Cola bottles, 1939.

Am Teich der Nationen auf der Golden Gate International Exposition auf Treasure Island flattern die Flaggen einiger Länder im Wind. Als der Teich nach der Ausstellung trockengelegt wurde, fand man am Boden eine 30 Zentimeter dicke Schicht von Coca-Cola-Flaschen, 1939.

Flottant au vent, les drapeaux de différents pays surplombent le lac des Nations lors de l'Exposition internationale du Golden Gate organisée sur Treasure Island. Une fois l'événement terminé, le drainage du lac a mis au jour une couche de bouteilles de Coca-Cola haute de 30 centimètres. 1939.

Anonymous

Night view of the one of the two Elephant Towers from the Portals of the Pacific at the western entrance of the Golden Gate International Exposition. The fair attracted about 17 million visitors in the months it was open during parts of 1939 and 1940. The multicolored lighting was so bright that the exposition was visible for more than 100 miles in every direction, 1940.

Einer der beiden Elephant Towers an den Portals of the Pacific am Westeingang der Golden Gate International Exposition bei Nacht. Die Ausstellung zog rund 17 Millionen Besucher an, und das in nur einigen Monaten in den

Jahren 1939 und 1940. Die vielfarbigen Lichter waren so hell, dass man sie noch in über 150 Kilometer Entfernung sehen konnte, 1940.

Vue nocturne de l'une des deux Elephants Towers du Portals of the Pacific à l'entrée ouest de l'Exposition internationale du Golden Gate. Celle-ci a accueilli quelque 17 millions de visiteurs durant ses mois d'ouverture en 1939 et 1940. Les jeux de lumières étaient tels qu'ils se voyaient à plus de 150 kilomètres à la ronde. 1940.

"During the last decade the world's two largest bridges have been flung across San Francisco Bay...and to celebrate their completion, the world's largest man-made island now has risen from the waves."

„Während der letzten zehn Jahre wurden die beiden längsten Brücken der Welt über die San Francisco Bay geworfen … und um ihre Fertigstellung zu feiern, hat sich nun die größte menschengemachte Insel aus den Wellen erhoben."

« Au cours de la dernière décennie, c'est par-dessus la baie de San Francisco qu'ont été jetés les deux ponts les plus longs du monde… et pour célébrer leur achèvement voici que surgit des flots la plus grande île artificielle au monde. »

ALMANAC FOR THIRTY NINERS, SAN FRANCISCO FEDERAL WRITERS PROJECT, 1938

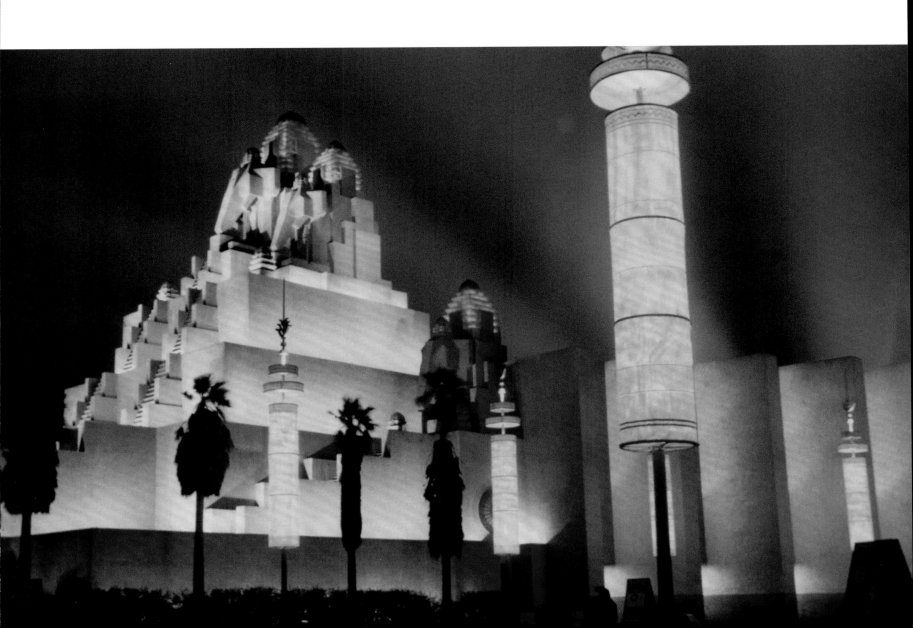

"San Francisco has always been the West Coast's most cosmopolitan city. Since the tempo of the Pacific war has increased, it has become one of the greatest crossroads of the world."

„San Francisco war schon immer die kosmopolitischste Stadt der Westküste. Seit sich das Tempo des Kriegs im Pazifik verschärft hat, ist sie zu einer der größten Kreuzungen der Welt geworden."

« San Francisco a toujours été la ville la plus cosmopolite de la côte Ouest. Depuis que le rythme de la guerre du Pacifique s'est emballé, elle est devenue l'un des plus grands carrefours du monde. »

LIFE MAGAZINE, 1944

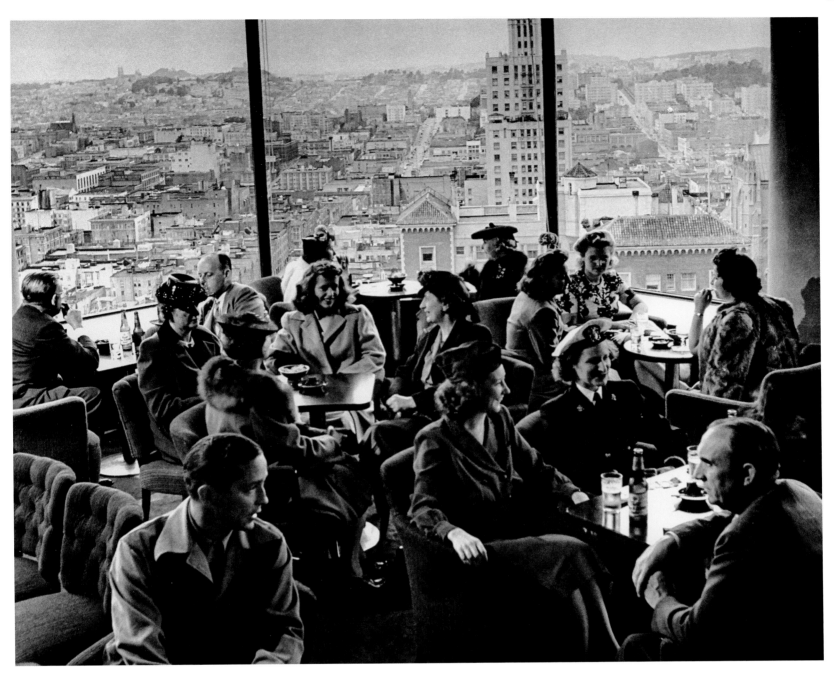

←

Charles W. Cushman

Sunbathers celebrate July Fourth on Marina Green, near where sailboats dock at Fort Mason, a couple miles east of the Golden Gate Bridge. As is customary for San Franciscan summers, the temperature only reached the upper 60s that day, July 4, 1940.

Sonnenanbeter feiern den 4. Juli auf dem Marina Green nahe dem Yachthafen von Fort Mason, ein paar Kilometer östlich der Golden Gate Bridge. Wie es für die Sommer in San Francisco üblich ist, erreichten die Temperaturen nur knappe 20 Grad, 4. Juli 1940.

Les amateurs de bronzage célèbrent le 4-Juillet, fête nationale, sur Marina Green, près du quai d'accostage des voiliers à Fort Mason, quelques kilomètres à l'est du Golden Gate Bridge. Comme c'est souvent le cas en été à San Francisco, la température ce jour-là dépasse à peine les 20 °C. 4 juillet 1940.

↑

Ralph Crane

Dining on the top of the Mark Hopkins Hotel on Nob Hill. The woman in uniform in the right foreground is a reminder that World War II was still being fought, 1944.

Das Restaurant im obersten Stock des Mark Hopkins Hotels in Nob Hill. Die Frau in Uniform rechts im Vordergrund erinnert daran, dass der Zweite Weltkrieg noch nicht beendet war, 1944.

Dîner au sommet de l'hôtel Mark Hopkins, à Nob Hill. Au premier plan à droite, l'uniforme de la jeune femme rappelle que la Seconde Guerre mondiale n'est toujours pas terminée. 1944.

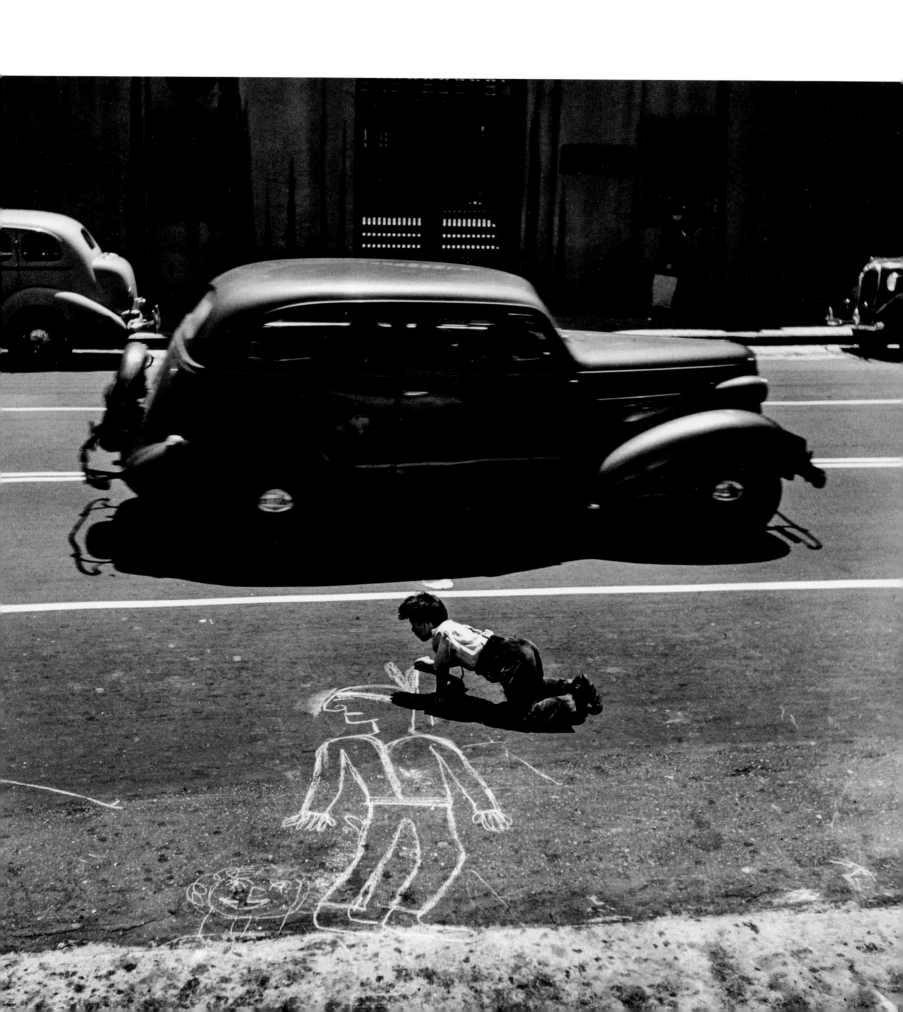

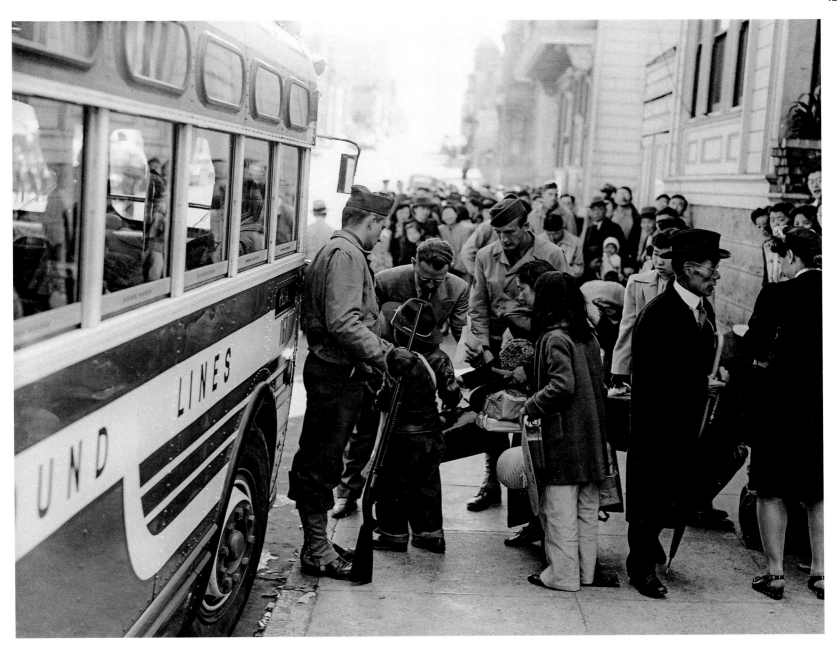

John Gutmann

Car traffic might have made completing this chalk drawing risky business. The photographer acknowledged this in his title for the picture, The Artist Lives Dangerously, *1938.*

Diese Kreidezeichnung im Verkehr fertig-zubekommen, war bestimmt nicht unge-fährlich. Der Fotograf nahm das im Titel des Bildes zur Kenntnis, The Artist Lives Dangerously, *1938.*

La circulation automobile aurait pu rendre périlleux l'achèvement de ce dessin à la craie. Le photographe en est convenu dans le titre qu'il a donné à l'image, The Artist Lives Dangerously. *1938.*

Dorothea Lange

Some of the Japanese who were removed from their residences on the first day of evacuations from their Japantown neighborhood. About 120,000 Japanese Americans were forcibly relocated to detention camps during World War II because of perceived security risks to the nation, many of them from the San Francisco Bay Area. An official checks the ID tag of the boy in the cowboy hat as he boards, April 1942.

Einige Japaner, die am ersten Tag der Eva-kuierung von Japantown ihre Wohnungen verlassen mussten. Etwa 120 000 Amerikaner japanischer Herkunft wurden wurden auf-grund von mutmaßlichen Sicherheitsrisiken für die Nation während des Zweiten Welt-kriegs in Internierungslager zwangsumgesie-delt, viele von ihnen stammten aus der San Francisco Bay Area. Ein Beamter überprüft die Identitätskarte des Jungen, bevor er in den Bus steigt, April 1942.

Certains des Japonais contraints de quitter leur domicile au premier jour de l'évacuation du quartier.Près de 120 000 Américains d'ori-gine japonaise dont de nombreux résidents de la « Bay Area », jugés dangereux pour la sécurité nationale, seront déplacés de force dans des camps de détention. Un fonction-naire vérifie l'identité du jeune garçon coiffé d'un chapeau de cow-boy qui s'apprête à monter à bord du bus. Avril 1942.

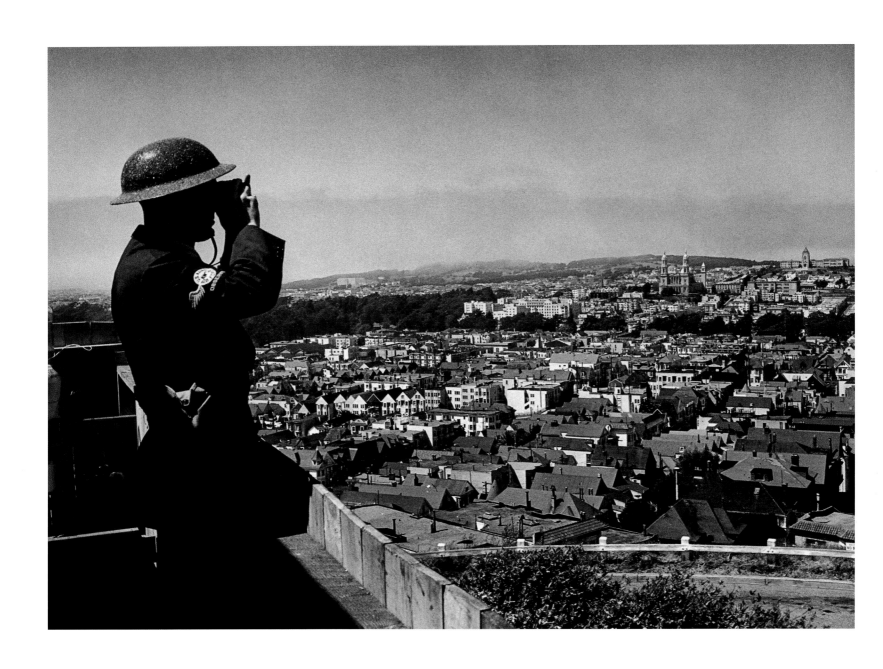

↑
Hansel Mieth

During World War II, plenty of military personnel were based in or passed through the city as its forts and harbor defenses were considered key lines of protection against a possible attack, and more than a million and a half soldiers shipped out of San Francisco for duty in the Pacific, 1942.

Während des Zweiten Weltkriegs war in der Stadt viel Militärpersonal, da ihre Befestigungsanlagen und der Hafen als eine der wichtigsten Verteidigungslinien gegen einen möglichen Angriff galten. Mehr als anderthalb Millionen Soldaten traten von hier aus ihren Dienst im Pazifik an, 1942.

Basés sur place ou en transit, San Francisco a accueilli pendant la Seconde Guerre mondiale de très nombreux militaires car ses forts et défenses portuaires étaient considérés comme des lignes de défense essentielles face à une éventuelle attaque. Plus d'un million et demi de soldats y embarqueront pour aller servir dans le Pacifique. 1942.

→
Horace Bristol

A vessel built for World War II launches from the San Francisco shipyards. There were more than 30 shipyards in the bay, building around 1,400 vessels, or about one a day, for the war effort. They also generated almost half of the country's cargo shipping tonnage and 20 percent of its warship tonnage during the war, 1941.

Ein Schiff, gebaut für den Zweiten Weltkrieg, läuft in San Francisco vom Stapel. Es gab mehr als 30 Werften in der Bucht, die etwa 1.400 Schiffe, fast eins pro Tag, für den Krieg bauten. Hier entstand fast die Hälfte der Frachtschiffstonnage und 20 Prozent der Kriegsschiffstonnage während des Krieges, 1941.

Mise à l'eau d'un navire construit au début du second conflit mondial. La baie de San Francisco comptait plus de trente chantiers navals d'où seront lancés dans le cadre de l'effort de guerre quelque 1 400 vaisseaux, soit un par jour environ. Près de la moitié du tonnage marchand des États-Unis et 20 % de leur tonnage militaire y seront générés pendant la guerre. 1941.

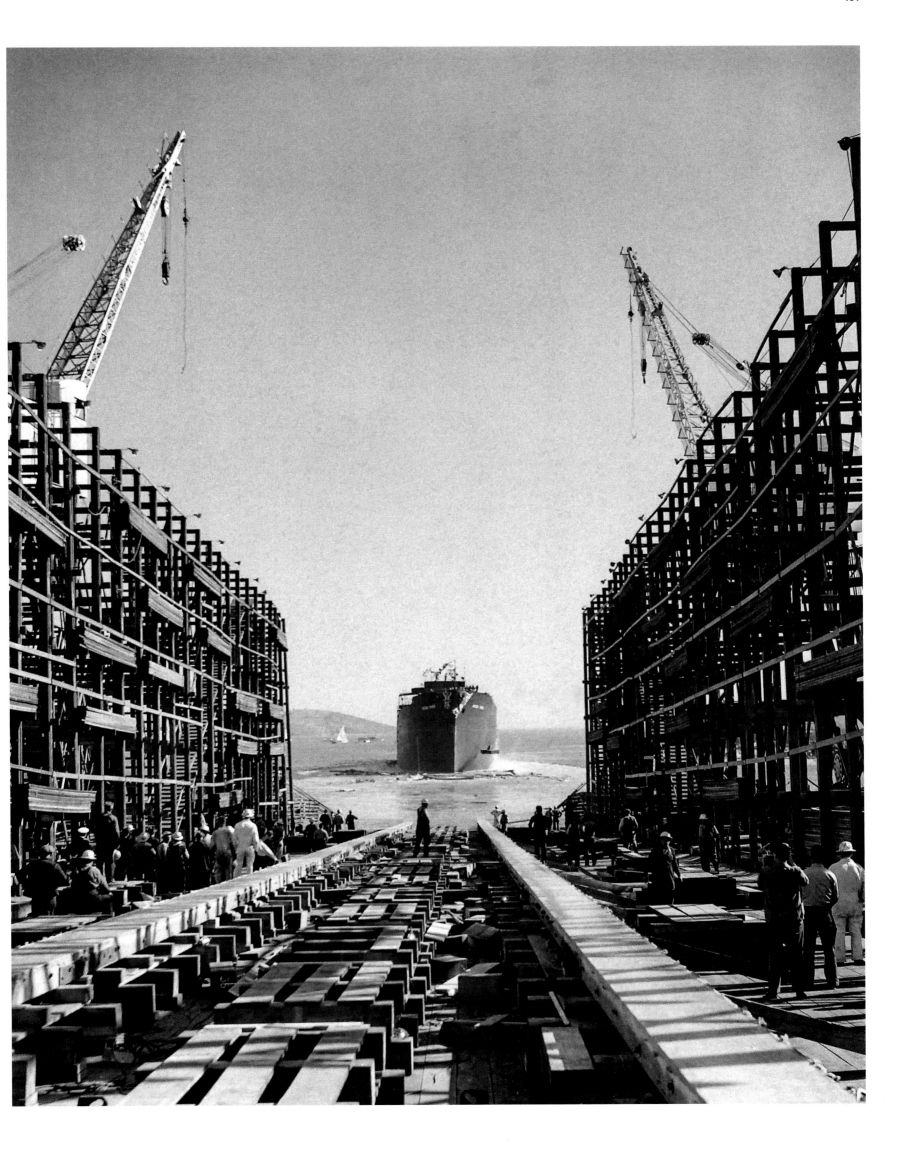

"The curtain rises today in San Francisco on a crucial act of the greatest drama of our time…In the dining rooms and hotel rooms and fireplaces of San Francisco today, the structure of our world is being formed for tomorrow."

„Der Vorhang hebt sich heute in San Francisco für einen entscheidenden Akt des größten Dramas unserer Zeit … In den Esszimmern, Hotelzimmern und Kaminen von San Francisco wird heute die Struktur unserer Welt für morgen geformt."

« Aujourd'hui à San Francisco, le rideau se lève sur un acte décisif du plus grand drame de notre temps… Aujourd'hui, dans les salles à manger, les chambres d'hôtel et les salons de San Francisco se met en place la structure du monde qui sera demain le nôtre. »

**SAN FRANCISCO CHRONICLE REPORT ON THE SIGNING OF THE CHARTER
FOR THE UNITED NATIONS, 1945**

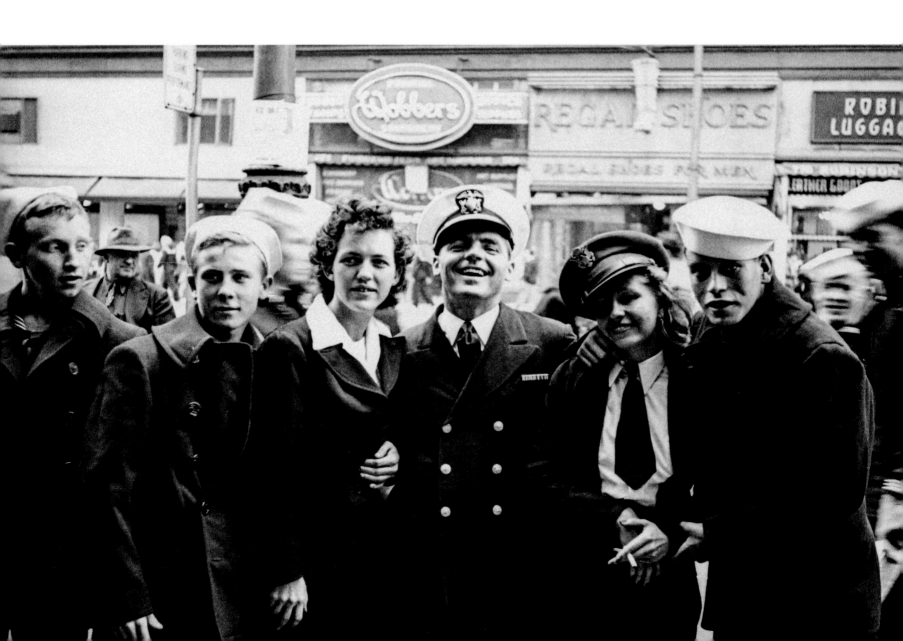

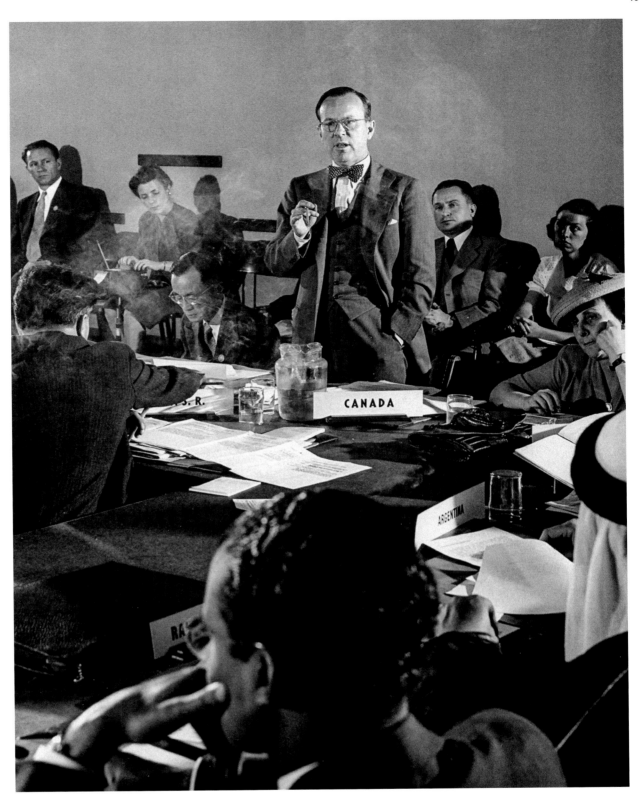

Anonymous

*Sailors and friends celebrate V-J Day,
when Japanese forces surrendered in World
War II, setting off festivities across the country.
With a mixture of joy and relief, these people
are posed in front of the Phelan Building at
760 Market between Third and Fourth streets,
August 15, 1945.*

*Seeleute und ihre Freunde feiern den V-J Day,
an dem die japanischen Streitkräfte kapitu-
lierten. Das wird in den ganzen USA gefeiert.
Aus Freude und Erleichterung posieren sie
hier vor dem Phelan Building, 760 Market
Street, zwischen Third und Fourth Street,
15. August 1945.*

*Des marins et leurs amis célèbrent le
« V-J Day », le jour de la victoire sur le Japon,
après la capitulation des forces nipponnes
qui déclencha des festivités dans tout le pays.
Avec un mélange de joie et de soulagement,
ce groupe pose devant le Phelan Building,
au 760 Market Street entre la 3ᵉ Rue et la
4ᵉ Rue. 15 août 1945.*

Gjon Mili

*A Canadian delegate speaks at the
San Francisco Conference in the War
Memorial Opera House near City Hall
to draft a Charter of the United Nations.
Representatives from 50 governments met
in the city for a couple months before
adopting the charter on June 26, 1945. A
few blocks from the Opera House, an open
space is named United Nations Plaza in
commemoration of the event, 1945.*

*Ein kanadischer Abgeordneter spricht auf
der Konferenz in der War Memorial Opera
nahe der City Hall in San Francisco, auf
der Abgesandte von 50 Regierungen einige
Monate am Entwurf einer Charta der
Vereinten Nationen arbeiteten. Sie wurde*

*am 26. Juni 1945 verabschiedet. Nur ein
paar Blocks weiter weiter erinnert heute die
United Nations Plaza dieses Ereignis, 1945.*

*Un délégué canadien prend la parole lors
de la conférence de San Francisco, organisée
dans les murs du War Memorial Opera, face
à l'hôtel de ville, en vue de parvenir à la
rédaction d'une Charte des Nations unies. Les
délégués de 50 gouvernements vont se réunir
deux mois durant avant d'adopter la Charte
le 26 juin 1945. À quelques rues de l'opéra,
une place piétonne nommée United Nations
Plaza commémore l'événement. 1945.*

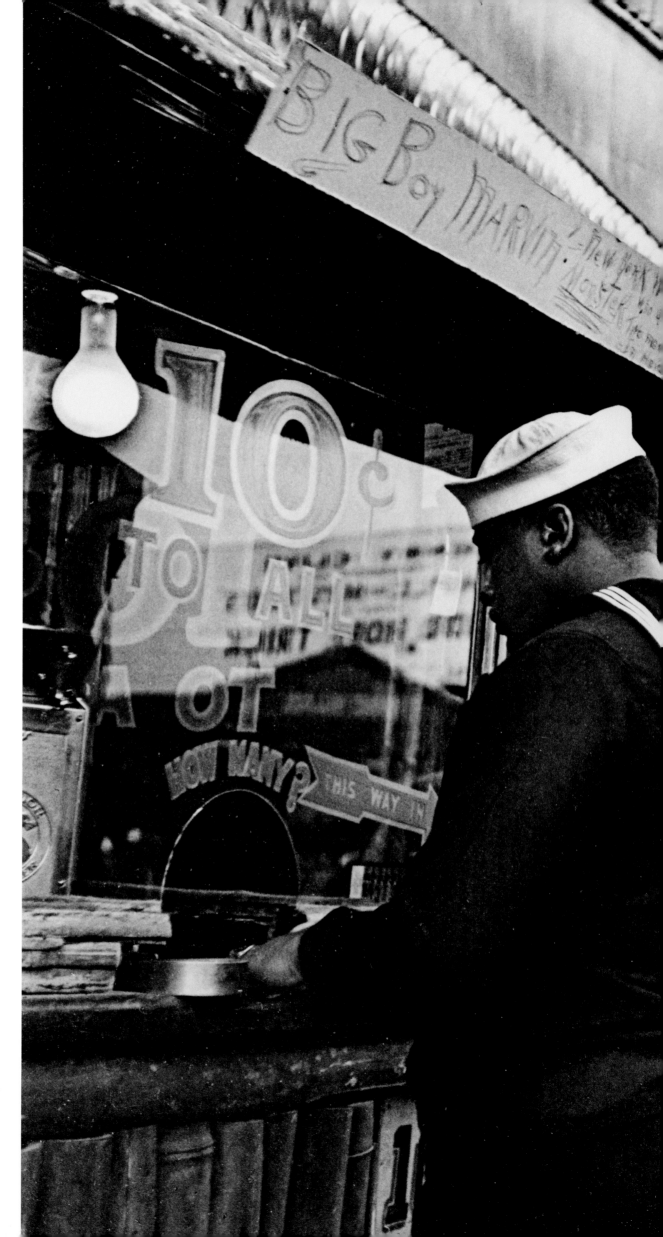

134

John Gutmann

Sailors pay a dime to view "New York Monster, Big Boy Marvin." This was one of the amusements on offer on the Gayway at the Golden Gate International Exposition, 1939.

Seeleute zahlen zehn Cent, um sich das „New York Monster, Big Boy Marvin" anzusehen. Es handelt sich um einen Unterhaltungsstand auf dem Gayway der Golden Gate International Exposition, 1939.

Pour voir « Big Boy Marvin, le monstre de New York », l'une des attractions proposées sur le « Gayway » lors de l'Exposition internationale du Golden Gate, ces marins paieront 10 cents chacun. 1939.

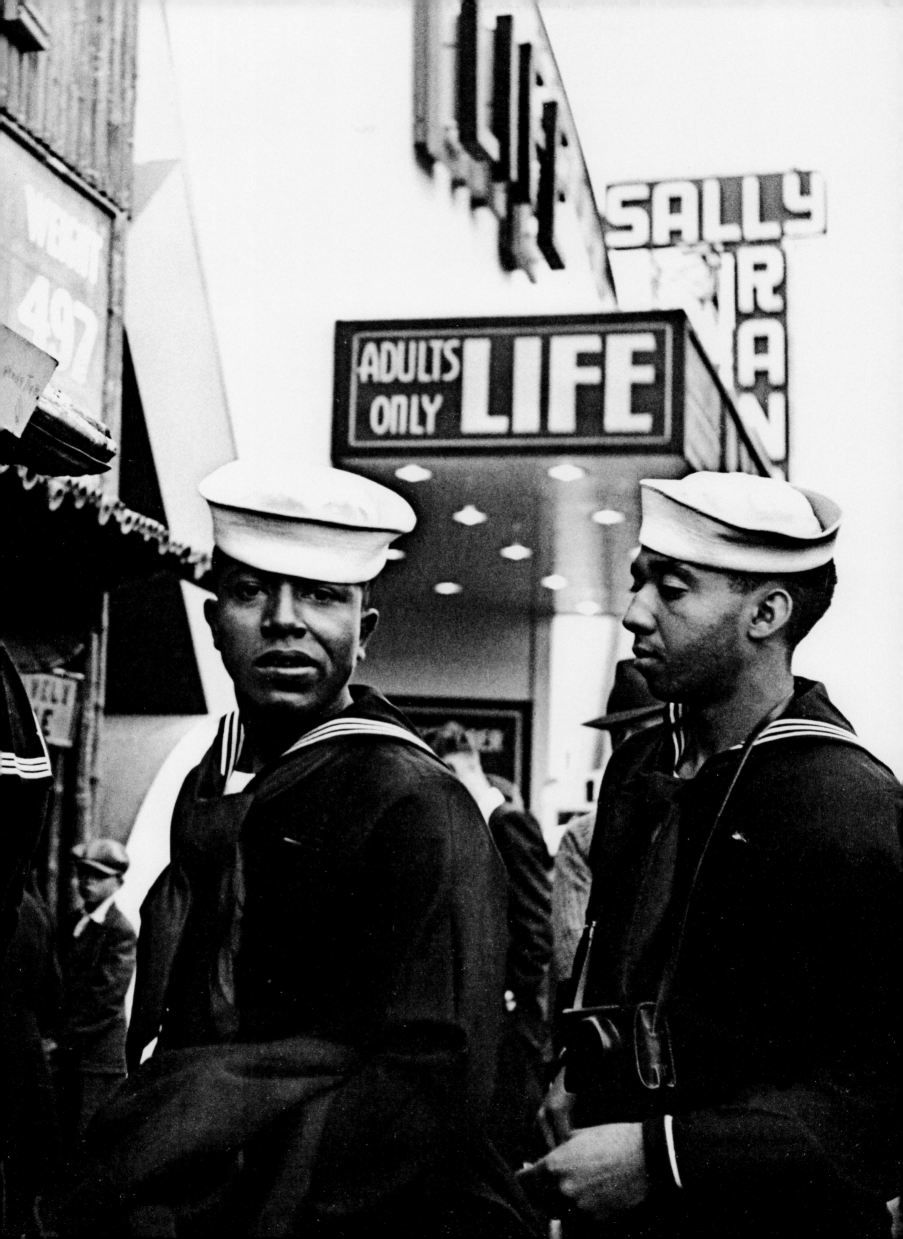

#3

Marching to a Different Beat 1946–1963

Civilians and returning military personnel were eager to resume peacetime life in San Francisco after World War II finally ended in September 1945. Life in the United States would never be the same, however, and the city was no exception. Its population jumped to 775,000 by 1950. Housing had a hard time keeping up with a new influx of ex-soldiers and defense workers who'd stay on instead of going back to Texas, Oklahoma, or other Southern states.

To help handle the overflow, developer Henry Doelger and his associates built large housing tracts in the outlying Sunset District and just south of San Francisco in Daly City. Their cookie-cutter functional design was mercilessly satirized as the ultimate in suburban conformity by local folk singer Malvina Reynolds in "Little Boxes," later a hit single for Pete Seeger. Nor were the little boxes available to everyone who needed them, as discriminatory practices denied ethnic minorities from owner-ship, though those barriers have long since been eliminated.

For all its relative tolerance of eccentrics and diversity, postwar San Francisco was in some respects a surprisingly conser-vative place. When General Douglas MacArthur – who had sug-gested using atomic bombs in the Korean War – was relieved of his command by President Harry Truman in 1951, the ex–military chief made San Francisco the first stop on his return, delivering a speech to a packed crowd in the Civic Center. The city hosted the Republican National Convention in 1956 and again in 1964. Such events would have been unthinkable in the 21st century, when Republican figureheads did their best to avoid even setting foot in heavily Democratic San Francisco unless it was to raise campaign funds.

Minorities remained heavily underrepresented in city government, even as San Francisco became increasingly multicul-tural. Carried away by opportunities for overdevelopment, some politicians pushed for rapid freeway expansion, including a route that would have roared through Golden Gate Park's Haight-Ashbury panhandle, and another that would have run from the Bay Bridge to the Golden Gate Bridge. Neighborhood activism was crucial to a "Freeway Revolt" that defeated these plans and others from the late 1950s onward. Even so, both the Golden Gate Park and bridge-to-bridge freeways were rejected by just a single vote in separate decisions by the board of supervisors in the mid-'60s. Construction of the Embarcadero Freeway couldn't be stopped. It opened in the late 1950s and obstructed views of the waterfront for the next 30 years.

Even at the height of the McCarthy era, rumblings of dis-sension were gathering force. In 1949, Berkeley's KPFA—the first affiliate in the Pacifica network, so-named as it had been founded by pacifist Lewis Hill—became the first listener-sponsored radio station in the United States, bringing alternative media to the airwaves in FM radio's infancy. Seven of San Francisco State University's faculty were fired in the early '50s for refusing to sign a loyalty oath, at a time when few dared to rebuke mounting anti-Communist hysteria.

In North Beach, the stirrings of a new counterculture took root. Cofounded in 1953 by poet Lawrence Ferlinghetti, City Lights Books was the epicenter for a new school of literature that wore anti-conformity proudly on its sleeve. Allen Ginsberg, Jack Kerouac, and others spearheaded the Beat movement, celebrating spontaneous freedom, rhythmic stream-of-consciousness prose, and a healthy distrust of authority. Much of Kerouac's best-selling novel *On the Road*, based on his hectic cross-country adventures with pal Neal Cassady, took place in San Francisco; Ginsberg's epic poem "Howl" was first performed by its author in the city's Six Gallery in 1955. More poets and novelists joined their Beat movement, including Gary Snyder, Michael McClure, David Meltzer, Diane di Prima, and numerous others.

The Beat movement gave rise to the Beat Generation, who didn't just read Beat literature but lived it. Attracted by the neighborhood's then-low rents and reasonably open atmosphere, beatniks—as they were named by San Francisco's most popular newspaper columnist, Herb Caen—dressed in casual dark sweat-ers, women often sporting pants instead of skirts. Much of their time was spent not building careers or helping their respective partners with raising families. Scenesters like Ginsberg who were open about their sexual preference bolstered the city's interna-tional reputation as a haven for gays, though the gay community would not become a major force in San Francisco life and politics until the 1970s. The burgeoning numbers of coffee shops in and around North Beach were the most popular beatnik hangouts.

If their rebellion seems mild today, it was controversial at the time. When City Lights, a publisher as well as a store, issued *Howl*, Ferlinghetti and store manager Shigeyoshi Murao were arrested on obscenity charges. *Howl* was ruled not to be obscene after a lengthy trial, and beatniks celebrated their lifestyle with an August 1958 parade in Union Square.

Partly as an outgrowth of the Beat community, and per-haps as an echo of the long-gone wild years of the nearby Barbary Coast, North Beach also offered some of the most brazen nightlife of the '50s. Major jazz and folk musicians frequently headlined coffee galleries and small clubs. The most famous of these, the deliberately lowercase hungry i, launched Northern California's first musical superstars, the Kingston Trio. The clean-cut, harmo-nizing folkies had a long residency at the club before topping the charts in 1958 with the murder ballad "Tom Dooley," the first of their many hits in the late '50s and early '60s.

The hungry i and other North Beach nightspots were also crucial to cultivating a new brand of satirical, sociopolitical-conscious comedy. If the newspaper headline–generated routines of Mort Sahl now seem tame, in the 1950s few other comedians were directly commenting upon contemporary issues. Sahl was certainly mild compared to a competitor on the circuit, Lenny Bruce, who salted his skits with profanity. That got him arrested at the Jazz Workshop in 1961, and though he was acquitted, more legal hassles would nearly paralyze his career until his death five years later.

Civic pride blossomed with the arrival of San Francisco's first Major League Baseball team, the Giants, who moved from New York in time for the 1958 season. A new and legendarily windy ballpark, Candlestick Park, was soon constructed at the city's southernmost border, crowds braving the chill to watch baseball's top all-around superstar, slugging center fielder Willie

←
The San Francisco Story, *Robert Parrish, Warner Bros. 1952.* Heritage Auctions, HA.com

→
"San Francisco via TWA" poster, David Klein, 1952. Heritage Auctions, HA.com

Mays—also an African American sporting icon. Basketball's Golden State Warriors relocated to the city from Philadelphia in 1962, bringing with them another elite African American athlete, center Wilt Chamberlain.

With football's 49ers already entrenched in Golden Gate Park's Kezar Stadium, sports fans had plenty of squads to root for, though none would win championships in the '60s. The emergence of frequent cross-country passenger plane flights made it possible not only to link these teams to their leagues, but also to bring in yet more droves of tourists. Catered to by some of the country's top luxury hotels, tourism was now one of San Francisco's biggest industries, a status it maintains to the present.

The Bay Area's prosperity did not breed complacent obedience. In May 1960, students and other allies rallied at city hall to protest the anti-Communist crusade of the House Un-American Activities Committee hearings. Police forced them down the rotunda's stairs with fire hoses, resulting in a dozen hospitalizations (most of them exhausted police) and 64 arrests.

As civil rights groups in the South were fighting segregation, San Francisco activists organized solidarity marches and began picketing local businesses that discriminated against African Americans. One of the first of these actions targeted Mel's Drive-In, a restaurant chain owned by San Francisco Supervisor Harold Dobbs, who was running for mayor. Dobbs lost to John F. Shelley, the first Democrat elected mayor of San Francisco in 50 years. He would prove to be the first in an unbroken line of Democratic mayors stretching into the 21st century. The political foment brewing in 1963 also proved to be a harbinger of unrest more profound and transformative.

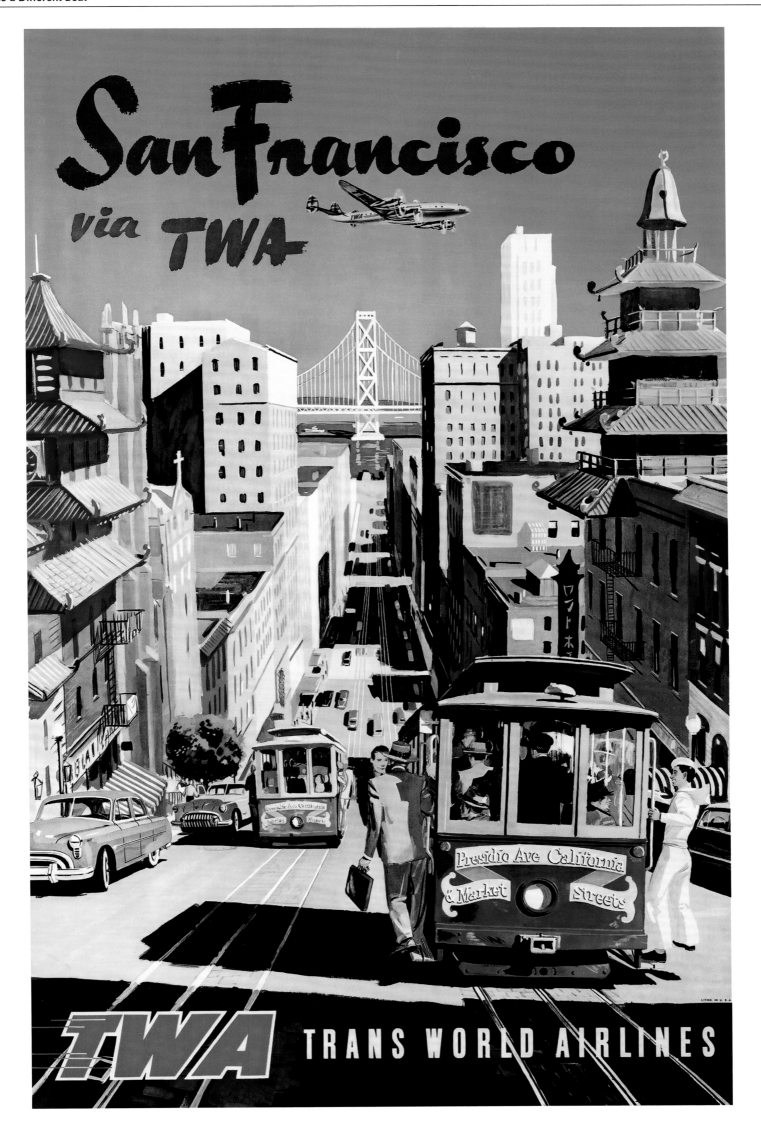

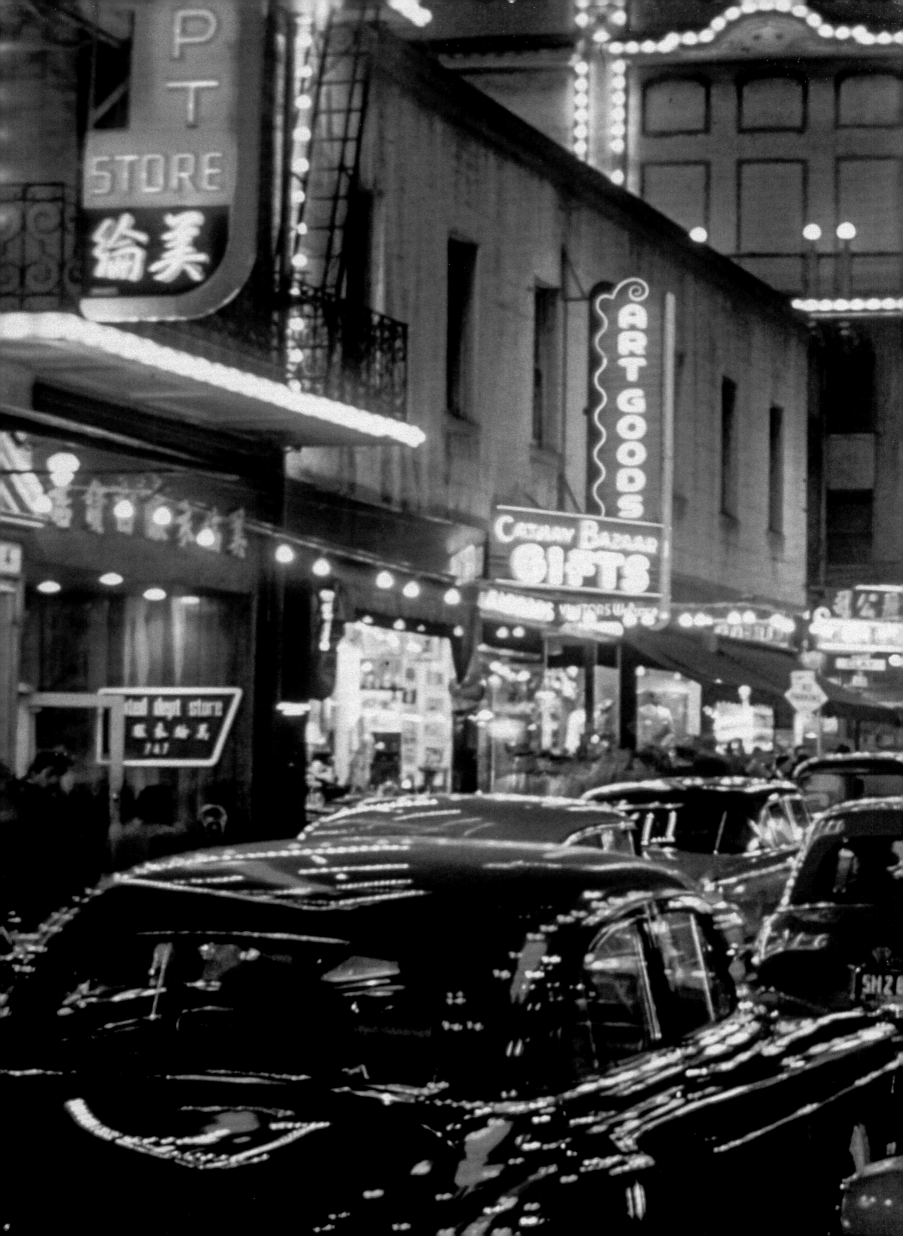

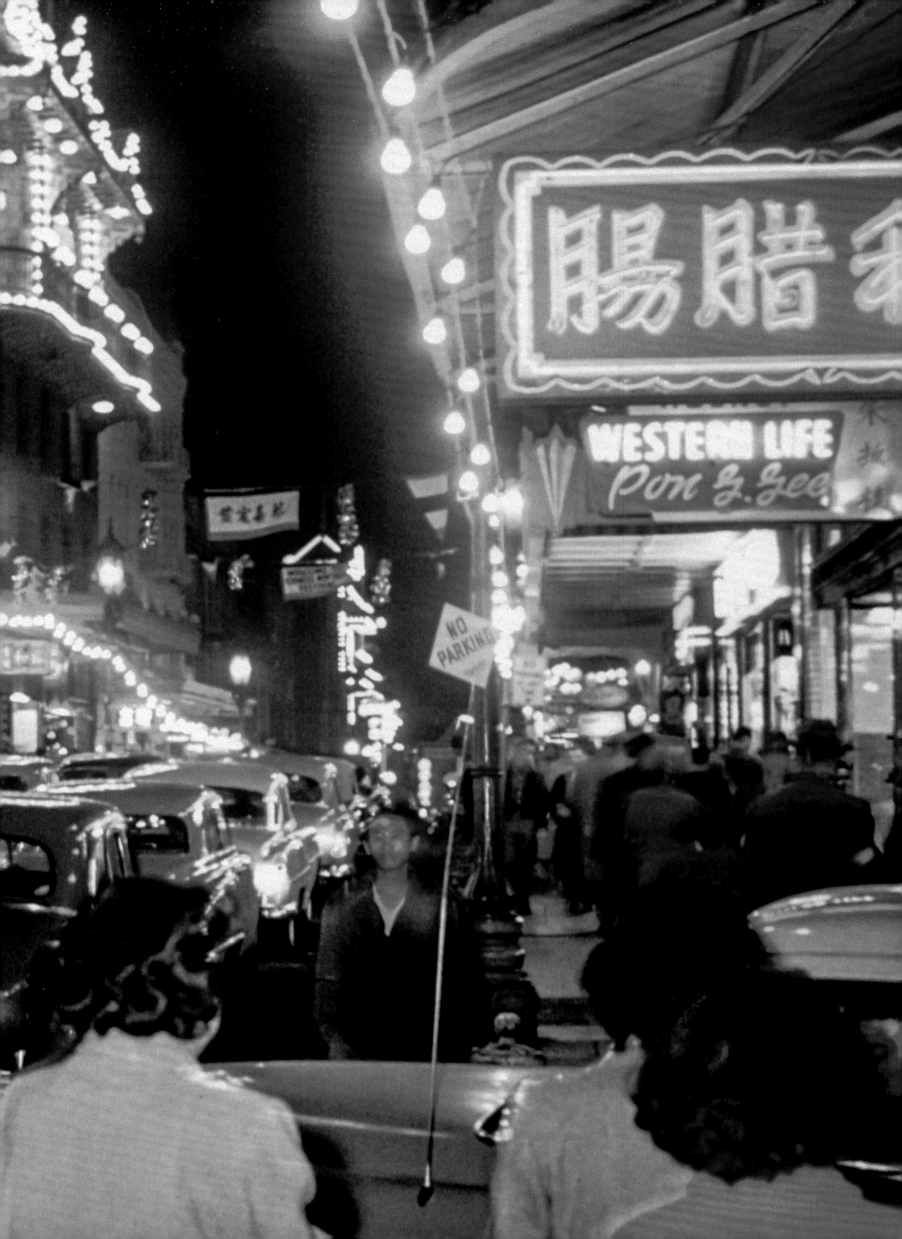

#3

Im Takt der Beatniks 1946–1963

p. 140/141
Anonymous

Chinatown's Grant Avenue at night. Densely packed with Chinese residents and businesses, the district also drew many tourists, eager for a glimpse of a culture that felt foreign and exotic without needing to step foot outside of the United States, c. early 1950s.

Die Grant Avenue in Chinatown bei Nacht. Mit seinen chinesischen Anwohnern und Geschäften war das Viertel auch ein Touristenmagnet für diejenigen, die einen Blick auf eine Kultur erhaschen wollten, die sich für sie fremd und exotisch anfühlte, ohne dafür die USA verlassen zu müssen, frühe 1950er-Jahre.

Chinatown la nuit, sur Grant Avenue. Fort d'une importante population chinoise et de nombreux commerces, le quartier attirait beaucoup de touristes curieux de découvrir, sans avoir besoin de quitter les États-Unis, une culture à la fois étrangère et exotique. Vers le début des années 1950.

Nach dem Ende des Zweiten Weltkrieges freuten sich Zivilisten und heimkehrende Soldaten darauf, ihren Alltag in Friedenszeiten wieder aufzunehmen. Das Leben in den USA sollte aber nie wieder dasselbe sein, und San Francisco machte dabei keine Ausnahme. Bis 1950 wuchs die Bevölkerung auf 775 000 Einwohner an. Es gab kaum genug Wohnungen für all die Ex-Soldaten und -Rüstungsarbeiter, die bleiben, anstatt nach Texas, Oklahoma oder andere Staaten im Süden der USA zurückzukehren.

Bauunternehmer Henry Doelger und seine Partner errichteten im abgelegenen Sunset District und im südlich von San Francisco gelegenen Daly City große Wohnsiedlungen, um bei der Bewältigung des Wohnungsproblems zu helfen. Die lokale Folksängerin Malvina Reynolds verspottete das immer gleiche Design der „Little Boxes", später eine Hitsingle von Pete Seeger, gnadenlos als ultimative Vorstadtkonformität. Auch wenn solche Barrieren heute beseitigt sind, waren damals die „kleinen Kisten" nicht für jeden erhältlich, der sie brauchte, denn ethnische Minderheiten wurden diskriminiert und durften keine dieser Häuser kaufen.

Obwohl relativ tolerant gegenüber Exzentrikern und vielfältigen Lebensweisen, war das San Francisco der Nachkriegszeit in mancher Hinsicht überraschend konservativ. Als General Douglas MacArthur – der den Einsatz von Atombomben im Koreakrieg vorgeschlagen hatte – 1951 von Präsident Harry Truman von seinem Amt entbunden wurde, machte der ehemalige Militärchef bei seiner Rückkehr als Erstes Halt in San Francisco und hielt eine Rede im gut gefüllten Civic Center. 1956 und 1964 war die Stadt die Gastgeberin des Nationalkongresses der Republikaner. Im 21. Jahrhundert wären solche Veranstaltungen undenkbar, da republikanische Führungspersönlichkeiten ihr Bestes tun, keinen Fuß in das stark demokratische San Francisco zu setzen, es sei denn, um Wahlspenden zu sammeln.

Auch wenn San Francisco zunehmend multikulturell wurde, blieben Minderheiten in der Stadtverwaltung stark unterrepräsentiert. Von den Möglichkeiten der Urbanisierung begeistert, strebten einige Politiker einen zügigen Ausbau der Highways an, einschließlich einer Strecke, die durch den Haight-Ashbury-Teil des Golden Gate Park führen sollte, und einer weiteren von der Bay Bridge zur Golden Gate Bridge. Das Engagement der betroffenen Bevölkerung war ausschlaggebend für die „Freeway Revolt", mit der diese und andere Pläne ab den späten 1950er-Jahren vereitelt wurden. Trotzdem wurden beide Freeways Mitte der 60er-Jahre nur mit einer denkbar knappen Mehrheit von der Stadtverwaltung abgelehnt, eine Stimme machte den Unterschied. Jedoch konnte der Bau des Embarcadero Freeway konnte nicht verhindert werden. Ende der 1950er-Jahre eröffnet, versperrte er in den folgenden 30 Jahren die Sicht auf das Ufer, an dem er entlangführte.

Selbst am Höhepunkt der McCarthy-Ära gab es Dissens unter der Konformität. 1949 wurde KPFA in Berkeley – die erste Partnerorganisation des von dem Gründer und Pazifisten Lewis Hill benannten Pacifica-Netzwerks – zum ersten von Hörern finanzierten Radiosender in den USA und brachte alternative Medien in den Äther, als das UKW-Radio noch jung war. An der San Francisco State University wurden Anfang der 50er-Jahre, in einer Zeit, als sich nur wenige trauten, die antikommunistische Hysterie zu kritisieren, sieben Dozenten gefeuert, weil sie sich weigerten, einen Loyalitätsschwur zu leisten.

In North Beach schlug eine neuen Counterculture Wurzeln. Vom Dichter Lawrence Ferlinghetti 1953 mitbegründet, wurde die Buchhandlung City Lights Books zum Epizentrum einer neuen literarischen Bewegung, die Antikonformität zu ihrem Markenzeichen machte. Allen Ginsberg, Jack Kerouac und weitere standen an der Spitze der Beat-Bewegung, die Spontaneität und Freiheit, rhythmische Bewusstseinsstrom-Prosa und ein gesundes Misstrauen gegenüber Autorität zelebrierte. Ein Großteil von Kerouacs Bestseller *On the Road* (dt. *Unterwegs*), der von Kerouacs hektischen Reisen und Abenteuern mit seinem Freund Neal Cassady handelt, spielt in San Francisco; Ginsberg trug sein episches Gedicht „Howl" 1955 in der Six Gallery der Stadt zum ersten Mal vor. Weitere Dichter und Autoren wurden Teil der Beat-Bewegung, etwa Gary Snyder, Michael McClure, David Meltzer, Diane di Prima und zahlreiche andere.

Die Beat-Bewegung brachte die Beat-Generation hervor, die die Beat-Literatur nicht nur las, sondern auch nach ihr lebte. Die Beatniks – so wurden sie vom populärsten Kolumnisten San Franciscos, Herb Caen, genannt – wurden von den damals niedrigen Mieten und der relativ offenen Atmosphäre in North Beach angezogen und trugen zwanglose dunkle Pullover, die Frauen oft Hosen statt Röcke. Einen Großteil ihrer Zeit verbrachten sie nicht mit Karriere oder Familiengründung, sondern mit Lesen, Schreiben, Zeichnen und für die damalige Zeit offenen sexuellen Beziehungen. Szenestars wie Ginsberg, die offen mit ihren sexuellen Vorlieben umgingen, trugen zum internationalen Ruf der Stadt als Zufluchtsort für Schwule bei, auch wenn die schwule Gemeinschaft erst in den 1970ern eine große Rolle in San Franciscos Alltag und Politik spielten. Überall in und um North Beach eröffneten Coffee Shops, die zu den beliebtesten Beatnik-Treffpunkten wurden.

Heute mag ihre Rebellion sanft erscheinen, damals sorgte sie für Kontroversen. Als City Lights, das auch als Verlag fungierte, *Howl* herausgab, wurden Ferlinghetti und der Geschäftsführer des Buchladens Shigeyoshi Murao unter dem Vorwurf der Obszönität festgenommen. Das Gedicht wurde vom Gericht nach einem langen Prozess für nicht obszön befunden, die Beatniks feierten ihren Lebensstil im August 1958 mit einer Parade über den Union Square.

Als Teil der Beats und vielleicht auch als Echo der längst vergangenen wilden Jahre der nahen Barbary Coast hatte North Beach auch eines der schamlosesten Nachtleben der 50er-Jahre zu bieten. Berühmte Jazz- und Folk-Musiker traten häufig in Cafe-Galerien und kleinen Clubs auf. Der berühmteste dieser Clubs, das hungry i, dessen Name bewusst gewählt war, brachte mit dem Kingston-Trio die ersten musikalischen Superstars Nordkaliforniens hervor. Die gut aussehenden Folkies waren lange Zeit fester Teil des Clubs, bevor sie 1958 mit der Ballade „Tom Dooley" die Spitze der Charts erreichten. Es war der erste ihrer vielen Hits in den späten 50ern und frühen 60ern.

Im hungry i und anderen Nachtclubs in North Beach entwickelte sich auch eine neue Art von satirischer und

gesellschaftspolitisch bewusster Comedy. Die Nummern von Mort Sahl mögen heutzutage harmlos scheinen, aber in den 50er-Jahren gab es nur wenige andere Komiker, die zeitgenössische Themen direkt aufgriffen. Sahl war aber milde im Vergleich zu seinem Konkurrenten Lenny Bruce, der in seinen Aufführungen rege Schimpfwörter benutzte, weswegen er 1961 im Jazz Workshop verhaftet wurde. Trotz Freispruchs legten weitere rechtliche Probleme seine Karriere bis zu seinem Tod fünf Jahre später fast auf Eis.

Die Giants, für die 1958er-Saison aus New York umgezogen und das erste Major-League-Team San Franciscos, wurden schnell zum Stolz der Einwohner. An der Südgrenze der Stadt wurde ein neues, heute für seinen Wind legendäres Baseball-Stadion namens Candlestick Park gebaut. Die Kälte konnte die Massen von Zuschauern nicht davon abhalten, einer der wichtigsten schwarzen Sportikonen, Allround-Superstar Willie Mays, zuzuschauen. 1962 zog die Baseballmannschaft Golden State Warriors von Philadelphia in die Stadt und mit ihnen ein weiterer afroamerikanischer Spitzensportler: Center Wilt Chamberlain.

Mit den im Kezar-Stadium des Golden Gate Park beheimateten 49ers hatten Sportfans eine Auswahl an Mannschaften zum Anfeuern, auch wenn keine in den 60er-Jahren einen Titel gewinnen konnte. Die steigende Anzahl von Inlandsflügen verband nicht nur die Teams mit ihren Ligen, sondern machte es

auch möglich, dass immer mehr Touristen nach San Francisco kamen. Der Tourismus war jetzt einer der wichtigsten Wirtschaftszweige San Franciscos und ist es bis heute.

Der Wohlstand in der Bay Area führte aber nicht zu selbstgefälligem Gehorsam. Im Mai 1960 demonstrierten Studenten und ihre Verbündete vor dem Rathaus gegen den antikommunistischen Kreuzzug des Ausschusses für unamerikanische Aktivitäten. Die Polizei zwang sie mit Feuerwehrschläuchen die Treppen der Rotunde hinab, was zu einem Dutzend Krankenhausaufenthalten (die meisten von ihnen erschöpfte Polizisten) und 64 Verhaftungen führte.

Als Bürgerrechtler in den Südstaaten gegen die Rassentrennung kämpften, organisierten Aktivisten in San Francisco Solidaritätsmärsche und Mahnwachen vor örtlichen Geschäften, die Afroamerikaner diskriminierten. Eine der ersten dieser Aktionen nahm Mel's Drive-in ins Visier, eine Restaurantkette im Besitz des Stadtrats und Bürgermeisterkandidaten Harold Dobbs. Dobbs verlor gegen John F. Shelley, den zum Bürgermeister gewählten Demokraten seit 50 Jahren. Er war der erste in einer bis heute ungebrochenen Abfolge von demokratischen Bürgermeistern. Die politischen Widerstände, die schon 1963 brodelten, erwiesen sich als Vorboten für viel größere Unruhen, die tiefgreifender und umwälzender waren.

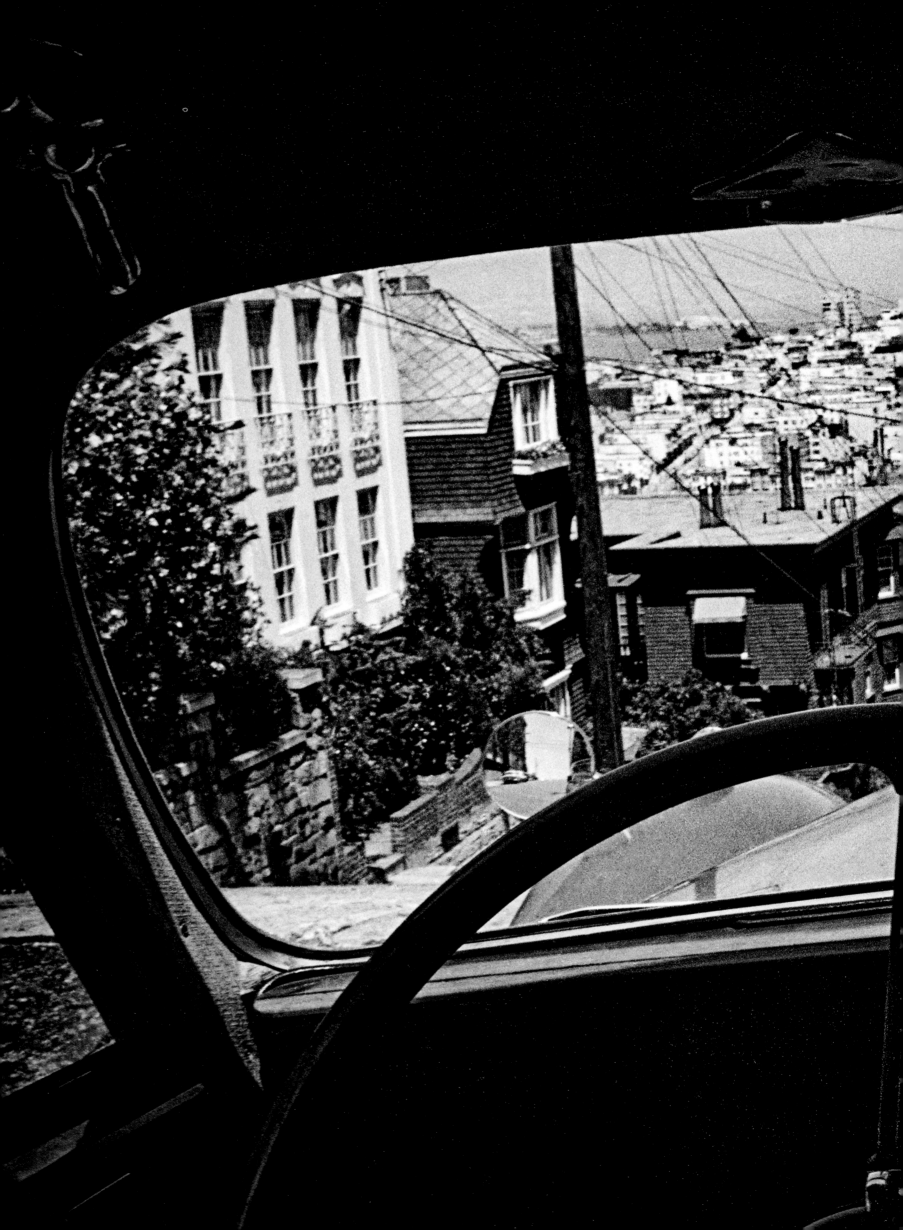

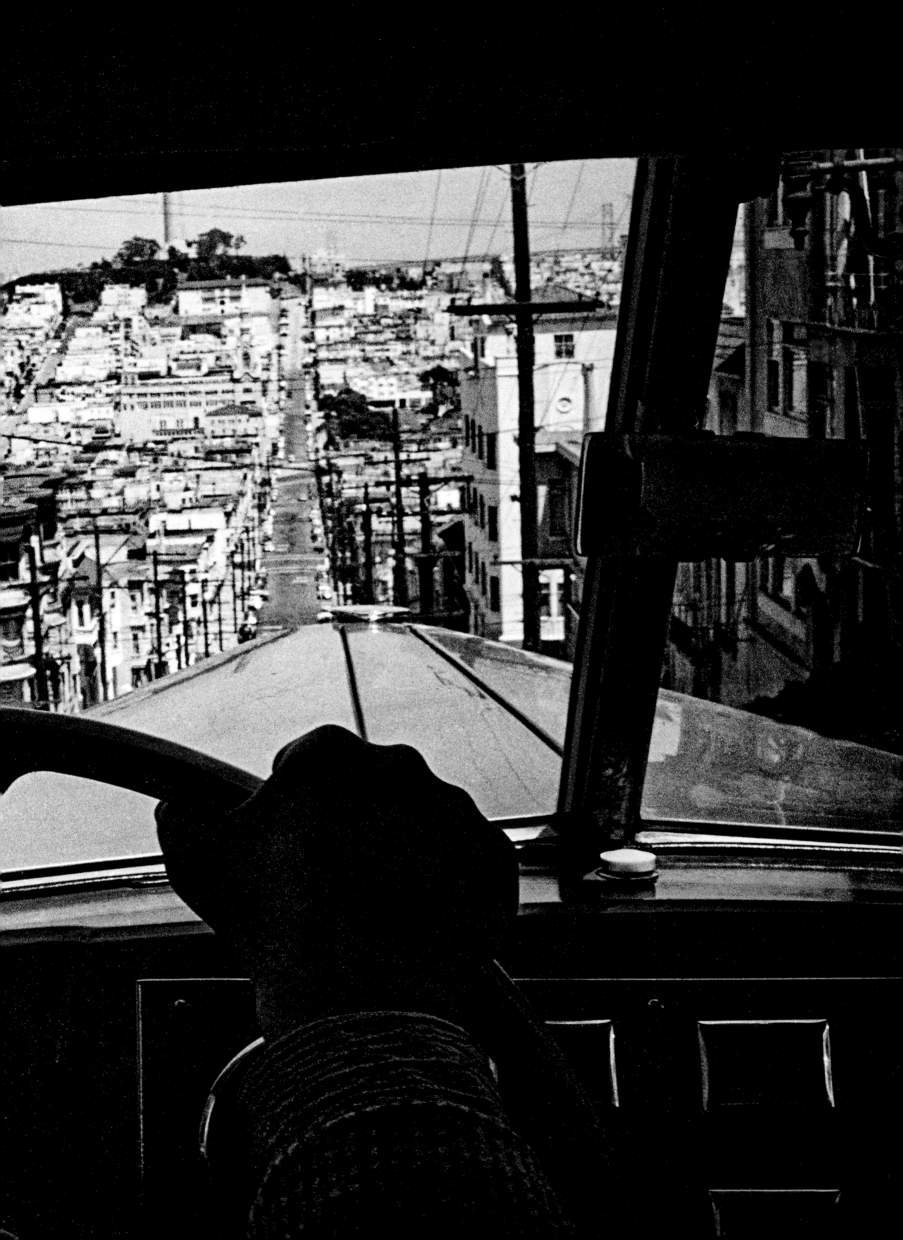

#3

À contre-courant 1946–1963

Fred Lyon

Driver's view of Russian Hill through the windshield as the car makes its way down Filbert Street, with Coit Tower atop Telegraph Hill in the distance, 1953.

Die Sicht eines Fahrers auf Russian Hill, der gerade die Filbert Street herunterfährt; der Coit Tower auf dem Telegraph Hill ist in der Ferne zu sehen, 1953.

Vue sur Russian Hill, alors que le conducteur s'apprête à descendre Filbert Street. Au loin, la Coit Tower qui surplombe Telegraph Hill. 1953.

Société civile, soldats démobilisés : tout le monde, à San Francisco, avait hâte de reprendre une vie normale et paisible une fois la Seconde Guerre mondiale définitivement terminée, en septembre 1945. Mais la vie, ici comme aux États-Unis, ne serait plus jamais la même. En 1950 la ville comptait déjà 750 000 habitants et il n'était pas facile d'absorber l'afflux d'anciens militaires et de travailleurs de la défense ayant choisi de rester au lieu de retourner au Texas, en Oklahoma ou dans d'autres États du Sud. Pour tenter de remédier à la situation, un promoteur immobilier du nom de Henry Doelger et ses associés entreprirent de bâtir de grands ensembles à prix modéré dans le quartier périphérique de Sunset District et à Daly City, au sud de San Francisco. Leur design fonctionnel et standardisé suscita d'impitoyables moqueries de la part d'une chanteuse folk locale, Malvina Reynolds, dont la composition « Little Boxes », reprise par Pete Seeger, deviendra même un tube. Il est vrai que les « petites boîtes » en question n'étaient pas accessibles à tous ceux qui en auraient eu besoin : la persistance de pratiques discriminatoires empêchait les postulants issus des minorités ethniques de s'en porter acquéreurs – obstacle levé depuis lors.

Malgré sa relative tolérance à l'égard de la diversité et des excentricités de toute espèce, la San Francisco d'après-guerre était, à certains égards, étonnamment conservatrice. Lorsqu'en avril 1951 le général Douglas MacArthur, qui n'avait pas hésité à envisager d'utiliser l'arme atomique pendant la guerre de Corée, fut relevé de son commandement par le président Truman, le vieux soldat fit de San Francisco la première étape de son retour ; une foule compacte assista au discours qu'il prononça à cette occasion au Civic Center. La ville accueillera également la convention nationale du Parti républicain en 1956, puis en 1964. De tels événements seraient inconcevables au XXIe siècle, quand les figures de proue du « Grand Old Party » évitent de poser le pied dans une agglomération acquise aux démocrates, sauf quand il leur faut absolument lever des fonds en prévision de leur campagne.

Les minorités demeuraient alors sous-représentées dans l'administration de la ville, quand bien même San Francisco prenait chaque jour une tonalité plus multiculturelle. Certains édiles, grisés par les perspectives d'un développement illimité, militaient en faveur d'une accélération de la construction d'autoroutes. Il était notamment question d'une voie rapide qui aurait tronçonné le quartier de Haight-Ashbury et le Panhandle, l'extension « en queue de poêle » du Golden Gate Park, et d'une autre qui aurait relié le Bay Bridge au Golden Gate Bridge. Les riverains devront en passer par une « Freeway Revolt », une révolte de l'autoroute, pour faire échouer ces plans et ceux qui se succéderont à partir de la fin des années 1950. Ces deux projets particuliers ne seront d'ailleurs rejetés à chaque fois qu'à une seule petite voix de majorité municipale, en 1964 et 1966. La construction de l'Embarcadero Freeway, elle, ne pourra être arrêtée. Le nouveau ruban de bitume sera inauguré en 1959 et obstruera trente ans durant le panorama du front de mer.

D'une façon générale, pourtant, et même au plus fort de la vague maccarthyste, les voix de la dissension gagnaient en assurance. Ainsi, au début des années 1950, en un temps où l'on osait rarement s'opposer à l'hystérie anticommuniste alors

prédominante, sept membres du corps enseignant de l'Université d'État de San Francisco furent ni plus ni moins licenciés pour avoir refusé de souscrire au « serment de loyauté » exigé des fonctionnaires de l'État de Californie. De même en 1949, une station de radio de Berkeley, KPFA, filiale du réseau Pacifica – ainsi nommé parce qu'il avait été fondé par le pacifiste Lewis Hill – avait-elle été la première directement financée par ses auditeurs : les médias alternatifs prenaient pied sur une bande FM encore balbutiante, tandis qu'à North Beach s'enracinaient les prémices d'une nouvelle contre-culture. Fondée en 1953 par le poète Lawrence Ferlinghetti et l'universitaire Peter Martin, la librairie et maison d'édition indépendante City Lights Books se fera l'épicentre d'une nouvelle école littéraire revendiquant fièrement son anticonformisme. Allen Ginsberg, Jack Kerouac, parmi d'autres, seront les figures de proue du mouvement beat, qui célébrait la liberté spontanée, une écriture accordée à la cadence du courant de conscience et une saine méfiance à l'égard de toute autorité. Pour une large part, *Sur la route*, le best-seller de Kerouac inspiré de ses tribulations à travers le pays avec son ami Neal Cassady, se déroule à San Francisco ; « Howl » (« Hurlement »), l'autre manifeste de la Beat Generation et poème épique signé Ginsberg, sera pour la première fois déclamé par son auteur à la Six Gallery en 1955. D'autres poètes et romanciers rejoindront le mouvement, dont Gary Snyder, Michael McClure et David Meltzer, Diane di Prima, pour ne citer qu'eux.

La Beat Generation ne s'est pas contentée de consommer avec gourmandise la littérature beat : elle l'a vécue au quotidien. Attirés par les loyers bon marché et l'atmosphère raisonnablement libérale du quartier, les beatniks – ainsi que les baptisa Herb Caen, le journaliste le plus lu de San Francisco – s'habillaient de pulls sombres et décontractés, les femmes préférant souvent le pantalon à la jupe. Ils consacraient le plus clair de leur temps non à quelque carrière ou à la vie de famille mais à la lecture, à l'écriture, au dessin et à une liberté sexuelle encore peu commune à l'époque. Des personnalités influentes telles que Ginsberg, en affichant ouvertement leurs préférences amoureuses, renforcèrent l'image internationale de la ville, chaque jour un peu plus assimilée à un havre de tolérance pour les homosexuels. La communauté gay attendra néanmoins les années 1970 pour peser sérieusement sur la vie et la politique de San Francisco. Les cafés toujours plus nombreux à s'ouvrir du côté de North Beach et de ses environs deviendront aussitôt les repaires favoris des beatniks.

Si leur effervescence peut sembler bien timide de nos jours, elle faisait alors l'objet de vives controverses. Après la publication de *Howl and Other Poems* par City Lights, Ferlinghetti et le responsable de la librairie, Shigeyoshi Murao, seront arrêtés pour délit d'obscénité. Il faudra un long procès, en 1957, pour que le poème et ses diffuseurs soient finalement lavés de l'infamante accusation. Quelques mois plus tard, le 13 août 1958, les beatniks pourront célébrer leur art de vivre à l'occasion d'une grande parade joyeuse sur Union Square. Sans doute est-ce un effet collatéral du mouvement beat, et peut-être un écho aux années folles et révolues du tout proche Barbary Coast : la vie nocturne, dans le quartier de North Beach, comptait parmi les plus animées des années 1950. De grands musiciens de jazz et de folk se succédaient régulièrement à l'affiche de ses cafés et petits clubs. Le

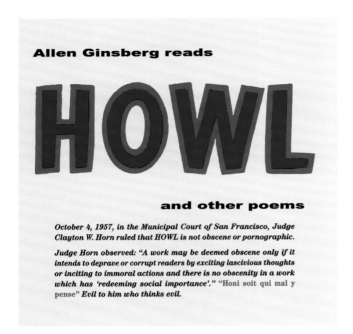

←
Howl and Other Poems, *Allen Ginsberg,*
Fantasy, 1959. Book published in 1956.

→
I Left My Heart in San Francisco, *Tony*
Bennett, Columbia Records, 1962.

plus renommé d'entre eux, baptisé en lettres minuscules hungry i (littéralement « moi l'affamé », mais le « i » se prononce également « eye », c'est-à-dire « l'œil »), peut ainsi se targuer d'avoir lancé le Kingston Trio, premier groupe californien à rejoindre le gotha des superstars musicales. Avant de trôner au sommet des hit-parades en 1958 avec leur ballade « Tom Dooley », ces trois étudiants bon chic, bon genre avaient inlassablement répété leurs mélodies traditionnelles devant le public du night-club. Ils enchaîneront les tubes entre la fin de ces années 1950 et le début des sixties.

Le hungry i, à l'exemple d'autres hauts lieux du North Beach nocturne, joua également un rôle majeur dans le développement d'une nouvelle forme de comédie satirique et sociopolitique, le monologue sur scène, ou « stand-up ». Si les numéros de Mort Sahl, basés sur une revue de presse caustique, paraissent aujourd'hui un peu fades, il faut garder à l'esprit que les humoristes, à l'époque, n'étaient pas si nombreux à oser évoquer directement les sujets d'actualité. À l'évidence, Sahl était inoffensif quand on le compare à l'un de ses concurrents d'alors, Lenny Bruce, qui émaillait ses sketches d'« obscénités » variées. Elles conduisirent à son arrestation en 1961, au Jazz Workshop, et malgré son acquittement, de nouveaux démêlés judiciaires finiront par enrayer presque définitivement sa carrière jusqu'à sa mort cinq ans plus tard.

En 1958, la fierté locale trouva un autre terrain d'épanouissement. À la suite du déménagement des Giants de New York vers San Francisco, les passionnés de base-ball ont pu enfin soutenir une formation capable de jouer les premiers rôles en Major League. Promptement édifié à la lisière méridionale de la ville, le stade de Candlestick Park deviendra aussi légendaire que le vent qui le balaie – pas de quoi décourager les foules qui braveront le froid pour y applaudir l'*outfielder* (joueur de champ extérieur) Willie Mays, vedette adulée et icône afro-américaine de sa discipline. Quatre ans plus tard, ce sera au tour des Warriors, une équipe de basket de Philadelphie, de venir s'installer à San Francisco, accompagnée d'une autre superstar noire, le pivot Wilt Chamberlain. Le football américain et les 49ers (*Forty-niners*, un

clin d'œil aux chercheurs d'or de 1849) occupaient déjà le Kezar Stadium, dans le Golden Gate Park, aussi les équipes à encourager ne manquaient-elles pas, même si aucune d'entre elles ne parvint à remporter son championnat au cours de la décennie 1960–70. Au moins, pour leurs déplacements nationaux, profitaient-elles de la multiplication des liaisons aériennes, lesquelles permirent à la région d'accueillir encore plus de visiteurs. Adossée à certains des meilleurs hôtels de luxe du pays, l'industrie du tourisme prit une importance considérable à San Francisco, un statut qu'elle a conservé de nos jours.

La prospérité de la « Bay Area » n'entraîna pas pour autant l'extinction des dissidences. En mai 1960, alors que le comité d'enquête de la Chambre des représentants sur les activités anti-américaines (HCUA) siégeait à l'hôtel de ville de San Francisco, la tonalité violemment anticommuniste des audiences suscita pendant trois jours la mobilisation de centaines de protestataires, dont une majorité d'étudiants. Ceux d'entre eux qui tentèrent de forcer l'accès aux séances furent rejetés au bas des escaliers de l'édifice à l'aide, notamment, de lances à incendie. Les incidents donneront lieu à 64 arrestations et à 12 hospitalisations (huit côté policier). De fait, pendant que les organisations de défense des droits civiques, dans le sud des États-Unis, combattaient la ségrégation, San Francisco recensait de plus en plus de marches de solidarité et de manifestations dénonçant les entreprises qui pratiquaient la discrimination à l'égard des Afro-Américains. En octobre 1963, l'une des premières actions de ce type visa Mel's Drive-in, une chaîne de restaurants appartenant à Harold Dobbs, membre du conseil municipal et candidat à la mairie – la victoire lui échappera au profit de John Shelley, premier maire non républicain élu à San Francisco en cinquante ans et fondateur d'une lignée de maires démocrates qui demeurera ininterrompue jusqu'au XXIe siècle.

La fièvre politique du début des années 1960 annonçait une agitation d'une tout autre ampleur, profondément transformatrice.

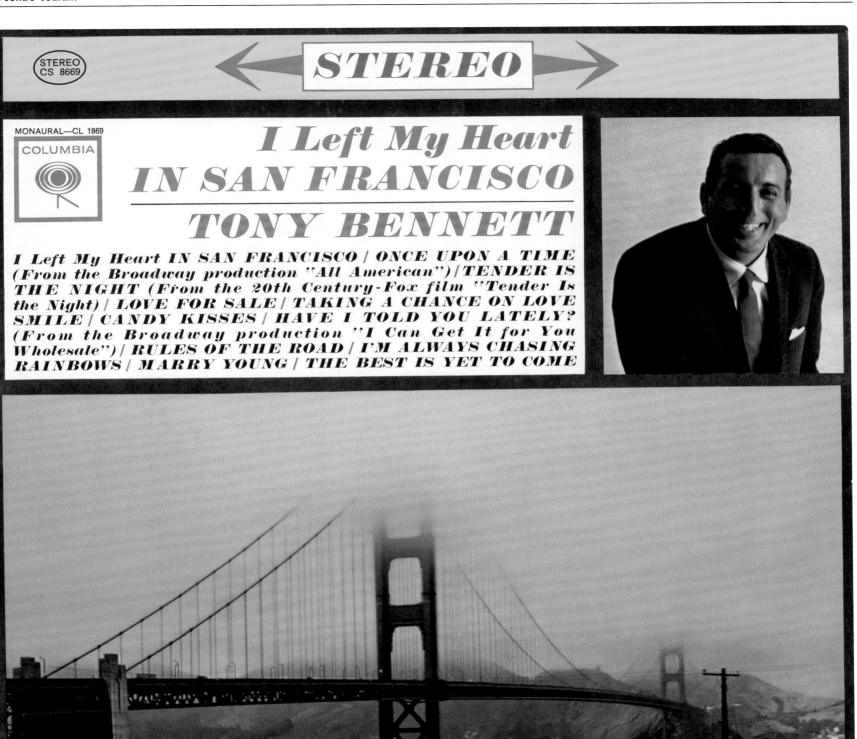

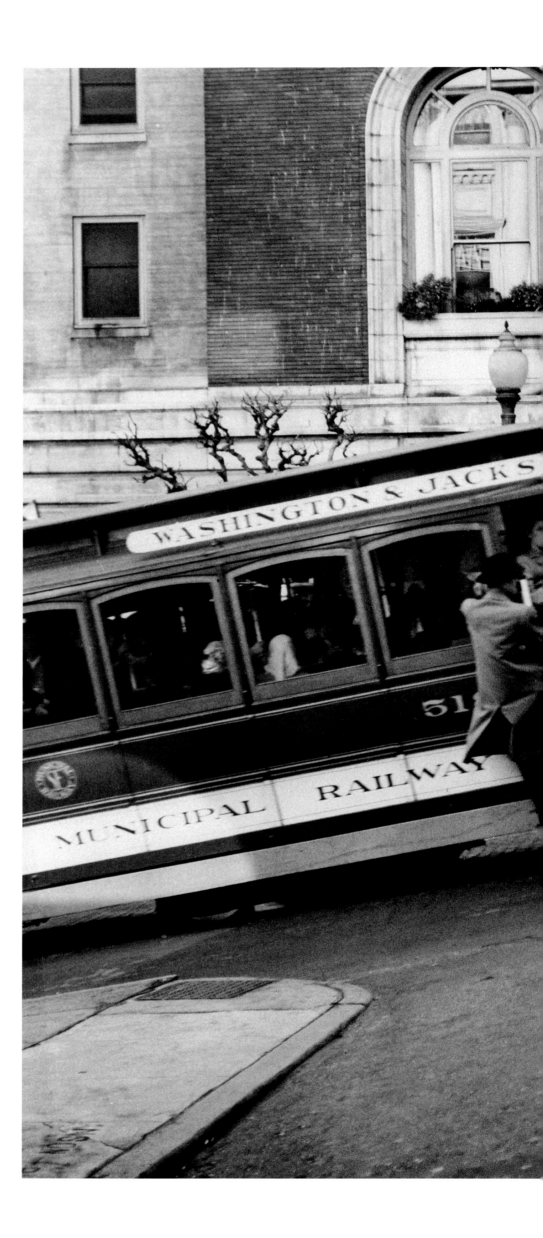

Max Yavno

Passengers crowding one of the cable cars that ran to Washington and Jackson streets in Pacific Heights. The cars were taken much more often by commuters than tourists in the mid-20th century, 1947.

Ein überfüllter Cable-Car-Wagen auf dem Weg zu Washington und Jackson Street in Pacific Heights. Mitte des 20. Jahrhunderts waren die meisten Fahrgäste noch Pendler und nicht Touristen, 1947.

Les passagers s'entassent dans l'un des cable cars qui desservent alors Washington Street et Jackson Street dans le quartier de Pacific Heights. Au milieu du xxe siècle, ce mode de transport servait beaucoup moins aux touristes qu'aux allers-retours entre le domicile et le travail. 1947.

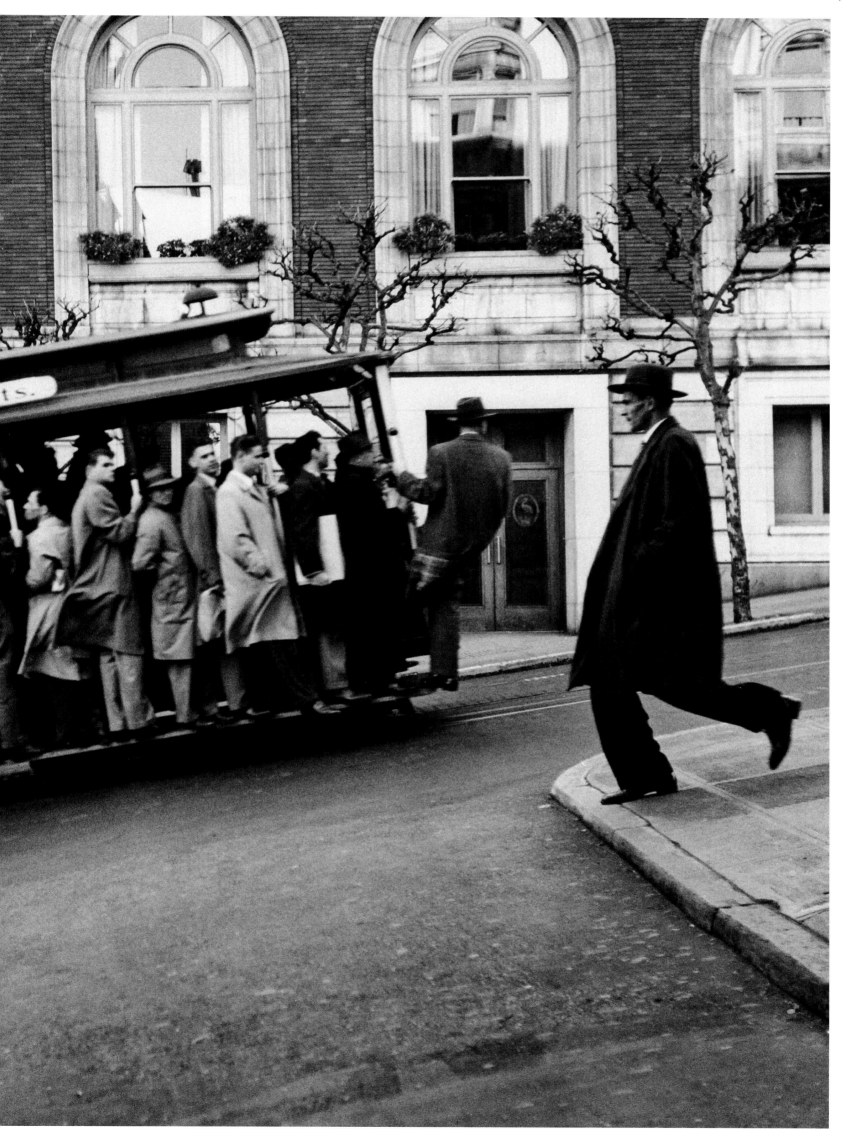

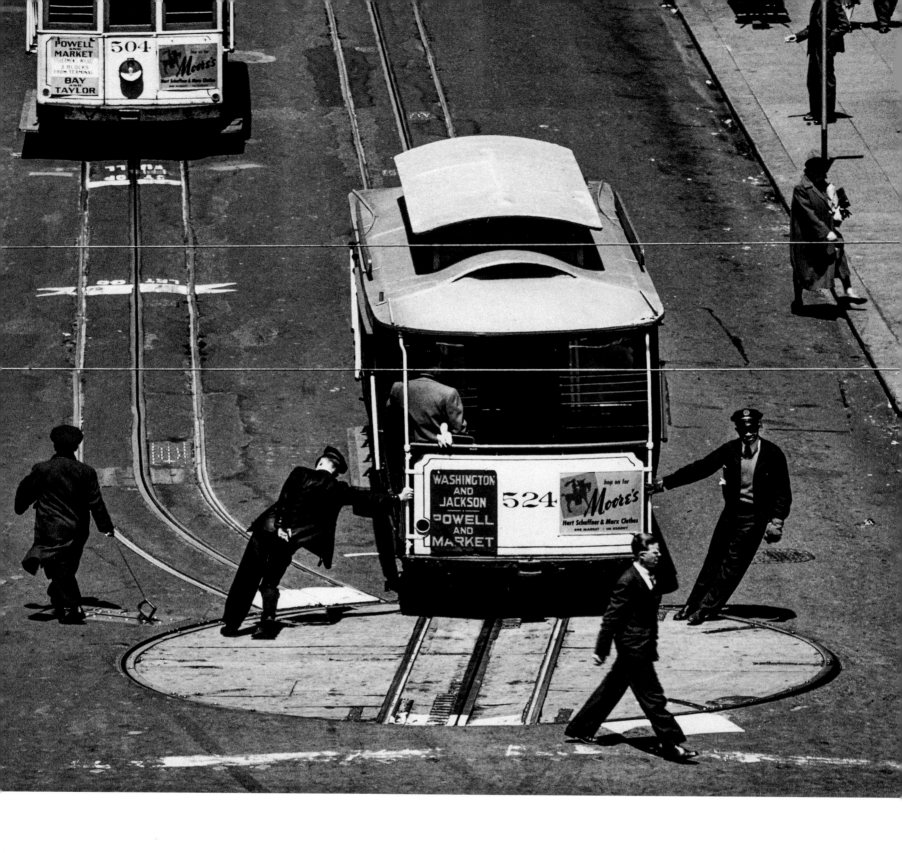

↑

Max Yavno

Downtown turnaround at Powell and Market streets, the busiest hub of the city's cable car lines. Conductors dismount and turn the vehicles in a circle so they're facing north instead of south, 1947.

Downtown-Wendestation an Powell und Market Street, der Knotenpunkt des Cable-Car-Netzes mit dem meisten Betrieb. Die Schaffner steigen aus und drehen die Wagen nach Norden, 1947.

À l'angle de Powell Street et de Market Street, la plate-forme tournante la plus fréquentée des lignes de cable cars de la ville. Descendus de leur machine, les conducteurs la font pivoter afin de l'orienter au nord et non plus vers le sud. 1947.

→

Minor White

At work on San Francisco railway tracks. Several streetcars fan out from downtown to many of the city's neighborhoods on the system known as MUNI, featuring some of the most scenic views—and, at times, slowest rides—on US urban transit, 1949.

Arbeiten an Schienen in San Francisco. Mehrere Bahnen des Systems MUNI fahren von Downtown in die verschiedenen Viertel. Hier gab es die besten Ausblicke und manch- *mal die langsamsten Fahrten im amerikanischen öffentlichen Nahverkehr, 1949.*

L'entretien d'une voie ferrée urbaine. Plusieurs tramways se déploient du centre-ville en direction de nombreux quartiers grâce au système connu sous le nom de Muni (San Francisco Municipal Railway), qui offre certaines des vues les plus impressionnantes et parfois les trajets les plus lents jamais recensés dans les transports en commun américains. 1949.

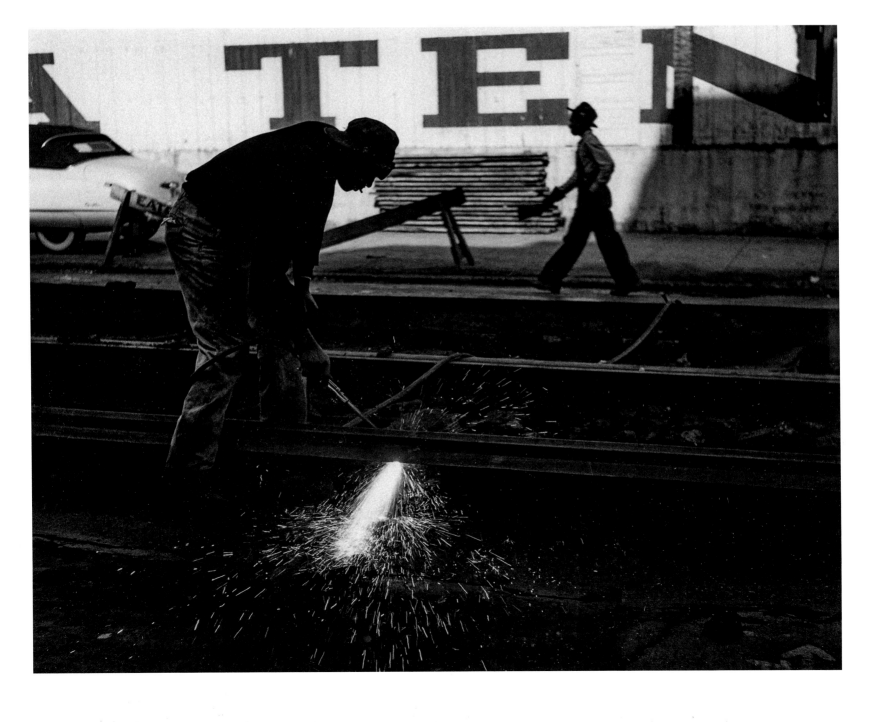

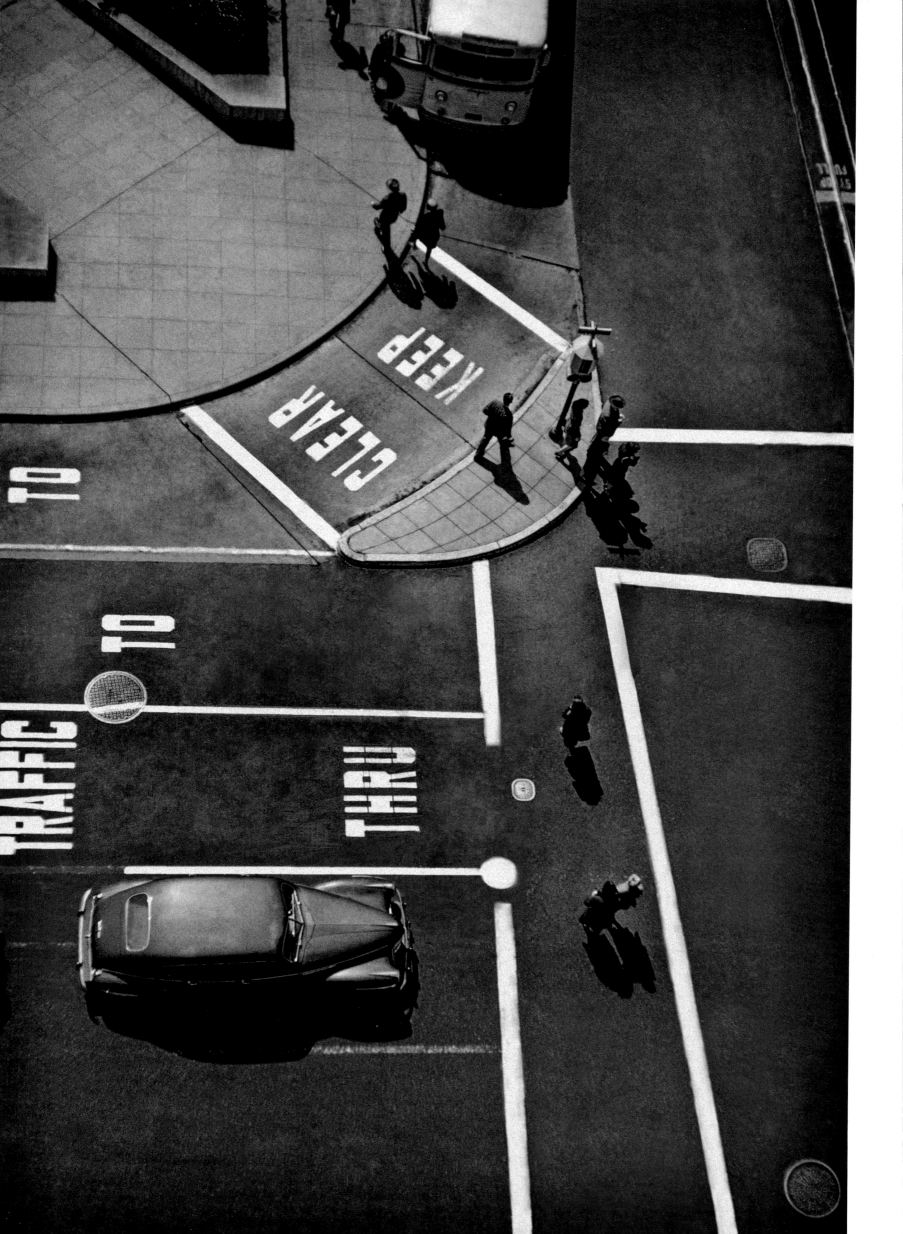

"But oh, San Francisco! It is and has everything…The wonderful sunlight there, the hills, the great bridges, the Pacific at your shoes. Beautiful Chinatown. Every race in the world. The sardine fleets sailing out. The little cable-cars whizzing down the city hills."

„Aber dann, San Francisco! San Francisco ist alles, hat alles … Das wunderbare Licht dort, die Hügel, die fantastischen Brücken, der Ozean vor Deinen Füßen. Chinatown, eine Augenweide. Alle Völker der Welt. Die Sardinenflotten auf dem Weg aus dem Hafen. Die kleinen Cable Cars, die die Stadthügel runterflitzen."

« Mais oh, San Francisco ! Elle est tout, elle… La merveilleuse lumière du soleil, les collines, les grands ponts, le Pacifique à vos pieds. Le magnifique Chinatown. Tous les peuples du monde. Les flottes de sardiniers en route pour le large. Les petits cable cars qui dévalent les collines de la ville. »

DYLAN THOMAS, 1950

←
Fred Lyon

The corner of Post and Powell streets at Union Square, the park at the center of the city's upscale shopping district. Fancy hotels and top theaters are also nearby, 1947.

Der Union Square an der Ecke Post und Powell Street; der Park liegt im Zentrum des Viertels mit teuren Geschäften, eleganten Hotels und Theatern, 1947.

L'angle de Post Street et de Powell Street à la hauteur d'Union Square, dont le parc occupe le cœur du quartier commerçant haut de gamme de la ville. Hôtels de luxe et grands théâtres se concentrent également à proximité. 1947.

↓
Minor White

For just 75 cents, you could take a ride to Alcatraz and see its fabled prison while it was still a federal penitentiary. It closed in 1963, but boats still go there from Fisherman's Wharf, offering historical tours of the former jail, 1948.

Für nur 75 Cent konnte man eine Tour nach Alcatraz machen, als die Insel noch als Strafanstalt genutzt wurde. 1963 schloss das Gefängnis, aber man kann es noch immer bei einer historischen Tour von Fisherman's Wharf aus besuchen, 1948.

Pour 75 cents, il était possible d'aller faire un tour à Alcatraz et voir sa légendaire prison quand elle servait encore de pénitencier fédéral. Elle a été fermée en 1963 mais on trouve toujours du côté de Fisherman's Wharf des bateaux proposant la visite historique de l'ancienne prison. 1948.

→
Fred Lyon

Tending the jib of a precariously heeling sailboat in the San Francisco Bay near Alcatraz Island, 1952.

An der Fock eines gefährlich sich neigenden Segelboots in der Bay von San Francisco nahe Alcatraz, 1952.

Réglage du foc d'un voilier qui donne sérieusement de la gîte dans la baie de San Francisco, près de l'île d'Alcatraz. 1952

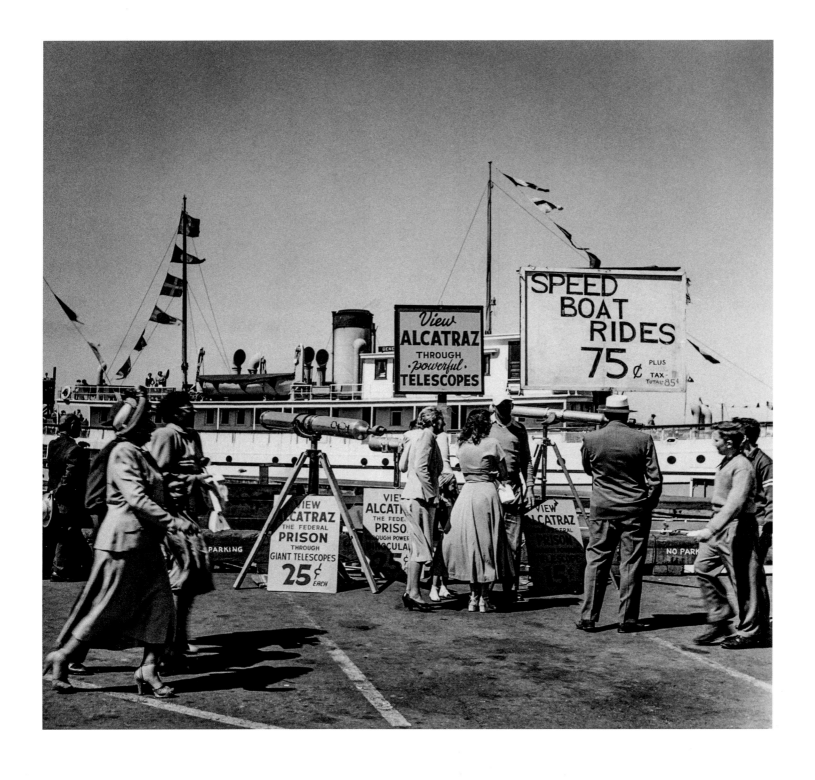

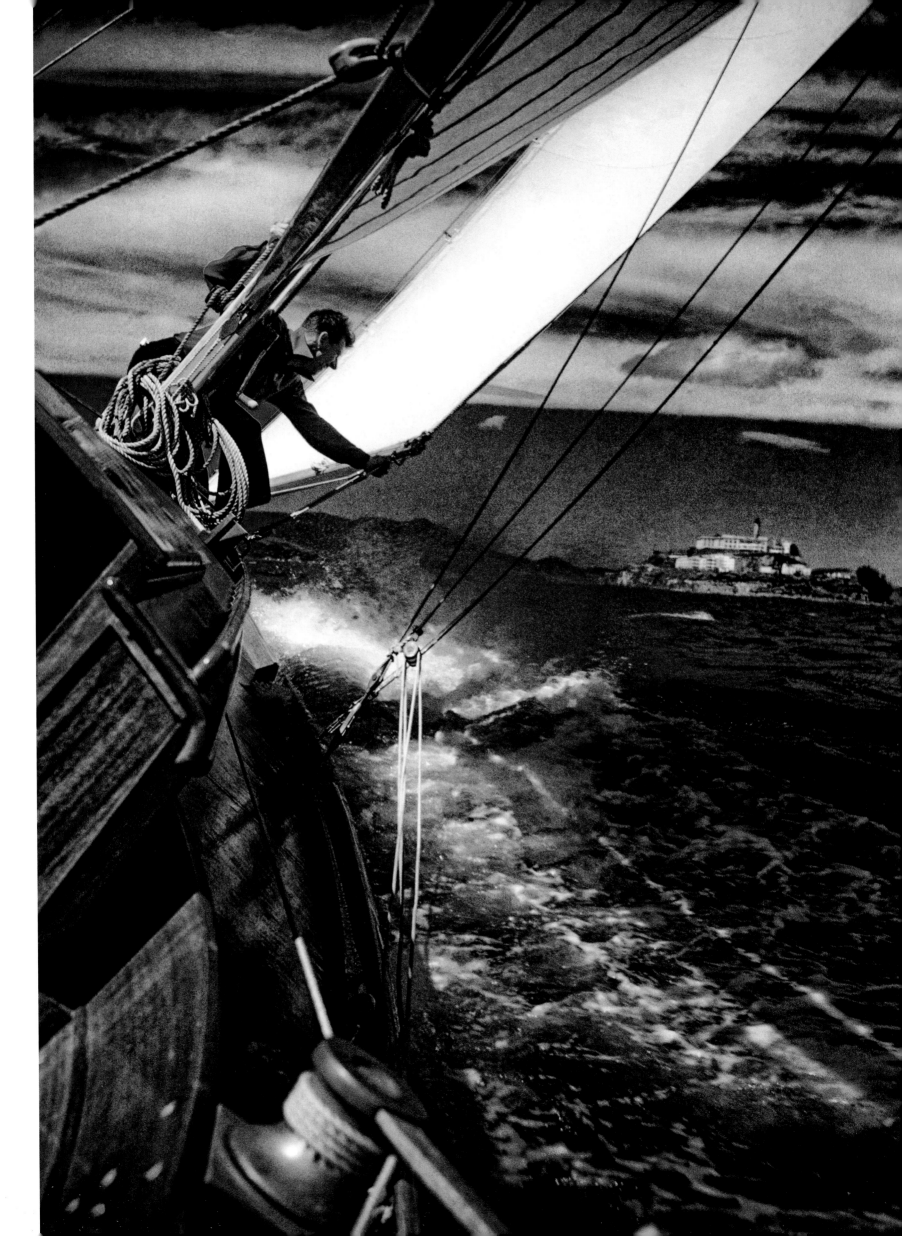

Fred Lyon

Anne Lyon, wife of photographer Fred Lyon, getting into her Riley automobile on a windy day in Nob Hill, just below the Mark Hopkins Hotel, 1953.

Anne Lyon, die Ehefrau des Fotografen Fred Lyon, steigt an einem windigen Tag in Nob Hill vor dem Mark Hopkins Hotel in ihren Riley, 1953.

Anne Lyon, épouse du photographe Fred Lyon, monte dans sa Riley un jour de grand vent à Nob Hill, en contrebas de l'hôtel Mark Hopkins. 1953.

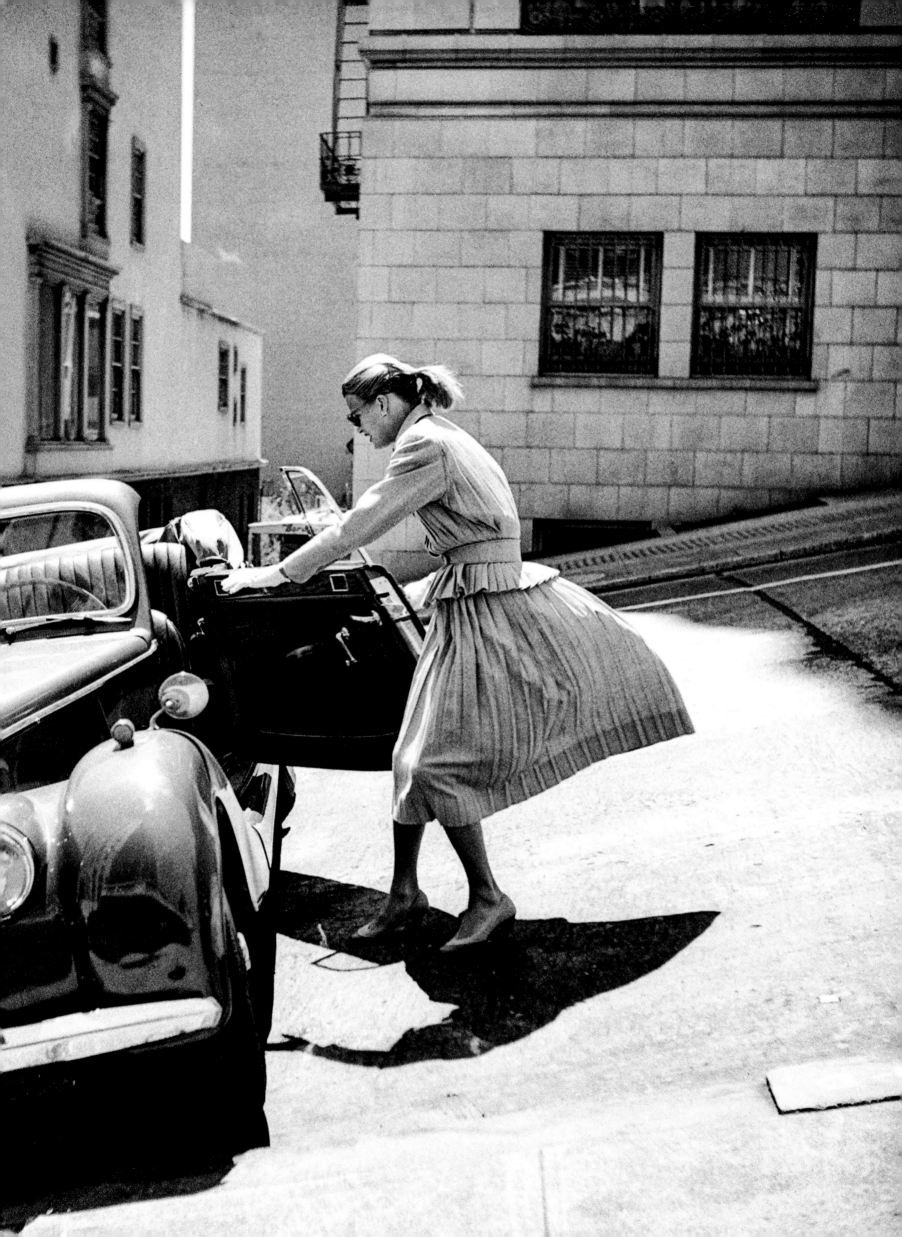

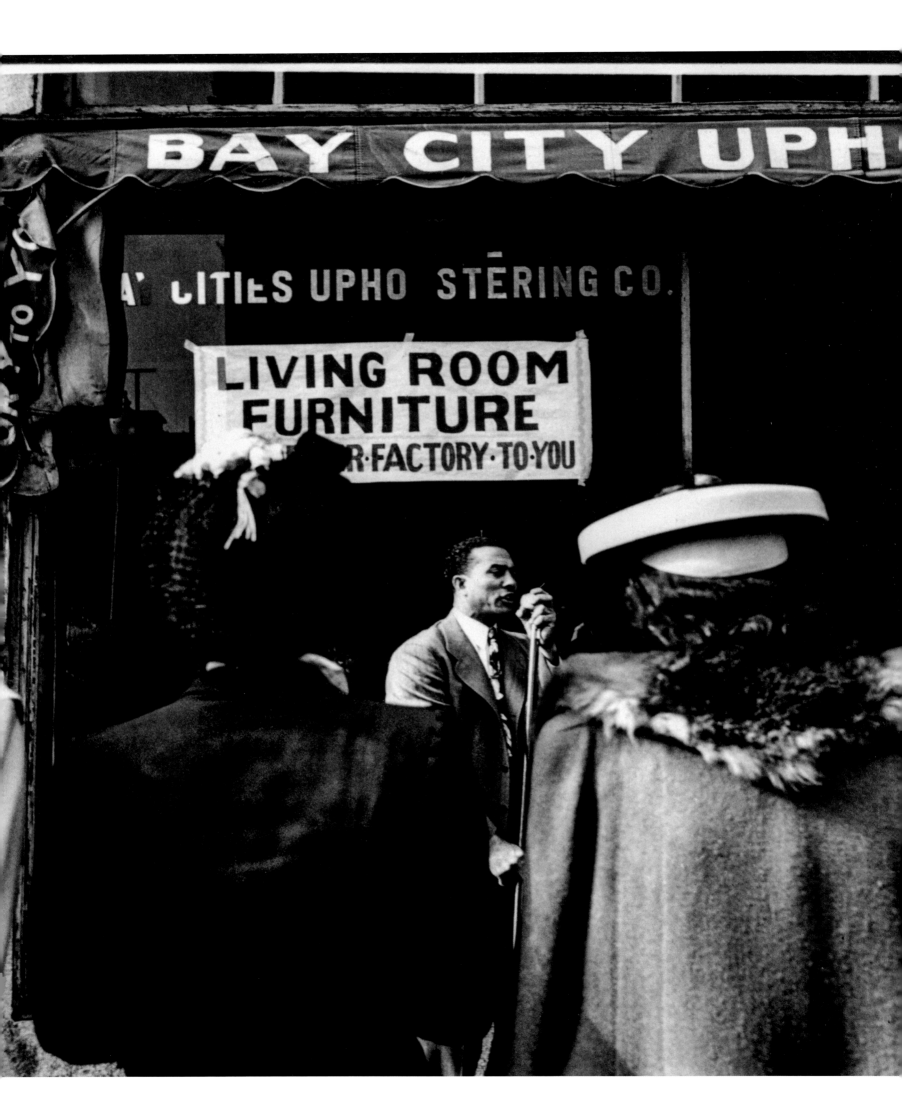

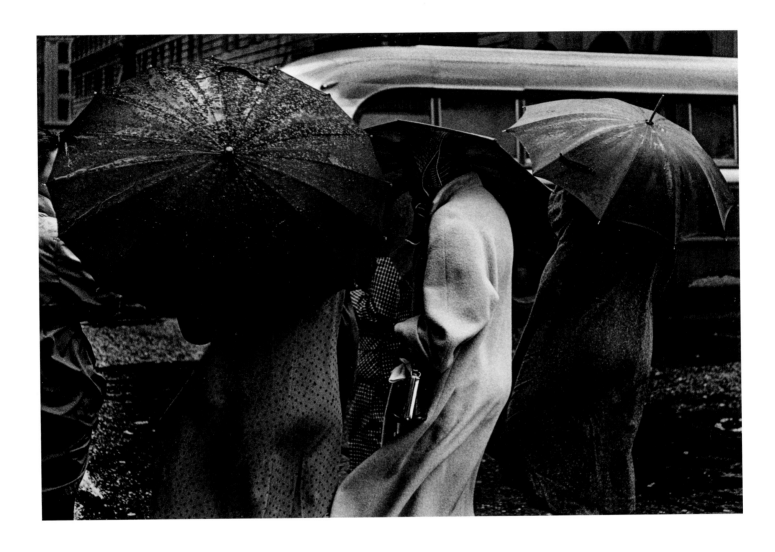

←

Imogen Cunningham

Sidewalk evangelist gathers a crowd in front of an upholstery shop, 1946.

Ein Straßenprediger schart vor einem Polstergeschäft eine Menge um sich, 1946.

Un prédicateur évangéliste exhorte ses auditeurs en pleine rue devant un magasin d'ameublement. 1946.

↑

Pirkle Jones

Women huddle with their umbrellas in an image titled Figures in Rain: San Francisco. *It seldom rains in the city from late spring to early fall, but in the intervening months there can be drenching downpours, 1955.*

Auf dem Foto Figures in the Rain: San Francisco *retten sich Frauen unter ihre Regenschirme. Es regnet nur selten von Frühlingsende bis Herbstanfang, aber in der restlichen Zeit kann es regelrechte Wolkenbrüche geben, 1955.*

Des femmes s'abritent sous leur parapluie sur cette photo intitulée Figures in Rain: San Francisco. *Il est rare qu'il pleuve entre la fin du printemps et le début de l'automne mais le reste de l'année peut donner lieu à des averses diluviennes. 1955.*

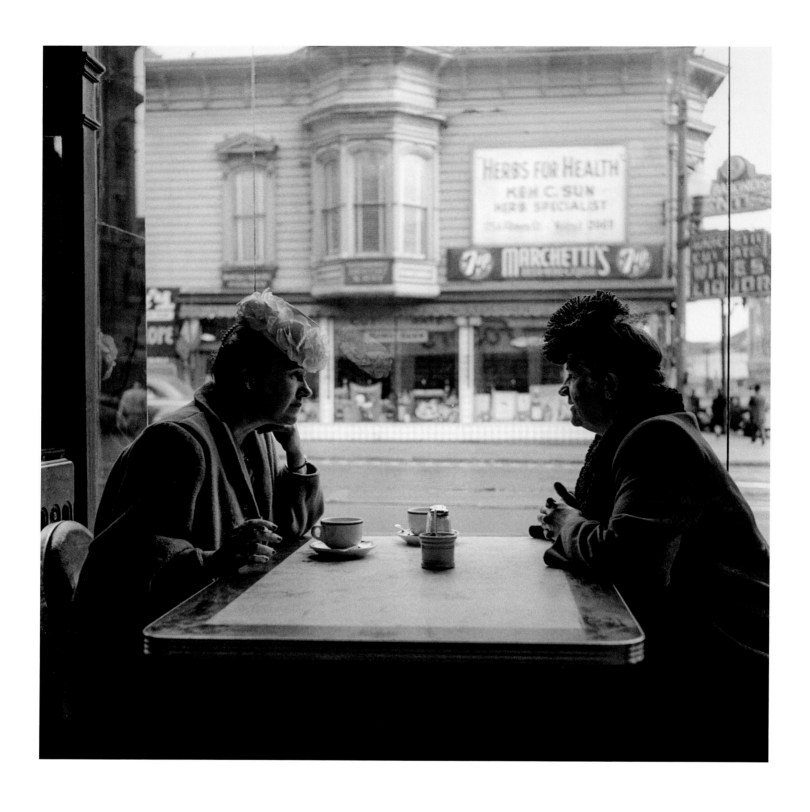

Imogen Cunningham

Two friends take tea at Foster's cafeteria, which had several dozen branches throughout the Bay Area. The chain's specialties were sourdough English muffins. The Foster's on Sutter Street, between Powell and Stockton streets, would play a significant role in literary history in 1954 when Allen Ginsberg wrote the first section of Howl *there, c. 1940s.*

Zwei Freundinnen beim Tee in Foster's Cafeteria, von der es in der Bay Area mehrere Dutzend gab. Die Spezialität der Kette waren Sauerteigbrötchen. Das Foster's an der Sutter Street, zwischen Powell und Stockton Street, spielte eine wichtige Rolle in der Literaturgeschichte: 1954 schrieb Allen Ginsberg dort den ersten Teil von Howl, *1940er-Jahre.*

Deux amies prennent le thé à la cafétéria Foster's, qui comptait plusieurs dizaines de succursales dans la région. Elle avait pour spécialité le muffin anglais au levain. En 1954, le Foster's de Sutter Street, entre Powell Street et Stockton Street, jouera un rôle important dans l'histoire littéraire puisque Allen Ginsberg y écrira la première strophe de son poème « Howl ». Vers les années 1940.

↓
Fred Lyon

Butcher sharpens knife in a North Beach storefront. A largely Italian neighborhood for much of the 20th century, the area is renowned for its food establishments, Italian and otherwise, from delis to upscale restaurants, 1954.

Ein Metzger schärft sein Messer in North Beach. Im 20. Jahrhundert war die Gegend lange italienisch geprägt und ist bekannt für das gute Essen, italienisches sowie anderes, in den Feinkostgeschäften und Restaurants, 1954.

Derrière sa vitrine, un boucher de North Beach aiguise son couteau. Habité pendant la plus grande partie du XXᵉ siècle par une population largement italienne, le quartier est réputé pour ses commerces de bouche – italiens ou non – qui vont de l'épicerie fine au restaurant gastronomique. 1954.

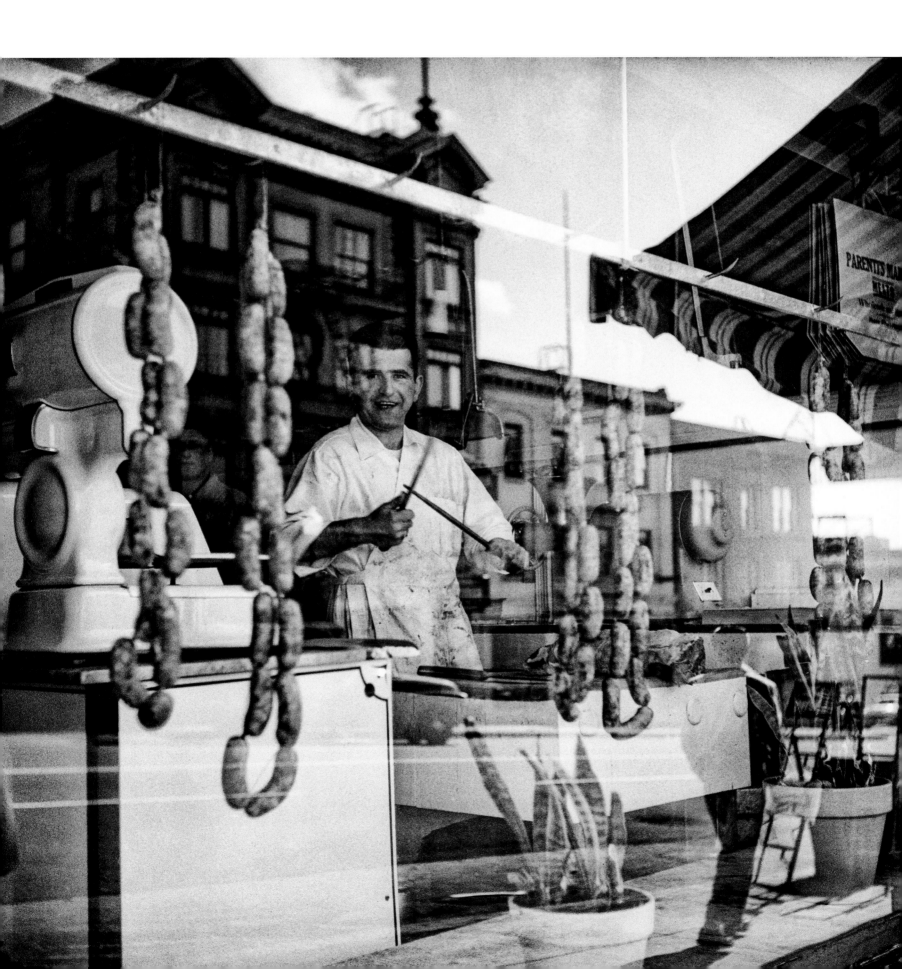

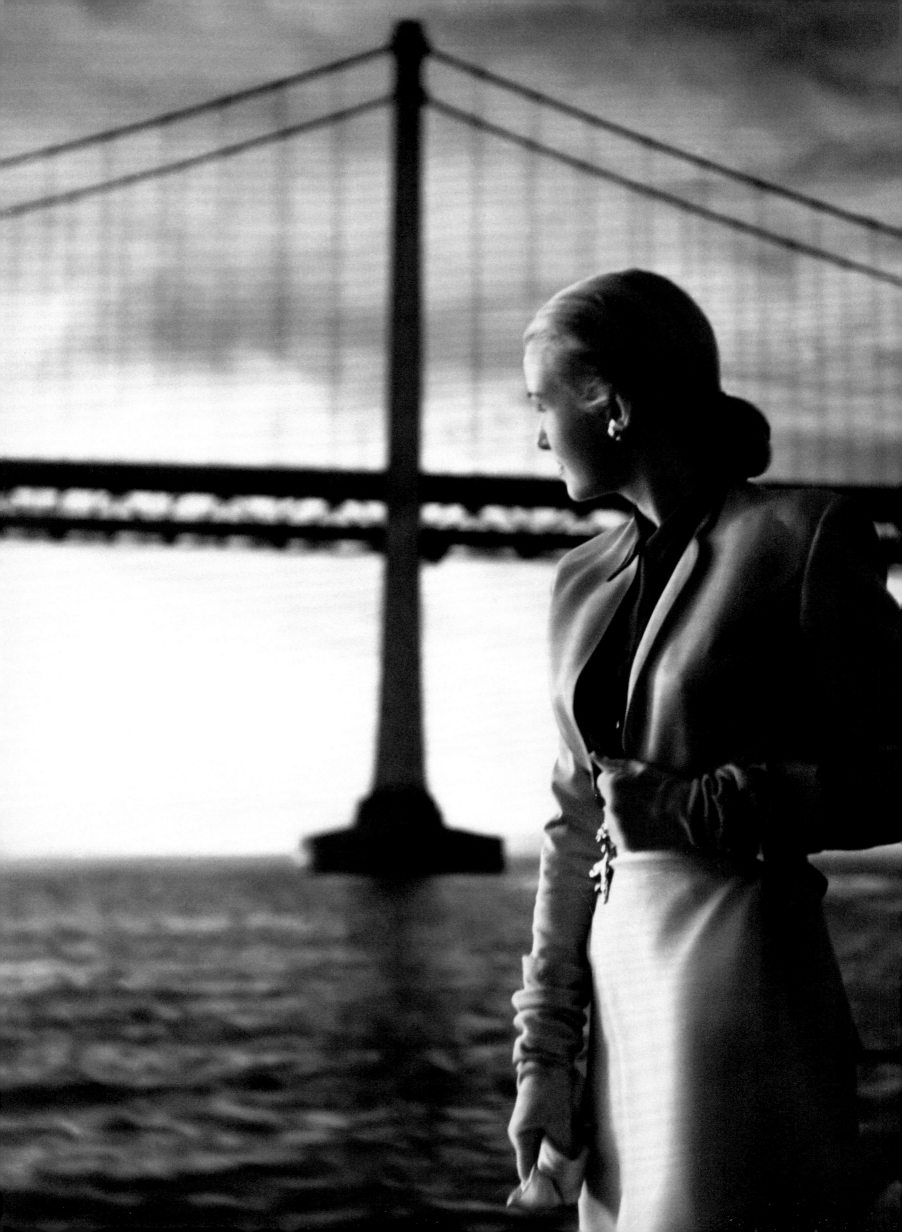

*"I got the blues when my baby left me by the San Francisco Bay,
she take the ocean liner and she gone so far away."*

JESSE FULLER, "SAN FRANCISCO BAY BLUES," 1954

Louise Dahl-Wolfe

*A fashion model posing with an ominously
stormy view of the Golden Gate Bridge as
the backdrop. A decade later, another blonde,
played by Kim Novak, would nearly drown
in the bay with the bridge in the back-
ground in the most famous scene in Alfred
Hitchcock's* Vertigo, *1948.*

*Ein Model posiert vor einer unheilvoll
umstürmten Golden Gate Bridge. Ein Jahr-
zehnt später ertrinkt eine andere Blondine,
gespielt von Kim Novak, in der berühmtesten
Szene aus Alfred Hitchcocks* Vertigo *beinahe
in der Bucht, 1948.*

*Sous un menaçant ciel d'orage, un mannequin
pose devant le Golden Gate Bridge. Dix ans
plus tard, une autre blonde, interprétée par
Kim Novak, manquera se noyer dans la baie,
avec en toile de fond le même pont, au cours
de la scène la plus célèbre du film d'Alfred
Hitchcock* Sueurs froides. *1948.*

Fred Lyon

Boys toss a ball on a typically foggy San Francisco day in West Portal, a residential neighborhood toward the southwestern part of the city, c. early 1950s.

Jungen spielen Ball an einem typisch nebeligen Tag in West Portal, einer Wohngegend im Südwesten der Stadt, frühe 1950er-Jahre.

À West Portal, un quartier résidentiel situé au sud-ouest de la ville, de jeunes garçons jouent au ballon par un jour de brouillard comme San Francisco en connaît tant. Vers le début des années 1950.

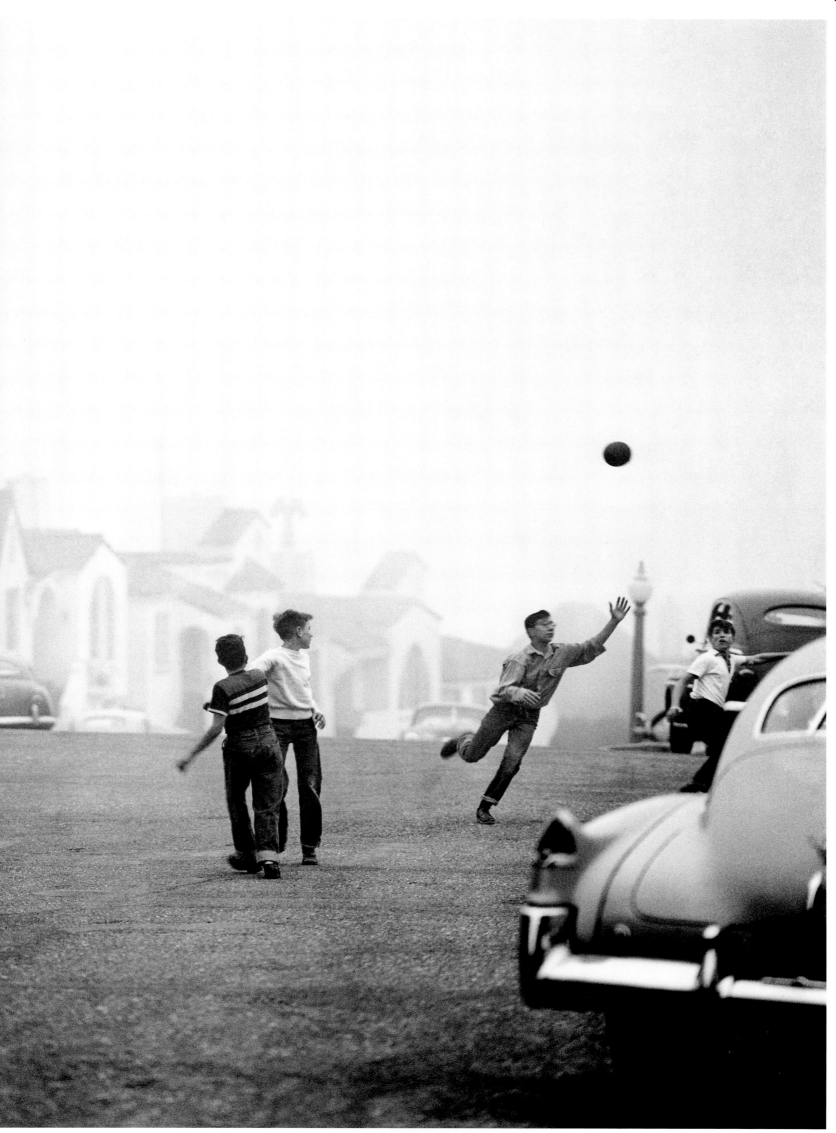

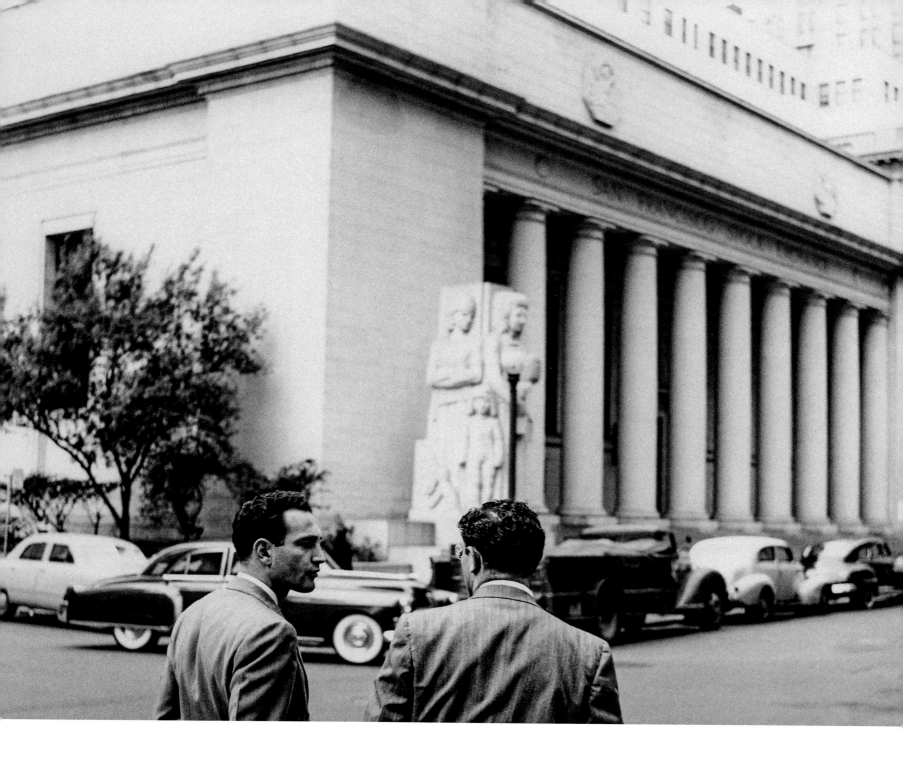

Minor White

The San Francisco Stock Exchange at Pine and Sansome streets, in the heart of the downtown Financial District. As The San Francisco Call-Bulletin *reported in 1955,* "The San Francisco Stock Exchange provides one important reason why this city is known as the Pacific Coast's 'financial capital.' Its volume exceeds that of Los Angeles," 1949.

Die Die Börse von San Francisco an Pine und Sansome Street, im Herzen des Finanzbezirks. 1955 berichtete das San Francisco Call-Bulletin: „Die Börse San Franciscos ist ein wichtiger Grund, warum die Stadt als die ‚Finanzhauptstadt' der Pazifikküste bekannt ist. Ihr Handelsvolumen ist größer als das von Los Angeles", 1949.

La Bourse de San Francisco, à l'angle de Pine Street et de Sansome Street, au cœur du Financial District. Si l'on en croit le San Francisco Call-Bulletin en 1955, « la Bourse de San Francisco est l'une des principales raisons pour lesquelles cette ville est considérée comme la "capitale financière" de la côte Pacifique. Le volume de ses transactions dépasse celui de Los Angeles ». 1949.

↓
William Heick

Montgomery Street, the "Wall Street of the West," and a drag for spotting the latest in flashy cars. This one's turning onto Montgomery from California, in front of a building that served as the corporate headquarters for Bank of America, 1948.

Montgomery Street, die „Wall Street des Westens" und der beste Ort, um die neusten Autos zu sehen. Auf dem Bild biegt gerade eines vor dem Gebäude, in dem die Bank of America ihren Hauptsitz hatte, von der California auf die Montgomery Street ab, 1948.

Du côté de Montgomery Street, la « Wall Street de l'Ouest », le dernier cri tape-à-l'œil est de rigueur en matière automobile. Cette Oldsmobile vient de tourner depuis California Street, devant un bâtiment qui abrita le siège de la Bank of America. 1948.

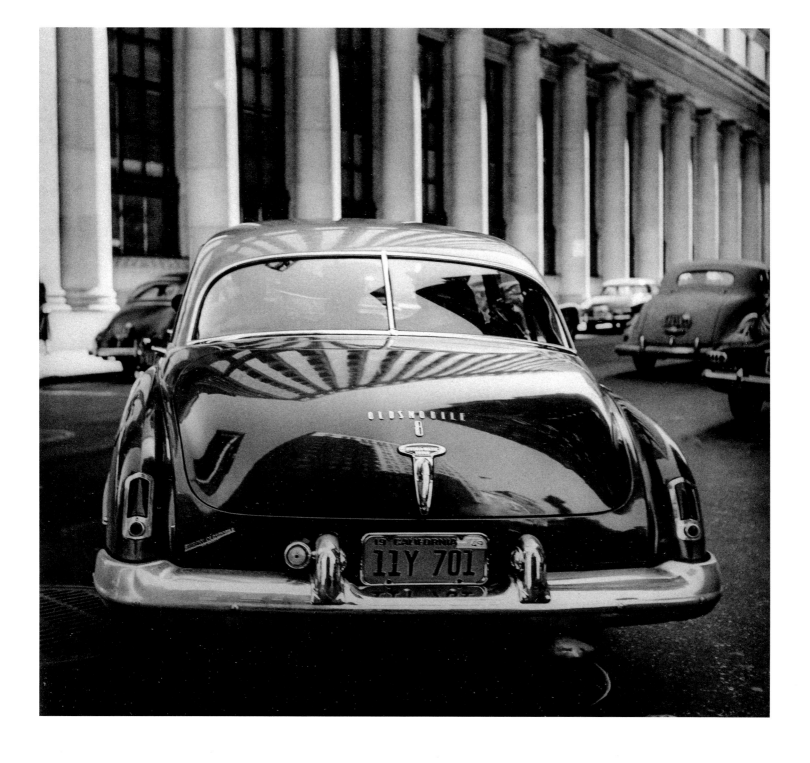

"But I realize now that the deep change began on the first day I brought her to San Francisco. You know what San Francisco does to people who have never seen it before."

„Aber ich weiß jetzt, dass die tiefgreifende Veränderung an dem Tag begann, als ich sie nach San Francisco brachte. Du weißt, was San Francisco mit Menschen macht, die es noch nie gesehen haben."

« Mais je réalise maintenant que le changement profond a commencé le premier jour où je l'ai emmenée à San Francisco. Vous savez l'effet que fait San Francisco aux gens qui la découvrent. »

VERTIGO, ALFRED HITCHCOCK, 1958

Max Yavno

Postwar San Francisco housing took a manufactured, generic feel as development accelerated in some outlying districts, which is reflected in the title of this picture: Keyboard Houses, *1947.*

Die schnell errichteten Nachkriegsneubauten in den Vororten wirkten wie aus der Retorte und unpersönlich. Das spiegelt sich auch im Titel des Fotos wider: Keyboard Houses, *gleichförmig wie die Tasten auf dem Klavier, 1947.*

Au cours de l'après-guerre, l'immobilier évolua vers une forme de standardisation de type industriel, à l'image de ces maisons alignées comme les touches d'un clavier (keyboard) *– la photo s'intitule* Keyboard Houses. *1947*

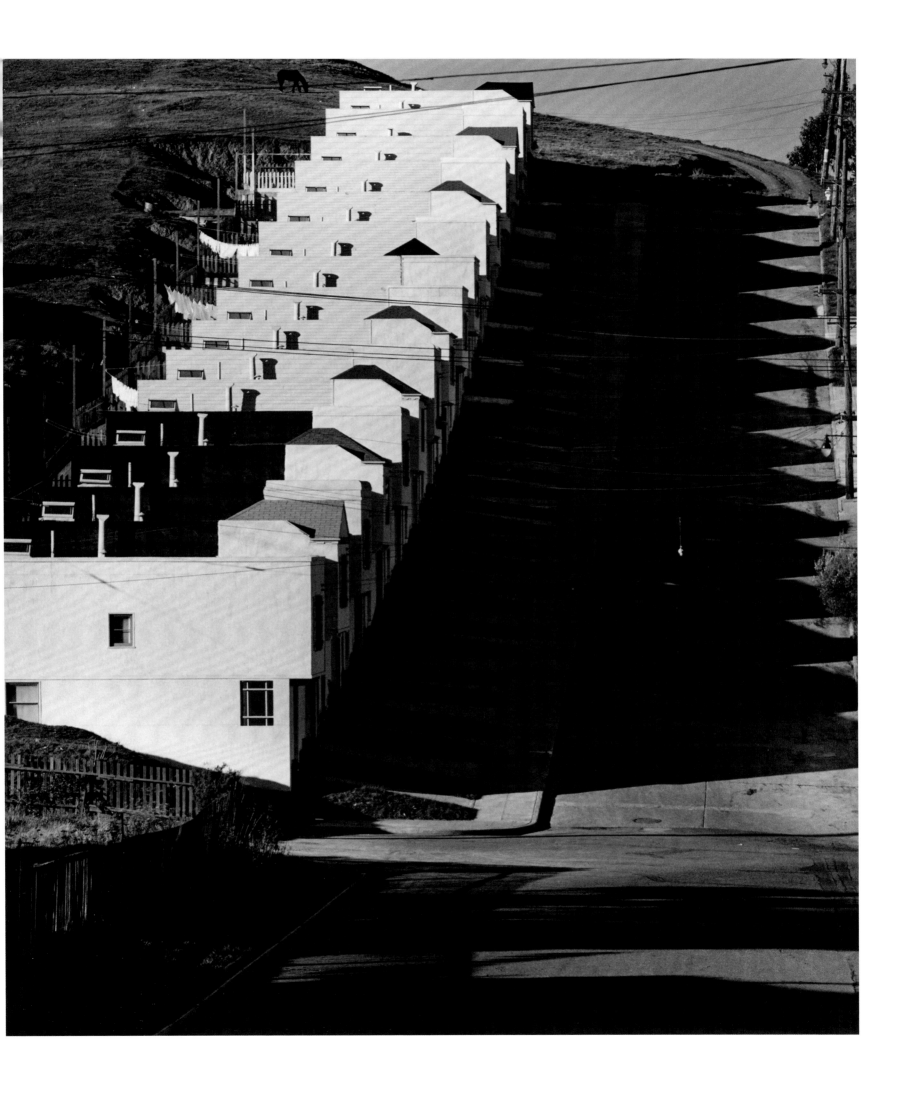

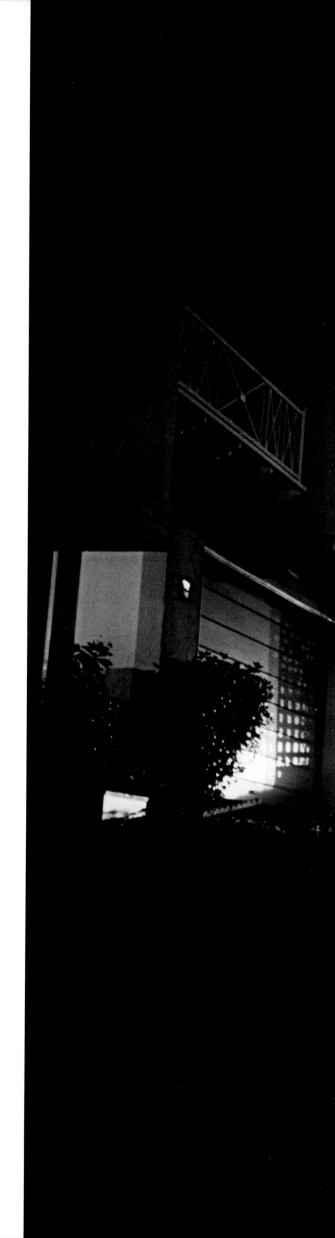

Fred Lyon

*Nighttime at Seal Rock Drive at Lands End,
a few blocks above the Sutro Baths and the
actual Seal Rocks in the ocean near the Cliff
House. In a city famed for its fog, this area is
one of its foggiest, 1953.*

*Der Seal Rock Drive in Lands End bei
Nacht, ein paar Blocks über den Sutro Baths
und den namensgebenden Seal Rocks am
Meer beim Cliff House. In einer Stadt, die
für ihren Nebel bekannt ist, ist diese Gegend
eine der nebeligsten, 1953.*

*La nuit est tombée sur Seal Rock Drive
à Lands End, quelques rues en amont des
Sutro Baths et des îlots rocheux nommés Seal
Rocks, au pied de la Cliff House. Cette zone
est l'une des plus brumeuses d'une ville elle-
même réputée pour son brouillard. 1953.*

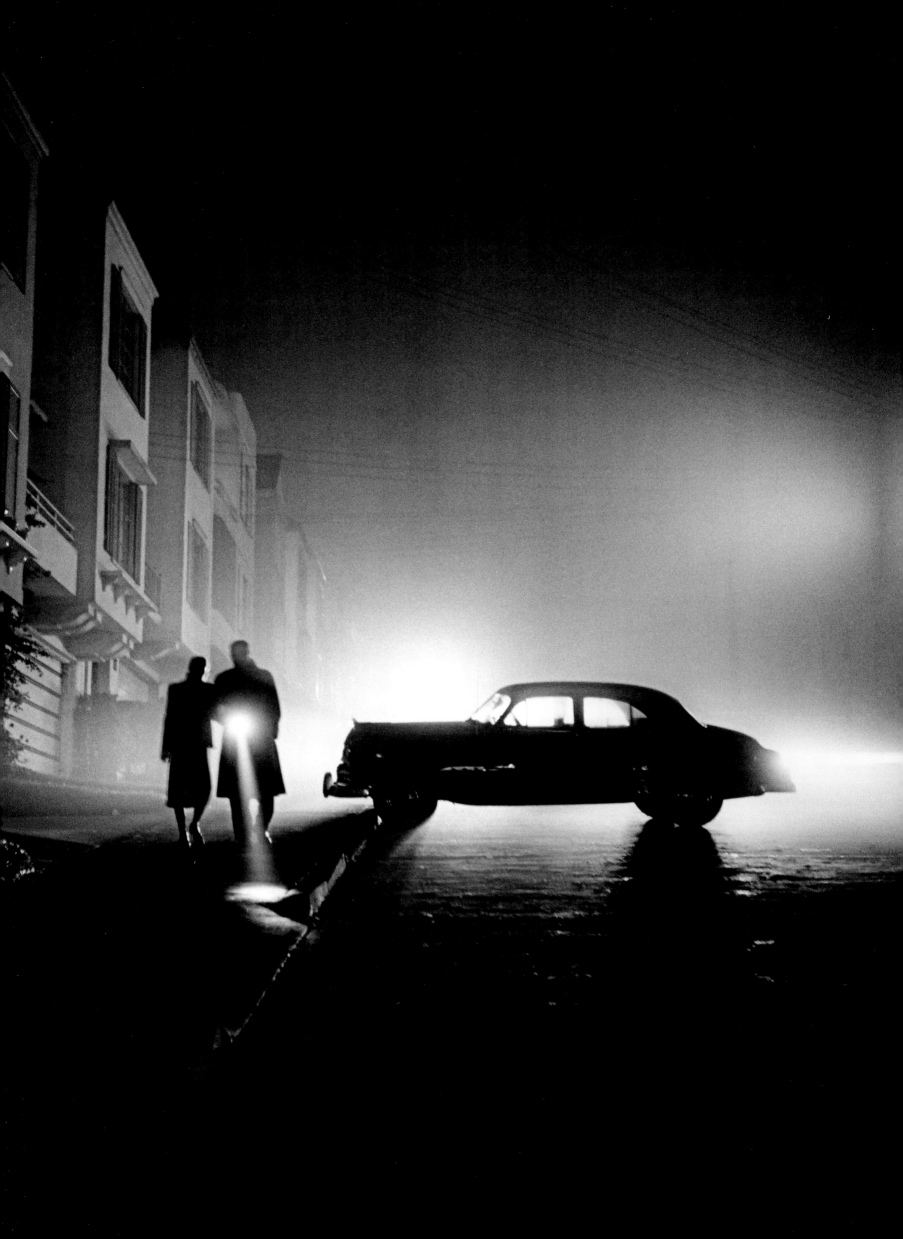

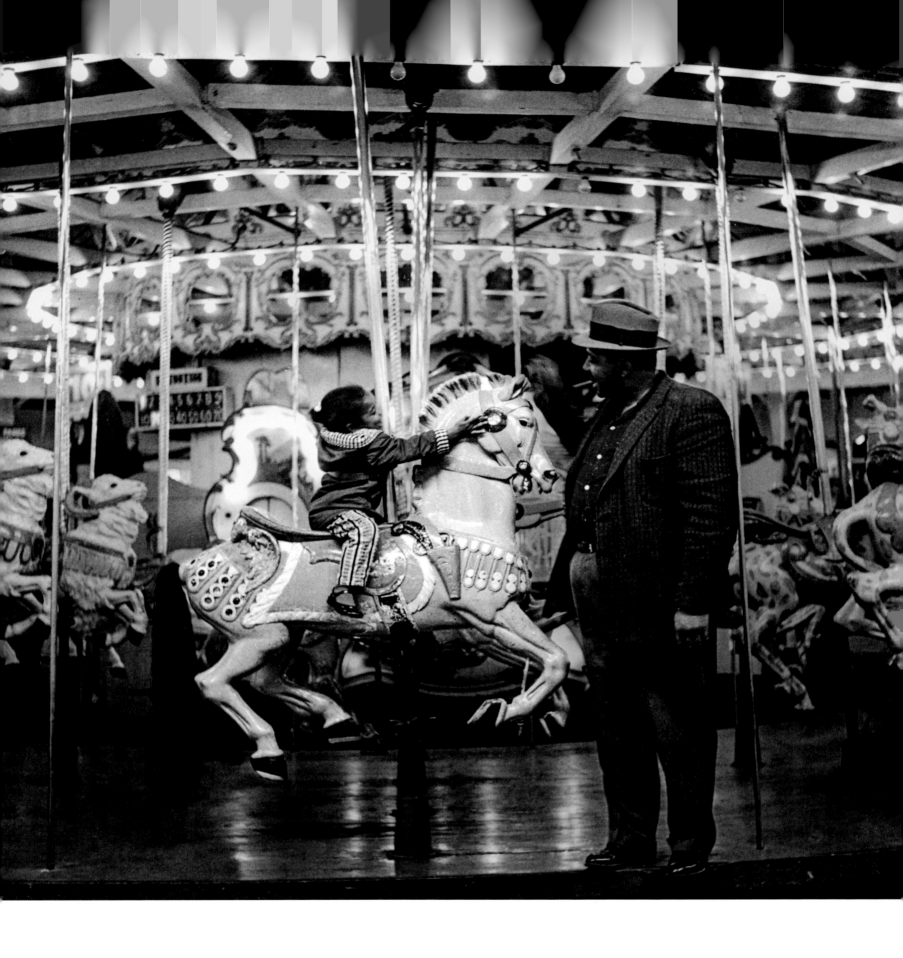

David Johnson

Father watches his daughter on a Fillmore District carousel, 1950.

Ein Vater schaut seiner Tochter auf einem Karussell im Fillmore District zu, 1950.

Le regard d'un père sur sa fillette embarquée dans un tour de manège. Quartier de Fillmore. 1950.

William Heick

Two men confer at the corner of Fillmore and Post streets. In the years just after World War II, this was one of the busier spots of the Fillmore District when it reached its peak as the center of San Franciscan African American culture, 1949.

Zwei Männer unterhalten sich an der Ecke Fillmore und Post Street. In den Jahren nach dem Zweiten Weltkrieg, als die Gegend das Zentrum der afroamerikanischen Kultur in San Francisco bildete, war dies einer der belebtesten Orte im Fillmore District, 1949.

Deux hommes discutent à l'angle de Fillmore Street et de Post Street. Dans les immédiates années d'après-guerre, cette zone était l'une des plus animées du quartier de Fillmore. Celui-ci incarnait alors plus que jamais le cœur de la culture afro-américaine de San Francisco. 1949.

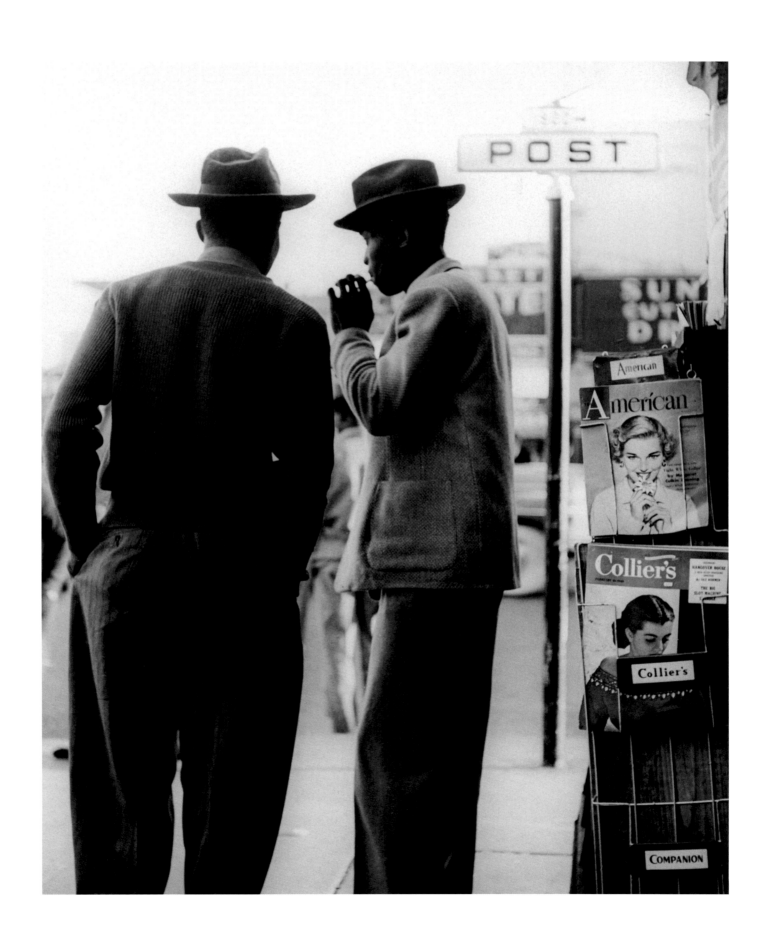

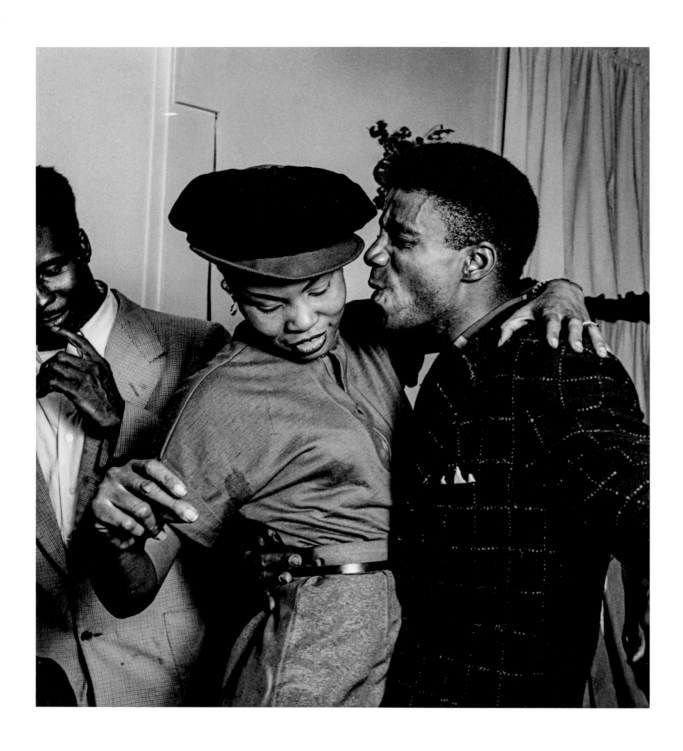

↑
David Johnson

*Couple dancing at a joint in the Bayview
District, a largely African American neighbor-
hood near the southeast corner of the city.
African Americans have had a strong
presence in the area since housing was built
during World War II for workers in the nearby
Hunters Point Naval Shipyard, c. 1950.*

*Ein Paar tanz in einer Kneipe im Bayview
District im Südosten der Stadt. Viele Afro-
amerikaner lebten hier, seit im Zweiten
Weltkrieg Wohnungen für die Arbeiter in der
nahe gelegenen Werft Hunter Point Marine
gebaut wurden, um 1950.*

*Un couple danse dans une boîte de nuit
de Bayview, au sud-est de la ville, un
quartier majoritairement afro-américain
depuis la construction de logements pour
les ouvriers du chantier naval voisin de
Hunters Point, pendant la Seconde Guerre
mondiale. Vers 1950.*

→
David Johnson

Fillmore, 1947.

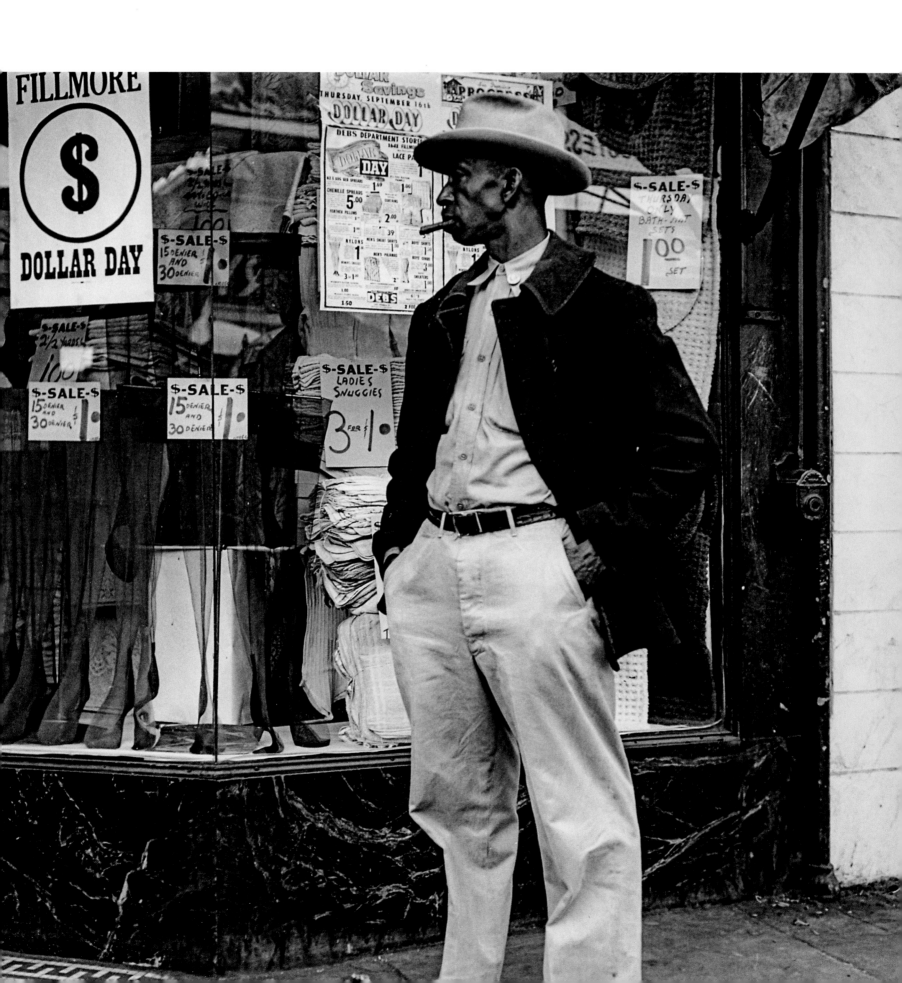

↓
Fred Lyon

The Barbary Coast was still alive as the
1950s dawned, if only as a name to draw
thrill seekers, at Spider Kelly's North Beach
nightclub. On Pacific Avenue near Broadway,
it was among several racy joints in the
neighborhood's small red-light district of
sorts, 1950.

Die Barbary Coast gab es in den 1950ern
noch, wenn auch nur als Namen, der Besucher
in Spider Kelly's Nachtclub in North Beach
locken sollte. Auf der Pacific Avenue in
der Nähe des Broadway war es einer von
mehreren anrüchigen Schuppen im kleinen
Rotlichtviertel der Gegend, 1950.

Barbary Coast bougeait encore à l'aube des
années 1950, ne fût-ce que pour attirer par sa
réputation les amateurs de sensations fortes.
L'aguichant night-club de Spider Kelly à
North Beach, sur Pacific Avenue, voisine de
Broadway, comptait parmi les adresses en vue
du secteur le plus chaud du quartier. 1950.

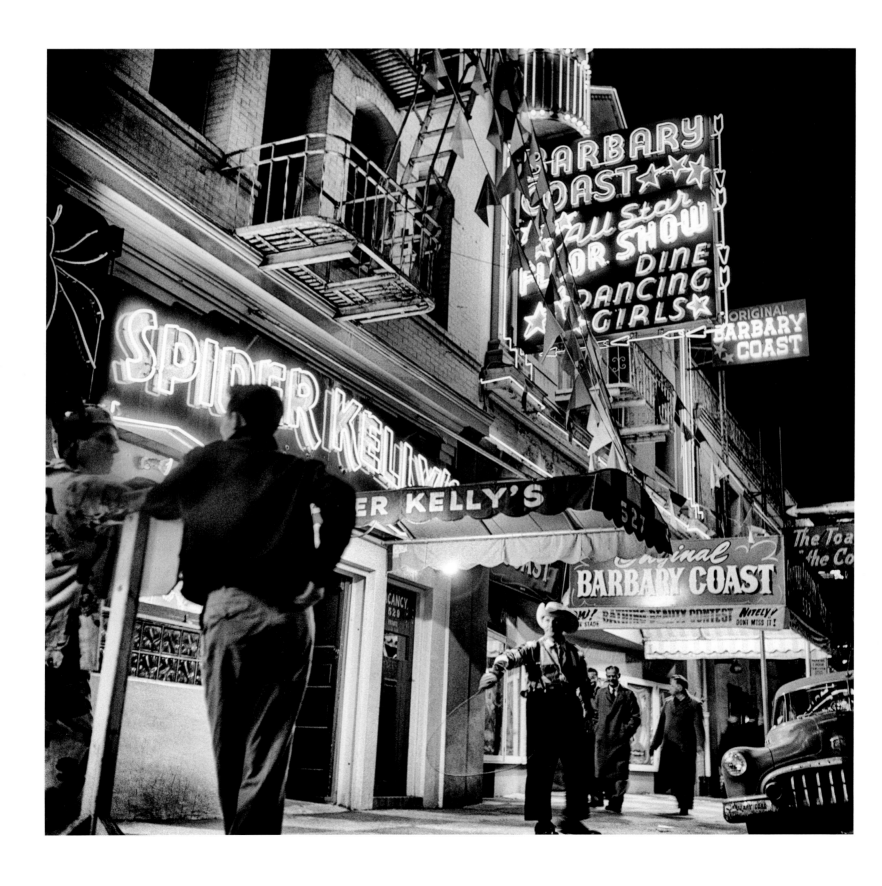

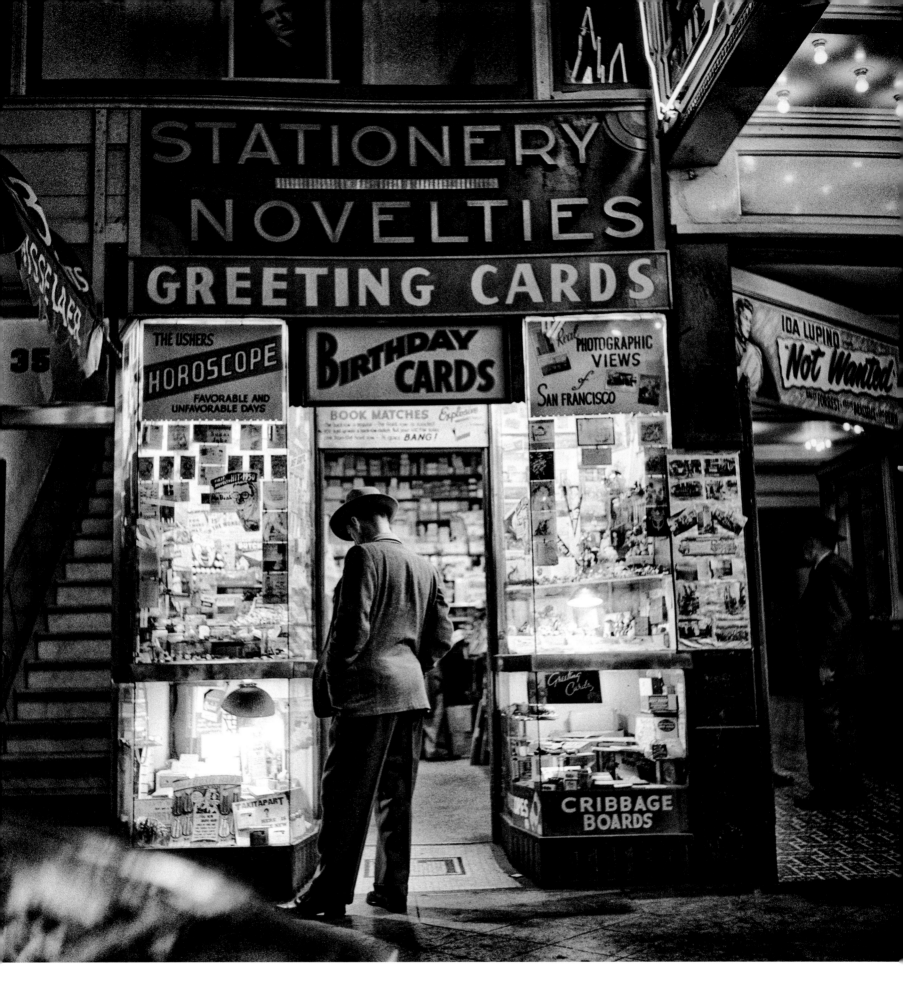

↑
Fred Lyon

Customer peers into a novelty shop on Powell Street, just off Union Square. The all-night movie house next door is showing the drama Not Wanted, *c. 1949.*

Ein Kunde schaut in einen Laden für Geschenkartikelladen an der Powell Street, nah am Union Square. Das Nachtkino daneben zeigt das Drama Not Wanted *(dt.* Verführt*), um 1949.*

Un badaud lorgne la vitrine d'un magasin d'articles de fantaisie sur Powell Street, juste à côté d'Union Square. La séance de nuit du cinéma voisin propose le film d'Ida Lupino Not Wanted *(Avant de t'aimer). Vers 1949.*

Fred Lyon

The California Street cable car, near where the route begins at California and Market streets, a couple blocks from the Embarcadero. In the background is the Ferry Building, whose 245-foot-high clock tower has been a waterfront landmark since its 1898 opening, c. 1940s.

Die California-Street-Linie, in der Nähe eines ihrer Endpunkte an California und Market Street, nur ein paar Blocks vom Embarcadero. Im Hintergrund ist das Ferry Building zu sehen, dessen 75 Meter hoher Glockenturm seit der Eröffnung 1898 ein Wahrzeichen der Uferpromenade ist, 1940er.

Un cable car de la ligne California Street non loin de son point de départ à l'angle de California Street et de Market Street, tout près de l'Embarcadero. À l'arrière-plan, le Ferry Building dont la tour et l'horloge, du haut de leurs 75 mètres, constituent depuis leur inauguration en 1898 l'un des jalons du front de mer. Vers les années 1940.

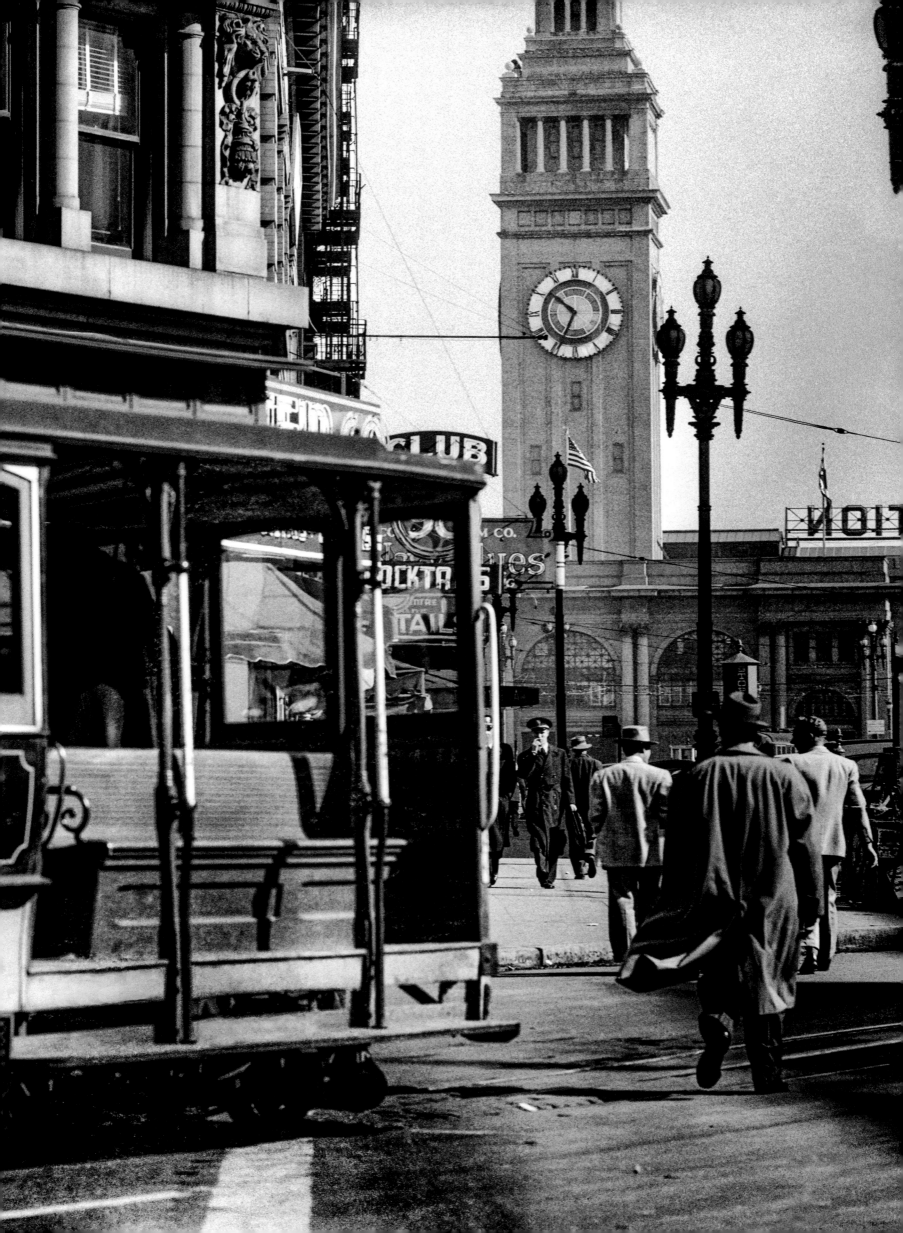

Leonard McCombe

Socialites at a tea for Pat Nixon, wife of then vice president (and future president) Richard Nixon, during the Republican National Convention. Held in San Francisco's Cow Palace in both 1956 and 1964, such a convention would be inconceivable in the region today, when Republicans have less support in the city than they do in any other US metropolis. 1956.

Prominente bei einer Teeparty für Pat Nixon, die Frau des damaligen Vizepräsidenten (und zukünftigen Präsidenten) Richard Nixon, während des Nationalkongresses der Republikaner. Eine solche Veranstaltung, wie sie 1956 und 1964 im Cow Palace abgehalten wurde, wäre heute in der Stadt undenkbar, denn in keiner anderen US-Metropole haben die Republikaner weniger Wähler, 1956.

Un thé des plus mondains offert à Pat Nixon, épouse du vice-président de l'époque (et futur président) Richard Nixon lors de la convention nationale du Parti républicain. Organisée au Cow Palace de San Francisco en 1956 et 1964, une telle convention serait aujourd'hui inconcevable dans la métropole américaine la moins favorable au « Grand Old Party ». 1956.

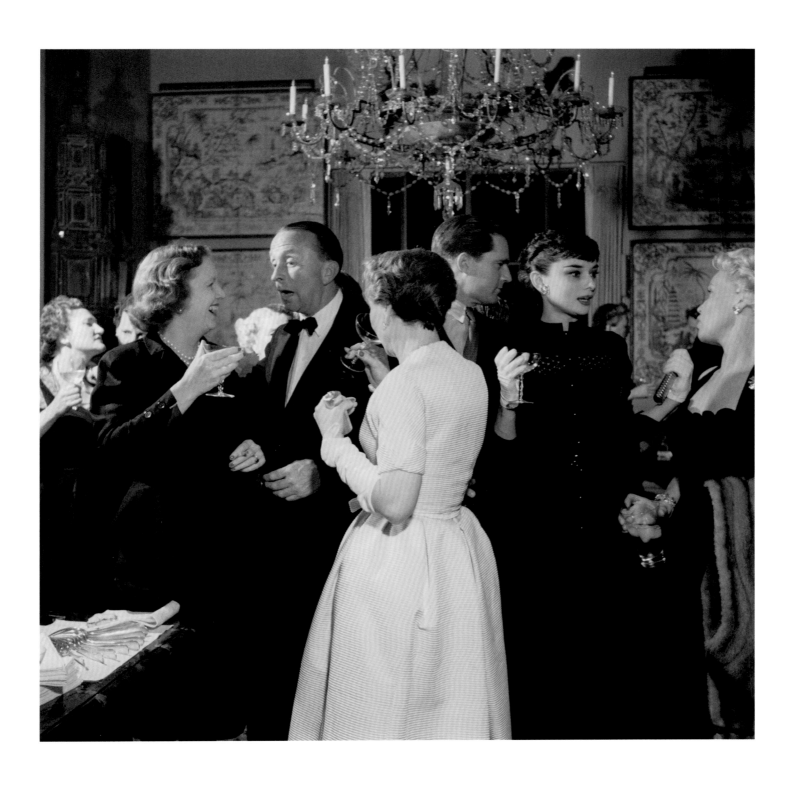

↑
Slim Aarons

Film and stage star Audrey Hepburn at a San Francisco party given for her by socialite Whitney Warren Jr., a leading patron of San Francisco arts, 1953.

Film- und Theaterstar Audrey Hepburn auf einer Party in San Francisco der Gastgeberin Whitney Warren Jr., eine der wichtigsten Kunstmäzeninnen der Stadt, 1953.

Star de cinéma et de théâtre, Audrey Hepburn se mêle aux invités d'une soirée donnée en son honneur par Whitney Warren Jr, célèbre mécène de San Francisco. 1953.

*"I left my heart in San Francisco
High on a hill, it calls to me
To be where little cable cars climb halfway to the stars
The morning fog may chill the air, I don't care
My love waits there in San Francisco."*

**DOUGLASS CROSS AND GEORGE CORY,
"I LEFT MY HEART IN SAN FRANCISCO," 1953**

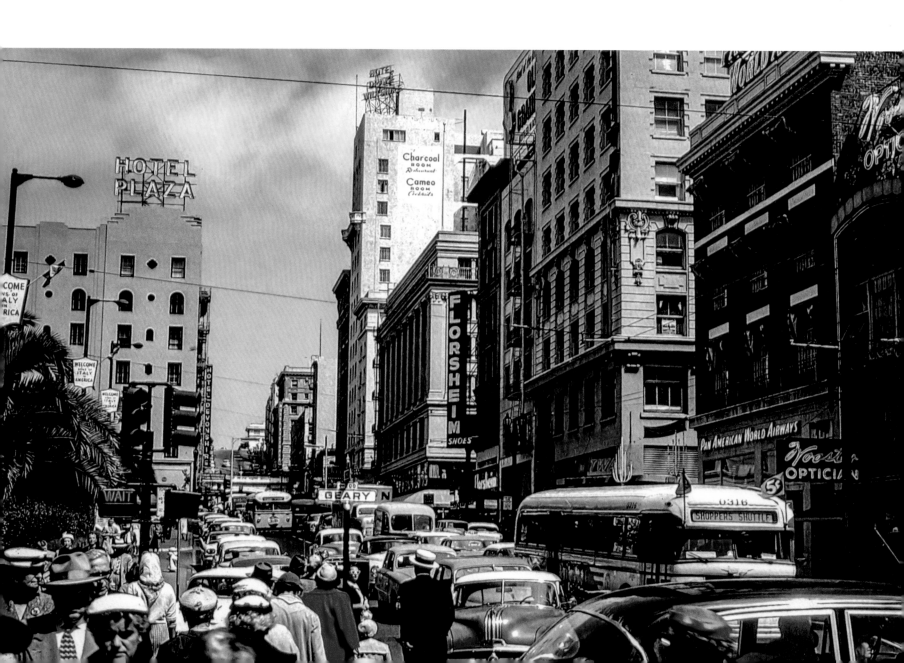

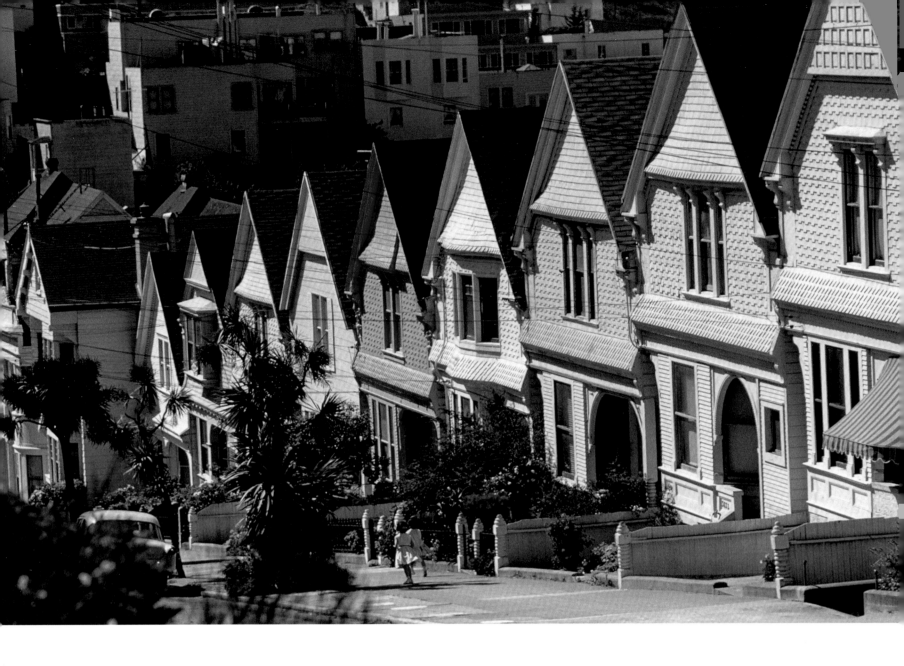

←
Anonymous

Looking north from Geary and Stockton streets, with Union Square on the left. As much of a town center as anything in San Francisco, the square is bordered by many shops, services, and hotels within easy walking distance of one another, 1960.

Blick Richtung Norden von Geary und Stockton Street, der Union Square liegt links. Man könnte den Platz das Stadtzentrum von San Francisco nennen. Er wird von Geschäften und Hotels gesäumt, die alle fußläufig zu erreichen sind, 1960.

Direction nord depuis l'angle de Geary Street et de Stockton Street. Union Square, sur la gauche, qui constitue à San Francisco l'hypercentre par excellence, est bordée de nombreux hôtels, boutiques et services en tout genre très voisins les uns des autres. 1960.

↑
Charles W. Cushman

Row houses on the stretch of 21st Street that rises west of Noe Street, on the northern edge of Noe Valley. One of the city's most desirable residential neighborhoods, it's also among the hilliest, 1956.

Reihenhäuser an einem Teil der 21st Street, westlich der Noe Street und am nördlichen Rand von Noe Valley. Es ist nicht nur eine der begehrtesten Wohngegenden der Stadt, sondern auch eine der hügeligsten, 1956.

Maisons alignées en rang d'oignons sur la partie de la 21ᵉ Rue qui grimpe à l'ouest de Noe Street, à la lisière nord de Noe Valley. Ce quartier résidentiel, l'un des plus recherchés de la ville, en est aussi l'un des plus escarpés. 1956.

↓
Anonymous

Weatherbeaten storefront of a Grant Avenue restaurant, c. 1950s.

Verwitterte Fassade eines Restaurants an der Grant Avenue. Hier gibt es Chop Suey, wie das Schild verkündet, 1950er-Jahre.

Le message est clair : ce restaurant de Grant Avenue propose bien du chop suey. Vers 1950.

→
Anonymous

Grant Avenue by daylight. At night, the lanterns strung across the road light up to lend Chinatown a distinctive glow, c. 1950.

Grant Avenue bei Tageslicht. Nachts verleihen die Laternen über den Straßen Chinatown ihr charakteristisches Leuchten, um 1950.

Grant Avenue de jour. La nuit, les lanternes tendues en travers de la voie s'illuminent et enveloppent Chinatown d'un halo très caractéristique. Vers 1950.

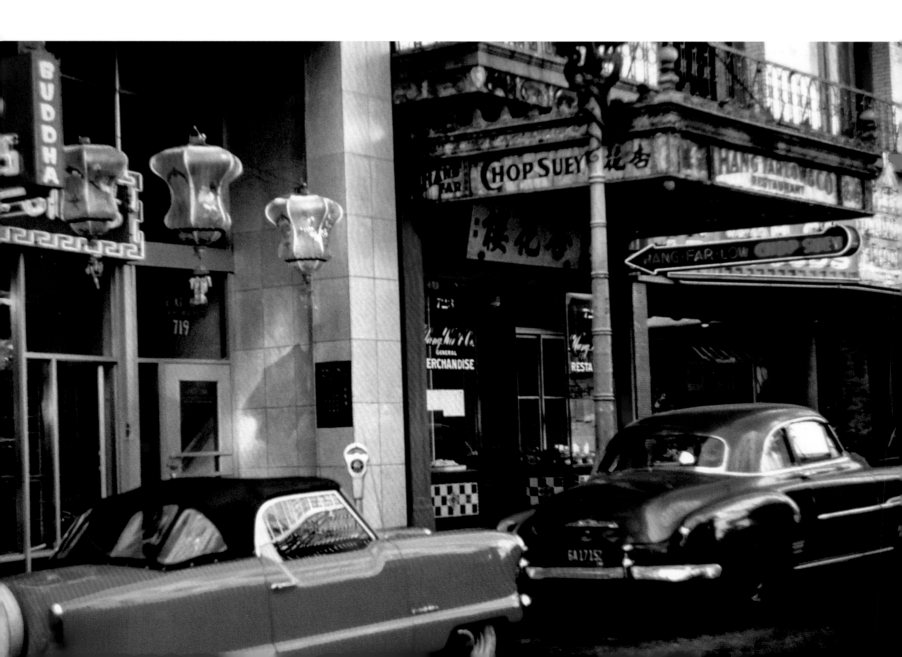

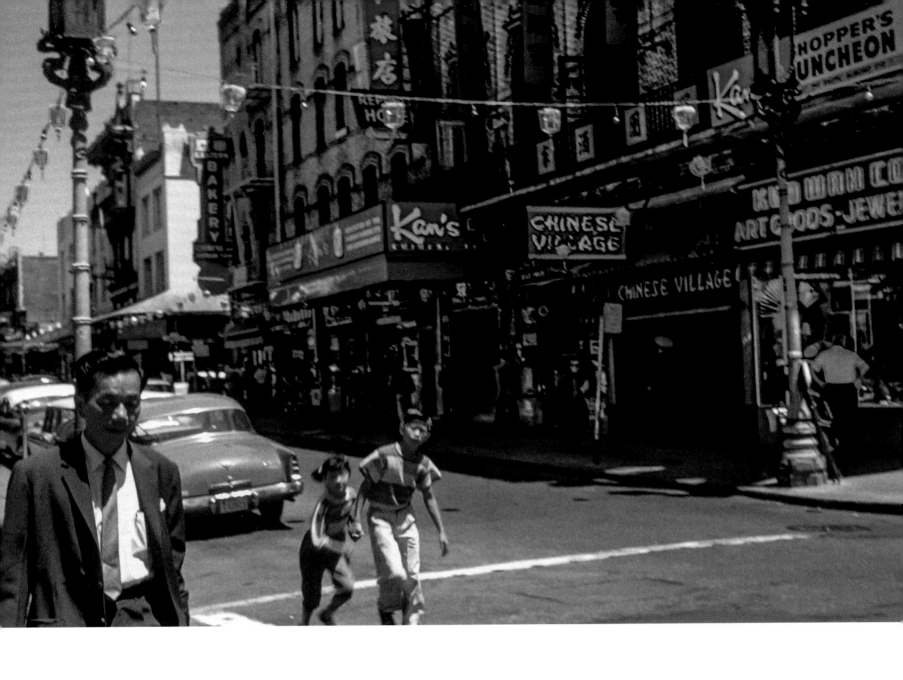

p. 190/191
Werner Bischof

In San Francisco, the wharf usually means Fisherman's Wharf and good times, or at least good eating. This passerby doesn't seem to be in the mood to dig into the food and laughs touted by the wall paintings, 1953.

In San Francisco meint man mit der Werft normalerweise Fisherman's Wharf und Vergnügungen oder zumindest gutes Essen. Dieser Passant scheint nicht in der Stimmung für das Essen und den Frohsinn zu sein, der von der Wandmalerei angepriesen wird, 1953.

Évoquer le « wharf » (le quai), à San Francisco, c'est généralement parler de Fisherman's Wharf et des bons moments qui lui sont associés, au moins gastronomiques. Tous les promeneurs, cependant, ne sont pas forcément d'humeur à faire honneur aux victuailles vantées par ce genre de fresque. 1953.

*"San Francisco put on a show for me. I saw her across the bay, from the
great road that bypasses Sausalito and enters the Golden Gate Bridge.
The afternoon sun painted her white and gold—rising on her hills like a
noble city in a happy dream."*

*„Nun setzte sie sich für mich in Szene. Ich sah sie auf der anderen Seite
der Bucht liegen, als ich die große Straße herunterkam, die an Sausalito
vorbei zur Golden Gate Bridge führt. Die Nachmittagssonne malte sie
weiß und golden – auf ihren Hügeln erhoben wie eine noble Stadt in
einem glücklichen Traum."*

*« San Francisco se mit en frais pour moi. Je l'aperçus de l'autre côté de
la baie, depuis la grand-route qui contourne Sausalito et s'engage sur
le Golden Gate. Le soleil d'après-midi la peignait de blanc et d'or,
telle une cité noble de rêve heureux. »*

JOHN STEINBECK, *TRAVELS WITH CHARLEY: IN SEARCH OF AMERICA*, 1962

Werner Bischof

*Painter atop a Golden Gate Bridge span.
Constant coats are needed for the bridge to
keep its orange hue. They also keep the steel
from corroding or rusting, an ever-present
danger since there's so much salt in the sea
air, 1953.*

*Ein Maler auf einem der Kabel der Golden
Gate Bridge. Es braucht regelmäßigen
Anstrich, damit die Brücke ihre orange Farbe
behält. So wird auch der Stahl vor Rost und
Korrosion geschützt, eine konstante Gefahr
aufgrund des hohen Salzgehalts in der Luft
dieser Gegend, 1953.*

*Un peintre en équilibre sur l'un des câbles
porteurs du Golden Gate Bridge. Pour que
l'ouvrage conserve sa teinte orange, il est néces-
saire de multiplier les couches qui empêchent
également l'acier de se corroder ou de rouiller,
une menace constante en raison de l'extrême
salinité de l'air dans le détroit. 1953.*

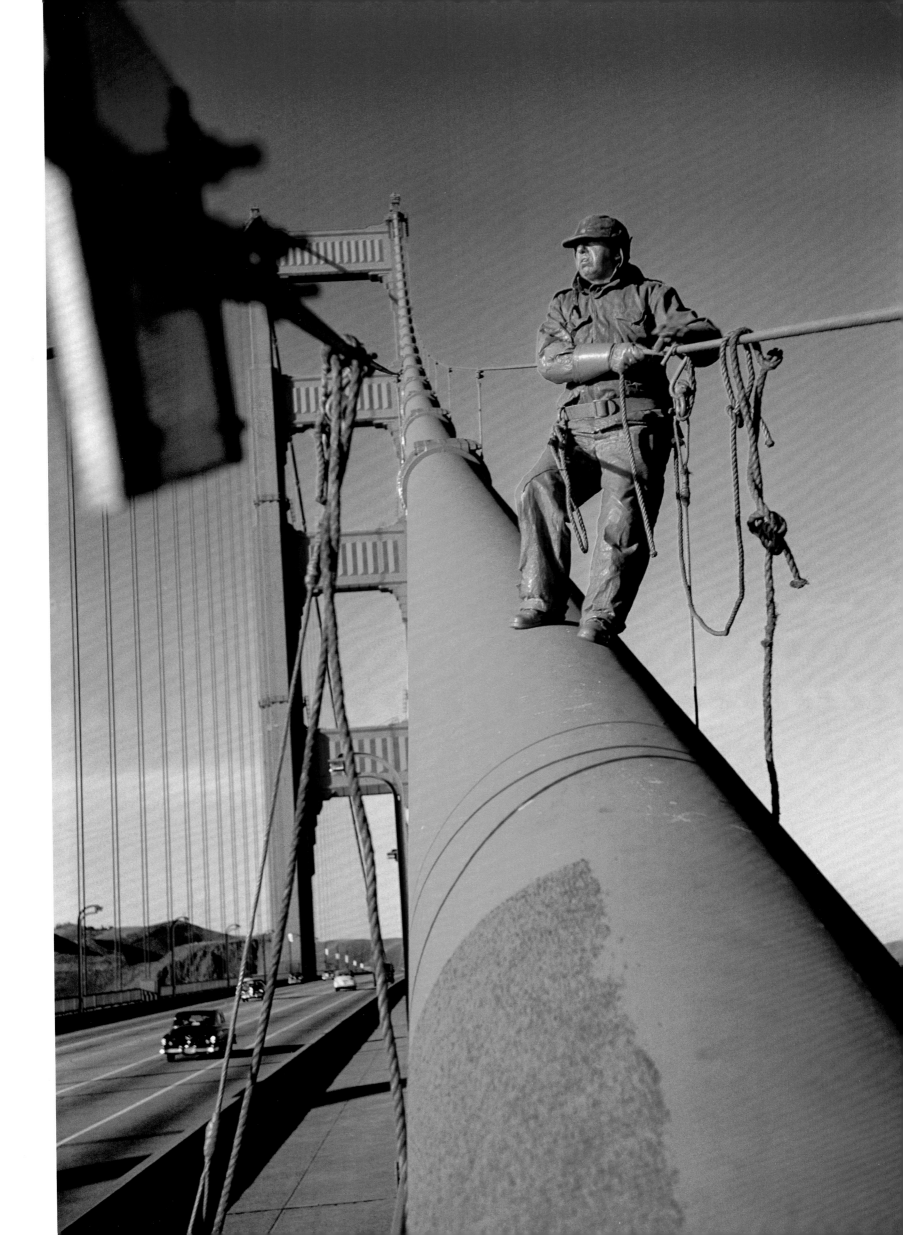

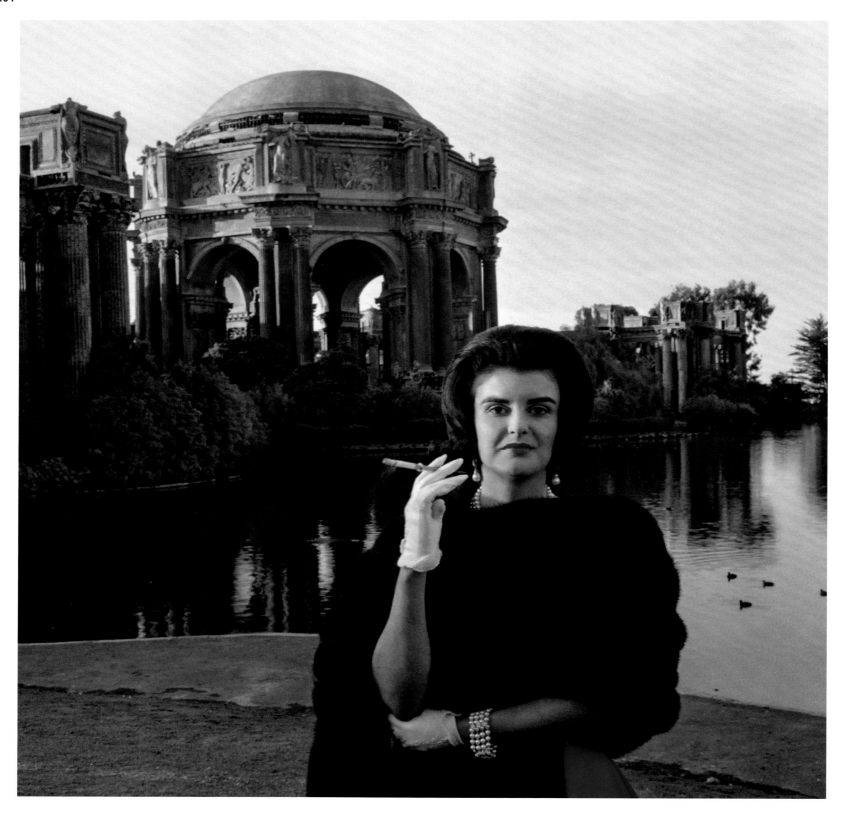

↑
Slim Aarons

San Franciscan "It Girl" and property heiress Dolly Fritz posing in front of the famed lagoon of the neo-classical The Palace of Fine Arts. Situated in the Marina district, the Palace of Fine Arts was originally built for the 1915 Panama-Pacific Exposition and was the only building on the site not to be demolished once the Exposition ended. Today the iconic building is used as an event space, to quote from its website: "this San Francisco treasure brings the wow factor to corporate events, private parties, trade shows, conferences, galas, weddings, and more," 1961.

„It-Girl" aus San Francisco und Immobilien-erbin: Dolly Fritz posiert vor der berühmten Lagune des neoklassizistischen Palace of Fine Arts. Dieses Gebäude im Marina District wurde ursprünglich für die Panamapazifik-Ausstellung 1915 erbaut und war das einzige auf dem Gelände, das nach dem Ende der Ausstellung nicht abgerissen wurde. Heute wird es als Veranstaltungsort genutzt, wie es auf seiner Website heißt: „Dieses Kleinod verleiht Firmenveranstaltungen, privaten Partys, Messen, Konferenzen, Galas, Hochzeiten und vielem mehr den Wow-Faktor" (1961).

Riche héritière et « it-girl », Dolly Fritz pose devant le célèbre plan d'eau du Palace of Fine Arts. Bâti dans le style néo-classique à l'occasion de l'Exposition internationale Panama-Pacifique (1915), l'emblématique édifice sera le seul à échapper à la démo-lition une fois la manifestation terminée. Situé dans le Marina District, il accueille aujourd'hui toutes sortes d'événements, ainsi que l'indique le site internet : « … séminaires d'entreprise, fêtes privées, salons profession-nels, conférences, galas, mariages… », 1961.

↓

Werner Bischof

Some of the outlying districts where visitors rarely venture have a markedly different, almost suburban, and more uniform architectural feel than the city's more renowned neighborhoods. This was taken a little southeast of Twin Peaks in the general area of Miraloma Park, which even many longtime San Franciscan residents seldom see. 1953.

Einige der weiter außerhalb gelegenen Gegenden, in die Touristen nur selten kommen, ähneln in ihrer Einheitlichkeit viel mehr normalen Vororten als den bekannteren Vierteln der Stadt. Das Foto wurde etwas südöstlich von Twin Peaks in der Gegend um Miraloma Park aufgenommen, die selbst viele der langjährigen Anwohner selten zu Gesicht bekommen, 1953.

Certains des quartiers périphériques, où les visiteurs s'aventurent rarement, présentent un visage architectural résolument différent et plus uniforme que les secteurs les plus célèbres de la ville, presque un côté banlieue. Cette photo a été prise légèrement au sud-est des Twin Peaks, dans le quartier de Miraloma Park, dont les vieux habitants de San Francisco eux-mêmes n'ont souvent qu'une vague idée. 1953.

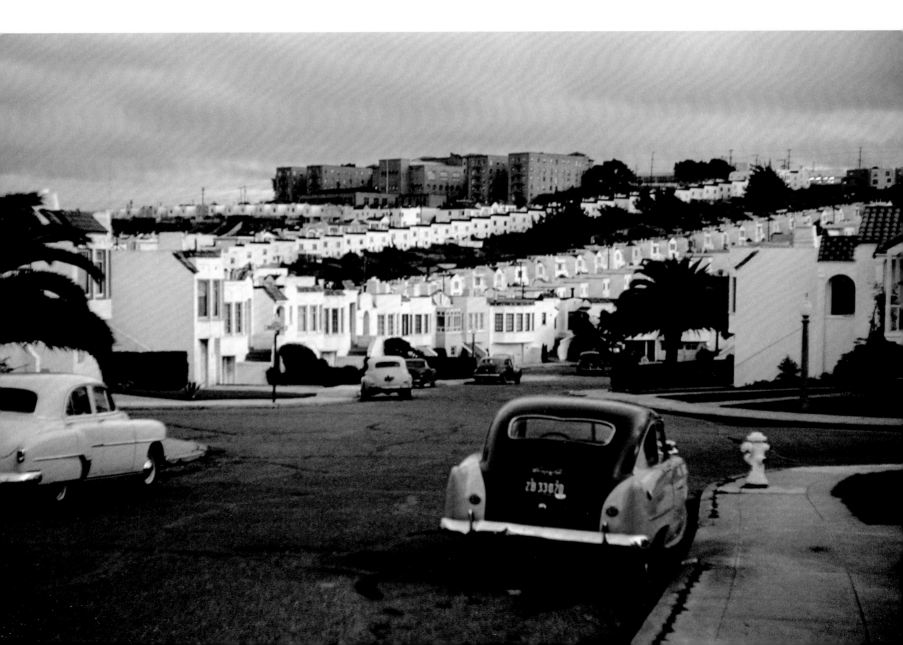

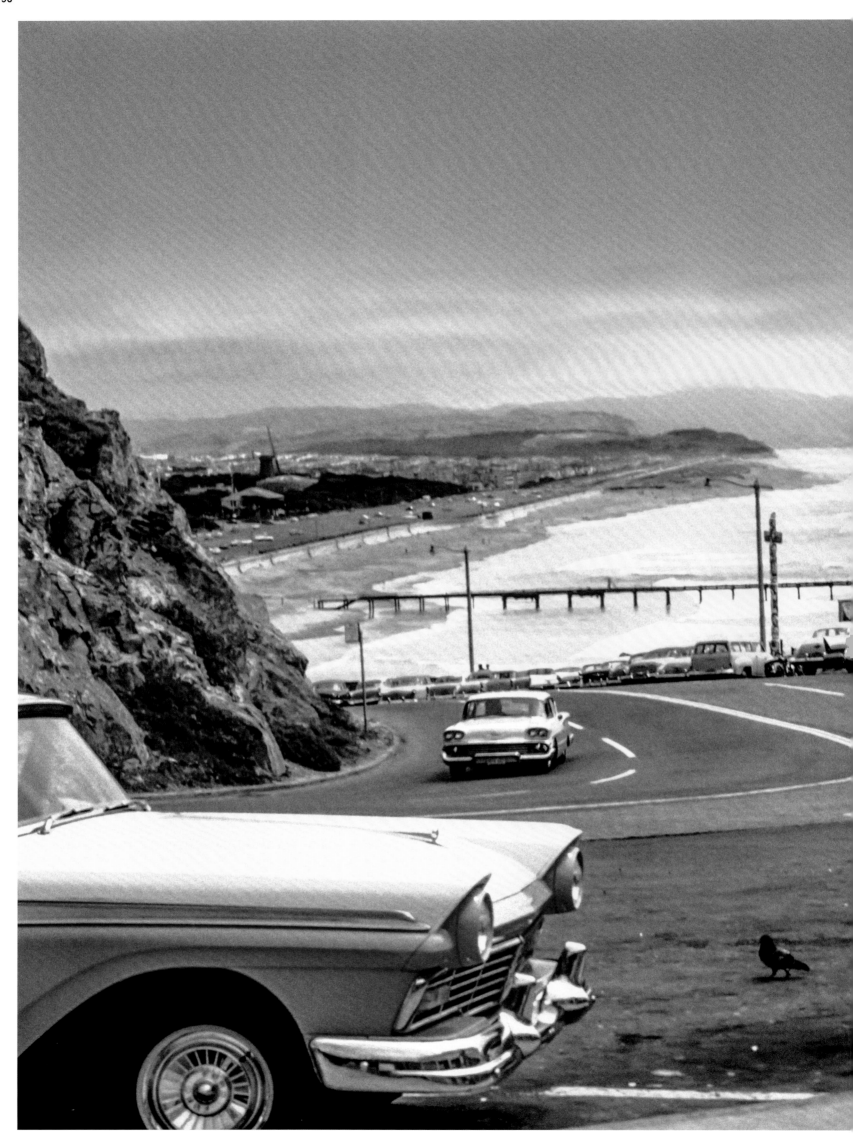

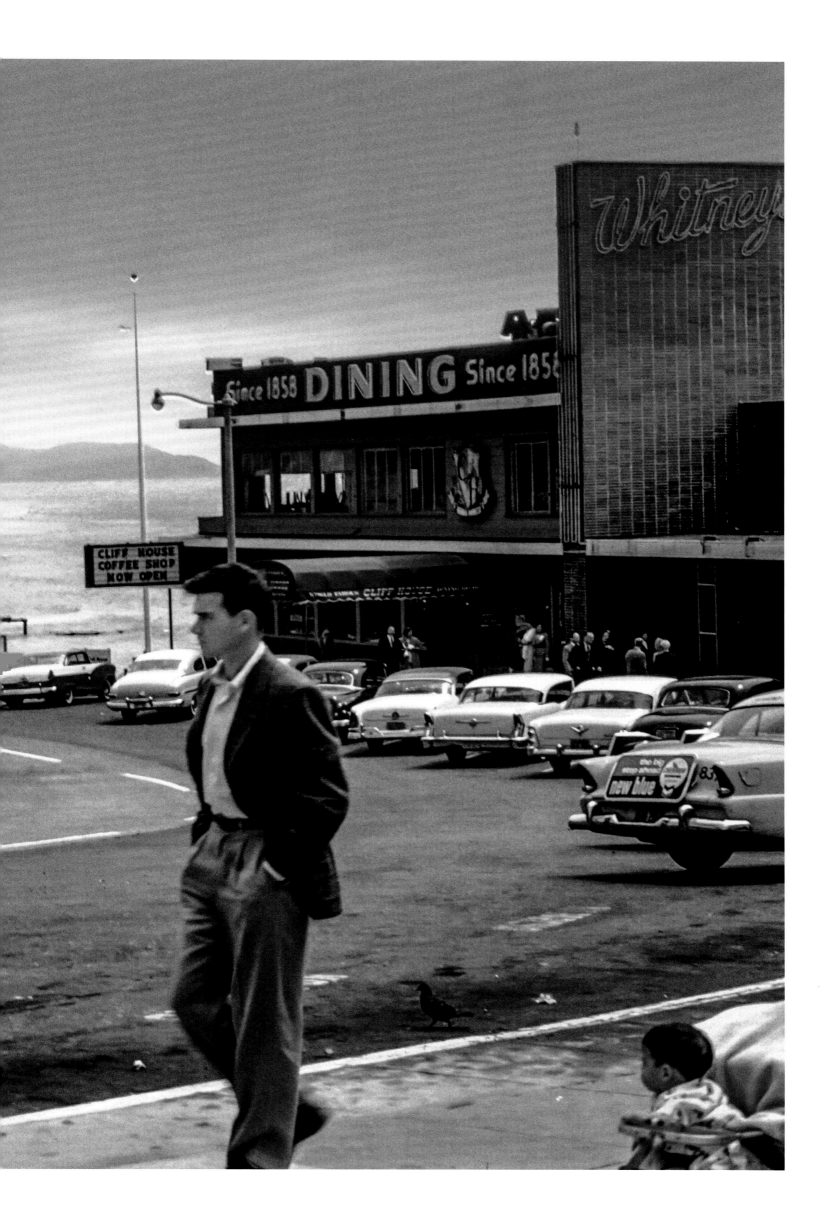

p. 196/197
Anonymous

Perched above the water just north of Ocean Beach, the Cliff House, home to several restaurants and bars, was rebuilt and renovated several times after opening in the Civil War era. The young dude has the strutting sense of cool and informal wear gaining steam in the Beat era, even if that scene was mostly associated with North Beach, 1958.

Das Cliff House, nördlich von Ocean Beach direkt oberhalb des Wassers gelegen, beherbergte einige Bars und Restaurants und wurde mehrmals renoviert und umgebaut, seit es in der Zeit des Bürgerkriegs eröffnet wurde. Der junge Kerl trägt die Coolness und zwanglose Kleidung, die in der Beat-Ära immer beliebter wurden, auch wenn diese Szene hauptsächlich mit North Beach assoziiert wird, 1958.

Perchée sur la falaise au nord d'Ocean Beach, la Cliff House, qui abrite différents restaurants et bars, a été reconstruite et rénovée plusieurs fois depuis son ouverture au cours de la Guerre de Sécession. Au premier plan, le jeune homme affiche sa décontraction et la tenue informelle qui gagnent du terrain en ce début d'ère « beat », même si cette scène reste surtout associée à North Beach. 1958.

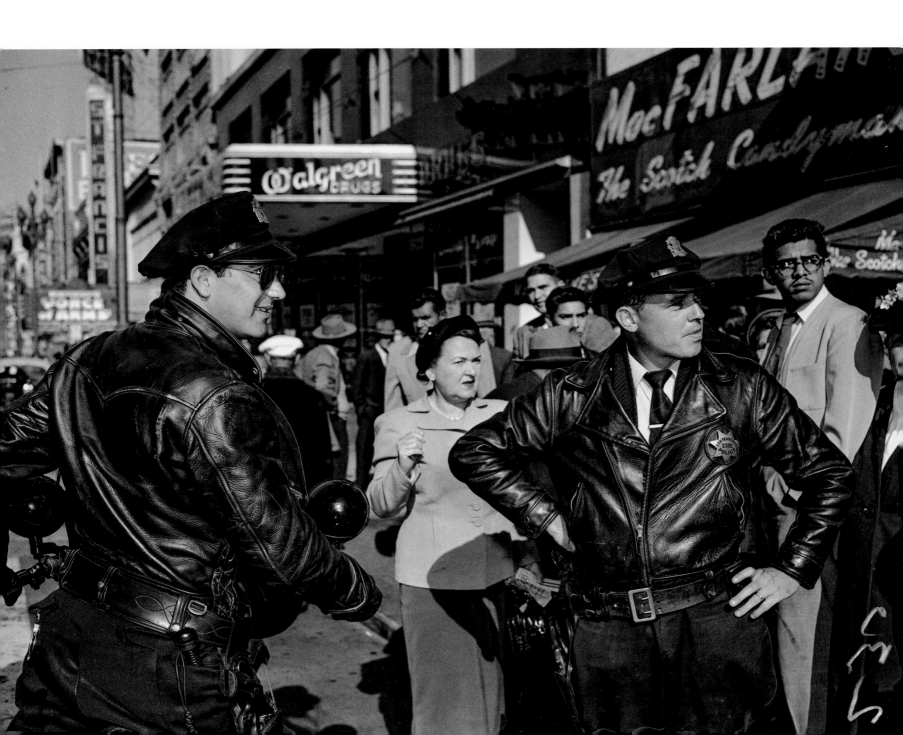

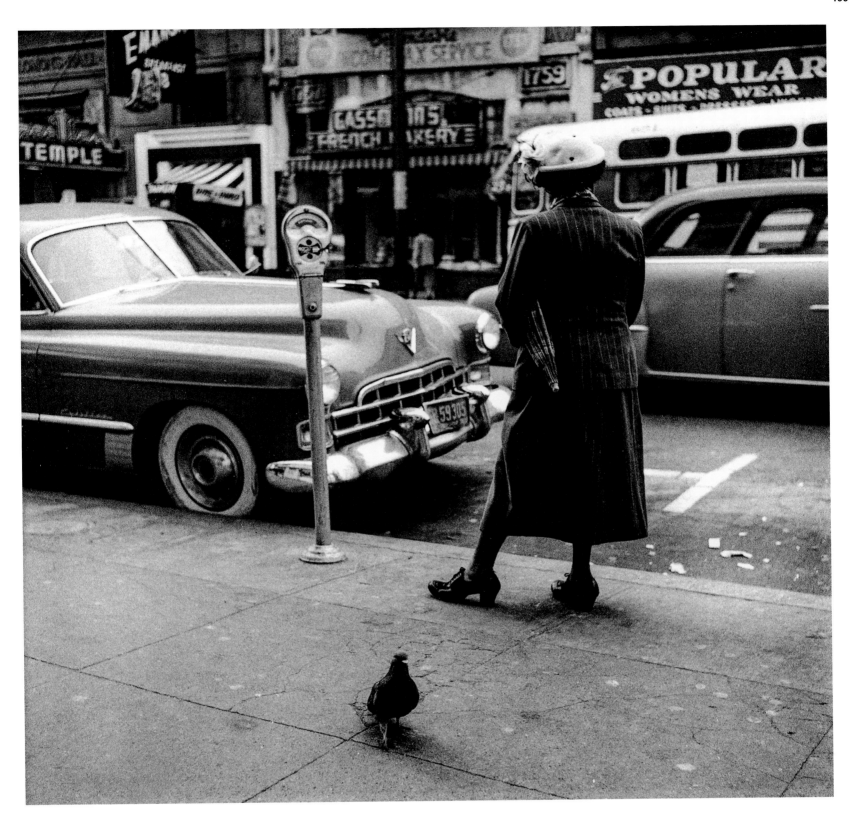

←

Anonymous

Police officers John Kellejian and Joseph Daly stopped a man from jumping off the eighth floor of a downtown building near Market and Sixth streets when this picture was taken, 1951.

Die Polizisten John Kellejian und Joseph Daly hatten gerade einen Mann davon abge- halten, vom siebten Stock eines Gebäudes in der Nähe von Market und Sixth Street zu springen, als dieses Foto gemacht wurde, 1951.

Quand cette photo a été prise, les agents John Kellejian et Joseph Daly venaient d'empêcher un homme de sauter du huitième étage d'un immeuble du centre-ville, non loin de Market Street et de la 6ᵉ Rue. 1951.

↑

Gerald Ratto

A woman walks by a barbershop, French bakery, and women's wear store on the Fillmore Street shopping drag near Sutter Street in the Fillmore District, 1952.

Eine Frau geht an einem Frisörsalon, einer französischen Bäckerei und einem Geschäft für Damenmode auf der Fillmore Street in Höhe der Sutter Street im Fillmore District vorbei, 1952.

Échoppe de barbier, boulangerie française, mode féminine… On trouve toutes sortes de commerces sur Fillmore Street dans le quartier du même nom – ici à proximité de Sutter Street. 1952.

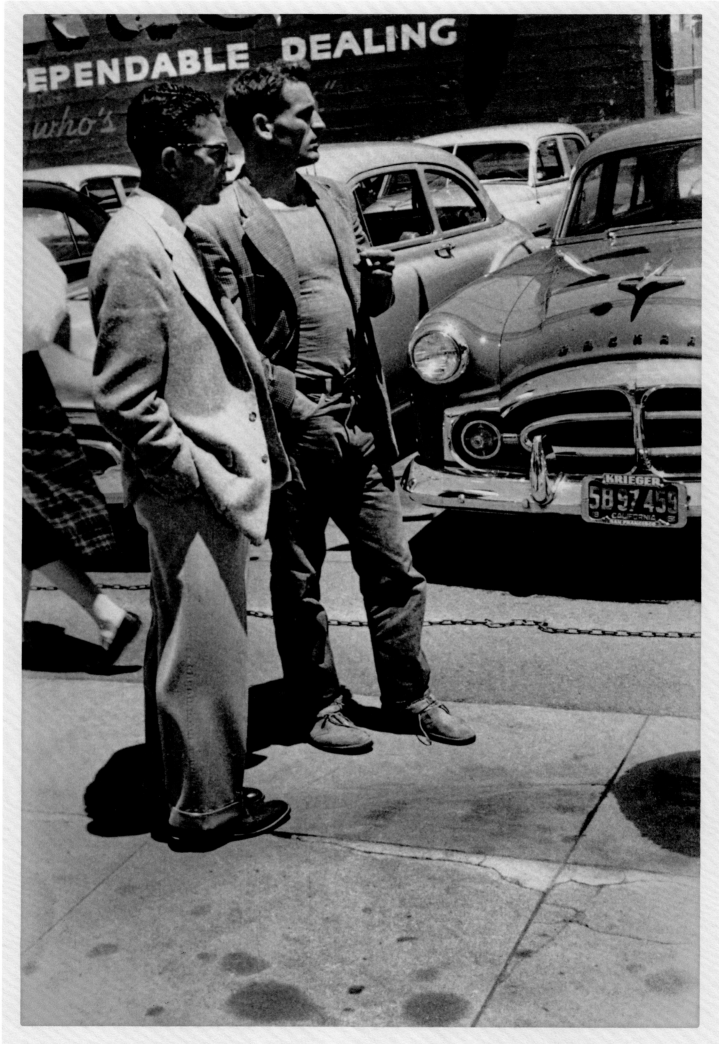

Neal Cassady with cigarette beside salesman surveying used Cars,
North Beach San Francisco 1955.
Allen Ginsberg

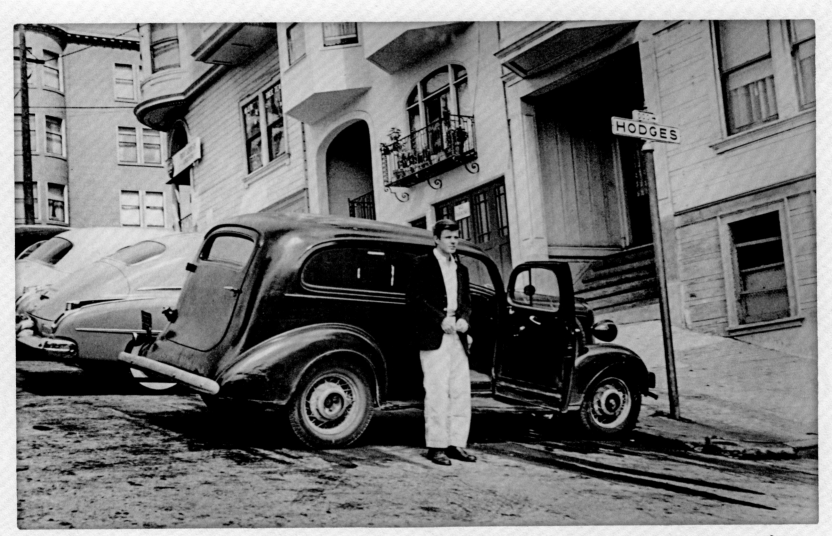

Peter Orlovsky age 21 with our first car "The Hearse", early summer 1955, Telegraph Hill a block up from our apartment rooms on Montgomery near Broadway corner. We drove to Yosemite, The Car cost $125.°° second hand.

Allen Ginsberg

Allen Ginsberg

Neal Cassady (right) and salesman on a North Beach sales lot. As a running/driving buddy of Jack Kerouac, Cassady, the inspiration for Dean Moriarty, the chief cross-country driver in Kerouac's On the Road, was at the forefront of the city's literary Beat scene, if more as a personality than a writer, 1955.

Neal Cassady (rechts) und ein Verkäufer betrachten Autos bei einem Autohändler in North Beach. Cassady war ein wichtiger Teil der literarischen Beat-Szene, wenn auch mehr als Persönlichkeit denn als Autor.

Er reiste mit Jack Kerouc umher und diente als Inspiration für Dean Moriarty aus Kerouacs On the Road, 1955.

Au côté du vendeur, Neal Cassady (à droite) passe en revue les voitures exposées devant ce garage de North Beach. Compagnon de route de Jack Kerouac, il a inspiré le personnage de Dean Moriarty, conducteur émérite auprès de qui l'auteur de Sur la route sillonne le pays. Il était lui-même aux avant-postes de la scène littéraire beat de la ville, par sa personnalité plus que pour son œuvre. 1955.

Allen Ginsberg

Poet Peter Orlovsky, a longtime partner of Allen Ginsberg, with the pair's first car, "The Hearse." On this part of Vallejo Street by Hodges Alley in North Beach, the road is so steep that cars have to park sideways, as they do on many of the city's hills, 1955.

Der Dichter Peter Orlovsky, der langjährige Lebensgefährte von Allen Ginsberg, mit dem ersten Auto des Paars, dem „Leichenwagen". An diesem Teil der Vallejo Street nahe der Hodges Alley in North Beach ist die Straße so steil, dass die Autos seitwärts parken

müssen, sowie auf vielen anderen Hügeln der Stadt auch, 1955.

Le poète Peter Orlovsky, compagnon de longue date d'Allen Ginsberg, adossé à la première voiture du duo surnommée « The Hearse » (le corbillard). La route est si raide sur ce tronçon de Vallejo Street, près de Hodges Alley à North Beach, que les véhicules doivent se garer latéralement, comme c'est le cas sur de nombreuses hauteurs de la ville. 1955.

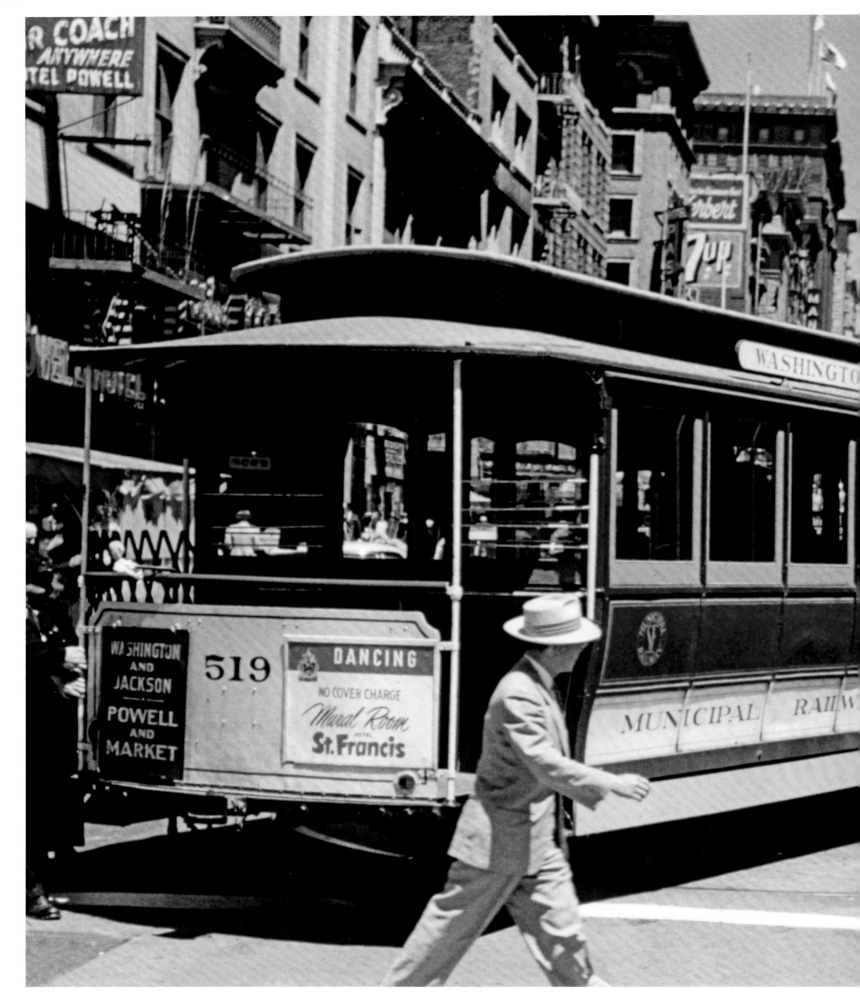

Charles W. Cushman

The turnaround where riders board cable cars at Market and Powell streets. This is still where most tourists start their cable car journeys today, although this line, which ran from downtown to Pacific Heights, stopped running in 1956, a couple of years after this picture was taken, 1954.

Passagiere steigen an der Wendestation an, Market und Powell Street ein. Die meisten Touristen beginnen ihre Fahrt mit den Cable Cars immer noch an diesem Ort, auch wenn die Linie von Downtown nach Pacific Heights 1956, kurz nach der Aufnahme dieses Bildes, eingestellt wurde, 1954.

La plaque tournante où les usagers montent dans les cable cars à l'angle de Market Street et de Powell Street. C'est là encore, aujourd'hui, que la plupart des touristes entament leur périple tracté, bien que cette ligne qui reliait le centre-ville à Pacific Heights ait été fermée en 1956, deux ans après cette photo. 1954.

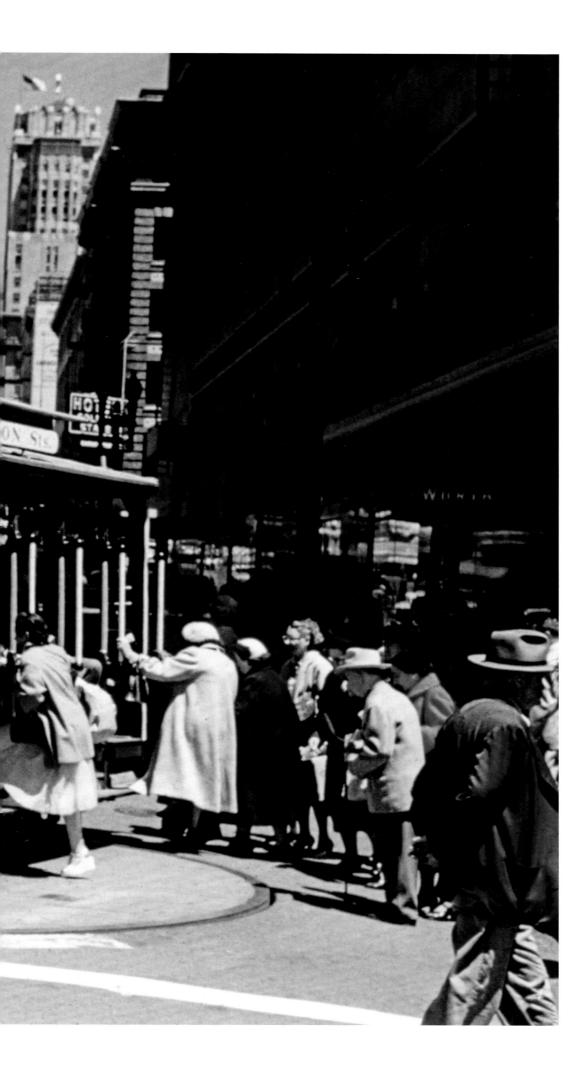

"I wanted to get to San Francisco, everybody wants to get to
San Francisco and what for? In God's name under the stars what for?
For joy, for kicks, for something burning in the night."

„Mir machte das nichts aus, schließlich wollte ich nur wieder
nach San Francisco, alle wollen nach San Francisco, und warum?
In Gottes Namen und unter den Sternen warum? Aus Spaß,
aus Jux und Tollerei, damit etwas brennt in der Nacht."

« […] je voulais aller à San Francisco. Tout le monde veut y aller,
et pourquoi faire? Au nom du Ciel et des étoiles, pourquoi faire?
Pour la joie, pour le pied, pour cet éclat dans la nuit.»

JACK KEROUAC, *ON THE ROAD*, 1957

Imogen Cunningham

*Ocean Beach from Sutro Heights, simply
titled* The Beach, San Francisco. *From 1894
to 1967, a long iron pier, variously known as
Lurline Pier and Olympic Pier, stretched far
into the water a few blocks north of Golden
Gate Park, 1955.*

*Ocean Beach von den Sutro Heights aus, der
Titel des Bildes lautet schlicht* The Beach,
San Francisco. *Von 1894 bis 1967 ragte hier
ein eiserner Pier, bekannt als Lurline Pier
oder Olympic Pier, weit ins Meer hinein, nur
ein paar Blocks nördlich vom Golden Gate
Park, 1955.*

*Vue sur Ocean Beach depuis Sutro Heights,
simplement intitulée* The Beach, San
Francisco. *De 1894 à 1967, une longue jetée
en fer, indifféremment appelée Lurline Pier
ou Olympic Pier, s'avançait assez loin dans
la mer. On est ici à quelques rues au nord
du Golden Gate Park. 1955.*

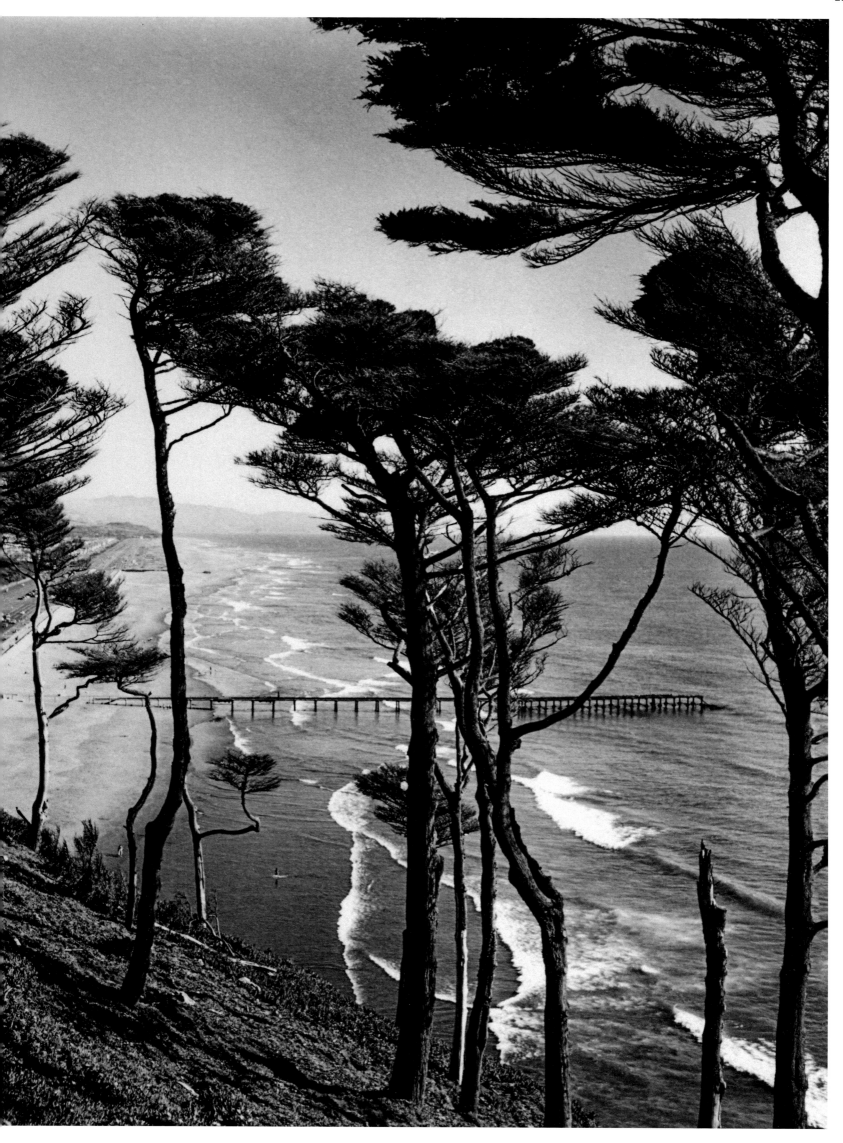

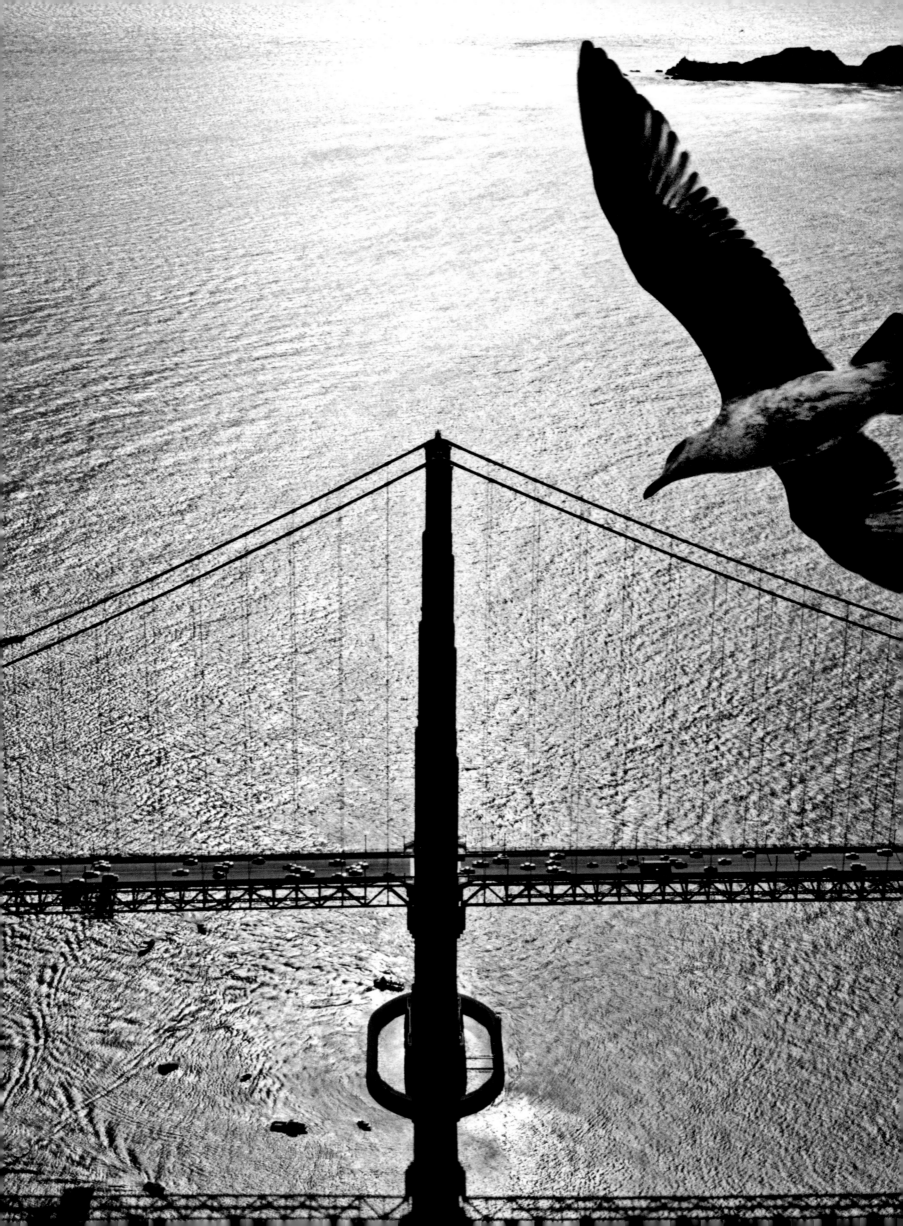

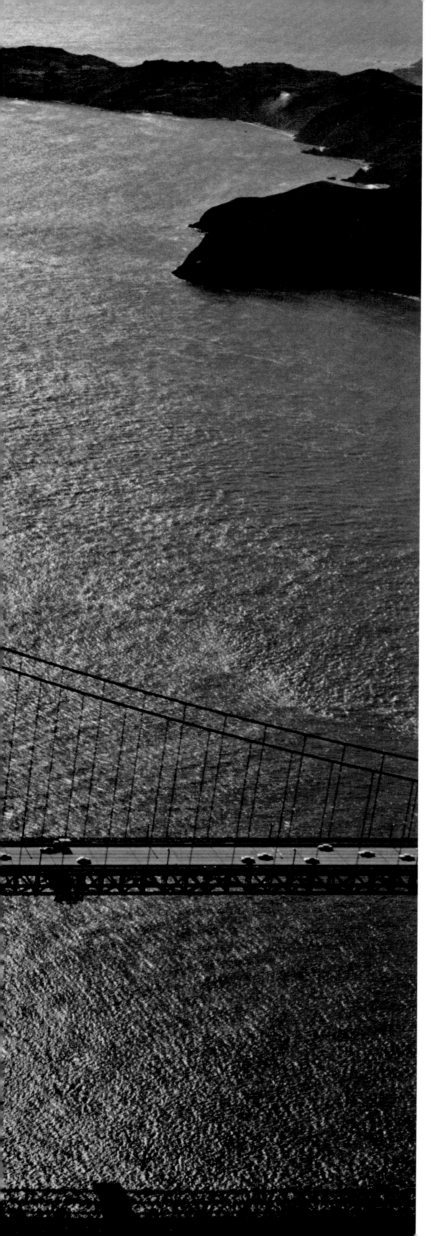

Fred Lyon

Aerial view of the Golden Gate Bridge. By the mid-1950s, the toll was 25 cents per car, compared to 50 cents when the bridge first opened in 1937, c. mid-1950s.

Die Golden Gate Bridge aus der Luft gesehen. Mitte der 1950er-Jahre betrug die Mautgebühr 25 Cent und somit nur die Hälfte der 50 Cent, die für jedes Auto bei der Eröffnung im Jahr 1937 verlangt wurden, Mitte 1950er.

Vue aérienne du Golden Gate Bridge. Au milieu des années 1950, le passage coûtait 25 cents par voiture contre 50 cents à l'ouverture du pont en 1937. Vers le milieu des années 1950.

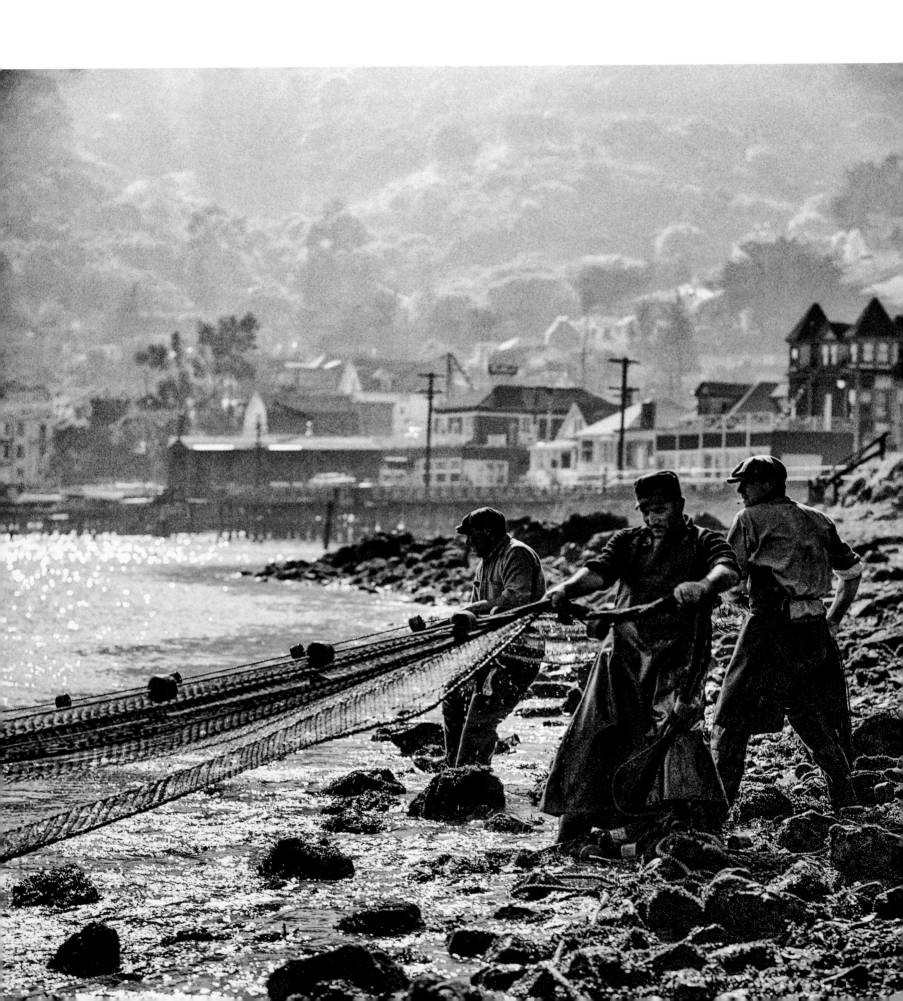

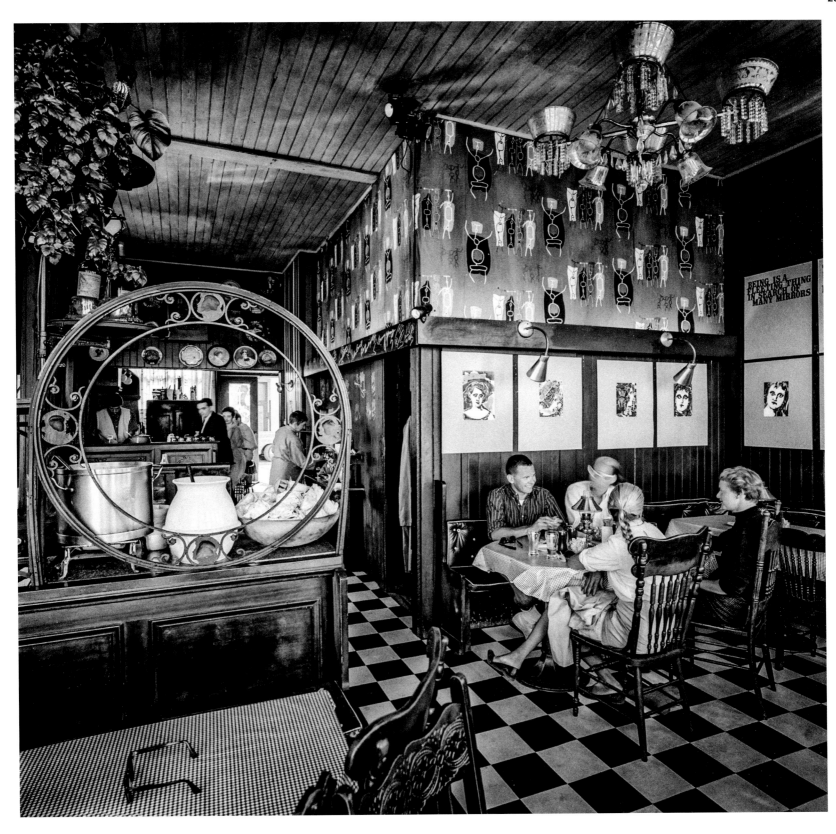

Fred Lyon

Fishermen on the Sausalito waterfront. Portuguese fishermen formed a large part of the town's community when it was established in the 19th century. For local fishermen, the return of the Pacific herring to spawn in their front yard was the high point of most years. Between November and April, but most often in January, the herring run brought a feeding frenzy of sea lions, seagulls, and other waterfowl, c. 1952.

Fischer am Ufer in Sausalito. Portugiesische Fischer machten einen großen Teil der Bevölkerung des Orts aus, als er im 19. Jahrhundert gegründet wurde. Für die lokale Fischerei war die Rückkehr des pazifischen Herings zum Laichen praktisch direkt vor der

Haustür ein jährliches Highlight. Zwischen November und April, aber vor allem im Januar, verursachte die Rückkehr der Heringe auch Fressgelage bei Seelöwen, Möwen und anderen Wasservögeln, um 1952.

L'heure de tirer les filets sur le front de mer de Sausalito. Au XIXᵉ siècle, la ville abritait de nombreux pêcheurs portugais. Pour les gens du métier, le retour des harengs du Pacifique venus frayer presque à leurs pieds représentait souvent le point d'orgue de l'année. Entre novembre et avril – généralement en janvier, la remonte des harengs provoquait une frénésie gloutonne chez les otaries, les mouettes et les autres espèces marines. 1955.

Fred Lyon

Interior of the Glad Hand restaurant, perched on pilings over Sausalito's waterfront. In the 1950s, it was favored by local artists and writers for its one-dollar dinners. The patrons' exuberance could extend to rowdiness on occasion, such as the evening one diner threw his best buddy through the front window. Today, its expanded version lives on as Scoma's, 1950.

Innenansicht des Restaurants Glad Hand, das auf Pfählen am Ufer von Sausalito steht. In den 1950ern war es bei Künstlern und Autoren wegen des Abendessens für 1 Dollar beliebt. Manchmal konnte die Ausgelassenheit der Gäste auch in Raufereien umschlagen; einmal warf ein Gast seinen besten Freund durch eines der Fenster. Das

erweiterte Restaurant gibt es unter dem Namen Scoma's noch heute, 1950.

L'intérieur du restaurant Glad Hand, perché sur pilotis au-dessus du front de mer de Sausalito. Dans les années 1950, ses dîners à un dollar en firent un repaire apprécié des artistes et écrivains locaux. À l'occasion, l'exubérance de ses habitués pouvait aller très loin, ainsi le soir où un convive jeta son meilleur ami par la fenêtre. Aujourd'hui agrandi, l'établissement s'appelle Scoma's. 1950.

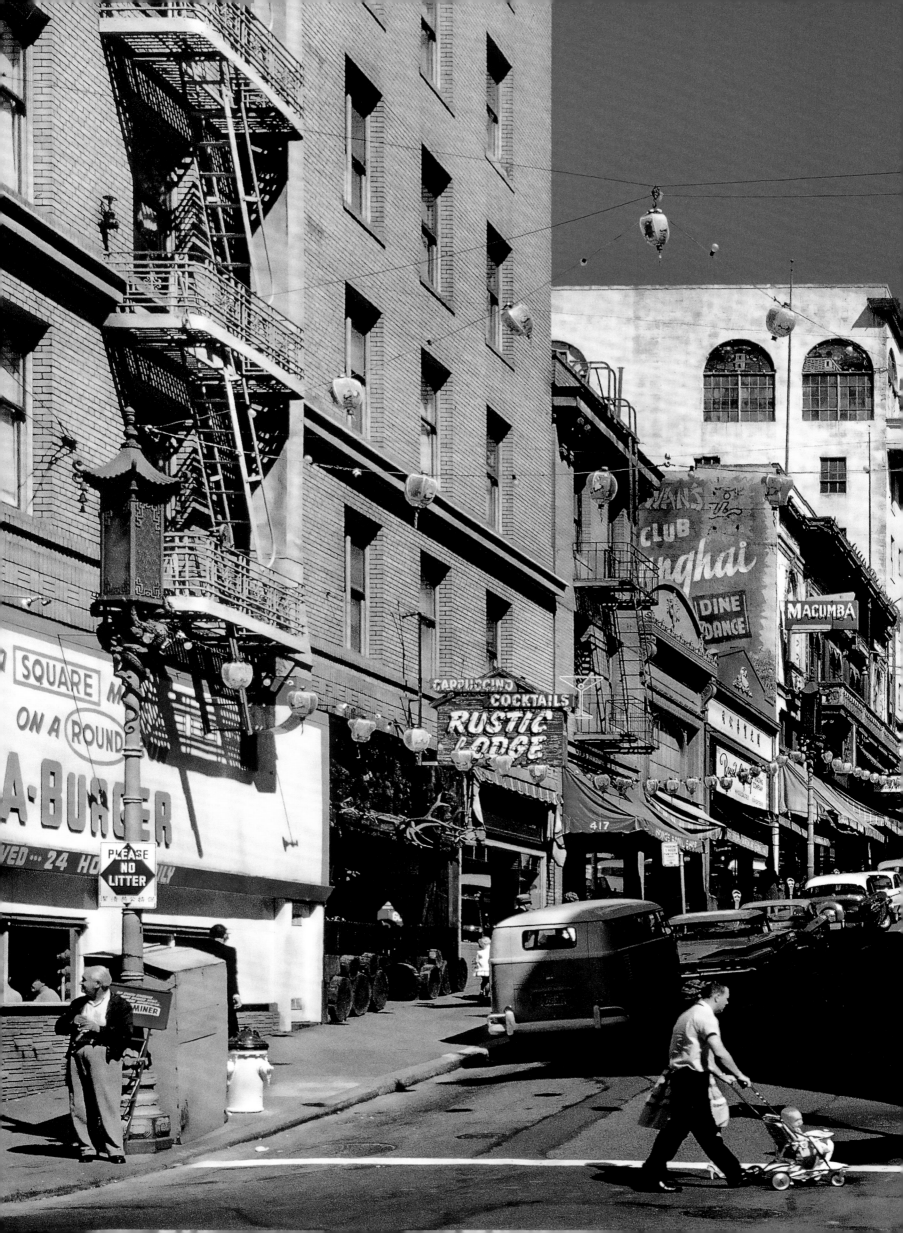

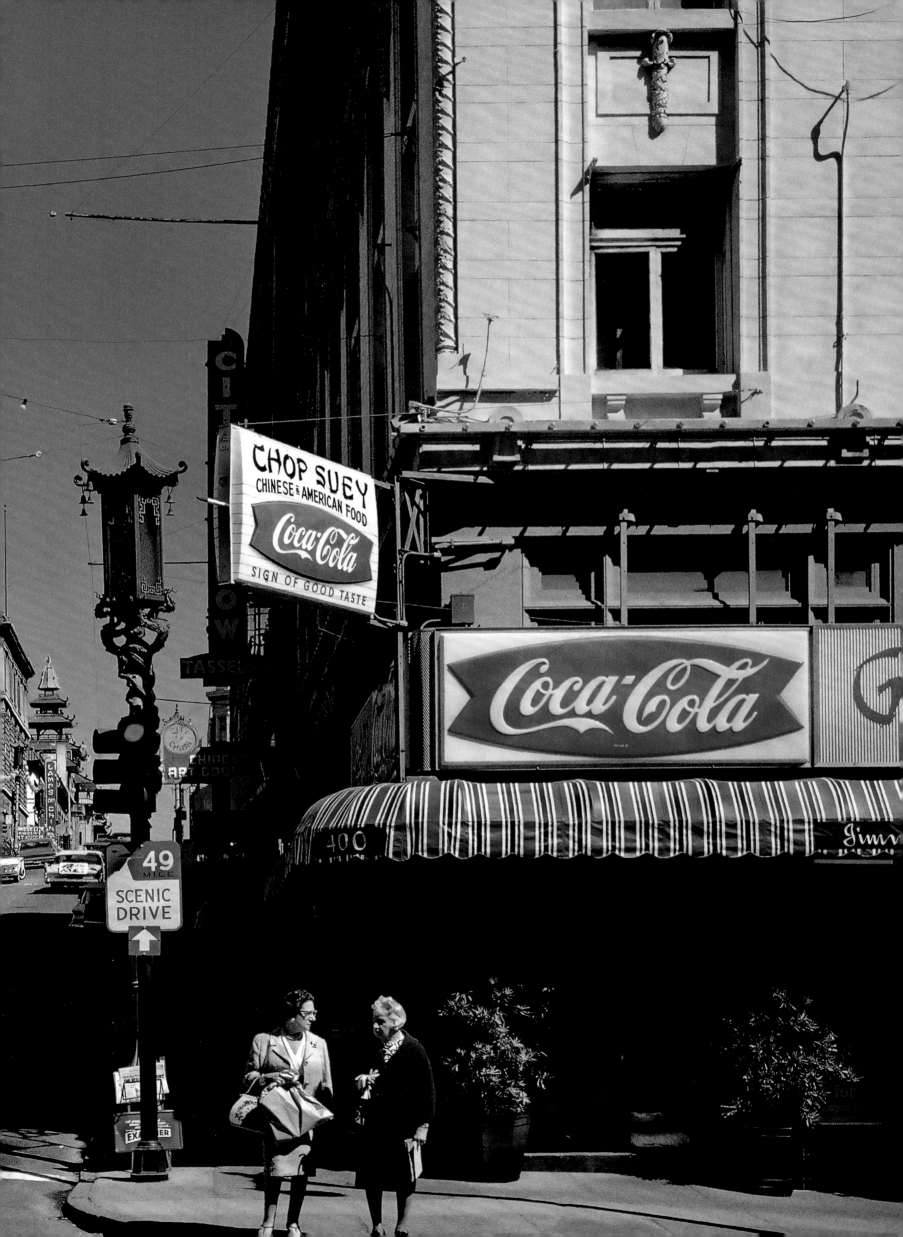

p. 210/211
Fred Herzog

Looking up the south end of Grant Avenue near Bush Street. Grant Avenue is the heart of Chinatown, a dozen densely clustered blocks of restaurants, shops, hotels, and street life. In the musical The Flower Drum Song, *Richard Rodgers and Oscar Hammerstein even celebrated the street with the anthemic "Grant Avenue," 1962.*

Der Blick die Grant Avenue hinauf, nahe der Bush Street. Grant Avenue ist das Herz von Chinatown, einem Dutzend enger Blocks voller Restaurants, Geschäfte, Hotels und Straßenleben. In dem Musical The Flower Drum Song, *feierten Richard Rodgers und Oscar Hammerstein die Straße mit der Hymne „Grant Avenue", 1962.*

La pointe sud de Grant Avenue, à proximité de Bush Street. Grant Avenue, où bat le cœur de Chinatown, abrite une importante densité de restaurants, boutiques, hôtels – tout ce qui compose la vie d'un quartier animé. Dans leur comédie musicale Au rythme des tambours fleuris, *Richard Rodgers et Oscar Hammerstein lui ont consacré une ode qui porte son nom. 1962.*

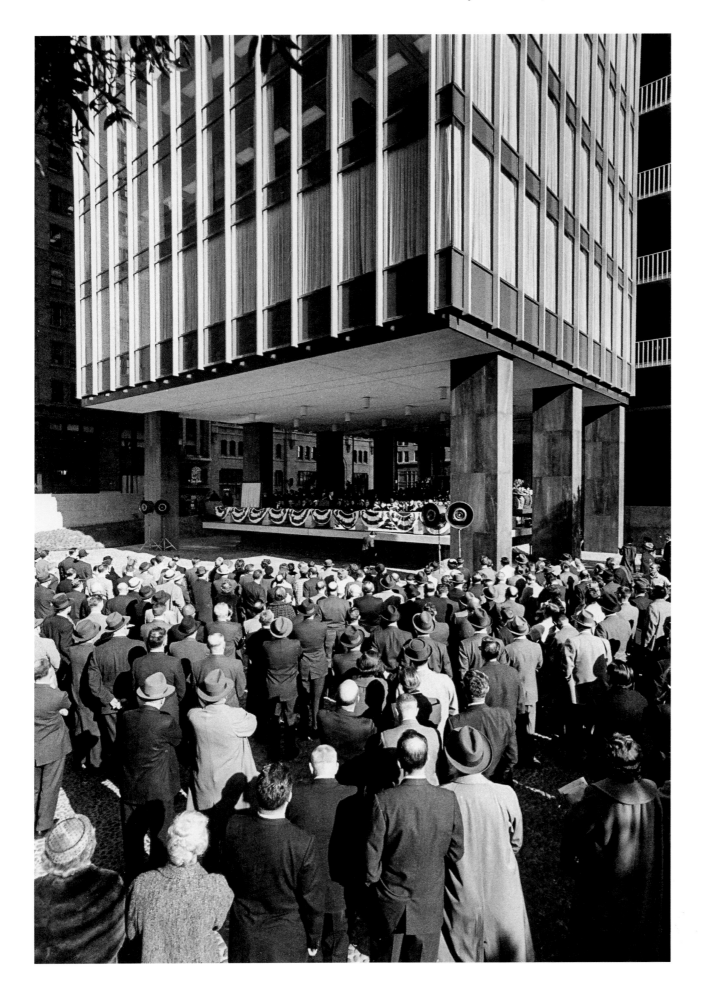

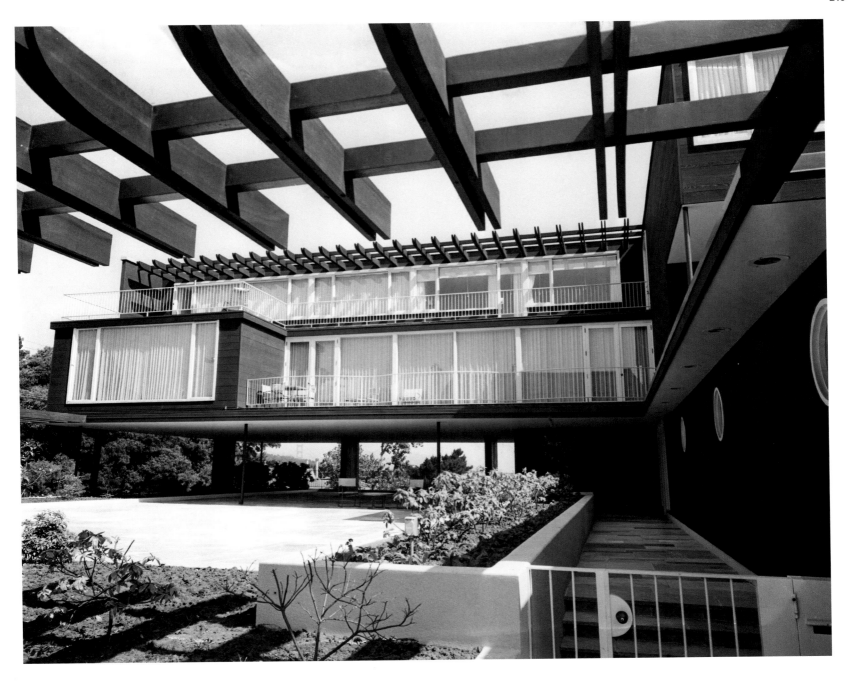

← **Jon Brenneis**

Dedication ceremony for the Crown Zellerbach Building at One Bush Plaza, near where Bush and Battery streets intersect just north of Market Street in the Financial District. The 20-story structure was the first of its size in the city designed in the International Style, 1960.

Die Eröffnungsfeier für das Crown Zeller-bach Building auf der Bush Plaza, nahe der Kreuzung Bush und Battery Street etwas nördlich der Market Street im Finanzdistrikt. Das 20-geschossige Gebäude war das erste der Stadt, das im Internationalen Stil gebaut wurde, 1960.

Cérémonie d'inauguration du Crown Zellerbach Building, également connu sous le nom de One Bush Plaza, à proximité de l'angle de Bush Street et de Battery Street, juste au nord de Market Street dans le Financial District. Cet immeuble de bureaux de vingt étages a été conçu dans le style international, une première à San Francisco. 1960.

↑ **Bob Campbell**

The Russell House, shortly after it opened in Pacific Heights near Washington and Maple streets. It was designed by architect Erich Mendelsohn for Madeleine Haas Russell, a noted philanthropist and great-grandniece of Levi Strauss. The four-floor home features a sizeable ground-level patio and master bedroom whose circular bay windows offer views of the actual San Francisco Bay, 1951.

Das Russel House, kurz nach seiner Eröffnung in Pacific Heights, nahe Washington und Maple Street. Es wurde vom Architekten Erich Mendelsohn für Madeleine Haas Russell entworfen, eine bekannte Philanthropin und Urgroßnichte von Levi Strauss. Teil des vierstöckigen Gebäudes ist ein Patio von beachtlicher Größe und ein Schlafzimmer mit Ausblick über die Bucht von San Francisco, 1951.

La Russell House peu après son achèvement à Pacific Heights, non loin de Washington Street et de Maple Street. Elle a été dessinée par l'architecte Erich Mendelsohn pour Madeleine Haas Russell, philanthrope de renom et arrière-petite-nièce de Levi Strauss, l'inventeur des blue-jeans. Cette structure de quatre niveaux comprend un grand patio au rez-de-chaussée et en haut une chambre spectaculaire d'où le regard, par les baies vitrées circulaires, embrasse la baie. 1951.

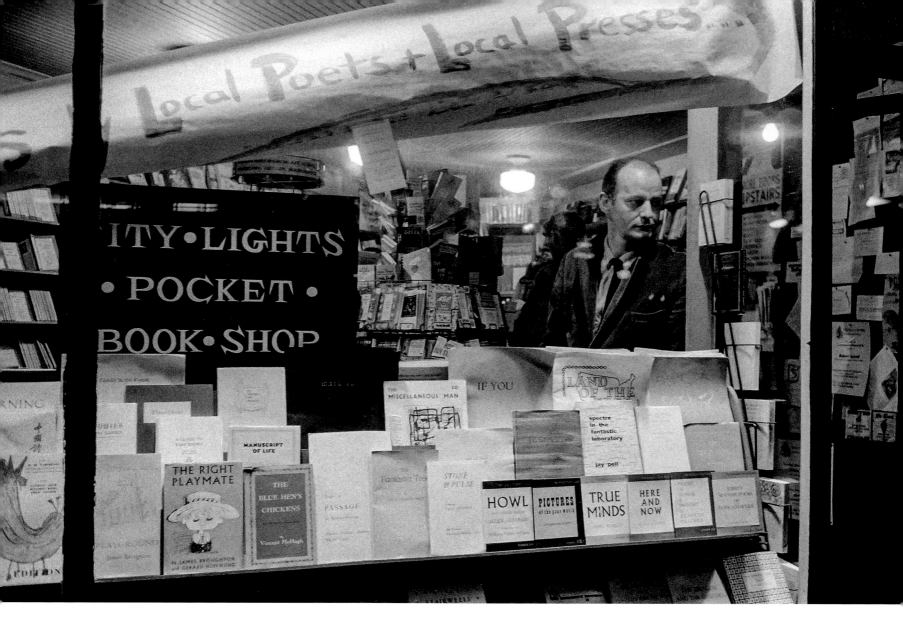

↑
Nat Farbman

Major Beat poet Lawrence Ferlinghetti
gazes out of City Lights, the bookstore he
cofounded in North Beach in 1953. It quickly
became a center of the city's burgeoning
literary community and counterculture.
City Lights also published many notable
books by Beat authors, most famously Allen
Ginsberg's Howl and Other Poems, for
which Ferlinghetti was tried on grounds of
obscenity and acquitted, 1957.

Lawrence Ferlinghetti, einer der wichtigsten
Beat-Dichter, sieht aus dem Fenster von City
Lights, der Buchhandlung, die er 1953 in
North Beach mitgründete. Sie wurde schnell
zu einem Zentrum der aufblühenden
Literaturgemeinde und der Counterculture.
City Lights gab auch einige der wichtigsten
Werke der Beat-Autoren heraus, am berühm-
testen davon Allen Ginsbergs Howl and
Other Poems, aufgrund dessen Ferlinghetti
der Obszönität angeklagt, dann aber freige-
sprochen wurde, 1957.

Lawrence Ferlinghetti, l'un des grands poètes
de la Beat Generation, contemple la librairie
City Lights dont il fut l'un des fondateurs
à North Beach en 1953 et qui devint vite
le centre de la communauté littéraire et de
la contre-culture naissante de San Francisco.
City Lights publia également pléthore
d'ouvrages majeurs de l'ère beat dont le plus
célèbre, Howl and Other Poems d'Allen
Ginsberg, mena l'éditeur devant les juges
pour « obscénité ». Il sera acquitté. 1957.

→
Walter Lehrman

Allen Ginsberg gives one of his first public
readings of his epic poem Howl at San
Francisco State's Poetry Center, using an
early typescript of the work, November 1955.

Allen Ginsberg gibt der ersten öffentlichen
Lesungen einer frühen Fassung seines
epischen Gedichts Howl im Poetry Center
der San Francisco State University,
November 1955.

Allen Ginsberg donne l'une des premières
lectures publiques de son épique poème
« Howl » au Poetry Center de San Francisco,
en s'aidant d'une première version dactylo-
graphiée de l'œuvre. Novembre 1955.

*"I GREET YOU AT THE BEGINNING OF A GREAT CAREER
[STOP] WHEN DO I GET MANUSCRIPT OF* HOWL?"

*„ICH GRÜSSE SIE AM BEGINN EINER GROSSARTIGEN KARRIERE
[STOPP] WANN BEKOMME ICH DAS MANUSKRIPT VON* DAS GEHEUL?"

*«JE VOUS SALUE À L'AUBE D'UNE GRANDE CARRIÈRE.
QUAND RECEVRAI-JE LE MANUSCRIT DE* HOWL?»

LAWRENCE FERLINGHETTI, TELEGRAM TO ALLEN GINSBERG

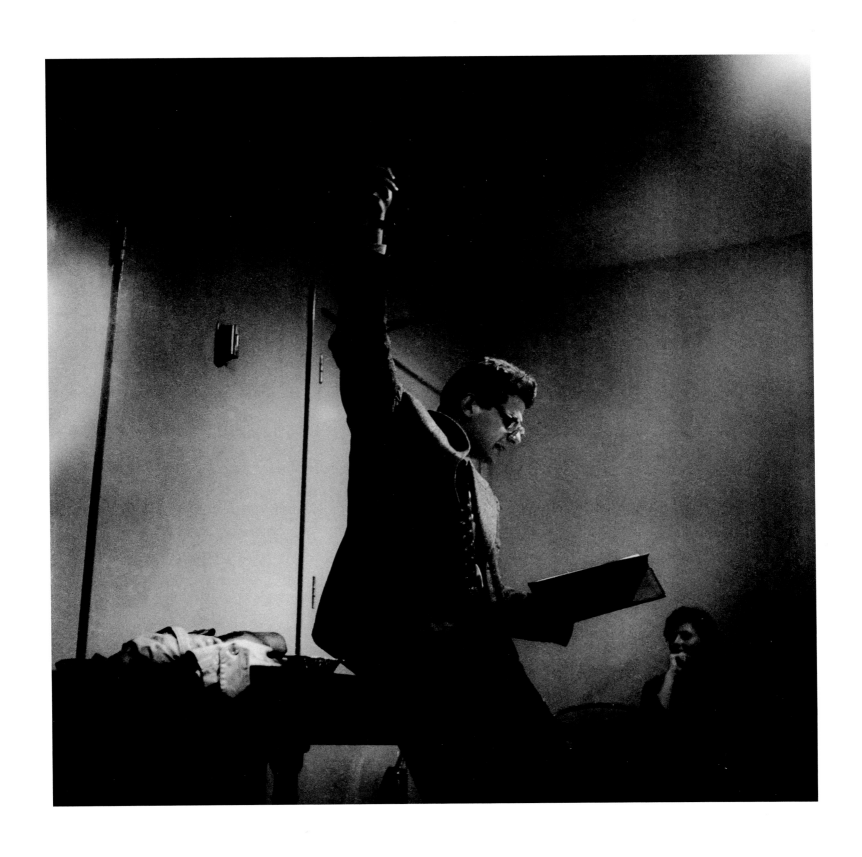

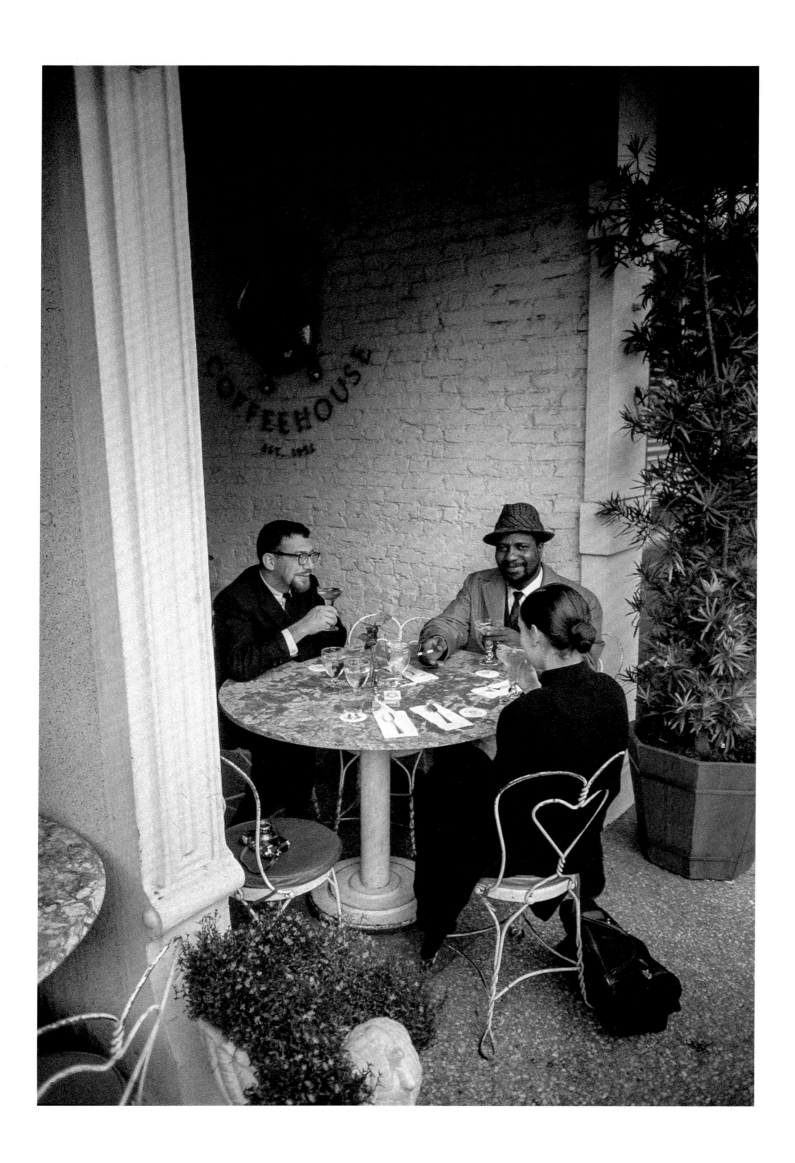

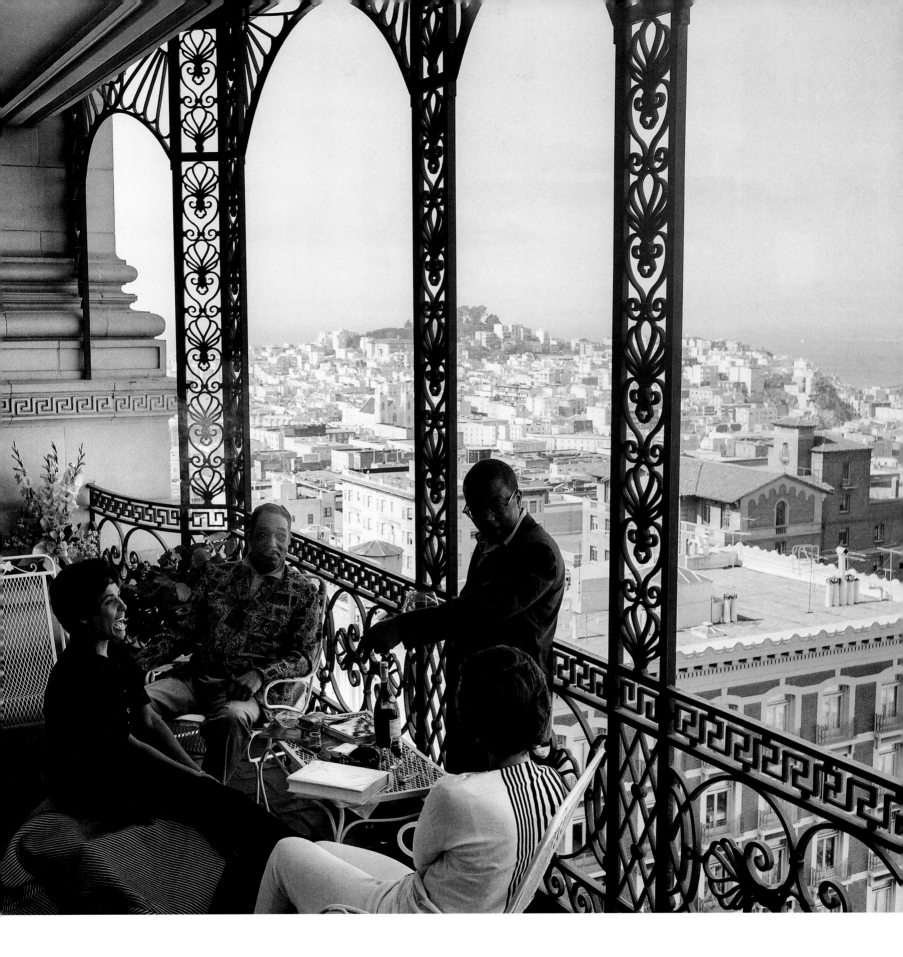

←
William Claxton

Jazz piano great Thelonious Monk (center) has a drink and a smoke with a couple of friends. On April 29 of this year, he recorded a live album at the Black Hawk. His previous LP, Thelonious Alone in San Francisco, *had also been taped in town, testifying to its place as a home away from home for many jazz stars, 1960.*

Der große Jazzpianist Thelonious Monk (Mitte) trifft sich auf einen Drink und eine Zigarette mit ein paar Freunden. Am 29. April desselben Jahres nahm er sein Live-album im Black Hawk auf. Davor hatte

er die LP Thelonious Alone in San Francisco, *auch in der Stadt aufgenommen – ein Beweis dafür, dass die Stadt für viele Jazz-stars ein zweites Zuhause war, 1960.*

Le grand pianiste de jazz Thelonious Monk (au centre) prend un verre avec quelques amis. Le 29 avril de cette année, il enregistrait au Black Hawk un album live. Son disque précédent, Thelonious Alone in San Francisco, *avait également été produit dans cette ville où tant de stars de jazz se sentaient comme chez elles. 1960.*

↑
Gordon Parks

Jazz giant Duke Ellington (center), singer Lena Horne (left), arranger Billy Strayhorn, and Patricia Willard enjoying the lovely view from a Fairmont Hotel balcony atop Nob Hill, 1960.

Der Jazzgigant Duke Ellington (Mitte), Sängerin Lena Horne (links), Arrangeur Billy Strayhorn und Patricia Willard genießen den Ausblick vom Balkon des Fairmont Hotels auf dem Nob Hill, 1960.

Le géant du jazz Duke Ellington (au centre), la chanteuse Lena Horne (à gauche), l'arrangeur Billy Strayhorn et la journaliste Patricia Willard profitent d'une vue magnifique depuis le balcon de l'hôtel Fairmont, au sommet de Nob Hill. 1960.

"*Near Fillmore and in the Tenderloin, especially, those institutions known as 'after-hours joints' present music and entertainment until long after dawn has streaked the sky.*"

„*Vor allem in der Nähe von Fillmore und im Tenderloin bieten die als 'After-Hour-Kaschemmen' bekannten Einrichtungen Musik und Unterhaltung bis weit nach Sonnenaufgang.*"

«*Près de Fillmore et dans le Tenderloin, en particulier, ces établissements connus sous le nom d'after hours proposent de la musique et du divertissement longtemps encore après que l'aube a blanchi le ciel.*»

SAN FRANCISCO CHRONICLE, 1958

William Claxton

Jazz saxophonist Pony Poindexter literally hanging out at a cable car on the California Street line, which runs from Market Street near the Embarcadero to Van Ness Avenue just past Nob Hill. Poindexter had studied at Oakland's Candell Conservatory of Music before playing with stars like Lionel Hampton and Stan Kenton, 1960.

Jazz-Saxofonist Pony Poindexter hängt wörtlich an einem Waggon der Linie California Street rum, die von der Market Street nahe dem Embarcadero zur Van Ness Avenue direkt hinter Nob Hill fährt. Poindexter studierte am Candell Conservatory of Music in Oakland, bevor er zusammen mit Stars wie Lionel Hampton oder Stan Kenton auftrat, 1960.

Le saxophoniste de jazz Pony Poindexter agrippé à un cable car de la ligne qui relie Market Street, près de l'Embarcadero, à Van Ness Avenue, juste après Nob Hill. Poindexter étudia au Conservatoire Candell, à Oakland, avant de jouer avec des stars telles que Lionel Hampton et Stan Kenton. 1960.

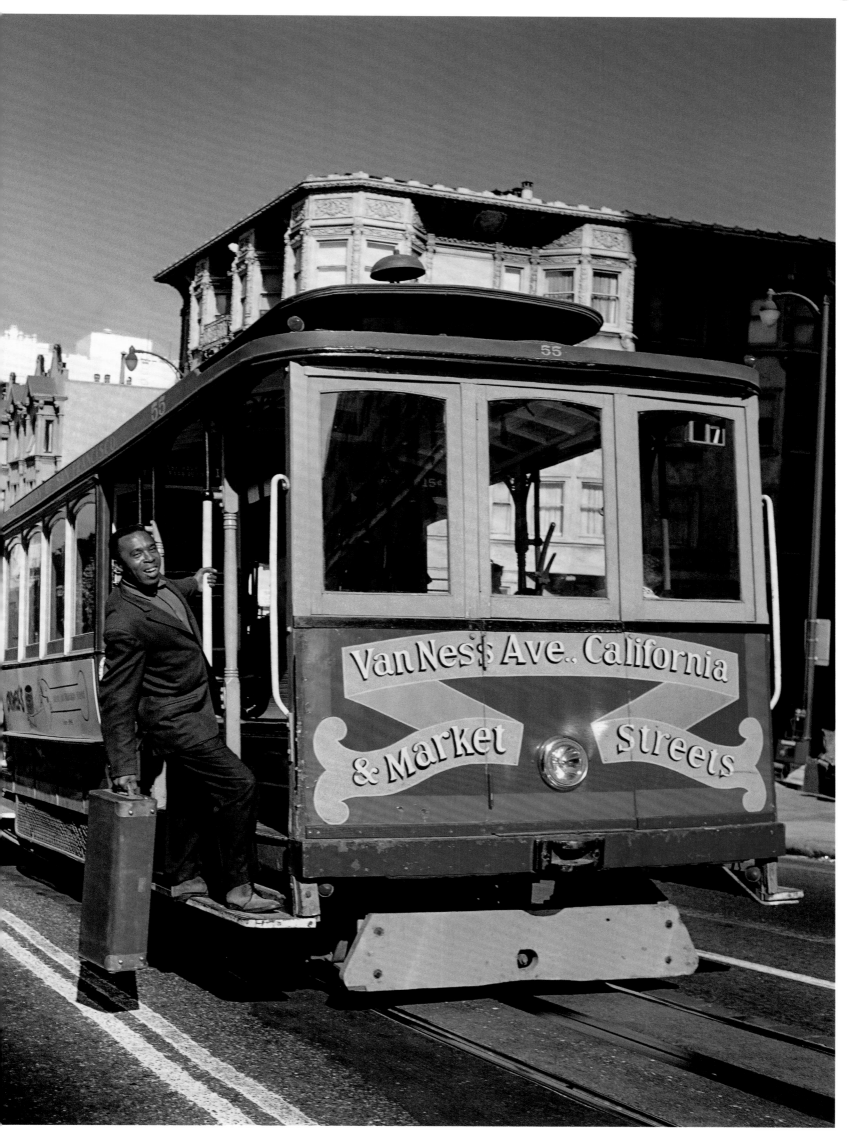

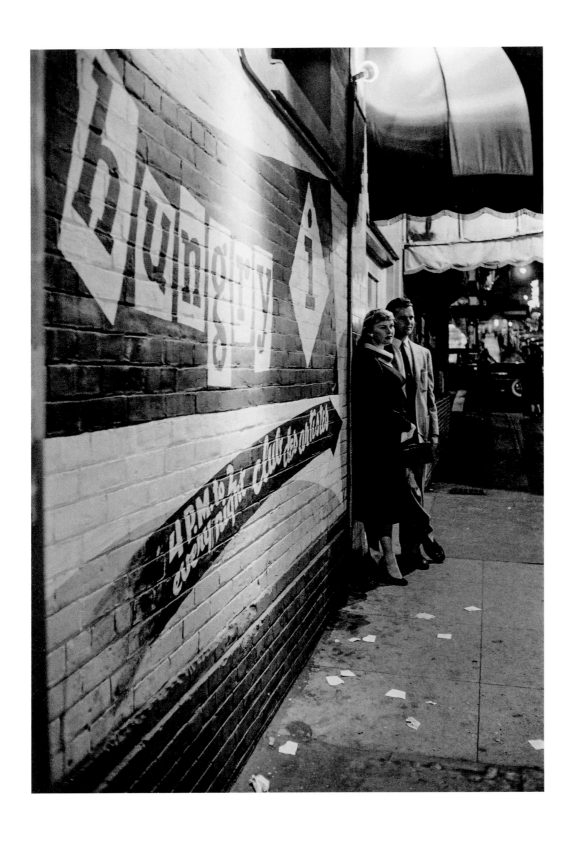

↑

Nat Farbman

The hungry i (as it was spelled, in lowercase) was the top nightclub in North Beach, and the best venue in all of San Francisco for music and comedy in the late 1950s. It's most renowned as the spot where the Kingston Trio, who recorded their second album there, built their following before becoming the biggest folk act in the United States, 1955.

Das hungry i (man legte Wert auf die Klein- schreibung) war der beliebteste Nachtclub in North Beach und die beste Anlaufstelle für Musik und Comedy in ganz San Francisco in den späten 1950ern. Am bekanntesten ist es als der Ort, an dem das Kingston Trio, das hier sein zweites Album aufnahm, seine ersten Fans hatte, bevor es zur größten Folk- Nummer der USA wurde, 1955.

Le hungry i était le meilleur night-club de North Beach, et l'adresse incontournable pour la musique et la comédie à la fin des années 1950. C'est là que le Kingston Trio, qui y enregistra son deuxième album, se fit connaître avant de devenir le plus grand groupe de folk des États-Unis. 1955.

↓
Leigh Wiener

At Turk and Hyde streets in the Tenderloin, the Black Hawk was one of the most prestigious jazz clubs in the country in the 1950s and early 1960s, and vital to expanding the audience of one of Northern California's most popular post-bop musicians, pianist Dave Brubeck. This shot was taken during a two-night stint by Miles Davis in April, 1961.

An der Ecke Turk und Hyde Street im Tenderloin, war das Black Hawk während der 1950er- und frühen 1960er-Jahre einer der angesehensten Jazzclubs des Landes. Einer der beliebtesten Post-Bop-Musiker Kaliforniens, der Pianist Dave Brubeck, wurde hier einem breiteren Publikum bekannt. Dieser Schnappschuss wurde aufgenommen, als Miles Davis hier an zwei Abenden auftrat, April 1961.

Situé à l'angle de Turk Street et de Hyde Street dans le quartier du Tenderloin, le Black Hawk était dans les années 1950 l'un des clubs de jazz les plus prestigieux du pays. Au début de la décennie suivante, il contribuera de manière décisive à élargir l'audience de l'un des musiciens post-bop les plus populaires de Californie, le pianiste Dave Brubeck. Cette photo a été prise le soir de l'un des deux concerts donnés là par Miles Davis, en avril 1961.

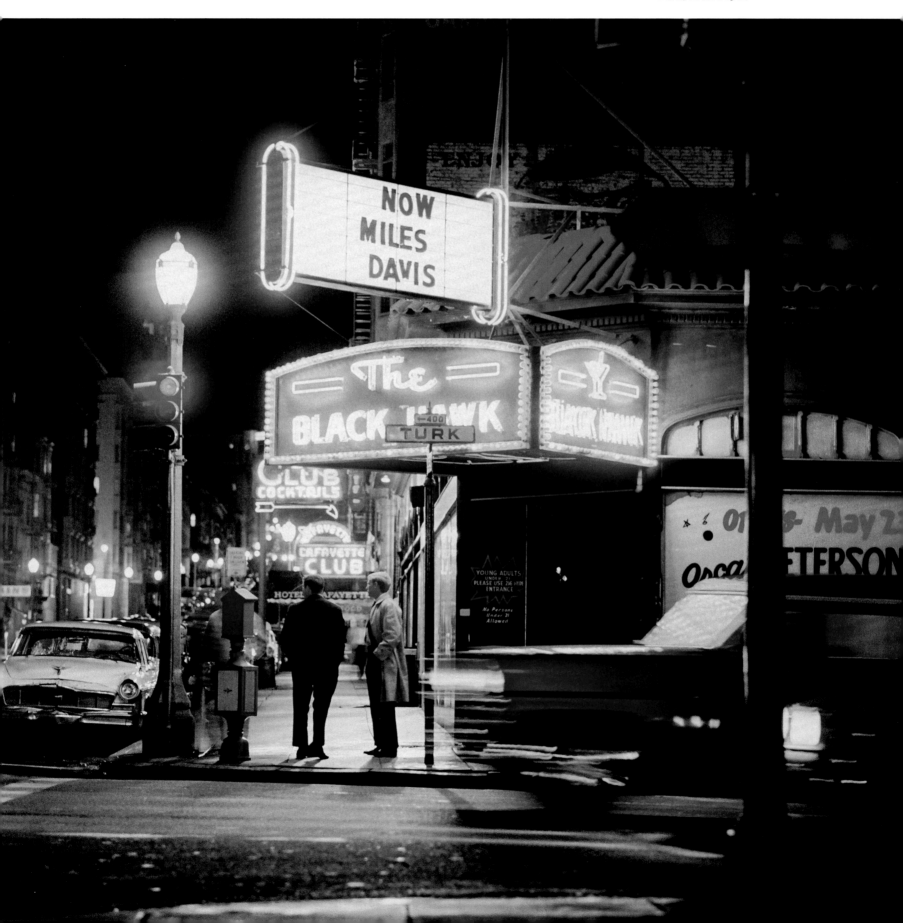

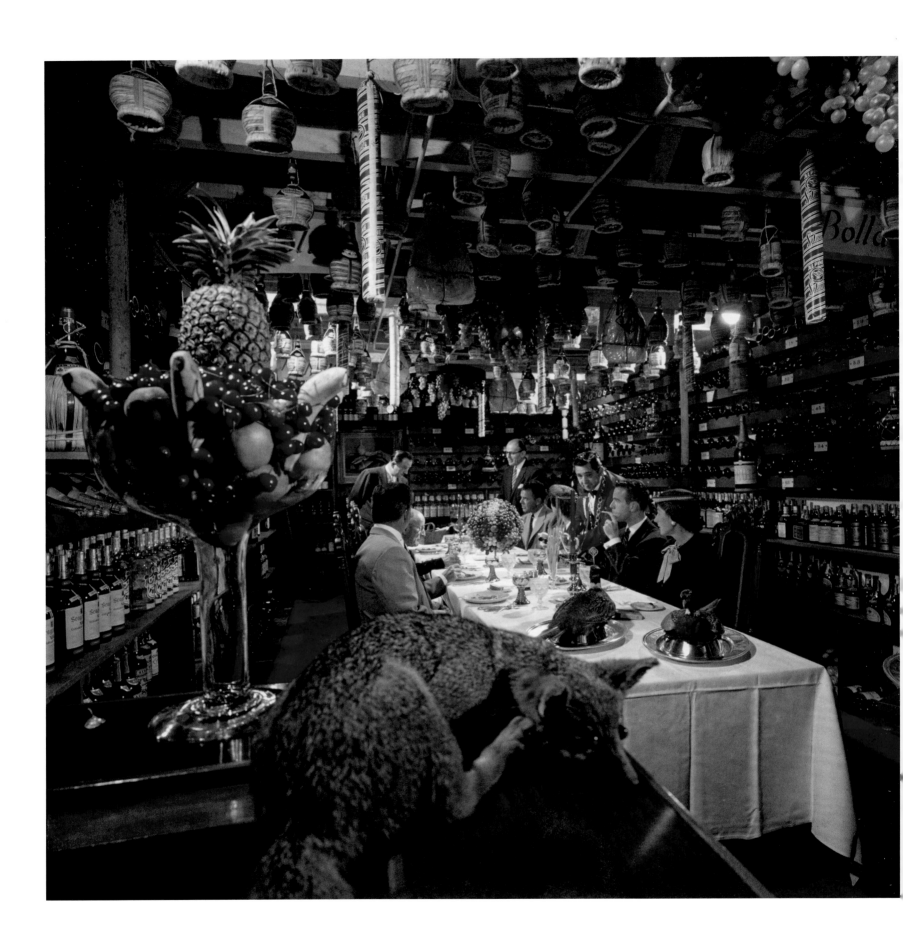

↑

Nat Farbman

In the wine cellar of the Blue Fox, whose gourmet dining and lavish setting drew celebrities like Joe DiMaggio, Marilyn Monroe, and Frank Sinatra. Billed as "the restaurant across from the morgue" near Portsmouth Square where North Beach, the Financial District, and Chinatown nearly intersect, 1956.

Der Weinkeller des Blue Fox lockte mit seinem ausgezeichneten Essen und prunkvollen Dekor zogen Berühmtheiten wie Joe DiMaggio, Marilyn Monroe und Frank Sinatra an. Bekannt als „das Restaurant gegenüber vom Leichenschauhaus", liegt es nahe des Portsmouth Square, wo North Beach, der Finanzdistrikt und Chinatown aufeinandertreffen, 1956.

Dîner dans la cave à vin du Blue Fox, dont la cuisine gastronomique et le cadre somptueux ont drainé des célébrités telles que Joe DiMaggio, Marilyn Monroe et Frank Sinatra. Surnommé « le restaurant en face de la morgue » et situé près de Portsmouth Square où se rejoignent North Beach, le Financial District et Chinatown. 1956.

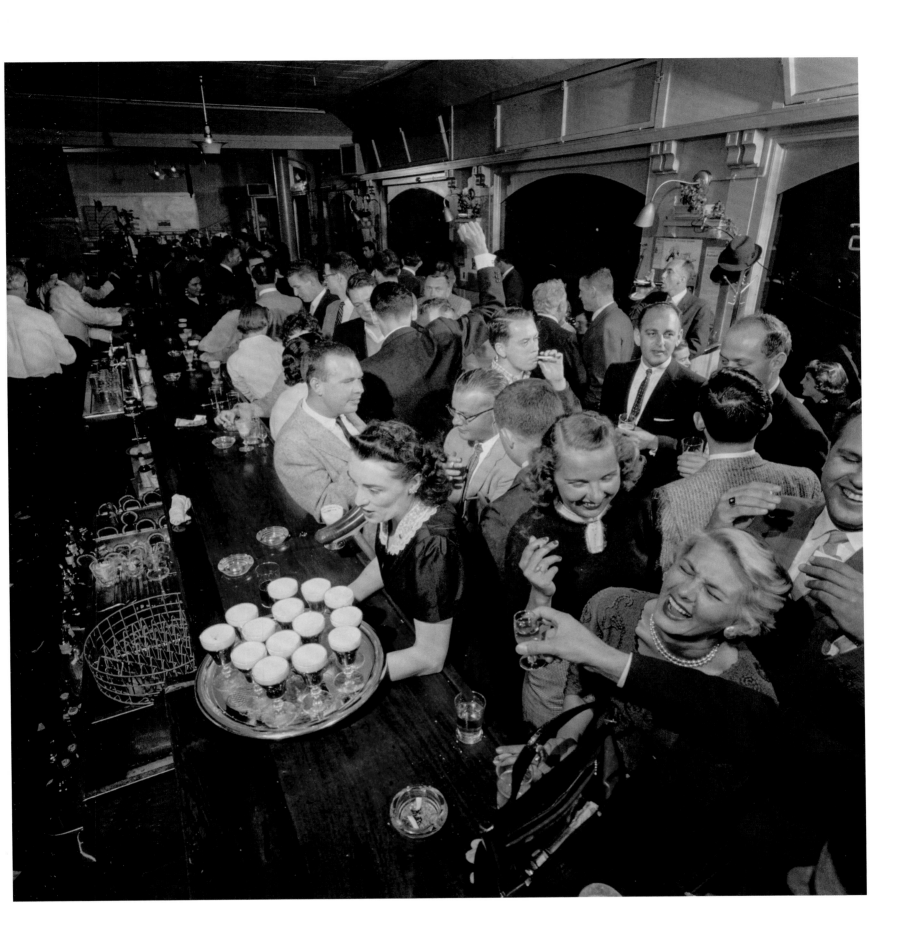

↑
Nat Farbman

Merrymakers jam the Buena Vista Cafe bar in Fisherman's Wharf at the corner of Hyde and Beach streets. Famed for its Irish coffee, it's across the street from where the most popular cable car ride ends after passengers board at Powell and Market streets downtown, 1956.

Feiernde füllen die Buena Vista Cafe Bar an der Fisherman's Wharf an der Ecke Hyde und Beach Street, die für ihren Irish Coffee bekannt war. Gleich gegenüber war der Endpunkt der Cable-Car-Linie, die an der Powell und Market Street begann, 1956.

Une joyeuse assemblée se presse au bar du Buena Vista Cafe à Fisherman's Wharf, au coin de Hyde Street et de Beach Street. Célèbre pour son Irish coffee, il fait face au terminus de la plus fréquentée des lignes de cable cars, dont les passagers ont embarqué à l'angle de Powell Street et de Market Street, au centre-ville. 1956.

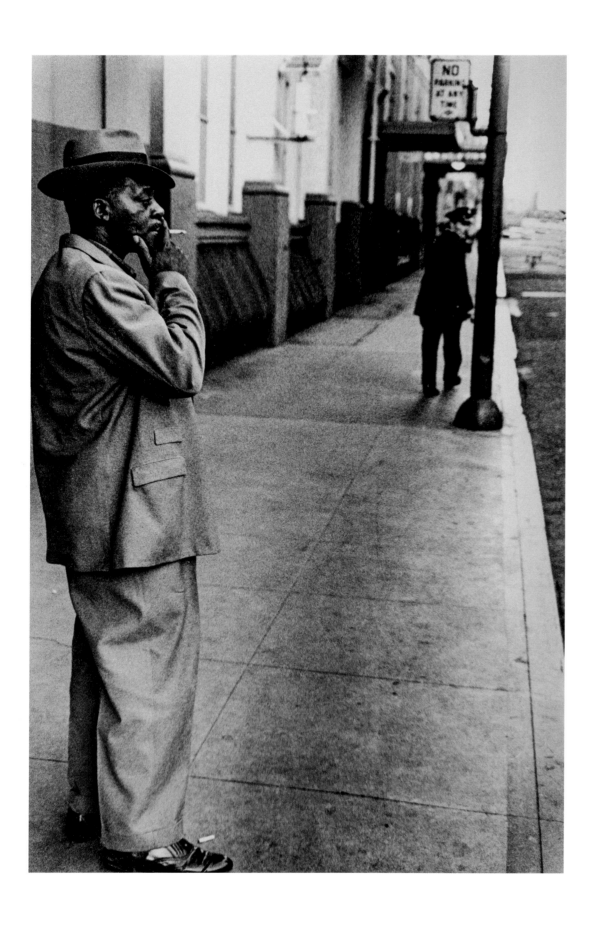

↑
Ralph Gibson

South of Mission Street, 1961.

Südlich der Mission Street, 1961.

Au sud de Mission Street. 1961.

→
Imogen Cunningham

Pedestrian heeding the oft-dispensed advice to dress for all kinds of unpredictable San Francisco weather, 1957.

Eine Fußgängerin, die sich an den oft erteilten Rat hält, sich für jedes mögliche Wetter passend anzuziehen, 1957.

À San Francisco les conditions météorologiques sont le plus souvent imprévisibles, et certains s'habillent de façon à parer à toute éventualité. 1957.

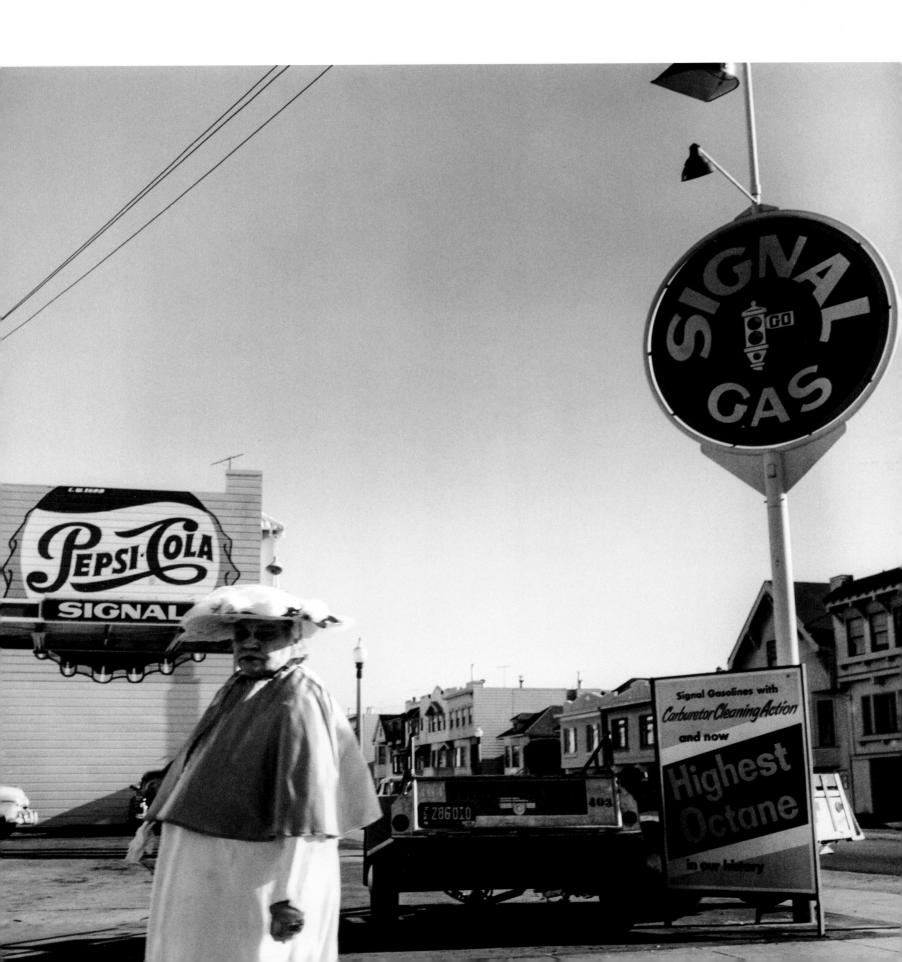

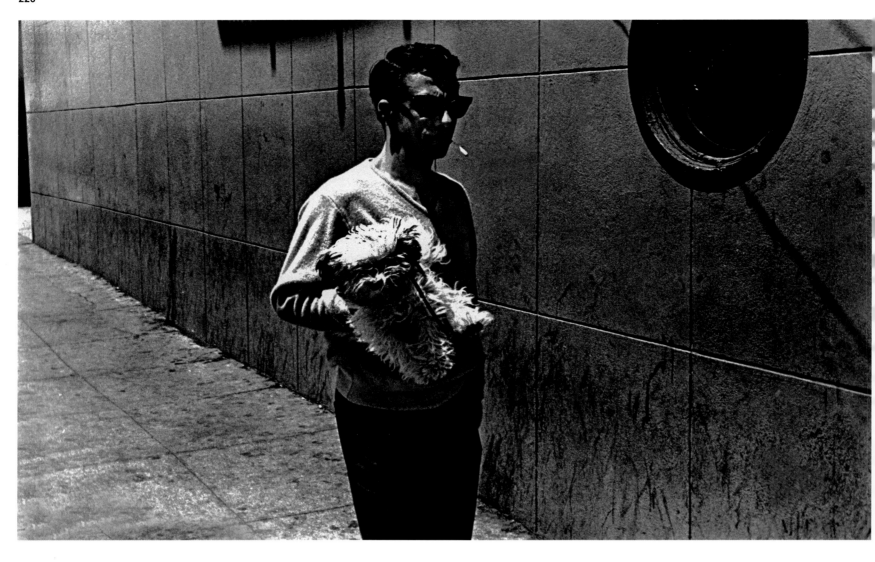

↑
Ralph Gibson

A beatnik-looking fellow carries a poodle in the Tenderloin, the neighborhood at the western edge of downtown. Although it has long had a reputation for risqué nightlife and high crime, many of the colorful characters on its streets are just going about their everyday business, 1961.

Ein wie ein Beatnik aussehender Mann trägt einen Pudel durch den Tenderloin, die Gegend am westlichen Rand von Downtown. Obwohl sie seit Langem einen schlechten Ruf wegen des gewagten Nachtlebens und der hohen Kriminalität hat, gehen viele der schrägen Charaktere auf den Straßen einfach nur ihren Alltagsbeschäftigungen nach, 1961.

De faux airs de beatnik, un caniche au bras: bienvenue dans le Tenderloin (à l'ouest du centre-ville). S'il a longtemps traîné une image de quartier difficile, dangereux la nuit et à forte criminalité, la plupart des personnages parfois originaux qui peuplent ses rues vaquent surtout à leurs occupations quotidiennes. 1961.

↓
Ralph Gibson

Sleeping on the street in North Beach. San Francisco has had a large homeless population throughout its history, even in boom times, and especially in tough times. It's still not uncommon to see people sleeping outdoors in daylight and all kinds of neighborhoods and weather, 1960.

Ein Mann schläft in North Beach auf der Straße; in San Francisco gab es immer viele Obdachlose, in guten, aber vor allem in schlechten Zeiten. Es ist in fast allen Vierteln immer noch nichts Ungewöhnliches, Menschen am Tag und bei jedem Wetter auf der Straße schlafen zu sehen, 1960.

Coucher dehors, à North Beach. Tout au long de son histoire, San Francisco a connu une importante population de sans-abri, même lors de forte croissance économique et notamment en période de crise. Il n'est toujours pas rare, en pleine journée, de voir des gens dormir dans la rue, quel que soit le quartier et par tous les temps. 1960.

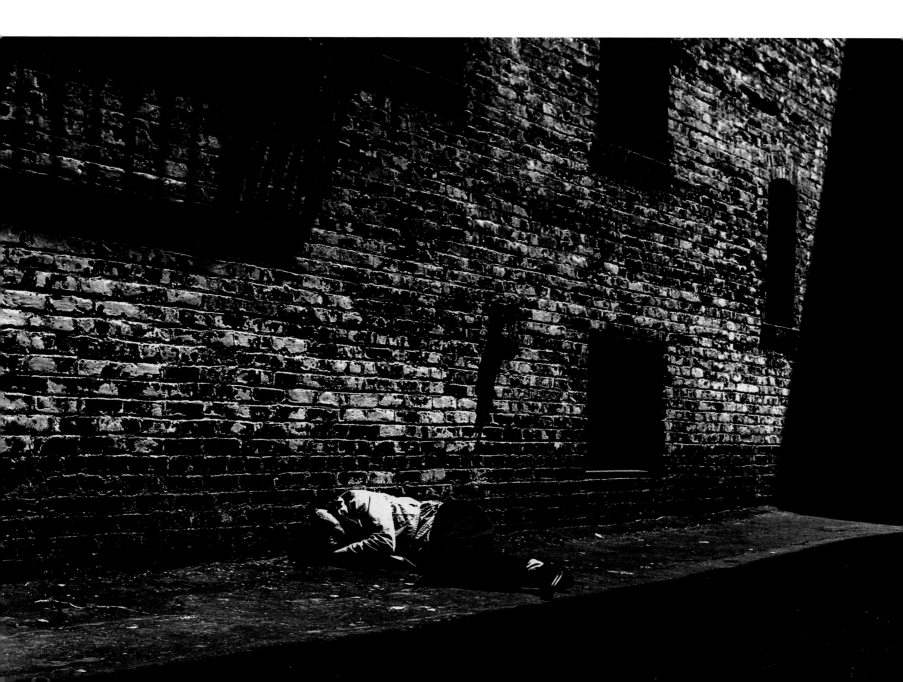

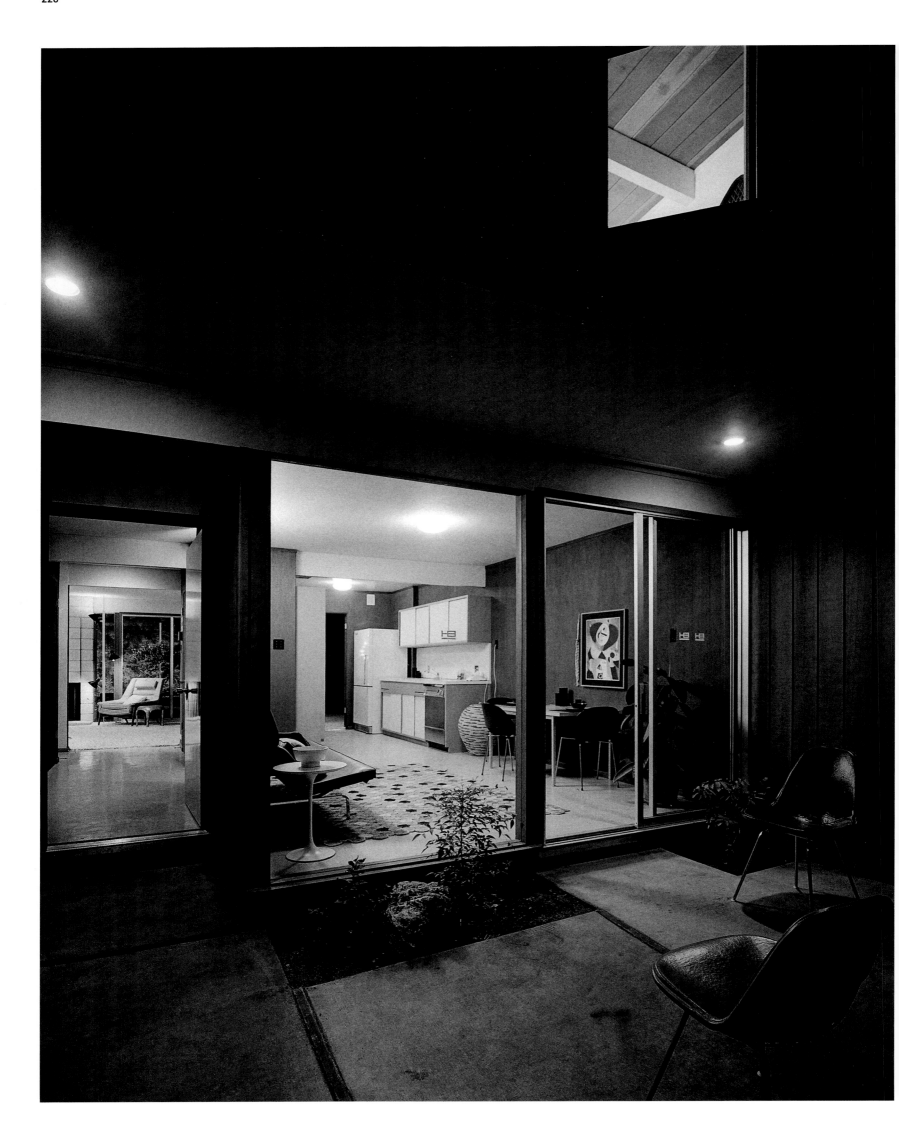

"We were the first volume builder in California to use many of the things that are now commonplace: sliding glass doors, built-in range and oven, metal cabinets, metal sash, radiant heat in floors."

„Wir waren das erste Bauunternehmen in Kalifornien, das viele der Dinge einsetzte, die heute ganz üblich sind: Glasschiebetüren, eingebauter Herd und Ofen, Metallschränke, Metallfenster, Fußbodenheizungen."

« Nous avons été le premier constructeur d'importance, en Californie, à utiliser toutes sortes de choses qui sont aujourd'hui monnaie courante : baies vitrées coulissantes, cuisinière et four encastrés, armoires et châssis métalliques, chauffage radiant au sol. »

BUILDER JOSEPH EICHLER, 1963

Gerald Ratto

One of the homes that typifies developer Joseph Eichler's buildings in Diamond Heights, a precipitously sloping neighborhood a little south of Twin Peaks. He favored architecture in the "California modern" style with glass walls, open floor plans, and skylights, early 1960s.

Ein Gebäude, das typisch für die Häuser des Bauunternehmers Joseph Eichler in Diamond Heights ist, einem Viertel an den steilen Hängen etwas südlich von Twin Peaks. Er bevorzugte den „California Modern"-Stil mit Glaswänden, offenen Grundrissen und Oberlichtern, frühe 1960er-Jahre.

Une maison caractéristique des réalisations du promoteur immobilier Joseph Eichler à Diamond Heights, quartier vertigineusement escarpé situé légèrement au sud des Twin Peaks. Eichler privilégiait une architecture de style « californien moderne » avec murs de verre, espaces décloisonnés et puits de lumière. Début des années 1960.

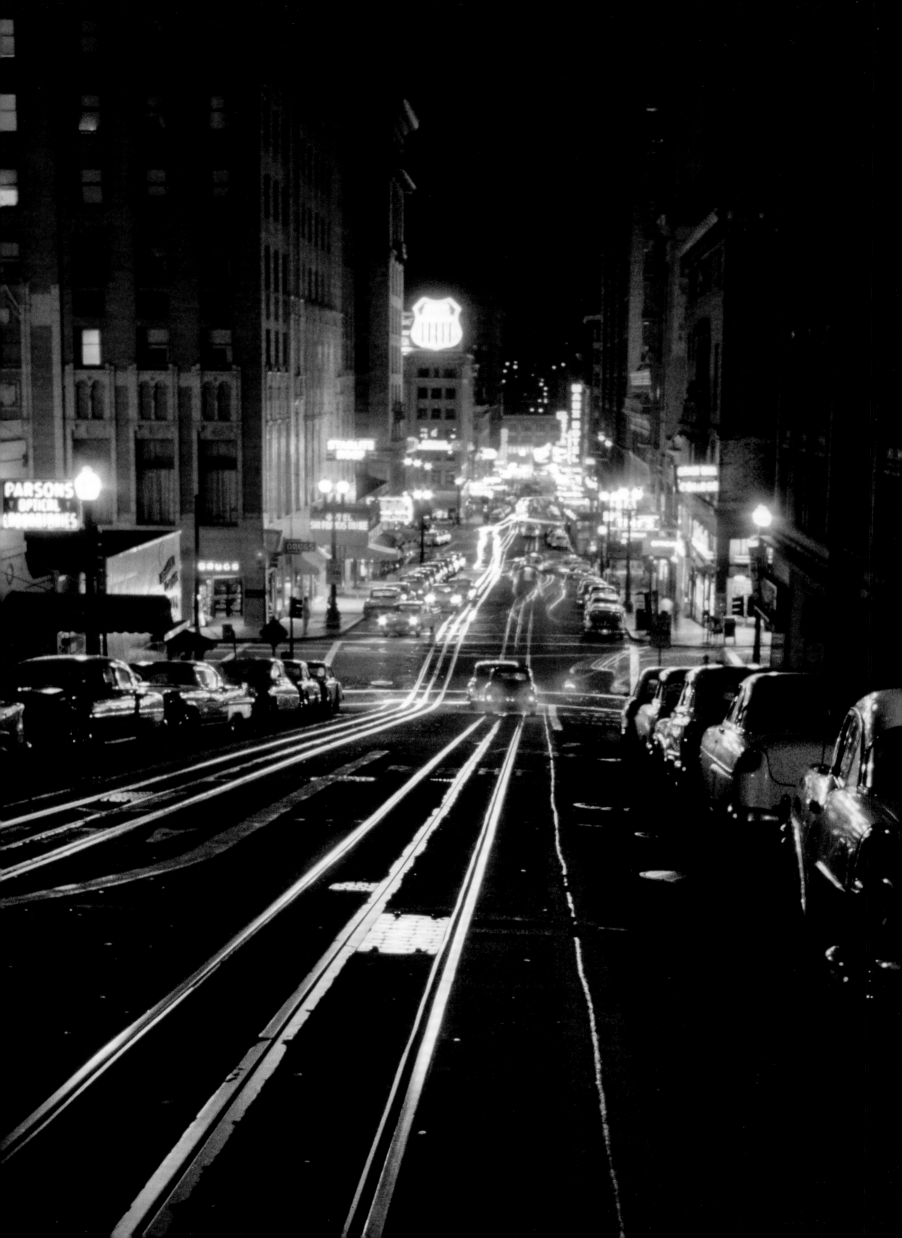

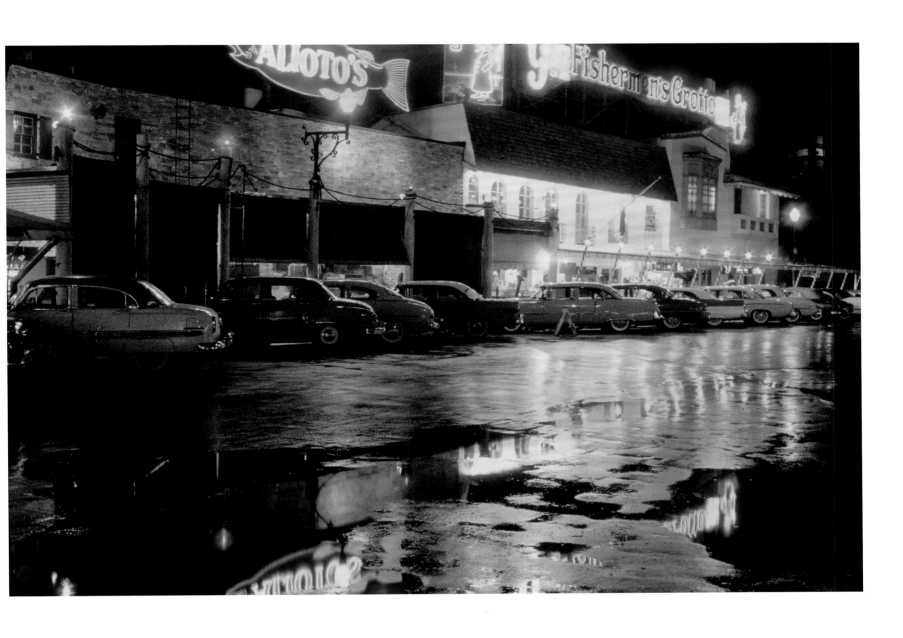

Anonymous

Looking down Powell Street cable car tracks as they descend from Nob Hill toward downtown's night-lights. This was taken between Bush and Pine streets, where Powell has a steep 17.5 percent grade, 1957.

Blick über die Gleise auf der Powell Street, die von Nob Hill zu den Lichtern Downtowns bergab führen. Das Foto wurde zwischen Bush und Pine Street aufgenommen, wo das Gefälle 17,5 Prozent beträgt, 1957.

Entre Bush Street et Pine Street, les rails du cable car de Powell Street, inclinée ici à 17,5 %, plongent de Nob Hill vers le cœur de la ville et les lumières de la nuit. 1957.

Anonymous

A rainy night at Fisherman's Wharf hasn't discouraged cars from making the drive to No. 9 Fishermen's Grotto and Alioto's. Both seafood eateries grew out of fish stalls operated by Sicilian immigrants, 1957.

Eine regnerische Nacht an der Fisherman's Wharf hat die Besitzer dieser Autos nicht abgehalten, hierherzukommen. Die beiden Seafood-Restaurants, No. 9 Fishermen's Grotto und Alioto's entstanden aus Ständen von sizilianischen Immigranten, 1957.

La pluie nocturne n'a pas découragé les propriétaires de ces berlines venues jusqu'à Fisherman's Wharf dîner au N°9 Fishermen's Grotto ou chez Alioto. Ces deux restaurants de fruits de mer étaient à l'origine de simples étals de poissons tenus par des immigrés siciliens. 1957.

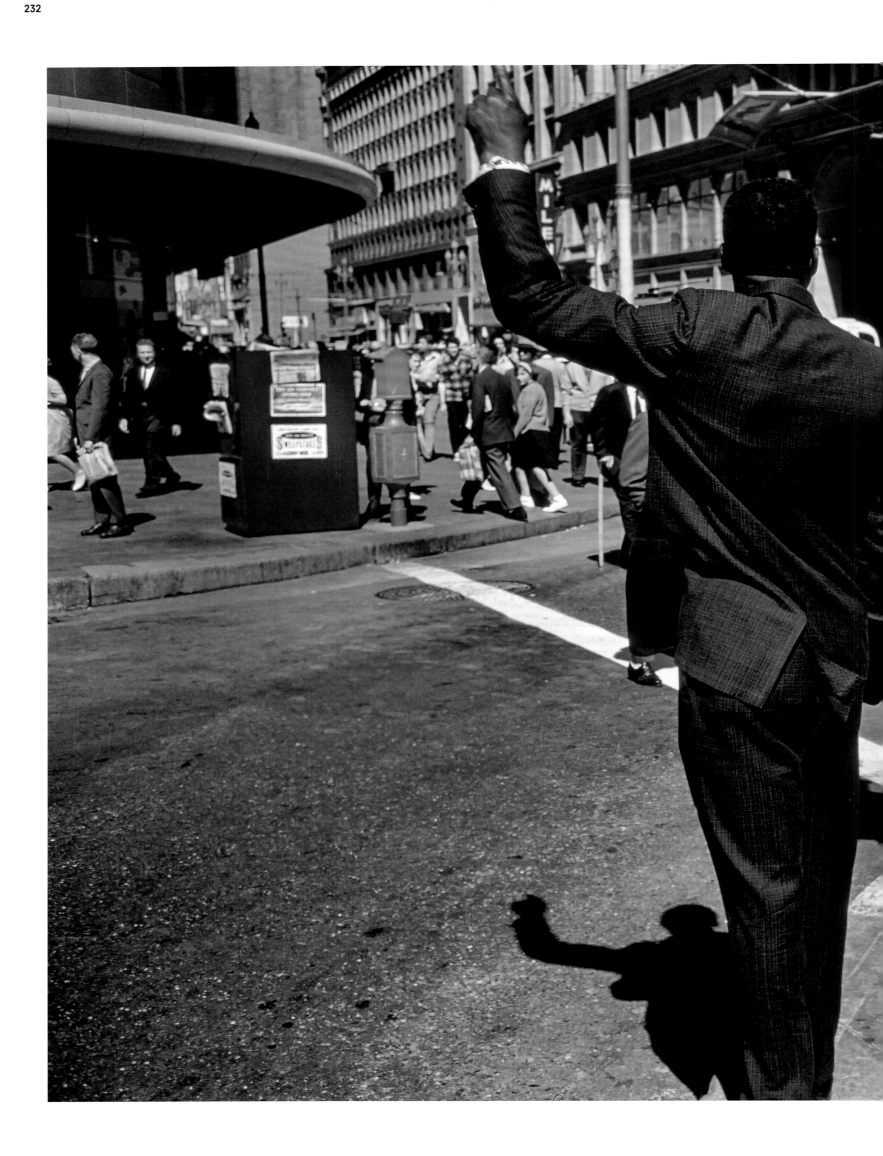

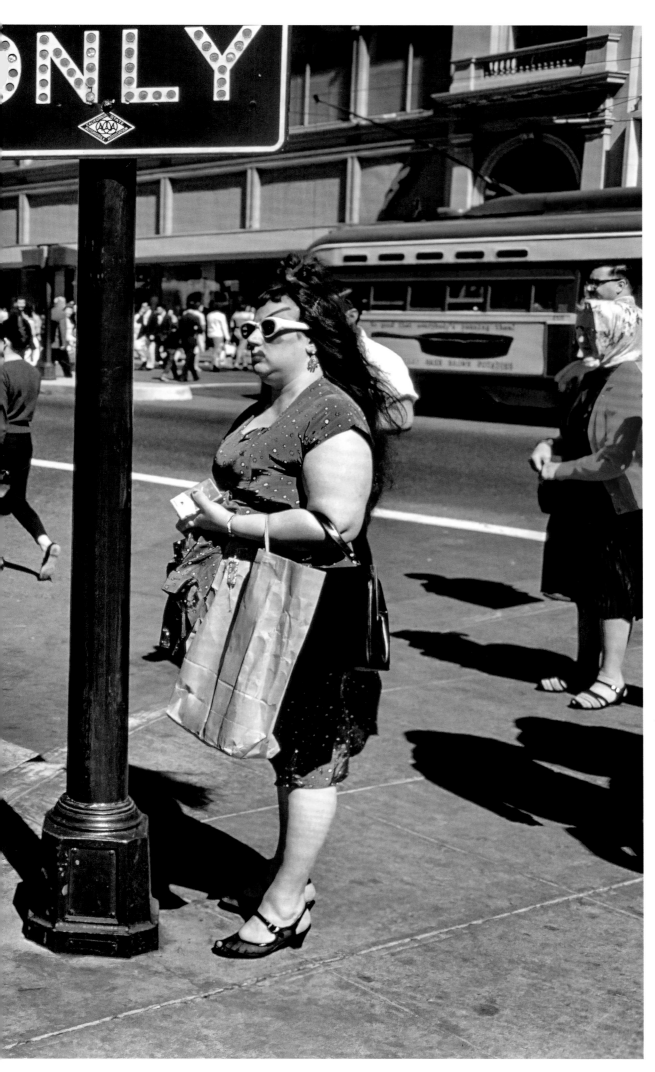

Fred Herzog

Downtown San Francisco, across the street from Market Street's Emporium department store. This corner near where cable cars board passengers at Market and Powell streets underwent significant alteration when a BART train station was built, and the multistory West-field San Francisco Centre mall occupies the space where the Emporium once reigned, 1962.

Downtown, gegenüber vom Kaufhaus Emporium an der Market Street. Die Cable-Car-Haltestelle Market und Powell Street wurde umfassend umgestaltet, als das BART-System gebaut wurde. Heute steht das mehrstöckige Einkaufszentrum Westfield San Francisco Centre da, wo früher das Emporium stand, 1962.

Centre-ville de San Francisco, face à l'Emporium, le grand magasin de Market Street. Ce carrefour proche du point où les cable cars embarquent leurs passagers, à l'angle de Market Street et de Powell Street, connaîtra d'importantes modifications lorsque sera construite une gare destinée au réseau BART. L'immense centre commercial Westfield San Francisco occupe aujourd'hui l'espace où régnait l'Emporium. 1962

Robert Frank

As part of his groundbreaking book The Americans, *Robert Frank photographed this couple in Alamo Square Park. Hailed for depicting everyday life throughout the country with a gritty lack of sentimentality, it boasted another San Francisco connection with an introduction by Jack Kerouac. According to R.J. Smith's* American Witness: The Art and Life of Robert Frank, *"Frank has always said that he liked this photograph because of the candor on the couple's faces and the intensity of their unguarded reaction to a stranger's approach," 1956.*

Für sein bahnbrechendes Buch Die Amerikaner *fotografierte Robert Frank dieses Paar im Almo Square Park. Das Buch wurde gefeiert, weil es das Leben in den USA ohne Sentimentalität darstellte. Seine Einleitung von Jack Kerouac schuf eine weitere Verbindung zu San Francisco. R. J. Smith schreibt in* American Witness: The Art and Life of Robert Frank: *„Frank sagte immer, dass er dieses Bild wegen der Offenheit auf den Gesichtern des Paars mochte und wegen der Intensität ihrer ehrlichen Reaktion auf einen Fremden", 1956.*

Robert Frank a photographié ce couple du parc d'Alamo Square dans le cadre de son magistral ouvrage intitulé Les Américains, *salué pour avoir dépeint le quotidien du pays avec un réalisme dénué de sensiblerie. La préface qu'en signa Jack Kerouac tissait un autre lien avec San Francisco. « Frank a toujours dit qu'il aimait cette photo pour la candeur des deux visages et l'intensité de leur réaction spontanée à l'approche d'un étranger », écrit R.J. Smith dans* American Witness: The Art and Life of Robert Frank. *1956.*

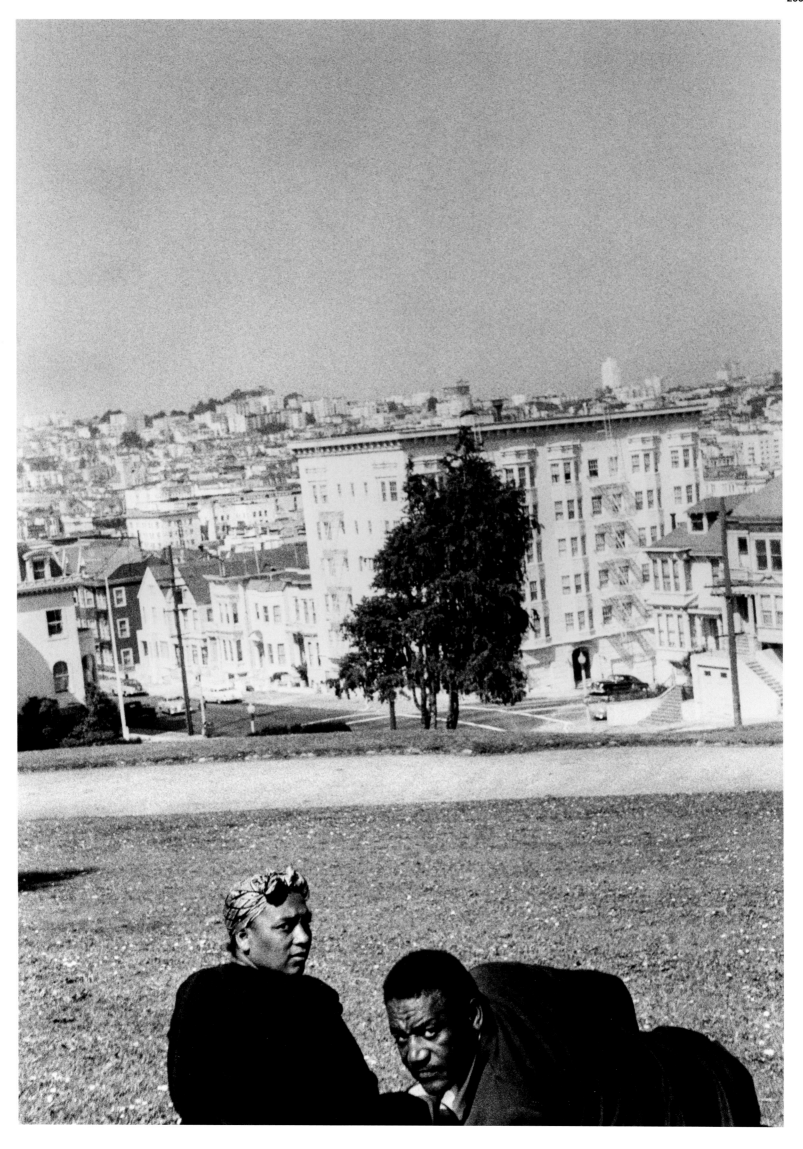

↓
Burt Glinn

Indoor sunglasses, an early miniskirt, and abstract wall paintings—what else did you need at this San Francisco beatnik party as the 1960s dawned? Maybe some jazz or a folk hootenanny, either on the hi-fi or performed live by some of the guests. Acid rock was still relatively far in the future, but marijuana was already supplementing booze as a refreshment of choice, 1960.

Sonnenbrille im Haus, ein frühes Minikleid und ein abstraktes Gemälde – was brauchte man sonst bei einer Beatnik-Party in San Francisco am Anfang der 1960er? Vielleicht noch etwas Jazz oder Folk, entweder über die Stereoanlage oder live von Gästen gespielt. Acid Rock lag noch in der Zukunft, aber Marihuana hatte sich schon zum Alkohol als Erfrischung der Wahl gesellt, 1960.

Lunettes de soleil d'intérieur, mini-jupe avant l'heure, peinture abstraite au mur – que demander de plus à une petite sauterie beatnik dans la San Francisco du début des sixties? Peut-être un peu de jazz ou du bon vieux folk sur la chaîne hi-fi, voire carrément live pour peu que certains des invités décident d'y mettre du leur… L'acid rock se fera attendre encore un certain temps mais la marijuana, elle, aide déjà l'alcool à détendre l'atmosphère. 1960

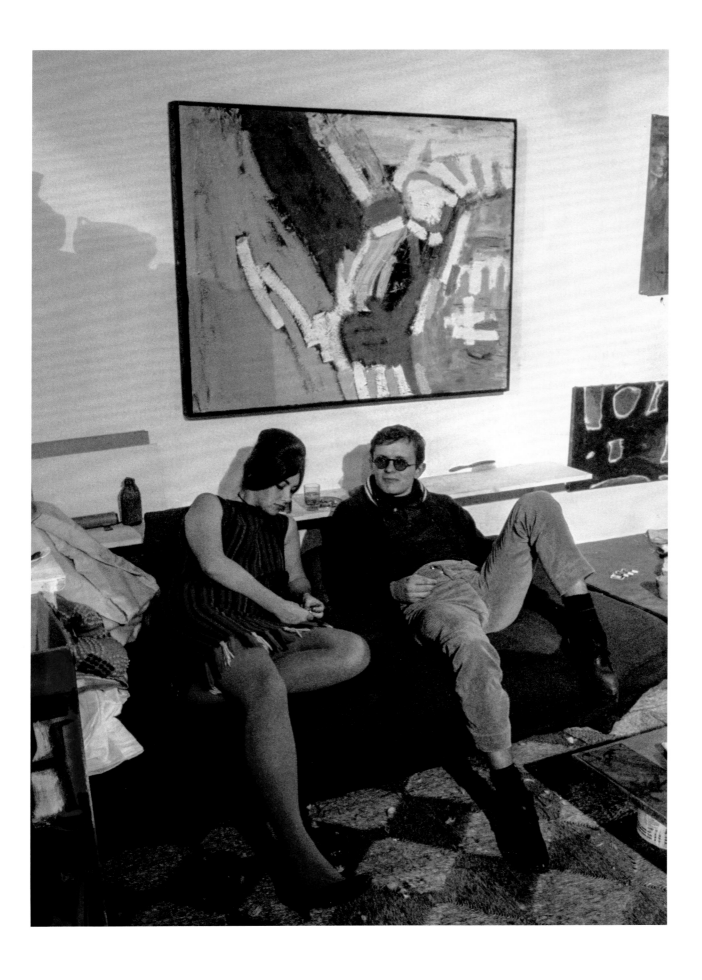

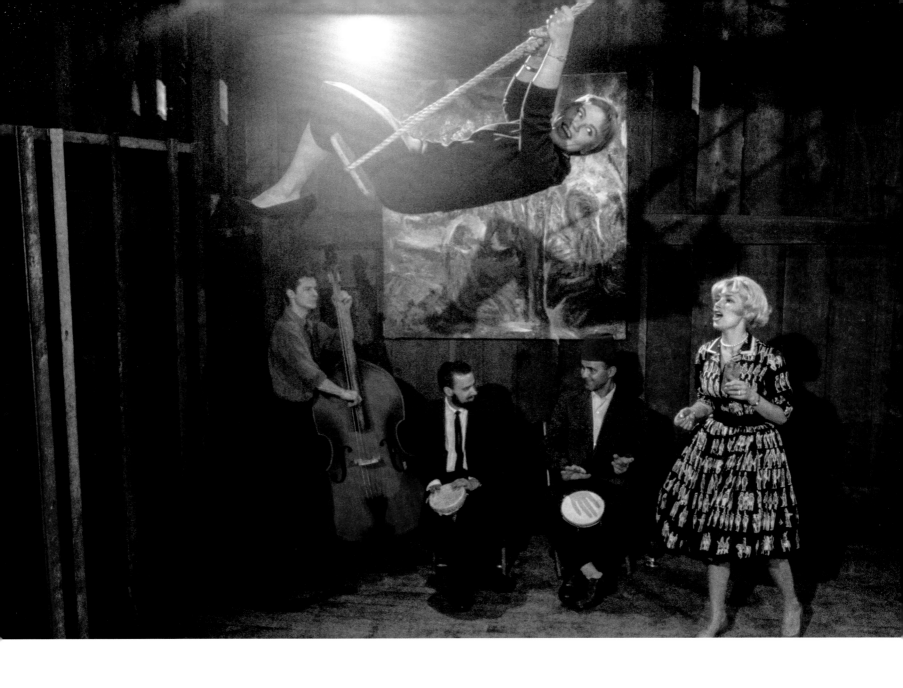

↑

Burt Glinn

A wild and crazy beatnik party hosted by artist David Stone Martin, who illustrated many LPs for jazz stars like Ella Fitzgerald, Billie Holiday, and Lester Young. The girl on a swing sports the black sweater and pants Beats often wore as a badge of honor as dress codes loosened and evaporated, 1960.

Eine wilde Beatnik-Party des Gastgebers und Künstlers David Stone Martin, der viele LPs für Jazzstars wie Ella Fitzgerald, Billie Holiday und Lester Young illustrierte. The Frau auf der Schaukel trägt den schwarzen Sweater und die Hose, die für die Beats ein Ehrenzeichen war, als sich Kleiderordnungen aufzulösen begannen, 1960.

Sacrée soirée que cette surboum beatnik organisée par l'artiste David Stone Martin, qui illustra de nombreuses pochettes de disque pour des stars du jazz telles que Billie Holiday, Ella Fitzgerald ou Lester Young. La jeune femme sur la balançoire arbore pull et pantalon noirs, nouvelles marques de distinction à mesure que les codes vestimentaires se relâchent et finissent par s'écrouler. 1960

*"The poets are shouting their poems in nightclubs, at dance recitals,
in art galleries, on radio and TV. Their work has gained respectful hearing
from local and even national critics."*

„*Die Dichter schreien ihre Gedichte in Nachtclubs, bei Tanzaufführungen,
in Kunstgalerien, im Radio und im Fernsehen. Ihre Arbeit hat Gehör bei
lokalen und sogar nationalen Kritikern gefunden.*"

«*Les poètes crient leurs poèmes dans les boîtes de nuit, les spectacles de
danse, les galeries d'art, à la radio et à la télévision. Leur travail a conquis
une audience respectueuse parmi les critiques locaux et même nationaux.*»

LIFE MAGAZINE, 1957

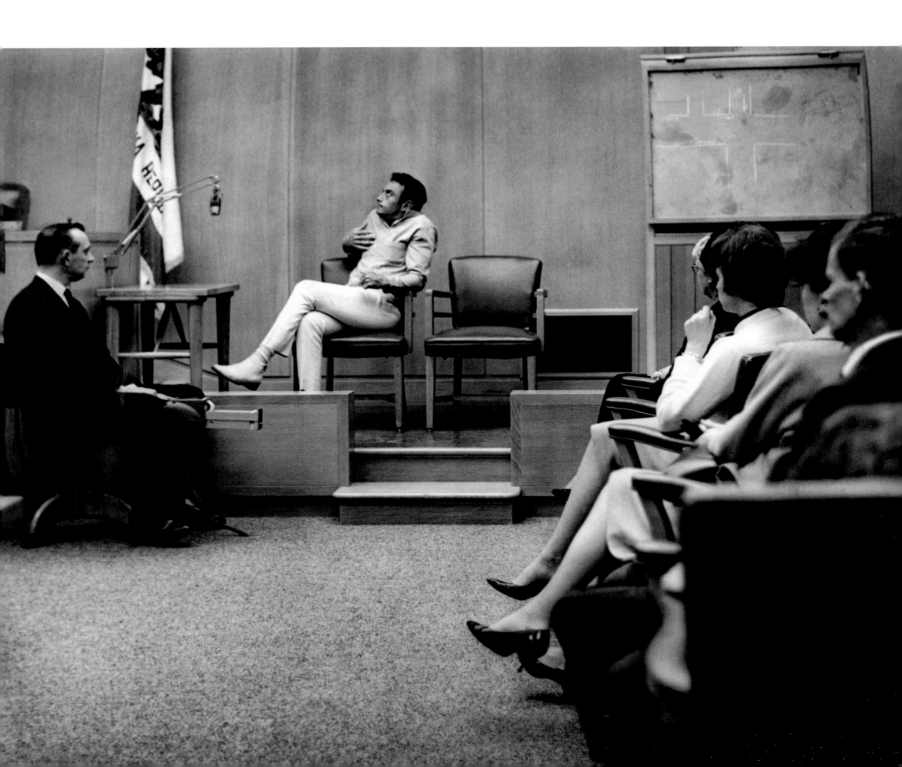

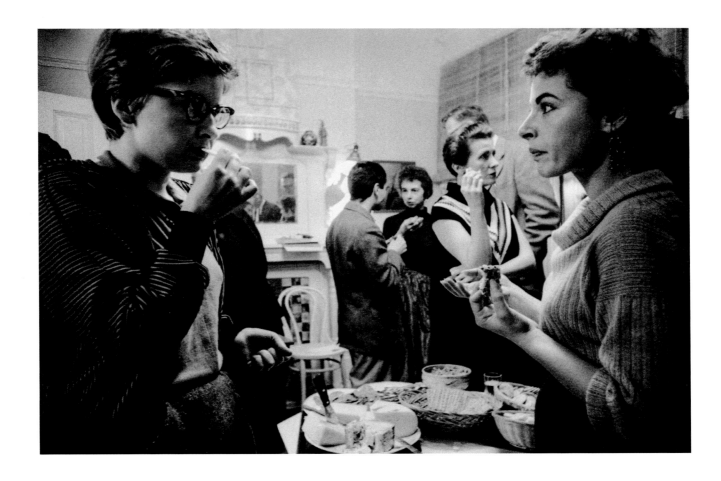

Sid Tate

Lenny Bruce on the witness stand with jurors at his first obscenity trial by the San Francisco Municipal Court. The comedian had been arrested for using profanity in an October 1961 performance at the city's Jazz Workshop. Although he was acquitted, he'd battle obscenity charges in several cities before his 1966 death, 1962.

Lenny Bruce im Zeugenstand vor den Geschworenen bei seinem ersten Obszönitätsprozess vor dem Stadtgericht in San Francisco. Der Comedian war dafür festgenommen worden, weil er bei einer Aufführung im Jazz Workshop 1961 Obszönitäten geäußert hatte.

Obwohl er freigesprochen wurde, musste er vor seinem Tod 1966 noch weitere Prozesse dieser Art in anderen Städten durchmachen, 1962.

Dévisagé par les jurés, Lenny Bruce à la barre des témoins lors de son premier procès pour obscénité devant le tribunal municipal de San Francisco. L'humoriste avait été arrêté pour avoir proféré des insanités le soir d'un spectacle donné en octobre 1961 au Jazz Workshop de la ville. Bien qu'acquitté, il devra faire face au même type d'accusation dans d'autres villes encore avant de mourir prématurément en 1966. 1962.

Nat Farbman

Literary devotees eat, drink, and socialize at a poetry reading in Kenneth Rexroth's Scott Street home in the Lower Haight neighborhood. Already in his 50s at the time, the poet was hugely influential on the birth of the city's Beat movement, 1957.

Literaturbegeisterte essen, trinken und unterhalten sich bei einer Lesung in Kenneth Rexroths Wohnung an der Scott Street Wohnung in der Lower Haight im Viertel. Der Dichter, der zu dieser Zeit die 50 bereits überschritten hatte, nahm großen Einfluss auf die Beat-Bewegung in der Stadt, 1957.

Des passionnés de littérature grignotent, trinquent et échangent lors d'une lecture poétique chez Kenneth Rexroth qui habitait Scott Street, dans le quartier de Lower Haight. Déjà quinquagénaire à l'époque, le poète a eu une influence considérable sur la naissance du mouvement beat à San Francisco. 1957.

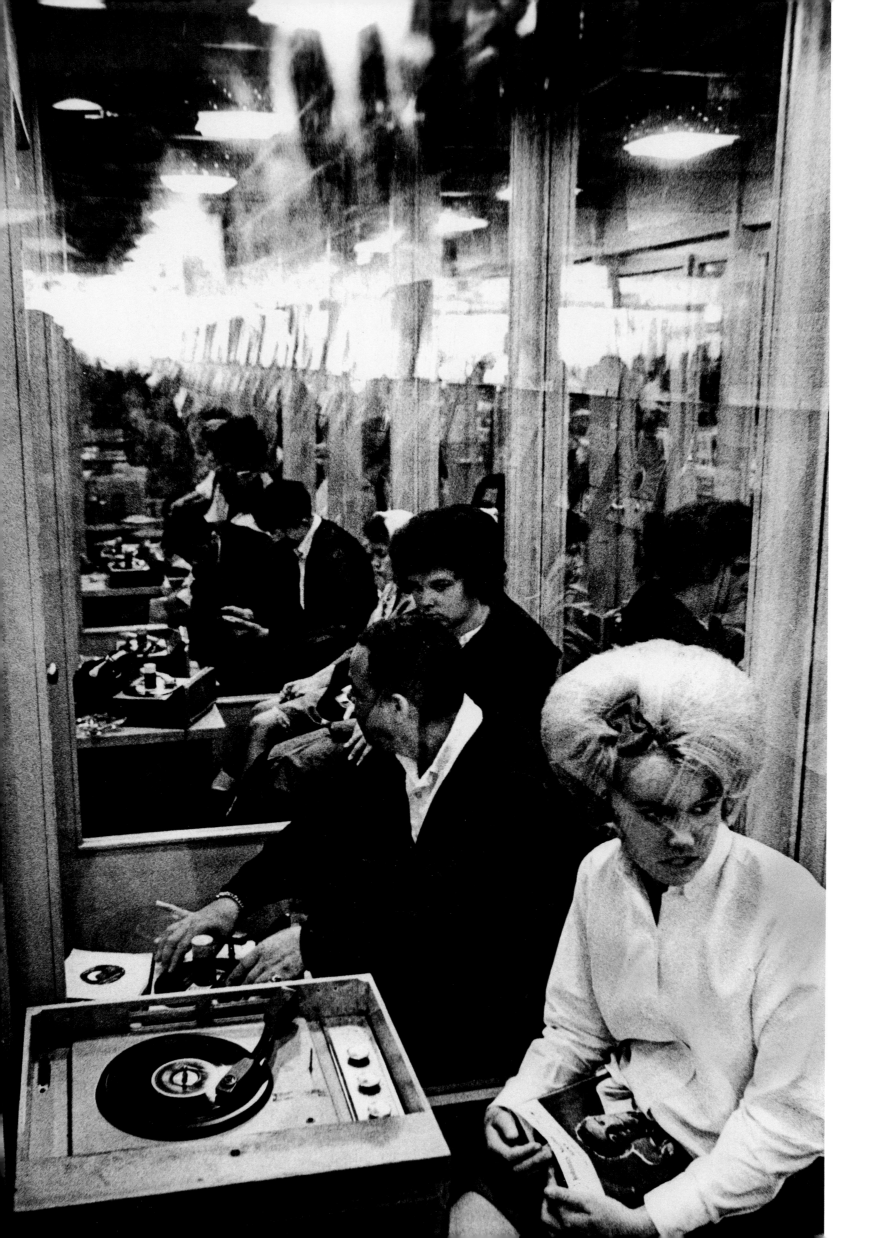

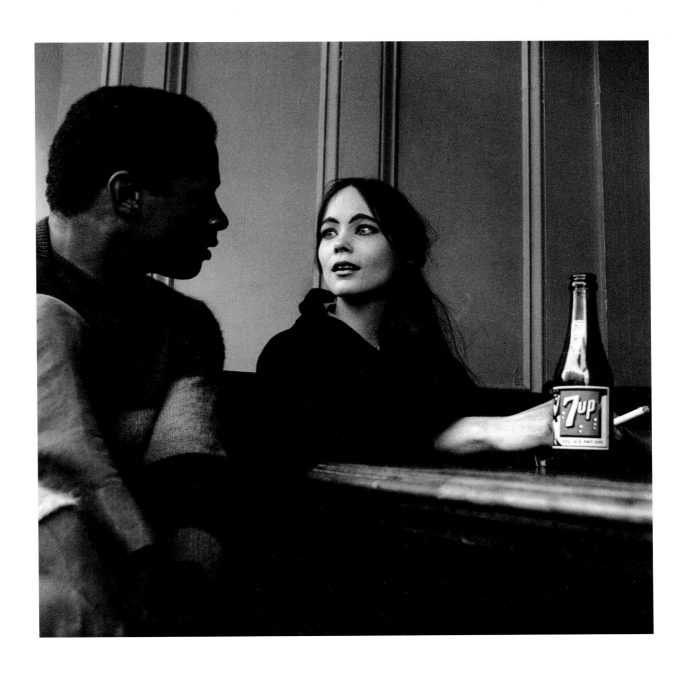

←

Ralph Gibson

Music fans spin vinyl at a downtown shop, back in the days of big beehives and booths for listening to discs before you bought them. As US record sales tripled between 1953 and 1960, so did the number of record stores multiply, especially in San Francisco, 1961.

Musikfans hören sich eine Platte an, als es dafür im Geschäft noch extra Kabinen gab, bevor man eine LP kaufte. Plattenverkäufe verdreifachten sich in den USA zwischen 1953 und 1960, und so vermehrten sich auch die Musikläden, besonders in San Francisco, 1961.

Au temps du vinyle, on se pressait chez les disquaires du centre-ville où la musique pouvait s'écouter avant de s'acheter. Entre 1953 et 1960, les ventes de microsillons ont triplé aux États-Unis tandis que le nombre des magasins de disques se multipliait, notamment à San Francisco. 1961.

↑

Imogen Cunningham

Couple at the Coffee Gallery. On Grant Avenue just a couple blocks up the road from City Lights bookstore, it hosted readings by major local poets like Bob Kaufman and Lawrence Ferlinghetti. In the early '60s a then-unknown Janis Joplin performed there. Grace Slick even sang at the venue at her first 1965 gig with the Great Society, a year before she joined Jefferson Airplane, 1960.

Ein Paar in der Coffee Gallery, nur ein paar Blocks vom City Lights Bookstore auf der Grant Avenue entfernt, die Poesielesungen von lokalen Größen wie Bob Kaufman und Lawrence Ferlinghetti veranstaltete. In den frühen 60ern trat hier eine damals unbekannte Janis Joplin auf. Selbst Grace Slick sang hier bei ihrem ersten Auftritt mit der Great Society, ein Jahr bevor sie zu Jefferson Airplane ging, 1960.

Un couple à la Coffee Gallery. Située sur Grant Avenue, un peu plus haut que la librairie City Lights, cette salle accueillait des lectures données par de grands poètes locaux tels que Bob Kaufman et Lawrence Ferlinghetti. Au début des années 1960, une Janis Joplin alors inconnue s'y est produite et Grace Slick y chantera, elle aussi, lors de son premier concert en 1965 avec The Great Society, un an avant de rejoindre Jefferson Airplane. 1960.

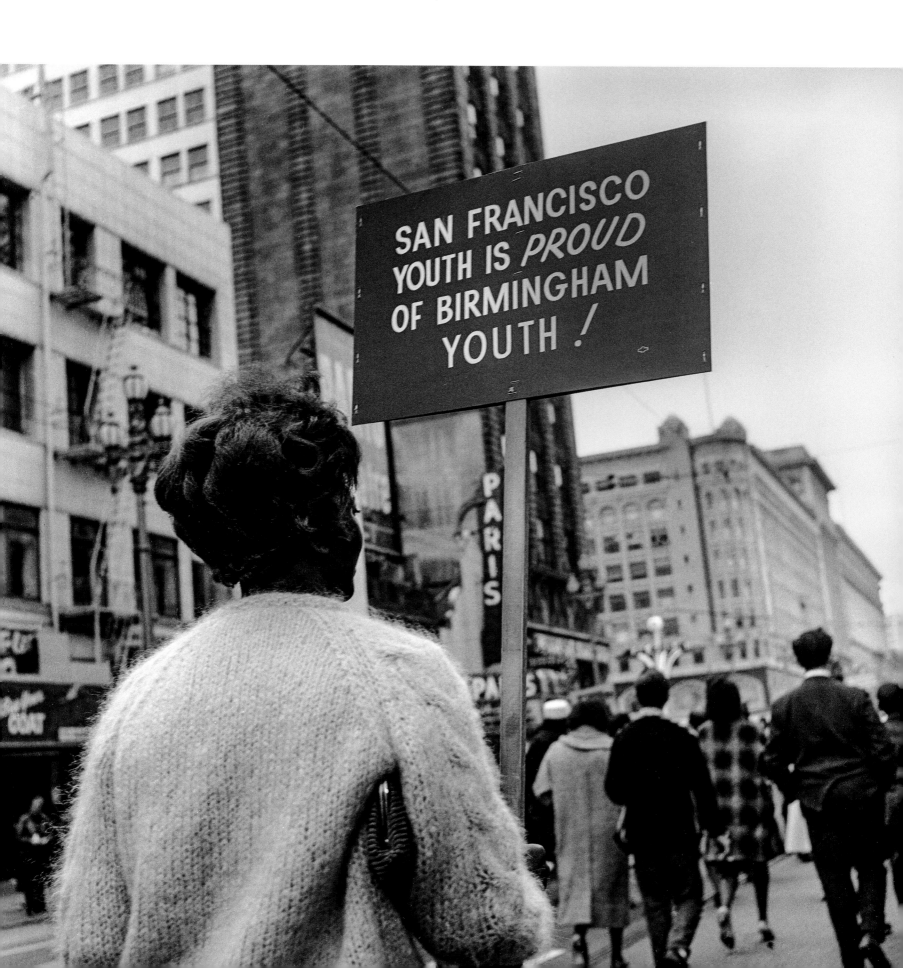

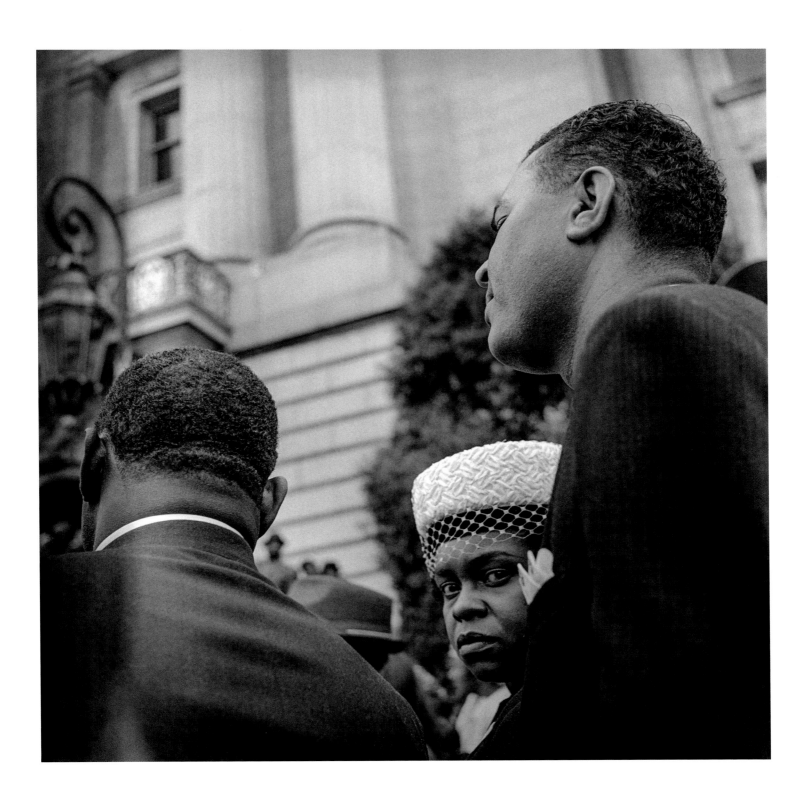

←

Imogen Cunningham

At a civil rights rally from Market Street to Civic Center, a marcher expresses sympathy for four young African American girls who were killed in a bombing at a Birmingham, Alabama, church on September 15, 1963. A few days after those deaths, 2,500 marched on Post Street in protest, 1963.

Bei einem Marsch der Bürgerrechtsbewegung zeigt dieses Schild Mitgefühl für die vier afro-amerikanischen Mädchen, die am 15. September 1963 in Birmingham, Alabama, bei einem Bombenanschlag auf eine Kirche getötet

wurden. Ein paar Tage später protestierten 2 500 Menschen auf der Post Street, 1963.

Lors d'une manifestation en faveur des droits civiques, une marcheuse exprime sa compassion pour les quatre jeunes filles noires tuées le 15 septembre 1963 dans l'explosion d'une bombe à l'église de Birmingham, en Alabama. Quelques jours après cet attentat raciste perpétré par le Ku Klux Klan, 2 500 personnes manifestaient sur Post Street. 1963.

↑

Imogen Cunningham

Grave expressions at a civil rights march that, like many demonstrations in the city, went from Market Street to Civic Center. The movement was both picking up unstoppable momentum and haunted by tragic violence, if mostly in other parts of the United States rather than San Francisco, 1963.

Ernste Mienen bei einem Marsch der Bürger-rechtsbewegung, welcher, wie viele andere Demonstrationen in der Stadt auch, von der Market Street zum Civic Center führte. Die Bewegung gewann unaufhaltsam an

Einfluss, traf aber vor allem in anderen Teilen der USA auch immer wieder auf Gewalt, 1963.

Les visages sont graves lors de cette marche pour les droits civiques qui va de Market Street au Civic Center, à l'exemple de la plupart des manifestations. Le mouvement est alors en voie de prendre un irrésistible élan et en même temps hanté par une violence tragique, moins à San Francisco toutefois que dans d'autres régions des États-Unis. 1963.

↓

Imogen Cunningham

San Francisco sculptor Ruth Asawa in front of her home on Saturn Street in Corona Heights. Acclaimed from her early-career wire sculptures, she later created several popular public fountains in the city, the first and most famous being the "Andrea" mermaid fountain in Ghirardelli Square. She was also crucial to establishing the San Francisco School of the Arts, which in 2010 was renamed in her honor, c. late 1950s.

Die Bildhauerin Ruth Asawa vor ihrem Haus in Corona Heights an der Saturn Street. Gefeiert für ihre frühen Drahtskulpturen, schuf sie später einige der beliebten öffentlichen Brunnen der Stadt. Der erste und berühmteste ist der Meerjungfrauenbrunnen „Andrea" auf dem Ghirardelli Square. Sie war auch maßgeblich an der Gründung der San Francisco School of the Arts beteiligt, die 2010 nach ihr benannt wurde, späte 1950er-Jahre.

Saluée à ses débuts pour ses tissages de fil de fer, la sculptrice Ruth Asawa a notamment réalisé dans la ville plusieurs fontaines publiques très admirées – ainsi la sirène « Andrea », la première et la plus célèbre d'entre elles, sur Ghirardelli Square. Elle jouera également un rôle crucial dans la création de la San Francisco School of the Arts, qui sera rebaptisée en son honneur en 2010. Vers la fin des années 1950.

→

Ernst Haas

Colorful modern high-rise architecture asserting itself in the city in the mid-20th century, though the fin of a car parked nearby steals the show in this shot, 1961.

Farbenfrohe und moderne Hochhäuser wurden ab der Mitte des 20. Jahrhunderts fester Teil des Stadtbildes, auch wenn die Heckflosse im Vordergrund ihnen auf diesem Foto die Show stiehlt, 1961.

Avec le milieu du xxᵉ siècle, une architecture de grande hauteur, tout en couleurs et en modernité, gagne du terrain à San Francisco. Au premier plan, inspiré de l'aéronautique et alors très en vogue, l'aileron arrière d'une voiture garée. 1961.

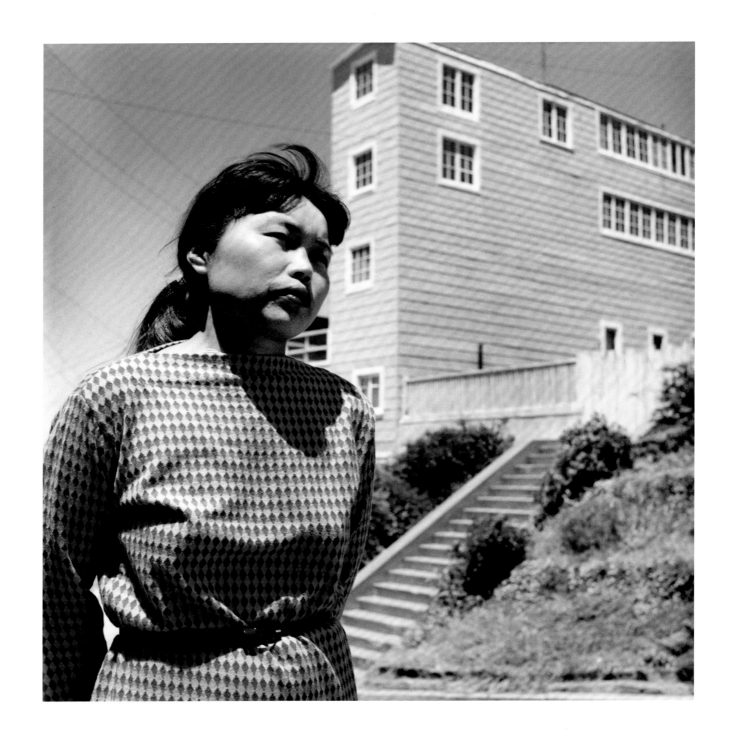

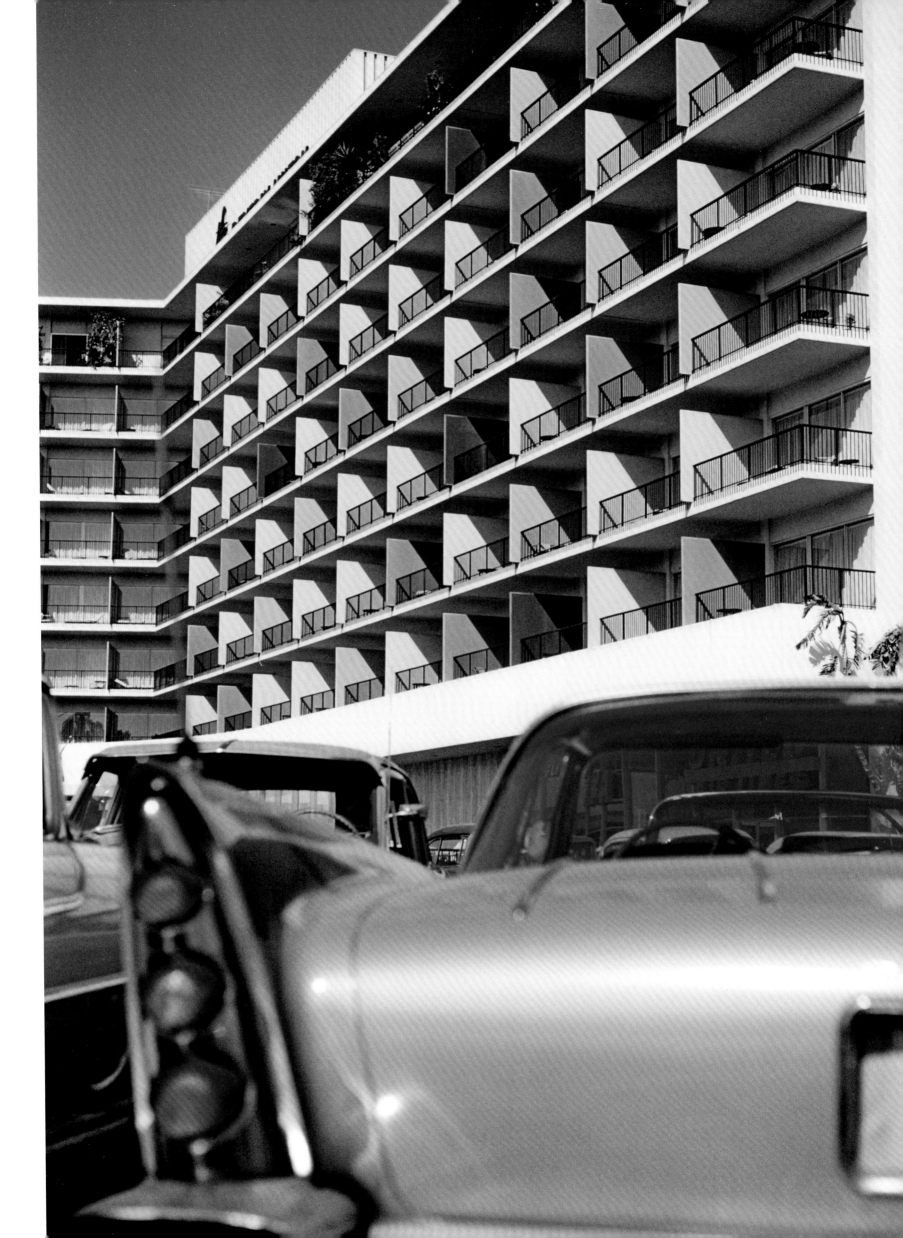

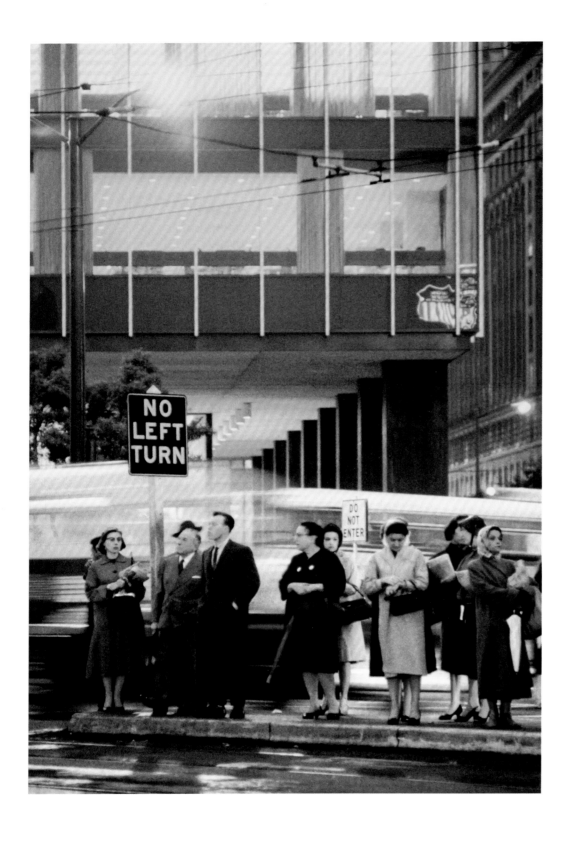

→
Ernst Haas

The Golden Gate Bridge at sunset, when the traffic can turn into blurs of light for the camera, 1961.

Die Golden Gate Bridge bei Sonnenuntergang, wenn der Verkehr für die Kamera zu bloßen Lichtschlieren werden kann, 1961.

Sous l'œil du photographe, le Golden Gate Bridge au crépuscule semble agité de trépidations furtives, comme autant de lucioles phosphorescentes. 1961.

↑
Ernest Braun

Downtown street corners might not be quite as crowded with pedestrians as they are in New York or London, but San Francisco has plenty of foot traffic. Unlike California's other major metropolis, Los Angeles, it's a place where walking remains the most pleasant and efficient way to get around in many neighborhoods, 1962.

Die Straßen in Downtown sind vielleicht nicht so voll wie in New York oder in London, aber San Francisco hat trotzdem eine Menge Fußgänger. Anders als in Kaliforniens anderer Metropole, Los Angeles, bleibt das Zufußgehen die angenehmste und beste Art, in den Vierteln der Stadt herumzukommen, 1962.

Aux carrefours du centre-ville, les piétons ne se pressent peut-être pas aussi nombreux qu'à New York ou à Londres, mais contrairement à Los Angeles, l'autre grande métropole californienne, San Francisco est une ville où la marche reste le moyen le plus agréable et le plus efficace de se déplacer dans bien des quartiers. 1962.

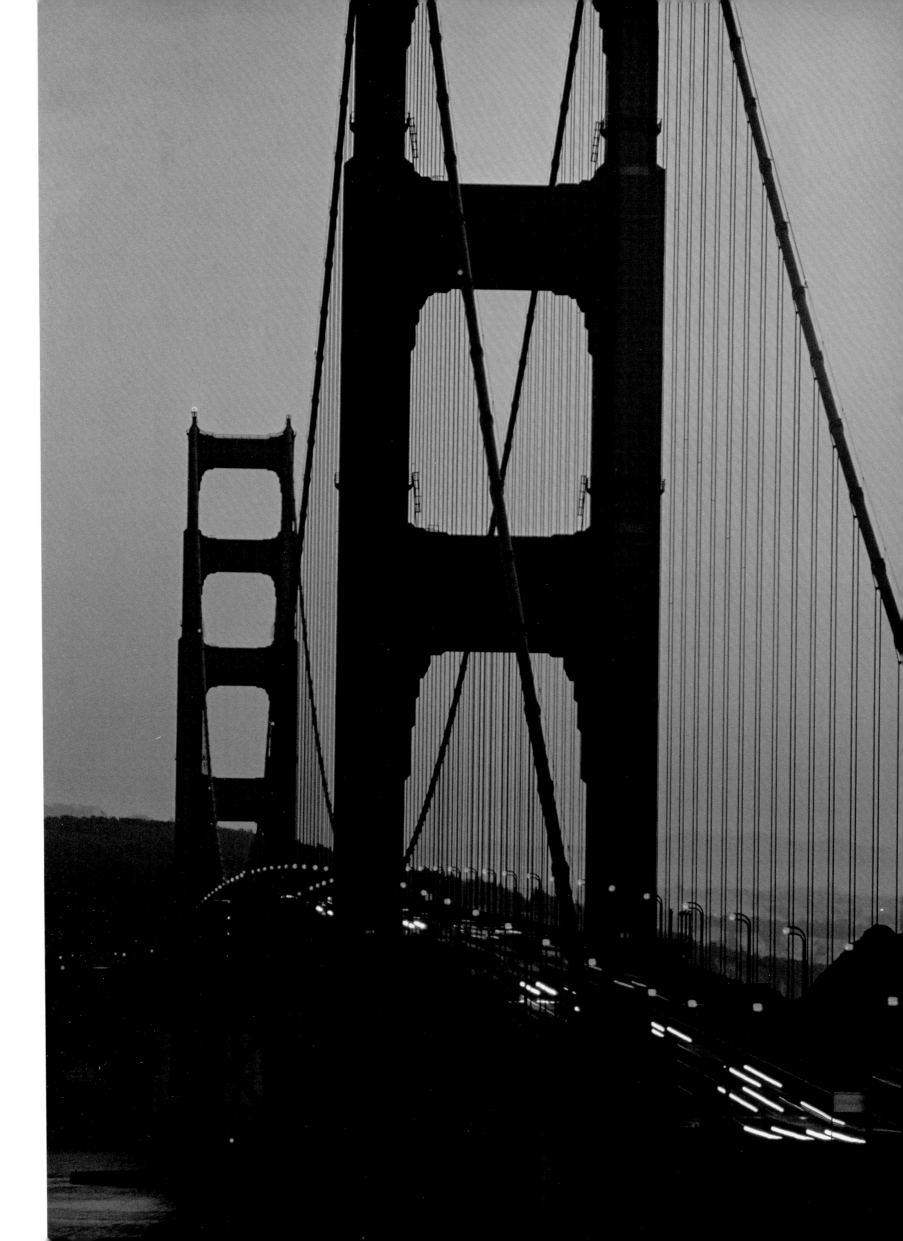

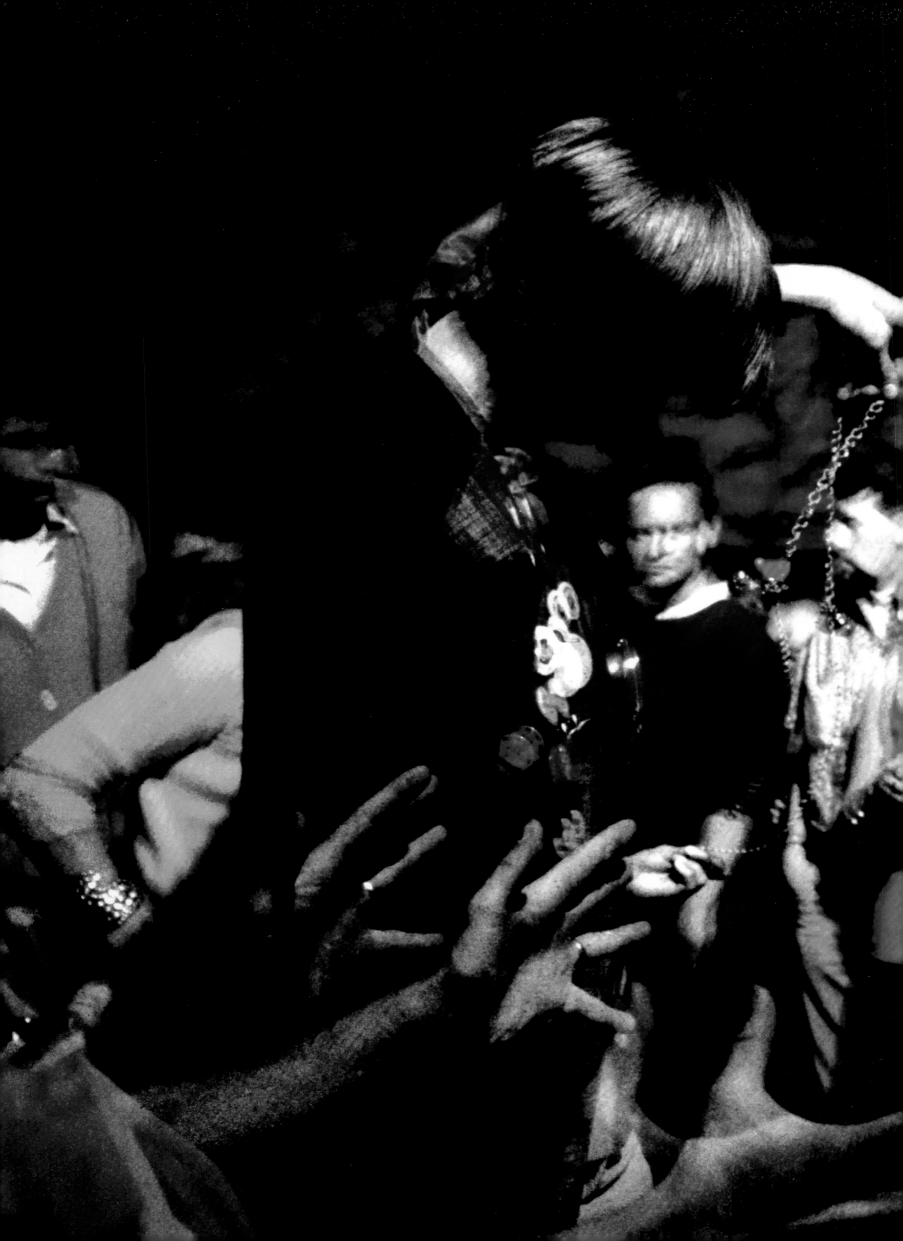

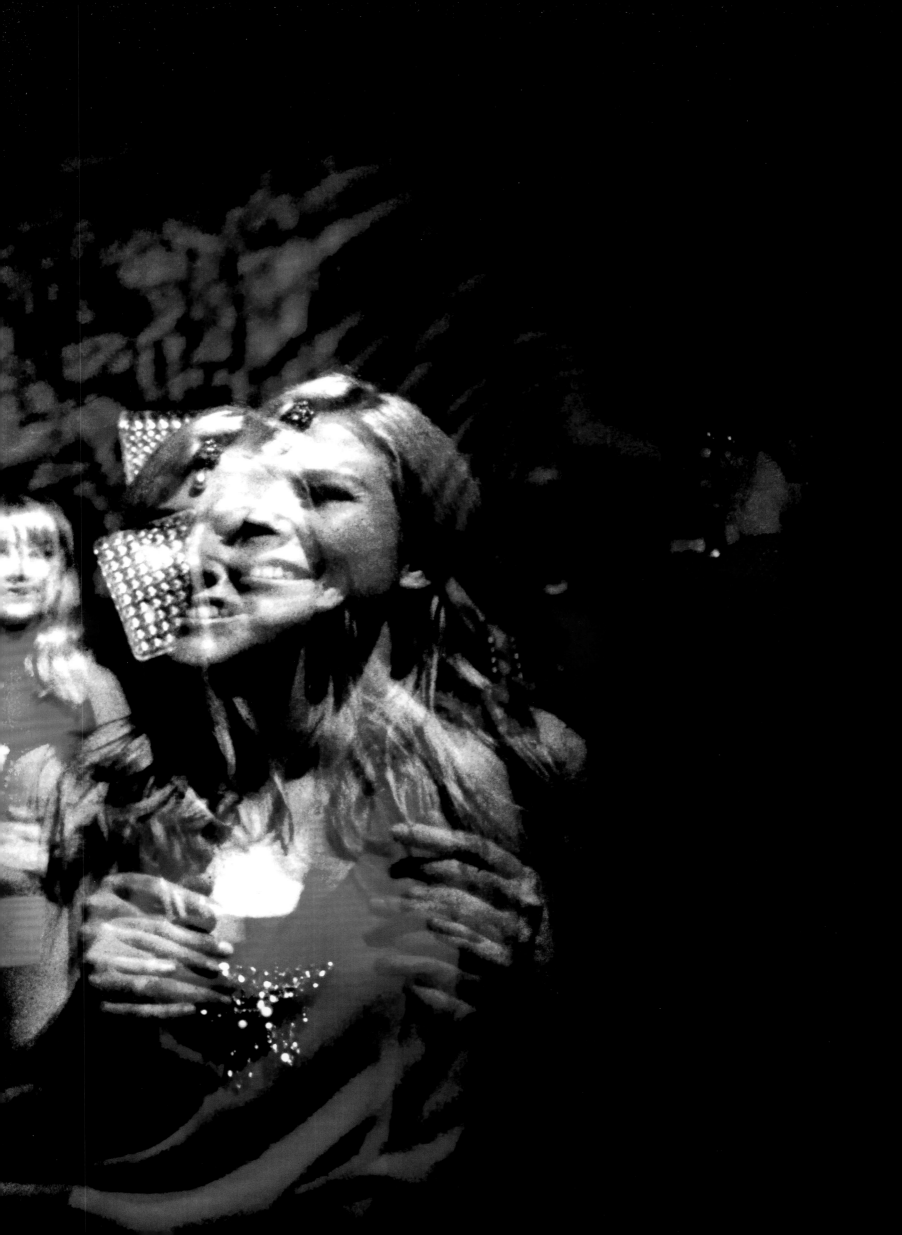

#4

The Summer of Love and the Winter of Discontent 1964–1978

p. 248/249
Steve Schapiro

Multiple exposure of dancers at the Fillmore West. The club was one of the first major venues to use light shows at rock concerts, which became multimedia events where audiences were as psychedically colorful as the performers, 1967.

Mehrfachbelichtung von Tänzern im Fillmore West. Der Club war einer der ersten, die Lichtshows bei Rockkonzerten einsetzten. Später wurden sie zu Multimediaevents, bei denen das Publikum so psychedelisch bunt war wie die Musiker, 1967.

Superposition de plusieurs vues de danseurs au Fillmore West. Le club fut l'un des premiers à utiliser des light-shows lors des concerts de rock, plus tard transformés en spectacles totaux qui portaient le public à un même point d'incandescence psychédélique que les musiciens sur scène. 1967.

Political activism in San Francisco is about as old as the city itself and had taken several forms throughout its first century. But by the mid-1960s, a number of factors galvanized a youth movement to resist established authority that would gain more international attention than any protests that had previously rocked the region. San Francisco State University, the University of California at Berkeley, and other local colleges were drawing some of the most liberal and socially conscious students in the country. After UC Berkeley banned the distribution of political material on campus in fall 1964, thousands of students took part in the Free Speech Movement. A December sit-in resulted in nearly 800 arrests, but also restored rights to political activity on university grounds by the following month.

Thousands more students and youth protested US involvement in the Vietnam War at a time when millions of young men were subject to the military draft. As a major center for draft induction, Oakland saw an especially large share of anti-war demonstrations, with conflicts between police and youth escalating in tension, sometimes to the point of violence.

Another youthful revolution was in the making, if more cultural than political. The city had produced the first American rock group to credibly emulate the Beatles-led sounds of the British Invasion, the Beau Brummels. Hordes of Bay Area ex-folkies eagerly electrified in their wake, bringing with them a hunger for not just blending folk with rock, but also mixing Indian and Middle Eastern influences, experimentation with loud electronic distortion, and lyrics reflecting their real-life experiments with free love and drug use.

San Francisco arguably did more than any other region to popularize psychedelic rock—sometimes dubbed acid rock, in keeping with the slang for LSD, one of the drugs the musicians and their audiences consumed. A slew of bands formed and quickly gained large and devoted followings, their very names reflecting the freewheeling creativity in the air. Jefferson Airplane, Big Brother & the Holding Company, the Grateful Dead, Country Joe & the Fish, Quicksilver Messenger Service, and Moby Grape were just the most popular. Compelling and charismatic singers like Airplane's Grace Slick and Marty Balin, and Big Brother's Janis Joplin, were complemented by thrilling risk-taking guitarists like Jorma Kaukonen (Jefferson Airplane), James Gurley (Big Brother), John Cipollina (Quicksilver), and Jerry Garcia (the Dead). By the end of the '60s, they'd be joined by more multicultural outfits like psychedelic funksters Sly & the Family Stone and Latin-blues-jazz fusioneers Santana.

The Haight-Ashbury neighborhood, bordering the eastern edge of Golden Gate Park, had taken over from North Beach as Counterculture Central. Attracted by cheap rents, hordes of students and young adults moved into the district, often living together communally. Along with the music came casual promiscuity and drug use, motivated at its onset at least as much by a quest for enlightenment as hedonism. The freakily dressed, impossibly long-haired musicians and listeners were now dubbed "hippies" by *San Francisco Chronicle* columnist Herb Caen. Not all of the neighborhood residents were young white hippies; African Americans comprised much of the population, both in Haight-Ashbury and a little to the northeast in the grittier Western Addition, which is still one of the city's most heavily Black-populated districts.

Head shops sprang up to service psychedelic needs, as did community organizations dispensing free clothes, food, and medical treatment. Free and benefit rock concerts were also commonplace, especially in the Panhandle, the narrow block-wide strip jutting out of Golden Gate Park's entrance. The Human Be-In, held in the park's Polo Fields in January 1967, drew tens of thousands with its free rock music and poetry, astounding many attendees who had no idea there were so many fellow freaks.

At the Avalon and Fillmore ballrooms, multimedia light shows enhanced both the musical and drug experience. Florid concert posters with wavy, challenging-to-decipher lettering quickly became valued as artworks in their own right. Entranced by the records and reports of Haight-Ashbury hippie utopia, about 100,000 young people from all over the country descended upon the area for what became known as the Summer of Love. Haight-Ashbury was too small to handle the hordes, many of them teenagers, and quite a few of them runaways. Excessive drug use was just one of the serious problems that ensued. Plenty of naive and oft-disoriented newcomers were taken advantage of by dealers and hustlers, and sometimes victimized by crime and abuse. Some of the local counterculture went as far as to consider the Summer of Love a cheap media creation, and the hippie dream was considered by many to have soured by summer's end.

As the Summer of Love faded, local political activism was fervent as ever. By the late '60s, outraged community groups managed to stop the San Francisco Redevelopment Agency's program of "slum clearance" but not until it had demolished thousands of homes, including many historic Victorians, and displaced businesses in the predominantly Black district of the Fillmore. Black activism took a more militant turn as the '60s waned. Fed up with police brutality and other injustices, the Black Panthers formed in Oakland, soon joined by numerous affiliates throughout the nation.

Much of the public reacted in horror to their most publicized images, many of which showed Panthers armed and seemingly ready for combat, though this was intended more as self-defense than aggression. The FBI and local law enforcement surveilled and often harassed them. Flamboyant Panther leaders like Eldridge Cleaver (author of the best-selling prison memoir *Soul on Ice*) and Huey Newton hit the headlines when controversial shootouts with the police put them in jail for stretches, Cleaver fleeing to Cuba in 1968 to avoid imprisonment. Often overlooked were their less controversial programs for social and economic justice, such as their free breakfasts for underprivileged children.

Bay Area colleges remained at the forefront of agitation for a more progressive community voice in both academic and public affairs. At San Francisco State, students shut down the university for five months in late 1968 and early 1969 to protest its lack of African American and ethnic studies programs, among other acts perceived as racist by many strikers. When UC Berkeley's plans to build housing and athletic fields on a vacant lot near campus stalled, residents turned it into a space for the community, People's Park. On May 15, 1969, Governor Ronald Reagan sent in police to clear the park. Casualties from battles between police and several thousand protesters included more than 100 hospitalizations, among them one observer shot to death. Reagan then brought in several thousand National Guard troops to patrol Berkeley streets for the next few weeks.

Notions that rock music could serve as a refuge were shattered by more violence at a rock festival on December 6, 1969. The Rolling Stones and the Grateful Dead had originally planned a sort

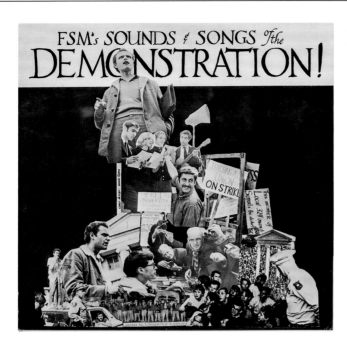

*FSM's Sounds & Songs of the
Demonstration!* Free Speech Movement,
FSM Records, 1965.

of Woodstock West in Golden Gate Park, but ended up settling for Altamont Speedway, 50 miles to the east. As Jefferson Airplane, Santana, the Flying Burrito Brothers, and Crosby, Stills, Nash & Young played, Hells Angels hired for security bashed numerous fans in the audience. While the Stones closed the concert, Berkeley teenager Meredith Hunter was stabbed to death by an Angel after pulling out a gun. It was a bitter end to a decade in which San Francisco had taken the world stage, the best of its hopes and dreams remaining a permanent centerpiece of its global image.

If Altamont had done much to dampen the idealism that had fired San Francisco through the 1960s, the first half of the 1970s raised little hope that the revolution would prevail. Key movements in the counterculture splintered. The San Francisco sound retreated from rock's vanguard. Yet the Summer of Love's faint afterglow also started to build new movements and communities whose legacy remains strong nearly half a century later.

One movement gained worldwide attention before it sputtered to a close in 1971. Native Americans had occupied Alcatraz in the final months of 1969, intending not only to bring their political goals to the fore, but also to establish a cultural center for their people on the island, which had fallen into neglect and disrepair after its federal prison closed in 1963. Internal power struggles quelled the new community's will and unity, as did the sheer hardship of bringing food, water, and other supplies to the inhospitable rock. Only 15 remained when they were removed by government officers in June 1971.

The occupation was nonetheless successful in raising a greater nationwide consciousness of crucial issues, both among Native American activists and federal policymakers. Alcatraz, which developers had hoped to exploit with residential and commercial projects, became part of the Golden Gate National Recreation Area. Served by ferries from Fisherman's Wharf, it became one of San Francisco's top tourist destinations, with displays acknowledging both its stormy past as a prison facility and its brief but rousing stint as a home for Native Americans.

African American struggles for justice had another bumpy road in the early 1970s, much of the action taking place in counties adjoining San Francisco. In August 1970, teenager Jonathan Jackson attempted to kidnap Superior Court judge Harold Haley at the Marin County Civic Center in an effort to gain release for three African American prisoners charged with the murder of a white prison guard. Four died in the ensuing shootout, including Jackson, Haley, and Black Panthers also participating in the kidnapping.

Angela Davis, a Black activist, went underground when it was found that Jackson's guns were registered to her. Davis was acquitted on charges related to the killings in 1972 and went on to have a long career teaching at San Francisco State and other colleges. Jonathan Jackson's older brother George, however, was shot to death the previous year while trying to escape from Marin County's notorious San Quentin Prison. Bob Dylan even weighed in on the matter with his "George Jackson" single.

The Marin County deaths tarnished the Black Panther Party's already volatile public image, even as it built some support within the Bay Area's African American community with its community-oriented programs and colorful newspaper. The party was steadily weakened by leadership infighting and the legal and personal problems of its charismatic but troubled cofounder Huey Newton. By the mid-'70s, both the party and its programs were in disarray, the movement all but dissolving by the end of the decade. Its most progressive ideals, however, had made incursions into the political mainstream, with a few Panthers bringing some of their principles into electoral politics and academia over the next few decades.

The Bay Area radical underground peaked in notoriety with the Berkeley kidnapping of heiress Patricia Hearst, granddaughter of publishing magnate William Randolph Hearst. The crime was pulled off by the Symbionese Liberation Army, a small band of activists—often viewed as extremists—hoping to use her abduction for freeing two imprisoned SLA members. They also demanded the Hearsts give $70 of food to every Californian who needed it, an impossible goal that the family's $2 million donation couldn't dent. Patty then announced she had joined the SLA and, on April 15, 1974, wielded a gun while she and her new comrades robbed a San Francisco bank, wounding a couple men in the process. Most of

Mondo Topless, Russ Meyer,
Eve Productions, 1966.
Heritage Auctions, HA.com

the SLA died in a shootout with Los Angeles police the following month, while Hearst was arrested in San Francisco by the FBI in September 1975. She served some prison time before her sentence was commuted by president Jimmy Carter.

The Hearst affair was just one event that burnished San Francisco's reputation as a haven for social deviants, some of them dangerous lunatics. Days after Hearst's arrest, Sara Jane Moore tried to assassinate President Gerald Ford as he left the St. Francis Hotel on Union Square. From the late '60s to early '70s, a serial killer identifying himself as "Zodiac" claimed responsibility for 37 deaths throughout the Bay Area. The exact number of his victims will never be determined, and his identity is still unknown, though he boasted about his crimes in numerous letters to leading newspapers.

In the mid-'70s, faith healer and preacher Jim Jones had amassed a considerable following, principally among African Americans, as leader of the Peoples Temple, headquartered in San Francisco's Fillmore District. Courted by some politicians who praised his free feeding programs and health clinics for the poor, he lost his allies when evidence of his cultlike control surfaced. After Jones and 900 followers founded a Peoples Temple Jonestown community in Guyana, the world was stunned by the news that he had ordered his followers to die by mass suicide with cyanide-laced drinks. Nearly a thousand died by that method on November 18, 1978. California Congressman Leo Ryan, who had traveled to Jonestown to investigate, and four people in his entourage were shot to death as they attempted to return to the United States. Jones shot himself to death the same day.

These sort of calamities might have made it seem like the city was descending from utopia to dystopia, but they hardly defined San Francisco life in the '70s. Commerce continued as usual in the Financial District, its skyline rising with the 1972 completion of the 853-foot Transamerica Pyramid, until very recently the city's tallest building. The same year, the Bay Area Rapid Transit (BART) system opened, connecting San Francisco to the East Bay by train with an underground Transbay Tube.

On the more creative end, fine dining became fine art with a proliferation of world-class restaurants featuring California cuisine, with Berkeley's Chez Panisse leading the way. Owner Alice Waters not only authored several popular cookbooks, but also promoted organic ingredients and sustainable food production, even establishing an Edible Schoolyard at a Berkeley Middle School. A network of worker-owned food co-ops established a People's Food System as a different way to bring environmentally conscious, sustainable food production into Bay Area palates. While many of those food co-ops didn't see out the century, the region remains a haven for both markets and eateries with an almost embarrassingly huge and diverse selection of eco-friendly ingredients.

Emerging directors Francis Ford Coppola and George Lucas put San Francisco on the forefront of cinema's cutting edge by forming a city-based film production company, American Zoetrope. Coppola set one of his best films, 1974's murder-surveillance thriller *The Conversation*, in San Francisco. Lucas hit pay dirt with *American Graffiti* and *Star Wars*, using his Marin County Skywalker Ranch as a base from the late '70s onward. Although not many other commercial filmmakers made the Bay Area their base, San Francisco remained the setting for memorable Hollywood thrillers (including *Dirty Harry* and a remake of *Invasion of the Body Snatchers*) and the comedy that made greater hay with a comic car chase over the city's steepest hills than any other, 1972's *What's Up, Doc?* Future stars Robin Williams and Whoopi Goldberg paid their dues as stand-up comics in the Bay Area in the '70s, and the San Francisco Mime Troupe brought free underground political satire to local parks, as they had since the '60s and continue to do today.

While veterans of the local Beat generation like Richard Brautigan continued to produce quality work, the literary scene gave rise to writers with a wider range of voices. Maxine Hong Kingston and (starting in the 1980s) Amy Tan's novels portrayed the Asian American experience with passionate realism. The most popular of these, Tan's *The Joy Luck Club*, would inspire a 1993 hit movie by Wayne Wang, whose first film (1982's *Chan Is Missing*) was one of the few with a naturalistic focus on everyday life in San Francisco's Chinatown. Originating as serialized newspaper

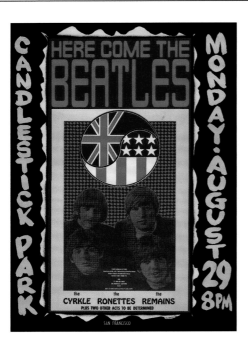

←
*Beatles final concert poster, Wes Wilson, 1966.
Heritage Auctions, HA.com*

→
*"Pow-Wow: A Gathering of Tribes for a Human
Be-In" poster, Rick Griffin, 1967.
Heritage Auctions, HA.com*

columns, in the late 1970s Armistead Maupin's *Tales of the City*
documented the city's diverse sexualities with an ensemble of off-
beat characters, generating eight sequels and a popular TV series.

Although San Francisco suffered a major blow when its most
storied venue, the Fillmore, closed in mid-1971, the city still offered
top-flight concerts at venues like Winterland, and a growing
number of arena shows promoted by Fillmore impresario Bill
Graham, his annual Day on the Greens filling Oakland Coliseum.
That stadium was also home to the Oakland Athletics Major League
Baseball team, who had relocated from Kansas City in 1968. By the
early '70s, they were stealing much of the thunder from their cross-
bay Giants rivals, winning three straight World Series from 1972 to
1974 with a colorful squad dubbed the Moustache Brigade for their
shaggy facial hair. The Golden State Warriors won their first National
Basketball Association title in 1975, led by superstar Rick Barry.

Sensing that San Francisco was no longer where the musical
and cultural action was at, *Rolling Stone* magazine, founded in the
city in 1967, left for New York in 1976. Yet at the same time, other
forms of art were on the rise, if so far underground they could
make Haight-Ashbury psychedelia seem mainstream. Outside
of New York and Los Angeles, no US city had as fervent a punk
rock scene as San Francisco. Like the hippies, the punks were
freakily wardrobed outsiders, cultivating a new style of music
louder and less commercial than the day's pop. When a North
Beach Filipino restaurant turned into a nighttime rock club, the
Mabuhay Gardens became the scene's linchpin. Acts like the
Avengers, Crime, the Dils, the Nuns, and, most notorious, the
Dead Kennedys filled the space with pogoing punksters.

The cultural movement most identified with '70s San
Francisco, however, had a sociopolitical impact whose reverberations
were felt long after the decade closed and far beyond the city limits.
Ever since the Barbary Coast's heyday, San Francisco had been toler-
ant of the gay community. By the middle of the 20th century, its gay
population was substantial, but for the most part closeted. Organized
gay political action started to build in the 1960s in reaction to attacks
by civic authorities, including City Assessor Russell Wolden, whose

unsuccessful 1959 run for mayor targeted "sex deviates"; a police
campaign to threaten or revoke gay bars' liquor licenses; and a raid
on a California Hall drag ball on New Year's Day in 1965. The Tavern
Guild, the first gay business association in the United States, was
launched in 1962 to fight police harassment and promote other gay
causes, but the gay community didn't wield much political power.

That started to change in the early '70s, when much of that
population began to settle in the Castro, a working-class district
near the western end of Market Street, overlooked by Twin Peaks.
Attracted by a neighborhood in which they could be open about
their sexuality, the gay community was the dominant cultural force
in the Castro by the mid-'70s. Plenty of gays, lesbians, bisexuals,
and transsexuals were moving to other parts of the city and Bay
Area at the same time, attracted by a region where their lifestyle
wouldn't suffer the kind of discrimination it did elsewhere.
Celebrated by disco diva Sylvester on record and in bars and the-
atrical productions targeting the LGBT crowd, their numbers still
hadn't translated into appreciable political power.

That changed with Harvey Milk, a middle-aged Castro cam-
era store owner and political activist whose energy, dedication, and
personable approach led him to City Hall. After a change in voting
laws in which supervisors would be elected by district rather than
by citywide voting, Milk became the first openly gay politician
on the San Francisco Board of Supervisors in November 1977. The
district-elected board also welcomed its first Chinese, Latino, and
Black woman supervisor at the same time, finally reflecting the
city's multicultural diversity.

As supervisor, Milk worked not only for gay rights, but also
for numerous progressive causes on behalf of all city residents. His
time in office was brief. Milk and Mayor George Moscone were
assassinated in City Hall on November 27, 1978 by Dan White, a
disenchanted conservative who'd recently resigned his position as
supervisor and been unable to reclaim it. Tens of thousands spon-
taneously marched from the Castro to City Hall by candlelight
that evening in Milk's memory. The vigil was a strikingly peaceful
expression of grief in a decade marked by violent tragedy.

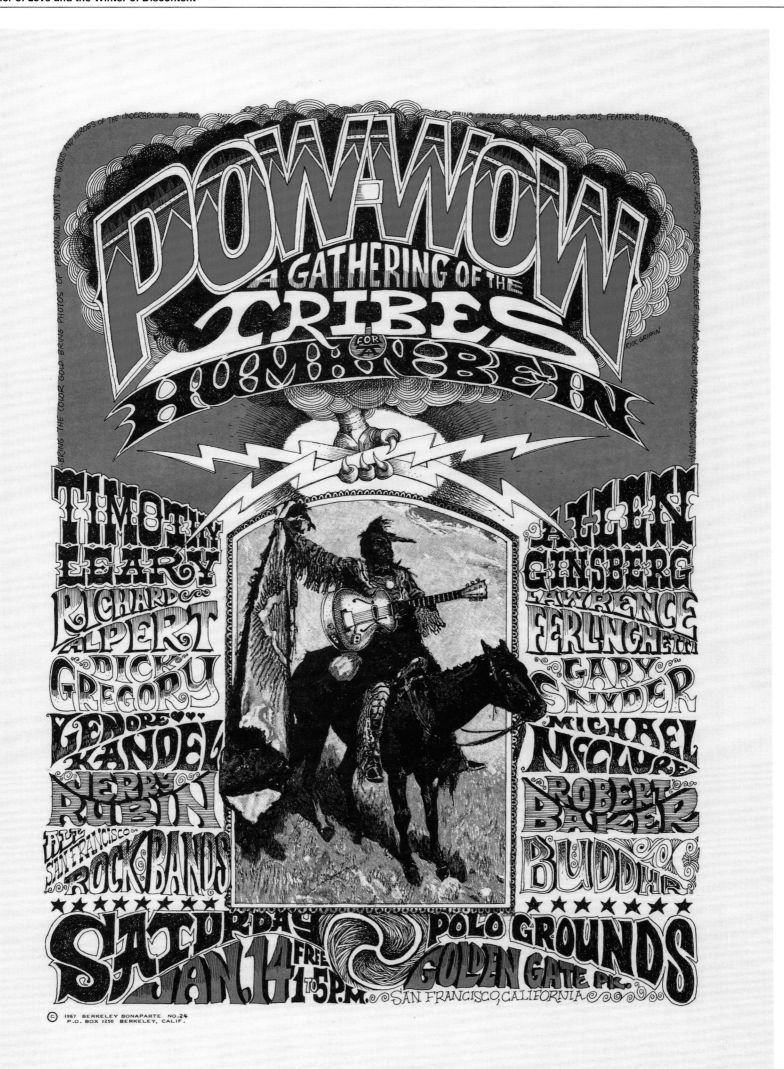

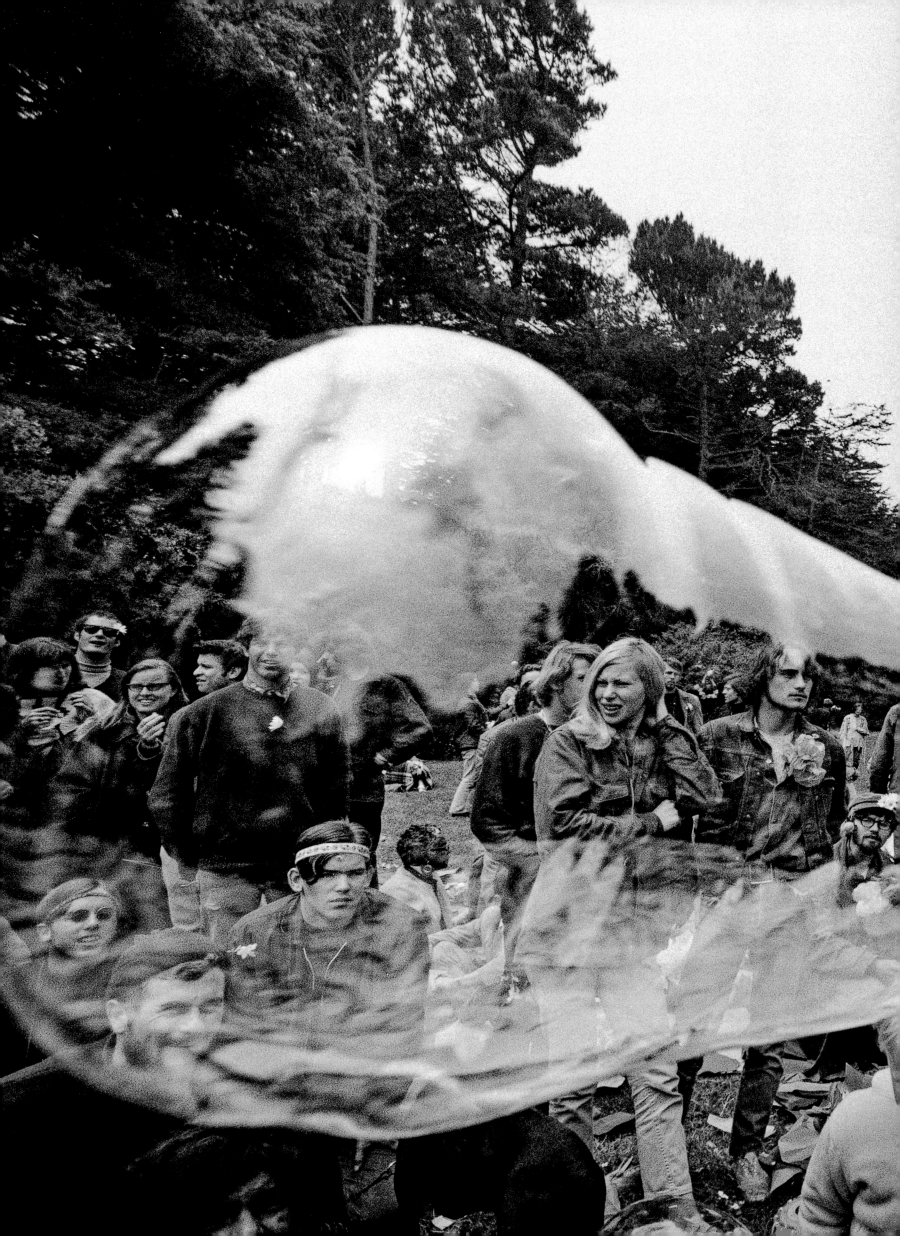

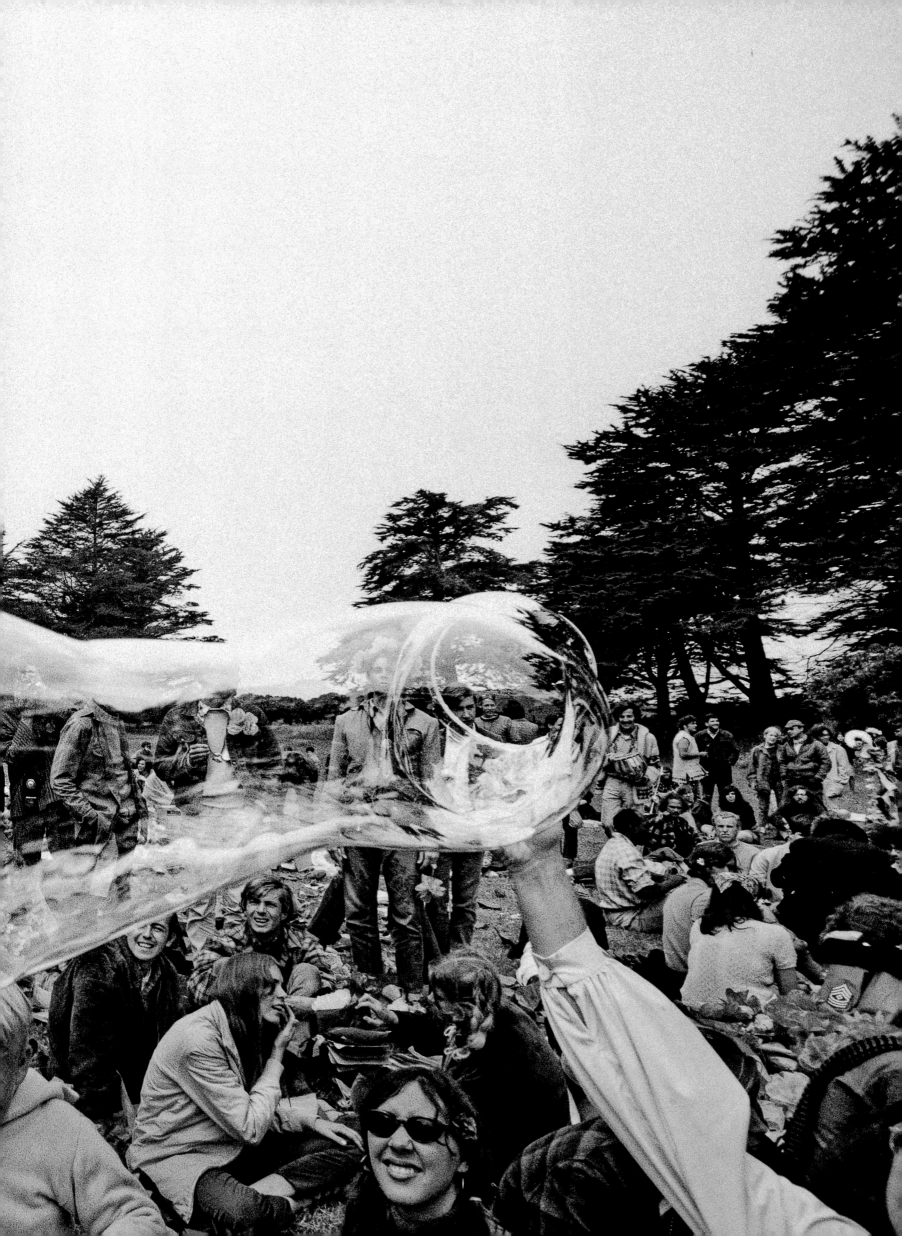

#4

Der Sommer der Liebe und der Winter des Missvergnügens 1964–1978

p. 256/257
Ted Streshinsky

A giant bubble refracts the view of the crowd at the Golden Gate Park Human Be-In. Created by artist Michael Bowen and promoted as a "gathering of tribes," it drew nearly 30,000 people to the Polo Fields in Golden Gate Park, 1967.

Eine riesige Seifenblase verzerrt das Bild der Menge beim Golden Gate Park Human Be-In. Geschaffen vom Künstler Michael Bowen und beworben als ein „Zusammenkommen der Stämme", brachte es fast 30 000 Menschen auf die Polo-Felder des Parks, 1967.

Une bulle géante déforme cette vue de la foule lors du Human Be-In organisé par l'artiste Michael Bowen. Présenté comme un « rassemblement de tribus », ce happening attira près de 30 000 personnes sur le terrain de polo du Golden Gate Park. 1967.

San Franciscos politischer Aktivismus ist fast so alt wie die Stadt selbst und hat seit der Stadtgründung verschiedenste Formen angenommen. Doch aus einer Reihe von Faktoren entstand Mitte der 1960er-Jahre eine Jugendbewegung gegen etablierte Autoritäten, die international mehr Aufmerksamkeit erregte als alle zuvor dagewesenen Proteste in der Region. Die San Francisco State University, die University of California in Berkeley und andere lokale Universitäten zogen einige der liberalsten und progressivsten Studenten des Landes an. Als es im Herbst 1964 verboten wurde, auf dem Campus der Universität Berkeley politisches Material zu verteilen, schlossen sich Tausende Studenten der Free-Speech-Bewegung an. Ein Sitzstreik im Dezember, bei dem fast 800 Teilnehmer verhaftet wurden, war erfolgreich: Das Recht auf politische Aktivitäten auf dem Campus wurde einen Monat später wiederhergestellt.

An den Protesten gegen die US-Beteiligung am Vietnamkrieg nahmen Tausende weitere Studenten und Jugendliche teil, Millionen junge Männer unterlagen der Wehrpflicht. Als eines der wichtigsten Zentren für die Einberufung gab es in Oakland besonders viele Antikriegsdemonstrationen, bei denen die Konfrontationen zwischen Polizei und Jugendlichen immer angespannter wurden und manchmal in Gewalt endeten.

Es gab eine weitere junge Revolution, eher kulturell als politisch. Mit den Beau Brummels brachte die Stadt die erste amerikanische Rockgruppe hervor, die den von den Beatles geprägten Sound der British Invasion glaubhaft nachahmte. Scharen ehemaliger Bay-Area-Folkies schalteten auf elektrisch um und mischten nicht nur Folk mit Rock, sondern experimentierten auch mit indischen und nahöstlichen Einflüssen, elektronischer Verzerrung und Texten, die ihre Experimente mit freier Liebe und Drogenkonsum widerspiegelten.

Mehr als irgendein anderer Ort hat San Francisco dazu beigetragen, den Psychedelic Rock populär zu machen – manchmal auch als Acid Rock bezeichnet, in Anlehnung an einen der Namen für LSD, eine bei Musikern und Publikum gleichermaßen beliebte Droge. Eine ganze Reihe von Bands wurde gegründet, die schnell große Anhängerschaften gewannen und deren Namen die ungezügelte Kreativität des Moments widerspiegelten. Jefferson Airplane, Big Brother & the Holding Company, The Grateful Dead, Country Joe & the Fish, Quicksilver Messenger Service und Moby Grape waren nur die beliebtesten. Charismatische Vokalisten wie Grace Slick und Marty Balin von Jefferson Airplane und Janis Joplin von Big Brother wurden durch experimentierfreudige Gitarristen wie Jorma Kaukonen (Jefferson Airplane), James Gurley (Big Brother), John Cipollina (Quicksilver) und Jerry Garcia (Greatful Dead) ergänzt. Weitere multikulturelle Bands kamen Ende der 6oer-Jahre hinzu, wie die psychedelischen Funks Sly & the Family Stone oder Santana mit ihrem Mix aus Latin, Blues und Jazz.

Das Haight-Ashbury-Viertel am östlichen Rand des Golden Gate Park war als Zentrum der Counterculture das neue North Beach. Angelockt von günstigen Mieten zogen Scharen von Studenten und jungen Erwachsenen in das Viertel und lebten oft in Kommunen. Mit der Musik kamen auch Promiskuität und Drogenkonsum, anfangs mindestens ebenso von

der Suche nach Erleuchtung motiviert wie von Hedonismus. Herb Caen, Kolumnist des San Francisco Chronicle, nannte die exzentrisch gekleideten, langhaarigen Musiker und ihre Zuhörer „Hippies". Aber das Viertel bestand nicht nur aus jungen weißen Hippies; ein Großteil der Bevölkerung waren Afroamerikaner, von Haight-Ashbury und der etwas weiter nordöstlich gelegenen, raueren Western Addition waren Afroamerikaner und sind es vor allem in Letzterer bis heute.

Es entstanden Headshops, um den psychedelischen Bedarf zu decken, und Organisationen, die kostenlose Kleidung, Lebensmittel und medizinische Versorgung zur Verfügung stellten. Gratis- und Benefiz-Rockkonzerte waren alltäglich, vor allem im Panhandle, einem etwa einen Block breiten Streifen am Eingang des Golden Gate Park. Im Januar 1967 fand das Human Be-In im Park statt und zog mit kostenloser Rockmusik und Lyrik Zehntausende an. Viele Besucher erkannten verblüfft, wie viele andere Freaks es noch gab.

Auf den Tanzflächen des Avalon und des Fillmore steigerten multimediale Lichtshows die Musik- und Drogenerfahrung. Die Konzertplakate mit verschnörkelter, schwer zu entziffernder Schrift wurden bald als eigenständige Kunstwerke geschätzt. Von den Berichten über die Hippie-Utopie in Haight-Ashbury verzaubert, strömten etwa 100 000 Jugendliche aus dem ganzen Land in die Gegend: Es war der „Sommer der Liebe". Viele von ihnen waren Teenager, und so mancher war von Zuhause weggerannt. Haight-Ashbury war zu klein für die Menschenmassen, woraus sich ernste Probleme ergaben, von denen der übermäßige Drogenkonsum nur eins war. Dealer und Gauner nahmen viele naive Neuankömmlinge ins Visier; einige wurden Opfer von Verbrechen und Missbrauch. Ein Teil der lokalen Szene betrachtete den Sommer der Liebe sogar als billiges Medienevent, und viele hielten den Hippie-Traum am Ende des Sommers für verdorben.

Während der Sommer der Liebe zu Ende ging, blieb der politische Aktivismus auf lokaler Ebene stark wie eh und je. Es gelang empörten Bürgern in den späten 6oer-Jahren das Programm der San Francisco Redevelopment Agency zur Beseitigung der Slums zu stoppen, aber erst nachdem Tausende historische Häuser abgerissen und viele Geschäfte im überwiegend schwarzen Stadtteil Fillmore verdrängt worden waren. Zur selben Zeit nahm auch der schwarze Aktivismus eine militante Wendung. Polizeigewalt und andere Ungerechtigkeiten führten zur Gründung der Black Panthers in Oakland, die bald zahlreiche Tochterorganisationen im ganzen Land hatten.

Obwohl es eher um Selbstverteidigung als um Aggression ging, reagierte ein Großteil der Öffentlichkeit mit Entsetzen auf die weithin verbreiteten Bilder der meist bewaffneten und scheinbar kampfbereiten Panthers. Das FBI und die örtlichen Behörden überwachten und schikanierten sie. Extravagante Panther-Führer wie Eldridge Cleaver (seine Memoiren *Seele auf Eis* waren ein Bestseller) und Huey Newton machten Schlagzeilen, als sie nach Schießereien mit der Polizei für längere Zeit ins Gefängnis kamen. Cleaver floh 1968 nach Kuba, um einer Inhaftierung zu entgehen. Ihre weniger kontroversen Programme für soziale und wirtschaftliche Gerechtigkeit wurden oft übersehen, beispielsweise das kostenloses Frühstück für unterprivilegierte Kinder.

Die Universitäten der Bay Area waren weiterhin an vorderster Front, wenn es darum ging, progressiveren Stimmen der Gesellschaft in akademischen und öffentlichen Angelegenheiten Gehör zu verschaffen. Studenten legten die San Francisco State University Ende 1968 bis Anfang 1969 für fünf Monate lahm, um gegen das Fehlen von Studienprogrammen für African American und Ethnic Studies und andere Dinge zu protestieren, die von vielen als rassistisch verstanden wurden. Als Pläne der UC Berkeley, Wohnungen und Sportplätze auf einem leeren Grundstück in der Nähe des Campus zu bauen, stockten, verwandelten Anwohner es in einen Platz für die Allgemeinheit, den People's Park. Am 15. Mai 1969 ließ Gouverneur Ronald Reagan den Park von der Polizei räumen. Nach den Kämpfen zwischen Polizei und mehreren Tausend Demonstranten mussten über 100 Personen ins Krankenhaus eingeliefert werden, ein Beobachter wurde erschossen. Reagan rief daraufhin ein große Zahl von Nationalgardisten in die Stadt, die auf Berkeleys Straßen patrouillierten.

Am 6. Dezember 1969 wurde die Vorstellung, dass Rockmusik eine Zuflucht sein könnte, durch Gewalt auf einem Rockfestival zunichte gemacht. Die Rolling Stones und die Grateful Dead planten ursprünglich eine Art westliches Woodstock im Golden Gate Park, einigten sich dann aber auf den Altamont Speedway, einen Motorsportparcours 80 Kilometer weiter östlich. Während der Auftritte von Jefferson Airplane, Santana, den Flying Burrito Brothers und Crosby, Stills, Nash & Young verprügelten eigentlich als Sicherheitsleute eingestellte Hells Angels zahlreiche Fans im Publikum. Noch während die Stones am Ende des Konzerts spielten, wurde Meredith Hunter, ein Teenager aus Berkeley, von einem Angel erstochen, nachdem er eine Waffe gezogen hatte. Es war das bittere Ende einer Dekade, in der San Francisco die Weltbühne mit Hoffnungen und Träumen erobert hatte, deren beste Facetten zum festen Bestandteil des globalen Images der Stadt geworden war.

Altamont hatte dem Idealismus, der im San Francisco der 1960er entflammt war, einen Dämpfer verpasst, und die erste Hälfte der 1970er bot wenig Grund zu der Hoffnung, dass sich die Revolution durchsetzen würde. Wichtige Bewegungen der Counterculture zersplitterten. Der San-Francisco-Sound war nicht mehr die Avantgarde der Rockmusik. Doch aus den Überresten des Sommers der Liebe entstanden neue Bewegungen und Gemeinschaften, deren Vermächtnis auch fast ein halbes Jahrhundert später noch Bestand hat.

Eine dieser Bewegungen erlangte Aufmerksamkeit weltweit, bevor sie 1971 endete. Native Americans hatten Alcatraz in den letzten Monaten des Jahres 1969 besetzt. Sie wollten nicht nur ihre politischen Ziele durchsetzen, sondern auch ein kulturelles Zentrum auf der Insel einrichten, die nach der Schließung des Gefängnisses 1963 verwahrloste. Aber der Aufwand, den Felsen mit Lebensmitteln und anderen Gütern zu versorgen, schadete dem Zusammenhalt auf lange Sicht fast so sehr wie die internen Machtkämpfe. Nur 15 Personen waren noch dort, als die Insel im Juni 1971 von Regierungsbeamten geräumt wurde.

Trotzdem schaffte es die Besetzung, in der ganzen Nation Aufmerksamkeit auf einige zentrale Fragen zu lenken, sowohl unter Native-American-Aktivisten als auch bei politischen Entscheidungsträgern. Alcatraz wurde Teil der Golden Gate National Recreation Area, obwohl es bereits Pläne für Wohn- und Gewerbeprojekte gab. Per Fähre von Fisherman's Wharf aus zu erreichen, wurde es zu einem der beliebtesten Ziele für Touristen in San Francisco. Sowohl die stürmische Vergangenheit des Gefängnisses als auch die kurze, aber bewegende Zeit der Besetzung sind auf Schautafeln dokumentiert.

Die afroamerikanischen Kämpfe für Gerechtigkeit waren in den frühen 1970ern weiterhin schwierig, sie spielten sich aber zum Großteil in den Gegenden um San Francisco herum ab. Im August 1970 versuchte der Teenager Jonathan Jackson, den Richter Harold Haley am Civic Center in Marin County zu entführen, um die Freilassung von drei Afroamerikanern zu erreichen, denen der Mord an einem weißen Gefängniswärter vorgeworfen wurde. Vier Personen starben bei der folgenden Schießerei,

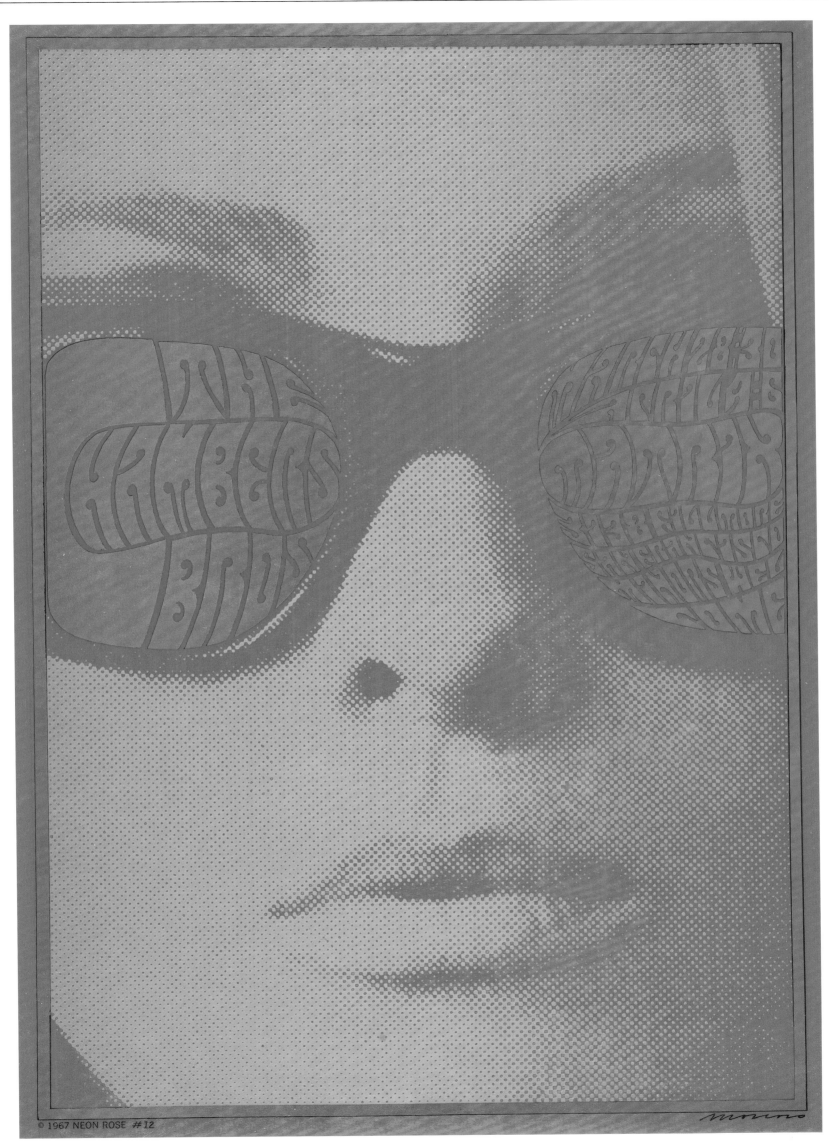

© 1967 NEON ROSE #12

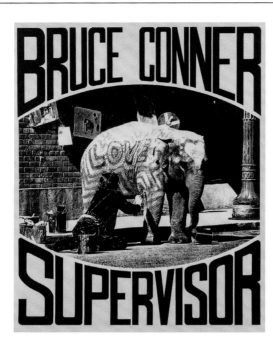

←
"Bruce Connor Supervisor" poster, Dagny
Jass, 1967.

→
Bullitt, *Peter Yates, Warner Bros., 1968.*
Heritage Auctions, HA.com

darunter Jackson, Haley und ebenfalls an der Entführung beteiligte Black Panthers.

Die schwarze Aktivistin Angela Davis tauchte unter, als sich herausstellte, dass Jacksons Waffen auf sie registriert waren. 1972 wurde sie von der Anklage, an den Todesfällen beteiligt zu sein, freigesprochen und machte später Karriere als Professorin an der San Francisco State University. Ein Jahr zuvor war Jonathan Jacksons älterer Bruder George erschossen worden, als er versuchte, aus dem berüchtigten Gefängnis San Quentin zu fliehen. Sogar Bob Dylan meldete sich in der Sache zu Wort: Seine Single „George Jackson" erreichte die Top 40.

Die Tode in Marin County schadeten dem ohnehin schon fragwürdigen Image der Black Panther Party, auch wenn sie sich durch ihre gemeinnützigen Programme und eine bunte Zeitung Unterstützung unter Afroamerikanern in der Bay Area erarbeitete. Führungsstreitigkeiten und rechtliche sowie persönliche Schwierigkeiten des charismatischen, aber problematischen Mitbegründers Huey Newton schwächten die Partei weiter. Mitte der 70er-Jahre waren die Partei und ihre Projekte im Niedergang begriffen, die Bewegung löste sich bis Ende des Jahrzehnts nahezu auf. Ihre fortschrittlichsten Ideale fanden jedoch den Weg in den politischen Mainstream, und einige Panthers brachten in den folgenden Jahrzehnten manche ihrer Prinzipien in die Politik oder die akademische Welt ein.

In Berkeley erreichte der radikale Untergrund der Bay Area einen Höhepunkt, als Patricia Hearst, Erbin und Enkelin des Großverlegers William Randolph Hearst, entführt wurde. Hinter dem Verbrechen stand die Symbionese Liberation Army, eine kleine Gruppe von oft als Extremisten angesehenen Aktivisten, die mit der Entführung die Freilassung von zwei inhaftierten SLA-Mitgliedern erreichen wollten. Außerdem verlangten sie, dass die Hearsts jedem bedürftigen Kalifornier Lebensmittel im Wert von 70 Dollar geben sollten; ein unmögliches Unterfangen, dem die 2-Millionen-Dollar-Spende der Familie nicht ansatzweise entsprechen konnte. Patty gab daraufhin ihren Eintritt in die SLA

bekannt und raubte am 15. April 1974 bewaffnet mit ihren neuen Kameraden eine Bank in San Francisco aus, wobei es einige Verletzte gab. Nur einen Monat später wurden die meisten Mitglieder der SLA bei einer Schießerei mit der Polizei von Los Angeles getötet, Hearst wurde im September 1975 in San Francisco vom FBI verhaftet. Sie saß einige Zeit im Gefängnis, bevor ihre Strafe von Präsident Jimmy Carter verringert wurde.

Die Hearst-Affäre verstärkte San Franciscos Ruf als Zufluchtsort für soziale Außenseiter, unter ihnen einige gefährliche Verrückte. Nur Tage nach Hearsts Verhaftung versuchte Sara Jane Moore Präsident Gerald Ford zu ermorden, als er das St. Francis Hotel am Union Square verließ. Von den späten 6oern bis Anfang der 70er bekannte sich ein Serienmörder zu 37 Toten in der Bay Area. Er nannte sich selbst „Zodiac". Obwohl er in zahlreichen Briefen an die größten Zeitungen San Franciscos mit seinen Verbrechen prahlte, ist seine Identität noch immer unbekannt, die genaue Anzahl der Opfer wurde nie ermittelt.

Jim Jones, Wunderheiler und Prediger, hatte als Gründer des Peoples Temple mit Sitz im Fillmore District Mitte der 70er-Jahre eine beachtliche Anhängerschaft um sich gesammelt, größtenteils Afroamerikaner. Einige Politiker umwarben ihn, vor allem aufgrund seiner kostenlosen Ernährungs- und Gesundheitsprogramme für die Armen, aber er verlor diese Verbündeten, als Beweise dafür zutage kamen, dass er seine Anhänger wie ein Sektenführer kontrollierte. Nachdem Jones und 900 seiner Anhänger die Gemeinde Peoples Temple Jonestown in Guyana gegründet hatten, schockierte die Nachricht die Welt, dass er seinen Anhängern einen Massensuizid mittels Zyanid befohlen hatte. So starben fast 1000 Menschen am 18. November 1978. Der kalifornische Kongressabgeordnete Leo Ryan und vier seiner Begleiter, die nach Jonestown gereist waren, um sich ein Bild der Lage zu verschaffen, wurden erschossen, als sie versuchten, die Rückreise anzutreten. Jones beging noch am gleichen Tag Selbstmord.

Obwohl Katastrophen dieser Art den Eindruck erwecken könnten, dass die Utopie der Stadt in eine Dystopie

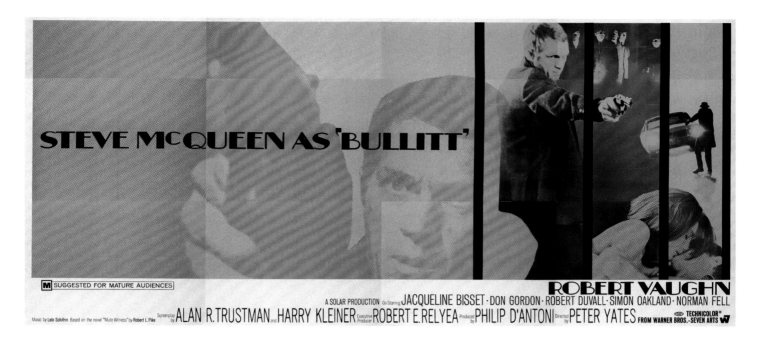

umschlug, bestimmten sie das Leben im San Francisco der 70er-Jahre kaum. Im Finanzdistrikt ging alles seinen normalen Gang, und die 1972 fertiggestellte Transamerica Pyramid, 260 Meter hoch und bis vor Kurzem das höchste Gebäude der Stadt, wurde Teil der Skyline. Im selben Jahr öffnete das U-Bahnsystem Bay Area Rapid Transit (BART), das San Francisco und die East Bay durch unterirdische Tunnel verbindet.

Es entstanden zahlreiche Weltklasserestaurants mit kalifornischer Küche, von denen das Chez Panisse in Berkeley das bekannteste ist. Die Gastronomie wurde zur Kunstform. Die Besitzerin Alice Waters schrieb nicht nur einige beliebte Kochbücher, sondern warb auch für Bio-Zutaten und nachhaltige Lebensmittelproduktion. An einer Mittelschule in Berkeley startete sie sogar das Projekt eines essbaren Schulhofes. Ein Netzwerk von Lebensmittelgenossenschaften gründete ein People's Food System, um umweltbewusste und nachhaltige Lebensmittel auf die Tische der Bay Area zu bringen. Viele dieser Genossenschaften waren zwar nur kurzlebig, die Region blieb aber ein Paradies für Märkte und Restaurants mit einer riesigen Auswahl an umweltfreundlichen Zutaten.

Die jungen Regisseure Francis Ford Coppola und George Lucas brachten San Francisco mit der Gründung der Produktionsfirma American Zoetrope an die Spitze des modernen Kinos. Einer von Coppolas besten Filme spielte in San Francisco, der Überwachungs-Thriller *Der Dialog* von 1974. Die Skywalker Ranch in Marin County wurde zu Lucas Hauptquartier, nachdem er mit *American Graffiti* und *Star Wars* Hits landete. Obwohl wenige andere kommerzielle Filmemacher ihr Zuhause in der Bay Area hatten, war San Francisco der Schauplatz für berühmte Hollywood-Thriller (darunter *Dirty Harry* und ein Remake von *Die Körperfresser kommen*) und eine Komödie, die die steilen Hügel der Stadt besser für eine Verfolgungsjagd zu nutzen wusste als irgendein anderer Film: *Is' was, Doc?* von 1972. Robin Williams und Whoopi Goldberg fingen in den 70ern in der Bay Area als Stand-up-Comedians an, und die San Francisco Mime Troupe

bringt seit den 1960er-Jahren kostenlos politische Satire in die örtlichen Parks.

Während die Veteranen der örtlichen Beat-Generation wie Richard Brautigan weiterhin Qualitätsromane schrieben, brachte die Literaturszene eine große Bandbreite von neuen Schriftstellern hervor. Romane von Maxine Hong Kingston und (ab den 80er-Jahren) Amy Tan schildern asiatisch-amerikanische Erfahrungen mit leidenschaftlichem Realismus. Der populärste dieser Romane, Tans *Töchter des Himmels*, wurde 1993 zum Kinohit, adaptiert von Wayne Wang, dessen erster Film (*Chan ist verschwunden*, 1982) einer der wenigen war, die den Alltag in San Franciscos Chinatown realistisch darstellten. Angefangen als Zeitungskolumne, dokumentierten Armistead Maupins *Stadtgeschichten* in den späten 1970ern die vielfältigen Sexualitäten der Stadt anhand einer Reihe von schrägen Charakteren, es folgten acht Fortsetzungen und eine beliebte Fernsehserie.

Es war ein schwerer Schlag für San Francisco, als das Fillmore, eine der berühmtesten Locations der Stadt, Mitte 1971 schloss. Aber an Orten wie dem Winterland bot die Stadt noch immer hochkarätige Konzerte. Dazu kamen immer mehr Shows in Stadien, beworben vom Fillmore-Impresario Bill Graham, dessen jährlicher Day on the Greens das Oakland Coliseum füllte. Das Stadion war auch die Heimat der Oakland Athletics, ein Major League Baseballteam, das 1968 aus Kansas City zugezogen war. Anfang der 70er stahlen sie den Giants, ihren Rivalen von der anderen Seite der Bucht, die Show und gewannen in den Jahren 1972 bis 1974 dreimal die World Series. Die farbenfrohe Truppe wurde wegen ihrer zotteligen Gesichtsbehaarung „Moustache Brigade" (Schnurrbartbrigade) genannt. Die Golden State Warriors gewannen 1975 ihren ersten NBA-Titel, angeführt vom Superstar Rick Barry.

Der *Rolling Stone*, 1967 in San Francisco gegründet, erkannte, dass die Stadt nicht mehr das Zentrum des musikalischen und kulturellen Geschehens war, und zog 1976 nach New York. Doch zur selben Zeit waren andere Kunstformen auf

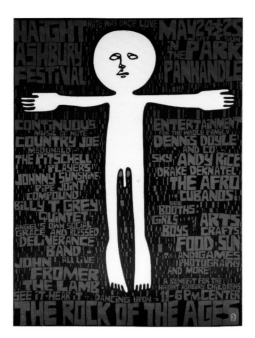

←
"The Rock of the Ages" poster, Wes Wilson,
1969.
Heritage Auctions, HA.com

→
The Electric Kool-Aid Acid Test, *Tom Wolfe,*
Farrar, Straus and Giroux, 1968.

dem Vormarsch, die das psychedelische Haight-Ashbury nach
Mainstream aussehen ließen. Nirgendwo in den USA gab es
eine so leidenschaftliche Punkrock-Szene wie in San Francisco,
ausgenommen New York und Los Angeles. Die Punks waren wie
die Hippies seltsam angezogene Außenseiter, die einen neuen
Musikstil hatten, lauter und weniger kommerziell als die dama-
lige Popmusik. Das Mabuhay Gardens in North Beach, ein phil-
ippinisches Restaurant, das sich in einen Rockclub verwandelte,
wurde zum Dreh- und Angelpunkt der Szene. Acts wie die Aven-
gers, Crime, die Dils, die Nuns und die Berüchtigtsten von allen,
die Dead Kennedys, füllten den Club mit Pogo tanzenden Punks.

Doch die soziopolitischen Auswirkungen der kulturel-
len Bewegung, mit der das San Francisco der 70er am meisten
identifiziert wird, reichen weit über die Dekade und die Stadt
hinaus. San Francisco war seit der Blütezeit der Barbary Coast
Homosexualität gegenüber tolerant gewesen. Mitte des 20. Jahr-
hunderts hatte die Szene eine beträchtliche Größe, hielt sich aber
zum größten Teil bedeckt. In den 1960er-Jahren begann sie, sich
politisch zu organisieren und reagierte damit auf Übergriffe städ-
tischer Beamter, darunter Russell Wolden, der 1959 erfolglos mit
dem Versprechen Wahlkampf für das Bürgermeisteramt machte,
gegen „sexuell Abartige" vorzugehen. Daneben gab es eine Poli-
zeikampagne, bei der Schwulenbars mit dem Entzug Schankli-
zenzen gedroht wurde, sowie eine Razzia auf dem Drag-Ball in
der California Hall an Silvester 1965. Die Tavern Guild, der erste
schwule Unternehmerverband in den USA, wurde 1962 gegrün-
det, unter anderem, um gegen Polizeischikanen vorzugehen, aber
die schwule Gemeinschaft verfügte noch über wenig Macht in
der Politik.

Das änderte sich ab Anfang der 1970er-Jahre, als ein gro-
ßer Teil der Gemeinschaft begann, sich im Castro niederzulassen,
einem Arbeiterviertel am westlichen Ende der Market Street, im
Schatten der Twin Peaks. Angezogen von einer Gegend, in der sie
ihre Sexualität nicht verstecken mussten, wurden sie Mitte der
70er zur wichtigsten kulturellen Kraft im Castro. Aus ähnlichen
Gründen zogen viele Schwule, Lesben, Bi- und Transsexuelle zur
gleichen Zeit in andere Teile der Stadt und der Bay Area. Gefeiert
auf Schallplatte von der Disco-Diva Sylvester, in Bars und in Thea-
terproduktionen, die sich an das LGBT-Publikum richteten, hatte
ihre Anzahl aber noch immer nicht zu spürbarem politischem
Einfluss geführt.

Das änderte sich mit Harvey Milk, dem Besitzer eines
Kameraladens und Aktivisten mittleren Alters aus Castro, des-
sen Energie und Engagement ihn bis ins Rathaus brachten. Im
November 1977 wurde Milk der erste offen schwule Politiker
von San Francisco, nach einer Änderung des Wahlrechts für den
Stadtrat, der nun pro Bezirk und nicht mehr stadtweit gewählt
wurde. In den so gewählten Rat zogen auch die ersten chinesi-
schen, lateinamerikanischen und schwarzen Stadträte ein, was
endlich die Vielfalt der Stadt widerspiegelte.

Als Stadtrat machte Milk sich nicht nur für die Rechte
von Homosexuellen zur Aufgabe, sondern auch zahlreiche andere
progressive Anliegen für alle Bewohner der Stadt. Seine Amts-
zeit war kurz. Am 27. November 1978 wurden Milk und George
Moscone, der Bürgermeister, von Dan White ermordet, einem
enttäuschten Konservativen, der kurz zuvor von seinem Amt
als Stadtrat zurückgetreten war und es nicht zurückbekommen
konnte. Am selben Abend zogen Zehntausende mit Kerzen vom
Castro zum Rathaus, um Milk zu gedenken. In einem von gewalt-
samen Tragödien geprägten Jahrzehnt war die Mahnwache ein
eindrucksvoll friedlicher Ausdruck von Trauer.

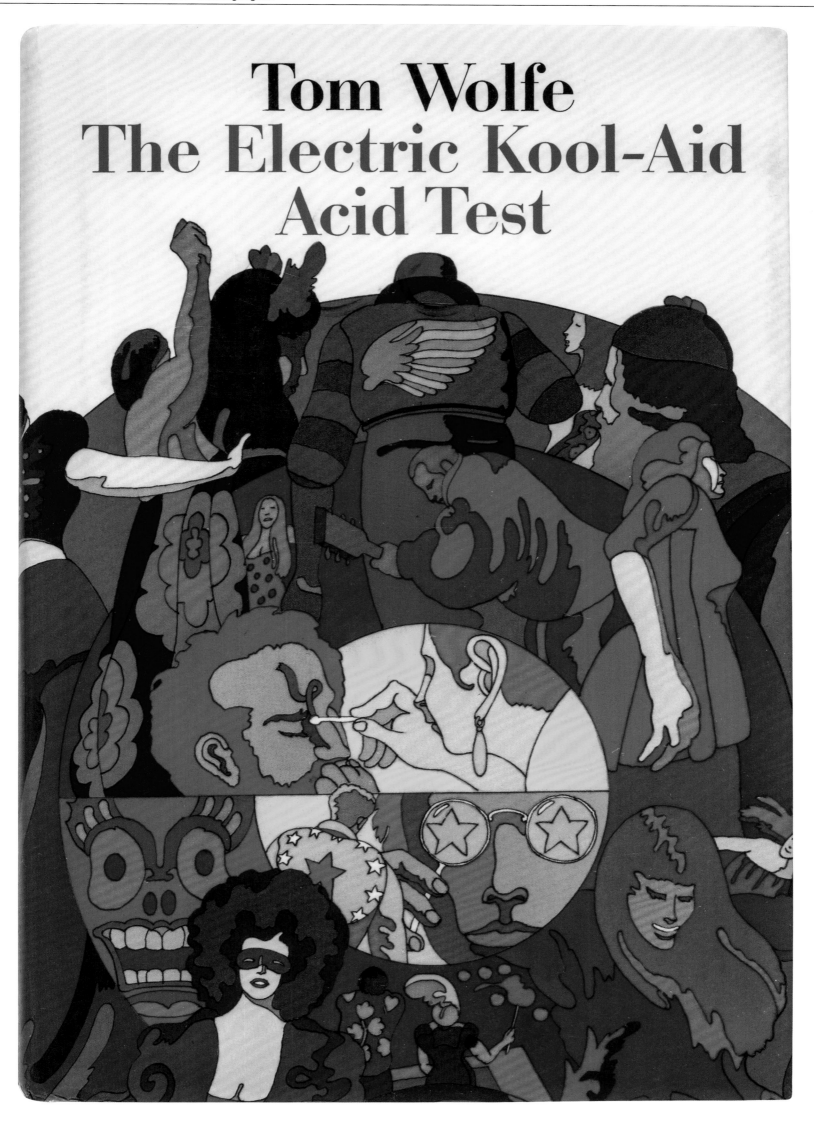

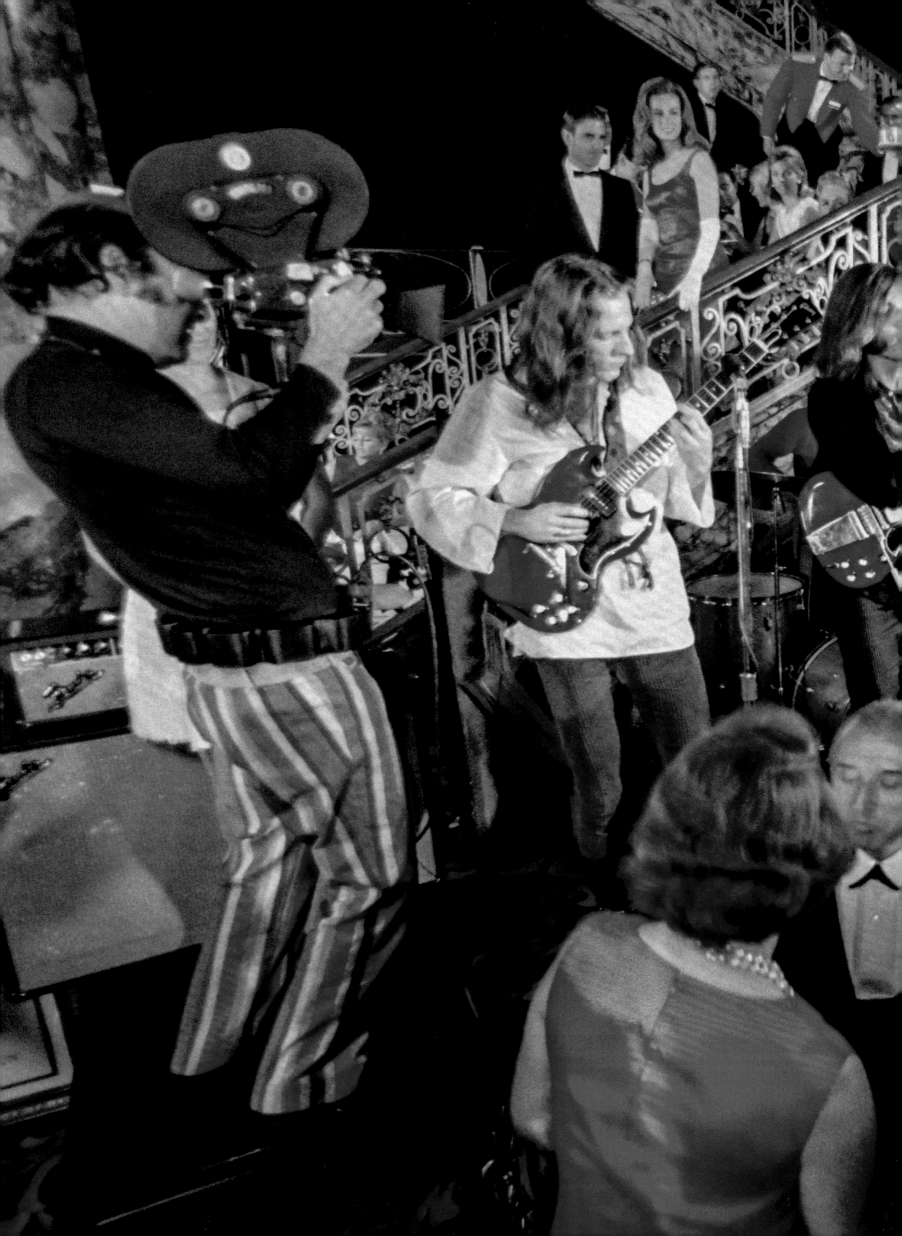

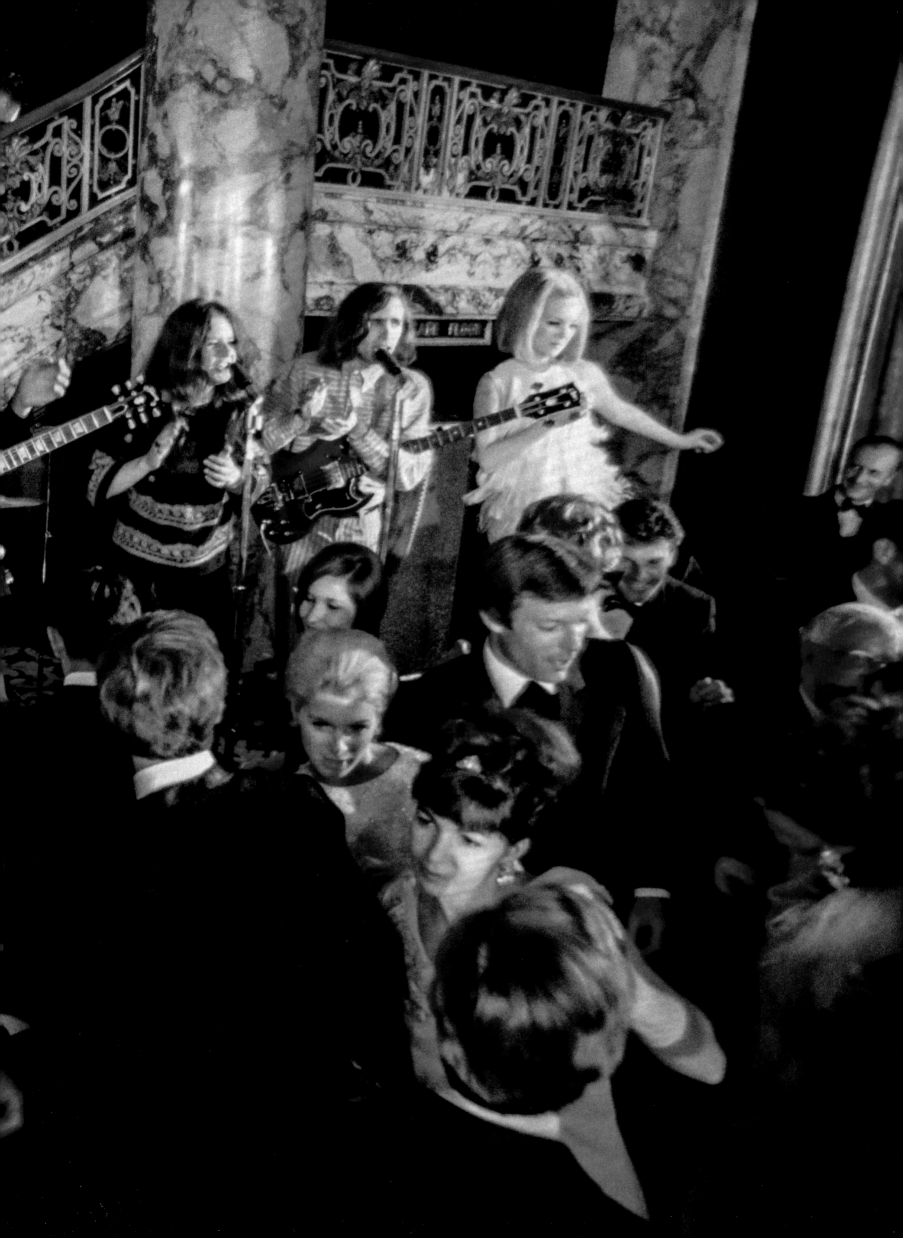

#4

Été de l'amour, hiver des colères 1964–1978

p. 266/267
Bob Willoughby

Big Brother & the Holding Company filming a party scene in Nob Hill's Fairmont Hotel for Petulia. *Starring Julie Christie, Richard Chamberlain, and George C. Scott, the San Francisco–set movie was directed by Richard Lester, who'd directed the Beatles'* A Hard Day's Night *and* Help! *The group appear only briefly in the film, which still marked the first time many people from outside the Bay Area saw the lead singer who'd soon vault into superstardom—Janis Joplin, 1967.*

Big Brother & the Holding Company filmen eine Partyszene im Fairmont Hotel in Nob Hill für Petulia *von Richard Lester, der schon bei* A Hard Day's Night *und* Help! *von den Beatles Regie geführt hatte. Die Gruppe tauchte nur kurz im Film auf, es war aber trotzdem das erste Mal, dass viele Leute außerhalb der Bay Area die Leadsängerin Janis Joplin sahen, die bald zum Superstar werden sollte, 1967.*

Big Brother & the Holding Company filmés lors d'une scène de fête à l'hôtel Fairmont de Nob Hill pour le film Petulia *de Richard Lester, qui avait déjà dirigé les Beatles dans* A Hard Day's Night *et* Help! *Le groupe n'apparaît que brièvement dans le film qui permit néanmoins à beaucoup de spectateurs étrangers à la région de découvrir sa chanteuse Janis Joplin, bientôt propulsée au rang de superstar. 1967.*

Le militantisme politique, à San Francisco, est à peu près aussi vieux que la ville. Et tout au long de son premier siècle d'existence, il aura revêtu bien des visages. Vers le milieu des années 1960, toutefois, l'agrégation d'un certain nombre de facteurs déclenchants eut pour effet de pousser une grande partie de la jeunesse californienne à résister à l'ordre établi. Plus que toutes les contestations qui avaient jusqu'alors échauffé la région, le phénomène sera attentivement observé à l'échelle internationale. Les étudiants les plus progressistes et les mieux conscients de la réalité sociale du pays se concentraient surtout sur les bancs des universités de San Francisco et de Berkeley. À l'automne 1964, l'interdiction de distribuer des documents à caractère politique sur le campus de Berkeley amena des milliers d'étudiants à rejoindre une initiative en faveur de la liberté d'expression baptisée «Free Speech Movement». En décembre, un sit-in se solda par près de 800 arrestations mais permit de rétablir dès le mois suivant l'autorisation des activités politiques dans l'enceinte de l'université. L'engagement des États-Unis au Vietnam suscita également la protestation de milliers d'étudiants et jeunes gens concernés par la conscription. Important centre d'incorporation, Oakland sera plus particulièrement ciblée par ces manifestations pacifistes et houleuses, au point de donner parfois lieu à de violents affrontements avec les forces de l'ordre.

La jeunesse, en ces années fiévreuses, avait aussi une autre révolution en chantier, plus culturelle que politique, celle-là. C'est à San Francisco qu'avait vu le jour le premier groupe de rock américain capable de soutenir tant bien que mal la comparaison avec le nouveau son venu d'outre-Atlantique lors du phénomène alors qualifié de «British Invasion», Beatlemania oblige. Dans le sillage de ces Beau Brummels (c'était leur nom), la galaxie folk de la «Bay Area» allait massivement s'électriser, brûlant de mêler ses harmonies au rock, évidemment, et aussi aux influences indiennes ou moyen-orientales ainsi qu'aux expérimentations à base de distorsions électroniques tonitruantes. Les textes, eux, célèbreront l'amour libre et l'usage de substances illicites – rien que du vécu.

La région de San Francisco a probablement fait plus que toute autre pour promouvoir le rock psychédélique, parfois appelé acid rock en référence au LSD («acide»), l'une des drogues privilégiées par les musiciens et leur public. Conquérant des masses d'adeptes fidèles, quantité de groupes essaimeront, dont la dénomination reflète la créativité débridée de l'époque : Jefferson Airplane, Big Brother & the Holding Company, the Grateful Dead, Country Joe & the Fish et Moby Grape sont les plus connus d'entre eux. Des voix irrésistibles et charismatiques comme celles de Grace Slick et Marty Balin (Jefferson Airplane) ou de Janis Joplin (Big Brother) s'appuyaient sur d'exceptionnels guitaristes prêts à toutes les audaces, tels Jorma Kaukonen (Jefferson Airplane), James Gurley (Big Brother) ou Jerry Garcia (Grateful Dead). Ce beau monde sera rejoint à la fin de la décennie par des formations d'essence plus multiculturelle d'où émergera le funk psychédélique de Sly & the Family Stone et le rock latino fusionnel, mâtiné de blues et de jazz, de Carlos Santana.

Le quartier de Haight-Ashbury, à l'est du Golden Gate Park, avait pris la relève de North Beach comme épicentre de la contre-culture. Séduites par ses loyers relativement modiques, des légions d'étudiants et de jeunes adultes y prirent racine, souvent en communauté. L'omniprésence de la musique s'accompagnait

de liberté sexuelle et d'une consommation de drogues motivée au moins autant, au début, par la quête d'illumination spirituelle que par l'hédonisme. «Si les *hippies* n'avaient pas existé, il eût fallu les inventer», écrira Herb Caen, chroniqueur au *San Francisco Chronicle*, qui s'il ne créa pas le mot – signifiant plus ou moins «éveillé, initié» – le popularisa pour désigner ces nouveaux résidents à tignasse interminable et dress code improbable. La population du quartier ne se composait pas que de jeunes hippies blancs ; les Noirs étaient nombreux à Haight-Ashbury et un peu plus au nord-est, dans le quartier moins tranquille de Western Addition, resté l'un des plus afro-américains de la ville. Pour répondre aux besoins de la nouvelle clientèle psychédélique, des salons de coiffure surgissaient de nulle part tandis que des associations entreprenaient de distribuer gracieusement vêtements, nourriture et traitements médicaux. Les concerts rock gratuits et caritatifs se succédaient, notamment sur le Panhandle, l'étroit ruban qui fait saillie à l'est du Golden Gate Park. Organisé sur le terrain de polo du parc en janvier 1967, le Human Be-In, un happening géant mêlant rock et poésie, rassembla des dizaines de milliers de *freaks* («monstres», ainsi qu'ils aimaient à se désigner eux-mêmes) venus assister à un concert gratuit et stupéfaits de se compter si nombreux.

À l'Avalon Ballroom comme au Fillmore Auditorium, principales salles de spectacle de Haight-Ashbury, l'expérience musicale et hallucinogène se nourrissait de la complicité palpitante de jeux de lumière sophistiqués. Le graphisme des affiches de concert, caractérisées par leur lettrage ondoyant et presque indéchiffrable, fit d'elles des œuvres d'art à part entière. Fascinés par ce qui s'écrivait et se disait de l'utopie hippie, près de 100 000 jeunes accourus de tous les États-Unis fondirent sur San Francisco et plus particulièrement Haight-Ashbury afin d'y vivre une saison qu'on nommera «l'été de l'amour» – «Summer of Love». Le quartier se révélera bien trop exigu pour accueillir une telle foule, composée majoritairement d'adolescents dont une solide proportion de fugueurs. Et la consommation de psychotropes ne sera pas l'unique problème à gérer : ces nouveaux venus, parfois naïfs et souvent désorientés, constituaient une proie facile pour les dealers, escrocs, agresseurs sexuels et autres criminels. Certaines figures de la contre-culture locale iront jusqu'à statuer que le «Summer of Love», somme toute, n'avait été qu'une médiocre création de la presse. À beaucoup, en tout cas, le rêve hippie, une fois l'été fini, laissa un goût amer.

L'activisme politique, en revanche, lui survivra, plus fervent que jamais. Au terme de la décennie, des associations indignées réussiront à stopper le programme de «démolition des taudis» initié en 1966, trop tard cependant pour éviter la destruction de milliers de bâtiments (dont de nombreuses maisons victoriennes chargées d'histoire) et le transfert de quantité d'entreprises vers le quartier de Fillmore, à majorité afro-américaine. Ces années-là, la lutte contre la ségrégation raciale prendra aussi un tour plus militant. Las des brutalités policières et injustices variées, deux défenseurs de la cause noire fonderont à Oakland le parti des Black Panthers, qui diffusera bientôt son idéologie dans tout le pays. Le grand public réagira avec effroi à leurs représentations les plus médiatisées, qui montraient des militants souvent armés et apparemment prêts à se battre, bien qu'il fût alors davantage question d'autodéfense que de visées agressives. Surveillées par le FBI et les forces de l'ordre, fréquemment harcelées, les Panthers auront droit

←
Stand! *Sly and the Family Stone, Epic Records*, 1969.

→
Gimme Shelter, *Albert Maysles, David Maysles, Charlotte Zwerin*, 20th Century-Fox, 1970.
Heritage Auctions, HA.com

aux gros titres lorsque plusieurs de leurs leaders charismatiques seront condamnés à de fortes peines à la suite de fusillades controversées avec la police. Certaines de leurs initiatives, plus rarement rappelées, portaient sur le terrain moins litigieux de la justice sociale, l'organisation, par exemple, de petits déjeuners gratuits pour les enfants défavorisés.

Du côté des universités, l'agitation croissait, entretenue par la volonté de faire émerger dans l'enseignement comme dans la vie politique un discours plus progressiste. En octobre 1968, les étudiants de l'Université d'État de San Francisco démarrèrent une grève qui allait durer cinq mois afin de protester notamment contre l'absence de programmes d'études afro-américaines et ethniques. De même, alors que l'Université de Berkeley projetait de bâtir des logements étudiants et des terrains d'athlétisme sur un terrain vague proche du campus, l'occupation des lieux par des milliers de manifestants désireux d'en faire un espace de libre parole – People's Park – dégénéra le 15 mai 1969 en affrontements brutaux avec la police du gouverneur de Californie Ronald Reagan. Ce nouveau « Bloody Thursday » fit plus de 100 blessés sérieux et un mort.

L'idée que la musique et le rock constituaient autant de sanctuaires se fracassa le 6 décembre sur les violences générées par le festival d'Altamont. À l'origine, ce n'est pas cette piste de stock-cars, 80 kilomètres à l'est de San Francisco, mais le Golden Gate Park qui devait accueillir la réplique de la côte Ouest au récent et triomphal Woodstock. La municipalité ayant mis son veto, les Rolling Stones, qui avaient pris l'organisation en main après les tergiversations des Grateful Dead, durent trouver en catastrophe une solution de rechange. Pendant que Santana, Jefferson Airplane, les Flying Burrito Brothers et Crosby, Stills, Nash & Young se succédaient sur scène, des bagarres éclataient dans le public à l'incitation des Hell's Angels engagés pour assurer la sécurité. Alors que les Stones achevaient leur prestation, un jeune Noir de Berkeley trouvait la mort, poignardé par l'un des Angels après avoir brandi une arme à feu. Le drame signa le cruel dénouement d'une décennie d'optimisme et de rêves qui aura placé San Francisco au centre du monde et demeure indissociable de l'image internationale qu'elle continue de renvoyer.

Si Altamont contribua à refroidir l'idéalisme qui avait animé San Francisco au fil des sixties, la première moitié des années 1970 ne raviva pas vraiment les rêves de révolution. Les principaux mouvements de la contre-culture se divisèrent. Le « son de San Francisco », qui lui était consubstantiel, rejoignit peu à peu l'arrière-garde du rock. Il subsistait néanmoins du « Summer of Love » une lueur fragile, assez rémanente pour inspirer de nouvelles causes et des combats dont le souvenir persiste encore près d'un demi-siècle plus tard. Ainsi en novembre 1969 l'occupation pacifique d'Alcatraz par un groupe d'activistes amérindiens attira-t-elle l'attention du monde entier. Sur cette île tombée dans l'abandon et le délabrement après la fermeture de son pénitencier fédéral en 1963, les occupants réclamaient la construction d'un centre culturel et universitaire prenant en compte leur philosophie de la nature. Au fil des mois, entre luttes de pouvoir internes, coupures d'eau, d'électricité, de téléphone et difficultés d'approvisionnement sur un rocher peu hospitalier, la résolution et l'unité des Amérindiens finirent par s'effriter. En juin 1971, il restait une quinzaine d'entêtés qui se laissèrent arrêter en moins d'une heure par les agents fédéraux. Le mouvement aura tout de même réussi à sensibiliser le pays à certains sujets majeurs, du côté des militants amérindiens comme dans la classe politique. Au lieu d'être livrée aux projets immobiliers et commerciaux espérés par les promoteurs, Alcatraz sera ainsi intégrée à la « zone récréative nationale du Golden Gate » avant d'être classée monument historique. Desservie par les ferries venus de Fisherman's Wharf, elle deviendra l'une des principales destinations touristiques de San Francisco, invitant les curieux à revisiter à la fois son passé carcéral et le séjour éphémère autant que vibrant de ces militants amérindiens.

En ce début de décennie, la soif de justice des mouvements afro-américains empruntera quant à elle d'autres chemins cahoteux, le plus souvent dans les environs immédiats de San Francisco. En août 1970, un adolescent nommé Jonathan Jackson tenta d'enlever le juge Harold Haley au palais de justice du comté de Marin afin d'obtenir la libération de trois prisonniers noirs accusés du meurtre d'un gardien de prison blanc. Jackson sera tué

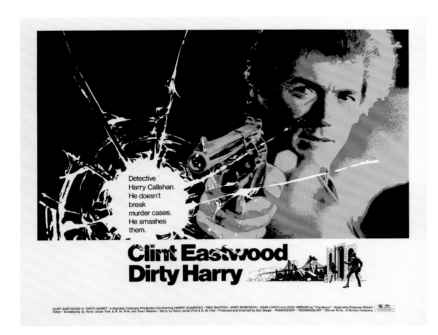

Dirty Harry, *Don Siegel, Warner Bros.,*
poster by Bill Gold, 1971.
Heritage Auctions, HA.com

au cours de sa fuite et de la fusillade qui s'ensuivra, de même que le juge Haley et deux Black Panthers participant à la prise d'otages. Les armes de Jackson étaient enregistrées au nom de la militante Angela Davis, interpellée deux semaines plus tard. Acquittée en 1972, elle poursuivra une longue carrière de professeur d'université. George Jackson, le frère aîné de Jonathan, avait été abattu l'année précédente lors d'une présumée tentative d'évasion de la célèbre prison de San Quentin, dans le comté de Marin. Bob Dylan lui rendra hommage avec le titre « George Jackson », qui figura un moment parmi les 40 meilleures ventes de disques du pays. La sanglante affaire du palais de justice n'en contribua pas moins à ternir l'image publique déjà vulnérable des Black Panthers, en dépit de leurs projets sociaux et de leur journal haut en couleur. Régulièrement affaibli par des luttes intestines au sein de sa direction ainsi que par les problèmes juridiques et personnels de son cofondateur Huey Newton, le parti passera de la débandade à une quasi-dissolution. Avec le temps, ses idéaux les plus progressistes, incarnés par quelques-uns de ses héritiers, regagneront du terrain dans le débat public, la vie politique et le monde universitaire.

La dissidence politique dans la région connaîtra un sommet radical en février 1974 avec l'enlèvement sur le campus de Berkeley de Patricia Hearst, petite-fille du magnat de la presse William Randolph Hearst. Le kidnapping était l'œuvre de l'Armée de libération symbionaise, un mouvement armé d'extrême gauche qui réclamait en échange de l'héritière la libération de deux de ses membres emprisonnés. Faute d'accord des autorités, l'ALS exigea que la famille Hearst distribuât l'équivalent de 70 dollars en nourriture à chaque Californien nécessiteux. L'opération échouera, malgré 2 millions de dollars versés par les Hearst. Coup de théâtre deux mois plus tard, lorsque Patty Hearst annonça qu'elle rejoignait l'organisation de ses ravisseurs. Le 15 avril, une photo envoyée à la presse la montrera l'arme au poing lors de l'attaque d'une banque de San Francisco qui fera deux blessés. Le mois suivant, la plupart des membres de l'ALS seront abattus par la police de Los Angeles mais il faudra attendre septembre 1975 pour que le FBI finisse par mettre la main sur la jeune fille, à San Francisco.

Condamnée à sept ans de prison, elle n'en fera que deux avant de voir sa peine commuée par le président Jimmy Carter.

L'affaire Hearst ne fut pas seule, alors, à asseoir la réputation qui commençait à coller à San Francisco : celle d'une ville devenue le refuge de tous les marginaux et déviants sociaux, fous dangereux compris. Le 22 septembre 1975, une certaine Sara Jane Moore tenta d'assassiner le président en exercice Gerald Ford alors qu'il quittait l'hôtel St. Francis, sur Union Square. De la fin des années 1960 au début de la décennie suivante, un tueur en série se présentant sous le nom de « Zodiac » revendiqua la paternité de 37 décès dans la région. Le nombre exact de ses victimes ne sera jamais déterminé, et son identité reste inconnue, même s'il s'est vanté de ses crimes dans de nombreux courriers adressés à la presse locale.

Au milieu des années 1970, le prédicateur et guérisseur Jim Jones s'était constitué une audience confortable, composée principalement d'Afro-Américains, à la tête d'une Église nommée « Peoples Temple » qui avait son siège dans le quartier de Fillmore. Courtisé par certains politiciens parce qu'il fournissait repas et soins gratuits aux déshérités, le mouvement perdit ses alliés lorsqu'apparut sa dimension sectaire. En 1977, Jones et près d'un millier d'adeptes s'installèrent au Guyana pour y fonder en pleine jungle une communauté utopique baptisée « Jonestown ». Le 18 novembre 1978, Leo Ryan, un député californien venu enquêter sur place, trois journalistes et un ancien membre de la secte seront abattus alors qu'ils s'apprêtaient à prendre l'avion du retour. Quelques heures plus tard, la planète abasourdie apprenait que Jones avait orchestré un suicide collectif en ordonnant à ses fidèles d'ingurgiter une boisson mélangée à du cyanure : 908 personnes, dont 300 enfants et Jones lui-même, tué d'une balle dans la tête, périrent à cette occasion.

De l'utopie à la dystopie, il n'y a pas loin, mais ce genre de calamité ne suffit pas à restituer ce qu'était réellement la vie à San Francisco dans les années 1970. Le commerce se poursuivait comme jadis dans le Financial District, dont l'horizon avait pris encore un peu plus de hauteur avec l'achèvement en 1972 des 260 mètres de la Transamerica Pyramid, qui restera pendant quarante-cinq ans le gratte-ciel le plus élevé de la ville. La même

"What's Up, Doc?" Peter Bogdanovich,
Warner Bros., 1972.
Heritage Auctions, HA.com

année vit le lancement du BART (Bay Area Rapid Transit), un réseau de transport ferroviaire à traction électrique reliant San Francisco à l'East Bay par des lignes qui empruntaient le Transbay Tube, un tunnel immergé.

Non moins inventive, la gastronomie devenait l'un des beaux-arts. Les grands restaurants proposant une cuisine spécifiquement californienne proliféraient, emmenés par une fameuse adresse de Berkeley, Chez Panisse. Sa fondatrice Alice Waters signa plusieurs livres de recettes à succès et milita très tôt en faveur de l'agriculture bio – elle créa même dans un collège de Berkeley une « cour d'école comestible », autrement dit, un potager biologique et pédagogique. De son côté, un réseau de coopératives alimentaires autogérées mettait en place le « People's Food System », initiative vouée à promouvoir dans la région une production alimentaire respectueuse de l'environnement. Si nombre de ces initiatives n'ont pas franchi le cap du nouveau siècle, la région reste un paradis pour les marchés et les restaurateurs qui ont à leur disposition une formidable variété d'ingrédients écologiques.

La création à San Francisco d'une société de production cinématographique, American Zoetrope, par deux jeunes réalisateurs prometteurs, Francis Ford Coppola et George Lucas, propulsa la ville à la pointe du septième art. Coppola y tournera en 1974 l'un de ses meilleurs films, le thriller *Conversation secrète*. Lucas, lui, touchera le jackpot avec *American Graffiti* puis *Star Wars*, et fera du ranch Skywalker, dans le comté de Marin, son quartier général. Rares ont été les metteurs en scène de cinéma à établir leur base dans la région, quoique San Francisco ait été le théâtre de films hollywoodiens mémorables, plutôt sombres comme *L'Inspecteur Harry* et un remake de *L'Invasion des profanateurs de sépultures*, ou plus légers, à l'image d'*On s'fait la valise, docteur ?* et de sa poursuite en voiture burlesque à travers les rues les plus escarpées de la ville. C'est aussi là que deux stars en herbe, Robin Williams et Whoopi Goldberg, firent leurs premiers pas à travers le stand-up. La San Francisco Mime Troupe, elle, s'évertua dès les années 1960 à faire descendre la satire politique des scènes de théâtre jusqu'aux parcs publics, et ce gratuitement. Elle s'y emploie toujours aujourd'hui.

Sur la scène littéraire, si des vétérans de la Beat Generation, tel que Richard Brautigan, continuaient à produire des œuvres de qualité, d'autres écrivains sont apparus, à l'éventail plus étendu. Ainsi les romans de Maxine Hong Kingston puis d'Amy Tan réussiront-ils à dépeindre avec un réalisme passionné l'expérience des Américains d'ascendance asiatique. Le plus connu d'entre eux, *Le Club de la chance*, paru en 1989, inspirera un film à succès de Wayne Wang, dont le premier vrai long métrage (*Chan Is Missing*, 1982) avait déjà été l'un des rares à explorer avec autant d'application naturaliste la vie quotidienne à Chinatown. À la fin des années 1970, les *Chroniques de San Francisco* d'Armistead Maupin, d'abord publiées dans les journaux, ont projeté sur la diversité sexuelle de la ville un précieux éclairage, à l'aide d'une galerie de personnages décalés qu'on retrouvera dans huit volets supplémentaires et une série télévisée très appréciée.

Côté musique, malgré le coup dur de la fermeture, en 1971, d'une salle aussi mythique que le Fillmore, San Francisco continua à accueillir des concerts de haut niveau dans des lieux comme le Winterland, sans compter les grands spectacles orchestrés de plus en plus souvent dans des stades par l'ex-patron du Fillmore, Bill Graham ; chaque année son « Day on the Greens » remplissait le Oakland Coliseum, repaire habituel de l'équipe de base-ball des Oakland Athletics. Ces derniers, venus de Kansas City en 1968, avaient volé la vedette à leurs rivaux de l'autre rive de la baie, les Giants, en remportant trois titres nationaux consécutifs de 1972 à 1974. Pour des raisons pileuses qui se devinent aisément, la formation avait reçu le sobriquet de « Brigade des moustaches ». Le basket n'était pas en reste puisque les Golden State Warriors s'adjugèrent la finale NBA en 1975, emmenés par leur superstar Rick Barry.

San Francisco, toutefois, ne pouvait plus se prévaloir d'abriter le cœur battant de l'avant-garde musicale et culturelle des États-Unis. Le magazine *Rolling Stone*, qui y avait vu le jour en 1967, déménagea à New York en 1976, et c'était déjà un signe. Dans le même temps, d'autres formes artistiques gagnaient en visibilité, même si leur marginalité foncière aurait pu faire passer le psychédélisme de Haight-Ashbury pour un courant académique. Hors

←
Fresh Fruit for Rotting Vegetables,
Dead Kennedys, Cherry Red Records, 1980.

→
Tales of the City, *Armistead Maupin,
HarperCollins, 1978.*

New York et Los Angeles, nulle part la scène punk rock n'était aussi fervente qu'à San Francisco. Arrivés dans le sillage des hippies, les punks, parés de leurs plus extravagants atours, cultivaient une asocialité provocante et un style musical que sa puissance sonore et son positionnement anti-commercial distinguaient viscéralement des succès pop du moment. Quand un restaurant philippin de North Beach du nom de Mabuhay Gardens décida de se transformer en club de rock, il s'imposa rapidement comme le pivot de la scène punk et de ce qu'on allait appeler la New Wave. Des groupes tels que les Avengers, Crime, the Dils, the Nuns et, plus illustres, les Dead Kennedys y défilèrent, cadençant tour à tour les pogos endiablés de leur jeune public.

Le mouvement culturel qui restera le plus étroitement associé à la San Francisco des années 1970 aura des répercussions longtemps après la fin de la décennie, et bien au-delà des limites géographiques de la ville. Depuis l'âge d'or du quartier de Barbary Coast, San Francisco avait toujours affiché sa tolérance à l'égard de la communauté homosexuelle et d'une population certes importante, au milieu du xxᵉ siècle, mais largement reléguée au « placard ». C'est au cours des sixties qu'avait commencé à se structurer une action politique ouvertement gay en réaction aux attaques des autorités locales, notamment d'un certain Russell Wolden, dont la candidature – infructueuse – à la mairie, en 1959, ciblait ni plus ni moins les « déviants sexuels ». Le mouvement se trouva conforté dans son élan par la campagne de répression menée à l'encontre des bars gays, menacés de perdre leur droit de vendre de l'alcool, et la descente de police menée dans un bal de travestis au California Hall, le 31 décembre 1964. Si la Tavern Guild, première association professionnelle gay des États-Unis, avait vu le jour en 1962 pour faire face au harcèlement policier et promouvoir la cause homosexuelle dans son ensemble, l'influence politique de la communauté restait embryonnaire.

Les choses évoluèrent au début des seventies lorsqu'une grande partie de la population concernée se mit à investir progressivement le Castro, un quartier ouvrier bordé par Market Street et la 19ᵉ Rue, au pied des Twin Peaks. Attirée par un environnement qui lui permettrait d'afficher ouvertement sa sexualité, la communauté gay y joua un rôle culturel prépondérant au milieu des années 1970. D'autres quartiers suivirent où atterrirent de nombreux gays, lesbiennes, bisexuels et transsexuels soucieux d'échapper enfin aux discriminations que suscitait leur mode de vie dans le reste du pays. À ce stade, cependant, les tubes disco d'une diva androgyne comme Sylvester ou la multiplication des bars et productions théâtrales spécifiquement destinés au public LGBT ne pouvaient compenser une absence encore criante de représentation politique.

Il en alla autrement dès lors que Harvey Milk, un quadragénaire du Castro, gérant d'un magasin de photo, rejoignit l'équipe chargée de l'administration de la ville. En 1977, à la suite d'une modification du mode de scrutin, les conseillers, appelés « superviseurs », furent en effet désignés à l'échelon d'arrondissement et non plus par l'ensemble du corps électoral. Porté par son énergie, son dévouement et une approche humaine de ses fonctions, Milk deviendra ainsi le premier politicien ouvertement gay à siéger au conseil municipal de San Francisco. La même instance accueillera également à cette occasion ses premiers élus d'origine chinoise, latino et afro-américaine (une femme, en l'occurrence) – traduction tardive et éloquente de la diversité multiculturelle de la ville.

Une fois élu, Milk se fera aussi le défenseur de multiples causes progressistes au profit de tout un chacun. Son mandat sera bref. Le 27 novembre 1978, il sera assassiné à l'hôtel de ville avec le maire George Moscone par Dan White, un conservateur aigri, peut-être dépressif, qui n'avait pas été autorisé à récupérer le poste de conseiller dont il venait de démissionner. Le soir du drame, en hommage à leur représentant disparu, des dizaines de milliers de personnes marcheront du Castro jusqu'à la mairie à la lueur de bougies. Au crépuscule d'une décennie marquée par la violence et la tragédie, cette veillée exprima la douleur commune avec une dignité remarquablement pacifique.

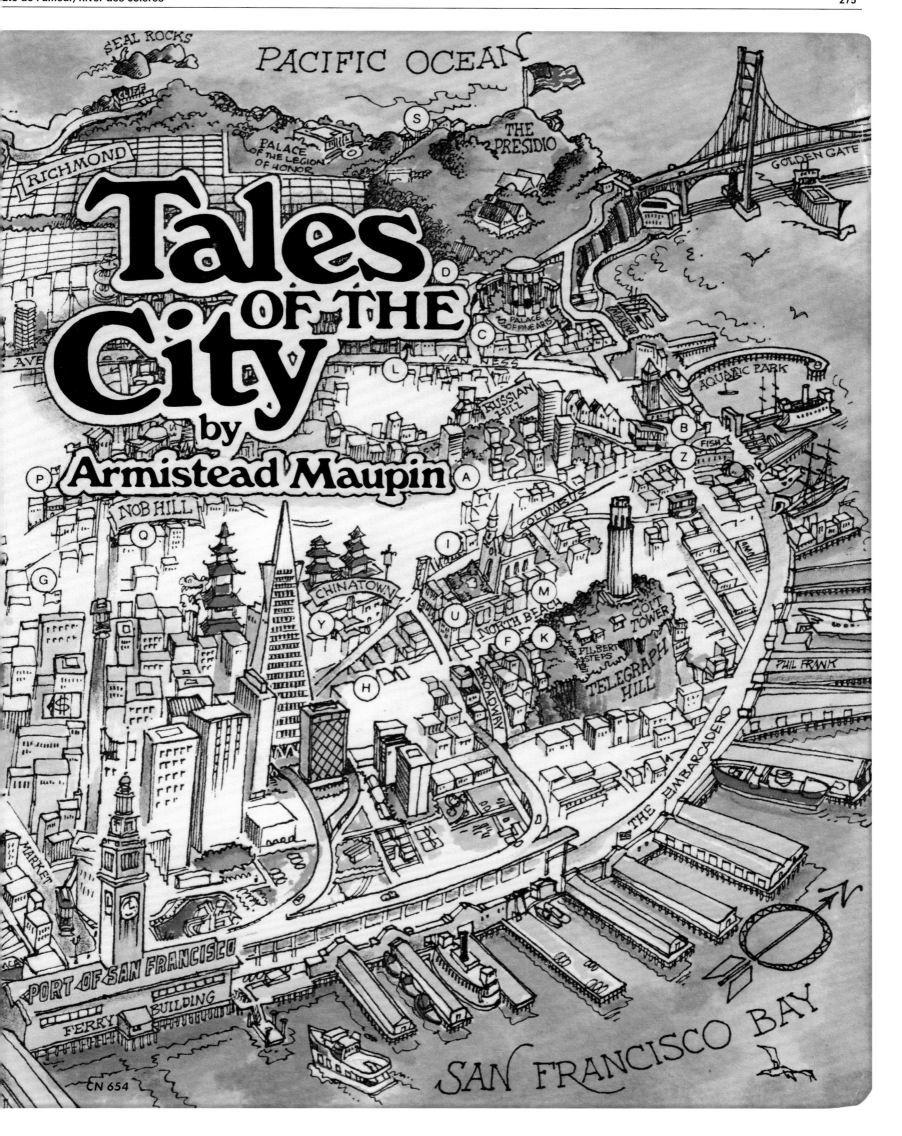

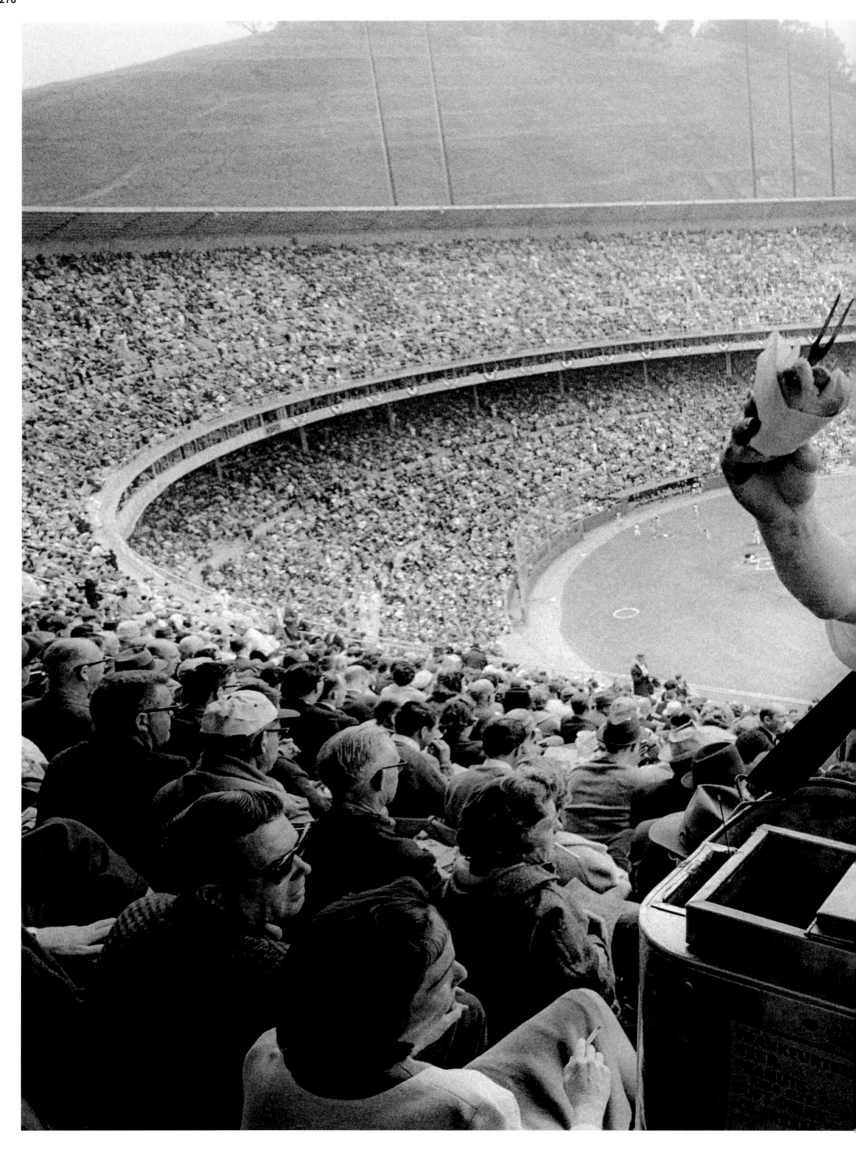

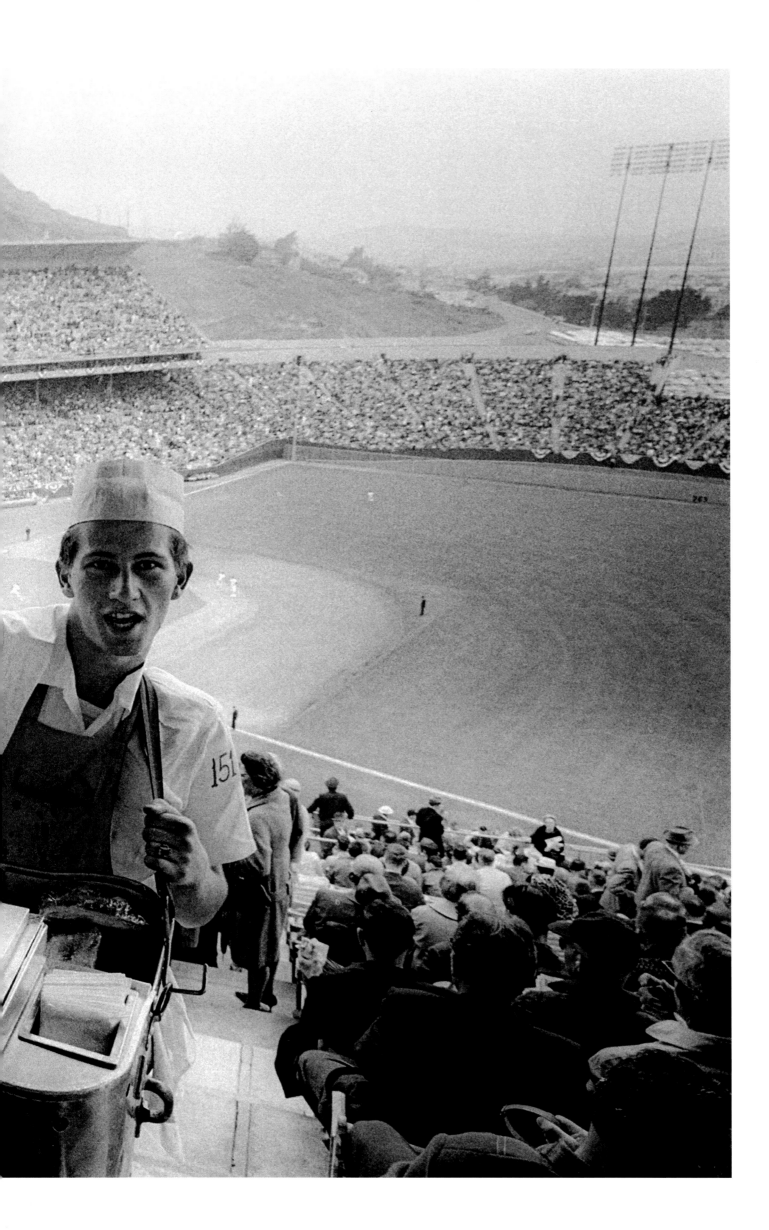

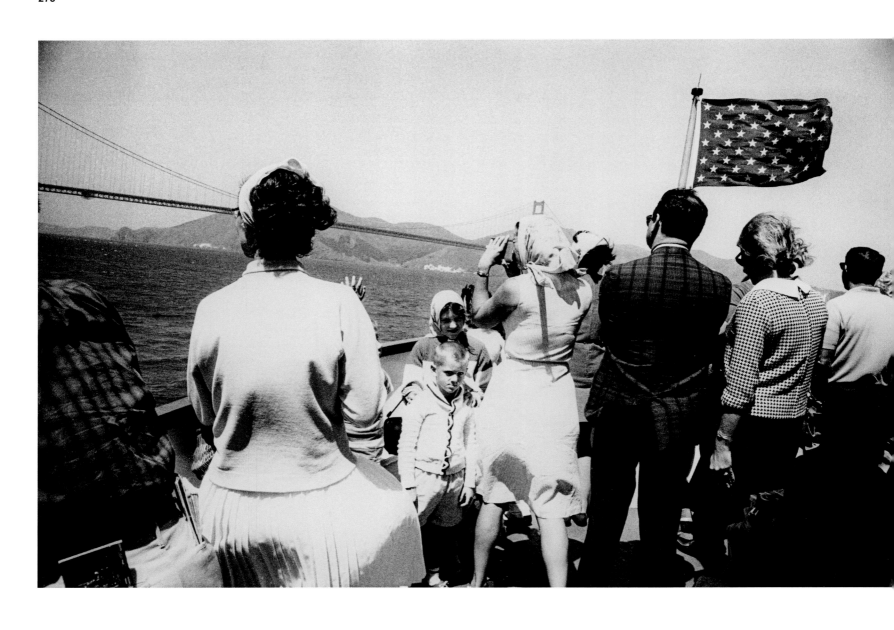

p. 276/277
Anonymous

*Vendor zealously hawks hotdogs in
Candlestick Park as the opening home game
of the San Francisco Giants gets underway
before a crowd of nearly 40,000 fans. Opened
in 1960, the stadium was home to superstars
Willie Mays, Juan Marichal, and Willie
McCovey for the next dozen or so years, 1965.*

*Ein Verkäufer versucht eifrig, seine Hotdogs
unter die Leute zu bringen. Fast 40 000 Fans
sind hier im Candlestick Park für das erste
Heimspiel der San Francisco Giants. 1960
eröffnet, war das Stadion in den kommenden
gut zehn Jahren das Zuhause von Superstars
wie Willie Mays, Juan Marichal, und Willie
McCovey, 1965.*

*Ferveur zélée d'un vendeur de hot dogs au
Candlestick Park alors que débute le premier
match à domicile des San Francisco Giants
devant 40 000 fans environ. Inauguré
en 1960, le stade a accueilli pendant une
dizaine d'années les superstars du base-
ball Willie Mays, Juan Marichal et Willie
McCovey. 1965.*

←
Garry Winogrand

Sailing on the San Francisco Bay near the Golden Gate Bridge. Many ferries and cruise boats carry passengers around the bay and to Marin County, Oakland, and other destinations every day, though visitors are often taken aback by cold and blustery conditions, 1964.

Segeln in der Bucht von San Francisco, nah an der Golden Gate Bridge. Zahlreiche Fähren und Rundfahrten transportieren täglich Passagiere durch die Bucht und bis nach Marin County, Oakland und zu anderen Zielen, auch wenn Touristen oft von Kälte und Wind überrascht sind, 1964.

Navigation à proximité du Golden Gate Bridge. De nombreux ferries et bateaux de croisière transportent quotidiennement leurs passagers autour de la baie de San Francisco, vers le comté de Marin, Oakland et d'autres destinations, en dépit du froid et des bourrasques qui ne manquent pas de saisir les voyageurs. 1964.

↓
Garry Winogrand

Conservatively dressed pedestrians don't know what to make of the slightly flashier youngsters in a passing convertible, 1964.

Konservativ angezogene Passanten wissen nicht, was sie von den etwas auffälliger angezogenen Jugendlichen im Cabriolet denken sollen, 1964.

Choc des mondes, des cultures et des modes vestimentaires au passage de cette voiture décapotable. 1964.

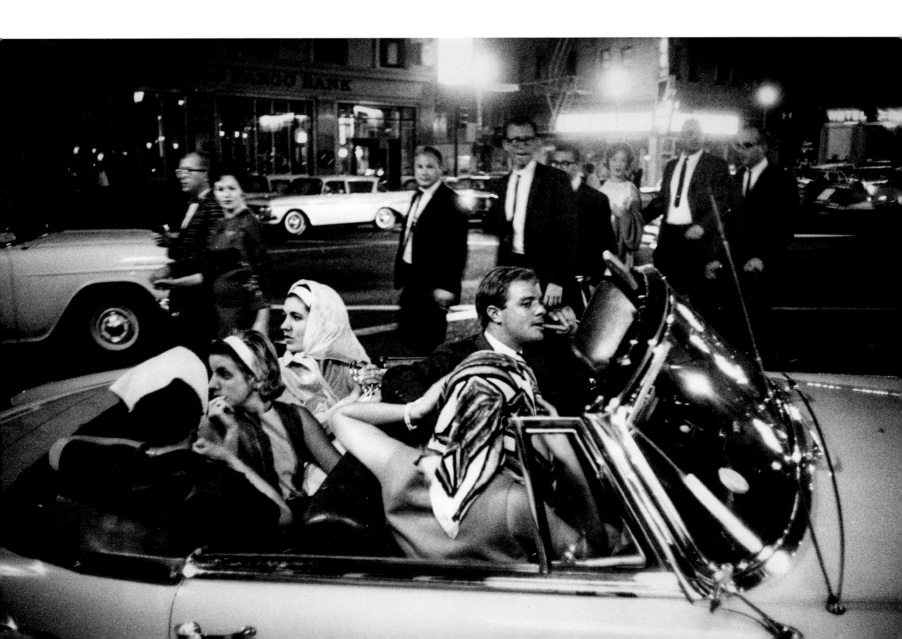

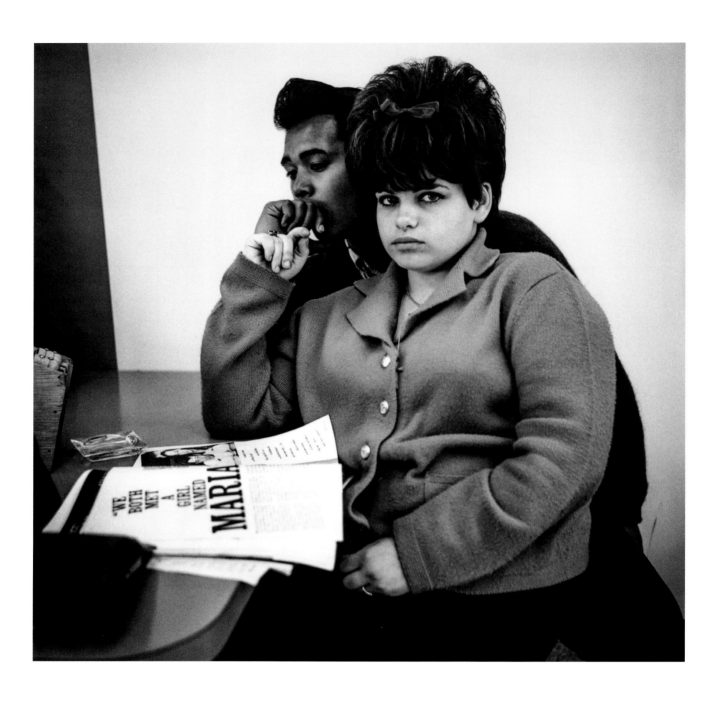

↑
Arthur Tress

Local teens hanging out at a downtown diner at Fifth and Market streets, reading a magazine story referencing the movie West Side Story, *1964.*

Teenager aus der Nachbarschaft vertreiben sich die Zeit in einem Diner an Fifth und Market Street, mit einem Magazin, in dem es um den Film West Side Story geht, *1964.*

Un snack-bar à l'angle de Market Street et de la 5e Rue où deux teenagers du quartier tuent le temps devant un magazine parlant du film West Side Story. *1964.*

→
Arthur Tress

Man standing in the front of a cable car on Powell Street, 1964.

Ein Mann steht vor einem Cable Car auf der Powell Street, 1964.

À l'arrêt du cable car, *sur Powell Street. 1964.*

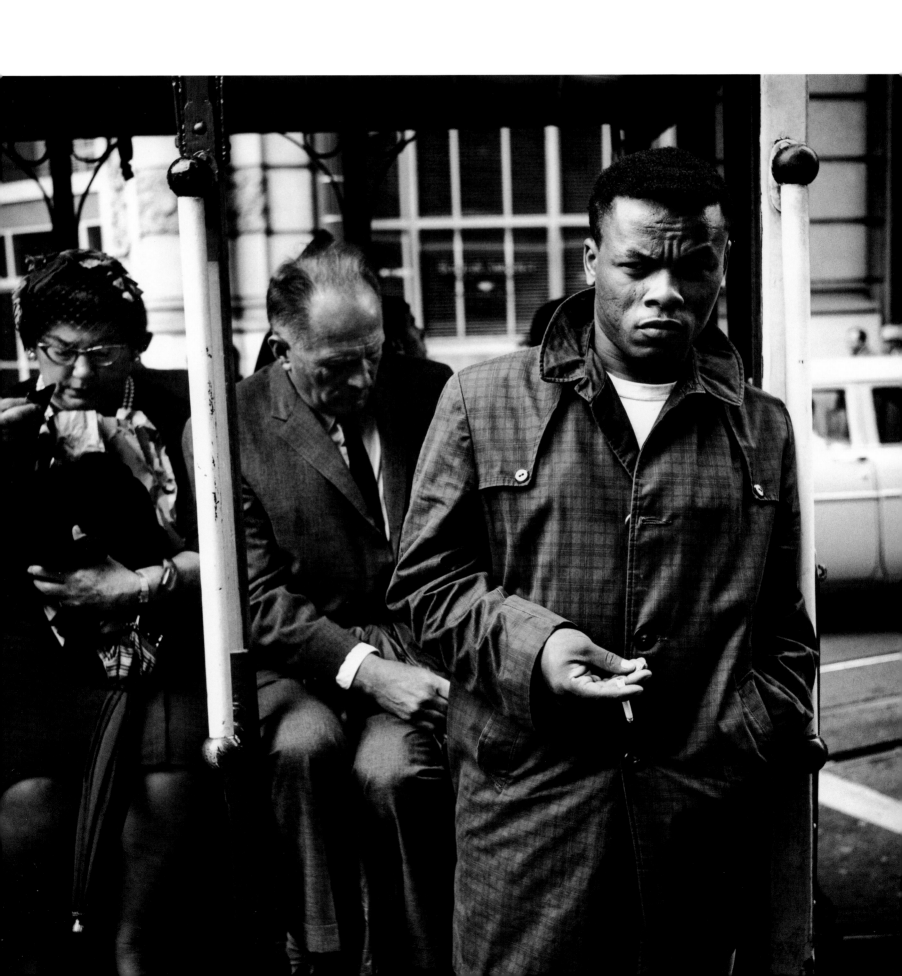

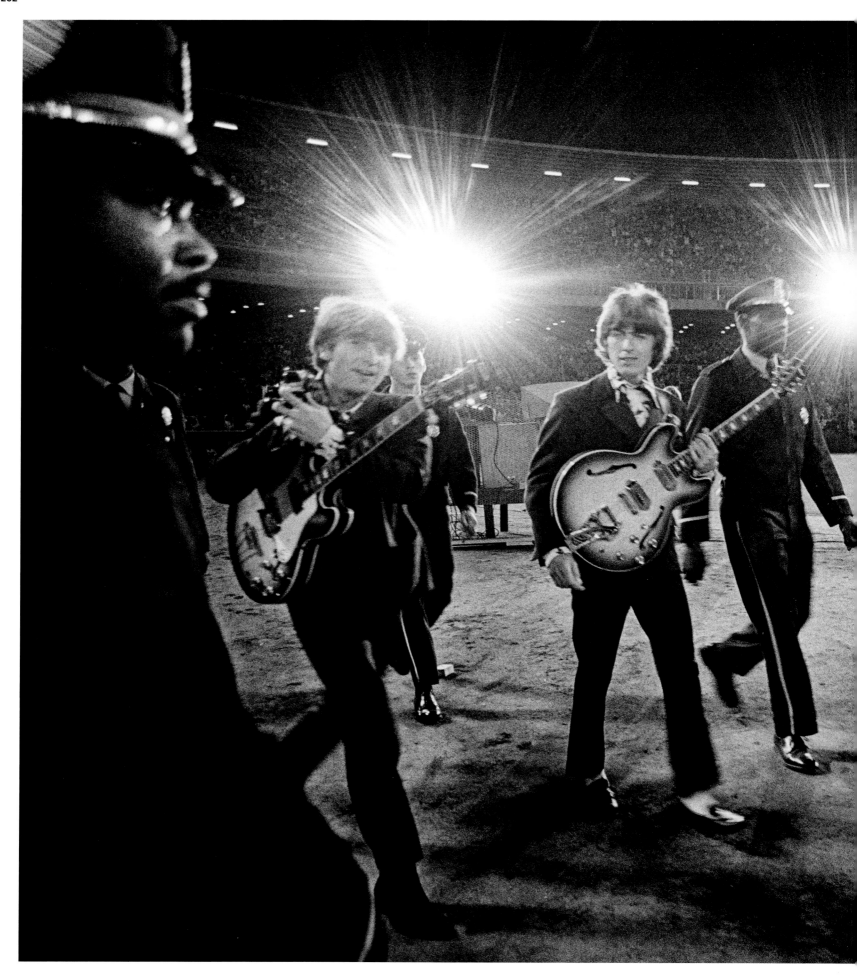

Jim Marshall

The Beatles finished their 1966 summer
tour of the United States in Candlestick
Park, where their half-hour set ended with a
rousing version of Little Richard's "Long Tall
Sally." Unknown to the audience and indeed
the world, this would be their last official
concert, as the group had tired of screaming
crowds and retreated to work on albums in
the studio, August 29, 1966.

Die Beatles beenden ihre US-Tour im Som-
mer 1966 im Candlestick Park, ihr halbstün-
diger Auftritt endet mit einer mitreißenden
Version von Little Richards „Long Tall
Sally". Die Zuschauer und der Rest der Welt
wussten nicht, dass es das letzte offizielle
Konzert der Gruppe war, die der kreischen-
den Zuschauermengen müde geworden
waren und sich ins Studio zurückzog,
29. August 1966.

À l'été 1966, les Beatles conclurent leur tour-
née américaine au Candlestick Park où leur
prestation d'une demi-heure se termina par
une version endiablée du « Long Tall Sally »
de Little Richard. Nul ne le savait alors,
mais ce sera leur dernier concert officiel car
le groupe supportait de moins en moins la
frénésie des foules en délire et se recentra sur
la production d'albums studio. 29 août 1966.

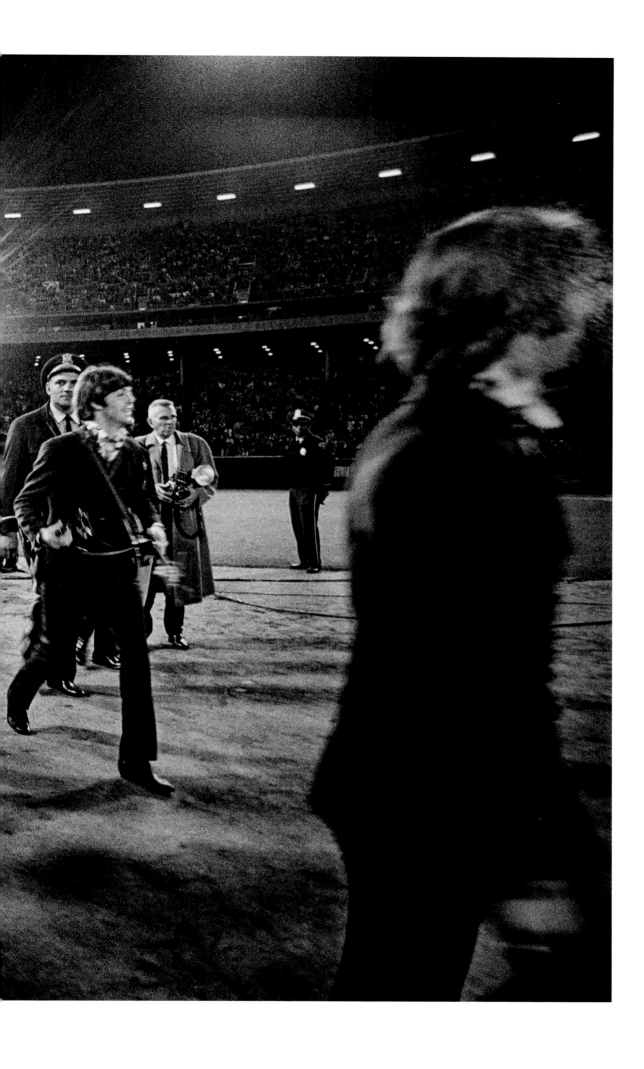

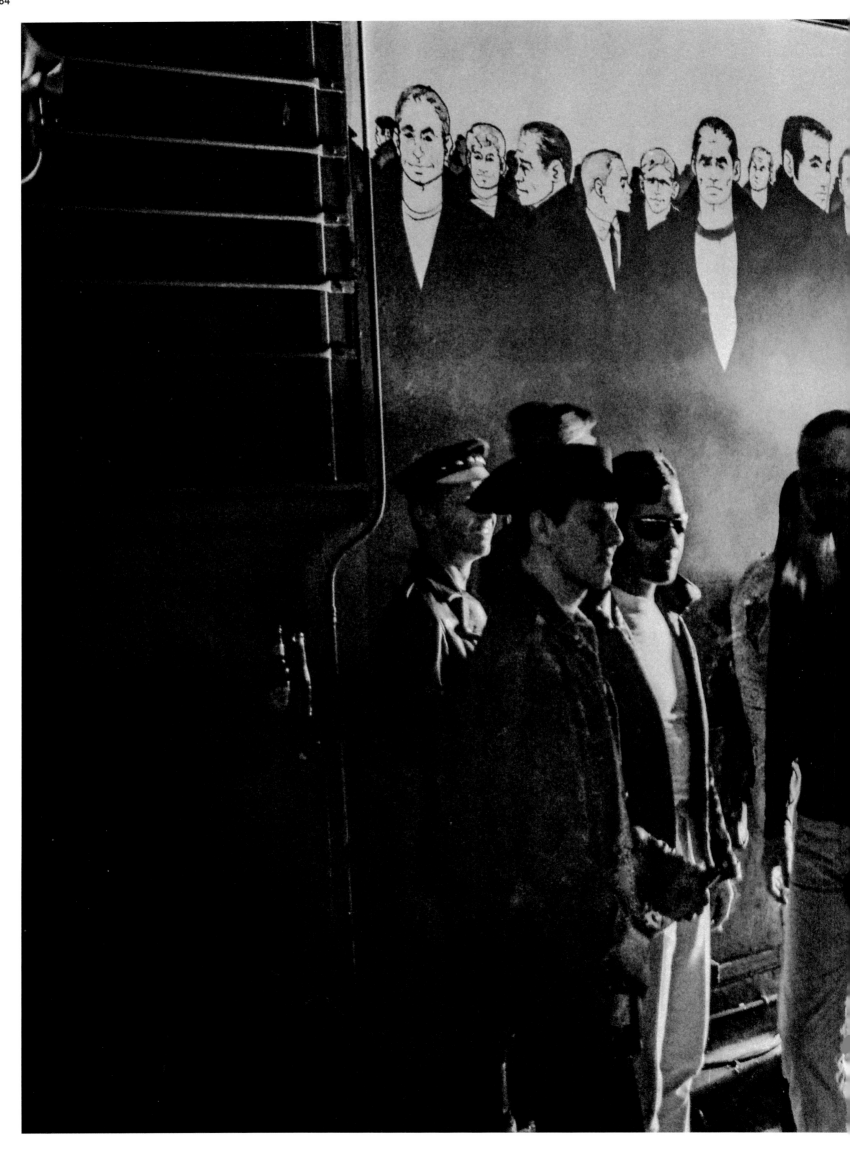

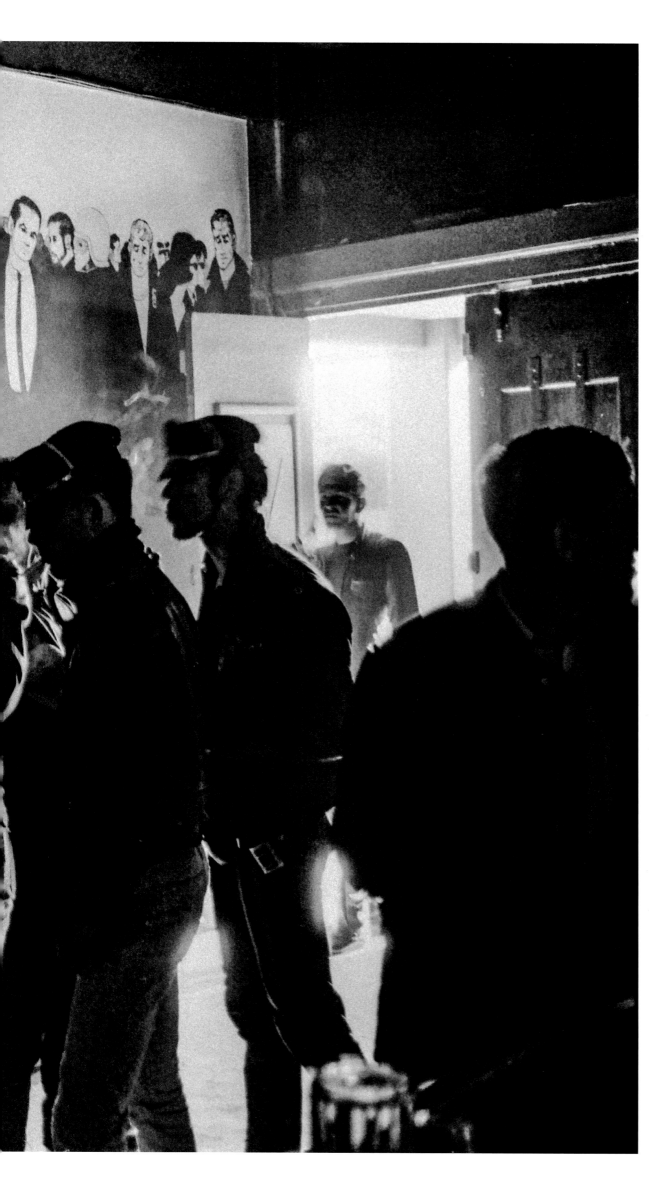

Bill Eppridge

The Tool Box on Fourth & Harrison Streets, which opened in 1962 as the first gay leather bar in the South of Market neighborhood. The mural was by local artist Chuck Arnett, who's among the leather-clad patrons featured in the artwork, and also made paintings and posters for other gay bars in the city. This photo was featured in Life magazine's 1964 article "Homosexuality in America," a rare acknowledgment from the mainstream media of the time that such a community existed, 1964.

Die Tool Box an Fourth und Harrison Street öffnete 1962 und war die erste schwule Lederbar im Viertel South of Market. Die Wandmalerei ist vom lokalen Künstler Chuck Arnett, der selbst unter den in Leder Gekleideten im Bild auftaucht, er schuf ähnliche Werke für andere Schwulenbars in der Stadt. Dieses Foto war Teil des Artikels „Homosexualität in Amerika", erschienen 1964 im Life Magazin, eine der wenigen Gelegenheiten, zu denen die Szene zur Kenntnis genommen wurde, 1964.

À l'angle de Harrison Street et de la 4ᵉ Rue, le Tool Box, ouvert en 1962, était le premier bar cuir homosexuel du quartier de South of Market. La fresque est l'œuvre de l'artiste local Chuck Arnett qui s'y est représenté et réalisa également des peintures et des affiches pour d'autres établissements gays de la ville. Cette photo figurait en 1964 dans l'article de Life intitulé « Homosexuality in America » : reconnaître l'existence d'une telle communauté était alors inattendu de la part d'un grand média. 1964.

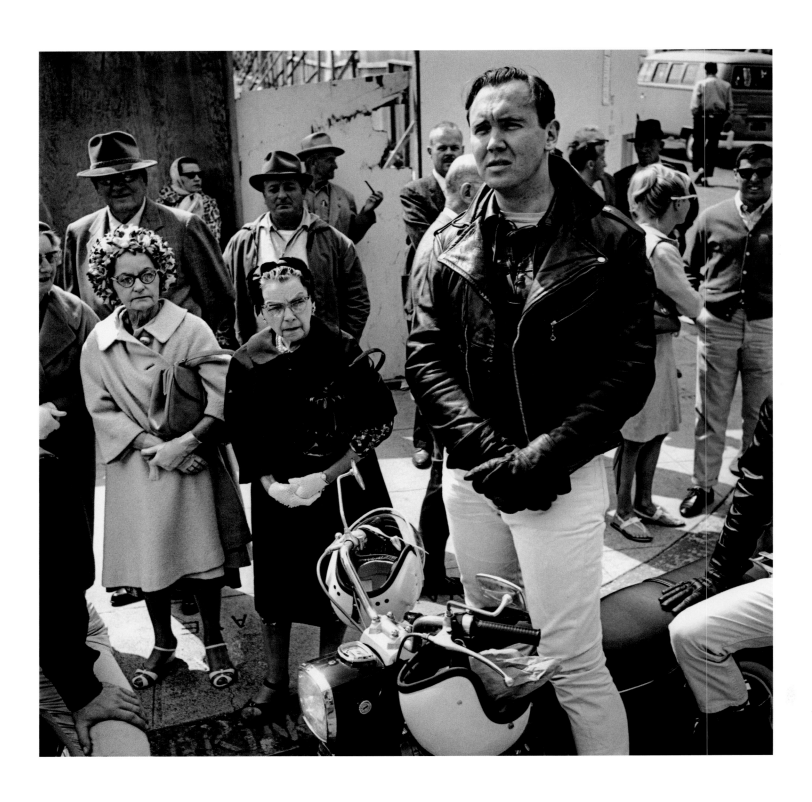

↑
Arthur Tress

Elderly women view a man and his motorcycle with suspicion as he watches a civil rights demonstration near Van Ness Avenue and Geary Boulevard, a few blocks north of Civic Center, 1964.

Ältere Damen betrachten einen Mann mit seinem Motorrad argwöhnisch, während er einer Bürgerrechtsdemonstration in der Nähe von Van Ness Avenue und Geary Boulevard, nur ein paar Blocks nördlich des Civic Centers, zuschaut, 1964.

De vénérables badaudes contemplent avec une méfiance non dissimulée un homme à moto qui assiste à une manifestation en faveur des droits civiques, à proximité de Van Ness Avenue et de Geary Boulevard, au nord du Civic Center. 1964.

→
Arthur Tress

Men watch a civil rights demonstration at Van Ness Avenue and Bush Street, on a stretch of Van Ness known as Auto Row for its cluster of car showrooms. As the civil rights movement gained steam, Auto Row saw protests, sit-ins, and pickets protesting dealers' discriminatory practices that didn't hire African Americans for positions other than janitorial work, 1964.

Männer beobachten eine Bürgerrechtsdemonstration in der Nähe von Van Ness Avenue und Bush Street. Dieses Stück der Straße wurde wegen der vielen Autohändler die Auto Row genannt. Als die Bürgerrechtsbewegung Schwung aufnahm, fanden hier

Proteste, Sit-ins und andere Demonstrationen gegen die diskriminierenden Einstellungspolitik der Autoverkäufer statt, die Afroamerikaner nur zum Putzen einstellten, 1964.

Groupe d'hommes assistant à une manifestation pour les droits civiques à l'angle de Bush Street et de Van Ness Avenue, dont un tronçon, « Auto Row », abritait de nombreux showrooms automobiles. Avec la montée en puissance du mouvement des droits civiques, Auto Row accueillera régulièrement sit-in et autres protestations dénonçant les pratiques discriminatoires des concessionnaires, qui limitaient l'embauche d'Afro-Américains aux travaux de nettoyage. 1964.

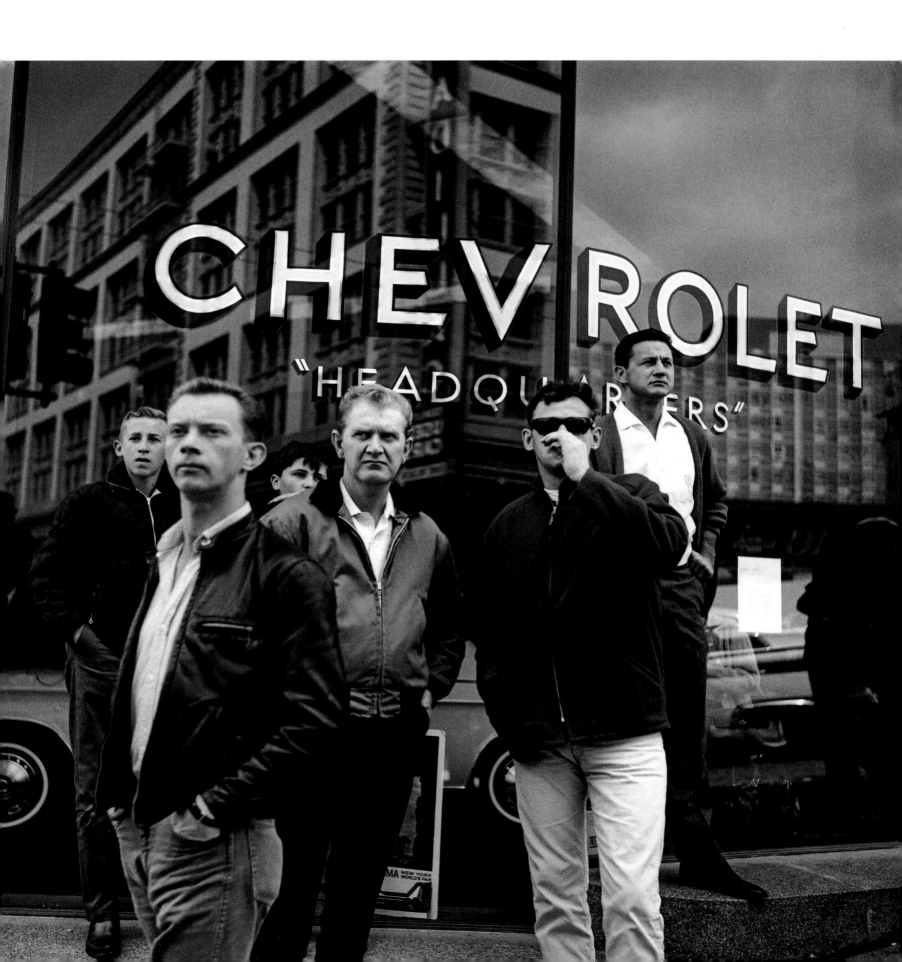

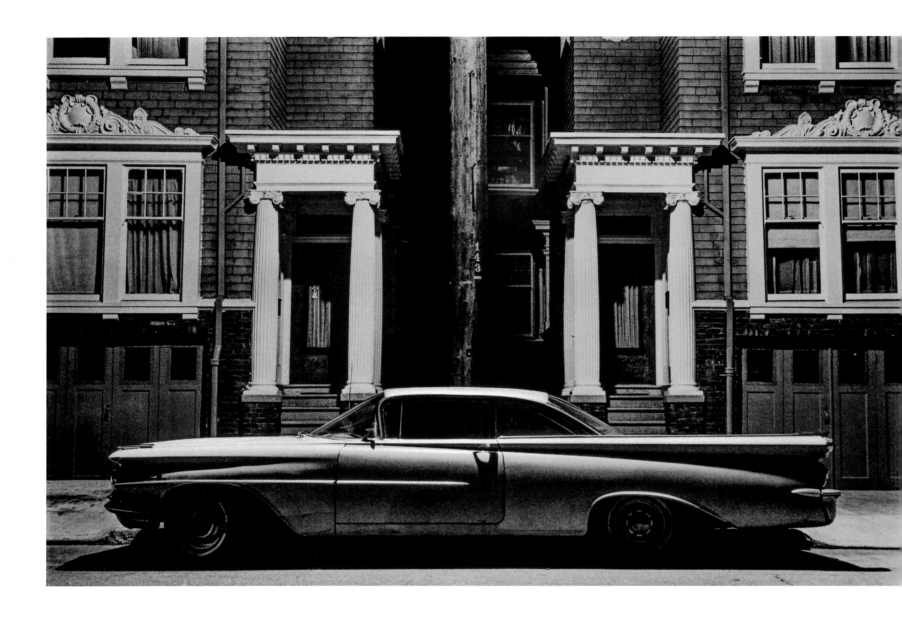

↑
William Gedney

There weren't many cars that took up as much parking space in San Francisco, or anywhere, in the mid-1960s as this mini-boat. Finding a place to park for such vehicles was a challenge even then, and would be virtually impossible today in a city known for scarce spots, 1966.

Es gab nur wenige Autos, in San Francisco und anderswo, die so viel Platz brauchten, wie dieses hier. Einen Parkplatz zu finden war damals schon eine Herausforderung und wäre heute, in einer für Parklückenknappheit bekannten Stadt, praktisch unmöglich, 1966..

Au milieu des années 1960, les belles Américaines n'étaient pas si nombreuses à pouvoir revendiquer un tel espace de stationnement, à San Francisco comme ailleurs. À l'époque déjà, pour ce genre de paquebot roulant, réussir à se garer était un défi de taille qui serait presque impossible à relever aujourd'hui. 1966.

→
Ted Streshinsky

The famed psychedelic bus that author Ken Kesey's Merry Pranksters rode across the country, in front of a Harriet Street warehouse after a thorough repainting and sprucing up for the Acid Test Graduation. Initially scheduled to take place at Winterland Ballroom, the event was instead held here in the South of Market neighborhood, 1966.

Der berühmte psychedelische Bus, mit dem Autor Ken Kesey und seine Merry Pranksters durch das ganze Land fuhren, steht hier vor einem Kaufhaus in der Harriet Street, nachdem er für die Acid Test Graduation

komplett neu bemalt und herausgeputzt wurde. Ursprünglich für den Winterland Ballroom geplant, fand das Event stattdessen im Viertel South of Market statt, 1966.

Stationné devant un entrepôt de Harriet Street, le célèbre bus psychédélique dans lequel les Merry Pranksters de l'écrivain Ken Kesey ont sillonné l'Amérique a été repeint à neuf en prévision de l'Acid Test Graduation : initialement prévu au Winterland Ballroom, l'immense rassemblement d'amateurs de LSD aura lieu ici même, dans le quartier de South of Market. 1966.

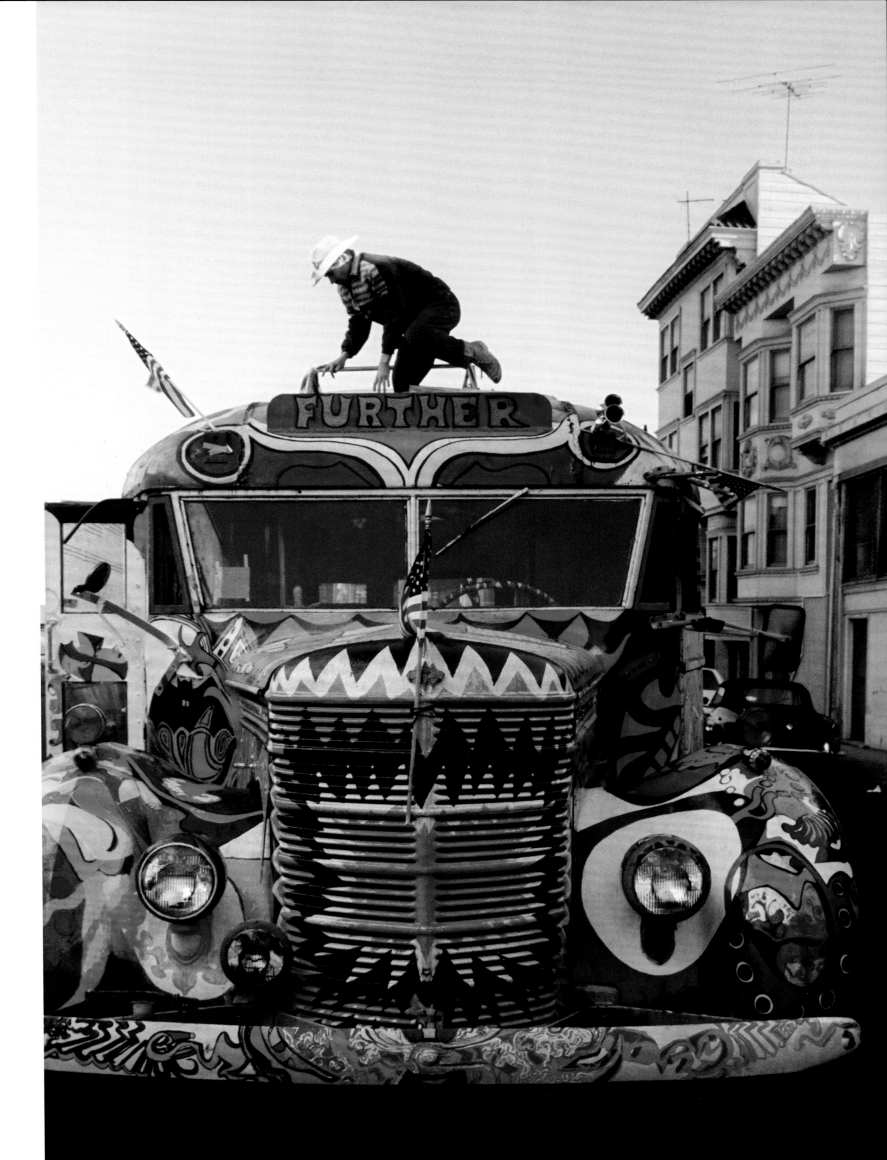

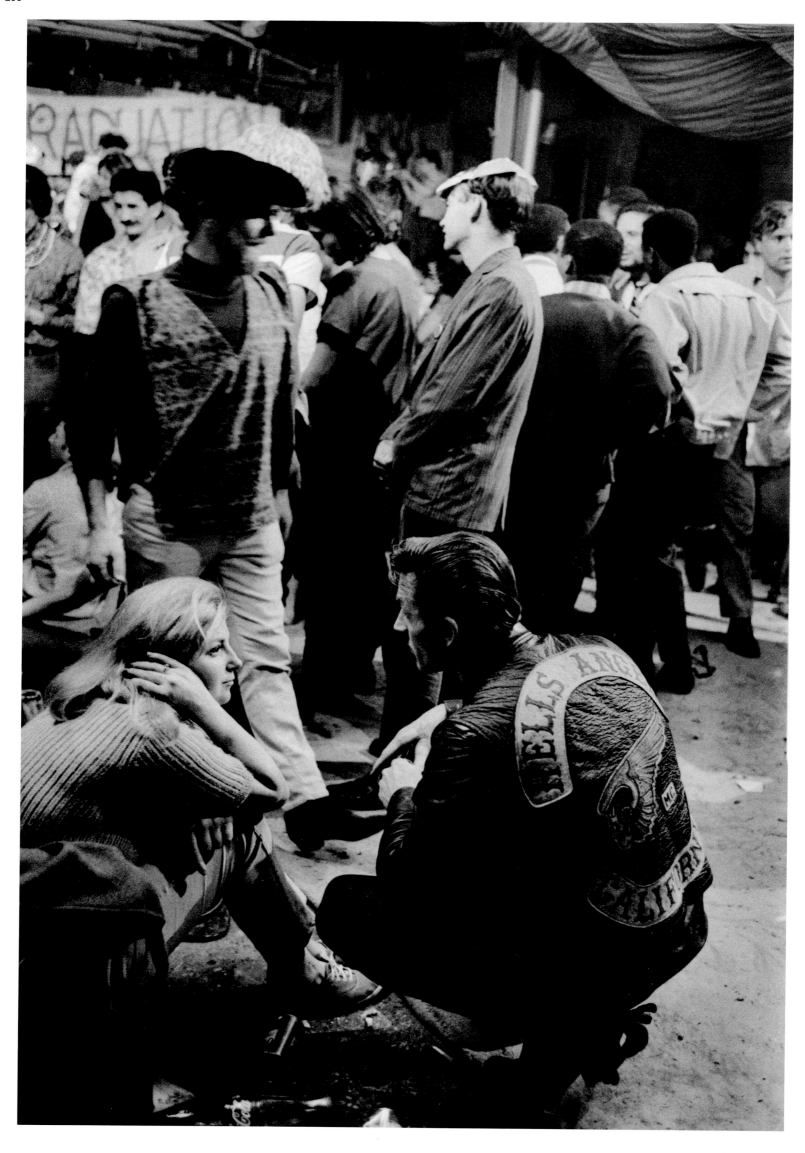

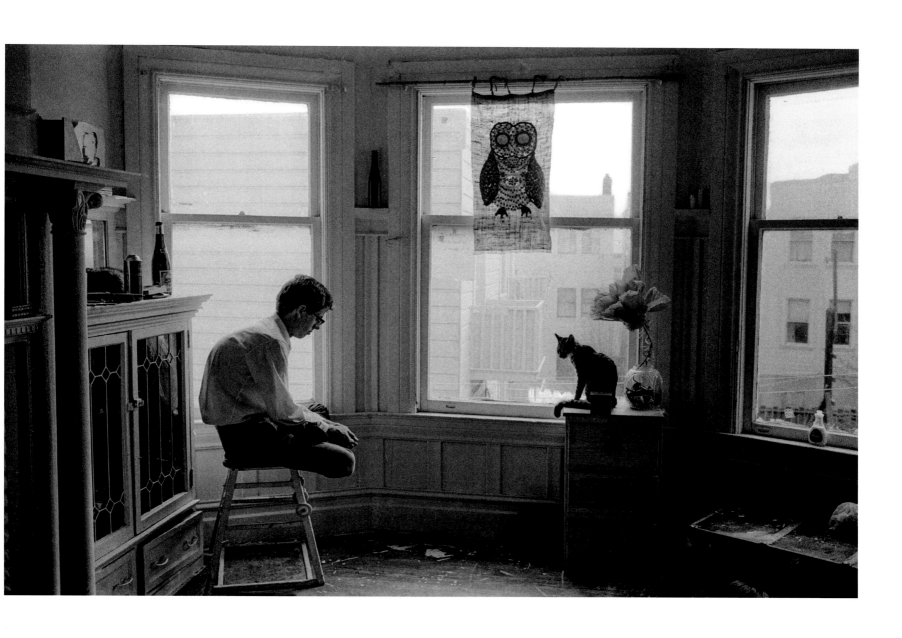

←
Ted Streshinsky

A Hells Angel at the Acid Test Graduation Party. Hunter S. Thompson introduced Ken Kesey to the Angels while Thompson was writing Hell's Angels *in the summer of 1965. The Pranksters turned many of the gang members on to LSD at Kesey's home in La Honda, about an hour's drive south of the city, and the two groups maintained an oddly amicable union to the end of the psychedelic era, 1966.*

Ein Hells Angel auf der Acid Test Graduation Party. Hunter S. Thompson hatte Ken Kesey den Angels vorgestellt, als Thompson im Sommer 1965 an seinem Buch Hell's Angels *arbeitete. In Keseys Haus in La Honda, etwa eine Stunde südlich der Stadt, brachten die Pranksters einige der Gangmitglieder zum LSD, und die beiden Gruppen pflegten für den Rest der psychedelischen Ära eine seltsam freundschaftliche Beziehung, 1966.*

Un Hells Angel à la fête qui suivit l'Acid Test Graduation. À l'été 1963, c'est Hunter S. Thompson, l'inventeur du gonzo journalisme, qui présenta Ken Kesey aux bikers alors qu'il écrivait son livre Hell's Angels. *Les Pranksters initieront au LSD de nombreux membres du club de motards, chez Kesey lui-même à La Honda, à une heure de route au sud de la ville. Les deux groupes maintiendront des liens curieusement amicaux jusqu'au terme de l'ère psychédélique. 1966.*

↑
Lawrence Schiller

A mathematician and early adopter of psychedelic experimentation sits in quiet contemplation while taking an acid trip. It was his biweekly practice to administer LSD to his cat and to himself, 1965.

Ein Mathematiker, der sich schon früh für psychedelische Experimente interessierte, sitzt während seines Trips ganz still da. Alle zwei Wochen gab er seiner Katze und sich selbst eine Dosis LSD, 1965.

Un mathématicien et adepte pionnier de l'expérimentation psychédélique repose dans une contemplation tranquille pendant son trip sous acide bimensuel – toujours partagé avec son chat. 1965.

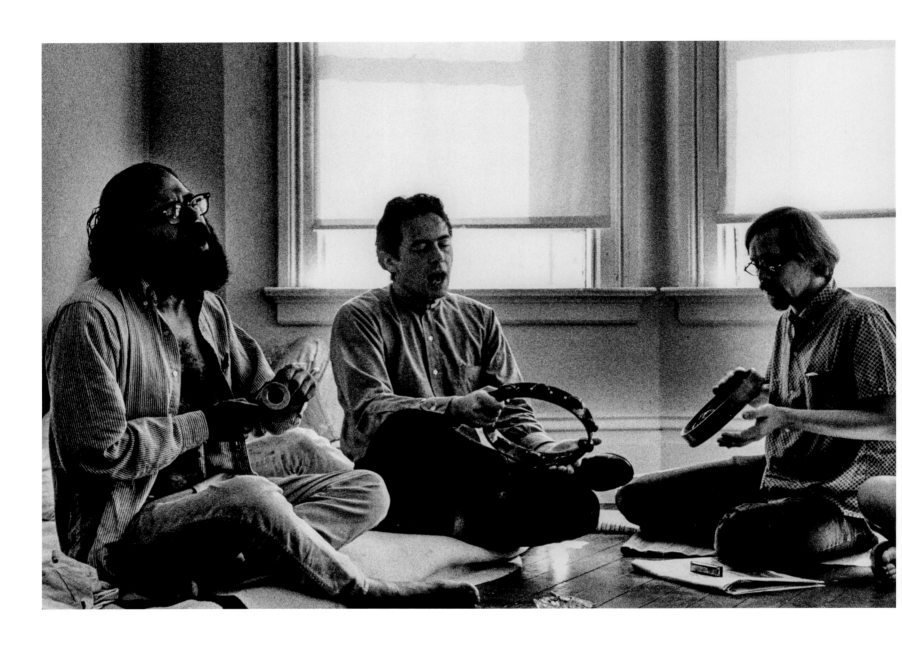

↑
Larry Keenan

Allen Ginsberg (left), Michael McClure (center), and Bruce Conner (right) chanting mantras at Ginsberg's Fell Street apartment, near the eastern edge of the Golden Gate Park panhandle. Poet McClure bridged the Beat and hippie scene, reading at both the 1955 Six Gallery event where Ginsberg debuted Howl *and the 1967 Be-In at Golden Gate Park. Prolific multimedia artist Conner made his mark with avant-garde film, collage, and photography, 1965.*

Allen Ginsberg (links), Michael McClure (mittig) und Bruce Conner (rechts) singen Mantras in Ginsbergs Wohnung an der Fells Street, nah am östlichen Rand des Golden Gate Park. Der Dichter McClure gehörte zu den Beats und den Hippies und las sowohl beim Six Gallery Event 1955, bei dem

Ginsberg Howl *vorstellte, als auch beim Be-In 1967 im Golden Gate Park. Der produktive Multimediakünstler Conner profilierte sich mit Avantgardefilmen, Kollagen und Fotografie, 1965.*

Allen Ginsberg (à gauche), Michael McClure (au centre) et Bruce Conner (à droite) chantent des mantras dans l'appartement du premier nommé sur Fell Street, non loin de la lisière orientale du Golden Gate Park. Poète, McClure a jeté un pont entre le mouvement beat et la scène hippie en lisant ses œuvres à la fois à la Six Gallery en 1955, le jour où Ginsberg y présenta « Howl », et au happening Be-In de 1967 dans ce même parc. Conner, artiste aussi éclectique que prolifique, a marqué les esprits avec ses films, collages et photos d'avant-garde. 1965.

→
Baron Wolman

Robert Crumb, snapped in San Francisco by Rolling Stone's *first staff photographer shortly after rising to fame as a cartoonist for underground comics. His* Zap Comix *mercilessly mocked the local hippie counterculture, yet found its greatest readership among that very community, in Haight-Ashbury and soon throughout the world. Although he wasn't much of a rock fan, he also designed the cover for the biggest-selling San Francisco psychedelic LP, Big Brother & the Holding Company's* Cheap Thrills, *1969.*

Die Zap Comix *des Comicgenies Robert Crumb machten sich gnadenlos über die örtliche Hippieszene lustig, doch gerade diese Community stellte seine größte Leserschaft, bevor er weltweit Erfolg hatte, 1969.*

Avec Zap Comix, *son magazine de bande dessinée, le génial Robert Crumb se moquait impitoyablement de la contre-culture hippie de San Francisco, laquelle communauté constituait en même temps son lectorat le plus important, à Haight-Ashbury comme bientôt dans le monde entier. 1969.*

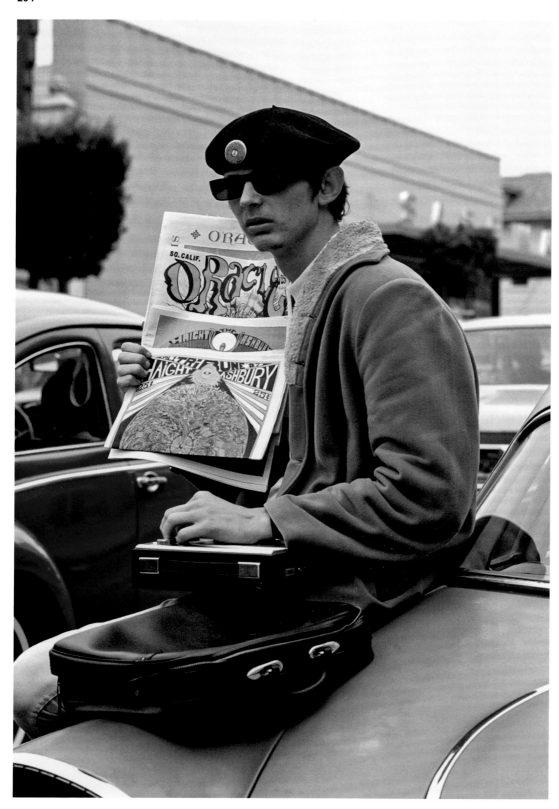

→
Ted Streshinsky

Author Tom Wolfe (right) with Grateful Dead guitarist-singer Jerry Garcia (center) and Dead manager Rock Scully at the intersection that gave the Haight-Ashbury District its name. Wolfe documented the psychedelic trips, motorized and otherwise, of Ken Kesey's Merry Pranksters in The Electric Kool-Aid Acid Test, *which often intersected with the early San Francisco acid rock scene, 1966.*

Autor Tom Wolfe (rechts) mit dem Gitarristen und Sänger der Grateful Dead, Jerry Garcia (Mitte), und seinem Manager Rock Scully an der Kreuzung, die dem dem Viertel Haight-Ashbury den Namen gab. Wolf dokumentierte die psychedelischen Trips, mit dem Bus oder anders, der Merry Pranksters um Ken Kesey in The Electric Kool-Aid Acid Test *und kam so auch mit der frühen Acid-Rock-Szene in San Francisco in Berührung, 1966.*

L'écrivain Tom Wolfe (à droite) aux côtés du guitariste-chanteur Jerry Garcia (au milieu) et du manager de Grateful Dead, Rock Scully, au carrefour qui donna son nom au quartier de Haight-Ashbury. Wolfe a consigné les périples psychédéliques des Merry Pranksters de Ken Kesey, motorisés et plus si affinités, dans son roman Acid Test, *qui recoupe souvent les débuts de l'acid rock à San Francisco. 1966.*

↑
Baron Wolman

The San Francisco Oracle, *a Haight-Ashbury local paper, was more noteworthy for its wildly freewheeling graphics than its oft-impenetrable prose, 1967.*

Das Bemerkenswerte an der Zeitung San Francisco Oracle *aus Haight-Ashbury waren ihre wilden Illustrationen und nicht die oft unverständliche Prosa, 1967.*

Le San Francisco Oracle, *un journal local né à Haight-Ashbury, valait davantage par son graphisme débridé que par sa prose fréquemment impénétrable. 1967.*

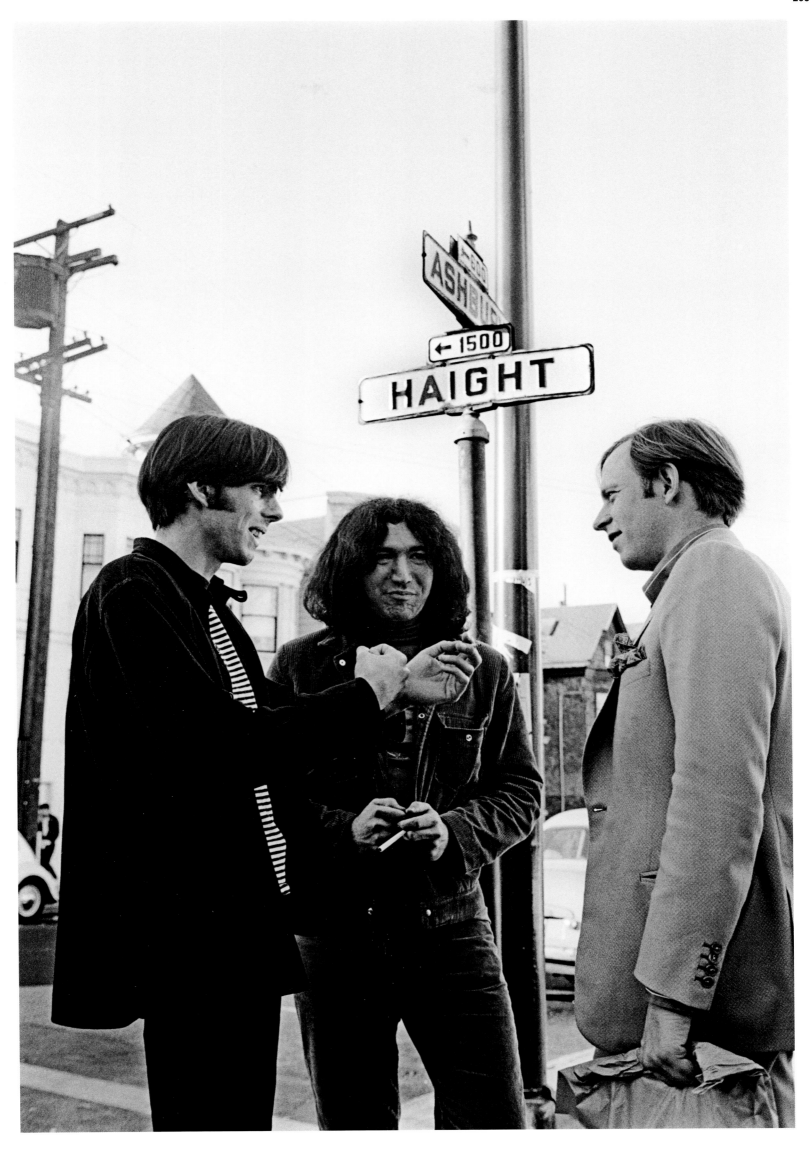

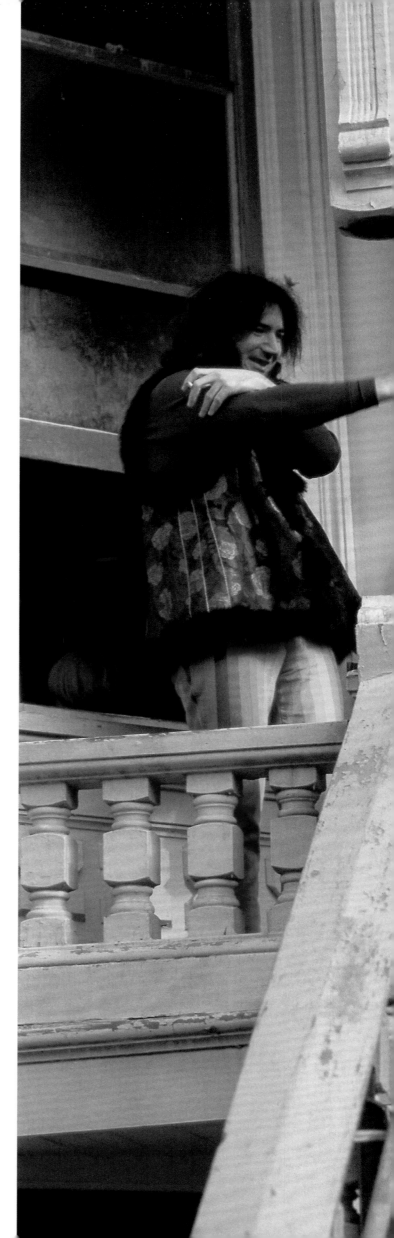

Linda McCartney

The Grateful Dead outside their communal home at 710 Ashbury Street, a few blocks up the hill from the corner of Haight and Ashbury. They sometimes played free concerts in the Golden Gate Park Panhandle, also just a few blocks down the hill, 1968.

Die Grateful Dead vor der 710 Ashbury Street, ihrem gemeinsamen Zuhause, ein paar Blocks den Hügel hoch von der Ecke Haight und Ashbury. Manchmal gaben sie Konzerte im Panhandle des Golden Gate Park, nur einige Blocks den Hügel hinunter, 1968.

Les Grateful Dead devant leur maison com-munautaire du 710 Ashbury Street, tout près du carrefour Haight-Ashbury. Ils donnaient parfois des concerts gratuits un peu plus bas, sur le Panhandle du Golden Gate Park. 1968.

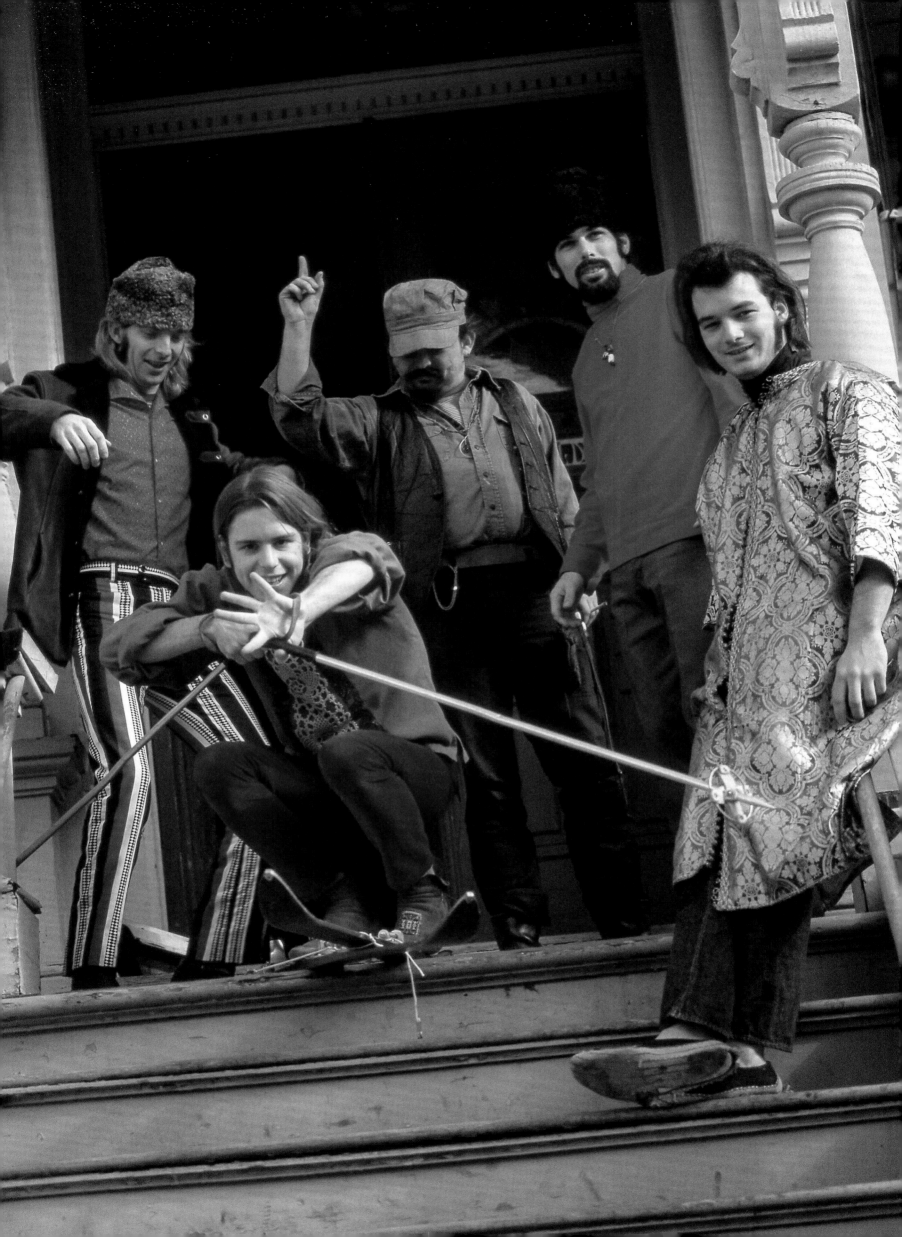

↓
Anonymous

The U.F.O. Gallery on Haight Street, just a block from the Haight-Ashbury intersection. Several art and poster stores geared toward hippies sprang up in the area in the late '60s, sometimes offering rock records, incense, and other paraphernalia as well. Just a block or two away on Haight Street, the Psychedelic Shop and the Drogstore (sic) catered to a similar clientele, c. late 1960s.

Die U.F.O. Galerie auf der Haight Street, wenige Blocks von der Kreuzung Haight und Ashbury entfernt. Einige an Hippies gerichtete Kunst- und Posterläden entstanden in der Gegend in den späten 60ern und verkauften manchmal auch Rockplatten, Räucherwerk und anderen Krimskrams. Nur ein oder zwei Blocks entfernt richteten sich der Psychedelic Shop und der Drogstore (sic) an die gleiche Klientel, späte 1960er.

La galerie U.F.O. sur Haight Street, à un pâté de maisons du carrefour Haight-Ashbury. À la fin des années 1960 sont apparues dans le quartier des boutiques destinées spécifiquement aux hippies, auxquels elles vendaient des affiches, de l'encens, des disques de rock, de l'art en général et toutes sortes de choses. Non loin de là, sur Haight Street, la Psychedelic Shop et le Drogstore (sic) s'adressaient à une clientèle similaire. Vers la fin des années 1960.

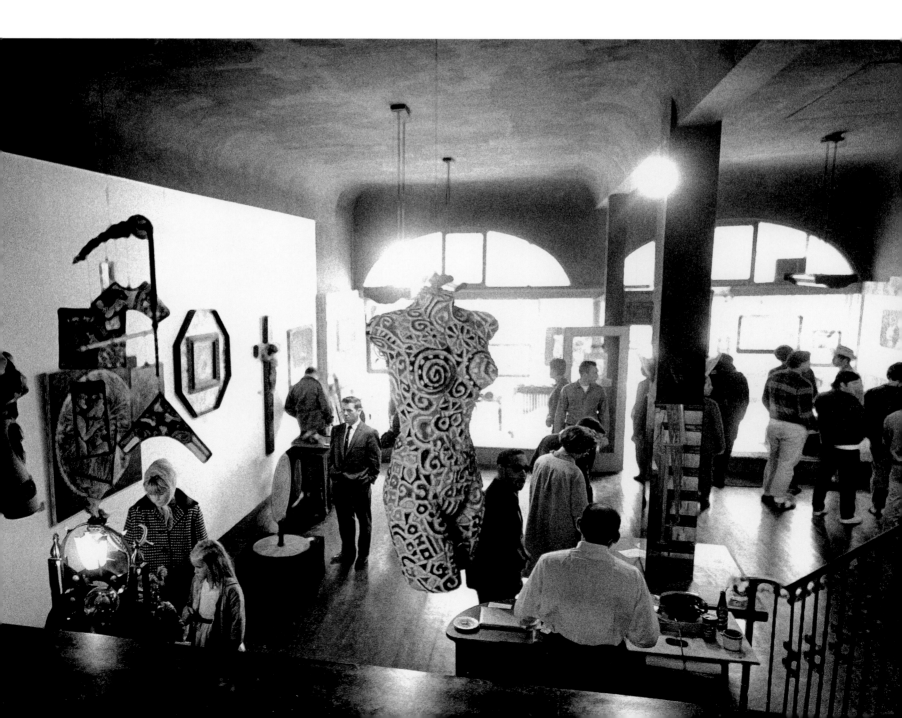

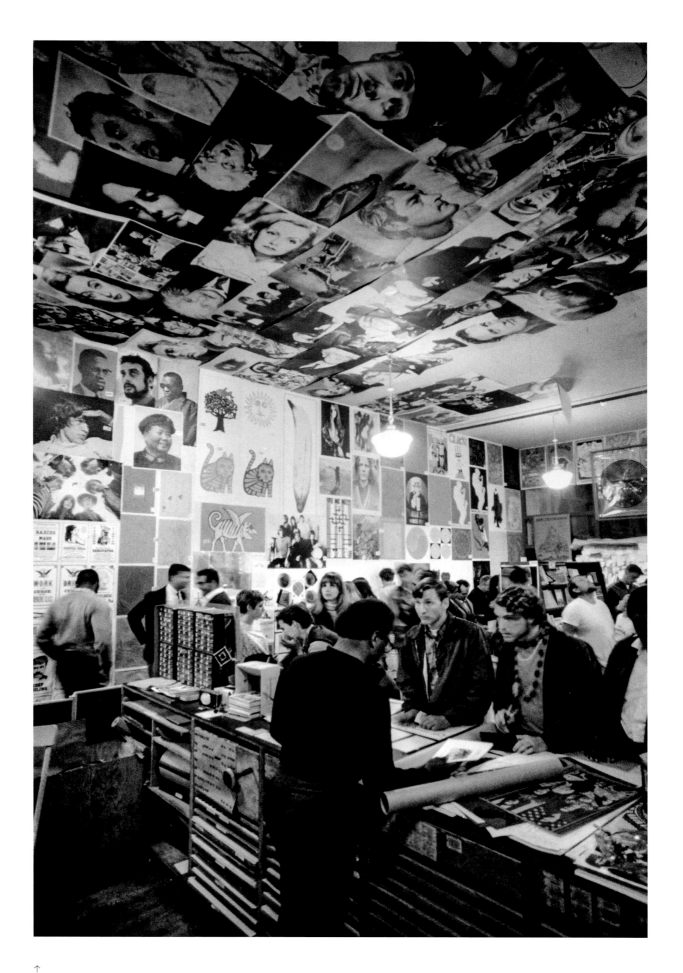

↑
Ted Streshinsky

Customers browse a potpourri of posters in the Print Mint on Haight Street, just a few doors from the intersection of Haight and Ashbury. The explosion of the San Francisco scene helped create a huge youth market for posters of all kinds, 1967.

Kunden stöbern in einer bunten Mischung aus Postern im Print Mint an der Haight Street nur ein paar Häuser von der Kreuzung Haight-Ashbury entfernt. Das explosive Wachstum der Szene in San Francisco schaffte unter Jugendlichen einen großen Markt für alle Arten von Poster, 1967.

Fondée par le poète Don Schenker et son épouse Alice sur Haight Street, à deux pas du carrefour Haight-Ashbury, la boutique Print Mint est assaillie de jeunes clients qui ne savent plus où donner de la tête. La scène psychédélique est alors à son zénith. 1967.

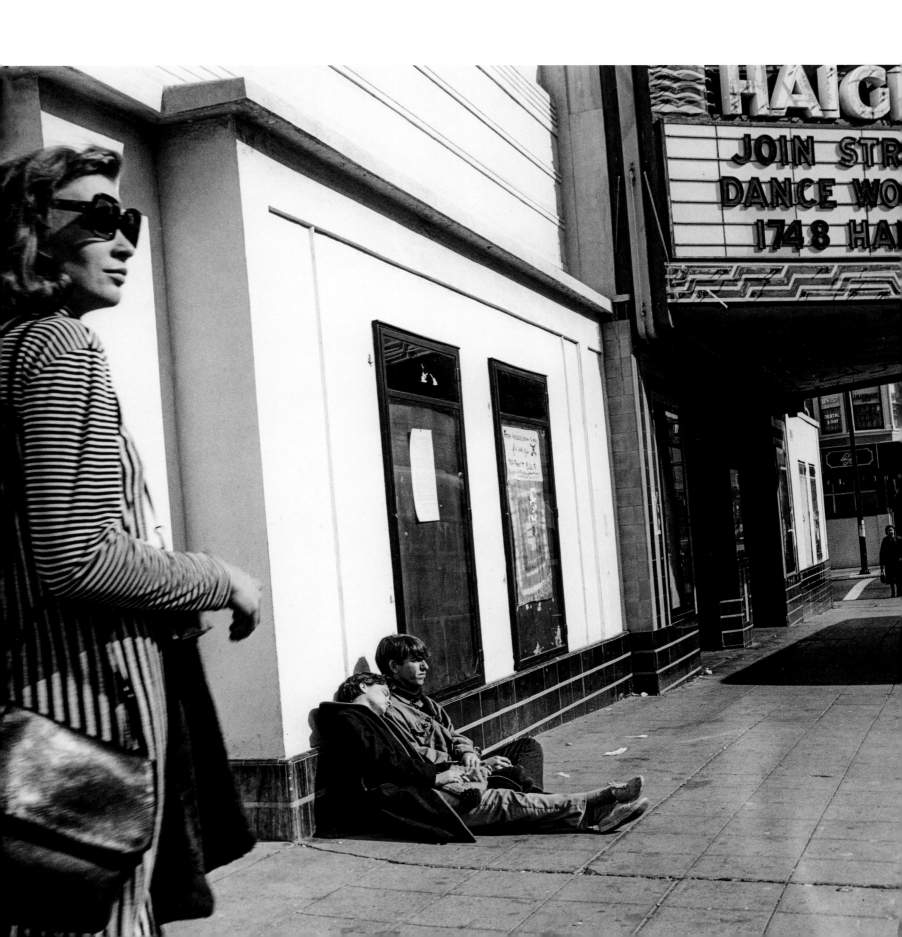

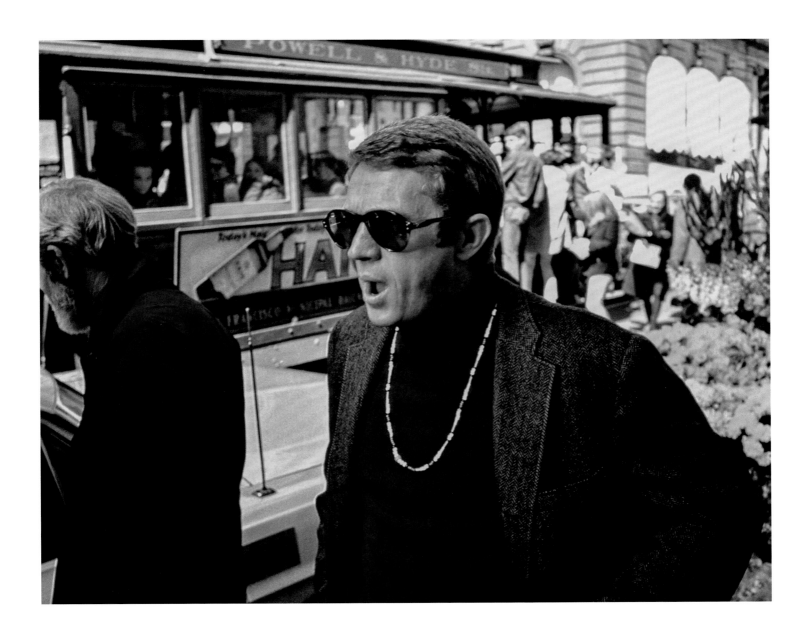

←
Imogen Cunningham

Outside the Haight Street Theater, about halfway between the corner of Haight and Ashbury and the entrance to Golden Gate Park, 1967.

Vor dem Haight Street Theater, in der Mitte zwischen der Ecke Haight und Ashbury sowie dem Eingang zum Golden Gate Park, 1967.

Devant le Haight Street Theater, à mi-chemin du carrefour Haight-Ashbury et de l'entrée du Golden Gate Park. 1967.

↑
Anonymous

Steve McQueen wears love beads hippies gave him on the set of Bullitt *as he walks past a Powell Street cable car, 1968.*

Steve McQueen trägt eine Liebeskette, die ihm Hippies, am Set von Bullitt *schenkten, als er gerade an einer Powell-Street-Bahn vorbeigeht, 1968.*

Steve McQueen, devant un cable car *sur Powell Street, porte le collier de perles d'amour que des hippies lui ont offert sur le tournage de* Bullitt. *1968.*

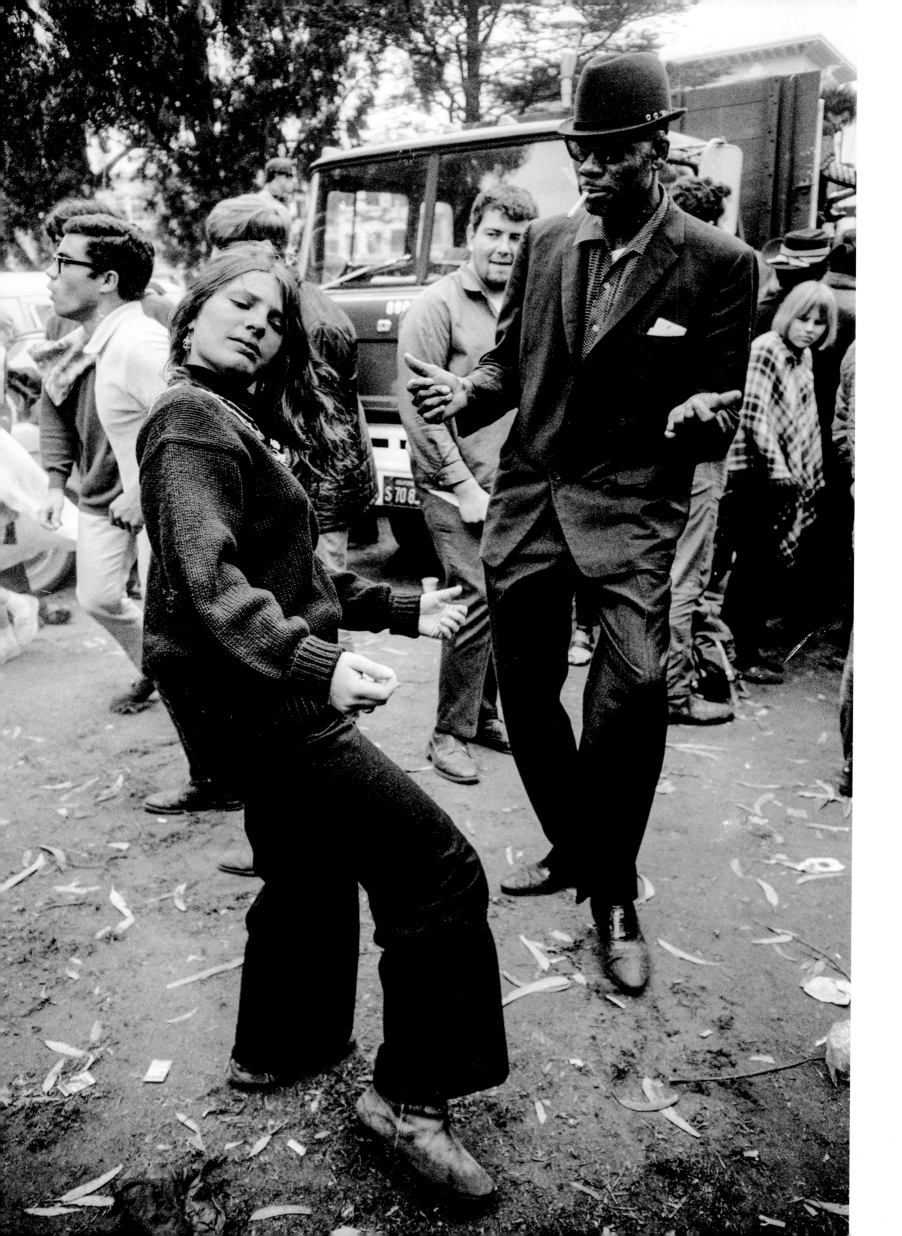

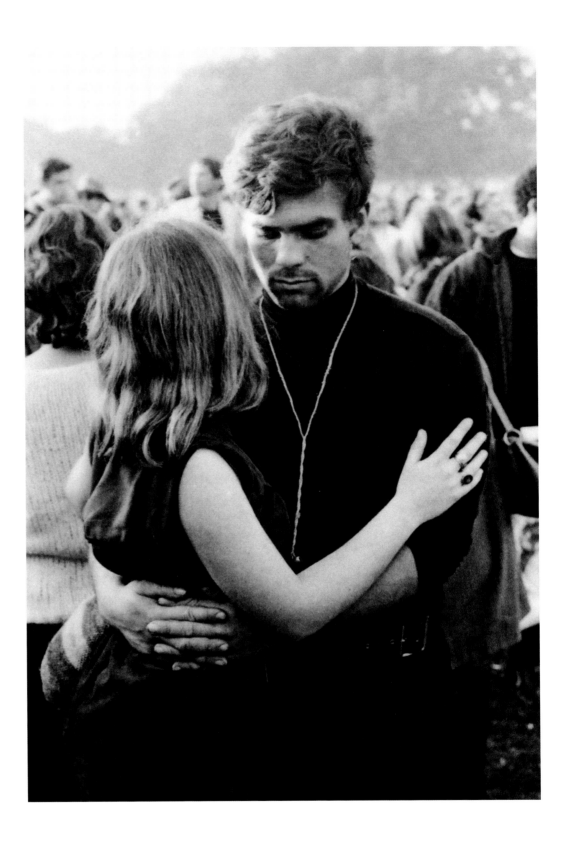

←
Steve Schapiro

Dancers in the Panhandle, the eight-by-one-block rectangular park that extends from the eastern edge of Golden Gate Park into the northern edge of Haight-Ashbury. Many free rock concerts took place in the Panhandle in the late 1960s by top local bands like Jefferson Airplane, Big Brother & the Holding Company with Janis Joplin, and the Grateful Dead, as well as touring acts like Jimi Hendrix, 1967.

Tänzer im Panhandle, dem acht Blocks langen Park, der vom östlichen Ende des Golden Gate Park bis an die nördliche Grenze von Haight-Ashbury heranreicht. Hier fanden in den späten 60ern eine Menge öffentliche Rockkonzerte statt, mit lokalen Bands

wie Jefferson Airplane, Big Brother & the Holding Company mit Janis Joplin und den Grateful Dead oder mit tourenden Künstlern wie Jimi Hendrix, 1967.

On danse sur le Panhandle, l'étroit rectangle en queue de poêle, long d'un peu plus d'un kilomètre, qui s'étend de la bordure orientale du Golden Gate Park à la limite nord de Haight-Ashbury. De nombreux concerts de rock gratuits s'y sont déroulés à la fin des années 1960, avec les meilleurs groupes locaux – Jefferson Airplane, Big Brother & the Holding Company (Janis Joplin en était) et les Grateful Dead. D'autres, comme Jimi Hendrix, y ont fait étape en tournée. 1967.

↑
William Gedney

Couple embracing at the Human Be-In in the Polo Fields of Golden Gate Park. The emerging hippie community didn't realize how great their numbers were until tens of thousands came to this gathering at the Polo Fields in the dead of winter, 1967.

Auf den Polofeldern im Golden Gate Park umarmt sich ein Paar beim Human Be-In. Die noch junge Hippie-Community war sich nicht darüber im Klaren, wie groß sie war, bis Zehntausende von ihnen zu diesem Treffen mitten im Winter kamen, 1967.

Flagrant délit de tendresse au Human Be-In, le happening géant organisé en plein hiver sur le terrain de polo du Golden Gate Park. Il faudra que des dizaines de milliers de personnes accourent à ce rassemblement pour que la toute jeune communauté hippie prenne conscience de son importance. 1967.

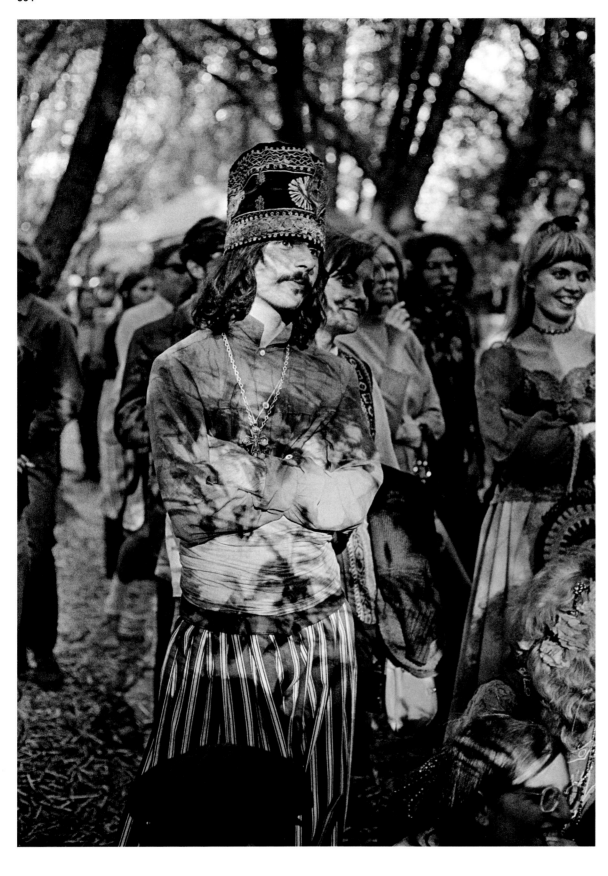

↑

Larry Fink

Young men and women dressed up for a Renaissance Fair a small ways north of San Francisco. Simulating medieval life with the costumes and cuisine of Elizabethan England, the fairs drew their share of youthful bohemians looking for an idyllic alternative to the 20th-century straight world, 1969.

Junge Männer und Frauen haben sich für einen Renaissancemarkt nur etwas nördlich von San Francisco verkleidet. Sie spielten das Mittelalter nach und aßen und kleideten sich wie im elisabethanischen England. Die Märkte zogen viele junge Bohemiens an, die auf der Suche nach einer idyllischen Alternative zur Welt des 20. Jahrhunderts waren, 1969.

Un festival déguisé fait revivre la fin du Moyen Âge et l'Angleterre élisabéthaine au nord de San Francisco. Dans ces « Renaissance fairs », de jeunes bohèmes venaient chercher une alternative édénique aux conventions sociales du XXᵉ siècle. 1969.

↓
Anonymous

George Harrison plays a borrowed guitar in Golden Gate Park during his brief visit to Haight-Ashbury in the Summer of Love. On his right is publicist Derek Taylor, who helped arrange a quick trip for Harrison to check out the Haight's hippie scene. Harrison and a growing crowd of admirers then walked down Haight Street before he ended his tour, August 7, 1967.

George Harrison spielt auf einer geliehenen Gitarre während seines Besuchs in Haight-Ashbury im Sommer der Liebe. Rechts von ihm steht sein Publizist, Derek Taylor, der den Trip für Harrison arrangiert hatte, damit sie sich die Hippieszene in Haight-Ashbury ansehen konnten. Nach dem Auftritt gingen er und eine Gruppe von Bewunderern die Haight Street entlang, bevor er seinen Besuch beendete, 7. August, 1967.

Dans le Golden Gate Park, quelqu'un a tendu une guitare à George Harrison lors de son bref passage à Haight-Ashbury pendant le « Summer of Love ». À sa droite, le journaliste et attaché de presse Derek Taylor, maître d'œuvre de cet aller-retour qui permit au membre des Beatles de découvrir à leurs dépens la scène hippie de la ville. Coursé par une foule pressante et presque hostile, Harrison filera par Haight Street sans demander son reste. 7 août 1967.

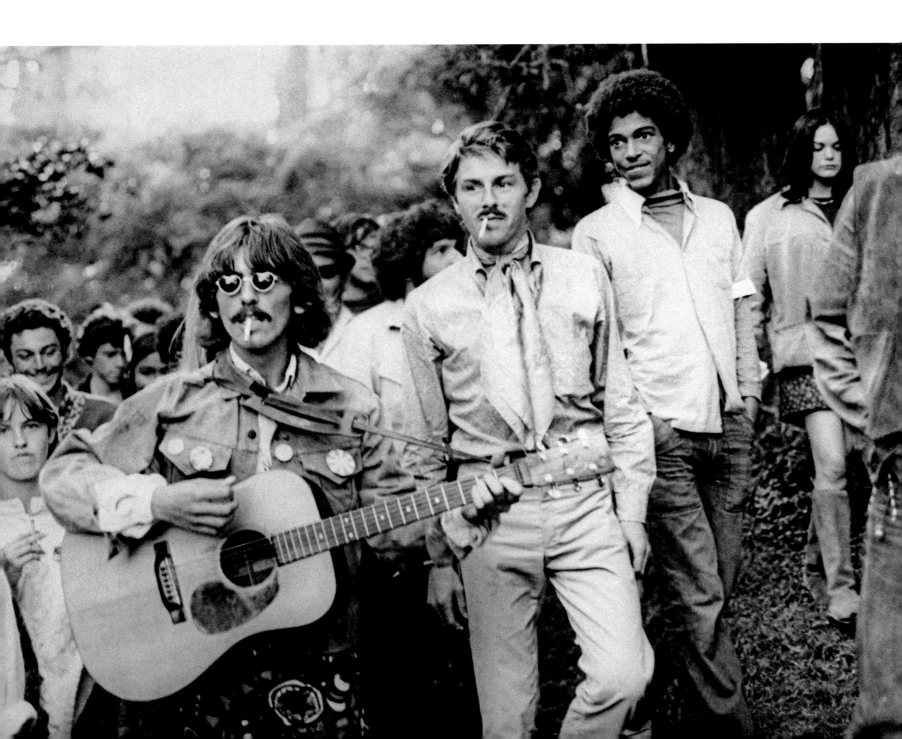

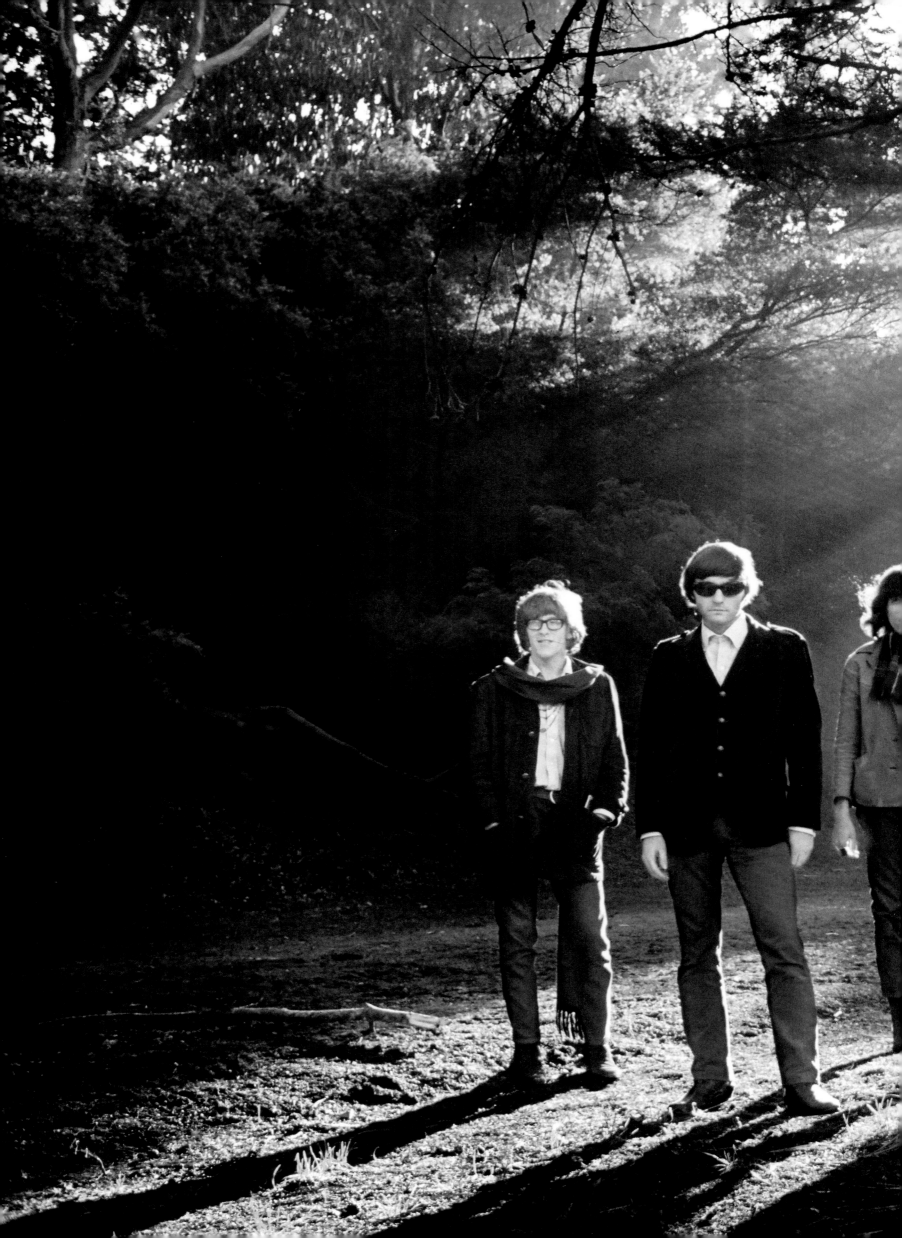

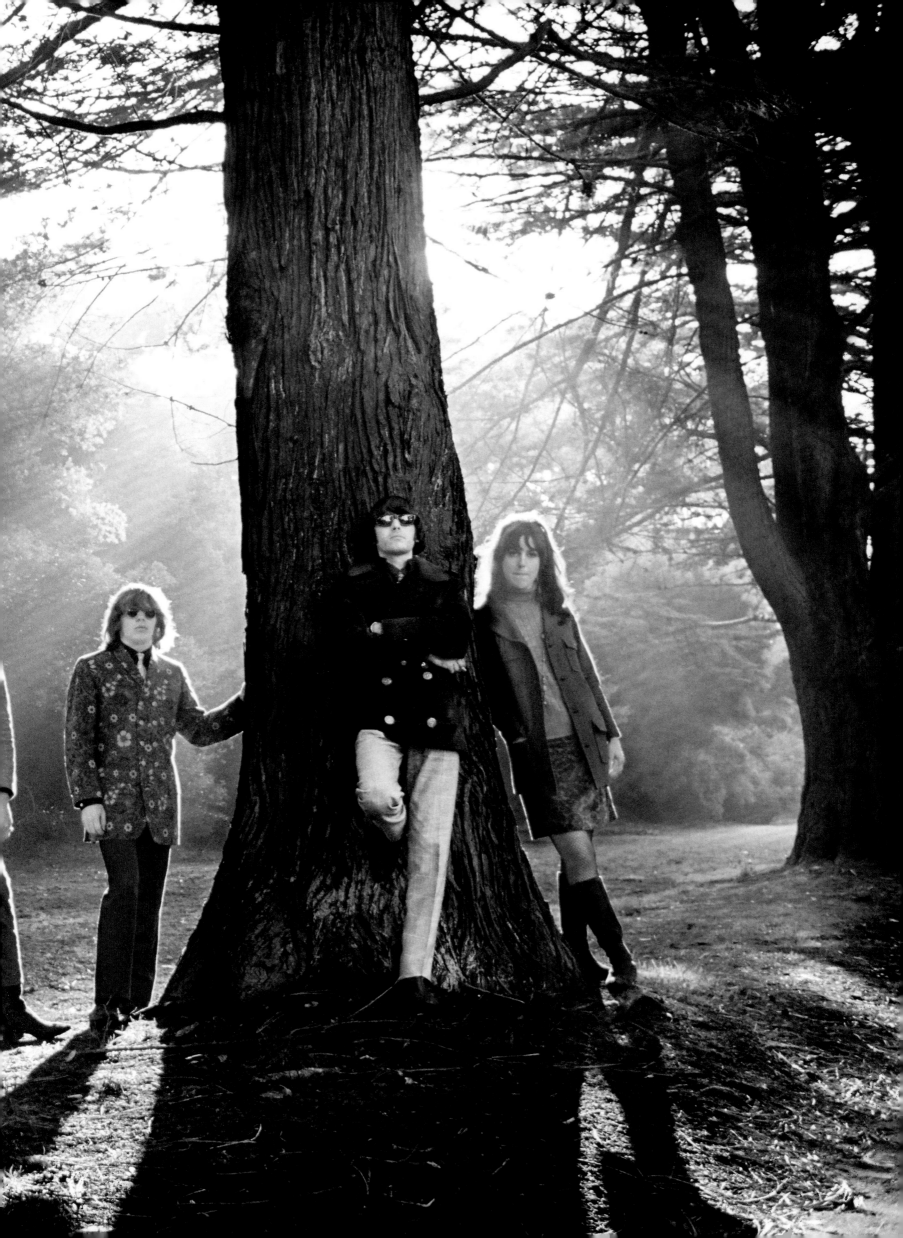

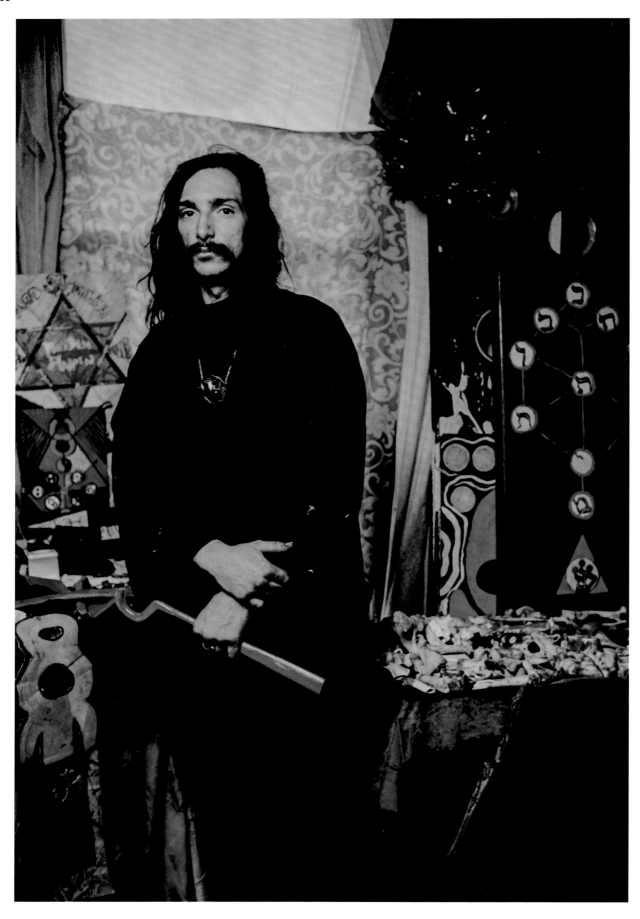

p. 306/307
Jim Marshall

Jefferson Airplane posing in Golden Gate Park for a Look *magazine feature around the time their second album,* Surrealistic Pillow, *was released. Featuring the Grace Slick–sung smashes "Somebody to Love" and "White Rabbit," it was the first San Francisco psychedelic album to become a national hit, 1967.*

Jefferson Airplane posiert im Golden Gate Park für das Look-Magazin, etwa zur Zeit der Veröffentlichung ihres zweiten Albums, Surrealistic Pillow. *Mit von Grace Slick gesungenen Songs wie „Somebody to Love" und „White Rabbit" wurde es als erstes Psychadelic Album aus San Francisco ein landesweiter Hit, 1967.*

Jefferson Airplane pose dans le Golden Gate Park pour le magazine Look, *à peu près au moment de la sortie de leur deuxième album,* Surrealistic Pillow. *Grâce en particulier à ses tubes « Somebody to Love » et « White Rabbit », chantés par Grace Slick, ce sera le premier album psychédélique de San Francisco à connaître un succès national. 1967.*

←

Steve Schapiro

Identified as a "medicine man," this anony-mous character posed against a backdrop of "magical" and religious imagery at the height of the hippie era, 1967.

Dieser unbekannte Mann war als „Medizin-mann" bekannt und posiert vor einem Hinter-grund aus „magischen" und religiösen Bildern auf dem Höhepunkt der Hippie-Ära, 1967.

Identifié comme un « guérisseur », ce person-nage anonyme pose sur fond de symboles ésotériques et religieux à l'apogée de l'ère hippie. 1967.

↓

Jim Marshall

Shortly after the June 1967 Monterey Pop Festival, Grace Slick and Janis Joplin, the two biggest San Francisco psychedelic stars, had their only joint photo session at Slick's Pacific Heights apartment on Washington Street, near Presidio Avenue, 1967.

Kurz nach dem Monterey Pop Festival im Juni 1967 nahmen Grace Slick und Janis Joplin, die zwei größten Psychedelic-Stars in San Francisco, zum ersten und einzigen Mal in Slicks Apartment an der Washington Street, nah an der Presidio Avenue, an einer gemeinsamen Fotosession teil, 1967.

Peu après le festival de Monterey en juin 1967, Grace Slick et Janis Joplin, les deux plus grandes stars psychédéliques de San Francisco, posent pour une séance photo commune dans l'appartement de Slick à Pacific Heights, sur Washington Street, près de Presidio Avenue. Cette première ne sera jamais réitérée. 1967.

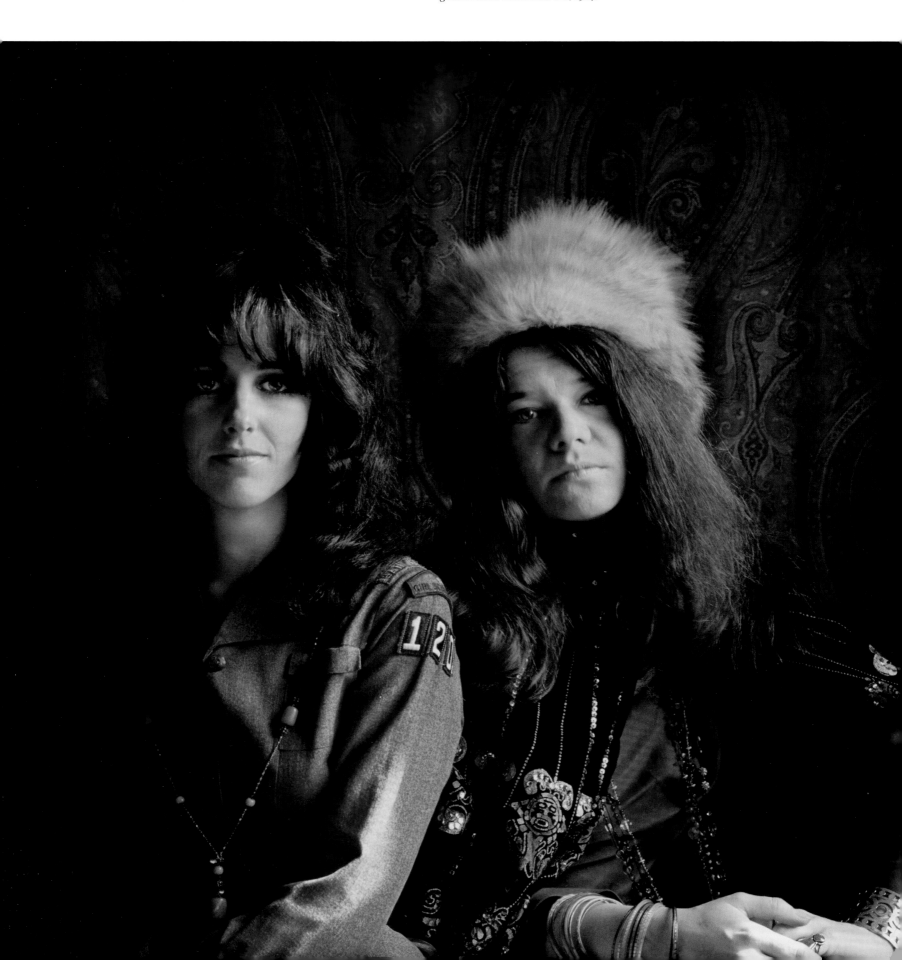

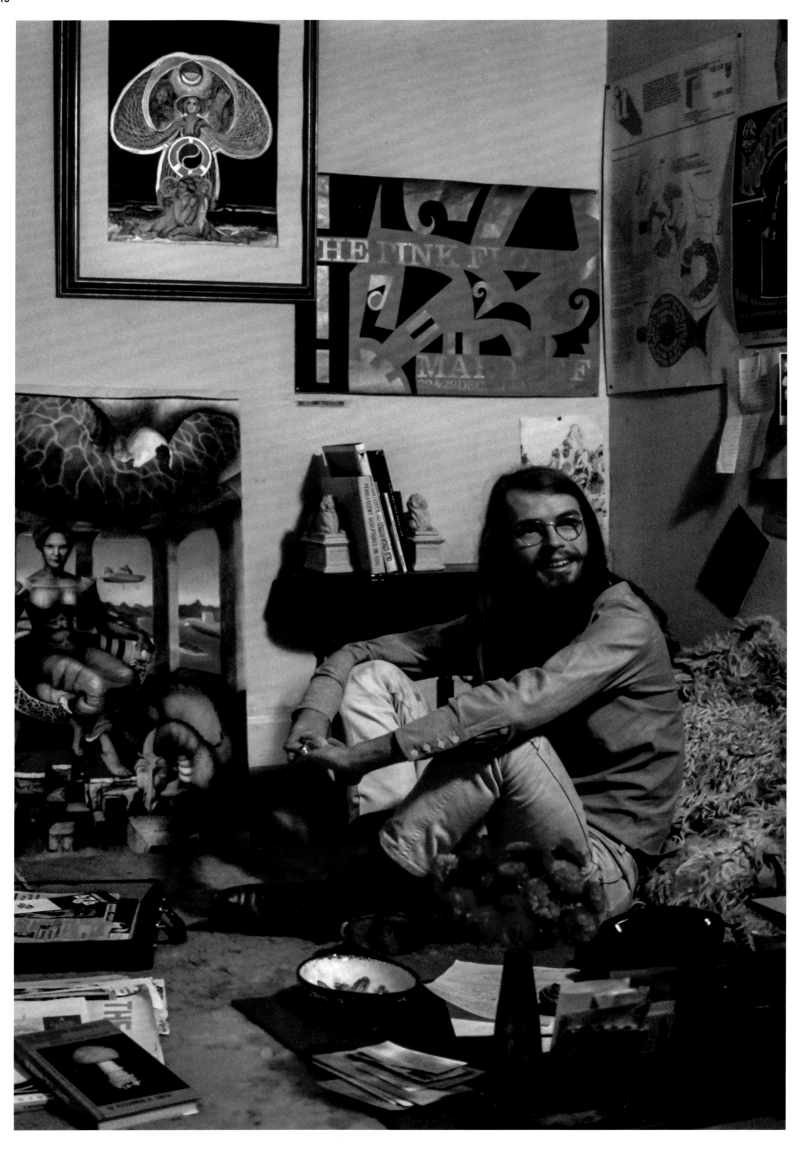

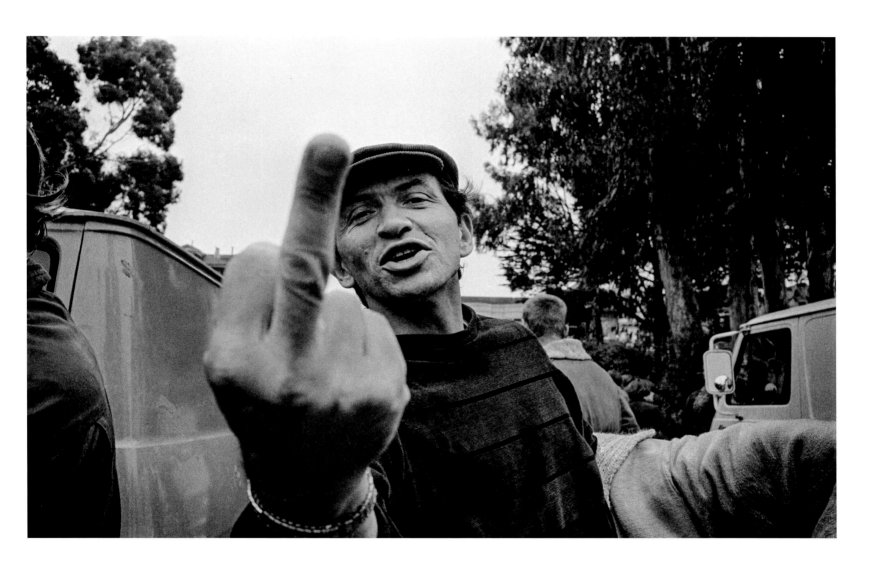

←
Ted Streshinsky

Rock promoter Chet Helms relaxing in Haight-Ashbury, with a poster for an early London show by Pink Floyd in the background. Along with Bill Graham, Helms was the most important promoter in the San Francisco psychedelic rock scene, especially for shows at the Avalon Ballroom, the Fillmore's chief rival, 1967.

Der Rock-Promoter Chet Helms entspannt sich in Haight-Ashbury, mit einem Poster von einer frühen Pink Floyd Show in London im Hintergrund. Zusammen mit Bill Graham war Helms der wichtigste Veranstalter in San Franciscos Psychadelica-Rockszene,

besonders im Avalon Ballroom, dem größten Rivalen des Fillmore, 1967.

Détente à Haight-Ashbury pour le promoteur de rock Chet Helms. À l'arrière-plan, une affiche annonçant un concert des Pink Floyd à Londres. Avec Bill Graham, Helms était l'organisateur le plus important de la scène psychédélique de San Francisco. Il dirigea notamment l'Avalon Ballroom, le principal rival du Fillmore. 1967.

↑
Jim Marshall

San Francisco rock impresario Bill Graham gives top local music photographer Jim Marshall the finger at Jimi Hendrix's free concert in the Golden Gate Park Panhandle at the beginning of the Summer of Love. It was just a week after Hendrix had wowed the crowd at his first major US concert at the Monterey Pop Festival, 1967.

Bill Graham, Rockshow-Direktor aus San Francisco, zeigt dem lokalen Musikfotografen Jim Marshall den Mittelfinger bei Jimi Hendrix öffentlichem Konzert im Golden Gate Park Panhandle zu Beginn des Sommers der Liebe. Das Foto entstand nur eine Woche

nachdem Hendrix die Zuschauer auf dem Monterey Pop Festival bei seinem ersten großen Konzert in den USA begeistert hatte, 1967.

Un doigt d'honneur qui fera date, administré par le producteur et promoteur de rock Bill Graham à Jim Marshall, l'un des meilleurs photographes de San Francisco. La scène se passe lors du concert gratuit que donna Jimi Hendrix sur le Panhandle du Golden Gate Park, au début du « Summer of Love ». Une semaine plus tôt, Hendrix avait impressionné le public de son premier grand concert américain au festival de Monterey. 1967.

"The important thing about San Francisco is that it's a scene. It's a warm, supportive, friendly city that historically had the bohemians, the Beats, that supported the arts, poetry, jazz and similarly today supports rock and roll."

„Das Wichtigste an San Francisco ist, dass es eine Schau ist. Es ist eine warme, hilfsbereite, freundliche Stadt, die in der Vergangenheit die Bohemiens, die Beats hatte, die Kunst, Poesie, Jazz unterstützt hat und auf ähnliche Weise heute den Rock 'n' Roll unterstützt."

« L'important, avec San Francisco, c'est qu'elle est une scène. C'est une ville chaleureuse, solidaire, amicale, qui dans son histoire aura connu les bohèmes et les beats, soutenu les arts, la poésie, le jazz et qui de la même manière soutient aujourd'hui le rock'n roll.. »

JANN WENNER, 1968

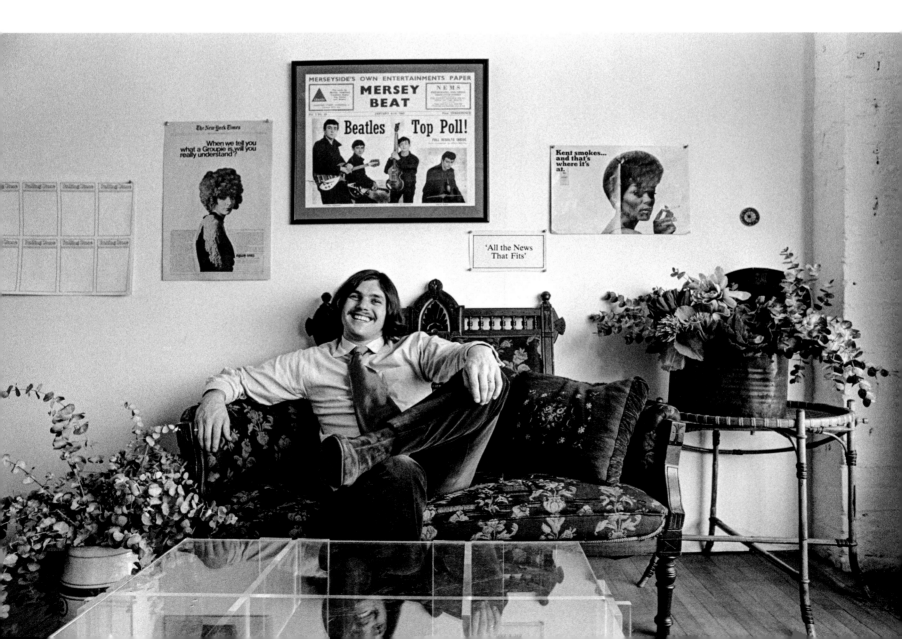

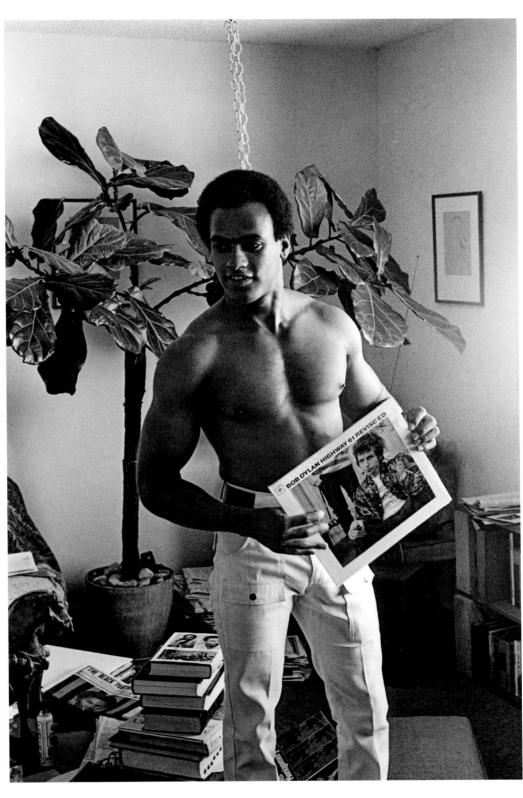

←

Baron Wolman

Jann Wenner, co-founder and publisher of Rolling Stone, *in his office at 746 Brannan Street in the South of Market neighborhood, a couple years after the magazine launched. The former UC Berkeley student founded the first large-circulation US publication to give serious coverage to rock music with* San Francisco Chronicle *music critic Ralph Gleason, 1969.*

Jann Wenner, Herausgeber und Mitbegrün-der des Rolling Stone, *in seinem Büro im Viertel South of Market an der 746 Brannan Street, nur ein paar Jahre nach Gründung des Magazins. Ehemals Student an der UC*

Berkeley, gründete er die erste Publikation mit hoher Auflage, die ernsthaft über Rock-musik berichtete, unter anderem Musik-kritiker Ralph Gleason vom San Francisco Chronicle, *1969.*

Tout sourire dans son bureau du 746 Brannan Street (South of Market), Jann Wenner, ancien étudiant de Berkeley, fonda en 1967 le magazine Rolling Stone *avec Ralph Gleason, critique de jazz au* San Francisco Chronicle. *Pour la première fois aux États-Unis, un titre à grand tirage accordait à la musique rock une place sérieuse. 1969.*

↑

Stephen Shames

Black Panther Party cofounder Huey Newton in his Berkeley home, shortly after his release from prison after his manslaughter conviction was overturned. He's holding a copy of Bob Dylan's 1965 album Highway 61 Revisited, *which he and other Panthers listened to while assembling early editions of the party paper, 1970.*

Mitgründer der Black Panther Party, Huey Newton, in seiner Wohnung in Berkeley, kurz nachdem seine Verurteilung wegen Totschlags aufgehoben und er aus dem Gefängnis ent-lassen wurde. Er hält Bob Dylans Album Highway 61 Revisited *aus dem Jahr 1965 in*

der Hand, das er und andere Panthers hörten, während sie frühe Ausgaben der Parteizeitung vorbereiteten, 1970.

Le cofondateur du Black Panther Party, Huey Newton, chez lui à Berkeley peu après sa sortie de prison suite à l'annulation de la condamnation pour meurtre prononcée contre lui en 1967. Il a en main l'album Highway 61 Revisited *de Bob Dylan, que ses camarades et lui écoutaient pendant le bouclage des premiers numéros du journal de leur mouvement. 1970.*

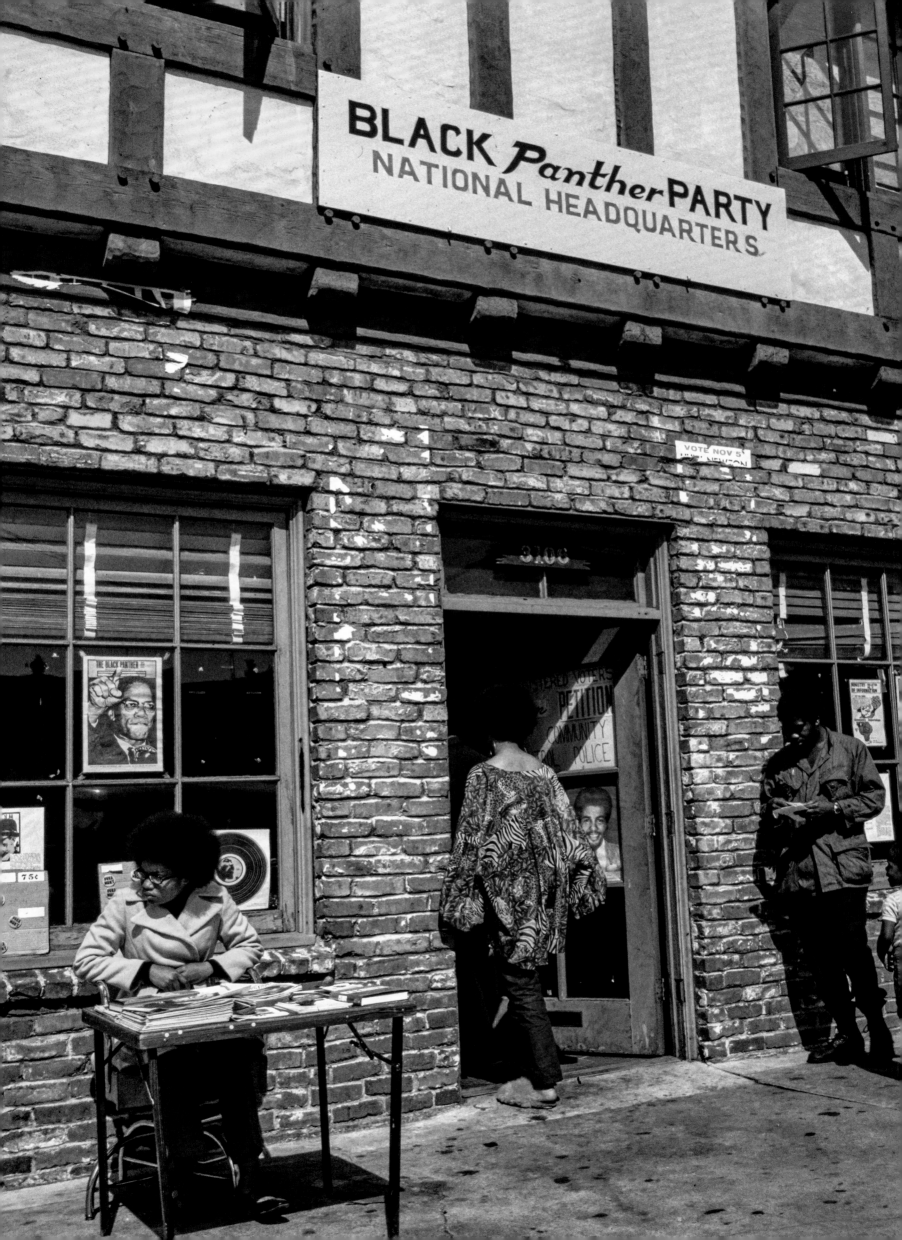

Ruth-Marion Baruch

The Black Panther Party National Headquarters in Oakland, where it was founded in 1966 as a response to police brutality in the African American community. The party also promoted social and economic justice, most famously in its free breakfast program for children, 1969.

Das nationale Hauptquartier der Black Panther Party in Oakland, wo sie 1966 als Reaktion auf Polizeigewalt gegen Afroamerikaner gegründet wurde. Die Partei setzte sich auch für soziale und wirtschaftliche Gerechtigkeit ein, am bekanntesten war ihr tägliches Frühstück für Kinder, 1969.

Le siège national du Black Panther Party à Oakland, où il a été fondé en 1966 en réponse à la brutalité policière vis-à-vis de la communauté afro-américaine. Le parti s'est également engagé activement sur le terrain de la justice sociale et économique, notamment par le biais d'un célèbre programme de petits déjeuners gratuits pour les enfants défavorisés. 1969.

"Big Brother is playing in the Panhandle and almost everybody is high. It is a nice afternoon between three and six o'clock, which the activists say are the three hours in the week when something is most likely to happen in the Haight-Ashbury."

„Janis Joplin singt mit Big Brother im Panhandle, fast alle sind high, und es ist ein ziemlich schöner Sonntagnachmittag zwischen drei und sechs Uhr, den drei Stunden in der Woche, wie die Aktivsten sagen, in denen es am wahrscheinlichsten ist, dass etwas im Haight-Ashbury passiert."

« Janis Joplin chante avec Big Brother dans le Pahandle, presque tout le monde est défoncé, c'est un beau dimanche après-midi entre trois et six heures, c'est-à-dire les trois heures de la semaine, selon les activistes, pendant lesquelles il est susceptible d'arriver quelque chose dans Haight-Ashbury […]. »

JOAN DIDION, *SLOUCHING TOWARDS BETHLEHEM*, 1967

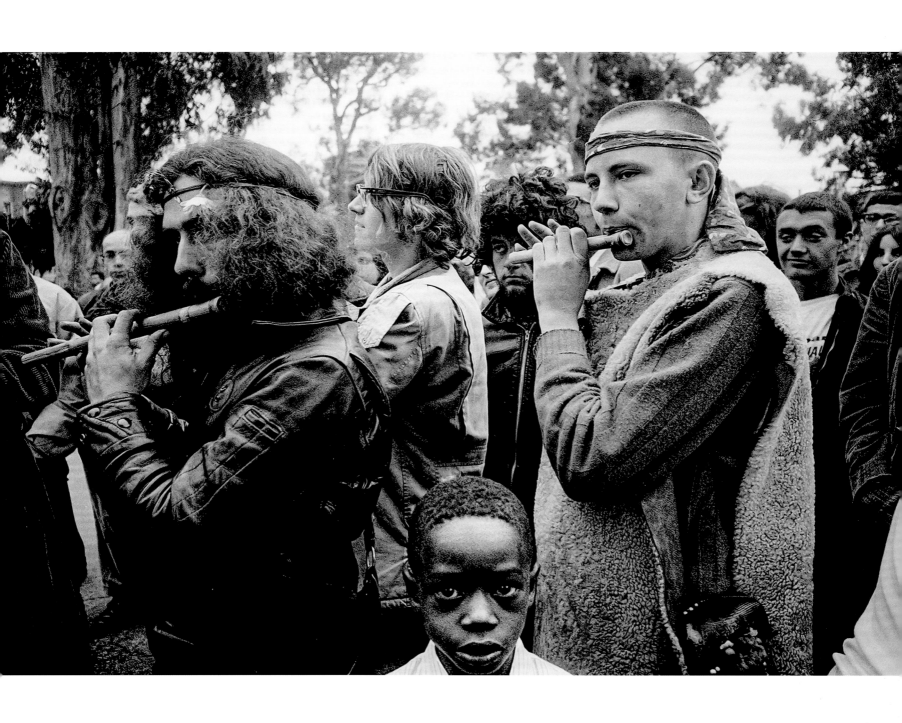

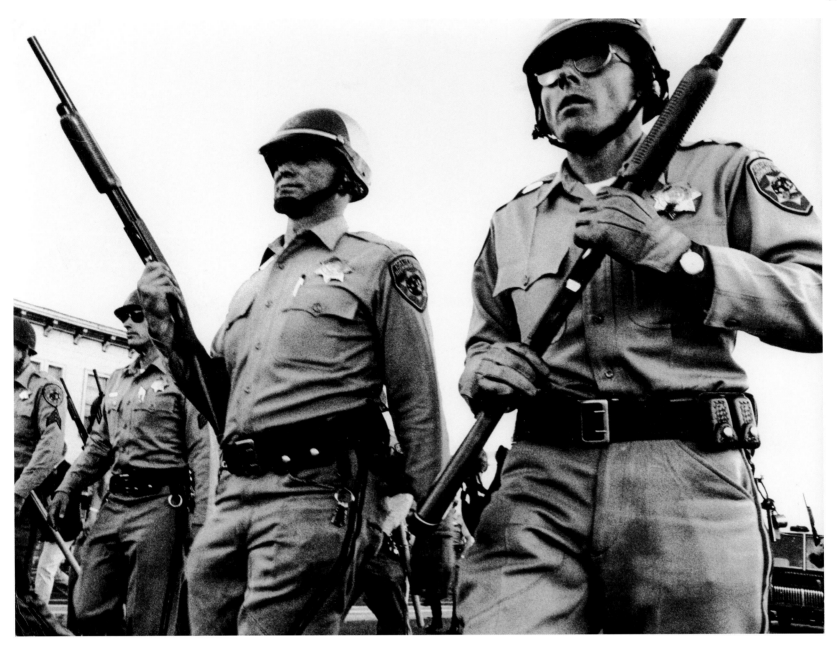

Steve Schapiro

A pair of hippies play flutes in a local park, though it seems the one in the sheepskin poncho might have just taken leave of the army given his atypical crew cut. Jams by non-professional musicians have remained a staple of city park life ever since, 1967.

Zwei Flöte spielende Hippies in einem Park. Die ungewöhnliche Kurzhaarfrisur des Mannes in der Schaffellweste lässt darauf schließen, dass er gerade seinen Wehrdienst beendet hat. Sessions von Amateurmusikern wurden ein Bestandteil des Lebens in den Parks der Stadt, 1967.

Deux hippies jouent de la flûte dans un parc de la ville. Si l'on en croit sa coupe de cheveux, l'homme au poncho portait encore récemment un tout autre genre d'uniforme. Au premier plan, un garçonnet semble avoir atterri là fortuitement. 1967.

Jean-Antony du Lac

California Highway Patrol in riot gear after a San Francisco Police officer shot and killed an unarmed African American teen in the Hunters Point/Bayview neighborhood in September 1966. California governor Pat Brown sent the National Guard and California Highway Patrol in response to rioting and demonstrations. A curfew was imposed for four days, 1966.

Kalifornische Highway Patrol mit Sturmausrüstung, nachdem ein Polizist aus San Francisco im September 1966 einen unbewaffneten afroamerikanischen Teenager im Viertel Hunters Point/Bayview erschossen

hatte. Der Gouverneur Pat Brown entsandte die Highway Patrol und die Nationalgarde als Reaktion auf Proteste und Demonstrationen. Es wurde eine viertägige Ausgangssperre verhängt, 1966.

La police d'État californienne en tenue anti-émeute après qu'un agent de San Francisco a abattu un adolescent afro-américain non armé dans le quartier ouvrier de Hunters Point en septembre 1966. En réponse aux manifestations et aux violences, Pat Brown, gouverneur de Californie, mobilisa également la Garde nationale. Un couvre-feu sera imposé quatre jours durant. 1966.

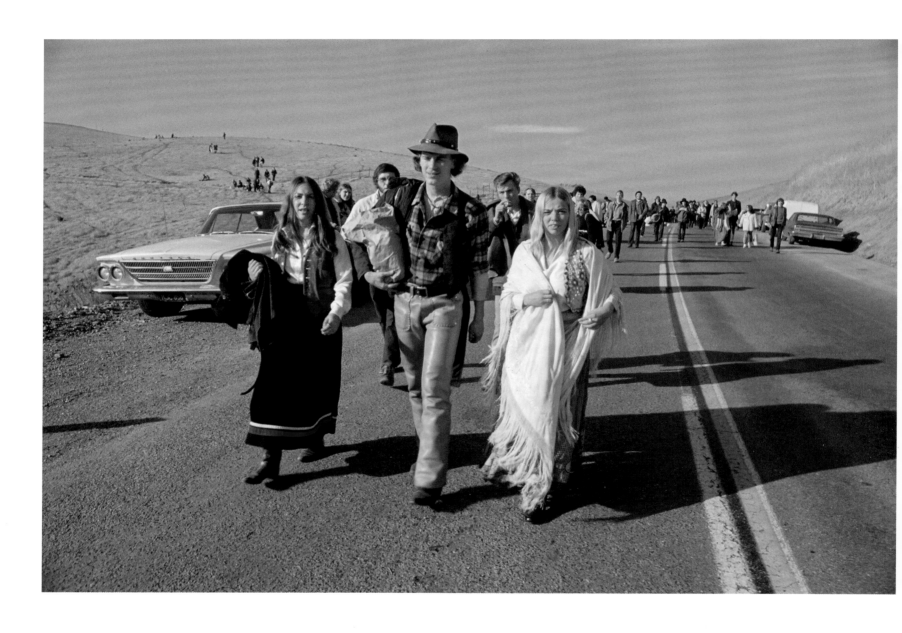

↑
Bill Owens

Rock fans walking to the Altamont festival in Livermore, about an hour's drive from San Francisco. An audience of about 300,000 came to see the Rolling Stones, Santana, the Flying Burrito Brothers, and Crosby, Stills, Nash & Young, December 6, 1969.

Rockfans gehen zum Altamont-Festival in Livermore, circa eine Autostunde von San Francisco entfernt. 300 000 Menschen kamen, um die Rolling Stones, Santana, die Flying Burrito Brothers sowie Crosby, Stills, Nash & Young zu sehen, 6. Dezember 1969.

Les amateurs de rock convergent vers le festival d'Altamont à Livermore, à près d'une heure de route de San Francisco. Quelque 30 000 personnes viennent entendre les Rolling Stones, Santana, les Flying Burrito Brothers et Crosby, Stills, Nash & Young. 6 décembre 1969.

→
Bill Owens

The massive traffic jam as cars tried to drive to the Altamont festival, which had been moved to the Altamont Speedway less than 48 hours before the event, December 6, 1969.

Die Besucher des Altamont-Festivals, das erst 48 Stunden zuvor auf den Altamont Speedway verlegt worden war, sorgen für einen enormen Stau, 6. Dezember 1969.

L'interminable embouteillage en direction du festival d'Altamont, déplacé sur la piste de stock-cars du même nom moins de quarante-huit heures avant l'événement. 6 décembre 1969.

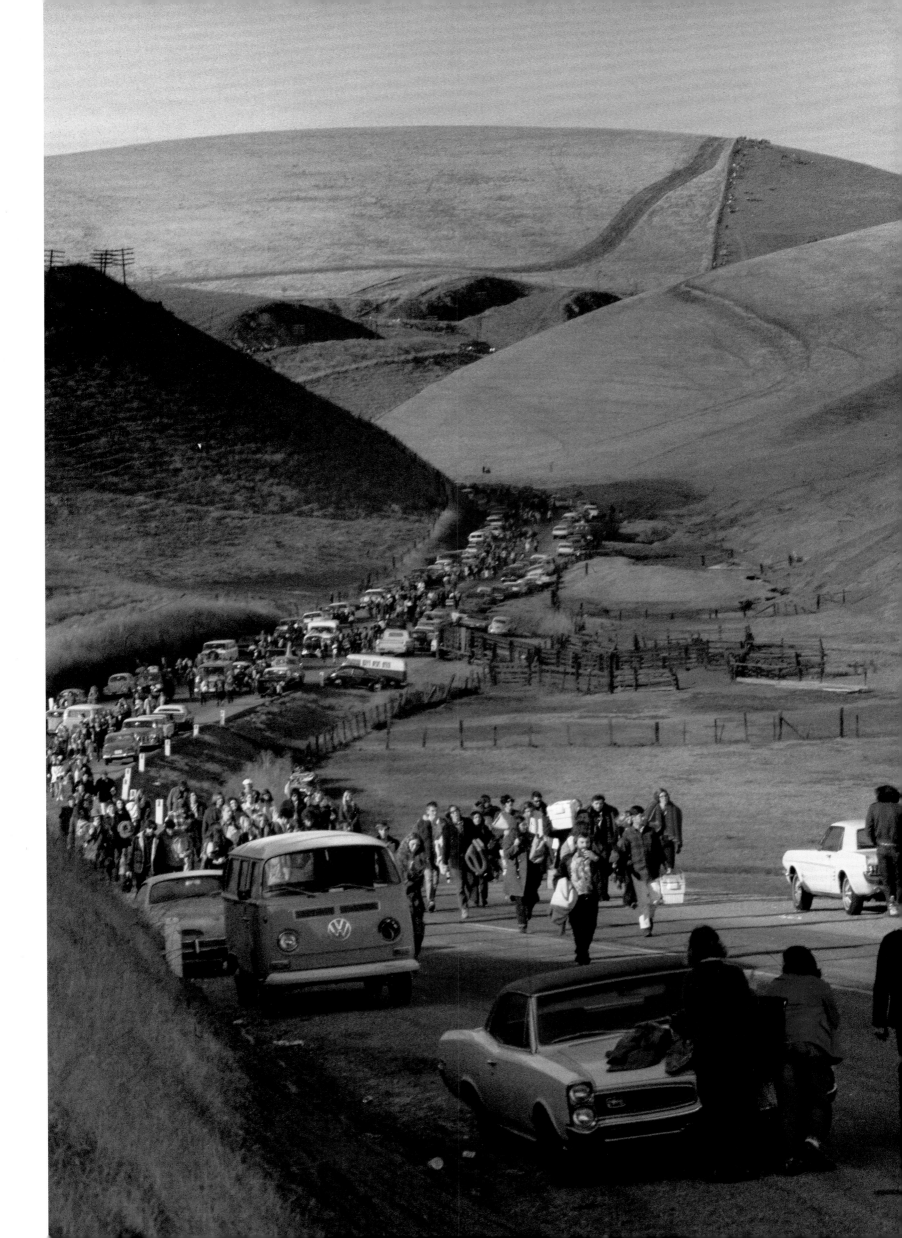

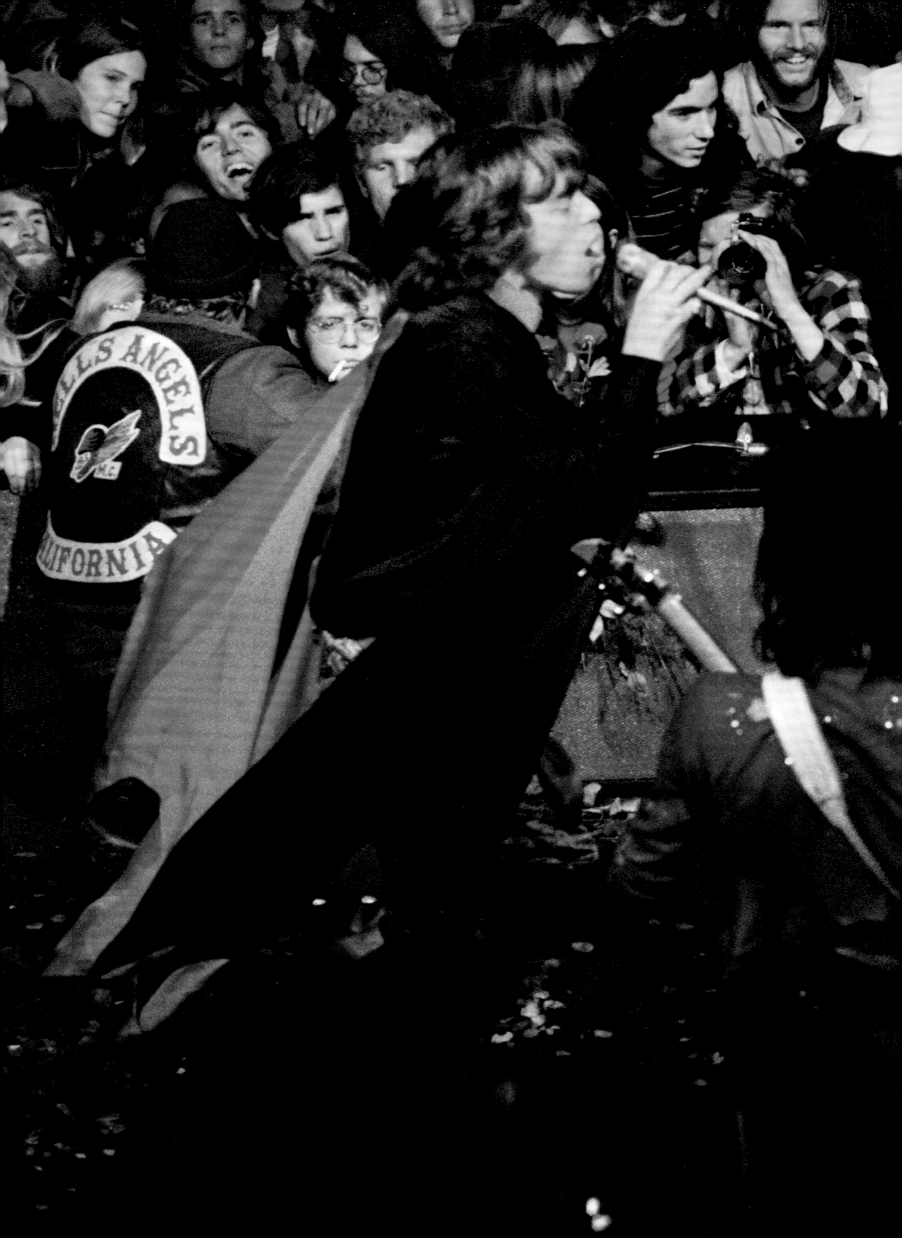

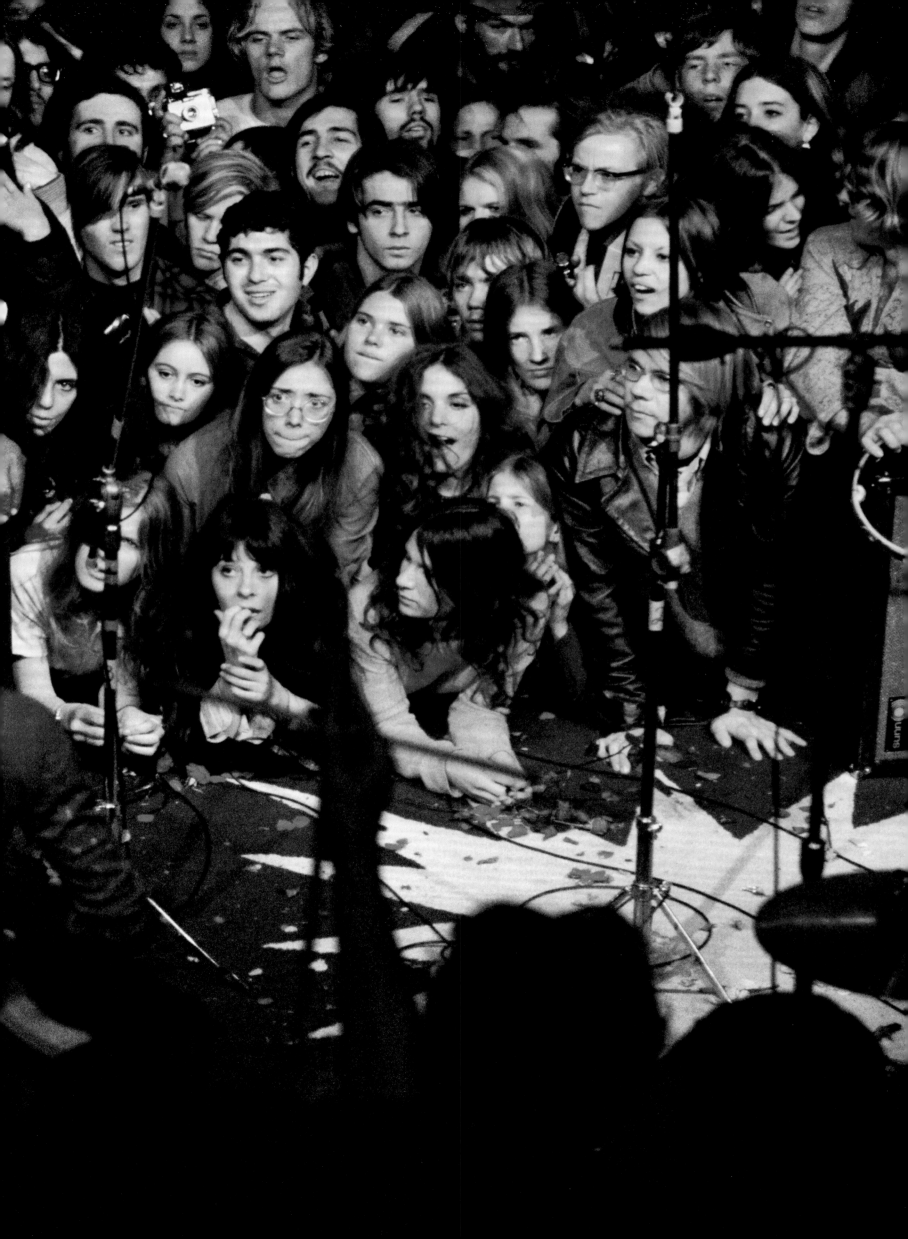

p. 320/321
Ethan Russell

Mick Jagger and Keith Richards onstage at Altamont. During their chaotic set, Berkeley teenager Meredith Hunter was stabbed to death after pulling a gun. The incident was captured on film in the documentary on the band's 1969 US tour, Gimme Shelter, *December 6, 1969.*

Mick Jagger und Keith Richards auf der Bühne in Altamont. Während ihres chaotischen Auftritts wurde der Teenager Meredith Hunter aus Berkeley erstochen, nachdem er eine Waffe gezogen hatte. Der Vorfall wurde auch Teil der Rolling-Stones-Dokumentation über ihre US-Tour 1969, Gimme Shelter, *6. Dezember 1969.*

Mick Jagger et Keith Richards sur scène à Altamont. C'est au cours de cette prestation chaotique que Meredith Hunter, un adolescent de Berkeley, sera poignardé à mort après avoir sorti un revolver. Le drame a été filmé dans Gimme Shelter, *le documentaire consacré à la tournée américaine du groupe en 1969. 6 décembre 1969.*

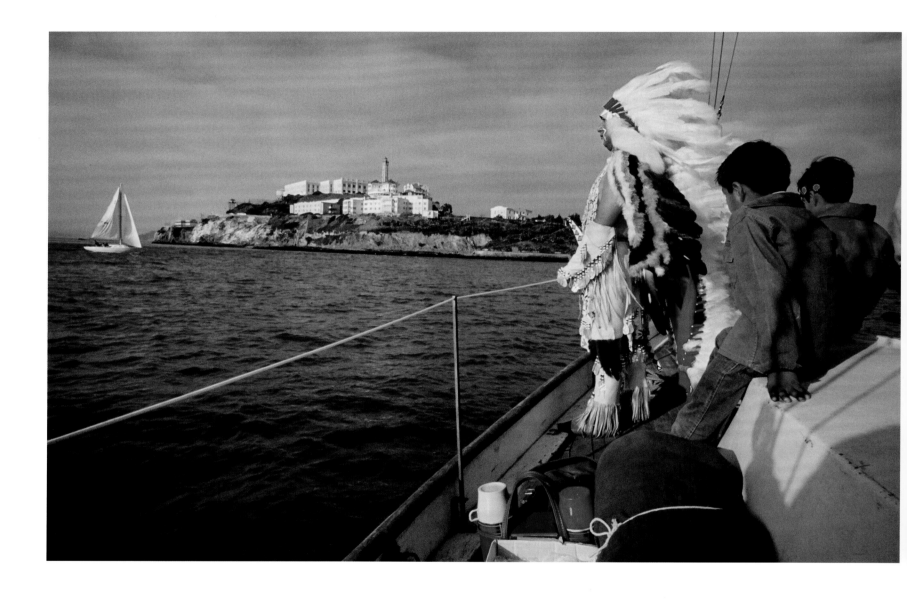

↑

Ralph Crane

Native American activists on a boat near Alcatraz Island, with Timm Williams of the Yurok tribe in headdress. Despite the difficulties of ferrying supplies to the rock and the hardship of life on the island as authorities pressured them to leave, it was occupied for about a year and a half by Native Americans to bring international attention to issues facing their community, 1969.

Native-American-Aktivisten auf einem Boot in der Nähe von Alcatraz, Timm Williams vom Stamm der Yurok trägt einen Kopfschmuck. Obgleich das Leben auf der Insel umständlich und die Versorgung mit Lebensmitteln schwierig war, wurde sie für anderthalb Jahre von amerikanischen

Ureinwohnern besetzt, die sich dem Druck, die Insel zu räumen, widersetzten, um internationale Aufmerksamkeit auf ihre Anliegen zu lenken, 1969.

Des militants amérindiens s'apprêtent à accoster l'île d'Alcatraz – Timm Williams, de la tribu Yurok, porte la parure de plumes traditionnelle. Malgré les difficultés d'approvisionnement et la rigueur de la vie sur l'île à mesure que les autorités les pressent de quitter les lieux, ils l'occuperont pendant près d'un an et demi pour attirer l'attention internationale sur les problèmes auxquels leur communauté est alors confrontée. 1969.

→

Ralph Crane

Alcatraz had been closed for six years and Native Americans occupying the island hoped to build a cultural center on the disused property. By mid-1971 they had left Alcatraz, which is now a National Historic Landmark as part of the Golden Gate National Recreation Area, 1969.

Alcatraz war seit sechs Jahren geschlossen, und die Native Americans, welche die Insel besetzt hatten, hofften, dort ein Kulturzentrum zu errichten. Nachdem sie die Insel 1971 verlassen hatten, wurde sie zu einem Teil der Golden Gate National Recreation Area und steht somit unter Denkmalschutz, 1969.

Le pénitencier fédéral avait été fermé six ans plus tôt et à sa place, les Amérindiens qui occupaient Alcatraz militaient pour la construction d'un centre culturel. En juin 1971, cependant, ils auront tous quitté l'île, aujourd'hui classée monument historique et intégrée à la « zone récréative nationale du Golden Gate ». 1969.

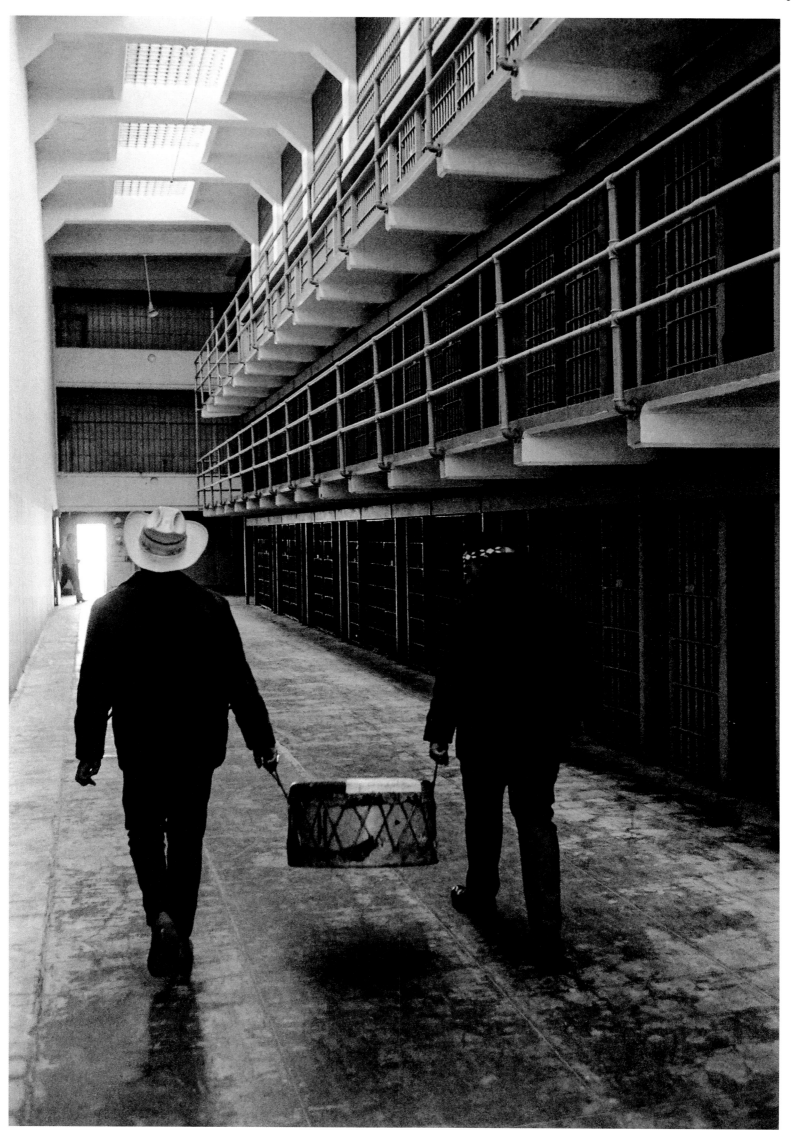

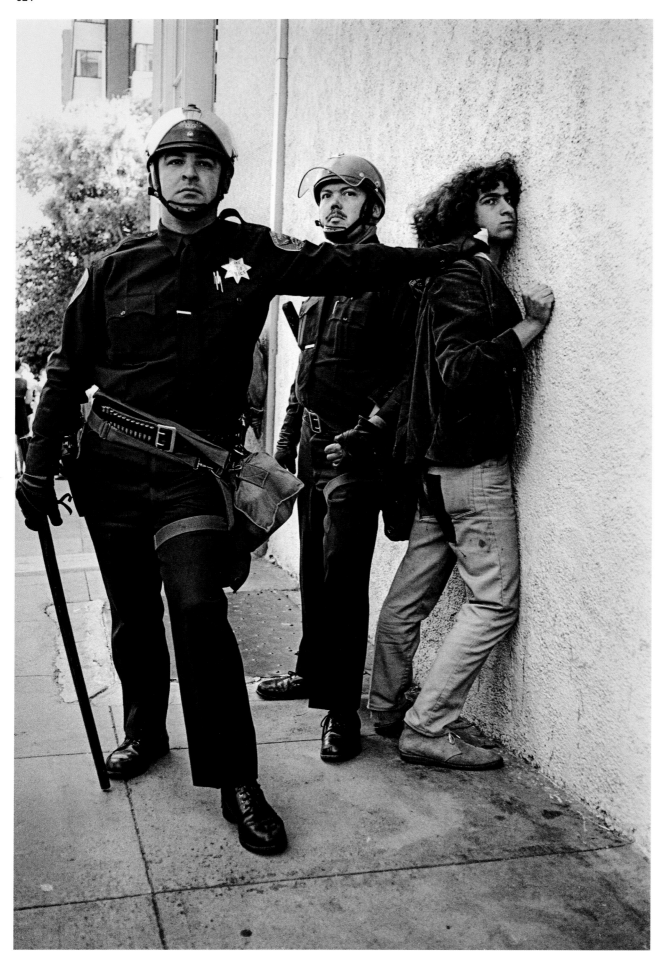

↑

Stephen Shames

UC Santa Cruz student Marc Norton arrested by police at a Students for a Democratic Society protest at an International Industrialists Conference in the Fairmont Hotel on Nob Hill, 1969.

Marc Norton, Student an der UC Santa Cruz, wird bei einem Protest der Students for a Democratic Society bei einer internationalen Konferenz für Industrielle im Fairmont Hotel auf dem Nob Hill verhaftet, 1969.

Marc Norton, étudiant à l'Université de Santa Cruz, arrêté par la police lors d'une manifestation du mouvement Students for a Democratic Society lors d'un congrès industriel international organisé à l'hôtel Fairmont de Nob Hill. 1969.

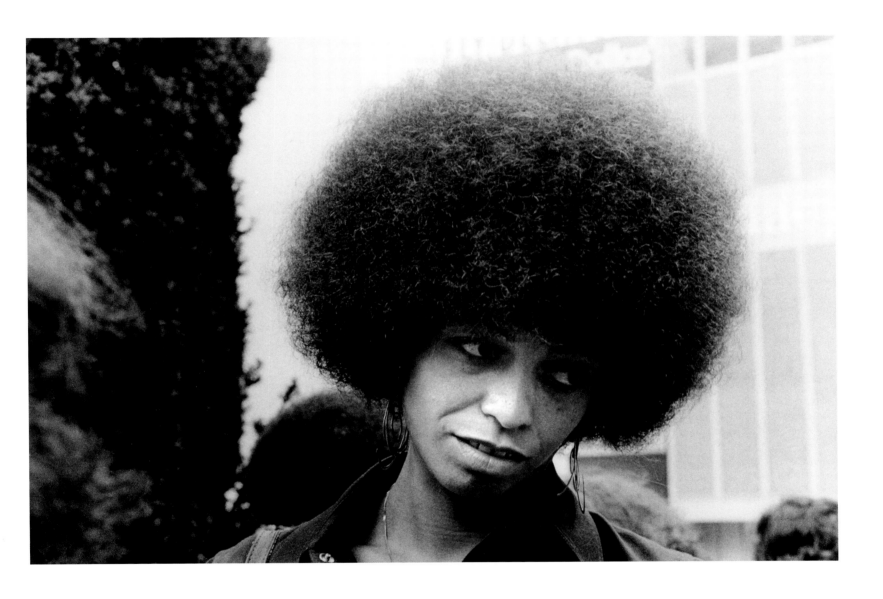

↑

Janet Fries

Activist Angela Davis in Union Square, a little more than a year after she was acquitted of charges related to the kidnapping and murder of a Marin County judge, who presided over the trial of a defendant accused of stabbing a prison guard. Davis had a long subsequent career as a respected author and professor, much of it spent teaching in San Francisco, 1973.

Angela Davis im Union Square, etwas mehr als ein Jahr nachdem sie von allen Vorwürfen in Verbindung mit der Entführung und Ermordung eines Richters freigesprochen wurde. Er saß einem Prozess vor, bei dem es um die Ermordung eines Gefängniswärters im Marin County ging. Für Davis folgte eine lange Karriere als angesehene Autorin und Professorin in San Francisco, 1973.

La militante Angela Davis sur Union Square, un peu plus d'un an après avoir été acquittée des charges liées à l'enlèvement et au meurtre d'un juge du comté de Marin alors qu'il présidait le procès d'un homme accusé d'avoir poignardé un gardien de prison. Elle poursuivra une longue carrière d'essayiste et de professeur d'université en Californie. 1973.

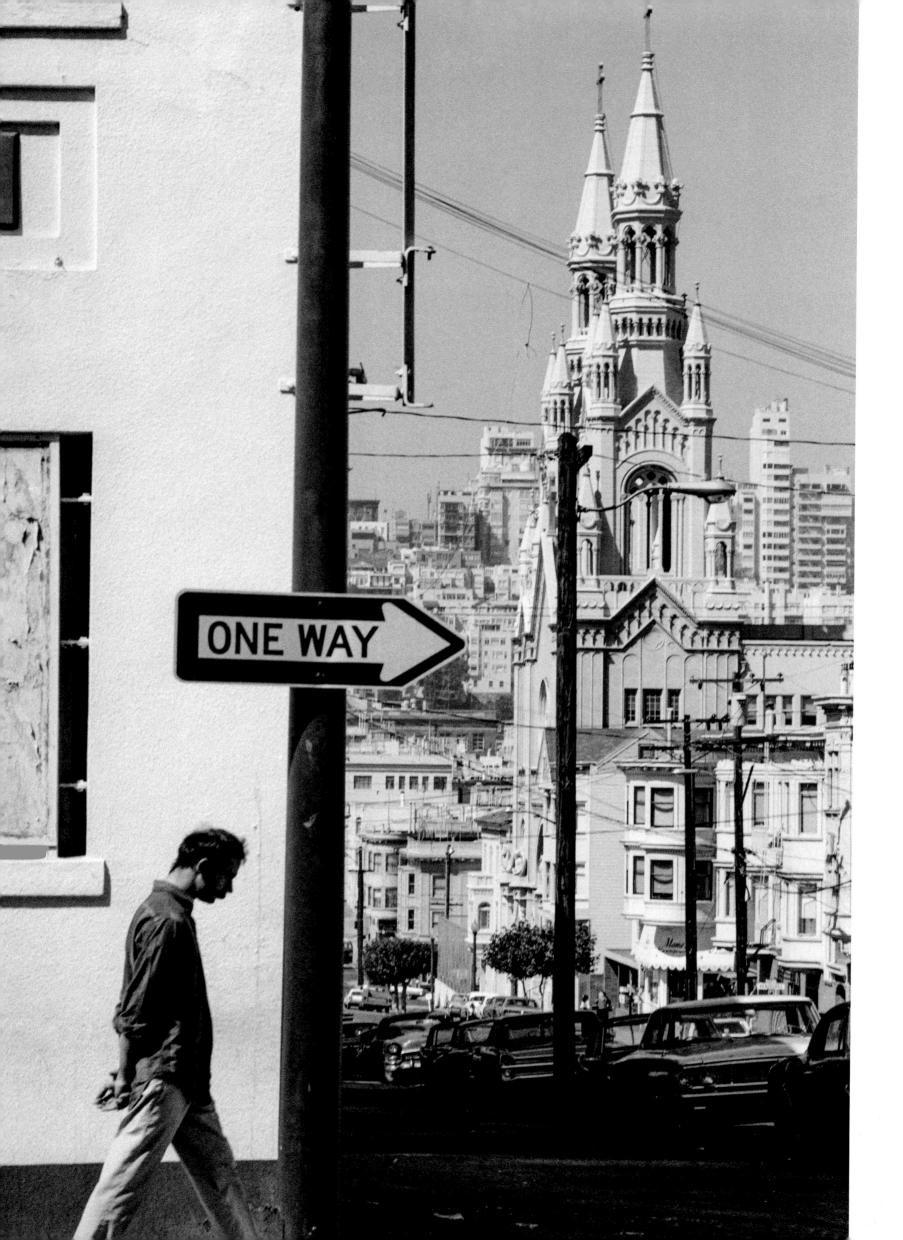

"Chicago is the great American city, New York is one of the capitals of the world, and Los Angeles is a constellation of plastic; San Francisco is a lady."

„Chicago ist das Urbild der amerikanischen City. New York ist eine der Hauptstädte der Welt, und Los Angeles ist ein Haufen Plastik; San Francisco eine Lady."

« Chicago est la grande ville américaine. New York est l'une des capitales du monde et Los Angeles est une constellation de plastique. San Francisco est une dame. »

NORMAN MAILER, *MIAMI AND THE SIEGE OF CHICAGO,* 1968

Dennis Stock

Saints Peter and Paul Church on Washington Square in North Beach, as seen from Telegraph Hill, with Russian Hill in the background. A vital part of the district's Italian American community, it's also a house of worship for Catholics of all ethnicities, offering services in Cantonese, 1968.

Blick vom Telegraph Hill auf Saints Peter and Paul in North Beach; im Hintergrund ist Russian Hill zu sehen. Die Kirche ist nicht nur ein wichtiger Teil der italienisch-amerikanischen Gemeinde, sondern auch für alle anderen Katholiken. Sie bietet sogar Gottesdienste auf Kantonesisch an, 1968.

L'église Saints Peter and Paul sur Washington Square à North Beach, vue de Telegraph Hill, avec Russian Hill à l'arrière-plan. Composante essentielle du quotidien de la communauté italo-américaine, très présente dans ce quartier, elle sert aussi de lieu de culte aux catholiques de toutes origines. On y célèbre ainsi des services en cantonais. 1968.

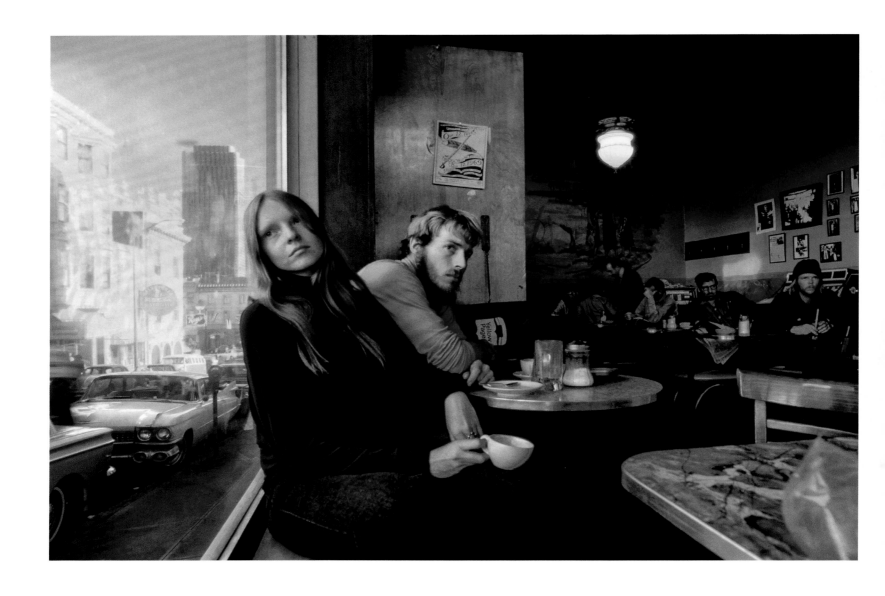

↑
Bruce Davidson

North Beach's Caffe Trieste was the first cof-
feehouse to specialize in espresso on the West
Coast. Opened in 1956 at Vallejo and Grant
streets, Francis Ford Coppola wrote much of
The Godfather's screenplay at this longtime
hangout for artists and writers, 1969.

Das Caffe Trieste in North Beach war das
erste Kaffeehaus an der Westküste, das sich
auf Espresso spezialisierte. Francis Ford
Coppola schrieb große Teile des Drehbuchs

für The Godfather in dem Café, das 1956
an der Vallejo und Grant Street öffnete und
bei Künstlern sehr beliebt war, 1969.

Ouvert en 1956 à l'angle de Vallejo Street
et de Grant Street, le Caffe Trieste de North
Beach a été le premier du genre, sur la côte
Ouest, à se spécialiser dans l'espresso. Francis
Ford Coppola rédigea une grande partie du
scénario du Parrain dans ce fameux repaire
d'artistes et d'écrivains. 1969.

→
Bob Kreisel

Feeding the ducks in the Palace of Fine
Arts lagoon. The curving walkway along
this artificial body of water draws strolling
San Franciscans and tourists in all seasons.
The downward slope of Pacific Heights looms
in the background, 1972.

Enten füttern am Teich des Palace of
Fine Arts. Der kurvige Weg um den
künstlichen Teich zieht das ganze Jahr
über Anwohner und Touristen für

einen Spaziergang vor den Hügeln
von Pacific Heights an, 1972.

Visite aux canards du plan d'eau artificiel
aménagé devant le Palace of Fine Arts.
La promenade serpentine qui le longe attire
en toute saison touristes et flâneurs locaux.
Au loin commence l'ascension de Pacific
Heights. 1972.

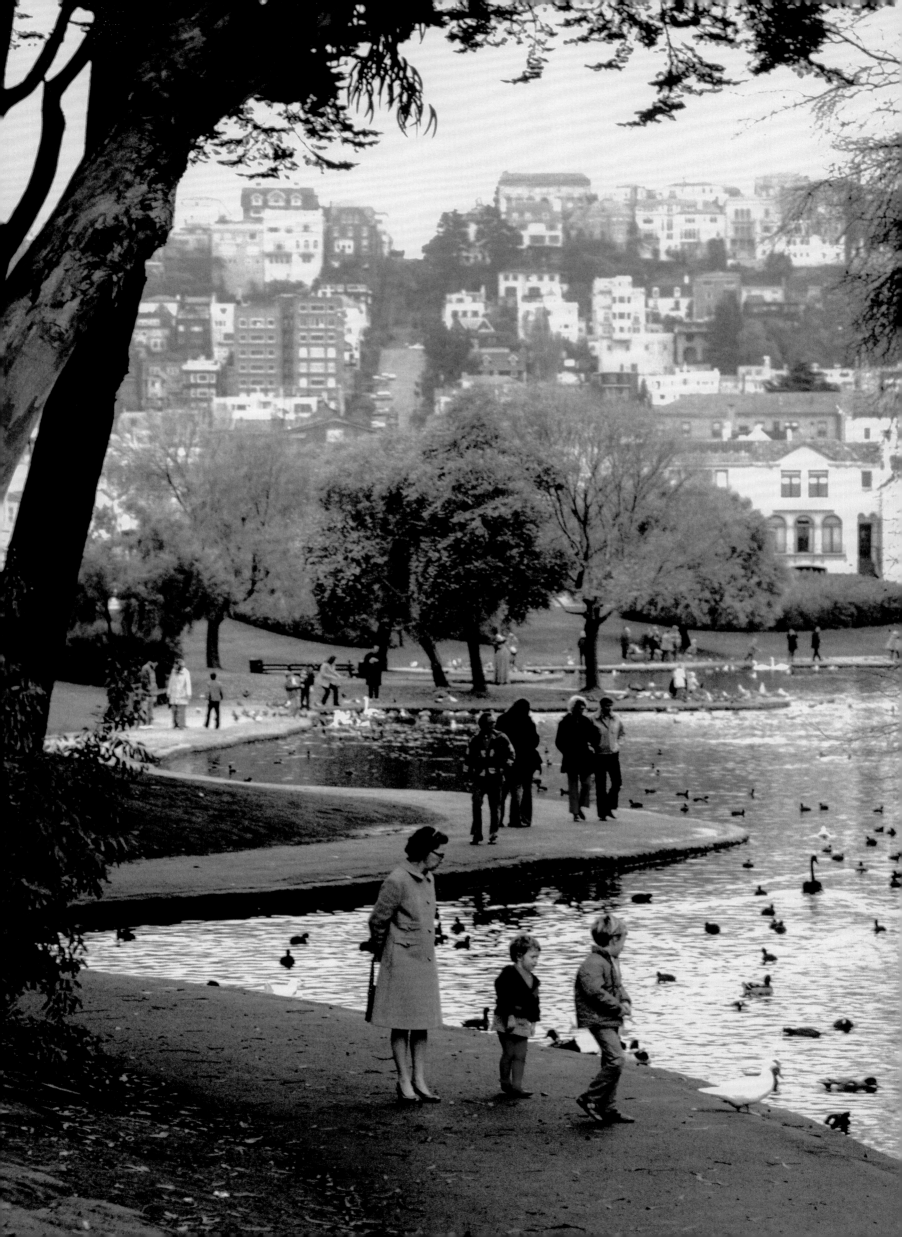

→
Michael Rougier

Houseboats have been part of the Sausalito waterfront for almost as long as the town has been around, growing to a community of almost 500 such abodes. Many artists and bohemians spanning several generations have taken up residence in the floating homes, despite periodic attempts by real estate developers and civic authorities to reduce the population, 1971.

Hausboote sind schon fast von Anfang an ein fester Teil von Sausalito, mittlerweile gibt es um die 500. Seit Generationen leben Künstler und andere Bohemiens in den schwimmenden Häusern, obwohl Bauunternehmer und die Behörden immer wieder Versuche unternehmen, ihre Anzahl zu reduzieren, 1971.

Les houseboats, *qui forment un village flottant de quelque 500 logements, sont identifiées au front de mer de Sausalito depuis presque aussi longtemps que la ville existe. Nombreux sont les artistes et les amateurs de bohème à y avoir élu domicile, en dépit des efforts réguliers déployés par les promoteurs immobiliers et les autorités municipales pour en réduire la population. 1971.*

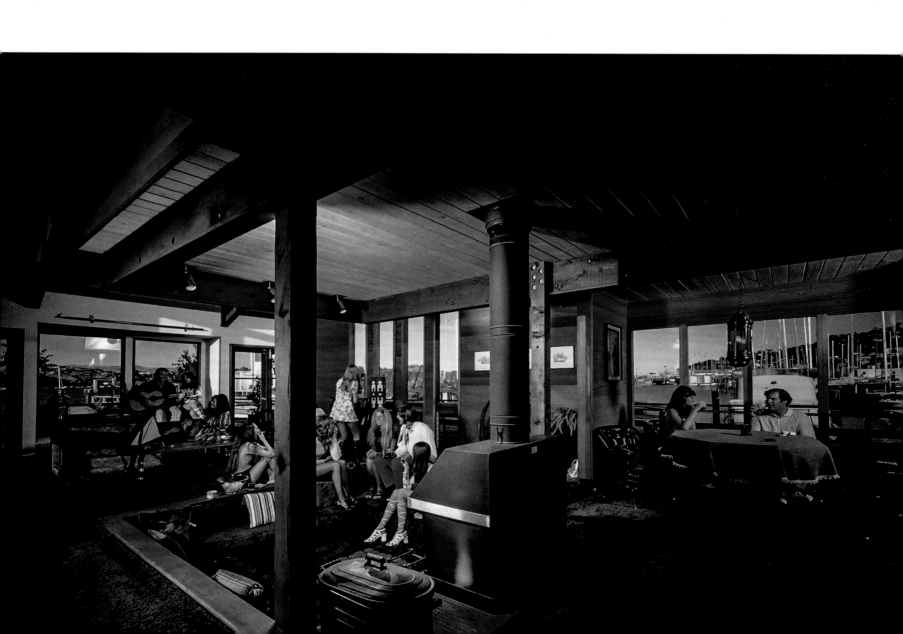

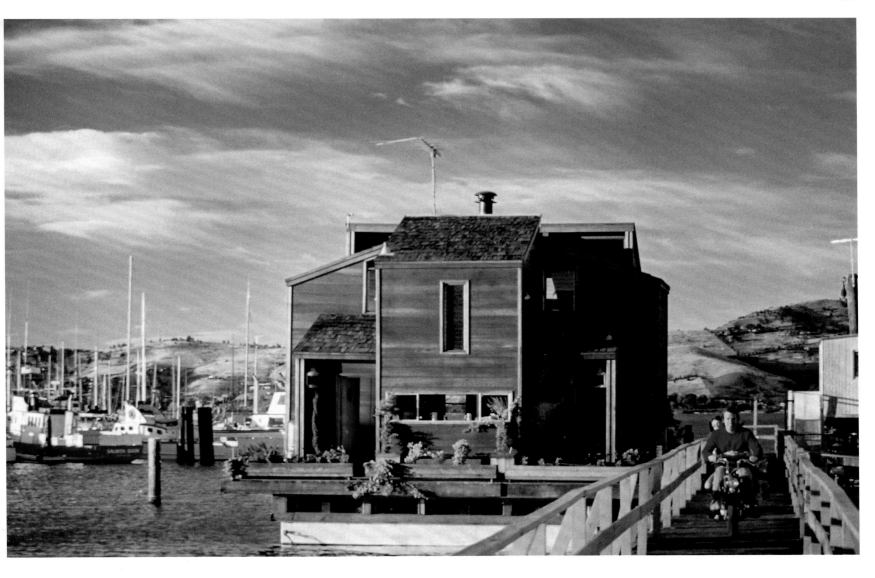

←

Michael Rougier

*Party in the sunken living room of a
Sausalito houseboat. Otis Redding wrote part
of "(Sittin' On) The Dock of the Bay" during
a 1967 stay on a houseboat on the main dock
of Waldo Point Harbor, 1971.*

*Eine Party im Wohnzimmer eines Hausboots
in Sausalito. Otis Redding schrieb Teile
von „(Sittin' On) The Dock of the Bay",
während er 1967 eine Weile auf einem
Hausboot im Hauptdock des Waldo Point
Harbor wohnte, 1971.*

*Fête flottante à bord d'une houseboat de
Sausalito. En 1967, Otis Redding écrivit le
premier couplet de «(Sittin' On) The Dock
of the Bay» lors de son séjour sur l'une
d'entre elles, amarrée au principal quai
du port de Waldo Point. 1971.*

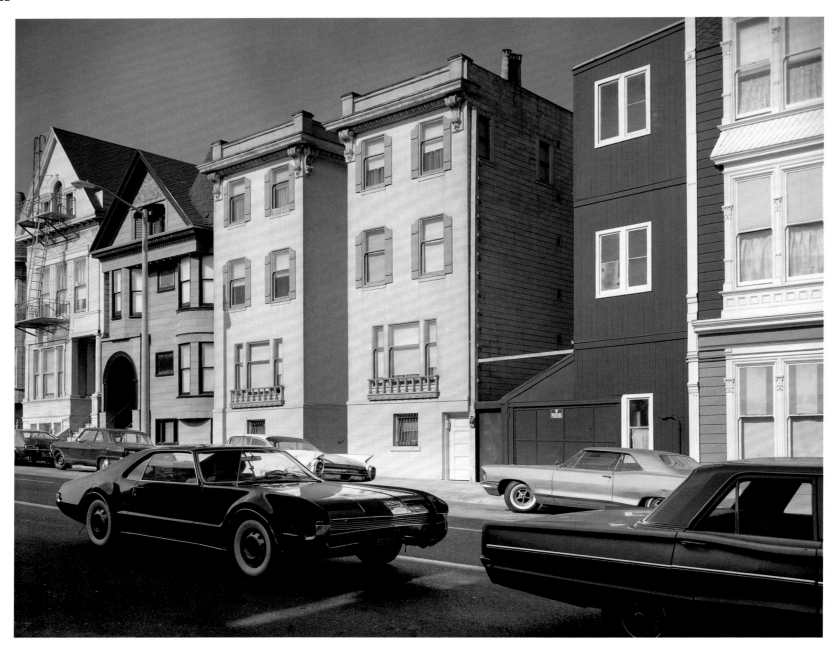

↑

Stephen Shore

Scott Street and 21st Street *is the title of this photo of typically varied, multicolored residential San Francisco architecture in the Lower Haight, between Oak and Fell streets. This block is part of "The Wiggle" route that lets bicyclists avoid steep hills on the way to Golden Gate Park, 1973.*

Scott Street and Twenty-first Street *ist der Titel dieses Fotos von den typisch farbenfrohen Wohnhäusern San Franciscos in Lower Haight, zwischen Oak und Fell Street. Dieser Block ist Teil der „Schlängel"-Route, die es Radfahrern ermöglicht, den Golden Gate Park zu erreichen und dabei steile Hügel zu vermeiden, 1973.*

Scott Street and 21st Street *est le nom que le photographe a donné à ce tableau caractéristique de l'architecture résidentielle hétéroclite et multicolore de San Francisco, dans le quartier de Lower Haight, entre Oak Street et Fell Street. Ce pâté de maisons fait partie de l'itinéraire appelé « The Wiggle » (le tortillard), qui permet aux cyclistes se dirigeant vers le Golden Gate Park d'éviter les rues trop raides. 1973.*

→

Stephen Shore

Downtown was starting to get crowded with modern high-rise buildings in the 1970s, as shown in this photo, simply titled Market Street, San Francisco, California, September 4, 1974.

In Downtown wurden ab den 1970er-Jahren auch viele moderne Hochhäuser gebaut, wie dieses Foto zeigt. Sein Titel lautet Market Street, San Francisco, California, September 4, 1974.

Avec la décennie 1970, les tours et la modernité commencent à envahir le centre-ville, ainsi que le montre cette photo sobrement intitulée Market Street, San Francisco, California, September 4, 1974. *1974.*

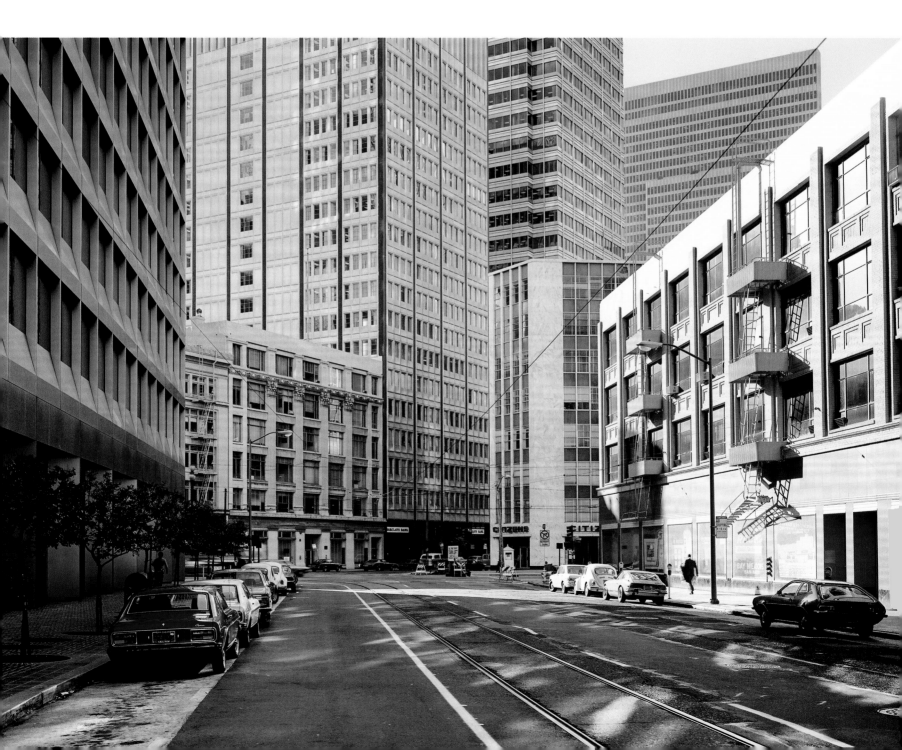

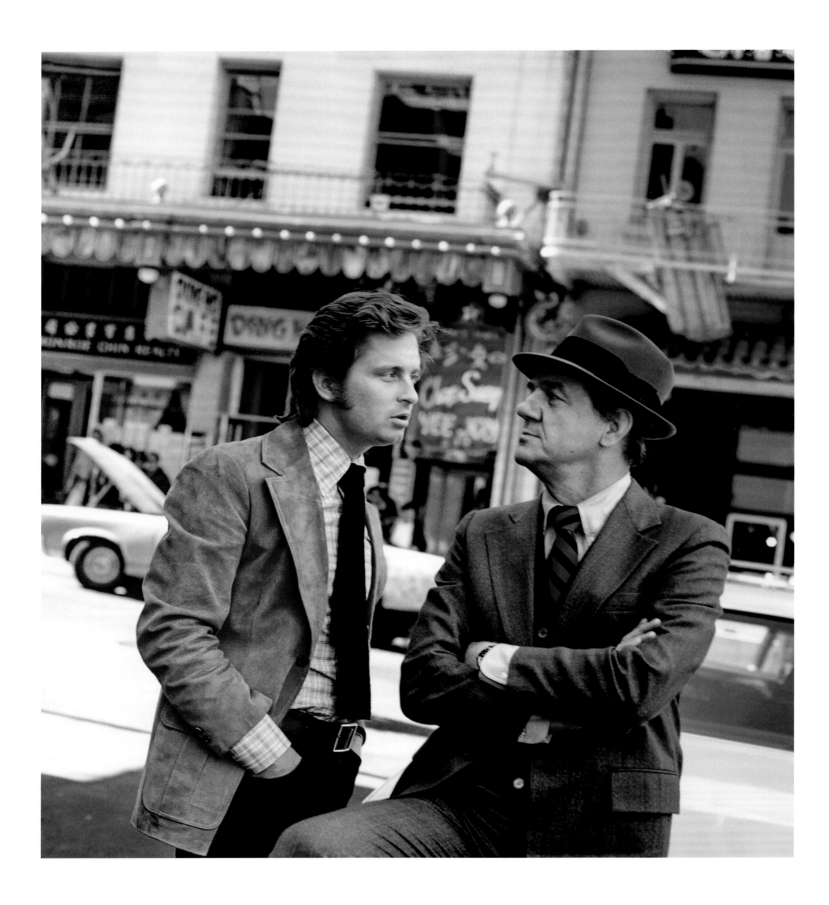

↑
Anonymous

Michael Douglas (left) and Karl Malden filming a scene in Chinatown for The Streets of San Francisco. *The pair starred as homicide inspectors in the popular television series for almost five years in the early to mid-1970s, often acting on location in the city. The series was crucial to launching Douglas into stardom, c. mid-1970s.*

Michael Douglas (links) und Karl Malden filmen eine Szene für Die Straßen von San Francisco *in Chinatown. In der beliebten Fernsehserie spielte das Duo fast fünf Jahre in den 1970ern zwei Polizisten der Mordkommission; meist wurde an Originalschauplätzen gefilmt. Die Serie machte Douglas als Schauspieler bekannt, Mitte 1970er.*

Michael Douglas (à gauche) et Karl Malden jouent à Chinatown une scène de la série télévisée Les Rues de San Francisco, *souvent tournée en extérieur et appelée à un grand succès international. Pendant près de cinq ans, du début au milieu des années 1970, ils incarneront deux inspecteurs de la brigade criminelle, un rôle décisif dans l'accession de Douglas à la célébrité. Vers le milieu des années 1970.*

Lawrence Schiller

Patty Hearst outside the court during her trial for her role in the Symbionese Liberation Army's armed robbery of the Sunset District branch of Hibernia Bank in April 1974. The granddaughter of powerful publisher William Randolph Hearst, she'd been kidnapped by the SLA a couple of months before the holdup. Captured in the act by a surveillance camera, she served time for the crime until her sentence was commuted in the late '70s by President Jimmy Carter, 1976.

Patty Hearst vor dem Gerichtsgebäude, in dem sie sich für ihre Rolle bei dem Bankraub der Symbionese Liberation Army (SLA) in der Zweigstelle Sunset der Hiberna Bank im April 1974 verantworten musste. Als Enkelin des mächtigen Verlegers William Randolph Hearst war sie ein paar Monate vor dem Überfall von der SLA entführt worden. Sie war von einer Sicherheitskamera während der Tat gefilmt worden und saß im Gefängnis, bis die Strafe in den späten 70ern von Präsident Jimmy Carter verringert wurde, 1976.

Patty Hearst à l'extérieur du tribunal où elle est jugée pour son rôle dans l'attaque d'une banque du quartier de Sunset par « l'Armée de libération symbionaise » en avril 1974. Petite-fille du magnat de la presse William Randolph Hearst, elle avait été kidnappée par l'ALS deux mois avant le hold-up. Filmée en flagrant délit par une caméra de surveillance, elle sera condamnée à sept ans de prison, peine ramenée à deux ans par le président Jimmy Carter en 1979. 1976.

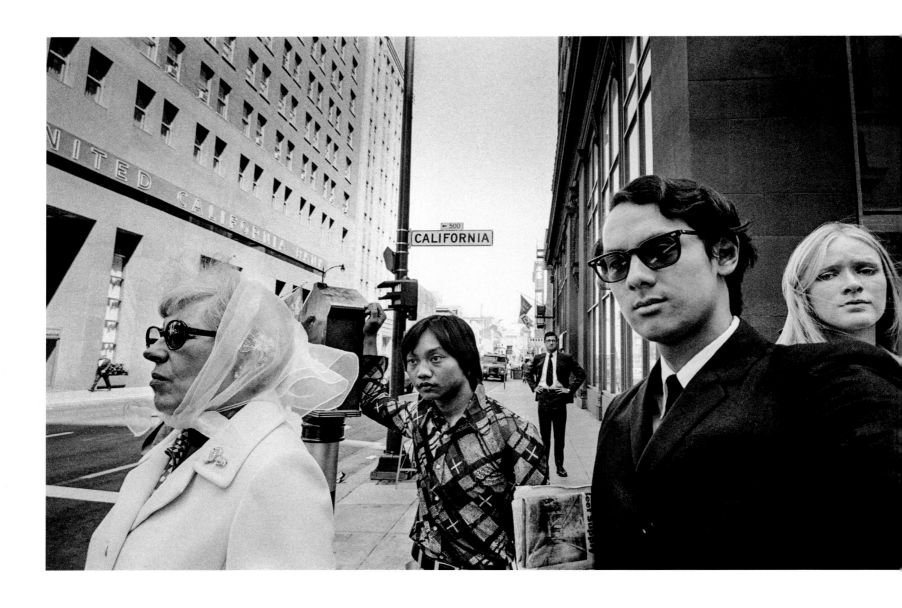

↑
Michael Jang

*Self-portrait by Jang (second from right)
in the Financial District at California and
Montgomery streets, 1973.*

*Selbstporträt von Jang (zweiter von rechts)
im Finanzbezirk an der Ecke California und
Montgomery Street, 1973.*

*Autoportrait du photographe (le deuxième
à partir de la droite) dans le Financial
District, à l'angle de California Street et
de Montgomery Street. 1973.*

→
Daniel Nicoletta

*Enchantra puts on makeup in preparation
for a celebration at the Castro Street Fair.
Founded by gay community leader (and later
San Francisco city supervisor) Harvey Milk
in 1974, it's held the first Sunday in October
in the heart of the Castro District, 1976.*

*Enchantra trägt zur Vorbereitung auf eine
Feier bei der Castro Street Fair Make-up auf.
Gegründet 1974 von Harvey Milk, einem
führenden Kopf der Gay Community und
späterem Stadtrat, findet das Festival am
ersten Sonntag im Oktober im Herzen des
Castro Districts statt, 1976.*

*Enchantra se refait une beauté en prévision
du Castro Street Fair, joyeux festival fondé
en 1974 par Harvey Milk, animateur de la
communauté homosexuelle et futur élu de
la ville de San Francisco. Elle se déroule
le premier dimanche d'octobre au cœur du
quartier de Castro. 1976.*

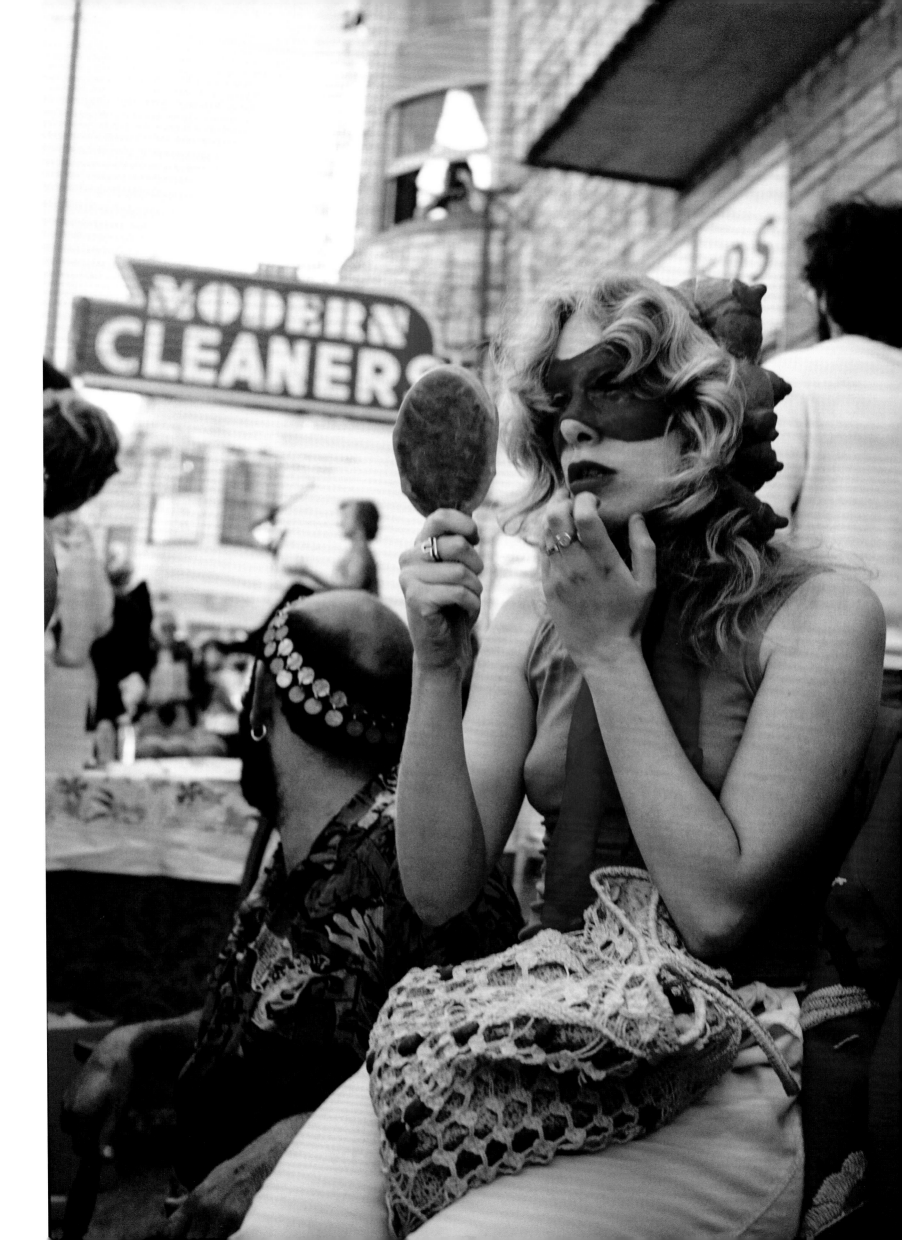

338

↓
Daniel Nicoletta

Leon Lott (left), December Wright (center), and Larry Williams (right) styling at the Castro Street fair. Williams's Soul Disco Club Frisco T-shirt lets us know this was disco music's heyday, and signifies its popularity and importance for local gays, 1976.

Leon Lott (links), December Wright (Mitte), und Larry Williams (rechts) gestylt bei der Castro Street Fair. Williams' T-Shirt vom Soul Disco Club Frisco lässt uns wissen, dass dies die Blütezeit der Discomusik war, und zeigt ihre Bedeutung und Beliebtheit in der schwulen Szene, 1976.

Leon Lott (à gauche), December Wright (au centre) et Larry Williams (à droite) peaufinent leur style durant le festival annuel de Castro Street. Le tee-shirt du dernier nommé révèle l'époque – l'âge d'or du disco – et confirme le succès de ce nouveau genre musical auprès de la communauté gay. 1976.

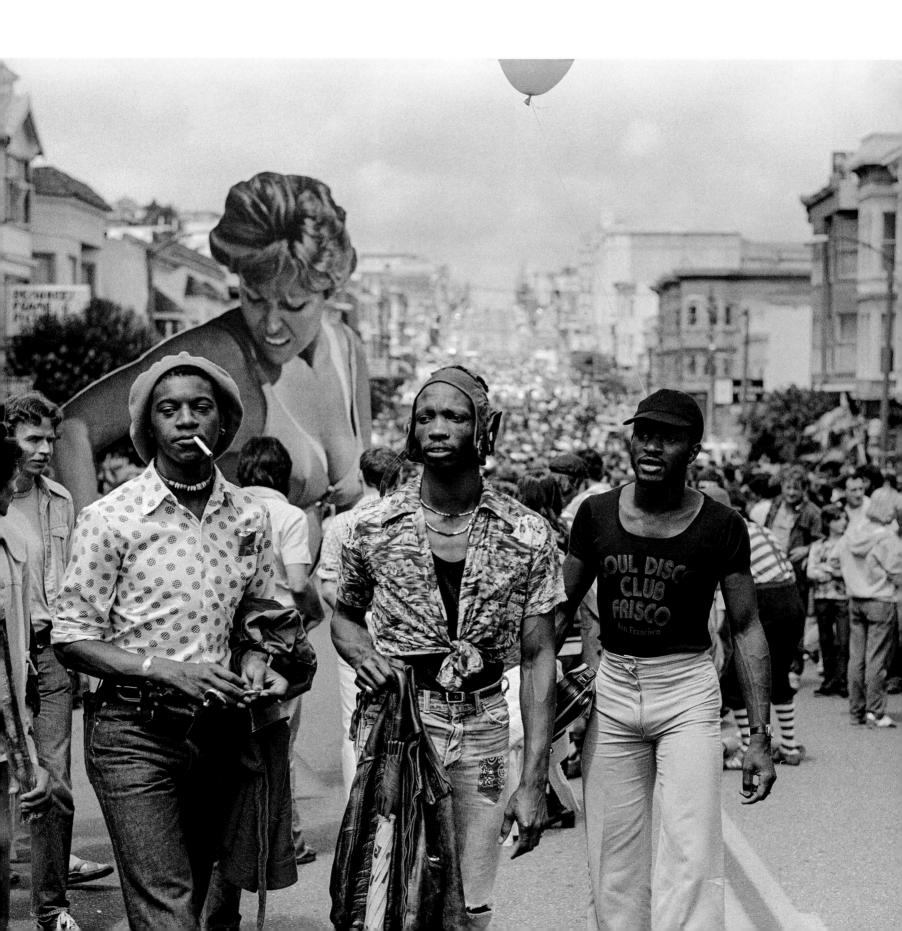

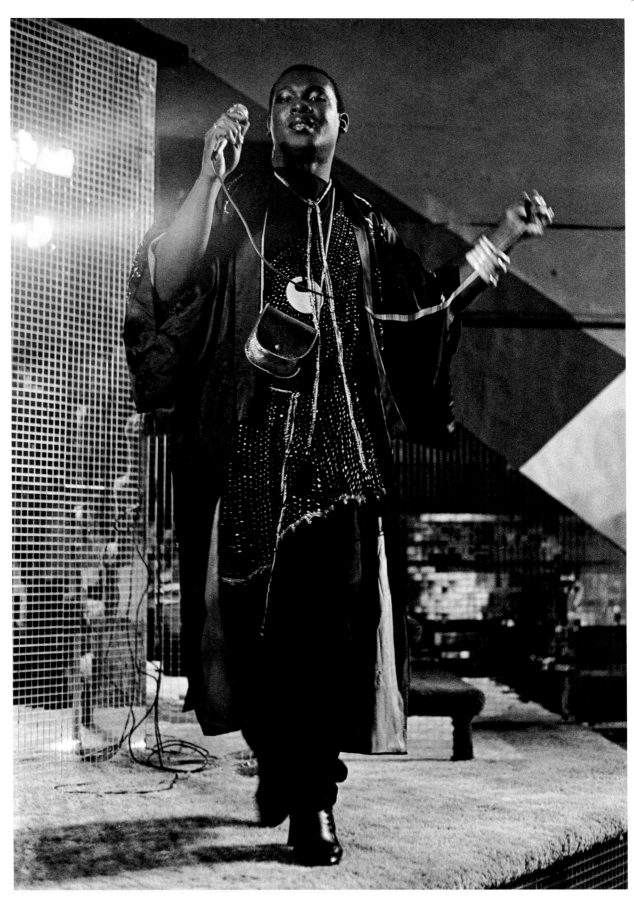

↑

Daniel Nicoletta

Sylvester onstage at the Trocadero Transfer after-hours dance club near Fourth and Bryant streets in the South of Market District. One of the first openly gay pop music stars, he scored huge disco hits with "You Make Me Feel (Mighty Real)" and "Dance (Disco Heat)" this year, topping the national dance music charts. His video for the former was filmed at the club, and showcased its spiral staircase and mirror balls, 1978.

Sylvester auf der Bühne des Nachtclubs Trocadero Transfer in der Nähe von Fourth und Bryant Street im Bezirk South of Market. Als einer der ersten offen schwulen Popstars landete er Hits wie „You Make Me Feel (Mighty Real)" und „Dance (Disco Heat)" in diesem Jahr und erreichte die Spitze der Charts. Das Video für ersteren Song wurde in diesem Club gefilmt und zeigte vor allem die Wendeltreppe und die Diskokugeln, 1978.

Sylvester sur scène au Trocadero Transfer, une boîte de nuit ouverte jusqu'à point d'heure et située à l'angle de Bryant Street et de la 4e Rue, dans le quartier de South of Market. Il a été l'une des premières stars de la pop ouvertement gay et signa en 1978 d'immenses succès disco avec « You Make Me Feel (Mighty Real) » et « Dance (Disco Heat) ». Le clip du premier des deux tubes a été tourné ici – on y reconnaît l'escalier en colimaçon et les boules à facettes. 1978.

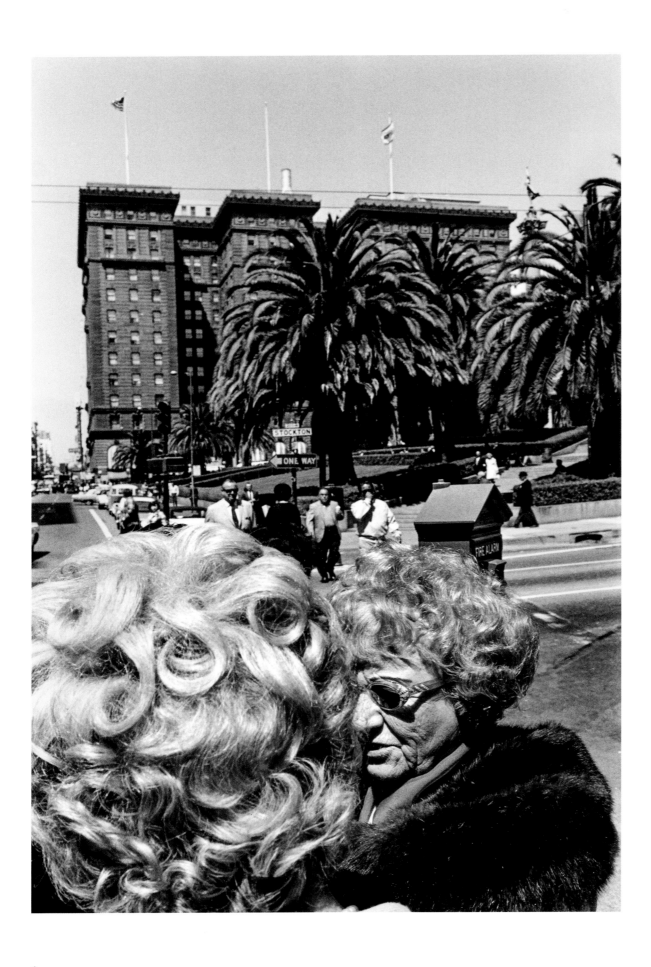

↑
Lee Friedlander

Pedestrians, palm trees, and the St. Francis Hotel as seen from the southeast corner of Union Square, at Stockton and Geary streets. Much of Francis Ford Coppola's The Conversation, *one of the most acclaimed San Francisco–set movies, was filmed on the square a few years later, 1970.*

Blick vom südöstlichen Union Square und der Ecke Stockton und Geary Street auf Fußgänger, Palmen und das St. Francis Hotel. Hier wurden ein paar Jahre später viele Szenen eines der bekanntesten Filme gedreht, die in San Francisco spielen, nämlich Der Dialog *von Francis Ford Coppola, 1970.*

Union Square à l'angle de Stockton Street et de Geary Street, face aux palmiers qui n'éclipsent pas la fière allure de l'hôtel St. Francis. Quelques années plus tard, Francis Ford Coppola tournera sur la place une grande partie de Conversation secrète, *l'un des films les plus réussis situés à San Francisco. 1970.*

↓

Daniel Nicoletta

Watching the Gay Pride Parade, though the woman in the hat seems to be doing her best to ignore it. Known as Gay Freedom Day when it started in the early '70s with crowds of just a few hundred partiers, it grew into a major festival a few years later, 1975.

Zuschauer bei der Gay Pride Parade, auch wenn die Frau mit dem Hut ihr Bestes zu tun scheint, um sie zu ignorieren. Zu Beginn der frühen 70er noch als Gay Freedom Day bekannt, wuchs die Veranstaltung von ein paar Hundert Feiernden in nur wenigen Jahren zu einem großen Festival heran, 1975.

Le défilé de la Gay Pride, apparemment, ne plonge pas tout un chacun dans la même allégresse. Connu à ses débuts, au début des années 1970, sous le nom de Gay Freedom Day, il réunissait alors quelques centaines de personnes avant de devenir un événement festif majeur quelques années plus tard. 1975.

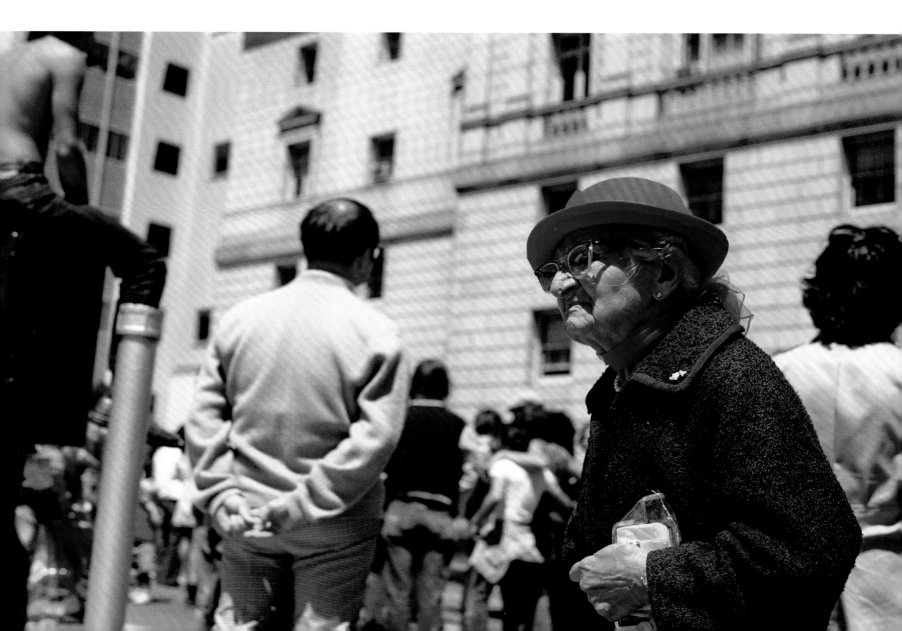

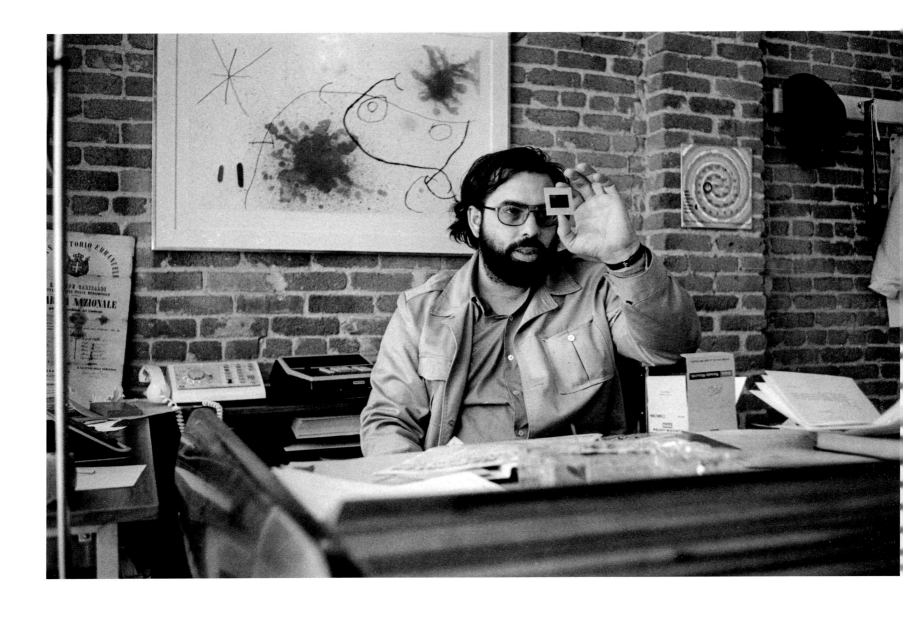

↑
Anonymous

Francis Ford Coppola at work in his American Zoetrope studio, which opened in December 1969 in a warehouse near Fourth and Folsom streets in the South of Market District. The company produced Coppola's films and several dozen others, including George Lucas's first hit movie, American Graffiti, *and works directed by other members of his family, most notably his daughter, Sofia, 1970.*

Francis Ford Coppola bei der Arbeit in seinem Studio, American Zoetrope, das im Dezember 1969 in einer Lagerhalle in South of Market, nahe Fourth und Folsom Street, eröffnet wurde. Die Firma produzierte Coppolas Filme und einige andere, darunter George

Lucas' ersten Hit, American Graffiti, *und Filme von Familienmitgliedern, deren bekannteste seine Tochter Sofia ist, 1970.*

Francis Ford Coppola à son bureau de la société de production American Zoetrope, qu'il lança en décembre 1969 dans un entrepôt situé à proximité de Folsom Street et de la 4ᵉ Rue (South of Market). Le studio produira non seulement ses films mais aussi plusieurs dizaines d'autres parmi lesquels le premier succès de George Lucas, American Graffiti, *et les réalisations de certains de ses proches, en particulier sa fille Sofia. 1970.*

→
Tom Munneke

Steve Jobs, cofounder of Apple, at the first West Coast Computer Faire in Brooks Hall underneath Civic Center Plaza. At this event the Apple II was unveiled, helping to launch a revolution in the popularization of home computers. Apple products solidified Silicon Valley's position as a center of the tech industry, which in turn would transform the character of the entire Bay Area by the next century, 1977.

Steve Jobs, Mitgründer von Apple, bei der ersten West Coast Computer Faire in der Brooks Hall unter der Civic Center Plaza. Bei dieser Messe wurde der Apple II vorgestellt, mit dem der Gebrauch privater Computer einen großen Schritt nach vorn machte. Apple trug auch maßgeblich dazu bei, das Silicon Valley

als Zentrum der Tech-Industrie zu etablieren und so den Weg für die tiefgehende Veränderung der Bay Area im nächsten Jahrhundert zu ebnen, 1977.

Steve Jobs, cofondateur d'Apple, lors de la première West Coast Computer Faire, organisée au Brooks Hall, un espace d'exposition bâti sous la Civic Center Plaza. C'est à cette occasion qu'a été dévoilé l'Apple II, dont on sait la contribution au déclenchement d'une véritable révolution dans la diffusion des ordinateurs domestiques. Les produits Apple conforteront la position de la Silicon Valley, épicentre des industries de la high-tech, lesquelles, au siècle suivant, transformeront la physionomie de toute la région de San Francisco. 1977.

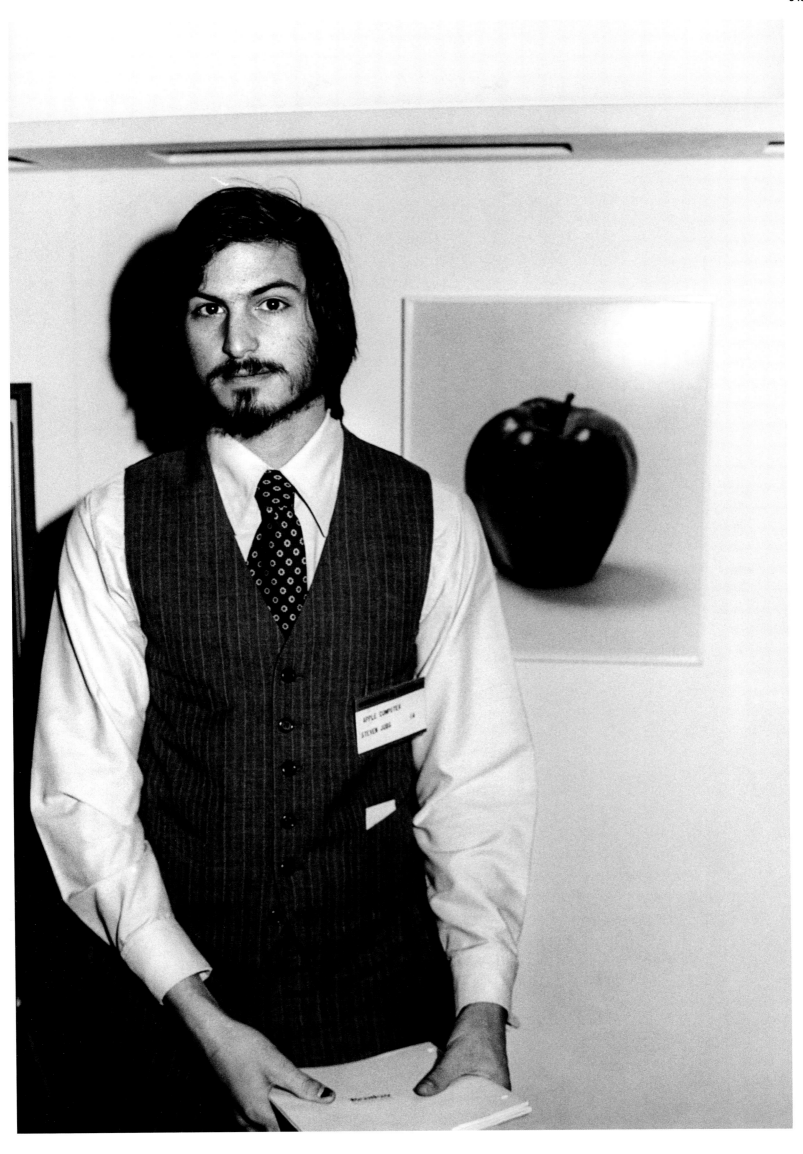

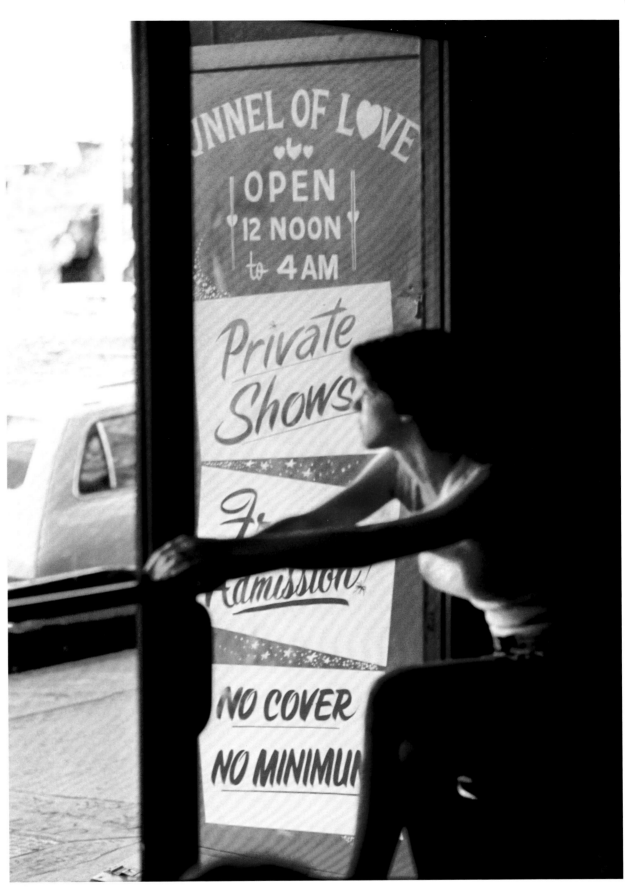

←

Lawrence Schiller

Just west from where this North Beach drag intersects Columbus Avenue near City Lights bookstore, Broadway is jammed with porn shops and theaters, 1976

Etwas westlich von der Stelle, an der diese Straße in North Beach in der Nähe des City Lights Bookstore die Columbus Avenue kreuzt, reihen sich Pornoläden und Kinos dicht and dicht auf dem Broadway, 1976.

Cette partie de Broadway toute proche de Columbus Avenue et de la célèbre librairie City Lights déborde de sex-shops, théâtres et cinémas X. 1976.

↑

Lawrence Schiller

Gazing out of the Tunnel of Love porn theater, open noon to 4 a.m. with no cover or minimum, 1976.

Blick aus dem Pornokino „Tunnel der Liebe", geöffnet von mittags bis vier Uhr nachts, ohne Eintritt oder Mindestverzehr, 1976.

Contemplation songeuse depuis le « Tunnel of Love », théâtre porno ouvert de midi à 4 heures du matin, sans droit d'entrée ni minimum de dépense requis. 1976.

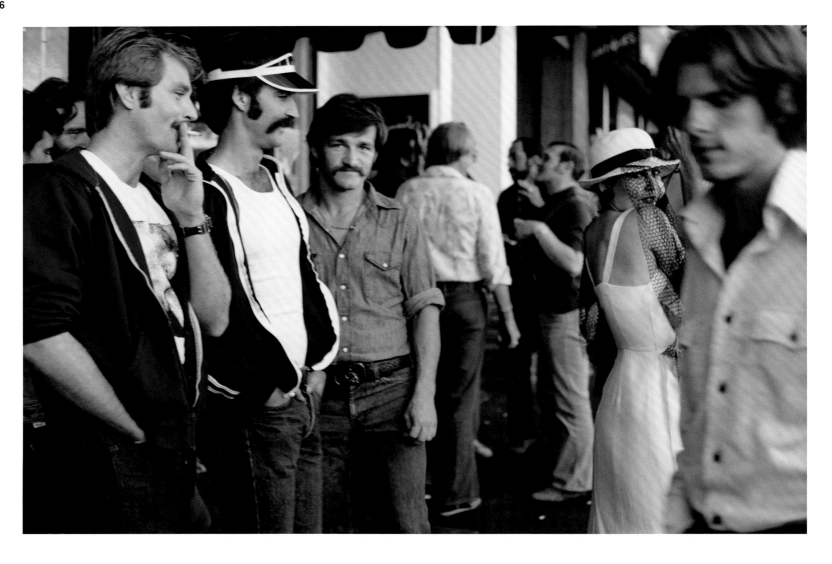

↑
Daniel Nicoletta

Crowd jams the street at the third Castro
Street Fair. The Castro neighborhood, especially
the blocks just south of where Castro and
Market streets meet, has been the center of
the gay community since the early '70s, 1976.

Menschen drängen sich in den Straßen bei
der dritten Castro Street Fair. Das Castro,
besonders die Blocks südlich der Kreuzung
Castro und Market Street, sind das Zentrum
des schwulen Lebens seit den frühen 70er-
Jahren, 1976.

Les rues s'animent le jour de la Castro
Street Fair, troisième du nom. Le quartier
du Castro, et plus particulièrement la zone
située au sud du carrefour où se croisent
Castro Street et Market Street, abrite le cœur
de la communauté gay depuis le début des
années 1970. 1976.

→
Terry Schmitt

Harvey Milk at the head of the 1978 Gay
Freedom Day Parade, the annual event now
known as Pride. Milk had been elected as
a city supervisor the previous year, but was
assassinated in City Hall five months after this
pararde, along with mayor George Moscone,
June 25, 1978.

Harvey Milk führt die Gay Freedom Day
Parade 1978 an, heute bekannt als Pride.
Milk war im Jahr zuvor zum Stadtrat
gewählt worden und wurde fünf Monate
nach dieser Parade im Rathaus ermordet,
wie auch der Bürgermeister George Moscone,
25. Juni 1978.

Harvey Milk en tête de la Gay Freedom Day
Parade, désormais connue sous le nom de
Gay Pride. Un an plus tôt, Milk a été élu au
conseil municipal de San Francisco. Il sera
assassiné avec le maire George Moscone dans
l'hôtel de ville cinq mois après cette photo.
25 juin 1978.

"So if there is a message I have to give, it is that I've found one overriding thing about my personal election, it's the fact that if a gay person can be elected, it's a green light. And you and you and you, you have to give people hope. Thank you very much."

„Wenn ich also eine Botschaft für Sie habe, dann die, dass, wenn meine Wahl etwas Überragendes hat, dann den Umstand, dass die Wahl eines Gays grünes Licht bedeutet. Und Sie und Sie und Sie, Sie müssen den Leuten Hoffnung geben. Ich danke Ihnen."

« Alors si je dois vous transmettre un message, le voici : l'enseignement primordial que j'ai tiré de mon élection personnelle, c'est que si un gay peut être élu, il s'agit d'un feu vert. Et vous, vous et vous, vous devez donner de l'espoir aux gens. Merci beaucoup. »

HARVEY MILK, 1978

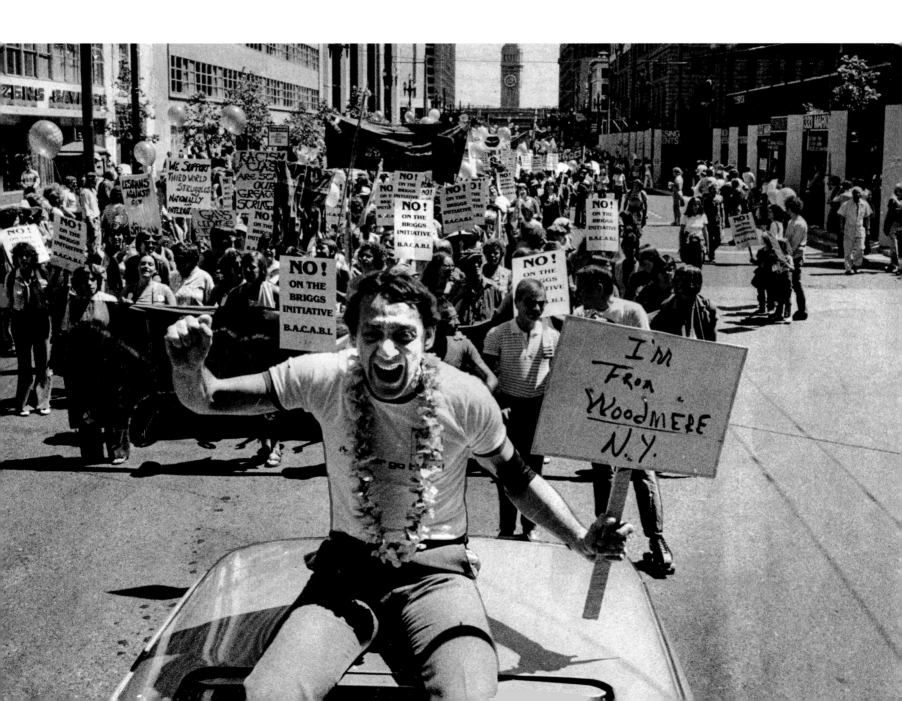

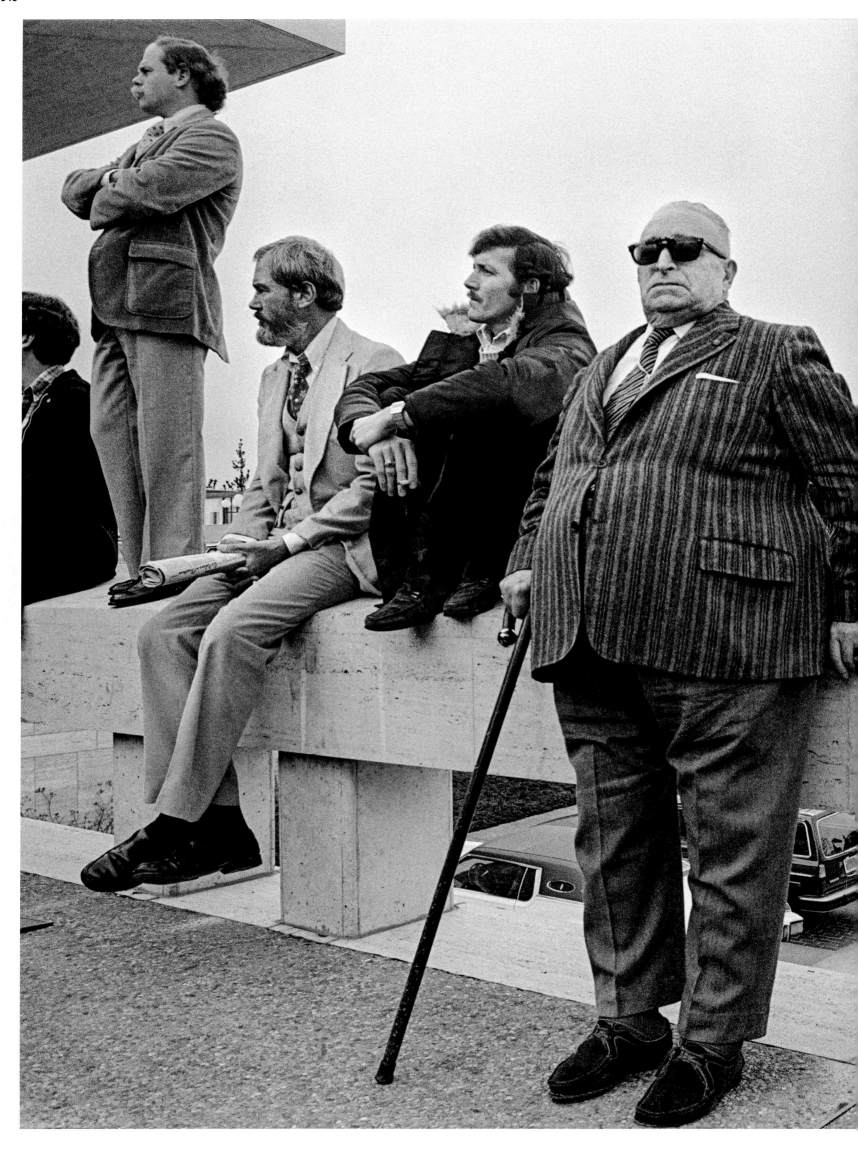

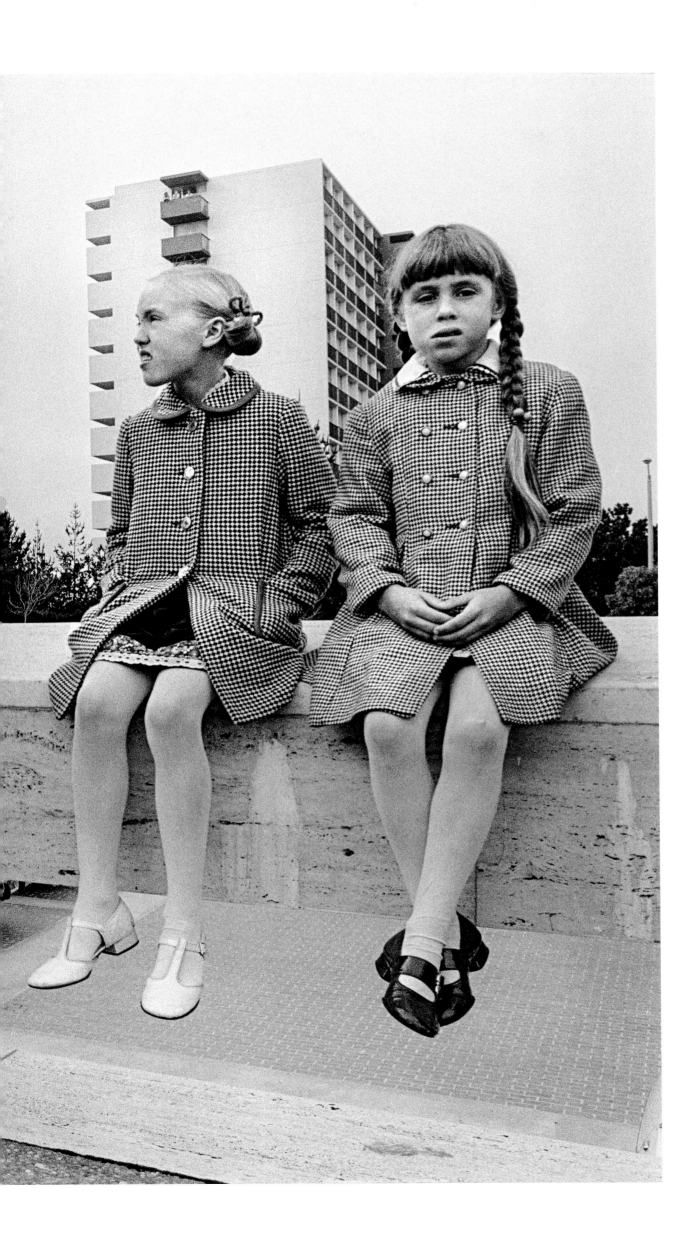

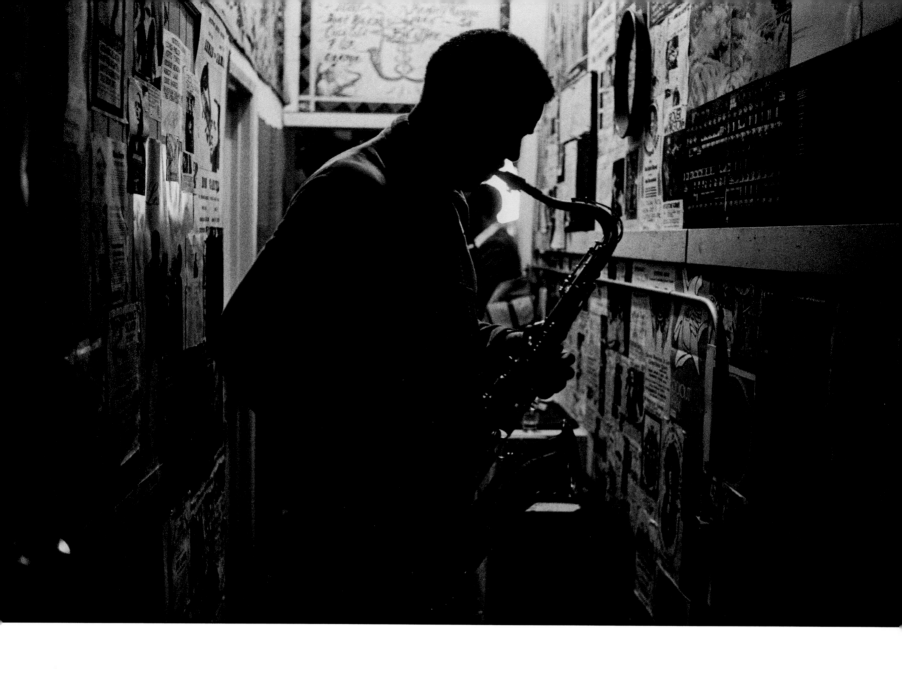

p. 348/349
Michael Jang

Onlookers at George Moscone's funeral, held at St. Mary's Cathedral near Geary and Gough streets. More than 3,000 mourners crowded into the church, with an equal number of shocked San Franciscans listening to the service through loudspeakers on the outside sidewalks, 1978.

Menschen bei George Moscones Beerdigung in der St. Mary's Cathedral nahe Geary und Gough Street. Mehr als 3 000 Trauernde füllten die Kirche, und genauso viele hörten sich den Gottesdienst über Lautsprecher auf den Bürgersteigen an, 1978.

Lors des funérailles de George Moscone à la cathédrale Old St. Mary's, près de Geary Street et de Gough Street. Plus de 3 000 personnes se pressent dans l'église tandis qu'autant d'habitants bouleversés écoutent la cérémonie retransmise par haut-parleurs à l'extérieur de l'édifice. 1978.

Bruce W. Talamon

Dexter Gordon warms up on sax backstage at the Keystone Korner on New Year's Eve. A major figure in jazz since bebop got off the ground in the 1940s, Gordon had only recently returned to the United States after about 15 years in Europe, 1977.

Dexter Gordon wärmt sich am Saxofon auf, Backstage im Keystone Korner an Silvester. Gordon, eine zentrale Figur des Jazz, seit Bebop in den 40ern bekannt wurde, war erst kurz zuvor zurück in die USA gekommen, nachdem er 15 Jahre in Europa verbracht hatte, 1977.

Dexter Gordon et son saxo s'échauffent backstage au Keystone Korner le soir du Nouvel An. Figure majeure du jazz depuis l'apparition du be-bop dans les années 1940, Gordon vient tout juste de rentrer aux États-Unis après une quinzaine d'années passées en Europe. 1977.

↓

Bruce W. Talamon

In North Beach near Vallejo and Stockton streets, Keystone Korner was the city's top jazz club in the 1970s, 1977.

An der Vallejo und Stockton Street in North Beach gelegen, war Keystone Korner in den 1970er-Jahren der beste Jazzclub der Stadt, 1977.

Situé à North Beach, non loin de Vallejo Street et de Stockton Street, le Keystone Korner était dans les années 1970 le meilleur club de jazz de la ville. 1977.

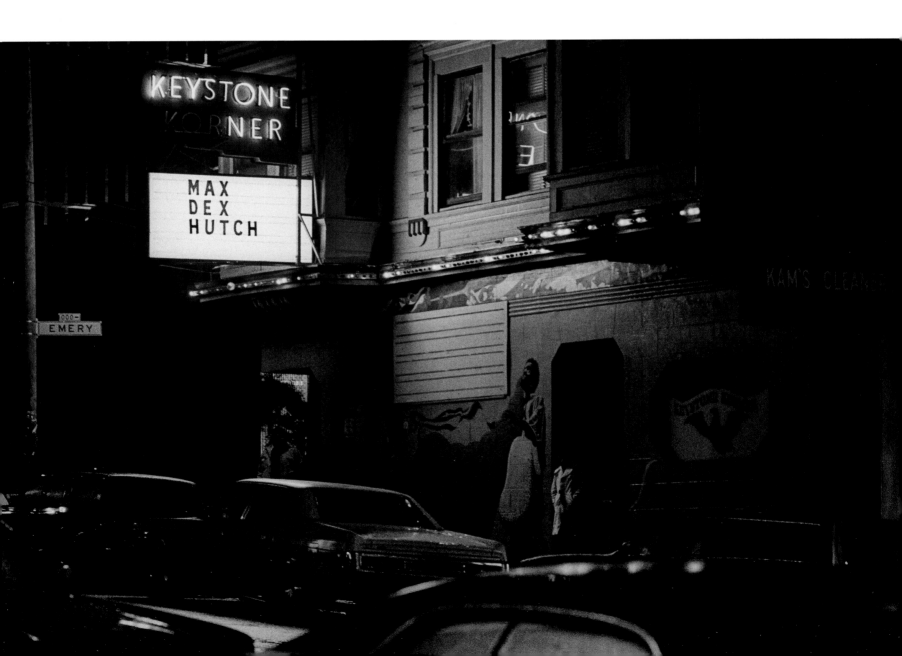

Homer Flynn

The Residents, one of the quirkiest acts in the history of recorded music, pose by the Golden Gate Bridge. Crafting all manner of disturbing and dissonant blends of avant-garde sounds, the San Francisco band members are unknown. Even in concert, they disguised themselves with the eyeball helmets they sport in this shot. This image was used on the back of the Ralph Records compilation Subterranean Modern, *1978.*

The Residents, eine der seltsamsten Gruppen in der bekannten Musikgeschichte, posieren vor der Golden Gate Bridge. Die Mitglieder der Gruppe kennt niemand, ihre Musik ist eine Melange aus allen Arten von beunruhigenden und dissonanten Avantgarde-Sounds. Selbst bei ihren Konzerten trugen sie dieselben Augenhelme wie im Foto, das auch auf der Rückseite der Sammlung Subterranean Modern *von Ralph Records verwendet wurde, 1978.*

The Residents, l'une des formations les plus excentriques de l'histoire de la musique, pose près du Golden Gate Bridge. L'identité des membres de ce groupe de San Francisco, qui bricole toutes sortes de mélanges sonores avant-gardistes aussi inquiétants que discordants, reste inconnue. Même en concert, ils se cachaient derrière des casques en forme de globe oculaire, comme ici. Cette photo illustrait le dos de la compilation Subterranean Modern *(Ralph Records). 1978.*

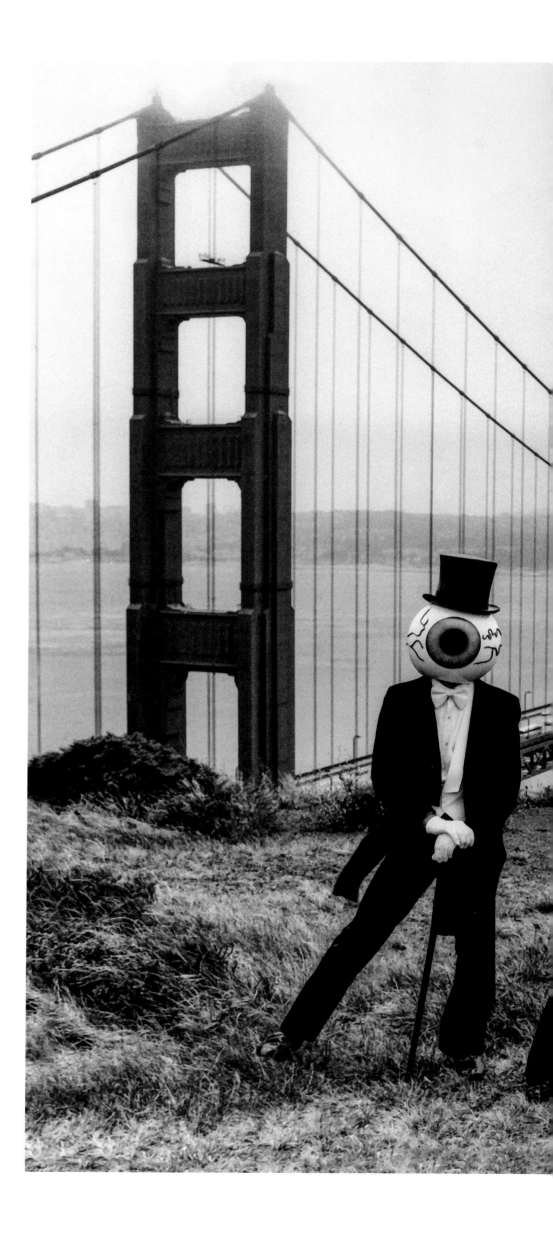

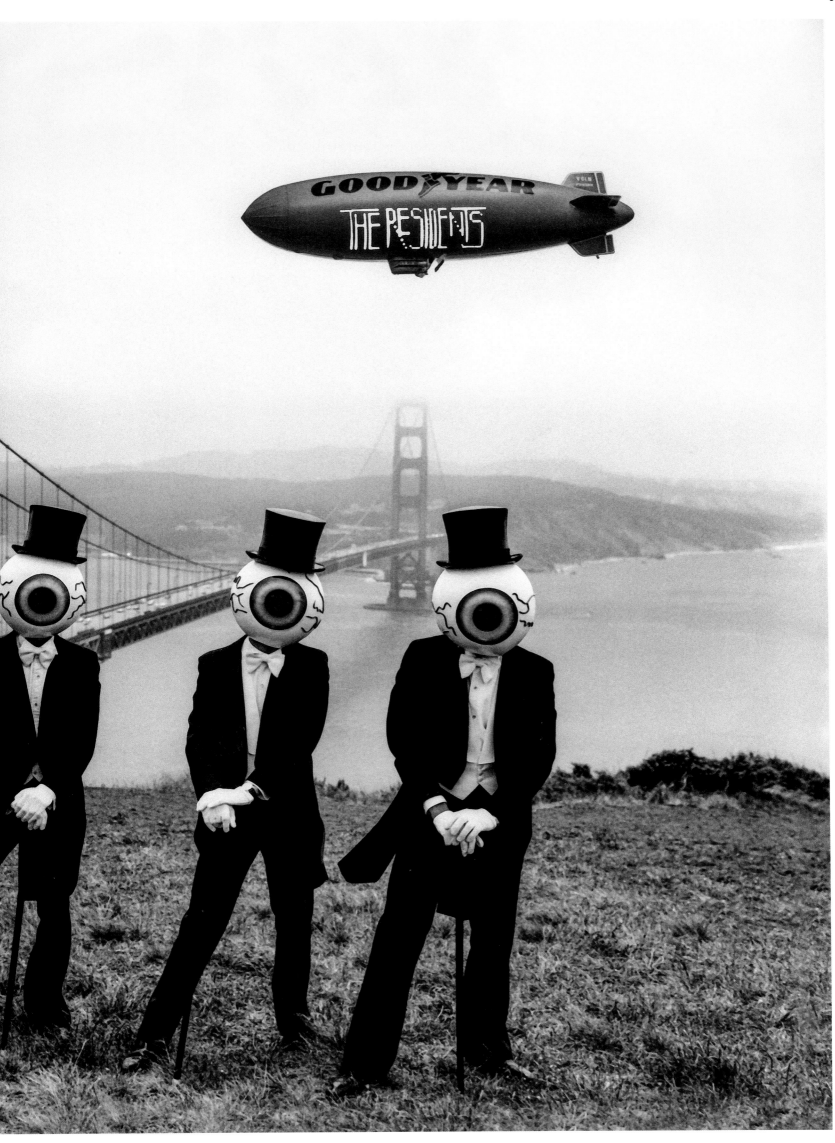

5

New Horizons
1979–TODAY

As the 1970s ended, the gay community's political power contin-
ued to rise after the assassination of Harvey Milk. San Franciscans
were shocked when his confessed killer, Dan White, was found
guilty only of voluntary manslaughter, not first-degree murder, six
months later. Several thousand angry marchers descended on City
Hall after the verdict was announced on May 21, 1979. The White
Night riots put about 100 from the crowd and 60 police officers
into the hospital. Others carried on Milk's advocacy for the visi-
bility of the gay community in all aspects of public life, but soon
a new focus for its energies came to the fore.

Starting in the early 1980s, the AIDS epidemic hit the
community hard. By 1985, more than 500 had died of the disease
in San Francisco; by 1988, more than 6,000 city residents were HIV
positive, with the Castro as epicenter. Gay leaders in San Francisco
quickly formed the San Francisco AIDS Foundation, opened
hospices, and organized services for people with HIV/AIDS. Many
walks and other public events to fund AIDS research and educa-
tion have been held in the city since. The AIDS Memorial Quilt
originated in San Francisco, whose Golden Gate Park now has an
AIDS Memorial Grove.

Now home to a large Latino community, the Mission
District celebrated its heritage with huge, lively murals. And
around the city, a host of street fairs, festivals, and parades cele-
brated everything from Chinese New Year and the Day of the
Dead to leather fetishes. A 1986 bonfire of a wooden effigy on
Baker Beach near Golden Gate Bridge was the ember that
would soon evolve into Burning Man, one of the largest and
most idiosyncratic countercultural gatherings. The annual Bay
to Breakers had become the world's largest footrace, many of
the more than 100,000 runners sporting outlandish only-in-San-
Francisco costumes.

Another major sporting event was interrupted by San
Francisco's biggest earthquake since 1906. On October 17, 1989 at
Candlestick Park, the Giants and A's were getting ready to play
the third game of the first (and so far only) "Bay Bridge" World
Series between the teams. The game wouldn't take place, as the
Loma Prieta earthquake struck just after 5 p.m. If not nearly
as damaging as the 1906 disaster, the destruction was almost as
shocking. A section of the Bay Bridge collapsed, and the upper
level of the double-deck Nimitz Freeway fell in Oakland. Near
Fort Mason, many residents of the Marina District had to aban-
don their landfill-rooted homes. There were 63 deaths, 3,757 inju-
ries, and about $6 billion property damage.

As it had in 1906, San Francisco quickly recovered. The
World Series, though hardly the uppermost concern of residents,
resumed 10 days later, the A's sweeping the Giants. The Bay
Bridge reopened just a month after its collapse, and thousands of
relieved pedestrians celebrated the occasion with a Bridge Walk
on its customarily car-jammed lanes. San Francisco would soon
become more prosperous than ever, if so expensive that its social
structure would be just as seriously tested as its infrastructure.

The seeds of some of the biggest changes to rock San
Francisco at the end of the 20th century had been planted years
before, and far south of the city. The area had been home to a
healthy electronics industry since the 1930s, its growth spurred

by Naval Air Station Moffett Field in the San Jose suburb of
Sunnyvale, some of which then served as a center for aeronautical
research. By the 1950s, silicon transistors and the integrated circuit
chip had been developed in companies closer to San Jose than
San Francisco. By the 1970s, the Silicon Valley, roughly spanning
Palo Alto to San Jose, was a center for the technology used in the
personal computers that began to revolutionize everyday work
and leisure.

Companies and entrepreneurs started to eye San
Francisco as a more desirable base for part or all of their opera-
tions. The city was more prominent in the international financial
community, closer to some major potential investors, and simply
a more exciting place to be than the comparatively anodyne San
Jose suburbs. It has since been difficult for city politicians to
strike a balance between growth and residential quality of life,
between business concerns and community issues, although the
most drastic effects of the tech industry wouldn't be felt until the
next century.

About a mile south of the Financial District, the compar-
atively cheap office space in or near the small, oval South Park
became home to numerous tech start-ups by the early 1990s. Even
if these were sometimes funded by Silicon Valley venture capital-
ists, a San Francisco address held some cachet to the wider world.
The city also had plenty of young artists whose design skills fitted
in well with the burgeoning internet and its associated products.

The Bay Area had already been among the earliest adapt-
ers of the online experience. The Whole Earth 'Lectronic Link
(aka the WELL), started there in the mid-1980s, might have been
the first widely known virtual community. In 1993, *Wired*, the
leading magazine covering the intersection of budding technol-
ogies with society at large, booted up just a block from South
Park. Local online communities offering services that could turn
a profit for their owners began emerging, like the classified ad site
Craigslist. The foundations were in place for the dot-com boom,
and San Francisco would play a big part. Start-ups were rampant,
investors hoping to strike a new web browser, Amazon, or online
video game in the modern equivalent of the California Gold
Rush. Wages for many talented citizens went up. Commercial and
residential rents went up too.

The city, never short of newcomers from all over the
world, had another set of opportunity-seekers to accommodate.
Plenty could afford to pay far higher rents than many longtime
residents. Neighborhoods that had been largely industrial, like
South of Market where so many newbies were working, started
to gentrify. So did some of the city's remaining pockets housing
low-income families.

As huge as the tech boom was, it couldn't come close
to accommodating all the would-be giants. By the 21st century,
and sometimes quite a few years sooner, many of the start-ups
had gone bust. Soaring San Francisco rents cooled off briefly. For
many, however, the boom had threatened to permanently alter
the city's character, and not just by putting even more homeless
on the streets. The 2000 closure of Downtown Rehearsal Space
(actually more than five miles south of downtown), home to
hundreds of rooms where rock bands rehearsed at reasonably

The Mayor of Castro Street: The Life
and Times of Harvey Milk, *Randy Shilts,
St. Martin's Griffin, 1982.*

affordable rates, even led to fears that the local music scene would die as a result.

Despite worries that San Francisco was on the verge of becoming Silicon Valley North, the creative and political movements that had helped define the city since the '50s continued to thrive. The mainstream art scene got a boost with the 1995 opening of a new Museum of Modern Art just south of downtown, and just north of the Moscone Center, a convention complex completed in 1981. Along with the nearby Yerba Buena Arts Center, the area offered major, often innovative contemporary exhibitions from world-renowned artists. Around Golden Gate Park's oval-shaped music concourse, the de Young art museum and the California Academy of Sciences underwent major renovations and improvements. After some early flak over its stark external architecture, the de Young's Harmon Observatory Tower has become a favorite destination for its panoramic glass-walled views of the park and its surrounding neighborhoods. A much-enlarged Asian Art Museum is now in the Civic Center, next to a similarly spruced-up main public library, whose spiraling atrium features many old catalog cards on its walls, hand-written patron notes intact.

Amidst the challenges of ever-denser commercial and residential developments, San Francisco continued to beautify with new and environmentally conscious projects. In the early '90s the Embarcadero Freeway, much loathed by pedestrians for its noise and blockage of waterfront views, was torn down. The waterfront could now be strolled or biked with open-air views for three miles south from Fisherman's Wharf, passing a newly revived Ferry Building and the Bay Bridge along the way. At its southern end, a new and handsome privately funded stadium for the San Francisco Giants, the first such Major League Baseball facility built without public funds in almost forty years, opened in 2000. Operating under various names ever since, it put an end to the team's periodic threats to abandon inhospitably cold and windy Candlestick Park for other cities like Toronto or Tampa.

Progressive activists still took to the streets for regular demonstrations at the turn of the century, though these were far less ridden with conflicts between protestors and police than they'd been in decades past. The city's leftward tilt guaranteed large turnouts for protests with nationwide momentum, with more than 100,000 marching against US intervention in the Middle East at some events in the early 1990s and early 2000s. Others were so issue-specific they had an only-in-the-Bay-Area feel, as when Berkeley's public (and usually quite left) radio station KPFA was shut down in 1999 by its governing Pacifica Foundation in a labor dispute. About 10,000 demonstrators took to Berkeley's streets to demand KPFA reopen, which it did shortly afterward.

One of the most imaginative and idiosyncratic such events was Critical Mass, inaugurated in 1992 as a twilight ride of bicyclists through auto-heavy city blocks. At its peak, thousands would gather near the Ferry Building the final Friday evening of every month to pedal en masse, stopping traffic to the delight of onlookers and annoyance of honking automobiles. Critical Mass has since been emulated in more than 300 cities throughout the world—a significant, if subtle, tribute to San Francisco's influence on global environmental consciousness.

In city hall, San Francisco politics continued to reflect the city's more inclusive nature. Flamboyant California State Assembly Speaker Willie Brown became the city's first African American mayor in 1995. He was succeeded by Gavin Newsom, who took office in 2004 and directed the city-county clerk to issue same-sex marriage licenses, though such couplings were not permanently legalized in California until 2013. Before taking office, Newsom—who would be elected California governor in 2019—had to beat stiff opposition from a more liberal candidate. The Green Party's Matt Gonzalez took 47 percent of the vote in a runoff, marking the closest the Greens have ever come to holding such a prominent office in the United States.

After the dot-com bubble burst at the start of the 2000s, a new surge of tech presence would again change San

The Golden Gate: A Novel in Verse, *Vikram Seth, Harcourt Brace Jovanovich, 1986.*

Francisco socioeconomics. In 1998, Google was founded by Stanford University students. Shortly after originating at Harvard, Facebook moved to Palo Alto in 2004, later settling in Menlo Park, between the city and Silicon Valley. The massive success of these and other similar companies needed a substantial workforce, and not all of their employees wanted to live close to their headquarters down the peninsula. So many Silicon Valley employees lived in popular San Francisco neighborhoods like the Mission that Google had a private fleet of buses to shuttle them back and forth from the city to Mountain View, 40 miles to the south. The large vehicles worsened San Francisco's already serious traffic problems, raising the ire of many neighborhood residents. Some of them had trouble even boarding public transportation when bus stops were occupied by the new fleets.

By the 2010s, some fast-rising companies had set up large headquarters or affiliate offices in San Francisco itself, including Uber, Lyft, Twitter, and Spotify (with Pandora already established in Oakland). As 2020 loomed, the city's total population was pushing 900,000, about 100,000 more than it was at the dawn of the new millennium. The city ranked as the second-most expensive in which to live in the United States, trailing only Manhattan, with average home prices exceeding $1 million and average rentals more than triple the national rate. That's testimony to how desirable a San Francisco address had become, but despite some strict rent control laws, it also increased the city's already large homeless population. By 2019, the city's homeless numbered nearly 10,000; over the preceding two years alone, San Franciscans who met the federal definition of homeless increased by 17 percent. Many couldn't afford to regain housing they might have lost, and evictions displacing less well-to-do residents grew into a bigger threat when the 2020 pandemic took a toll on the economy. Diversity also took a hit, with the African American population shrinking to 5.5 percent, from 13.4 percent in 1970. San Francisco also has the lowest percentage of children (13 percent) of any major US city.

In 2018, Facebook signed the biggest lease in San Francisco history to occupy the 600-foot Park Tower. Uber is building a vast new home south of the baseball stadium in Mission Bay, an area that's already seen massive construction of buildings for biotech companies and the University of California at San Francisco. In 2019 the Chase Center brought more traffic to the neighborhood, serving as the new home for the Golden State Warriors and staging big-name music concerts. Towering over all these new additions is the Salesforce Tower, which at 1,070 feet is the second tallest skyscraper west of the Mississippi. While its impact was softened by a rooftop park on the affiliated block-long Salesforce Transit Center, the fanfare accompanying its 2018 opening was dampened when the center and park were closed in September, just six weeks later. Cracks had been discovered in the structure's steel beams, though it reopened the following summer.

San Francisco maintained its stature as the leading center for demonstrations supporting women's rights, mitigation of climate change, and sanctuary for immigrants. About 100,000 walked from the Civic Center to the Ferry Building in the 2017 Women's March, which also acted as a fulcrum of resistance against newly inaugurated president Donald Trump. Later that month, protesters jammed San Francisco International Airport to condemn an executive order banning citizens from seven Muslim-majority nations from entering the United States. Ed Lee, the city's first Chinese American mayor, even led a May Day demonstration for immigrants down Market Street about six months before his unexpected death near the end of 2017.

Those who could remain in San Francisco, or at least commute there from other parts of the Bay Area, still had much to celebrate in the 2010s. The Giants won their first World Series in 2010, more than half a century after moving to the city, followed by two other world titles in 2012 and 2014. Led by superstar Stephen Curry, the Warriors repeated the feat shortly before moving back to San Francisco from Oakland's Oracle Arena, capturing three NBA titles between 2015 and 2018. For recreational

←
Mrs. Doubtfire, *Chris Columbus,
20th Century Fox, 1993.*

→
The Joy Luck Club, *Amy Tan, G. P.
Putnam's Sons, 1989.*

sports, a bike path now runs along the south side of the Bay Bridge, connecting the East Bay to Treasure Island. Another bike path opened on the Richmond–San Rafael Bridge in 2019, linking the East Bay with Marin County.

Plans are afoot to add another Transbay Tube to BART, in hopes of easing the traffic congestion that grows worse by the year. Considering the enormous expense, planning, and labor involved in that project, it's likely dedicated Bus Rapid Transit lanes to expedite traffic along San Francisco's busiest routes will be completed considerably earlier. It's also hoped a Central Subway running through downtown from the Giants' ballpark to Chinatown will open this year, 12 years since ground was first broken for the line.

Festivals remain a staple of San Francisco life, whether Hardly Strictly Bluegrass, which presents a weekend of free roots music in Golden Gate Park to hundreds of thousands of listeners every October; the annual Gay Pride parade in June, which draws more than a million participants, not all LGBTQIA, with its rainbow-colored, costumed marchers-partiers; and Litquake, drawing tens of thousands to its 10-day autumn festival of author readings and events.

Whether as a consequence of artist displacement from San Francisco or not, Oakland now has a formidable creative community of its own, using the city as inspiration for acclaimed novels and films. Michael Chabon's *Telegraph Avenue* was set there, as was Tommy Orange's *There There*, a finalist for the 2019 Pulitzer Prize. Oakland was also the setting for a pair of 2018 films highlighting the African American East Bay experience,

local rapper Boots Riley's *Sorry to Bother You* and Carlos López Estrada's *Blindspotting*.

Like much of the Bay Area, Oakland's also home to an increasing population of young professionals who can't afford San Francisco rents or homes, often commuting to well-paying jobs across the water. Neighborhoods not previously considered highly desirable, such as East Oakland, have seen a big growth in middle- and upper-middle-income home ownership, forcing some of the same displacement upon low-income residents as those suffered by many San Franciscans. On the political front, Oakland-born Kamala Harris, who rose to political prominence as San Francisco's district attorney, became the first woman vice president of the United States after she was elected as Joe Biden's running mate in 2020.

By 2020, the Bay Area was home to more billionaires per capita than any other region. Putting the inequality gap in stark relief, efforts to curb the coronavirus infections in 2020, including lockdowns and the closing of restaurants and theaters, hit low-wage service workers in tourism harder than tech employees who worked from home. In 2019's art house hit movie *The Last Black Man in San Francisco*, young African Americans resorted to desperate measures in a failed attempt to reclaim their family home in the Fillmore. Their struggle mirrored San Francisco's mission as it entered the third decade of the 21st century—to keep intact the many cultural, aesthetic, and geographic forces that make the city special. If the last 175 years are any guide, San Francisco will somehow adapt, survive, and thrive.

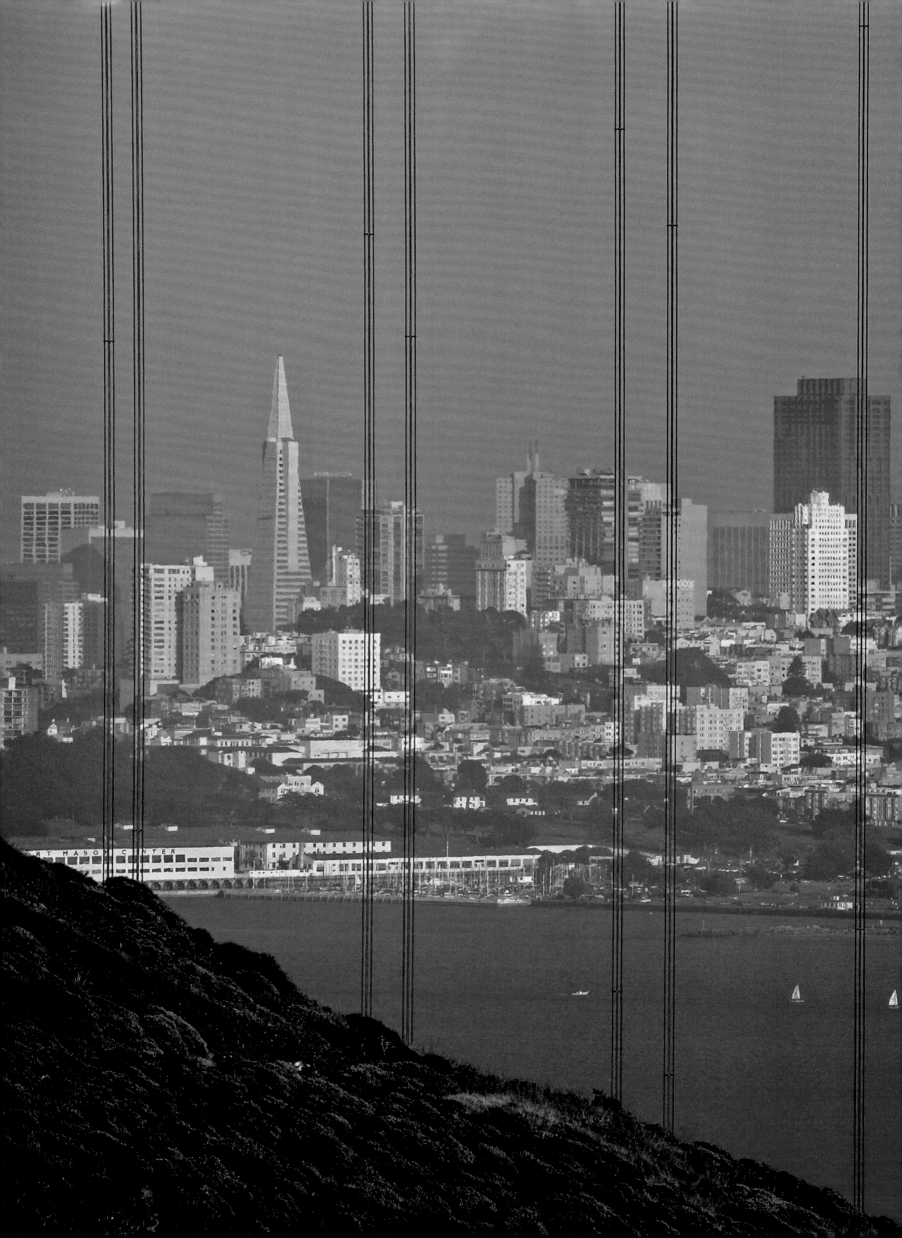

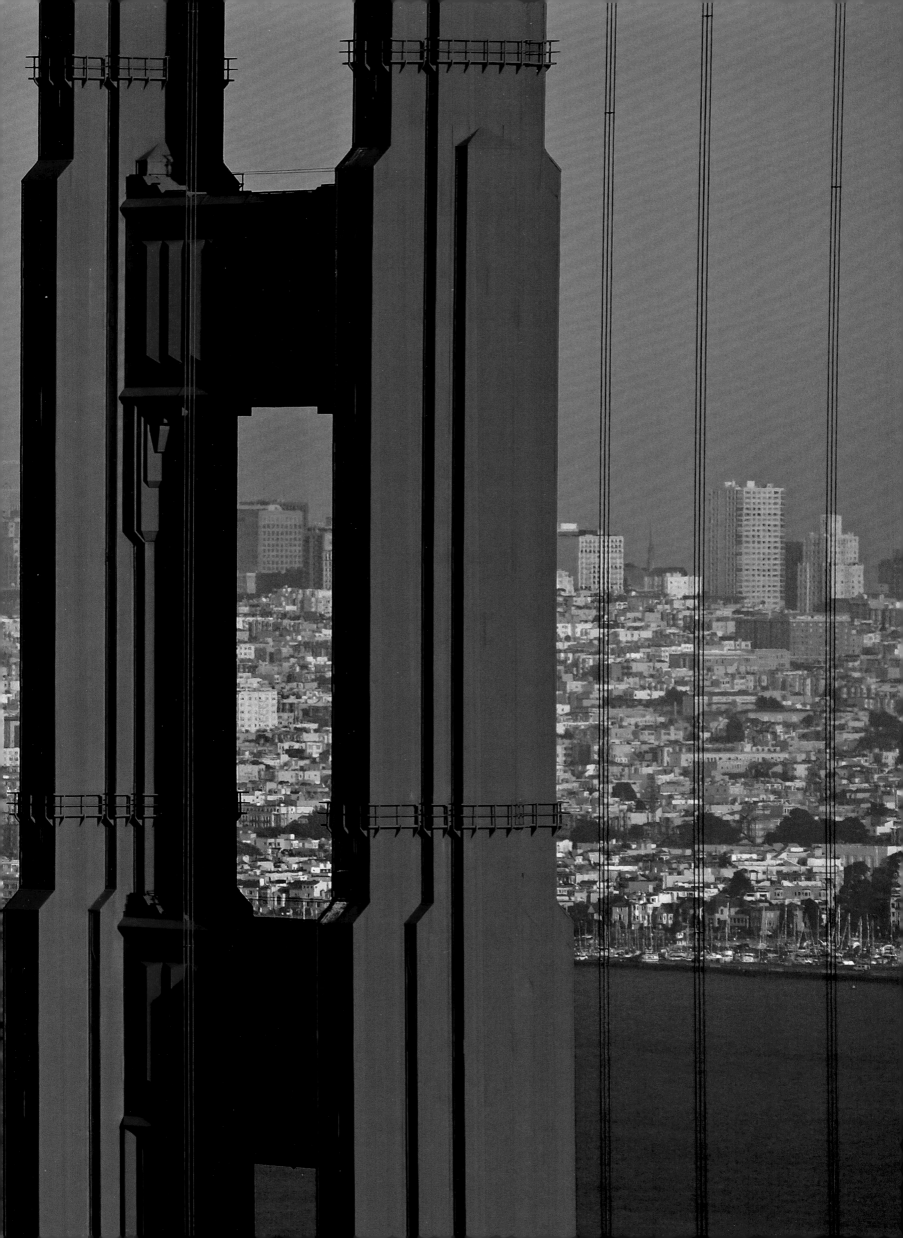

#5

Neue Horizonte
1979 BIS HEUTE

p. 360/361
Marvin Newman

The San Francisco skyline, as viewed through the Marin County side of the Golden Gate Bridge. On the left, the Transamerica Pyramid towers over the surrounding buildings. Fort Mason, the Marina Yacht Harbor, and the Marina Green are on the lower left, c. early 1980s.

Die San Francisco Skyline von der Marin County Seite der Golden Gate Bridge aus. Links überragt die Transamerica Pyramid die restlichen Gebäude. Fort Mason, der Marina Yachthafen und die Marina Green Wiese links unten, frühe 1980er.

San Francisco se découpe à l'horizon telle qu'on la voit depuis la partie du Golden Gate Bridge qui rejoint le comté de Marin. Sur la gauche, la Transamerica Pyramid domine les bâtiments environnants. Plus bas, Fort Mason, le port de plaisance du Marina District et Marina Green, un parc public. Vers le début des années 1980.

Der politische Einfluss der schwulen Community nahm Ende der 1970er nach Harvey Milks Ermordung weiter zu. Sechs Monate später waren die Einwohner San Franciscos schockiert, als der geständige Mörder, Dan White, nur des Totschlags und nicht des Mordes für schuldig befunden wurde. Einige Tausend wütende Demonstranten zogen nach der Urteilsverkündung am 21. Mai 1979 zum Rathaus. Die Ausschreitungen in der sogenannten Weißen Nacht brachten etwa 100 Demonstranten und 60 Polizeikräfte ins Krankenhaus. Andere setzten Milks Arbeit für die Sichtbarkeit der schwulen Community im gesamten öffentlichen Leben fort, doch bald musste sie ihre Energie für eine neue Sache einsetzen.

Von den frühen 1980er-Jahren an wurde die Gemeinschaft schwer von der Aids-Epidemie getroffen. 1985 waren in San Francisco schon mehr als 500 Menschen an der Krankheit gestorben; 1988 waren mehr als 6000 Einwohner der Stadt HIV-positiv. Das Castro war das Epizentrum der Epidemie. Führende Persönlichkeiten in der schwulen Community gründeten bald die San Francisco AIDS Foundation, eröffneten Hospize und organisierten Hilfe für Menschen mit HIV/Aids. Zahlreiche Märsche und andere Veranstaltungen zur Finanzierung von Aids-Forschung und -Aufklärung haben seither in der Stadt stattgefunden. Der Aids-Memorial-Quilt stammt aus San Francisco, und der Golden Gate Park beherbergt heute einen Aids-Memorial-Hain.

Im Mission District gab es inzwischen eine große Latino-Gemeinde, die ihre Geschichte mit riesigen Wandmalereien feierte. In der ganzen Stadt gab es eine Menge Straßenfeste, Festivals und Paraden, die alles vom chinesischen Neujahrsfest über den Tag der Toten bis hin zum Lederfetisch alles feierten. Am Baker Beach in der Nähe der Golden Gate Bridge wurde 1986 eine hölzerne Statue verbrannt. Bald wurde daraus Burning Man, eine der größten und eigenwilligsten Counterculture-Veranstaltungen. Das jährliche Rennen Bay to Breakers war zum größten Stadtlauf der Welt geworden, und viele der mehr als 100000 Läufer trugen, passend zu San Francisco, abgedrehte Kostüme.

Das größte Erdbeben seit 1906 unterbrach eine andere wichtige Sportveranstaltung. Am 17. Oktober 1989 bereiteten sich Giants und A's gerade auf ihr drittes Spiel der ersten (und bislang einzigen) Bay Bridge World Series im Candlestick Park vor. Das Spiel fand nicht statt, kurz nach 17 Uhr ereignete sich stattdessen das Loma-Prieta-Erdbeben. Nicht annähernd so verheerend wie bei der Katastrophe von 1906, war die Zerstörung trotzdem ähnlich schockierend. Ein Teil der Bay Bridge kollabierte, und in Oakland stürzte die obere Ebene des doppelstöckigen Nimitz Freeway ein. Im Marina District, nah an Fort Mason, mussten viele Anwohner ihre Häuser auf einer ehemaligen Müllkippe aufgeben. Es gab 63 Tote und 3757 Verletzte, der Sachschaden belief sich auf etwa 6 Milliarden Dollar.

San Francisco erholte sich schnell, wie schon 1906. Es gab zwar größere Sorgen, aber die World Series wurden zehn Tage später weitergespielt, und die A's besiegten die Giants. Nur einen Monat nach ihrem Einsturz wurde die Bay Bridge wieder eröffnet, und Tausende feierten diesen Anlass, indem sie die ansonsten üblicherweise von Autos verstopfte Brücke zu Fuß auf der Fahrbahn überquerten. San Francisco sollte bald wohlhabender denn je sein, aber auch so teuer, dass seine sozialen Strukturen ebenso auf die Probe gestellt wurden wie die Infrastruktur.

Die Saat für einige von San Franciscos größten Veränderungen am Ende des 20. Jahrhunderts war schon Jahre zuvor im Süden der Stadt gelegt worden. Seit den 1930er-Jahren gab es dort eine solide Elektronikindustrie, deren Wachstum vom Militärstützpunkt Moffett Field im Vorort Sunnyvale von San Jose profitierte, damals zum Teil ein Zentrum für Luftfahrtforschung. In den 1950er-Jahren gab es bereits Siliziumtransistoren und integrierte Schaltkreise, die Firmen entwickelt hatten, die näher an San Jose als an San Francisco lagen. Dieses Silicon Valley erstreckte sich grob von Palo Alto bis San Jose und war ab den 1970ern ein Zentrum für die Technologie der Personal Computer (PCs), die den Arbeits- und Freizeitalltag zu revolutionieren begann.

San Francisco wurde schon bald von Firmen und Unternehmern als wünschenswerter (Teil-)Standort in Betracht gezogen. In der internationalen Finanzwelt war die Stadt bekannter, lag näher an wichtigen potenziellen Investoren und hatte dazu mehr zu bieten als die vergleichsweise einschläfernden Vororte von San Jose. Von diesem Punkt an war es für die Politiker der Stadt schwierig, ein Gleichgewicht zwischen Wachstum und Lebensqualität der Anwohner, zwischen den Interessen der Konzerne und der Menschen zu finden, obgleich die drastischsten Auswirkungen der Tech-Industrie erst im nächsten Jahrhundert spürbar werden sollten.

Anfang der 1990er-Jahre fanden viele Tech-Start-ups vergleichsweise günstigen Büroraum in der Gegend rund um den South Park, etwa zwei Kilometer südlich des Finanzdistrikts. Manche wurden zwar durch Risikokapital aus dem Silicon Valley finanziert, aber eine Adresse in San Francisco war auf gewisse Weise ein Gütesiegel. Außerdem passten die Designfähigkeiten der vielen jungen Künstler, die es in der Stadt gab, gut zum sich entwickelnden Internet und den damit zusammenhängenden Produkten.

Die Bay Area passte sich früh an das Online-Erlebnis an. Der Whole Earth 'Lectronic Link alias WELL, Mitte der 1980er ins Leben gerufen, war möglicherweise die erste bekannte virtuelle Gemeinschaft. *Wired*, das wichtigste Magazin für die Schnittstelle zwischen neuen Technologien und Gesellschaft, wurde 1993 gegründet, nur einen Block von South Park entfernt. Lokale Onlinecommunities rund um Dienstleistungen, die für ihre Besitzer profitabel waren, entstanden, darunter die Kleinanzeigenseite Craigslist. Somit waren die Grundlagen für den Dotcom-Boom da, in dem San Francisco eine große Rolle spielte. Überall gab es Startups, Investoren hofften, einen neuen Webbrowser, Amazon oder ein Online-Videospiel zu finden; es war ein moderner Goldrausch. Die Löhne für viele talentierte Bürger stiegen, Geschäfts- und Wohnungsmieten auch.

Der Stadt hatte es nie an Neuankömmlingen aus der ganzen Welt gemangelt, und nun kam eine neue Gruppe von Glückssuchern hinzu. Viele von ihnen konnten sich weit höhere Mieten leisten als alteingesessene Anwohner. In Vierteln wie South of Market, die zuvor größtenteils industriell geprägt waren und wo jetzt viele der Neulinge arbeiteten, begann die Gentrifizierung, so auch in den verbleibenden Ecken der Stadt, in denen Familien mit geringem Einkommen lebten.

So groß der Tech-Boom auch war, er war nicht annähernd groß genug für alle Möchtegern-Giganten. Um die Jahrhundertwende, manchmal schon einige Jahre früher, gingen viele der

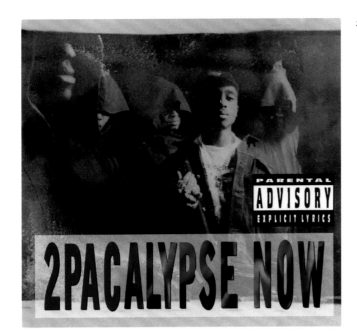

2Pacalypse Now, *2Pac, Interscope Records, 1991.*

Start-ups pleite. Die Mietpreise in San Francisco beruhigten sich kurz. Für viele drohte der Boom den Charakter der Stadt jedoch dauerhaft zu verändern, und das nicht nur dadurch, dass immer mehr Menschen obdachlos wurden. Als 2000 der Downtown Rehearsal Space (tatsächlich mehr als acht Kilometer südlich des Stadtzentrums gelegen), der Hunderte von einigermaßen günstige Proberäume für Rockbands zur Verfügung gestellt hatte, schloss, entstand auch die Angst vor dem Ende der lokalen Musikszene.

Die kreativen und politischen Strömungen, die die Stadt seit den 50er-Jahren geprägt hatten, gediehen weiter, entgegen allen Befürchtungen, dass San Francisco zu Silicon Valley Nord werden würde. Die Eröffnung des neuen Museum of Modern Art 1995, südlich des Stadtzentrums und nur etwas nördlich des 1981 fertiggestellten Moscone Centers, stärkte die Mainstream-Kunstszene weiter. Hier und im nahe gelegenen Yerba Buena Arts Center wurden innovative zeitgenössische Ausstellungen von weltbekannten Künstlern gezeigt. Dazu kamen die umfassenden Renovierungen des de Young Museum und der California Academy of Sciences, beide um den Music Concourse im Golden Gate Park gelegen. Nach anfänglicher Kritik an seiner sehr nüchternen Architektur ist der Harmon Observatory Tower des de Young mit seinem Panoramablick über den Park und dessen Umgebung zu einem beliebten Touristenziel geworden. Im Civic Center findet sich jetzt ein deutlich vergrößertes Museum für asiatische Kunst, neben einer ähnlich herausgeputzten Stadtbibliothek, in deren spiralförmigem Atrium alte Katalogkarten die Wände schmücken, inklusive handschriftlicher Notizen.

Inmitten der Herausforderungen, die aus dem immer dichter werdenden Stadtraum entstanden, verschönerten neue und umweltbewusste Projekte San Francisco weiter. In den frühen 90ern wurde der bei Fußgängern verhasste, laute Embarcadero Freeway abgerissen und gab so die Sicht auf die Bucht wieder frei. Die fünf Kilometer lange Uferpromenade südlich von Fisherman's Wharf war jetzt wieder zu Fuß oder mit dem Fahrrad zugänglich und bot Ausblicke auf das wieder in Betrieb genommene Ferry Building und die Bay Bridge. Am südlichen Ende wurde 2000 ein

neues Baseballstadion für die San Francisco Giants eröffnet, seit 40 Jahren das erste, das privat und nicht aus öffentlichen Geldern finanziert wurde. Den regelmäßigen Drohungen des Teams, den ungemütlich kalten und windigen Candlestick Park gegen Tampa oder Toronto einzutauschen, wurde durch das neue Stadion, das mittlerweile schon unter mehreren Namen betrieben wurde, ein Ende gesetzt.

Um die Jahrhundertwende waren progressive Aktivisten immer noch regelmäßig auf den Straßen, es gab aber merklich weniger Konflikte zwischen Polizei und Demonstranten als in den Jahrzehnten davor. Dass in den frühen 1990er- und 2000er-Jahren mehr als 100 000 Menschen gegen die US-Interventionen im Nahen Osten demonstrierten, ist auch der linksorientierten Politik der Stadt zu verdanken. Andere Proteste betrafen Anliegen der Bay Area, wie der gegen die Schließung von Berkeleys öffentlichem (und normalerweise recht linkem) Radiosender KPFA. Der Sender gehörte der Pacifica Foundation, die ihn wegen eines Arbeitsrechtskonflikts schließen wollte. Die Forderung der circa 10 000 Demonstranten, dass der Sender wieder öffnen sollte, wurde wenig später erfüllt.

Critical-Mass-Fahrten fanden erstmals 1992 statt und gehören zu San Franciscos einfallsreichsten Aktionen: eine abendliche Fahrradfahrt durch von Autos dominierte Blocks. Auf ihrem Höhepunkt trafen sich am letzten Freitag jedes Monats Tausende in der Nähe des Ferry Building, um dann zusammen durch die Stadt zu fahren, zur Freude von Beobachtern und zum Ärger hupender Autofahrer. Seitdem wurde Critical Mass in mehr als 300 Städten auf der ganzen Welt aufgegriffen – eine wichtige, wenn auch subtile, Hommage an den Einfluss San Franciscos auf das Umweltbewusstsein weltweit.

Die Politik San Franciscos spiegelte weiterhin die inklusive Natur der Stadt wider. 1995 wurde Willie Brown, der extravagante Präsident der kalifornischen Staatsversammlung, der erste afroamerikanische Bürgermeister. Auf ihn folgte 2004 Gavin Newsome, der das Standesamt der Stadt anwies, Heiratsurkunden auch für gleichgeschlechtliche Paare auszustellen, obwohl dies

Gun, with Occasional Music, *Jonathan Lethem, Harcourt Brace & Co., 1994.*

in Kalifornien bis 2013 noch nicht permanent legalisiert war. Newsome – 2019 zum Gouverneur von Kalifornien gewählt – musste sich gegen einen starken und liberaleren Kandidaten durchsetzen, bevor er das Amt antreten konnte. In der Stichwahl erhielt Matt Gonzalez von der Green Party 47 Prozent der Stimmen, im ganzen Land war ein Kandidat der Partei nie näher an eine so wichtige politische Position herangekommen.

Als Anfang der Nullerjahre die Dotcom-Blase platzte, veränderte eine neue Tech-Flut erneut die sozioökonomische Landschaft von San Francisco. 1998 wurde Google von Studenten der Stanford University gegründet. Kurz nach der Entstehung in Harvard zog Facebook 2004 nach Palo Alto und später nach Menlo Park, direkt zwischen die Stadt und das Silicone Valley. Der massive Erfolg dieser und ähnlicher Unternehmen brauchte viele Arbeitskräfte, von denen nicht alle nahe an den Firmenzentralen weiter südlich auf der Halbinsel leben wollten. So viele der Silicon-Valley-Angestellten wohnen in beliebten Vierteln von San Francisco wie der Mission, dass Google eine private Flotte von Shuttlebussen stellte, um sie täglich nach Mountain View zu bringen, 65 Kilometer weiter im Süden. Zum Unmut vieler Anwohner verschlimmerten die großen Fahrzeuge das bereits beachtliche Verkehrsproblem San Franciscos weiter. Für einige wurde es jetzt sogar schwierig, die öffentlichen Verkehrsmittel zu nutzen, da die Bushaltestellen ständig von den Shuttleflotten besetzt waren.

In den 2010ern hatten einige schnell wachsende Unternehmen ihren Hauptsitz, oder zumindest eine Zweigstelle, in San Francisco. Zu ihnen gehörten Uber, Lyft, Twitter und Spotify (Pandora hatte bereits einen Sitz in Oakland). Als sich das Jahr 2020 näherte, erreichte die Bevölkerungszahl die 900 000er-Marke, fast 100 000 mehr als noch zur Jahrtausendwende. Die Stadt war jetzt die zweitteuerste der USA, direkt nach Manhattan: Der Durchschnittspreis für ein Haus lag bei über einer Million Dollar, Mieten kosteten mehr als das Dreifache des nationalen Durchschnitts. Dies war nicht nur Beweis dafür, wie beliebt San Francisco geworden war, sondern auch Grund für den weiteren Anstieg der schon zuvor hohen Obdachlosenzahlen. 2019 gab es trotz strenger Mieterschutzgesetze fast 10 000 Obdachlose, und von 2020 bis 2021 stieg die Zahl der Menschen, die offiziell als wohnungslos gelten, um 17 Prozent. Viele konnten sich keine Wohnung leisten, wenn sie ihre alte erstmal verloren hatten. Zwangsräumungen wurden zu einer immer größeren Bedrohung, besonders im Zuge des Schadens, den die Pandemie 2020 an der Wirtschaft anrichtete. Auch der Diversität der Stadt litt unter all dem: 1970 waren 13,4 Prozent der Bevölkerung Afroamerikaner, heute sind es nur noch 5,5 Prozent. San Francisco hat mit nur 13 Prozent den niedrigste Kinderanteil von allen US-Großstädten.

2018 unterzeichnete Facebook den größten Mietvertrag in der Stadtgeschichte für den gesamten 185 Meter hohen Park Tower. Gegenwärtig baut Uber eine riesige neue Zentrale in der Mission Bay, südlich des Baseballstadions. In der Region wurde bereits massiv neu gebaut, besonders von verschiedenen Biotech Firmen und der University of California at San Francisco. Die Veranstaltungsarena Chase Center, fertiggestellt 2019, brachte mehr Verkehr in das Viertel und ist das neue Zuhause der Golden State Warriors sowie Konzertbühne für Stars. All das überragt der Salesforce Tower, mit 326 Metern der zweithöchste Wolkenkratzer westlich des Mississippi. Durch den 2,2 Hektar großen Dachgarten des angegliederten Busbahnhofs Salesforce Transit Center machte der Turm einen besseren Eindruck, aber die Freude über seine Eröffnung 2018 hielt nicht lange an. Center und Dachgarten wurden sechs Wochen später wieder geschlossen: Man hatte Risse in einigen Stahlträgern entdeckt. Die Wiedereröffnung fand im folgenden Sommer statt.

San Francisco bleibt einer der wichtigsten Demonstrationsorte für Frauenrechte, Klimaschutz und die Rechte von Migranten. Beim Women's March 2017 marschierten rund 100 000 Menschen vom Civic Center zum Ferry Building und bildeten damit auch ein Zentrum des Widerstands gegen den gerade vereidigten Präsidenten Donald Trump. Noch im selben Monat wurde der San Francisco International Airport von einer Protestaktion gegen das Einreiseverbot aus sieben, mehrheitlich muslimischen Ländern zum Stillstand gebracht. Der erste chinesisch-amerikanische Bürgermeister, Ed Lee, führte am 1. Mai selbst eine Demonstration für

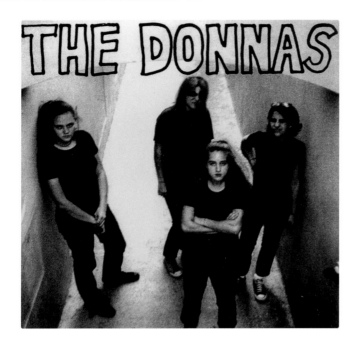

die Rechte von Immigranten an, knappe sechs Monate vor seinem plötzlichen Tod Ende 2017.

Wer sich San Francisco noch leisten konnte oder zumindest in die Stadt pendelte, hatte in den 2010er-Jahren viel zu feiern. Mehr als ein halbes Jahrhundert, nachdem sie in die Stadt gezogen waren, gewannen die Giants 2010 ihre erste World Series, zwei weitere Titel folgen 2012 und 2014. Vom Superstar Steph Curry angeführt machten es ihnen die Warriors nach, kurz bevor sie von Oakland zurück nach San Francisco kamen, gewannen sie zwischen 2015 und 2018 drei NBA Titel. Auch der Freizeitsport kam nicht zu kurz. Zwei neue Radwege entstanden, der eine südlich der Bay Bridge von der East Bay nach Treasure Island, der andere verbindet die East Bay mit Marine County über die Richmond-San Rafael Bridge.

Gegenwärtig gibt es Pläne, das U-Bahn-System BART um einen weiteren Tunnel unter der Bucht zu erweitern, um hoffentlich des immer schlimmer werdenden Autoverkehrs Herr zu werden. In Anbetracht es enormen Planungs-, Arbeits- und finanziellen Aufwands, den das Projekt erfordert, ist es wahrscheinlich, dass die Expressfahrbahnen speziell für Busse auf den am meisten befahrenen Straßen um einiges früher fertiggestellt werden. Es gibt auch die Hoffnung, dass nach zwölf Jahren Bauarbeiten die U-Bahn-Linie vom Stadion der Giants nach Chinatown zwölf Jahre nach Beginn der Bauarbeiten, in diesem Jahr endlich eröffnet werden kann.

Festivals sind noch immer eine Konstante in San Francisco, etwa Hardly Strictly Bluegrass mit einem kostenlosen Wochenende voller Folkmusik im Golden Gate Park. Dazu kommt die jährliche Gay-Pride-Parade im Juni, die mit ihren in den Regenbogenfarben kostümierten Teilnehmern und Feiernden regelmäßig mehr als eine Million Menschen sowohl aus dem LGBTQIA-Spektrum als auch andere anzieht, oder Litquake, ein zehn Tage dauerndes Literaturfestival im Herbst mit Autorenlesungen und anderen Veranstaltungen.

Oakland hat mittlerweile eine ansehnliche Kunstszene, vielleicht auch als Resultat daraus, dass so viele Künstler aus San Francisco verdrängt wurden. Sie nutzen die Stadt als Inspiration für Romane und Filme, wie Michael Chabons *Telegraph Avenue* oder *There There* von Tommy Orange, ein Finalist für den Pulitzer-Preis 2019. Oakland war auch das Setting für zwei Filme von 2018, die beide die afroamerikanische Erfahrung in der East Bay behandeln: *Sorry to Bother You* vom lokalen Rapper Boots Riley und Carlos López Estradas *Blindspotting*.

Wie an vielen Orten der Bay Area haben sich auch in Oakland mittlerweile immer mehr junge Fachkräfte niedergelassen, die sich die Mieten oder Wohnungen in San Francisco nicht leisten können und daher zu ihren gut bezahlten Stellen pendeln. Auch in Vierteln, die lange Zeit nicht begehrt waren, wie zum Beispiel East Oakland, kaufen jetzt immer mehr Menschen mit (gehobenem) Mittelklasse-Einkommen Häuser und verdrängen schlechter verdienende Anwohner genauso, wie es schon in San Francisco geschehen ist. In der Politik ist die in Oakland geborene Kamala Harris, ehemals Staatsanwältin in San Francisco, zur Vizepräsidentin von Joe Biden aufgestiegen.

2020 gab es prozentual mehr Milliardäre in der Bay Area als irgendwo sonst auf der Welt. Ungleichheiten wurden deutlich sichtbar, als Maßnahmen zur Eindämmung des Coronavirus schlecht bezahlte Arbeiter im Dienstleistungs- und Tourismussektor viel härter trafen als gut bezahlte Tech-Angestellte, die jetzt von zu Hause arbeiten konnten. In *The Last Black Man in San Francisco*, einem Arthausfilm von 2019, greifen junge Afroamerikaner zu verzweifelten Mitteln, um das Haus ihrer Familie im Fillmore zurückzubekommen. Ihr Kampf steht für San Franciscos wichtigste Aufgabe in der dritten Dekade des 21. Jahrhunderts – die vielen kulturellen, ästhetischen, und geografischen Kräfte, die die Stadt zu etwas Besonderem machen, zu bewahren. Wenn die letzten 175 Jahre ein Vorbild sind, dann wird San Francisco sich irgendwie anpassen, überlegen und gedeihen wird.

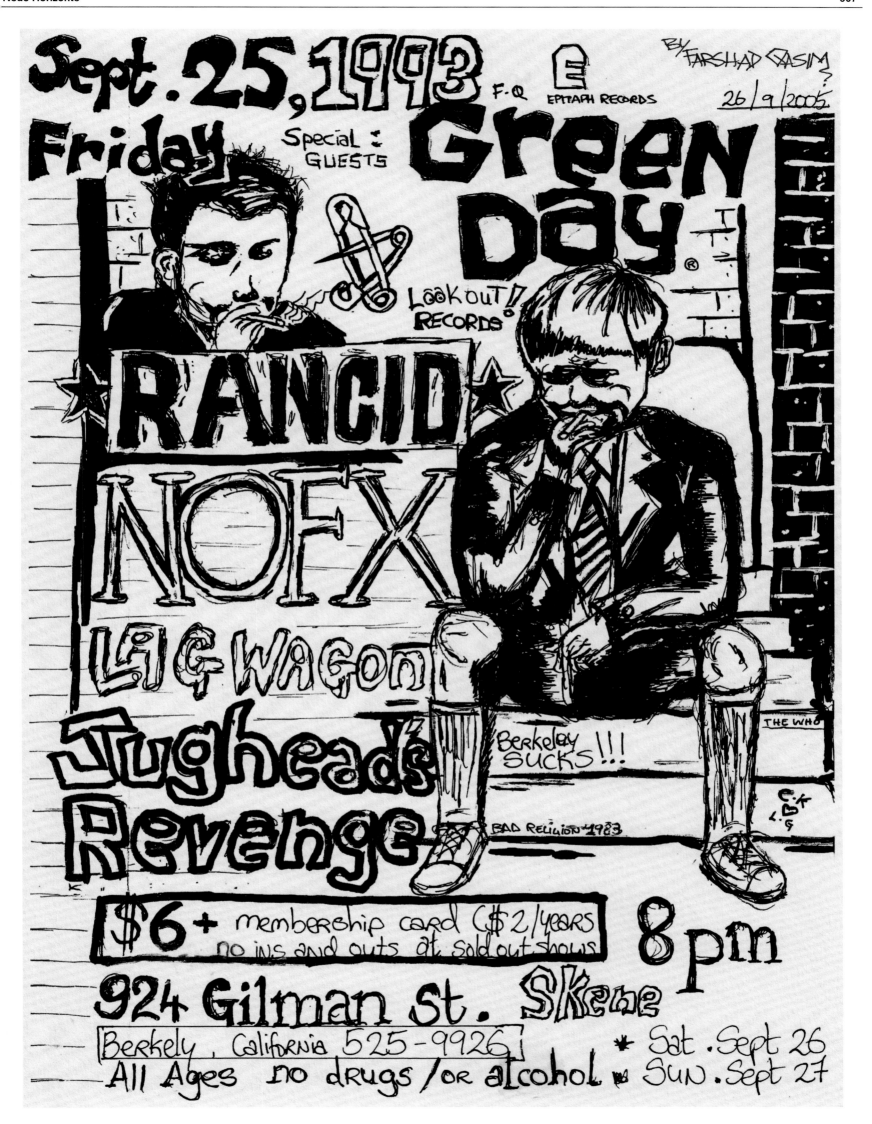

#5

Nouveaux horizons 1979 À NOS JOURS

p. 368/369
Ferdinando Scianna

One of many murals on San Francisco walls that reflects the city's multicultural heritage, 1985.

Eine der vielen Wandmalereien, die das multikulturelle Erbe der Stadt widerspiegeln, 1985.

L'une des nombreuses peintures murales de San Francisco, qui en reflètent l'héritage multiculturel. 1985.

Après l'assassinat de Harvey Milk, l'influence politique de la communauté gay a continué de s'accroître. Et quand Dan White n'a été reconnu coupable que d'homicide et non de meurtre avec préméditation, San Francisco a eu du mal à contenir son indignation. L'annonce du verdict, le 21 mai 1979, conduira plusieurs milliers de manifestants en colère à se diriger de nouveau vers l'hôtel de ville. Les émeutes de la « Nuit White » feront près de 100 blessés parmi les manifestants et une soixantaine dans les rangs policiers. La croisade de Milk en faveur de la visibilité homosexuelle trouvera certes d'autres hérauts mais bientôt, c'est une nouvelle priorité qui s'imposera et mobilisera toutes les énergies.

Apparue en 1981 avec pour épicentre le quartier du Castro, l'épidémie de sida frappa lourdement la communauté. En à peine quatre ans, elle tua plus de 500 personnes. En 1988, la ville dénombrait plus de 6 000 séropositifs – et ne resta pas pour autant sans réagir, créant dès 1982 la San Francisco AIDS Foundation, à l'initiative de leaders gays et de médecins. Toutes sortes de soutiens seront mis en place et des centres de soins palliatifs s'ajouteront à l'offre sanitaire. Marches et manifestations publiques destinées à lever des fonds pour la recherche et la sensibilisation au sida se tiendront régulièrement jusqu'à nos jours. Le Golden Gate Park abrite le National AIDS Memorial Grove, un site commémoratif dédié à toutes les victimes du sida, auxquelles le Patchwork des noms, né à San Francisco, rend également un vibrant hommage artistique. C'est aussi le cas de certaines des gigantesques fresques qui débordent de couleur et ornent les façades du Mission District, célébrant l'histoire et les émotions de son importante communauté latino-américaine. La célébration, à dire vrai, appartient à l'ADN de cette ville où s'enchaînent toute l'année d'innombrables défilés, foires, festivals, du Nouvel An chinois à la fête des fétichistes du cuir, en passant par le jour des Morts importé du Mexique. En 1986, c'est la crémation d'un mannequin géant sur la plage de Baker Beach, face au Golden Gate Bridge, qui lança Burning Man (« l'homme qui brûle »), l'un des rassemblements les plus originaux de la contre-culture, déplacé dans le Nevada à partir de 1990. Sur un plan plus sportif, chaque troisième dimanche de mai depuis 1912, la plus grande course à pied au monde, « Bay to Breakers », invite ses dizaines de milliers de participants à traverser la ville, de l'Embarcadero jusqu'à Ocean Beach pour 12 kilomètres d'un effort costumé : difficile d'imaginer ailleurs qu'à San Francisco les tenues qu'on y arbore à cette occasion et dont certains n'hésitent pas à se dispenser intégralement.

Le sport se retrouva aussi au cœur d'un nouveau drame. Le 17 octobre 1989, au Candlestick Park, le troisième match de la finale du championnat national de base-ball devait opposer pour la première fois les deux équipes séparées par la baie, Athletics d'Oakland et Giants de San Francisco. C'était sans compter sur la géologie et la faille de San Andreas qui juste après 17 heures déclencha le tremblement de terre dit de Loma Prieta, le plus important dans la région depuis 1906. Moins dévastateur, il n'en occasionna pas moins de sérieux bouleversements. Un tronçon de 15 mètres du Bay Bridge sera carrément coupé en deux et le tablier supérieur de l'autoroute 880, à Oakland, s'écroulera sur la voie inférieure. Près de Fort Mason, de nombreux résidents du Marina District, bâti sur des sols diversement remblayés en 1906, durent abandonner leurs maisons embourbées à la suite du phénomène de liquéfaction propre à certains séismes. Le bilan s'éleva à 63 morts, 3 757 blessés et quelque 6 milliards de dollars de dégâts matériels. Comme en 1906, San Francisco s'est vite rétablie. Dix jours plus tard, la finale de base-ball reprenait son cours à l'avantage écrasant des « A's » d'Oakland. Un mois seulement après son affaissement, le Bay Bridge était rouvert au public, qui fêta l'événement par une marche empruntant des voies habituellement congestionnées par le trafic automobile. San Francisco se préparait à connaître une prospérité plus éclatante que jamais, si chèrement payée toutefois que ses fondations sociales allaient être mises à l'épreuve, non moins rudement que venait de l'être son infrastructure urbaine.

De fait, les germes de certaines des grandes transformations qui s'apprêtaient à ébranler la ville à la fin du XXᵉ siècle avaient été semés longtemps auparavant, et plus au sud. Dans les années 1930, déjà, la région abritait une industrie électronique particulièrement compétitive, stimulée par la présence dans la banlieue de San José de la station aéronavale de Moffett Field, qui servait alors également de centre de recherche aéronautique. Au cours des années 1950, c'est à proximité de San José et non de San Francisco que s'élaborait surtout le développement des transistors en silicium et des circuits intégrés, autrement dit des puces électroniques. Au fil de la décennie 1970-1980, la Silicon Valley, qui s'étend à peu près de Palo Alto à San José, s'imposa comme le foyer ardent de la technologie destinée aux ordinateurs personnels, alors en passe de révolutionner tous les domaines de la vie, du travail aux loisirs. Entreprises et entrepreneurs commencèrent néanmoins à regarder d'un œil de plus en plus favorable l'installation à San Francisco de tout ou partie de leurs activités : aisément accessible à certains investisseurs potentiels, la ville pesait davantage auprès de la communauté financière internationale et elle était tout simplement plus grisante à vivre que les faubourgs de San José. Depuis lors, les élus locaux ont peiné à trouver le juste équilibre entre croissance et qualité de vie résidentielle, intérêts commerciaux et société civile. San Francisco devra attendre le siècle suivant pour ressentir les effets les plus spectaculaires de l'empreinte gravée en son sein par la high-tech.

Au début des années 1990, les start-up technologiques seront nombreuses à s'implanter au sud du Financial District, dans les espaces de bureaux plutôt bon marché situés non loin voire au cœur du petit quartier de South Park, qui se confond avec le parc ovale du même nom. Quand bien même elles étaient parfois financées par du capital-risque issu de la Silicon Valley, avoir son adresse à San Francisco conférait aux yeux du monde un évident cachet. La ville comptait également pléthore de jeunes artistes dont les compétences graphiques ne demandaient qu'à accompagner le développement de l'internet naissant et des activités qui lui étaient associées. La « Bay Area » figura ainsi parmi les premières à se convertir à l'expérience en ligne. Lancé en 1985, The WELL – « Whole Earth 'Lectronic Link » – fut sans doute la première communauté virtuelle reconnue comme telle. En 1993, c'est à quelques rues de South Park que naquit Wired (« Câblé »), le magazine de référence dédié à l'influence des technologies émergentes sur la société. Le Web vit également éclore des services communautaires en ligne susceptibles, comme l'avenir le prouvera, de rapporter à leurs propriétaires de substantiels bénéfices ; ce sera le cas du site de petites annonces Craigslist. Tout était réuni pour l'essor des sociétés en « .com » et à travers elles, le boom de l'internet. Dans

Zodiac, *David Fincher, Phoenix Pictures,*
2007.

cette histoire, San Francisco jouera un rôle majeur. Les start-up se multiplièrent comme des petits pains, encouragées par des investisseurs qui rêvaient tous, en un remake frénétique de la ruée vers l'or californienne, de dénicher le navigateur du futur, le nouvel Amazon ou le jeu vidéo inédit qui ringardiserait la concurrence. Et avec l'envolée des salaires de tous ces gens pétris de talent, les loyers ne manquèrent pas, eux non plus, de flamber.

Tout au long de son existence, San Francisco a vu débarquer du monde entier de nouveaux arrivants en quête de bonne fortune. Il fallut, une fois encore, trouver le moyen d'en accueillir une vague supplémentaire. À ceci près que ces novices avaient de quoi s'offrir des loyers nettement plus élevés que ce que le marché proposait jusque-là aux résidents de longue date. C'est ainsi que des quartiers d'entrepôts à population essentiellement ouvrière, comme South of Market, ont commencé à s'embourgeoiser à mesure qu'y emménageait une nouvelle catégorie d'habitants. Les derniers îlots à abriter des familles modestes subirent le même sort. Tout le monde, cependant, ne peut pas devenir un nabab, et du boom à la bulle, il n'y a jamais loin. Le xxiᵉ siècle s'était à peine élancé que de nombreuses start-up avaient déjà mis la clé sous la porte ; la flambée de l'immobilier et la gentrification de San Francisco se calmèrent alors pour un petit moment. Mais l'explosion de l'internet avait failli altérer irrévocablement la nature de la ville, et pas seulement en jetant à la rue une proportion croissante de sans-abri. La fermeture en 2000 du Downtown Rehearsal Space, un grand complexe qui hébergeait en périphérie des centaines de salles où les rockers venaient répéter à des tarifs raisonnables, fit même redouter l'extinction totale de la scène musicale locale.

La perspective de voir la ville réduite à une extension septentrionale de la Silicon Valley avait beau susciter une inquiétude latente, les mouvements créatifs et politiques qui avaient aidé San Francisco à forger son identité depuis les années 1950 n'ont pas cessé de prospérer. La scène artistique trouva un second souffle avec l'ouverture en 1995 du nouveau musée d'Art moderne, situé au sud du centre-ville et au-dessus du Moscone Center, le palais des congrès achevé en 1981. À l'instar du Yerba Buena Arts

Center voisin, le quartier verra se succéder une série d'expositions contemporaines majeures et souvent avant-gardistes qui mettront à l'honneur des artistes mondialement connus. Autour du Music Concourse, le vaste ovale en plein air offert aux mélomanes au cœur du Golden Gate Park, le musée De Young et l'Académie des sciences de Californie firent l'objet de rénovations significatives. Initialement vilipendée pour son austérité architecturale, la Harmon Observatory Tower devint l'une des destinations favorites des visiteurs du musée De Young, assurés d'avoir droit, derrière ses panneaux de verre, à une perspective panoramique sur le parc et les quartiers environnants. Le Civic Center, lui, s'est enrichi d'un musée d'Art asiatique substantiellement agrandi, jouxtant la bibliothèque centrale de la ville, elle aussi remise à neuf : dans le cadre d'un projet artistique et patrimonial, les murs de son atrium asymétrique s'ornèrent de dizaines de milliers de fiches issues du catalogue d'antan, annotées à la main en 12 langues par près de 200 représentants des communautés qui peuplent San Francisco.

Une intense évolution économique et immobilière, avec les difficultés qu'elle génère, n'interdit pas de soigner son apparence, ce que fit « San Fran » grâce au lancement de nouveaux projets résolument respectueux de l'environnement. Le début des années 1990 sera ainsi marqué par la démolition de l'Embarcadero Freeway, autoroute exécrée des piétons parce qu'elle leur cassait les oreilles et obstruait la vue du front de mer. Celui-ci pourra dès lors se parcourir sur 5 kilomètres à ciel ouvert, a pedibus ou à vélo, à partir de Fisherman's Wharf et jusqu'au Bay Bridge en passant par un Ferry Building rafraîchi. En 2000, les San Francisco Giants inaugureront dans le quartier de South Beach leur nouveau stade de base-ball, le magnifique Pacific Bell Park.

Le tournant du siècle ne marqua pas l'arrêt des manifestations progressistes, certes beaucoup moins heurtées que par le passé. La ville penchant clairement à gauche, tout rassemblement réunissait une forte participation qui lui conférait mécaniquement une portée nationale. À l'aube des années 1990 et 2000, certaines marches organisées contre l'intervention américaine au Moyen-Orient mobilisèrent plus de 100 000 personnes. D'autres actions

The Story of a Marriage,
Andrew Sean Greer, Picador,
2008.

s'inscriront dans le cadre de revendications trop spécifiques pour résonner au-delà de la région. Ce sera le cas en 1999 lorsqu'à la suite d'un conflit social, le réseau Pacifica Foundation décida de fermer KPFA, la station de radio de Berkeley à financement participatif, globalement très marquée à gauche. Un cortège de 10 000 mécontents descendra dans les rues de Berkeley pour exiger – et obtenir – l'annulation de la mesure. Quant à Critical Mass («Masse critique»), il appartient à la catégorie des événements inclassables et imaginatifs. Lancé en septembre 1992, il prenait la forme d'une balade à vélo dans des quartiers affectés par une très dense circulation automobile. Des milliers de cyclistes se retrouveront ainsi à pédaler de concert près du Ferry Building, le dernier vendredi soir de chaque mois, au grand dam des conducteurs réduits à klaxonner derrière leur volant, et à la vive satisfaction des badauds. Les «masses critiques» ont essaimé dans plus de 300 villes, hommage subtil et révélateur à l'influence de San Francisco sur la conscience écologique mondiale.

La politique continua de s'inscrire dans une dynamique toujours plus inclusive. En 1995 le flamboyant Willie Brown, président de l'Assemblée de l'État de Californie, devint le premier maire afro-américain de San Francisco. Son successeur en 2004, Gavin Newsom, défraiera la chronique en ordonnant aux officiers d'état civil de délivrer des certificats de mariage aux personnes de même sexe, en contravention avec la législation californienne du moment (le mariage homosexuel devra attendre 2013 pour être totalement légalisé en Californie).

Après l'éclatement de la bulle internet, au début des années 2000, l'équilibre socio-économique de San Francisco sera une fois encore bouleversé par une nouvelle expansion du secteur technologique. Google avait été fondé en 1998 par des étudiants de l'Université de Stanford. Facebook, créé en 2004 à Harvard, s'installa à Palo Alto la même année avant de rejoindre Menlo Park. L'extraordinaire succès de ces entreprises et d'autres start-up comparables se traduisit par d'importants besoins de main-d'œuvre. Parce qu'elles n'avaient pas toutes envie de vivre à proximité de leur lieu de travail, au sud de la péninsule, leurs recrues furent

si nombreuses à s'installer dans des quartiers populaires de San Francisco, comme le Mission District, que Google décida de mettre en service une flotte d'autobus privée, vouée à faire la navette entre la ville et Mountain View, son siège social, 65 kilomètres plus loin. Les difficultés de circulation déjà endémiques à San Francisco ne s'en portèrent pas mieux et la colère des résidents «traditionnels» s'exprima vertement: il leur arrivait de ne pas même pouvoir monter dans leur bus habituel lorsque l'arrêt municipal était accaparé par les luxueux véhicules de Google et consorts.

Dans les années 2010, certaines entreprises en plein boom implanteront directement leur siège ou une filiale à San Francisco même. Ce sera le cas d'Uber, de Lyft, de Twitter et de Spotify (la webradio Pandora était déjà basée à Oakland). À l'approche de 2020, la population totale de la ville approchera les 900 000 habitants, soit 100 000 de plus qu'au début du nouveau millénaire. Classée derrière Manhattan au deuxième rang des villes les plus chères des États-Unis, elle affichera des prix médians dépassant le million de dollars et des loyers trois fois supérieurs à la moyenne nationale. Une confirmation, si nécessaire, que posséder une adresse à San Francisco était vraiment devenu un must, mais par voie de conséquence, et en dépit de certaines législations réglementant plus strictement les loyers, la population déjà importante des sans-abri augmenta encore. En 2019 on en comptait plus de 10 000 et au cours des deux seules années précédentes, le nombre de personnes répondant à la définition fédérale de «homeless» avait bondi de 17 %. Beaucoup de gens, après avoir perdu leur logement, n'avaient plus les moyens d'en retrouver un, d'autant que lorsque la pandémie de Covid-19 frappa l'économie en 2020, les procédures d'expulsion visèrent les couches de locataires les moins aisés. La diversité en pâtira également puisque la population afro-américaine est passée de 13,4 % en 1970 à 5,5 %. Entre toutes les grandes cités américaines, c'est aussi San Francisco qui affiche la proportion d'enfants la plus faible (13 %).

Cela n'empêcha pas Facebook, en 2018, de signer le plus gros bail de l'histoire de San Francisco pour occuper la Park Tower et ses 184 mètres de hauteur. Uber se bâtit un immense et nouveau

bercail au sud de Mission Bay, théâtre depuis la fin des années 1990 d'une non moins massive opération de redéploiement urbain qui profita notamment aux activités des entreprises de biotechnologie et à l'Université de Californie à San Francisco (UCSF). Ouverte en 2019, l'arène du Chase Center, qui accueille maintenant à demeure les Golden State Warriors et des concerts de très haut niveau, a permis de revivifier la fréquentation du quartier. Surplombant du haut de ses 326 mètres ce foisonnement d'édifices, la Salesforce Tower est aujourd'hui le deuxième gratte-ciel le plus élevé à l'ouest du Mississippi ; il domine un grand parc aménagé sur le toit du Salesforce Transit Center, la nouvelle gare routière appelée à succéder au Transbay Terminal. La découverte de fissures dans une poutre en acier supportant le parc doucha toutefois l'enthousiasme qui avait accompagné son inauguration en août 2018. Fin septembre les lieux durent être fermés au public, jusqu'à l'été suivant.

Le loisir sportif, lui, s'étend dorénavant le long du Bay Bridge, grâce à une piste cyclable qui relie l'East Bay à l'île artificielle de Treasure Island. En 2019, une autre voie a été aménagée sur le pont Richmond-San Rafael, qui permet de pédaler de l'East Bay jusqu'au comté de Marin. Il est également prévu d'ajouter au réseau de transport BART un nouveau Transbay Tube, soit un deuxième tunnel sous la baie, dans l'espoir de réduire les embouteillages qui ne cessent de s'aggraver. Compte tenu de l'ampleur du coût, de la planification et de la main-d'œuvre indispensables à une telle opération, il est probable que les lignes dédiées et prioritaires du projet Bus Rapid Transit, chargées d'accélérer la circulation sur les axes les plus fréquentés, auront vu le jour bien avant. Très attendue aussi, l'inauguration cette année, douze ans après son premier coup de pioche, du Central Subway, une ligne de métro qui doit traverser le centre-ville, de l'arène des Giants jusqu'à Chinatown – ces Giants vainqueurs de trois titres nationaux de base-ball entre 2010 et 2014, imités par les Golden Gate Warriors peu avant leur départ d'Oakland pour revenir à San Francisco : trois titres NBA de 2015 à 2018.

Les festivals restent indissociables de la vie locale. Hardly Strictly Bluegrass attire en octobre dans le Golden Gate Park, gracieusement, des centaines de milliers d'amateurs d'une *old-time music* aux racines celtiques et afro-américaines. En juin, les marcheurs et fêtards de la Gay Pride sont plus d'un million, pas tous nécessairement LGBT, à défiler déguisés derrière l'étendard arc-en-ciel. Le monde littéraire a droit lui aussi à son festival, Litquake, qui chaque automne propose à des dizaines de milliers de visiteurs dix jours de lectures publiques, de rencontres avec les auteurs et d'événements disséminés un peu partout dans la ville.

San Francisco reste le carrefour incontournable des manifestations de soutien aux droits des femmes, à l'adaptation au changement climatique et à l'accueil des immigrés. Le 21 janvier 2017, près de 100 000 personnes ont défilé du Civic Center au Ferry Building lors d'une Marche des femmes qui servira de point d'appui à la contestation suscitée par l'investiture, la veille, du président Donald Trump. Quelques jours plus tard, des centaines de personnes envahiront l'aéroport international pour protester contre un décret gouvernemental interdisant aux ressortissants de sept pays musulmans l'entrée aux États-Unis. Le 1er mai, six mois avant sa mort brutale et inattendue, Ed Lee, le premier maire sino-américain de la ville, conduira en personne dans Market Street un cortège en faveur des travailleurs immigrés de la région.

Conséquence, ou non, de la migration de certains artistes issus de San Francisco, Oakland accueille désormais une formidable communauté créative auxquels elle inspire des œuvres à succès. Les romans *Telegraph Avenue* (Michael Chabon) et *Ici n'est plus ici*, finaliste du prix Pulitzer 2019 (Tommy Orange), l'ont choisie pour cadre, ainsi que deux films sortis en 2018 qui l'un comme l'autre éclairent le quotidien des Afro-Américains de l'East Bay : *Sorry to Bother You* (« Désolé de vous déranger »), réalisé par le rappeur Boots Riley, et *Blindspotting* (de blind spot, « angle mort »), signé Carlos López Estrada. Comme à peu près toute la « Bay Area », Oakland abrite également une population toujours plus importante de jeunes actifs qui ne peuvent pas se permettre de louer ou d'habiter à San Francisco et font généralement la navette entre leur domicile et un job bien payé de l'autre côté du pont. Des quartiers jugés autrefois peu engageants,

tel East Oakland, ont vu s'installer de plus en plus de propriétaires à revenu moyen ou supérieur. Certains de leurs résidents les moins aisés seront poussés à un exode comparable à celui qu'ont connu avant eux tant d'habitants de San Francisco. C'est aussi à Oakland qu'est née Kamala Harris ; son élection au poste de procureur du district de San Francisco, en 2003, lui valut une notoriété politique qui lui a permis de devenir en 2020 la première femme vice-présidente des États-Unis, sous l'autorité de Joe Biden.

Cette année-là, la « Bay Area » affichait la proportion de milliardaires par habitant la plus élevée du pays. Les efforts déployés pour endiguer la pandémie de Covid-19, en particulier les confinements successifs et la fermeture des restaurants et salles de spectacle, ont creusé davantage encore les inégalités. Les employés à bas salaire du secteur du tourisme ont été plus sévèrement touchés que les employés de la « tech » invités à travailler à domicile. Primé en 2019 au Festival de cinéma indépendant de Sundance, le film *Le dernier homme noir de San Francisco* montre de jeunes Afro-Américains tentant en vain de récupérer la maison de leur enfance dans le quartier gentrifié de Fillmore. Ce combat reflète la mission que s'est donnée la ville à l'aube de la troisième décennie du XXIe siècle : réussir à préserver les nombreux atouts culturels, esthétiques et géographiques qui lui confèrent sa force inimitable. À en juger d'après les 175 années qui viennent de s'écouler, San Francisco saura trouver le moyen de s'adapter, de survivre et de prospérer.

←
Andy Warhol

View from the Stanford Court Hotel, one of Nob Hill's most opulent dwellings. It was built on the site of railroad magnate Leland Stanford's mansion, which was destroyed in the 1906 earthquake. The buildings in the foreground are on Powell Street, near where cable car lines connect at Powell and California streets, c. 1980s.

Der Ausblick vom Stanford Court Hotel, einer der opulentesten Bleiben in Nob Hill. Es steht dort, wo bis zum Erdbeben von 1906 die Villa des Eisenbahntycoons Leland Stanford stand. Die Gebäude im Vorder-

grund sind an der Powell Street, in der Nähe kreuzen sich an der Powell und California Street die Cable-Car-Linien, um 1980.

L'hôtel Stanford Court, l'une des demeures les plus opulentes de Nob Hill. Il a été édifié sur le site du manoir appartenant au magnat des chemins de fer Leland Stanford, détruit lors du séisme de 1906. Les bâtiments au premier plan se trouvent sur Powell Street, à proximité du point de rencontre des lignes de cable cars, à l'angle de Powell Street et de California Street. Vers les années 1980.

↑
Mimi Plumb

The Mission District and downtown, as seen from the top of Bernal Hill in Bernal Heights, a residential neighborhood south of the Mission. Although seldom seen by visitors to the city, the hill's panoramic views rival those at Twin Peaks, 1987.

Der Mission District und Downtown, gesehen von der Spitze des Bernal Hill in Bernal Heights, einem Wohnviertel im Süden der Mission. Obwohl Besucher selten hierher kommen, kann der Ausblick mit dem von den Twin Peaks mithalten, 1987.

La cime de Bernal Hill, dans le quartier résidentiel de Bernal Heights, offre une perspective plongeante sur le Mission District et le centre-ville. Les visiteurs lui font rarement honneur mais cette colline offre des vues panoramiques qui en font une digne rivale des Twin Peaks. 1987.

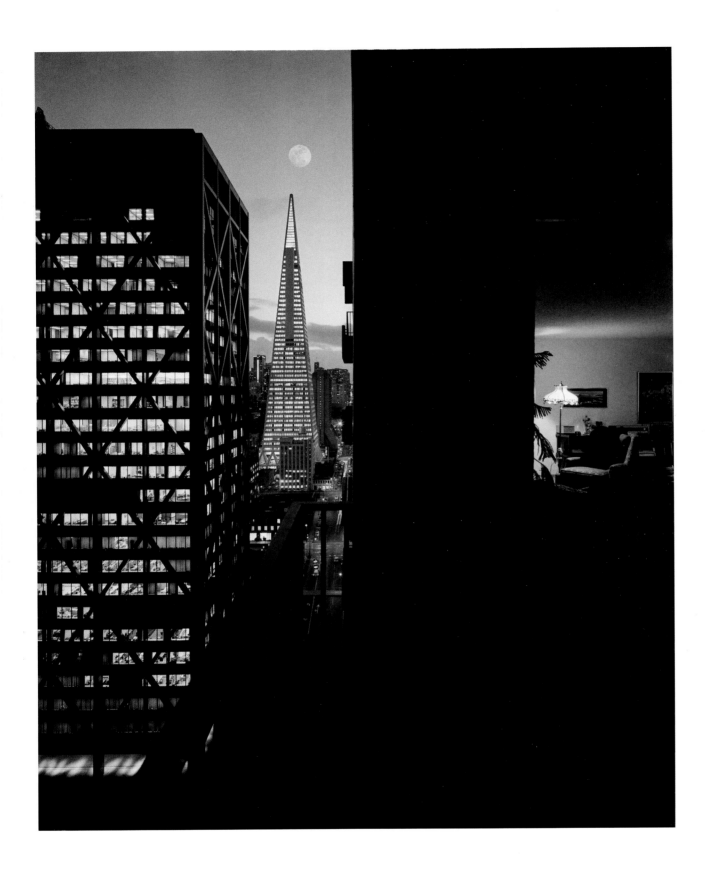

↑

Gene Wright

The moon nearly balances atop the Transamerica Pyramid as the Financial District lights up at night, c. 1980s.

Der Mond balanciert fast auf der Spitze der Transamerica Pyramid im bei Nacht hell erleuchteten Finanzbezirk, 1980er-Jahre.

La lune s'apprête à frôler le sommet de la Transamerica Pyramid, alors que la nuit tombe et que le Financial District s'illumine. Vers les années 1980.

→

Jet Lowe

Completed in 1918, the Hallidie Building in the Financial District on Sutter Street between Montgomery and Kearny streets. Designed by Willis Polk, it featured one of the first glass-curtain walls in the United States and was named after Andrew Hallidie, sometimes credited as creator of the cable car system, 1981.

Das Hallidie Building an der Sutter Street im Finanzviertel, zwischen Montgomery und Kearny Street wurde 1918 fertiggestellt. Von Willis Polk entworfen, hat es eine der ersten Glasfassaden in den USA und wurde nach Andrew Hallidie benannt, dem manchmal die Erfindung des Cable-Car-Systems zugeschrieben wird, 1981.

Achevé en 1918, le Hallidie Building se trouve dans le Financial District, sur Sutter Street, entre Montgomery Street et Kearny Street. Dessiné par Willis Polk, il comportait l'un des premiers murs-rideaux en verre des États-Unis et portait le nom d'Andrew Hallidie, considéré comme l'inventeur du système de cable cars. 1981.

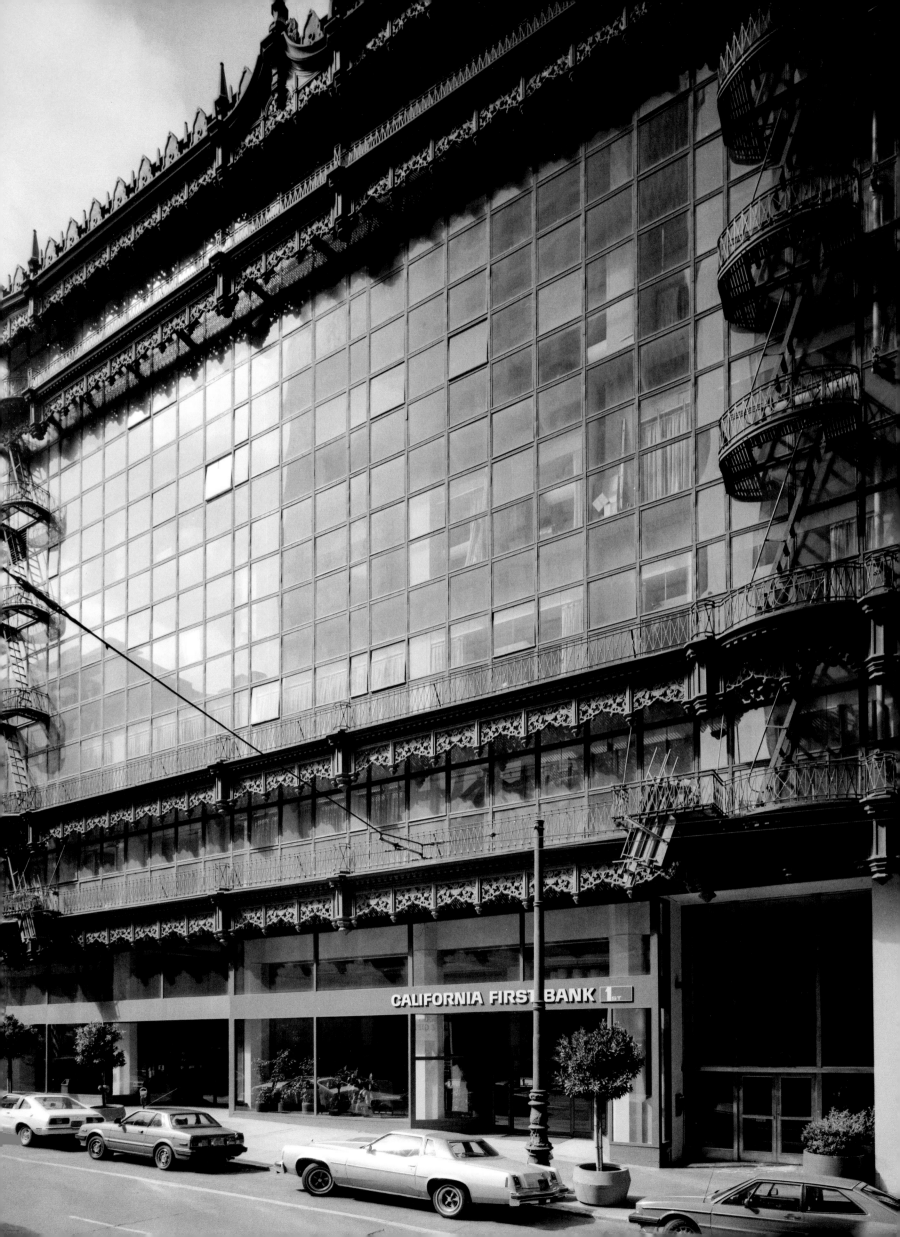

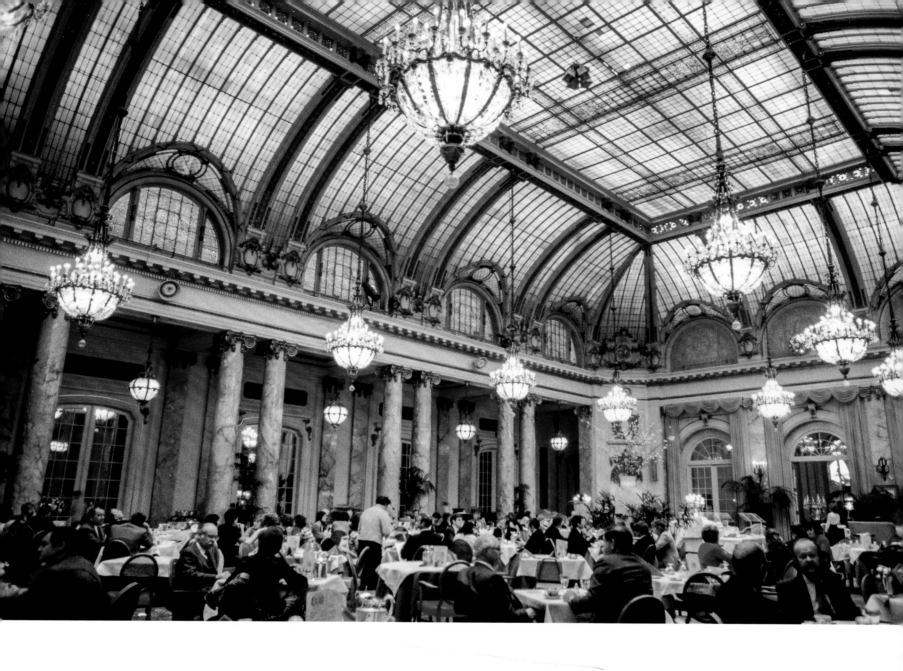

Ernest Braun

The Garden Court restaurant at the Palace
Hotel, at the corner of Market and New
Montgomery streets. Opened in 1909 shortly
after the luxury hotel's post-earthquake
restoration, it's famed for its stained glass
domed ceiling, crystal chandeliers, and
marble columns, 1981.

Das Garden Court Restaurant im Palace
Hotel, an der Ecke Market und New Montgo-
mery Street. Das Luxushotel wurde 1909
nach dem Erdbeben wieder eröffnet. Das
Restaurant ist berühmt für seine Kuppelde-
cke aus Buntglas, Kristallkronleuchter und
Marmorsäulen, 1981.

Le restaurant Garden Court du luxueux
Palace Hotel, à l'angle de Market Street et
de New Montgomery Street. Ouvert en 1909
peu après la réfection de l'hôtel consécutive
au tremblement de terre, il est réputé pour
sa superbe verrière, ses lustres en cristal et
ses colonnes de marbre. 1981.

↓
Ernest Braun

The world's largest produce cannery when it was built near Fisherman's Wharf in 1907, the Cannery was converted in the 1960s into a mall of shops and restaurants, c. 1980s.

Die Cannery war die größte Gemüse-konservenfabrik der Welt, als sie in der Nähe der Werft ntstand. Sie wurde in den 1960er-Jahren zu einem Einkaufszentrum umgebaut, um 1980.

Lors de sa construction près de Fisherman's Wharf en 1907, elle était la plus grande conserverie de fruits et de confitures au monde. The Cannery a été transformée en galerie marchande dans les années 1960. Vers 1980.

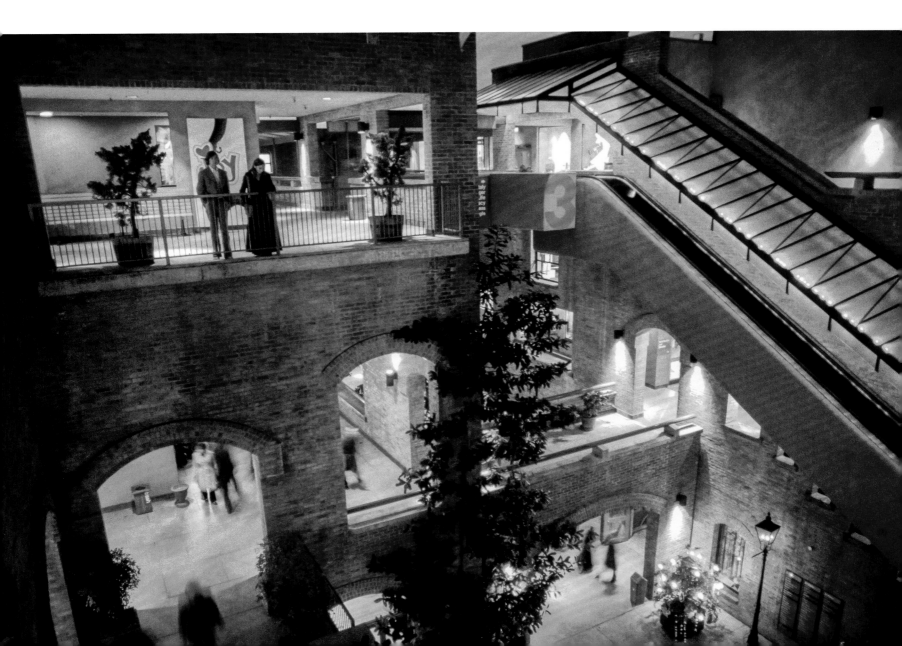

"The Landlord's here to visit
They're blasting disco down below
Says, 'I'm doubling up the rent
'Cause the building's condemned
You're gonna help me buy City Hall.'"
DEAD KENNEDYS, "LET'S LYNCH THE LANDLORD," 1980

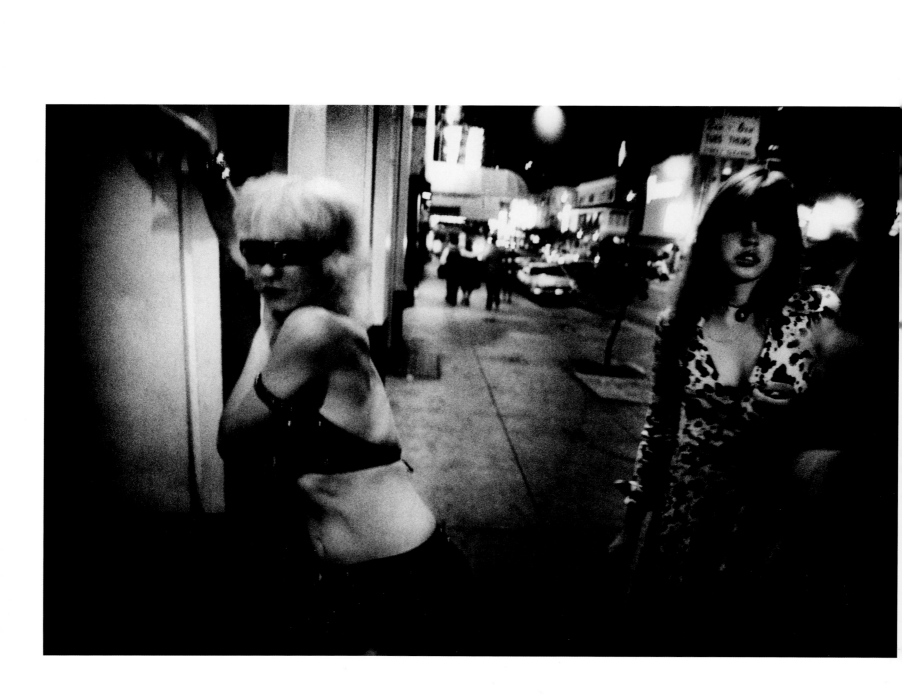

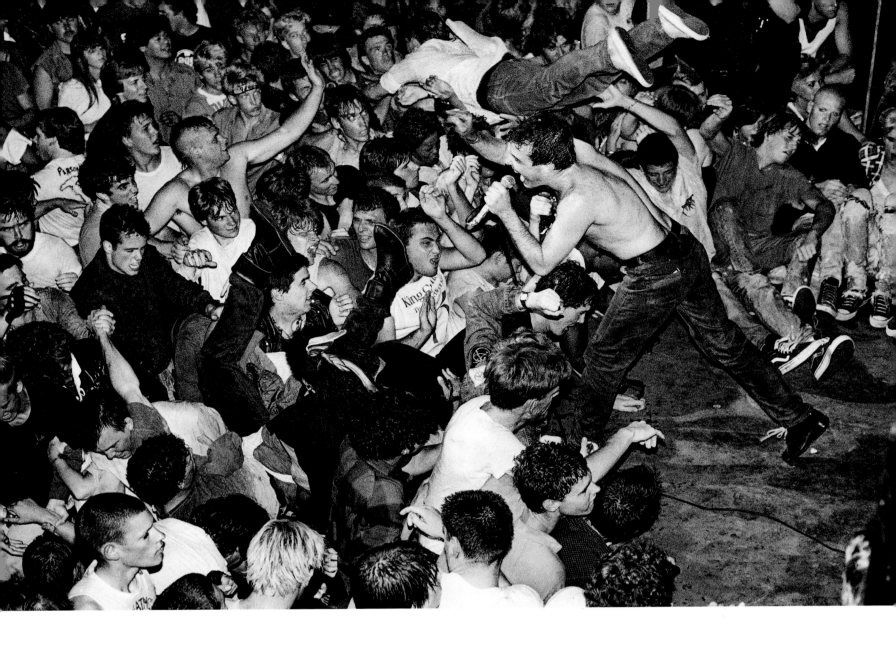

Stanley Greene

As the '80s got underway, the most infamous strip of North Beach remained populated by, in the words of the photographer, "clubs, topless strip joints and high priced hookers." He titled this picture North Beach Nights, 1980.

Auch in den 1980er-Jahren blieb der berüchtigtste Strip in North Beach voll von, in den Worten des Fotografen, „Clubs, Oben-ohne-Stripschuppen und teuren Nutten". Er nannte das Bild North Beach Nights, 1980.

À l'aube des années 1980, la zone de North Beach la moins bienséante restait peuplée de « boîtes, de stripteaseuses aux seins nus et de prostituées hors de prix », selon les mots du photographe qui a intitulé ce cliché North Beach Nights. 1980.

Stanley Greene

Dead Kennedys singer Jello Biafra at the Mabuhay Gardens, the city's top punk rock club, on Broadway in North Beach. As this show took place on the 15th anniversary of John F. Kennedy's death, both club and venue were accused of pushing the boundaries of good taste, 1978.

Jello Biafra, Sänger der Dead Kennedys, im Mabuhay Gardens, dem wichtigsten Punkrockclub der Stadt. Weil die Show am 15. Jahrestag von John F. Kennedys Tod stattfand, wurde Club und Band mangelnde Pietät vorgeworfen, 1978.

Jello Biafra, chanteur des Dead Kennedys, ici au Mabuhay Gardens, le meilleur club punk rock de la ville, sur Broadway à North Beach. Ce concert étant programmé le jour du 15ᵉ anniversaire de l'assassinat de John F. Kennedy, les organisateurs ont été accusés d'avoir poussé un peu trop loin les limites du bon goût. 1978.

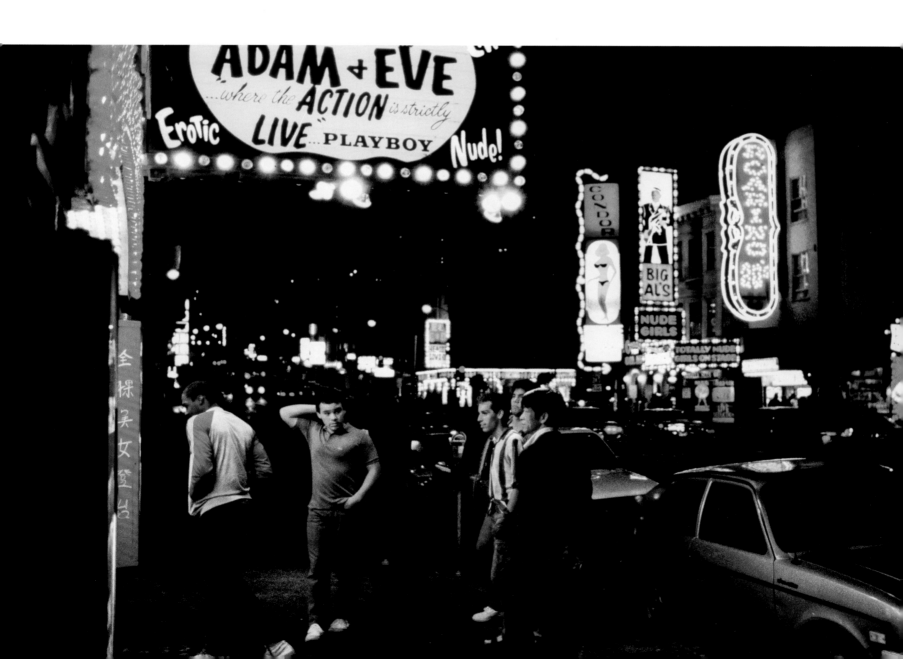

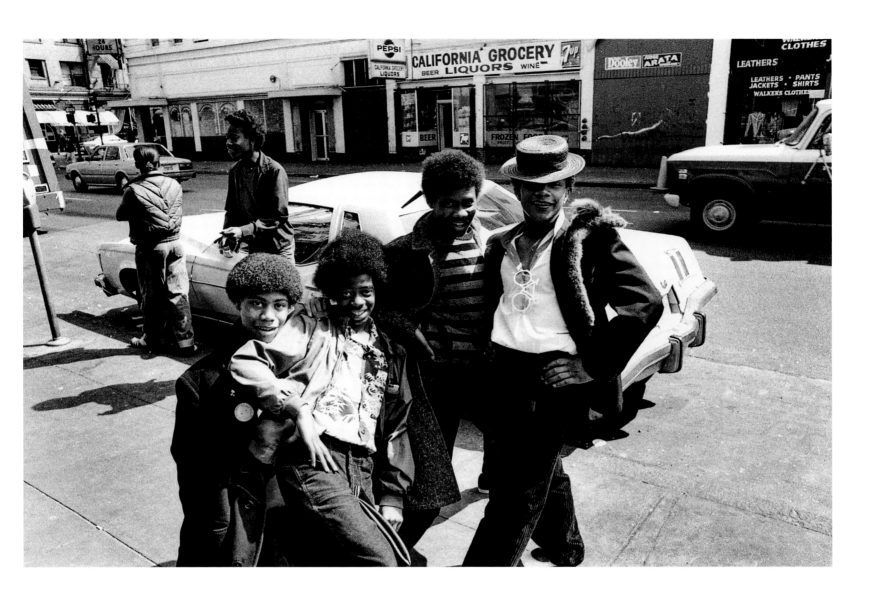

←
Ferdinando Scianna

Broadway in North Beach had in many ways not changed much over the past few decades. The strip was still clogged with adult entertainment and strip clubs, some of which, like the Condor and Big Al's, had been in business since the mid-'60s, 1985.

Der Broadway in North Beach war auf ein vielerlei Hinsicht über die Jahrzehnte hinweg gleich geblieben. Die Gegend war voll von „Erwachsenenunterhaltung" und Stripclubs, von denen es einige, wie das Condor oder das Big Al's, schon seit Mitte der 1960er gab, 1985.

À bien des égards, Broadway, à North Beach, n'a guère changé au cours des dernières décennies. Les trottoirs sont toujours envahis de divertissements « pour adultes » et de clubs de strip-tease dont certains, à l'image du Condor et du Big Al's, sont en activité depuis le milieu des sixties. 1985.

↑
Miron Zownir

Near the corner of Eddy and Mason streets, on the eastern edge of the Tenderloin, 1980.

In der Nähe der Ecke Eddy und Mason Street am östlichen Rand des Tenderloin, 1980.

À proximité de l'angle que forment Eddy Street et Mason Street, à la limite orientale du Tenderloin. 1980.

"It's Friday night. The unfettered city
Resounds with hedonistic glee.
John feels a cold cast of self-pity
Envelop him. No family."

VIKRAM SETH, *THE GOLDEN GATE,* 1986

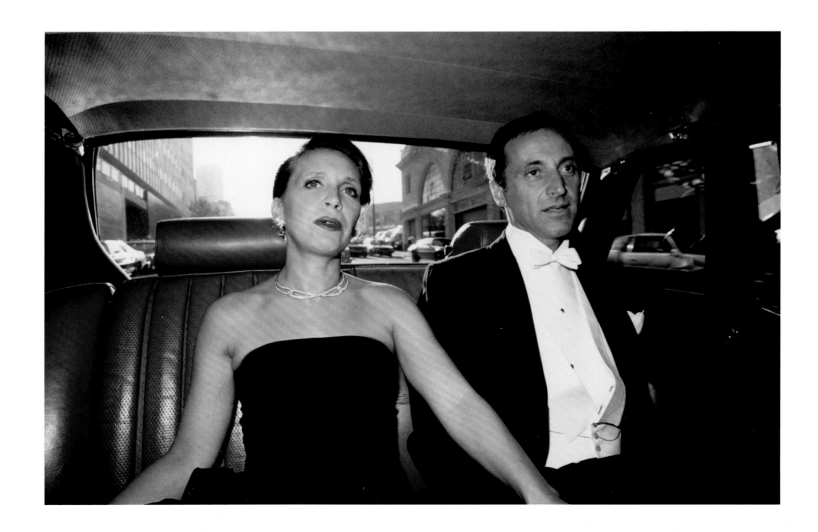

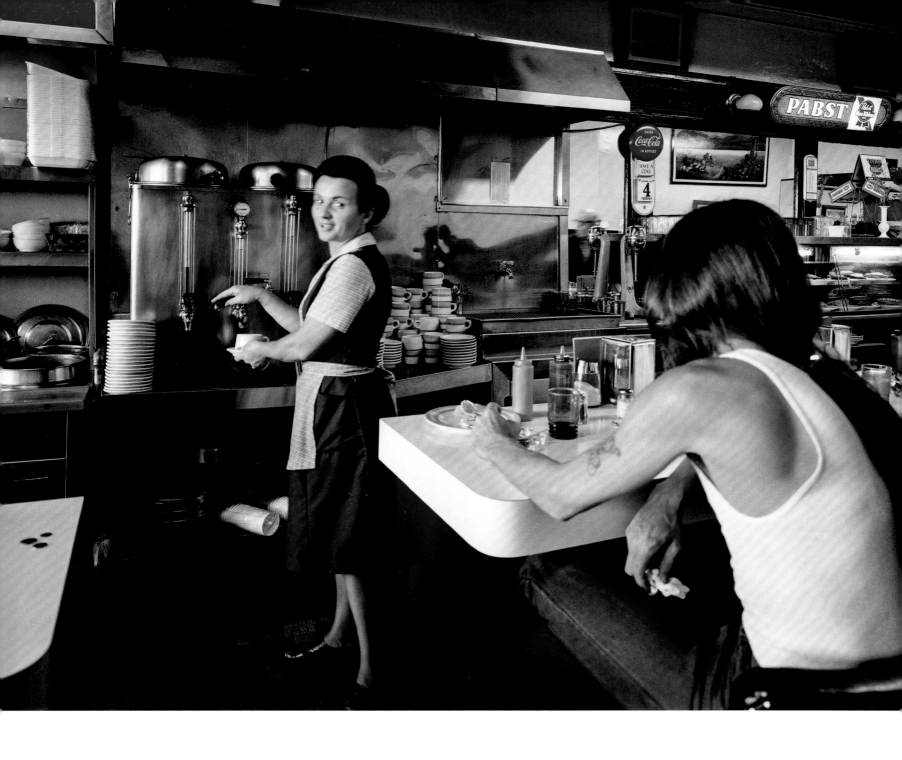

←

Ed Kashi

Best-selling romance novelist Danielle Steel with her husband of the time, shipping executive and vintner John Traina. Steele owned one of the Pacific Heights neighborhood's most palatial homes, the Spreckels Mansion, on Washington Street near Lafayette Park, 1982.

Danielle Steel, Bestsellerautorin von Liebesromanen, mit ihrem damaligen Ehemann, dem Reedereiunternehmer und Winzer John Traina. Steele gehörte eine der palastartigsten Villen in Pacific Heights, die Spreckles Mansion an der Washington Street in der Nähe von Lafayette Park, 1982.

Danielle Steel, dont les romans d'amour furent autant de best-sellers, avec son mari de l'époque, l'armateur et viticulteur John Traina. Steele possédait l'une des demeures les plus somptueuses du quartier de Pacific Heights, le manoir Spreckels sur Washington Street, près de Lafayette Park. 1982.

↑

Janet Delaney

A waitress named Pat serves coffee at the Gordon Cafe at 7th and Mission streets. This was part of the photographer's South of Market, 1978–1986 series, documenting the South of Market neighborhood as it changed when the area was redeveloped into the Moscone Center, 1980.

Im Gordon Café an der Seventh und Mission Street, schenkt die Kellnerin Pat Kaffee aus. Das Bild ist Teil der Serie South of Market, 1978–1986, mit der die Fotografin den Wandel des Viertels South of Market durch die Neugestaltung des Moscone Center dokumentierte, 1980.

Une serveuse prénommée Pat prépare du café au bien nommé Gordon Cafe, à l'angle de la 7e Rue et de Mission Street. Cette image fait partie de l'ouvrage South of Market, 1978–1986 qui rassemble le travail que la photographe a consacré à la transformation de ce quartier à la suite de l'extension du Moscone Center. 1980.

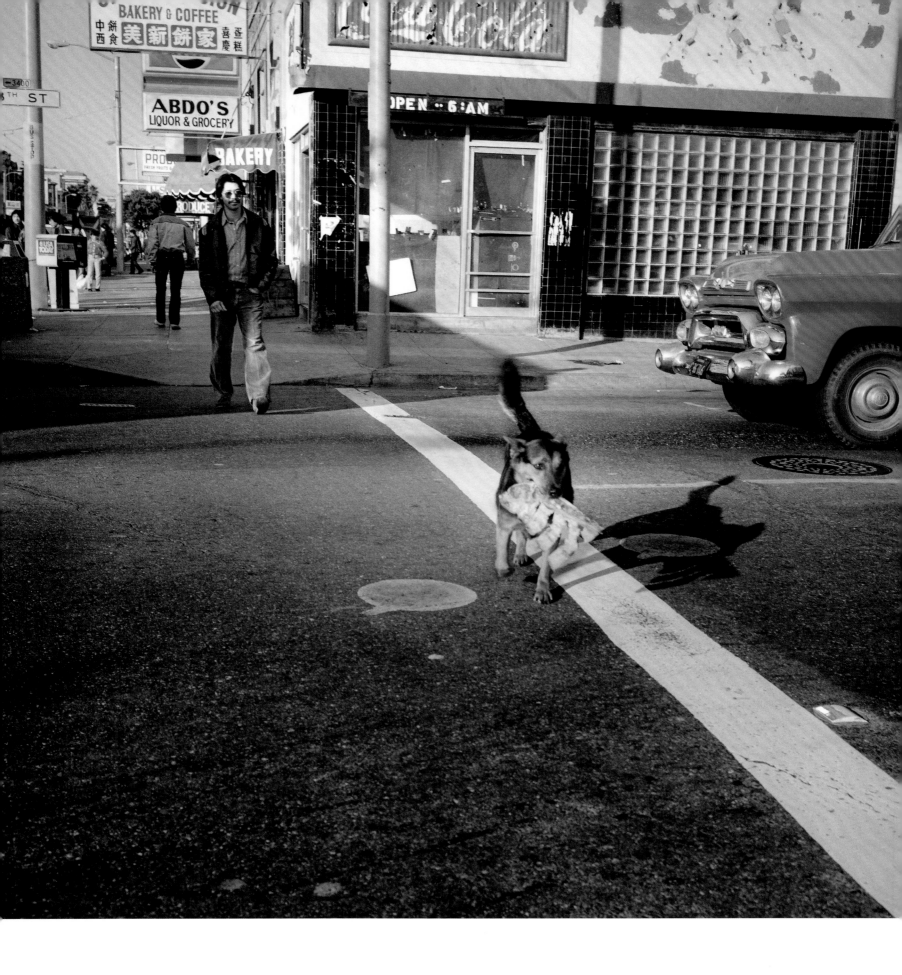

↑
Janet Delaney

Dog carrying ribs across the intersection at 18th and Mission streets in the Mission District. At the heart of the stretch of Mission Street between 14th and Cesar Chavez streets that serves as the neighborhood's bloodline, 1984.

Ein Hund trägt Rippchen über die Kreuzung Eighteenth und Mission Street im Mission District, die Hauptverkehrsader im Viertel zwischen Fourteenth und Cesar Chavez Street, 1984.

Dans le Mission District, à l'angle de la 18ᵉ Rue et de Mission Street, la côte de bœuf se porte à même la gueule. Ce tronçon de Mission Street, entre la 14ᵉ Rue et Cesar Chavez Street, atteste le pedigree du quartier. 1984.

→
John Harding

Market Street on the day before Christmas Eve, 1981.

Market Street am Tag vor Heiligabend, 1981.

Market Street, à quelques heures du réveillon de Noël. 1981.

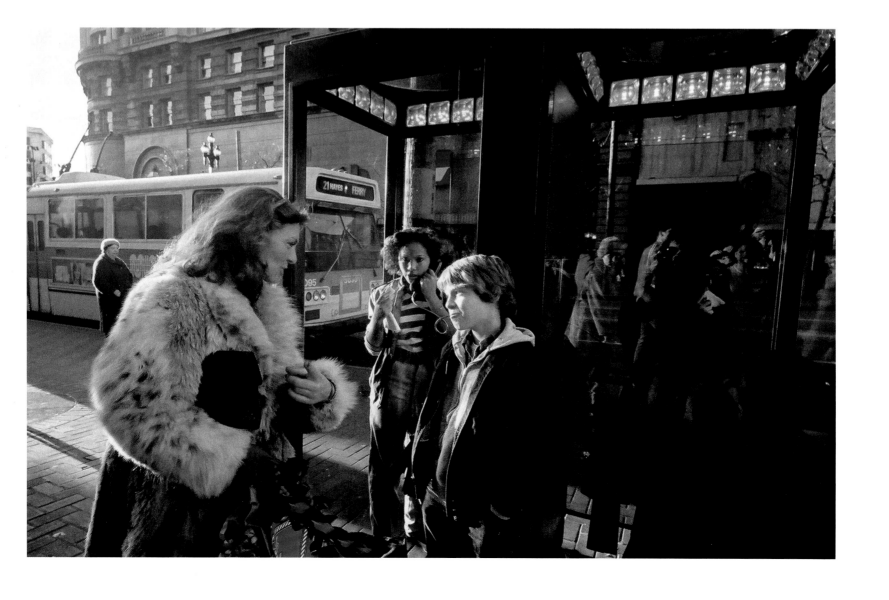

↓
John Harding

A youthful downtown after-work crowd celebrates cocktail hour at the Embarcadero Center. This complex near the Ferry Building has several levels of shops, restaurants, bars, movie theaters, offices, and hotels, connected by pedestrian bridges over several blocks in the Financial District, c. early 1980s.

Eine Gruppe junger Leute nach der Arbeit bei der Cocktailstunde im Embarcadero Center. Der Komplex in der Nähe des Ferry Building besteht aus mehreren Etagen mit Geschäften, Restaurants, Bars, Kinos, Büros und Hotels, die sich über einige Blocks des Finanzbezirks erstrecken und durch Fußgängerbrücken verbunden sind, frühe 1980er.

Après le travail, un groupe de jeunes du centre-ville démarre la soirée à l'Embarcadero Center. Ce complexe aménagé non loin du Ferry Building aligne sur plusieurs niveaux boutiques, restaurants, bars, cinémas, bureaux et hôtels, reliés par des passerelles qui enjambent plusieurs pâtés de maisons du Financial District. Vers le début des années 1980.

→
Thomas Hoepker

Flocks of music lovers enjoy the sun and sounds at an outdoor San Francisco rock concert, 1982.

Scharen von Musikliebhabern genießen die Sonne und die Musik bei einem Outdoor-Rockkonzert in San Francisco, 1982.

À San Francisco la musique se savoure aussi au soleil et à plusieurs. Concert rock en plein air. 1982.

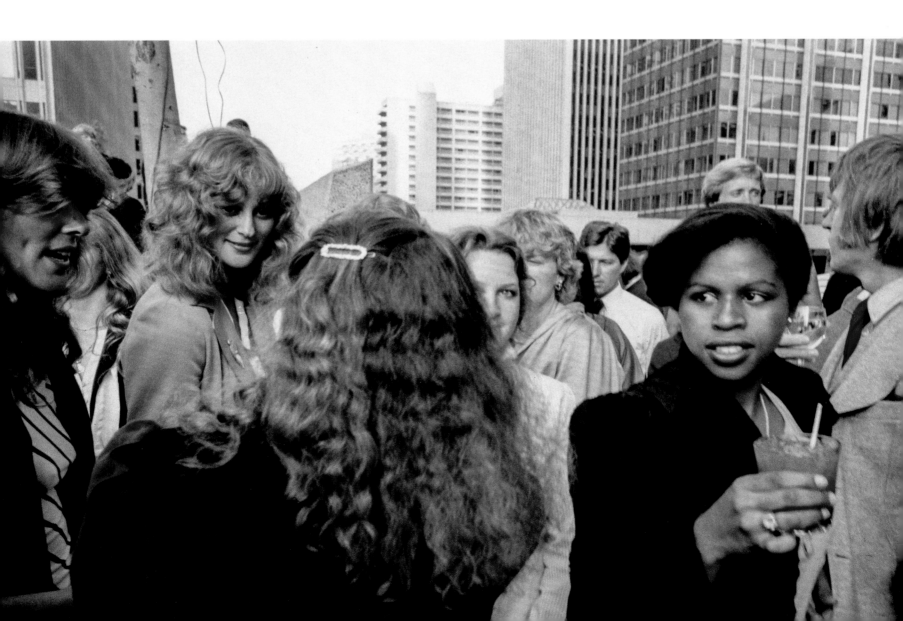

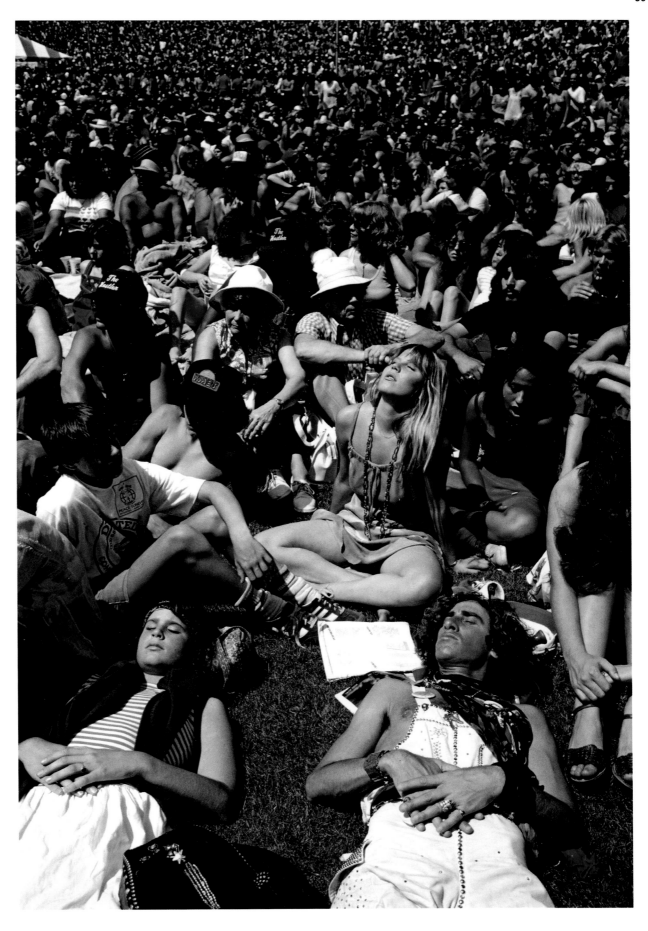

p. 392/393
Walter Iooss Jr.

San Francisco 49ers tight end Dwight Clark catches a touchdown pass from star quarterback Joe Montana in Candlestick Park with 58 seconds left. Known as "The Catch," it gave the football team a 28–27 comeback playoff victory over the Dallas Cowboys on the way to their first Super Bowl championship a couple weeks later, 1982.

Im Candlestick Park fängt Dwight Clark von den San Francisco 49ers einen Touchdown-Pass von Starquarterback Joe Montana mit nur 58 Sekunden Restspielzeit. Bekannt geworden als „Der Fang", drehte das Team so ein Play-off-Spiel gegen die Dallas Cowboys zu einem 28:27 Sieg. Nur Wochen später gewannen sie ihren ersten Superbowl, 1982.

« Receveur écarté » – wide receiver – des San Francisco 49ers, Dwight Clark récupère une passe du quarterback vedette Joe Montana pour un touchdown décisif au Candlestick Park, à cinquante-huit secondes de la fin du match. Connu sous le nom de « The Catch », ce geste a permis à son équipe de football américain de battre d'un souffle les Dallas Cowboys (28-27) et de remporter son premier Super Bowl quelques semaines plus tard. 1982.

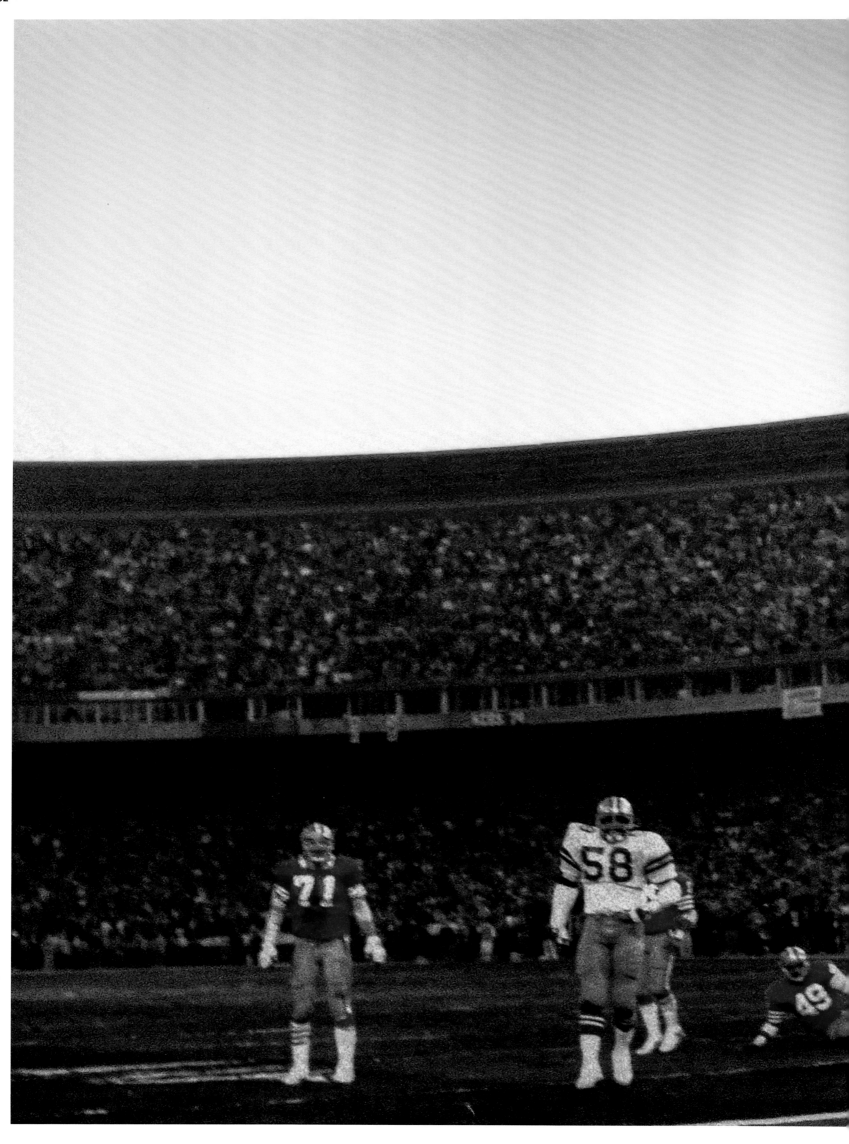

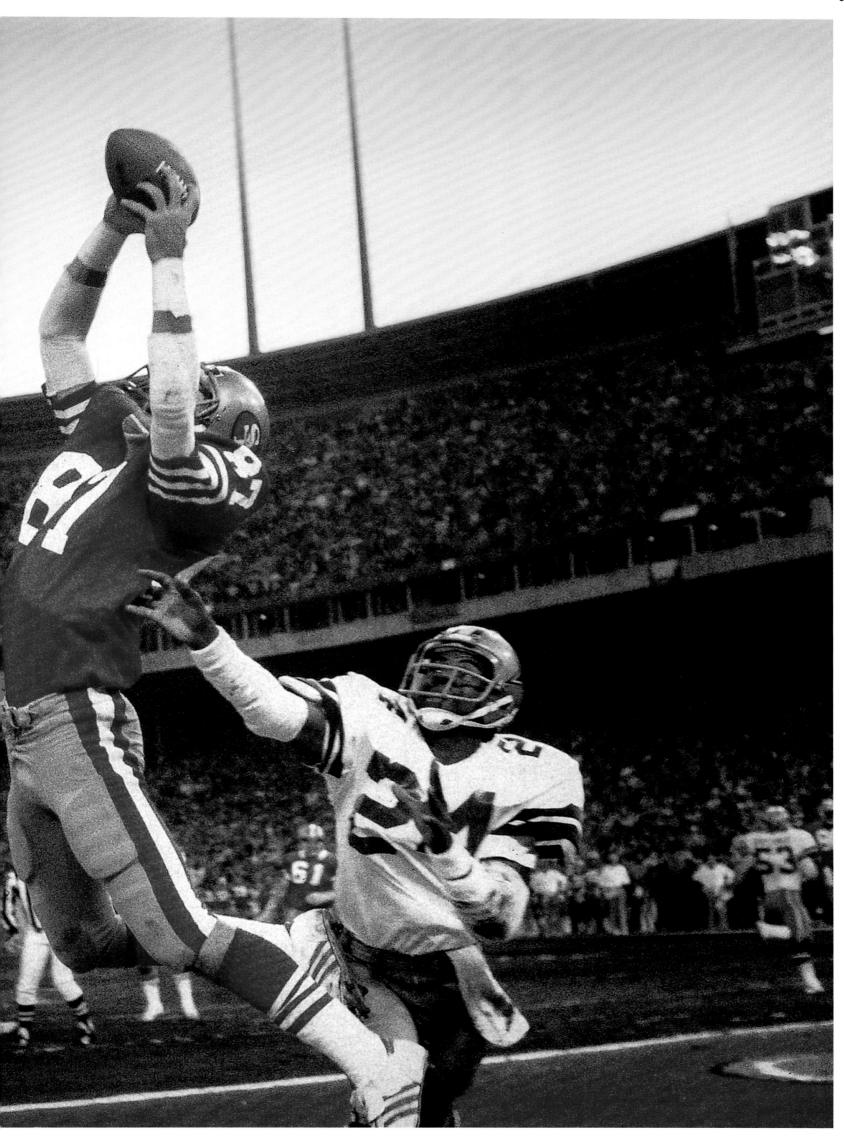

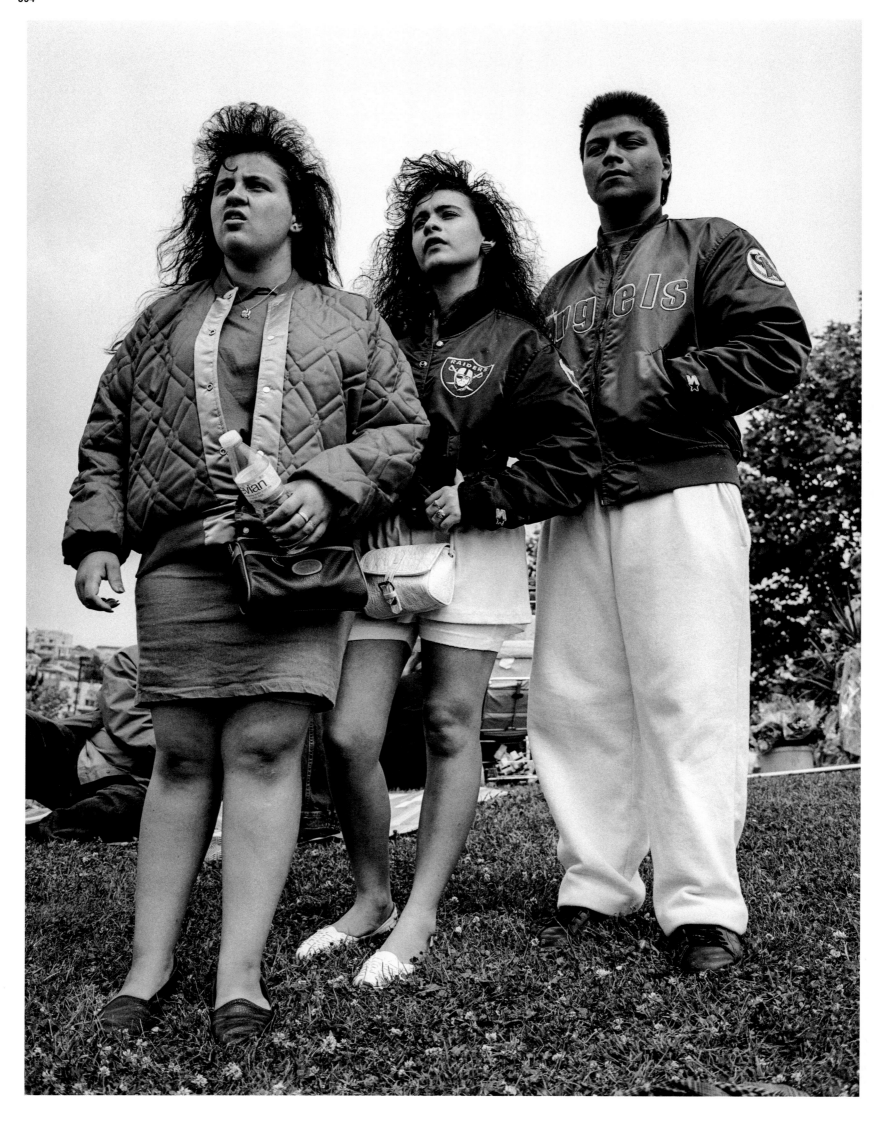

←

Ingeborg Gerdes

Mission District. The Oakland Raiders, whose jacket is worn by the woman in the center, were part of the National Football League from 1960 to 1981 and from 1995 to 2019, after which they moved to Las Vegas, c. mid-1980s–early 1990s.

Mission District. Die Oakland Raiders, deren Teamjacke die Frau in der Mitte trägt, waren von 1960 bis 1981 und von 1995 bis 2019 in der NFL; dann zogen sie um nach Las Vegas, Mitte 1980er bis frühe 1990er.

Dans le quartier du Mission District. Les Oakland Raiders, dont la jeune femme au centre porte un blouson siglé, étaient une franchise de football américain qui déménagea à Los Angeles en 1982 avant de revenir à Oakland en 1995 et de partir à Las Vegas en 2020. Vers le milieu des années 1980 et le début des années 1990.

↑

Frank Espada

Poet Alfonso Texidor at a Mission District bookstore reading. The Puerto Rico native was a popular community activist in the district, where he worked as a translator and editor for the bilingual newspaper El Tecolote, 1986.

Der Dichter Alfonso Texidor bei einer Lesung in einer Buchhandlung im Mission District. Geboren in Puerto Rico war er ein im District beliebter Aktivist und Übersetzer sowie Herausgeber der zweisprachigen Tageszeitung El Tecolote, 1986.

Le poète Alfonso Texidor lors d'une lecture publique dans une librairie du Mission District. Né à Porto Rico, cet activiste communautaire était très populaire dans le quartier où il travaillait comme traducteur et rédacteur en chef pour le journal bilingue El Tecolote. 1986.

*"Matchless in its Art Deco splendor, the Golden Gate is also unrivalled
as a symbol: it is a threshold that presides over the end of the continent
and a gangway to the void beyond."*

*„Unvergleichlich in seiner Art- déco-Pracht ist das Golden Gate auch als
Symbol unerreicht: Es ist eine Schwelle, die das Ende des Kontinents
markiert, und ein Durchgang in die Leere dahinter."*

*« Inégalable splendeur Art déco, le Golden Gate est aussi un symbole sans
pareil : c'est un seuil qui préside à la fin du continent et une passerelle vers
le vide au-delà. »*

THE NEW YORKER, 2003

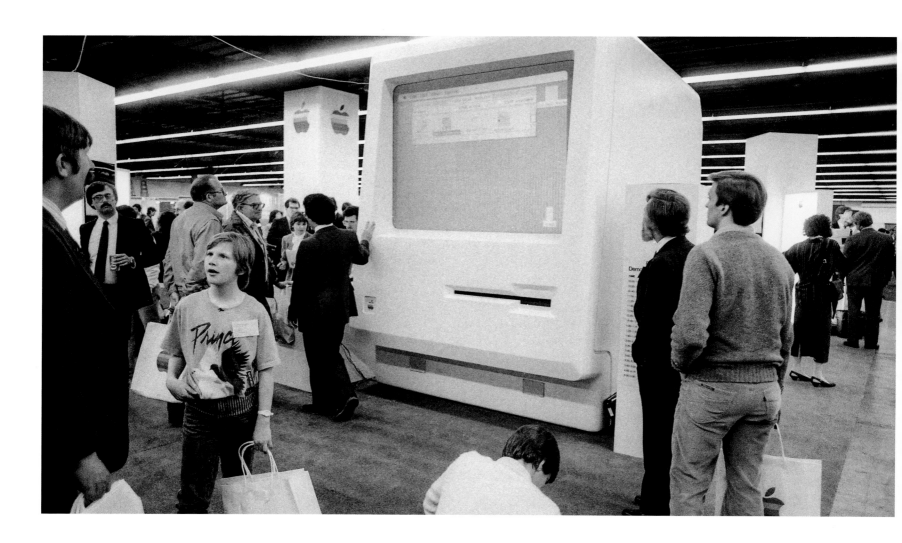

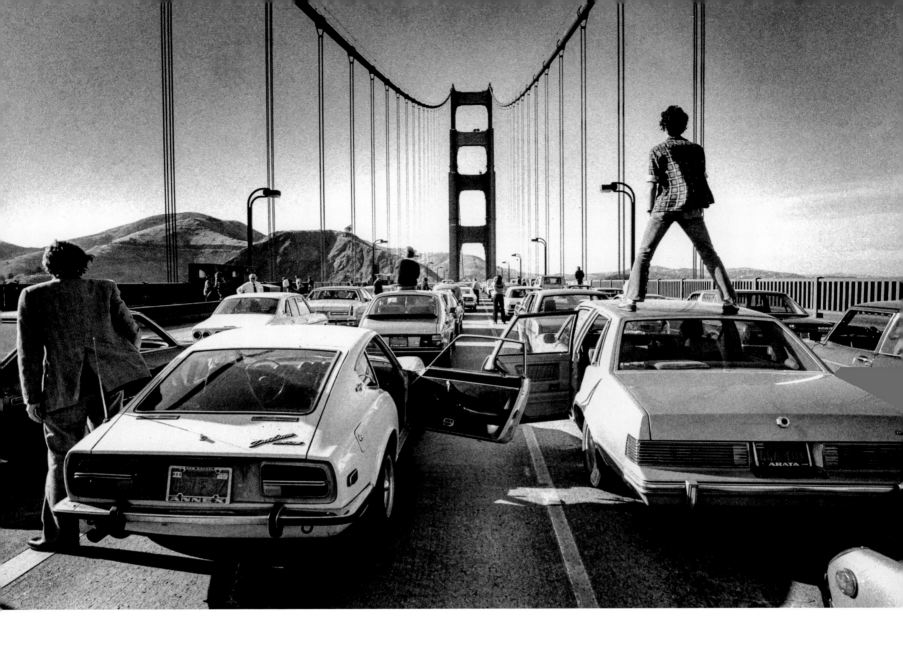

Steve Ringman

Milling around the latest in personal computer technology at the first Macworld in Brooks Hall underneath Civic Center Plaza. Like the magazine of the same name, this trade show was devoted to products by Apple, which was ramping up its growth into one of the world's biggest tech companies, 1985.

Besucher betrachten die neusten Computertechnologien auf der ersten Macworld in der Brooks Hall, unter der Civic Center Plaza. Wie bei dem gleichnamigen Magazin ging es bei der Messe um Apple-Produkte, die Firma war im Begriff, eines der größten Tech-Unternehmen weltweit zu werden, 1985.

Le premier Macworld, organisé à Brooks Hall sous la Civic Center Plaza, présente à une foule empressée les dernières innovations en matière d'ordinateurs personnels. Comme le magazine du même nom, le salon était consacré aux produits d'Apple, qui devra à sa fulgurante croissance de devenir l'une des plus grandes entreprises technologiques au monde. 1985.

Gary Fong

When San Francisco Chronicle photographer Gary Fong was stuck in traffic on the Golden Gate Bridge, he took this picture of the gridlock, some commuters even standing on their cars to get a better view of the delay. Although it seldom gets this bad, traffic is still a problem on the bridge at rush hour and travel-heavy weekends, especially since the BART train system doesn't run to Marin County, 1980.

Als Gery Fong, Fotograf für den San Francisco Chronicle, im Verkehr auf der Golden Gate Bridge feststeckte, machte er dieses Foto Pendlern im Verkehrsinfarkt.

Obwohl es nur selten so schlimm wird, sind Staus während der Rushhour und am Wochenende immer noch ein Problem, vor allem, weil das BART-System nicht nach Marin County führt, 1980.

Bloqué dans la circulation sur le Golden Gate Bridge, Gary Fong, photographe au San Francisco Chronicle, a sorti son appareil. S'il n'atteint que rarement de tels extrêmes, le trafic routier continue de poser problème aux heures de pointe et les week-ends de grande affluence, d'autant que le système de transport ferroviaire BART ne dessert pas le comté de Marin. 1980.

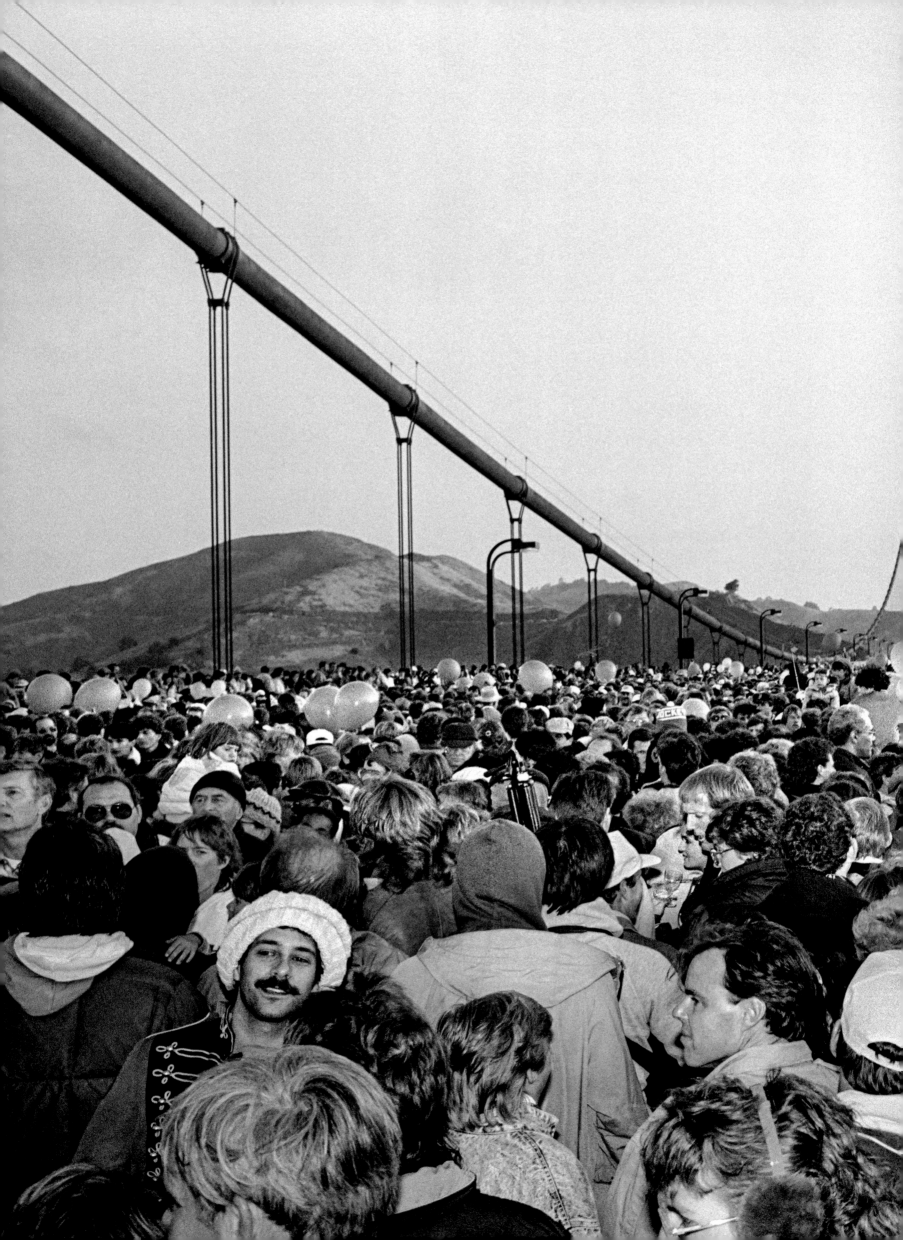

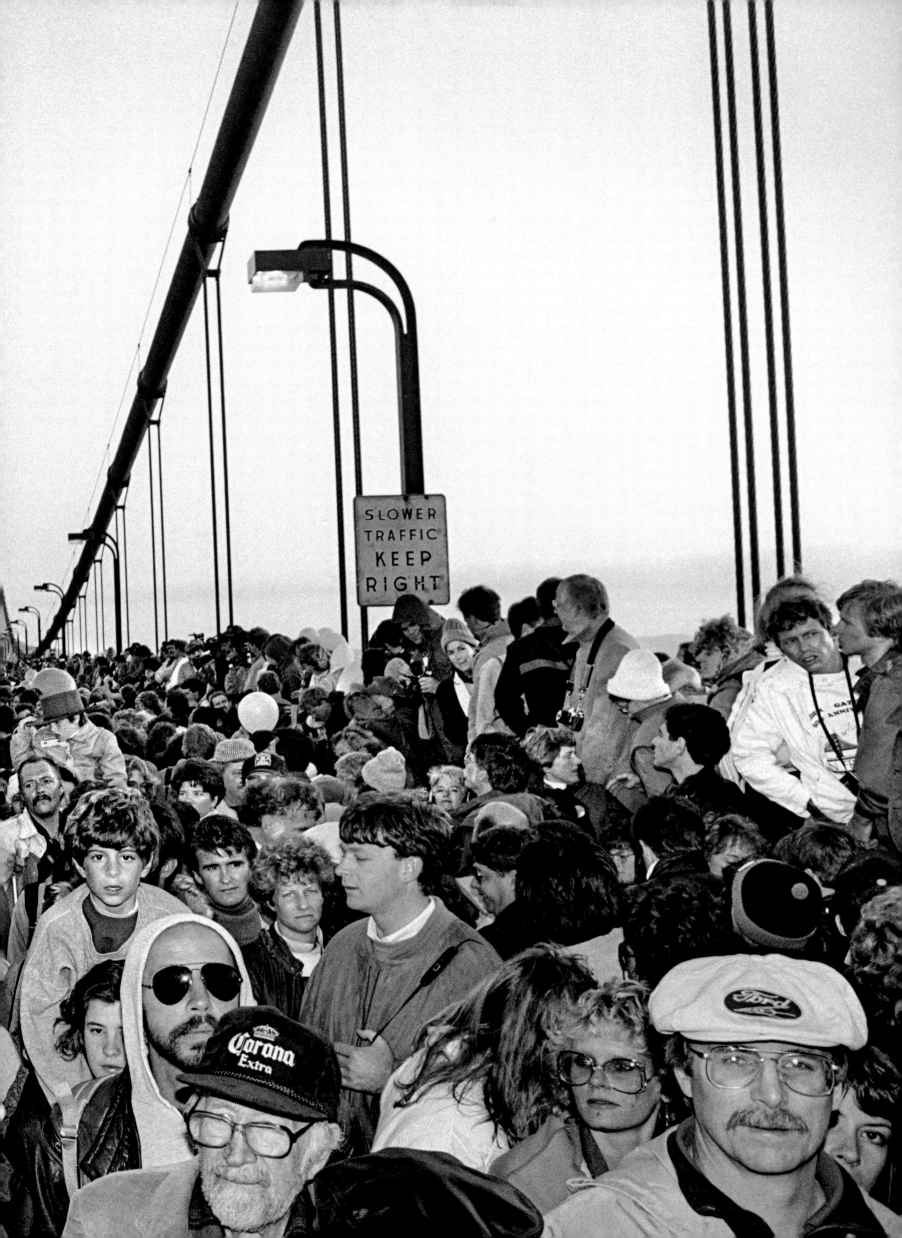

p. 398/399
Michael Jang

Crowds of 300,000 packed the Golden Gate Bridge when it was opened to pedestrians on its 50th anniversary. These were far more than the organizers expected, and the weight of the walkers temporarily flattened the normally arched roadbed, though engineers said the bridge was never in danger of collapsing, May 24, 1987.

300 000 Menschen kamen auf die Golden Gate Bridge, als diese aus Anlass ihres 50. Jahrestags für Fußgänger geöffnet wurde. Es waren viel mehr, als die Organisatoren erwartet hatte, und ihr Gewicht begradigte kurzzeitig die normalerweise gebogene Fahrbahn. Laut den Ingenieuren bestand aber keine Einsturzgefahr, 24. Mai 1987.

Quelque 300 000 personnes se sont pressées sur le Golden Gate Bridge lorsque celui-ci a été ouvert aux piétons à l'occasion de son 50ᵉ anniversaire. C'était beaucoup plus que ce qu'attendaient les organisateurs, et le poids des marcheurs ira jusqu'à aplatir temporairement la chaussée normalement arquée. Les ingénieurs déclareront cependant que les risques d'effondrement étaient nuls. 24 mai 1987.

↑
Stewart Harvey

The first Burning Man ceremony, held on Summer Solstice at Baker Beach, about a mile south of Golden Gate Bridge. Larry Harvey had been staging annual burnings of a tall manlike structure for a few years, but this was the first billed as Burning Man, and the first to draw a sizable crowd of 300 "burners." In the 1990s Burning Man evolved into a countercultural festival drawing tens of thousands of enthusiasts, though by then it had moved to a Nevada desert, 1989.

Die erste Burning-Man-Zeremonie, abgehalten während der Sommersonnenwende am Baker Beach, anderthalb Kilometer südlich der Golden Gate Bridge. Larry Harvey hatte jährlich Vdas Abbrennen einer Holzfigur organisiert, aber dies war die erste, die Burning Man genannt wurde und eine Gruppe von ca. 300 „Verbrennern" anlockte. In den 90er-Jahren wurde Burning Man zu einem Counterculture-Festival, das Zehntausende anzog, obwohl es mittlerweile in der Wüste von Nevada stattfand, 1989.

La première cérémonie du Burning Man lors du solstice d'été à Baker Beach, 1,5 kilomètre au sud du Golden Gate Bridge. Larry Harvey organisait depuis plusieurs années des crémations récurrentes de mannequins géants mais celle-ci sera la première à porter ce nom et à attirer un public substantiel, 300 personnes à l'époque. Dans les années 1990, « l'homme qui brûle » deviendra l'un des plus importants rassemblements de la contre-culture où afflueront des dizaines de milliers de passionnés malgré son déménagement dans le désert du Nevada. 1989.

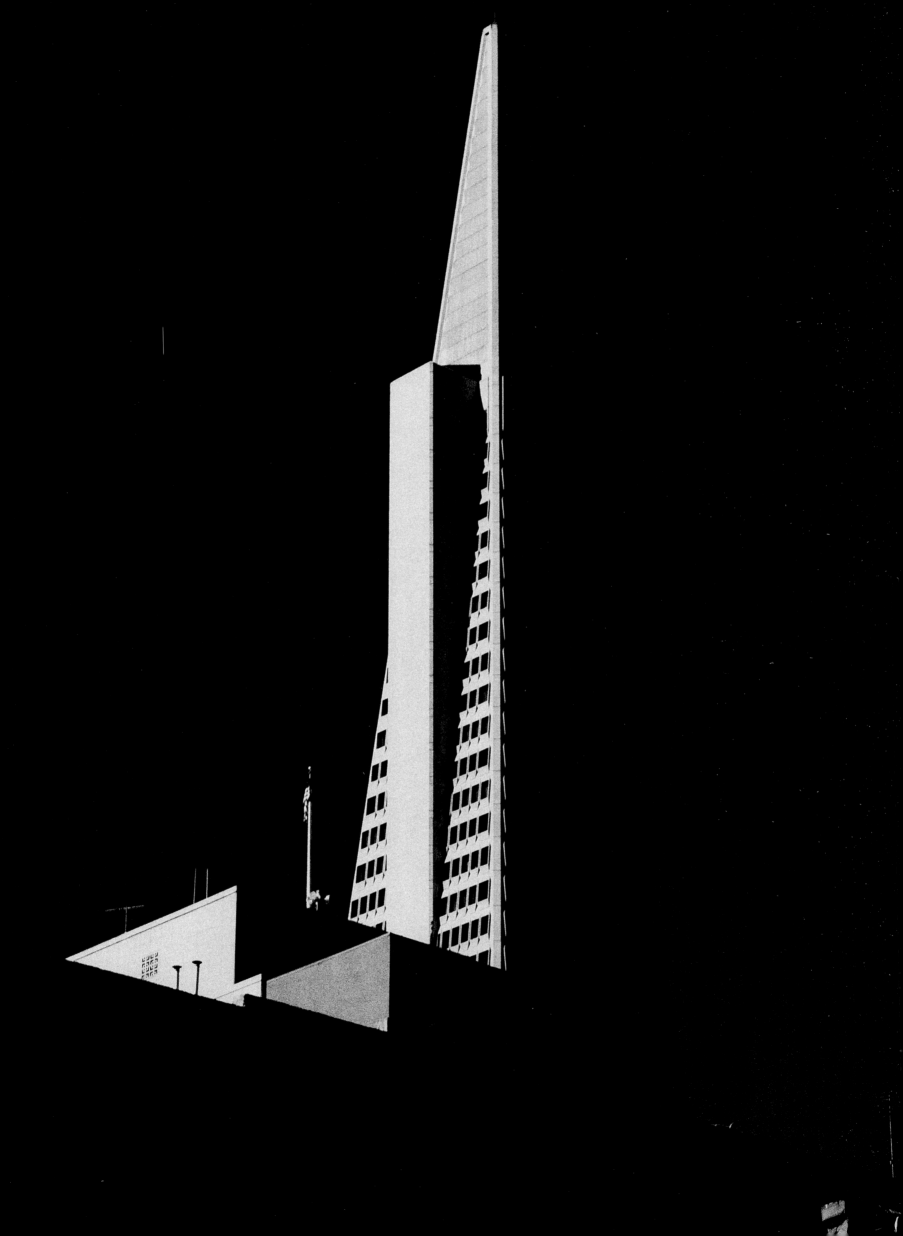

←
Albert Watson

*The upper reaches of the Transamerica
Pyramid in partial shadow, 1989.*

*Der obere Teil der Transamerica Pyramid,
teilweise im Schatten, 1989.*

*Théâtre d'ombres sur les hauteurs
de la Transamerica Pyramid. 1989.*

↑
Albert Watson

*In the center, the highest of these skyscrapers
served as a Standard Oil Building and
Chevron Tower before becoming part of
Market Center on Market Street between
First and Second streets, 1989.*

*Der höchste, in der Mitte zu sehende Wol-
kenkratzer, diente als Standard Oil Building
und als Chevron Tower, bevor er Teil des
Market Center an der Market Street zwi-
schen First und Second Street wurde, 1989.*

*Au centre de l'image, le plus haut de ces
gratte-ciel s'est tour à tour appelé Standard
Oil Building et Chevron Tower avant d'être
intégré au Market Center sur Market Street,
entre la 1re et la 2e Rue. 1989.*

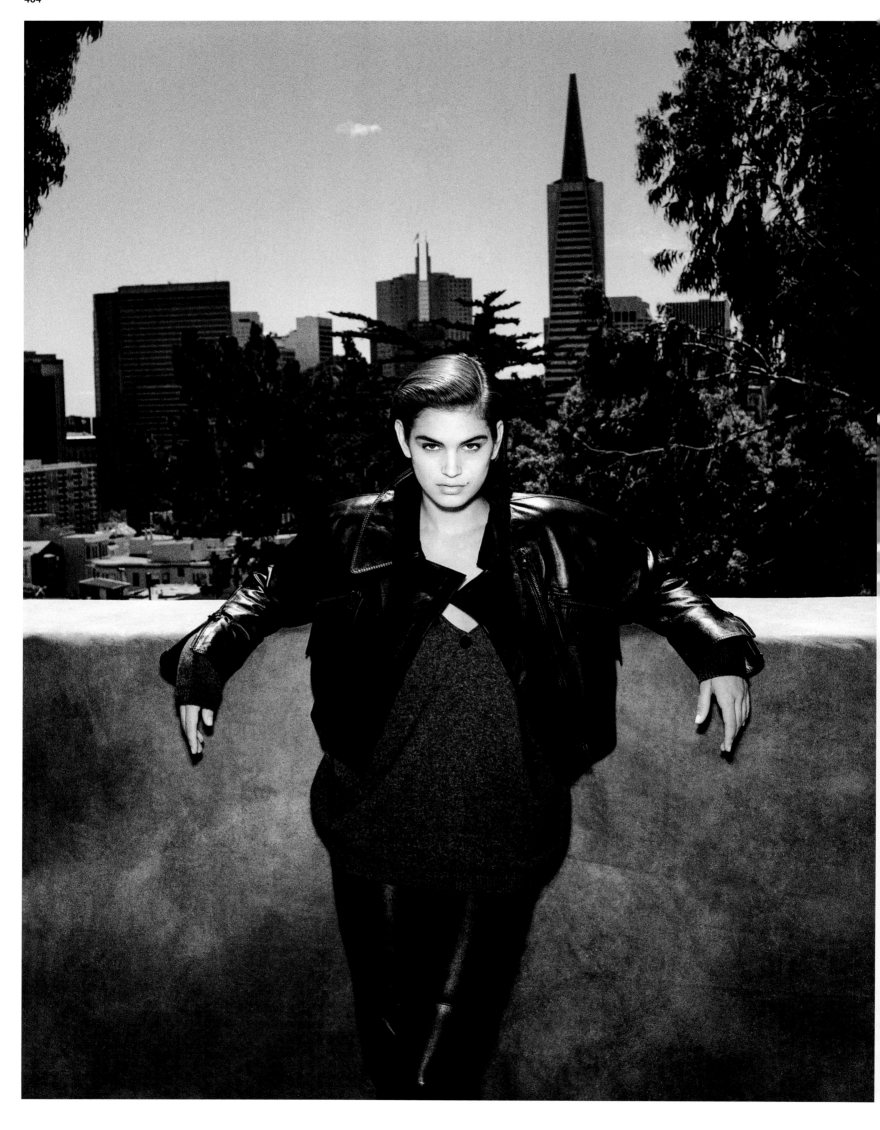

"Walking down to Market Street,
feeling my heart skip a beat,
To see someone who looks like you,
I guess that I'm not through.
Dreaming of the one I love,
you know what I'm dreaming of.
San Francisco days, San Francisco nights."

CHRIS ISAAK, "SAN FRANCISCO NIGHTS," 1993

←
Albert Watson

Cindy Crawford, with downtown as the back-
drop, the Transamerica Pyramid dominating
the skyline, 1989.

Cindy Crawford, mit Downtown und der
Transamerica Pyramid als Hintergrund, 1989.

Cindy Crawford et, à l'arrière-plan, le centre-
ville et la Transamarica Pyramid. 1989.

↓
Paul Kitagaki

Game three in the World Series between
the San Francisco Giants and local rivals
Oakland Athletics at Candlestick Park, and
the earthquake has just struck across the Bay
Area. This fan looks understandably shaken,
October 17, 1989.

Das dritte Spiel der Baseball World Series
zwischen den San Francisco Giants und ihren
lokalen Rivalen, den Oakland Athletics, im
Candlestick Park. Das Erdbeben hatte sich
grade ereignet und dieser Fan sieht ent-
sprechend erschüttert aus, 17. Oktober, 1989.

Au Candlestick Park, alors qu'un trem-
blement de terre vient de frapper la « Bay
Area », le troisième match de la finale natio-
nale de base-ball oppose les San Francisco
Giants à leurs rivaux et voisins des Oakland
Athletics. Une légitime stupeur peut se lire
sur le visage de cette fidèle des Giants.
17 octobre 1989.

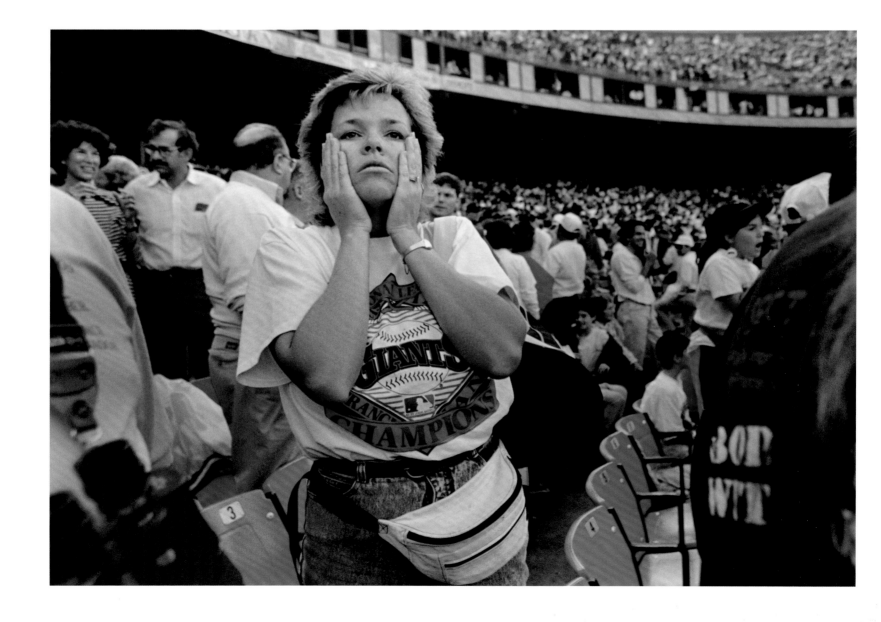

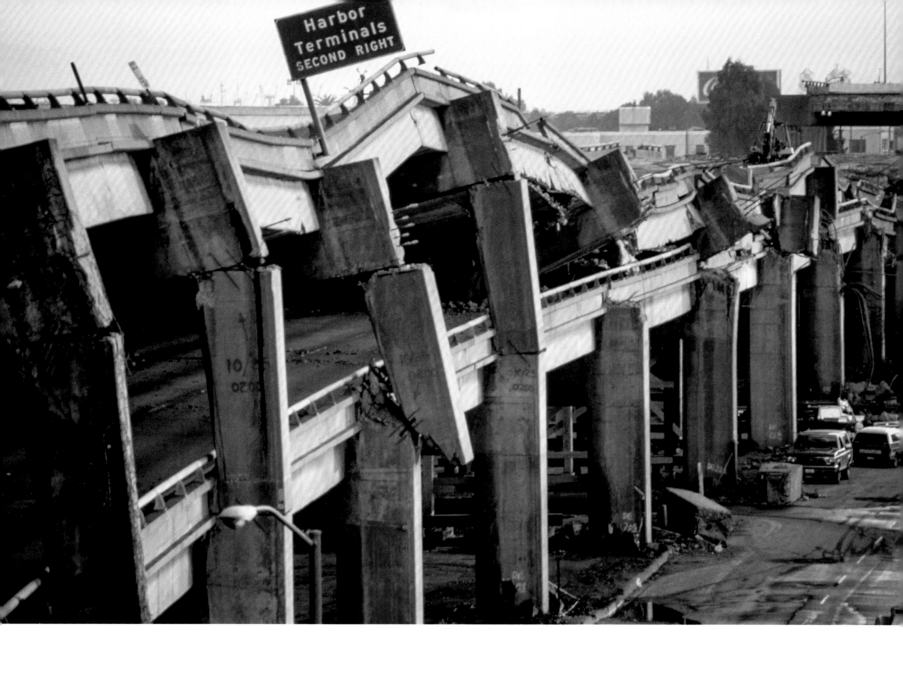

↑

Jim Sugar

Running through the center of Oakland, the Cypress Freeway collapsed in the Loma Prieta earthquake, killing 42 and injuring many more. This part of the freeway wasn't rebuilt until 1997, nearly a decade later. A 50-foot stretch of the Bay Bridge also collapsed in the disaster, with one fatality, October 17, 1989.

Der zentral durch Oakland verlaufende Cypress Freeway stürzte während des Loma Prieta Erdbebens ein, 42 starben und viele mehr wurden verletzt. Dieser Teil des Freeways wurde erst 1997 wieder aufgebaut, fast ein Jahrzehnt später. Ein 15 Meter langes Stück der Bay Bridge stürzte ebenfalls ein, es gab einen Toten, 17. Oktober, 1989.

Lors du tremblement de terre de Loma Prieta, en 1989, 42 personnes perdront la vie et de nombreuses autres seront blessées à la suite de l'effondrement du Cypress Freeway, l'autoroute qui traversait le centre d'Oakland. Ce tronçon ne sera reconstruit qu'en 1997. Le Bay Bridge s'affaissa également sur une quinzaine de mètres, causant la mort d'une infirmière de 23 ans. 17 octobre 1989.

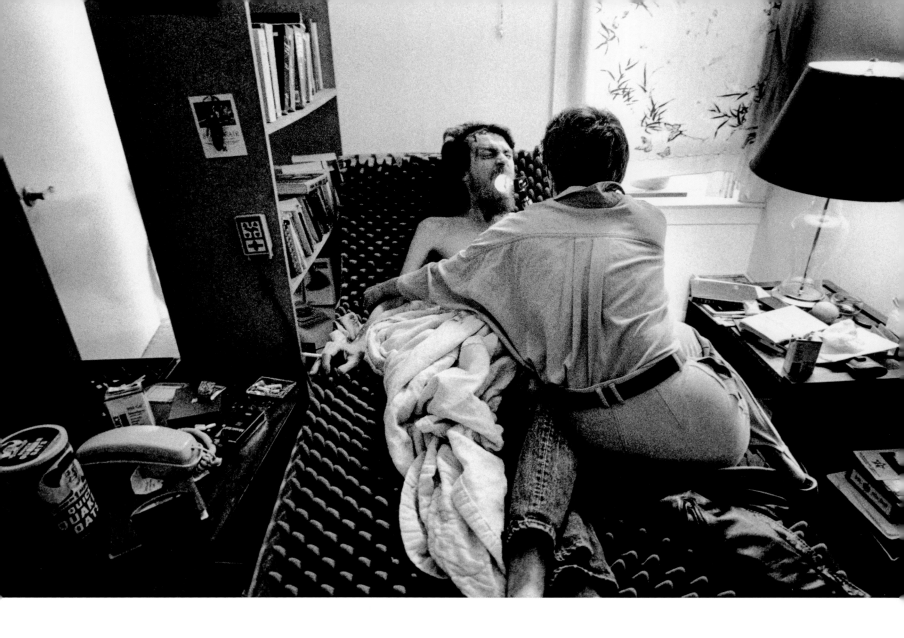

↑

Paul Fusco

Dr. Teresa Black examines James, an AIDS patient, in his room in the Ambassador Hotel near Mason and Eddy streets. On the edge of the Tenderloin District, the single-room occupancy hotel was home to several low-income residents with the illness, who were visited by a medical team each week, 1993.

Dr. Teresa Black untersucht einen Aids-Patienten, James, in seinem Zimmer im Ambassador Hotel in der Nähe von Mason und Eddy Street. Am Rande des Tenderloin gelegen, war das Einzelzimmerhotel die Heimat von vielen Erkrankten, die nur über ein geringes Einkommen verfügten. Sie wurden wöchentlich von einem Ärzteteam besucht, 1993.

Le docteur Teresa Black examine un patient atteint du sida, James, dans sa chambre de l'hôtel Ambassador, à proximité de Mason Street et d'Eddy Street. Situé en bordure du Tenderloin, cet hôtel social hébergeait plusieurs résidents à faible revenu frappés par la maladie. Ils recevaient chaque semaine la visite d'une équipe médicale. 1993.

→

Anonymous

A young girl, Jennifer, rides with her mother in the "Dykes on Bikes" group of the International Lesbian & Gay Freedom Day Parade (now known as Pride), which runs on Market Street between the waterfront and Civic Center. The lesbian motorcycle club has led the annual parades since 1976, with contingents leading similar events around the world in the ensuing decades, 1985.

Ein junges Mädchen fährt mit ihrer Mutter bei den „Dykes on Bikes" mit, einer Gruppe bei der internationalen Freiheitsparade für Schwule und Lesben, die heute Pride heißt. Sie verlief entlang der Market Street zwischen der Uferpromenade und dem Civic Center. Der Club für lesbische Motorradfahrerinnen hatte die jährliche Parade seit 1976 angeführt, ähnliche Gruppen taten in den kommenden Jahrzehnten dasselbe bei vergleichbaren Veranstaltungen weltweit, 1985.

Une petite fille, Jennifer, accompagne sa mère parmi les « Dykes on Bikes », le club de moto lesbien qui ouvre depuis 1976, sur Market Street, les défilés annuels de ce qui deviendra la Gay Pride, entre le front de mer et le Civic Center. Au cours des décennies suivantes, le mouvement fera des petits dans le monde entier. 1985.

"It is the virtual certainty of death from AIDS, once the syndrome has fully developed, that makes the disease so frightening, along with the uncertainty of nearly everything else about it."

„Die hohe Gewissheit, dass Aids zum Tod führt, wenn das Syndrom erst einmal voll entwickelt ist, macht die Krankheit so beängstigend. Ebenso wie die Ungewissheit über fast alles andere, was mit ihr zusammenhängt."

« C'est la quasi-certitude de mourir, une fois le sida complètement développé, qui rend la maladie si effrayante, de même que l'incertitude dont presque tout en elle, par ailleurs, fait l'objet. »

TIME, 1985

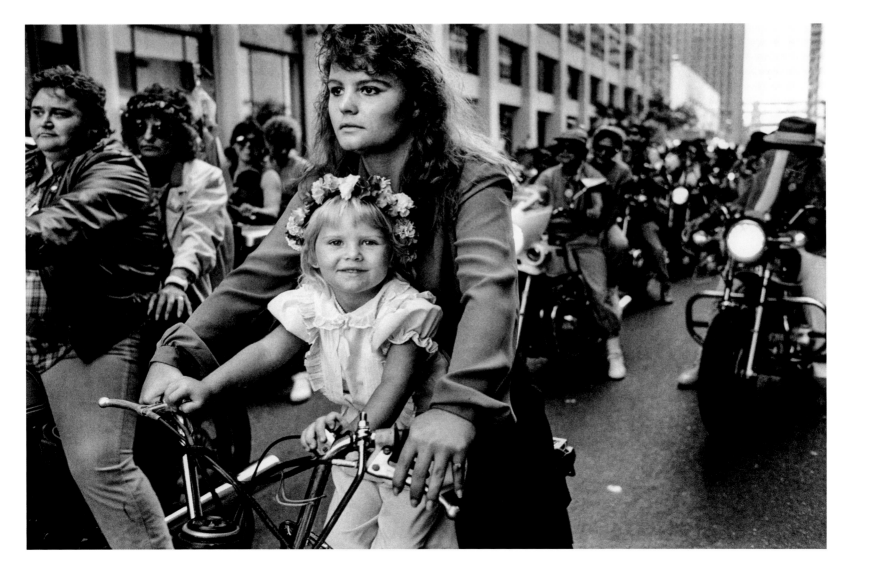

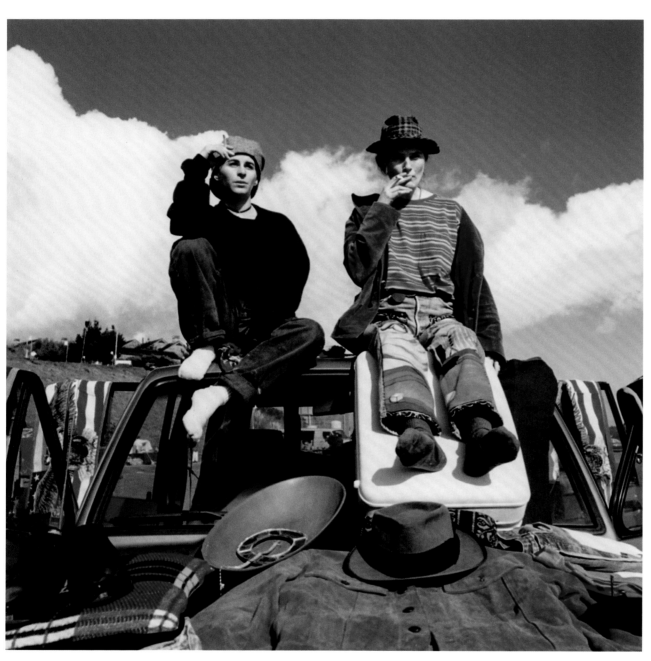

→

Mary Ellen Mark

Robin Williams started his career in stand-up comedy in the city in the mid-'70s; starred in one of the most popular San Francisco-set films, Mrs. Doubtfire; *and lived in the affluent Sea Cliff neighborhood between Golden Gate Bridge and Ocean Beach. His ashes were scattered in the San Francisco Bay after his 2014 death, and the following year the tunnel between Marin County and the bridge was named in his honor, 1998.*

Robin Williams begann seine Karriere als Stand-up-Comedian Mitte der 70er -Jahre in der Stadt, spielte in einem der beliebtesten San-Francisco-Filme, Mrs. Doubtfire, *mit, und lebte in dem wohlhabenden Viertel Sea Cliff zwischen der Golden Gate Bridge und Ocean Beach. Nach seinem Tod 2014 wurde seine Asche in der Bucht verstreut, im folgenden Jahr wurde der Tunnel zwischen Marine County und der Brücke nach ihm benannt, 1998.*

Robin Williams a démarré dans le stand-up à San Francisco au milieu des années 1970. Il jouera dans l'un des plus grands succès jamais tournés dans la ville, Madame Doubtfire, *et vivra à Sea Cliff, quartier chic s'il en est, entre le Golden Gate Bridge et Ocean Beach. Après sa mort en 2014, ses cendres seront dispersées dans la baie et l'année suivante, à titre d'hommage, le tunnel reliant le comté de Marin et le pont se verra attribuer son nom. 1998.*

↑

Nancy Kittle

Young people at the Marin City Flea Market, a few miles north of the Golden Gate Bridge. Staged in one of the few nonaffluent towns in Marin County, the long-running market was shut in the mid-1990s to make way for the Gateway Shopping Center, c. 1990.

Junge Leute auf dem Marin-City-Flohmarkt, ein paar Kilometer nördlich der Golden Gate Bridge. Der Markt fand lange Zeit in einem der wenigen nicht wohlhabenden Orte im Marin County statt, bis er Mitte der 1990er-Jahre dem Gateway Shopping-Center weichen musste, um 1990.

Jeunes exposants au marché aux puces de Marin City, à quelques kilomètres au nord du Golden Gate Bridge. Installé dans l'une des rares villes peu huppées du comté de Marin, ce très ancien rendez-vous a été fermé au milieu des années 1990 pour faire place au Gateway Shopping-Center. Vers 1990.

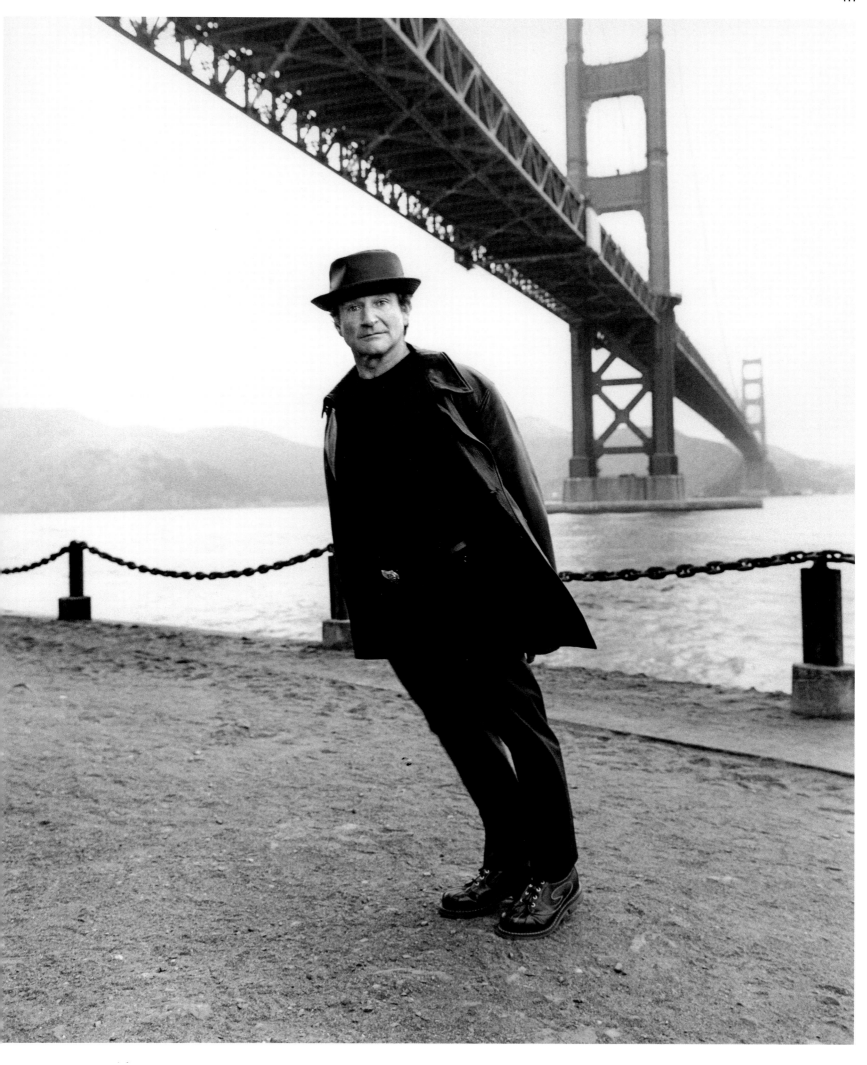

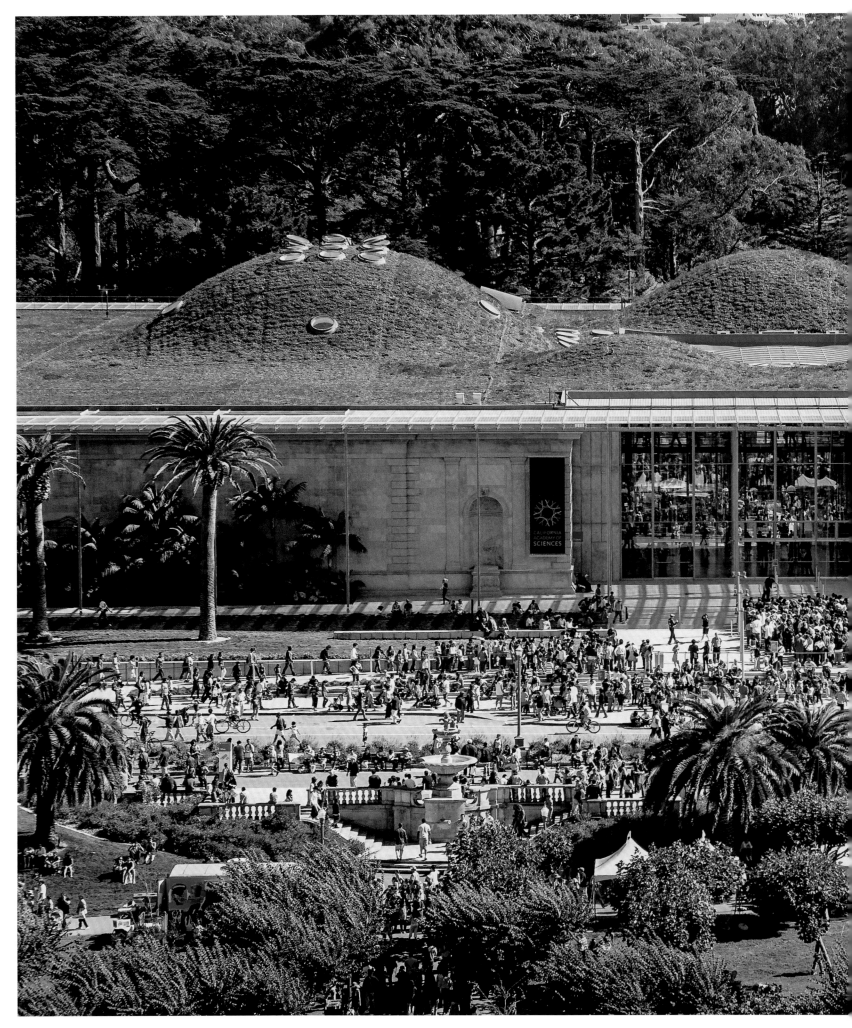

Tom Fox

When the renovated California Academy of Sciences opened in Golden Gate Park in 2008, this "living roof" was an added attraction. Edged by seven solar panels, its seven hills fill two and a half acres with nearly two million plants, 2008.

Als die renovierte California Academy of Sciences im Golden Gate Park 2008 öffnete, war das „lebendige Dach" eine zusätzliche Attraktion. Umrahmt von sieben Solarzellen, sind sieben Hügel und fast zwei Millionen Pflanzen auf einem Hektar verteilt.

Lorsqu'en 2008 l'Académie des sciences de Californie ouvrit ses portes, rénovée, au sein du Golden Gate Park, ce « toit vivant » fut un nouvel attrait.Bordées par sept panneaux solaires, ses sept collines accueillent près de deux millions de plantes sur un hectare. 2008.

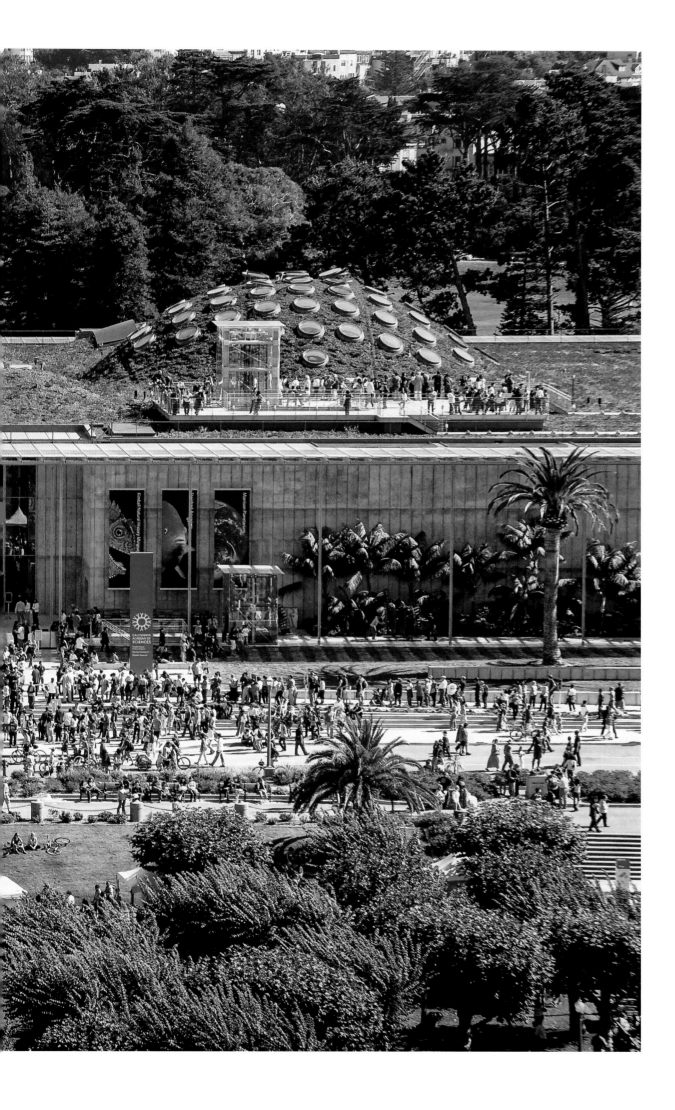

"Golden gate treasure
Got it the wharf, S.F. da letters
Roll in like fog, the battle is uphill."

SAN QUINN, "SAN FRANCISCO ANTHEM," 2008

Tom Baril

Telegraph Hill at the start of the new
millennium, crowned by Coit Tower. In the
bay to the right of the tower lies Alcatraz
Island, 2000.

Der Telegraph Hill, gekrönt vom Coit Tower,
am Beginn des neuen Jahrtausends. Rechts in
der Bucht liegt Alcatraz, 2000.

Telegraph Hill à l'orée du nouveau
millénaire, couronné par la Coit Tower.
Dans la baie, à droite de la tour, l'île
d'Alcatraz. 2000.

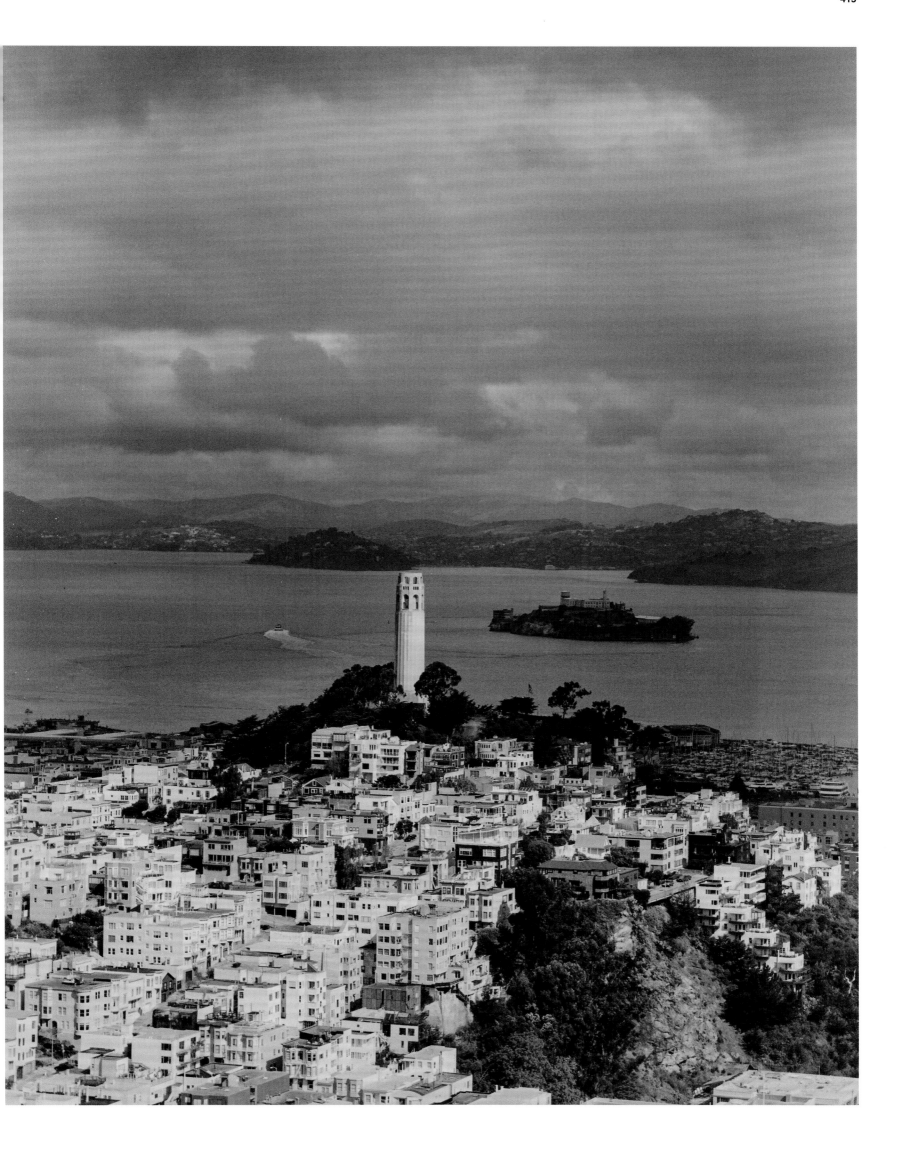

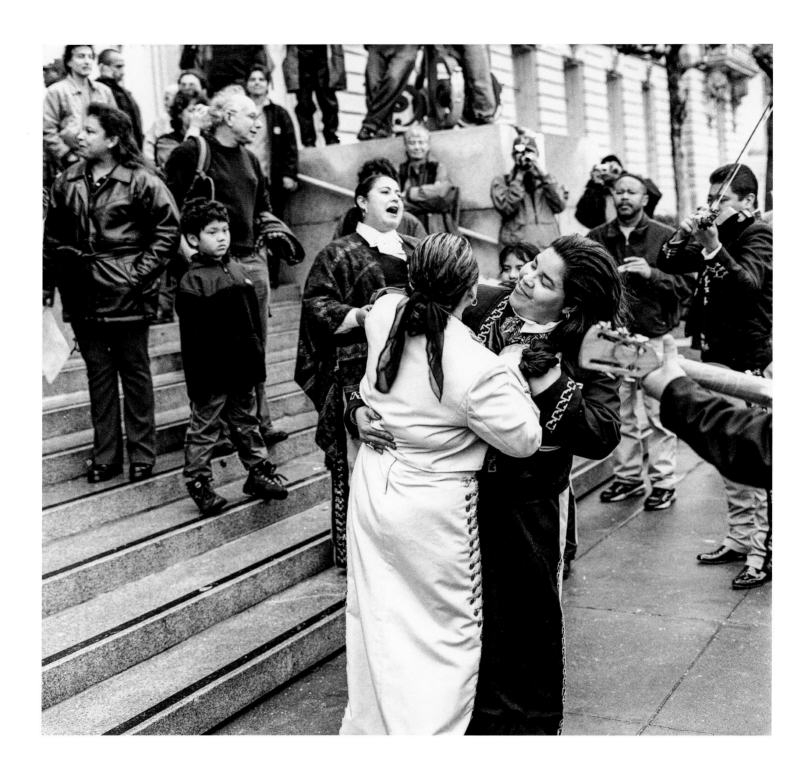

↑
Jeannie O'Connor

Newlyweds celebrate their marriage in front of City Hall. About 4,000 licenses were granted to same-sex couples in the city until the California Supreme Court ordered them halted. Although the court voided the licenses, in 2013 same-sex marriage was finally permanently legalized in California, 2004.

Ein frisch verheiratetes Paar feiert vor der City Hall. Um die 4 000 Heiratsurkunden wurden an gleichgeschlechtliche Paare ausgestellt, bis das oberste Gericht Kaliforniens einen Stopp verhängte. Das Gericht erklärte die Urkunden zwar für ungültig, doch die gleichgeschlechtliche Ehe wurde 2013 dauerhaft in Kalifornien legalisiert, 2004.

Allégresse néo-conjugale au pied de l'hôtel de ville. Quelque 4 000 actes de mariage ont été délivrés à des couples de même sexe à San Francisco jusqu'à ce que la Cour suprême de Californie ne mît fin à la pratique. Malgré l'annulation des certificats, le mariage homosexuel sera finalement légalisé en Californie, en 2013. 2004.

↓
Jeffrey Braverman

Michael Smith in high heels at the Embarcadero Center in an image titled Casual Friday *by the photographer, reflecting fluid boundaries of dress that arguably gain more acceptance in San Francisco than anywhere else in the United States, 2020.*

Michael Smith in High Heels am Embarcadero Center. Vom Fotografen Casual Friday *genannt, spiegelt das Bild die fließenden Grenzen auch bei der Kleidung wider, die in San Francisco wahrscheinlich mehr Akzeptanz gefunden haben als an jedem anderen Ort der USA, 2020.*

Michael Smith en talons hauts devant l'Embarcadero Center. Le photographe a intitulé Casual Friday *cette image qui reflète une fluidité vestimentaire sans doute mieux acceptée à San Francisco que partout ailleurs aux États-Unis. 2020.*

p. 418/419
Anton Corbijn

Depeche Mode, 2008.

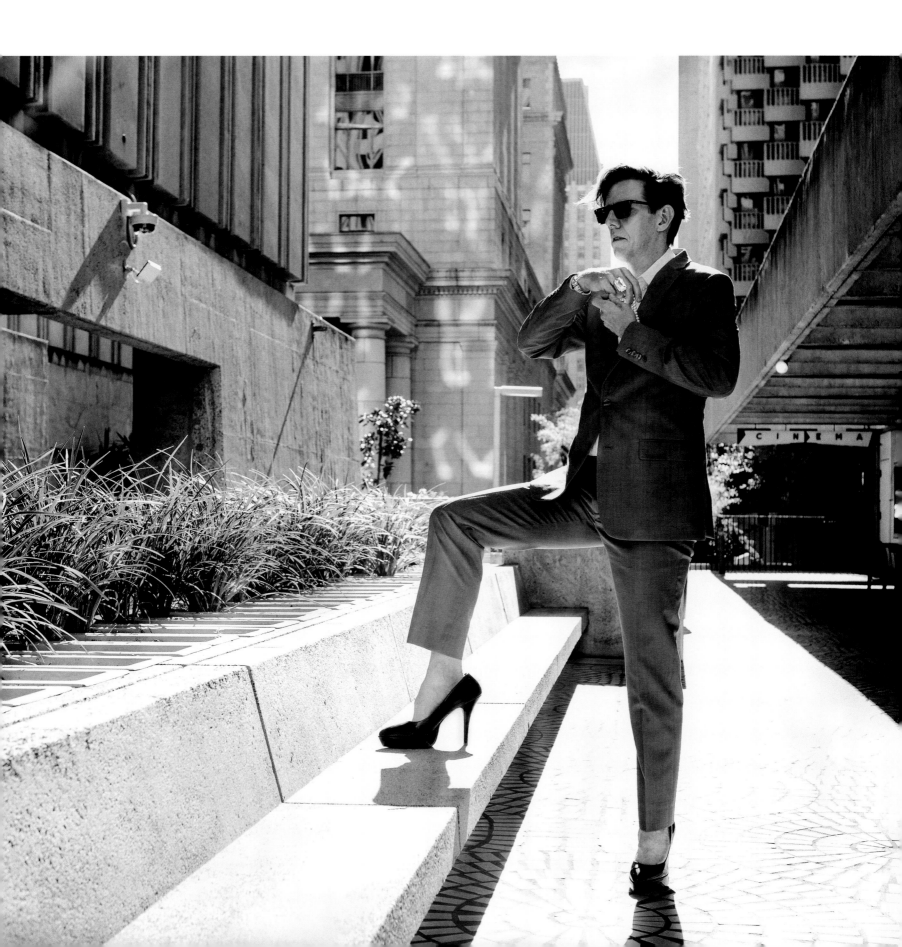

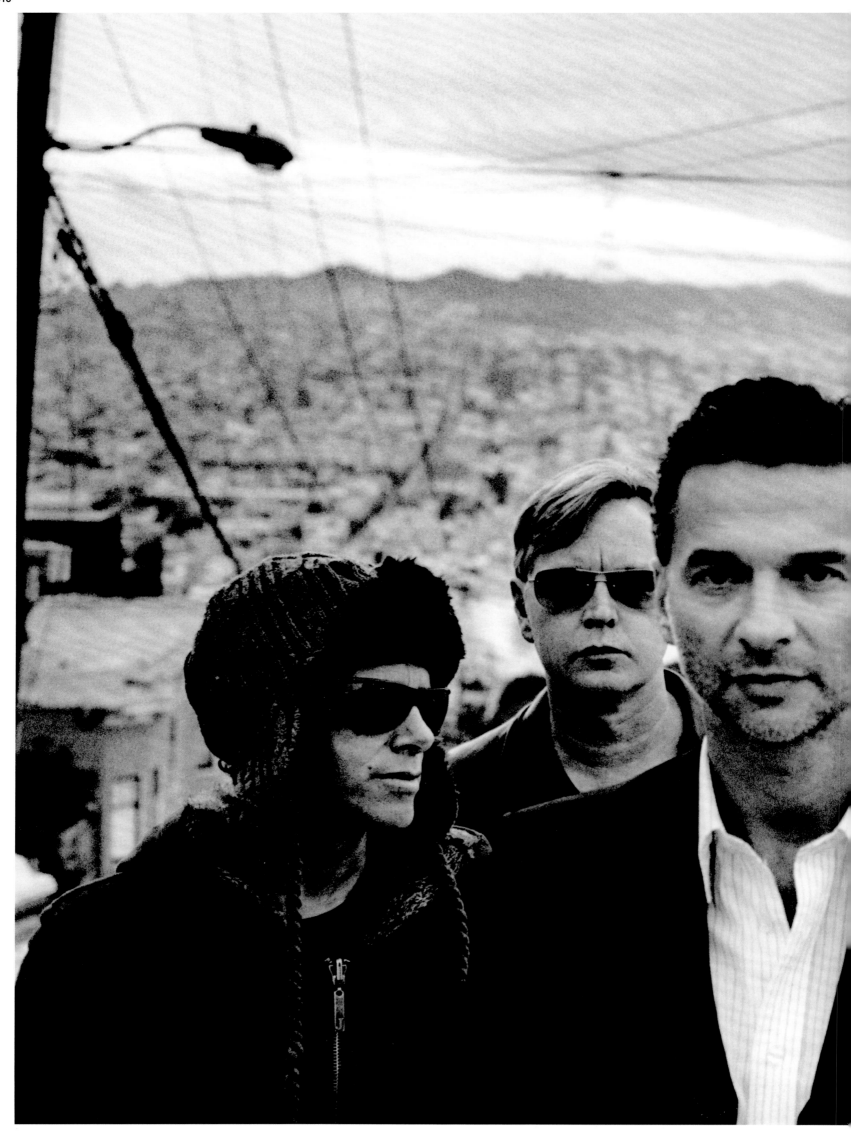

"There has never been a town like the one San Francisco is becoming, a place where a single industry composed almost entirely of rich people thoroughly dominates the local economy."

„Noch nie gab es eine Stadt wie San Francisco, einen Ort, an dem ein einziger Industriezweig, der sich fast ausschließlich aus reichen Menschen zusammensetzt, die lokale Wirtschaft vollständig dominiert."

« La ville que San Francisco est en train de devenir n'a pas de précédent – un lieu où une seule industrie constituée presque exclusivement de gens riches domine totalement l'économie locale. »

THE ATLANTIC, 2019

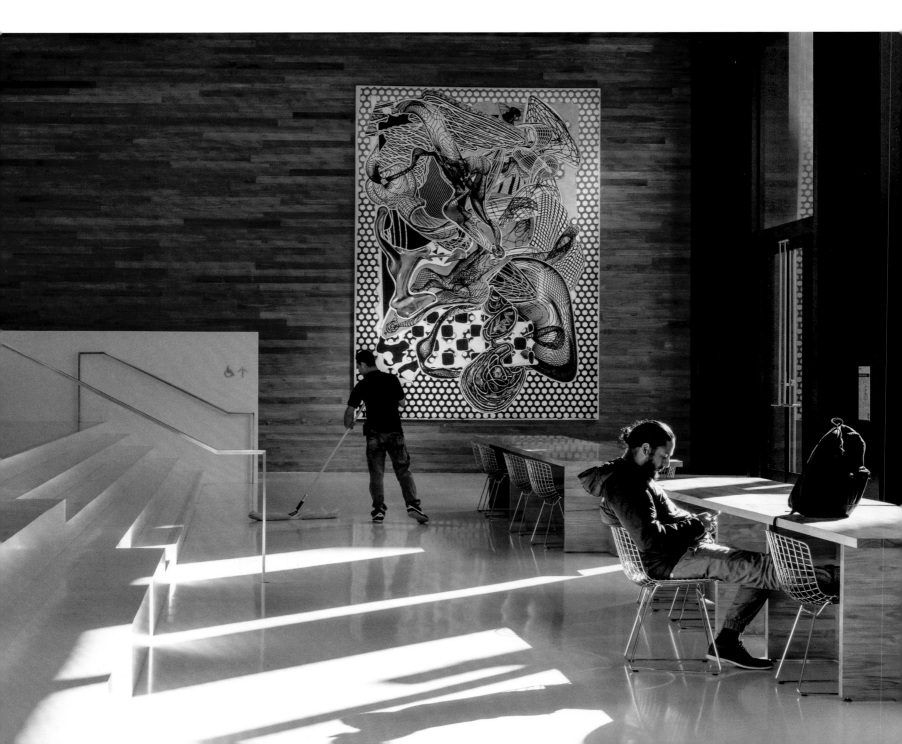

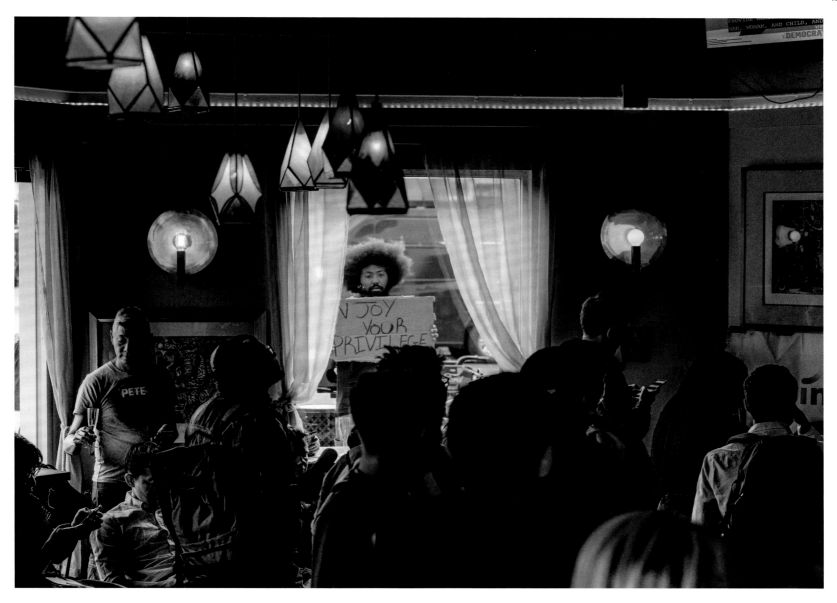

Janet Delaney

Inside the LinkedIn building at Second and Howard streets, a couple blocks south of Market Street at the memorably numbered 222 Second Street address. Many tech companies set up headquarters or large branches in the city in the early 21st century, including Facebook, Uber, Lyft, Twitter, and Spotify, 2016.

Im LinkedIn-Gebäude an der Second und Howard Street, ein paar Blocks südlich der Market Street. Die Adresse ist einfach zu merken: 222 Second Street. Viele Tech-Unternehmen haben seit Anfang des 21. Jahrhunderts ihre Hauptquartiere oder große Zweigstellen in der Stadt, zum Beispiel Facebook, Uber, Lyft, Twitter und Spotify, 2016.

222 2e Rue, adresse mémorisable sinon mémorable : l'intérieur de l'immeuble LinkedIn, à l'angle de la 2e Rue et de Howard Street, au sud de Market Street. Au début du XXIe siècle, de nombreuses entreprises high-tech installeront leur siège ou de grandes succursales à San Francisco, notamment Facebook, Uber, Lyft, Twitter et Spotify. 2016.

↑
Jason Henry

"Enjoy your privilege," reads the sign a man holds to the people inside watching a Democratic candidate debate in the Mission District, 2019.

„Genießt eure Privilegien" steht auf einem Schild, das ein Mann bei einer Debatte der demokratischen Kandidaten ans Fenster hält, 2019.

« Profitez de votre privilège », dit la pancarte tendue de l'extérieur aux spectateurs d'un débat politique entre candidats démocrates dans le Mission District. 2019.

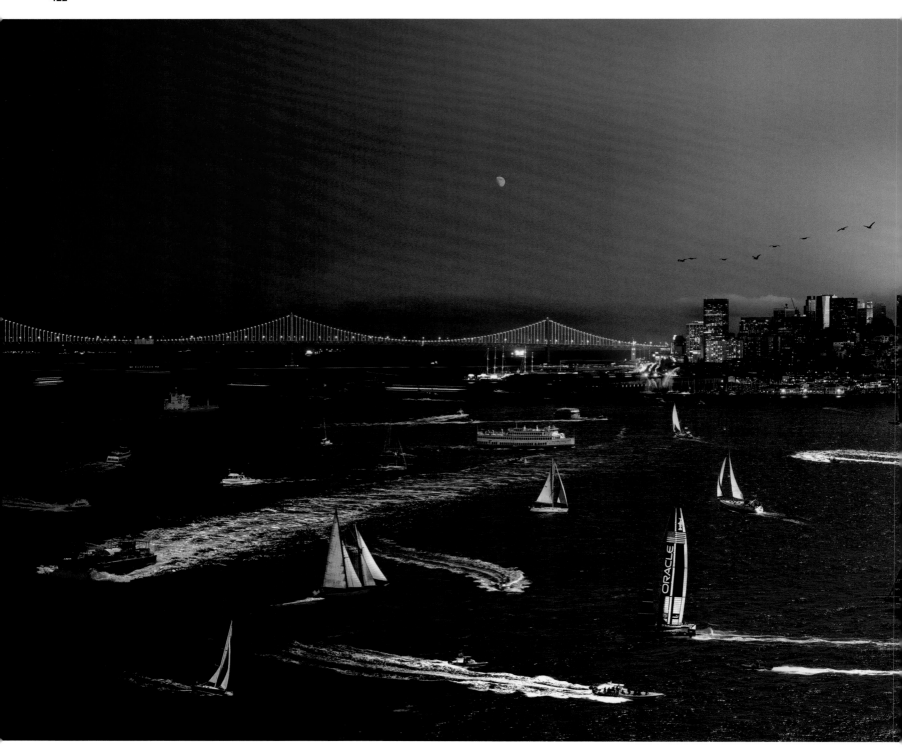

Stephen Wilkes

Boats in the bay during America's Cup,
edited together as a digital composite of
several thousand photos taken between dawn
and dusk during one day. The 34th annual
America's Cup yacht contest was held here
in September 2013 and won by Oracle Team
USA over Emirates Team New Zealand, 2013.

Boote in der Bucht während des America's
Cup, ein digitaler Zusammenschnitt von
mehreren Tausend Fotos, aufgenommen an
einem einzigen Tag zwischen Sonnenauf-
und Sonnenuntergang. Hier fand der 34.
America's Cup statt. Das Oracle Team USA
gewann die Regatta vor dem Emirates Team
New Zealand, 2013.

Bateaux dans la baie pendant l'America's
Cup, réunis sous la forme d'un composite
numérique rapprochant plusieurs milliers
de photos prises entre l'aube et le crépuscule
d'une même journée. La 34e édition de la
Coupe de l'America s'est tenue ici en sep-
tembre 2013, remportée par Oracle Team USA
face à Emirates Team New Zealand. 2013.

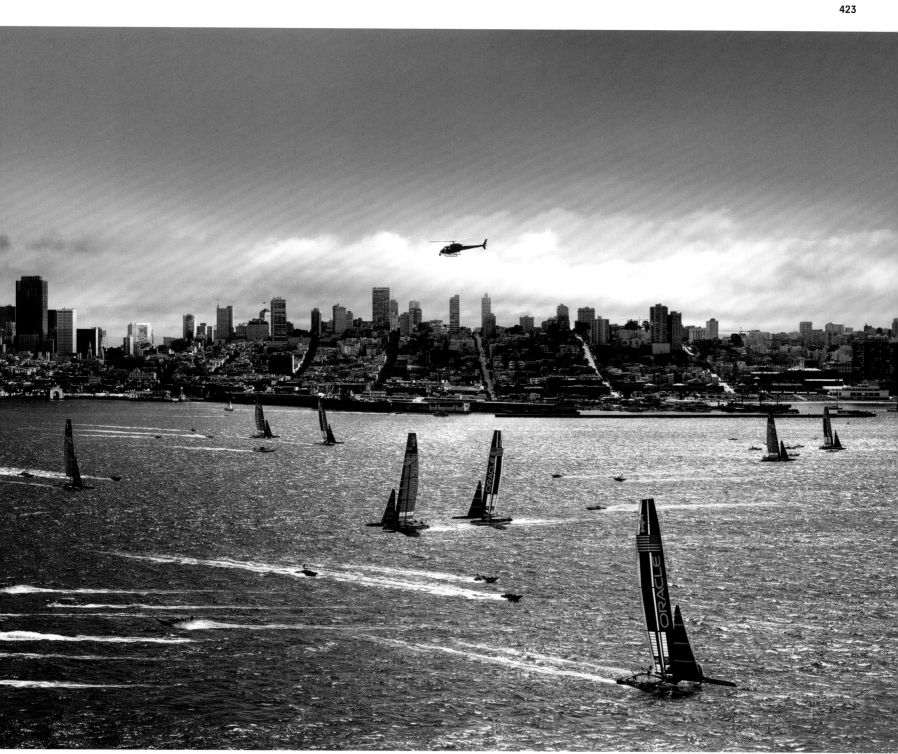

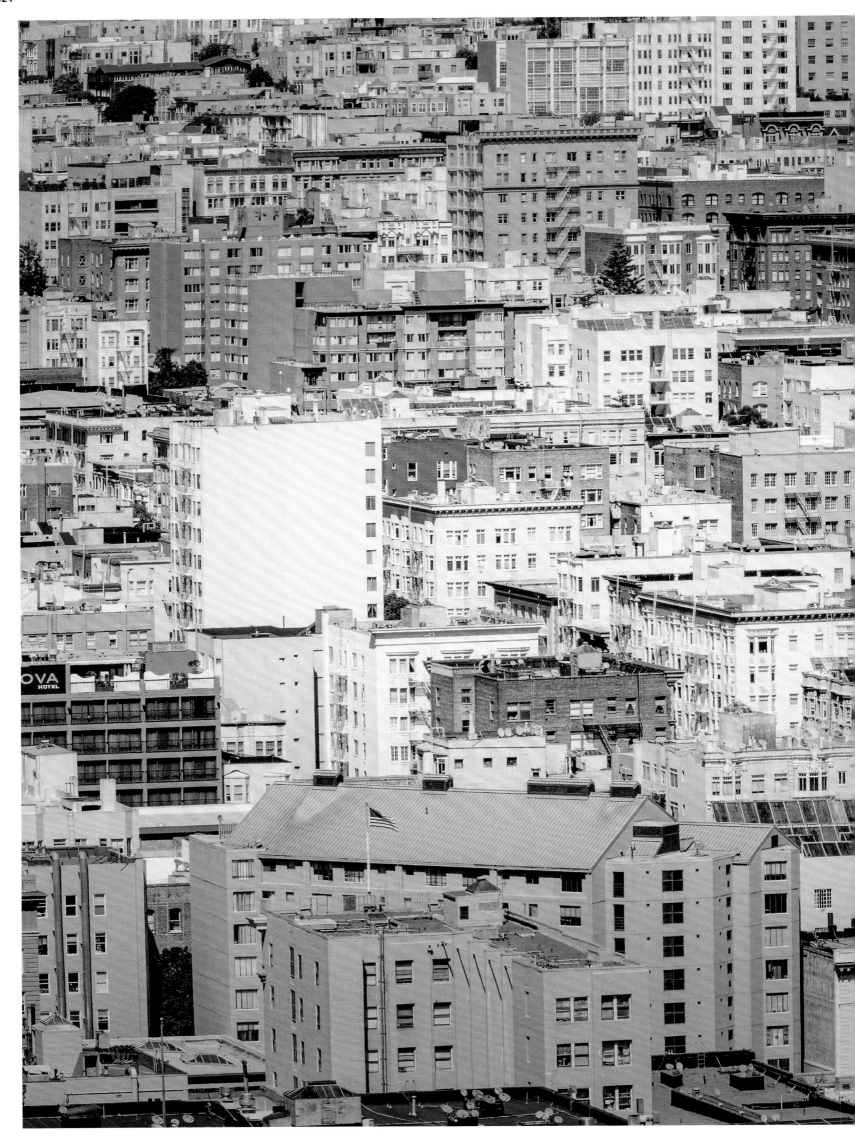

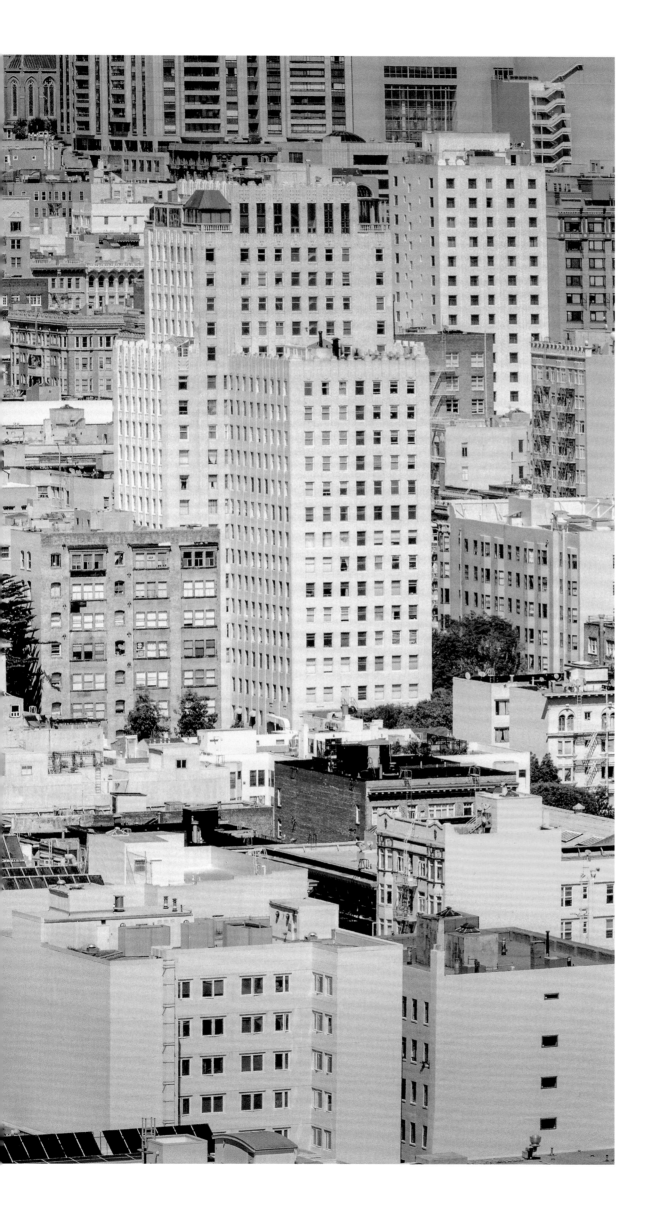

Jason Henry

Nob Hill as seen from the Fox Plaza tower near 10th and Market streets. Prices for property in the neighborhood might be astronomical, but that hasn't threatened its status as one of the most densely populated areas of the city, 2015.

Nob Hill vom Fox Plaza Gebäude gesehen, in der Nähe von Tenth und Market Street. Die Wohnungspreise in der Gegend sind zwar astronomisch, haben aber nichts daran geändert, dass es eine der dichtest besiedelten der Stadt ist, 2015.

Nob Hill vu de la Fox Plaza Tower à proximité de Market Street et de la 10e Rue. L'immobilier dans le quartier peut lui aussi atteindre des hauteurs vertigineuses, mais cela n'empêche pas cette zone de rester l'une des plus densément peuplées de la ville. 2015.

↑
Jason Henry

Professional skateboarders Ben Gore (left) and Leo Valls (right) bomb down Stanyan Street, which runs south from Geary Street in the Richmond District down to Haight-Ashbury and then up to Cole Valley. You'd be taking a big chance skating in the heavy traffic on Stanyan's steep stretch on the eastern edge of Golden Gate Park, which leads down to the Haight from the University of San Francisco, 2013.

Die professionellen Skateboarder Ben Gore (links) und Leo Valls (rechts) rasen die Stanyan Street hinunter, die von der Geary Street südwärts erst nach Richmond, dann hinunter nach Haight-Ashbury und schließlich wieder hoch zum Cole Valley führt. Man geht ein beträchtliches Risiko ein, wenn man im Verkehr den steilen Teil der Stanyan am östlichen Rand des Golden Gate Park von der University of San Francisco hinunter zur Haight führt, 2013.

Les skateurs professionnels Ben Gore (à gauche) et Leo Valls (à droite) dévalent Stanyan Street, qui part de Geary Street dans le quartier de Richmond et descend vers le sud avant de remonter vers Cole Valley. On évitera peut-être de se jeter en skate au milieu de la circulation toujours très intense sur le tronçon de Stanyan Street particulièrement abrupt qui relie l'Université de San Francisco à Haight-Ashbury. 2013.

→
Christian Delfino

Cable car tracks near Powell and Sutter streets. The masked pedestrians remind us this was taken after the onset of the COVID-19 pandemic, 2020.

Die die Cable-Car-Gleise nahe Powell und Sutter Street. Die maskierten Passanten erinnern daran, dass dieses Foto nach Beginn der Covid-19-Pandemie aufgenommen wurde, 2020.

Les rails du cable car près de Powell Street et de Sutter Street. La photo a été prise après le début de la pandémie de Covid-19, comme l'indiquent les visages masqués. 2020.

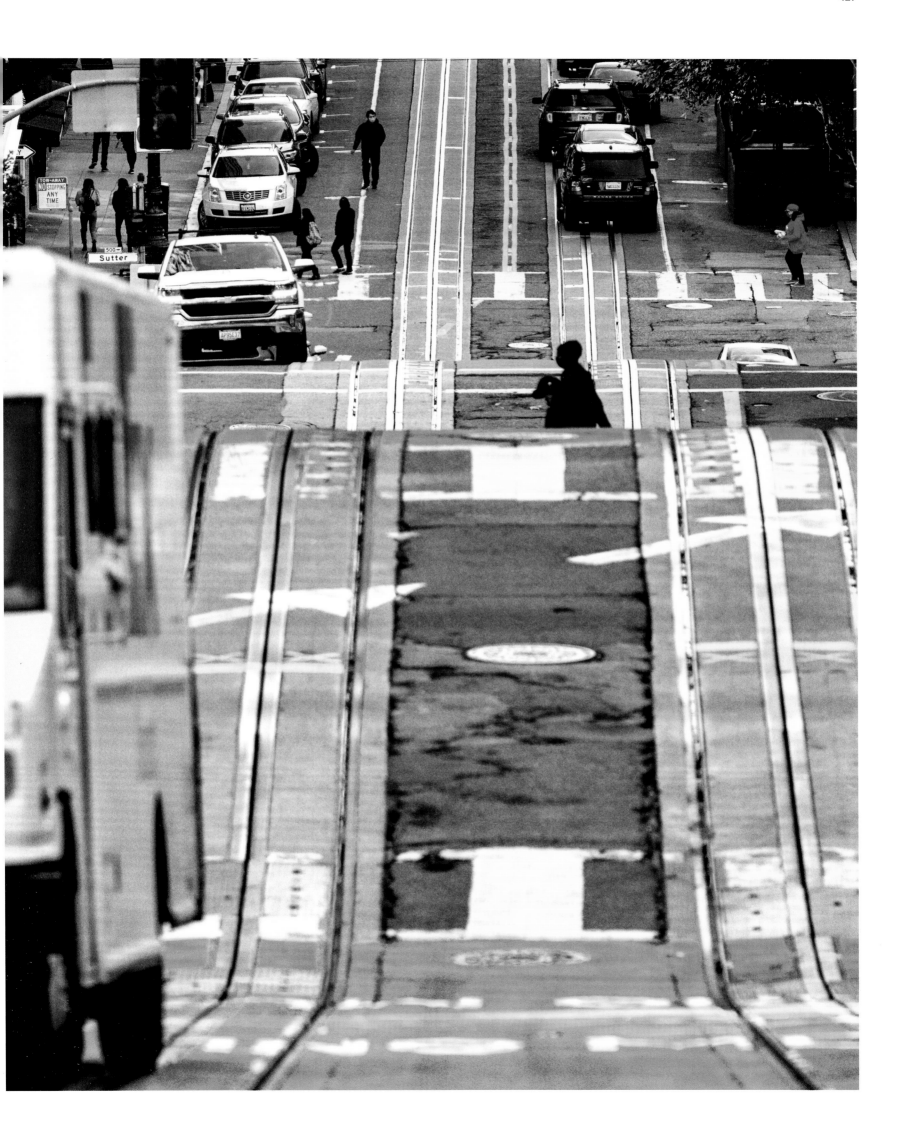

↑
Alex Ramos

The Mechanics Monument at the downtown intersection of Market, Bush, and Battery streets, as it appeared on the day the city's sky turned orange from wildfires. The bronze sculpture was built in 1901 by Douglas Tilden to honor industrialist Peter Donahue, a key figure in the construction of San Francisco's early railroads, September 9, 2020.

Das Mechanics Monument an der Kreuzung von Market, Bush und Battery Street in Downtown. Der Himmel ist hier wegen der Waldbrände dunkelorange. Die Bronzeskulptur wurde 1901 von Douglas Tilden zu Ehren des Industriellen Peter Donahue aufgestellt, einer Schlüsselfigur im frühen Eisenbahnbau in San Francisco, 9. September 2020.

Le Mechanics Monument, à l'intersection de Market Street, de Bush Street et de Battery Street, tel qu'il se découpait sur le ciel de la ville rendu orange par les incendies de forêt. La sculpture en bronze a été réalisée en 1901 par Douglas Tilden en l'honneur de l'industriel Peter Donahue, figure déterminante du développement des premiers chemins de fer de San Francisco. 9 septembre 2020.

→
Jean Fruth

Wildfires turned the city skies orange before the Giants played baseball this evening in Oracle Park. In the foreground is McCovey Cove. Wildfires have raged more fiercely in Northern California as the 21st century has progressed, sometimes drastically affecting air quality and visibility, September 9, 2020.

Waldbrände färben den Himmel orange, als an diesem Abend die Giants im Oracle Park spielen. Im Vordergrund ist die McCovey-Bucht zu sehen. Im ganzen Norden Kaliforniens haben Waldbrände im 21. Jahrhundert immer stärker gewütet, was manchmal die Luftqualität und Sichtweite drastisch verschlechtert, 9. September 2020.

Le ciel s'embrase avant le match de base-ball des Giants à l'Oracle Park. Au premier plan, McCovey Cove, cette partie de la baie qui porte le nom d'une ancienne légende de l'équipe. En Californie, les incendies de forêt font rage avec une intensité croissante depuis le début du XXIe siècle, jusqu'à affecter parfois radicalement la qualité de l'air et la visibilité. 9 septembre 2020.

p. 430/431
Noah Berger

A couple months after the COVID-19 pandemic shut down many activities and businesses, circles in Dolores Park encourage social distancing to stem the spread of the coronavirus. The Mission District park is an extremely popular spot for all sorts of recreation, including both scheduled and informal entertainment, though such events were only gradually returning a year later, 2020.

Ein paar Monate nachdem die Covid-19-Pandemie die meisten Aktivitäten unmöglich machte, sollen Kreise im Dolores Park das Social Distancing erleichtern und so die Übertragung des Virus eindämmen. Der Mission District ist sehr beliebt für Freizeit-aktivitäten aller Art, geplant oder spontan, doch Veranstaltungen gab es erst ein Jahr später wieder, 2020.

Quelques mois après que la pandémie de Covid-19 a mis à l'arrêt de nombreuses activités et entreprises, des cercles tracés dans Dolores Park encouragent la distanciation sociale afin d'endiguer la propagation du coronavirus. Le parc du Mission District est un lieu très apprécié pour toutes sortes de loisirs et divertissements, programmés ou informels, qui ne réapparaîtront toutefois que progressivement un an plus tard. 2020.

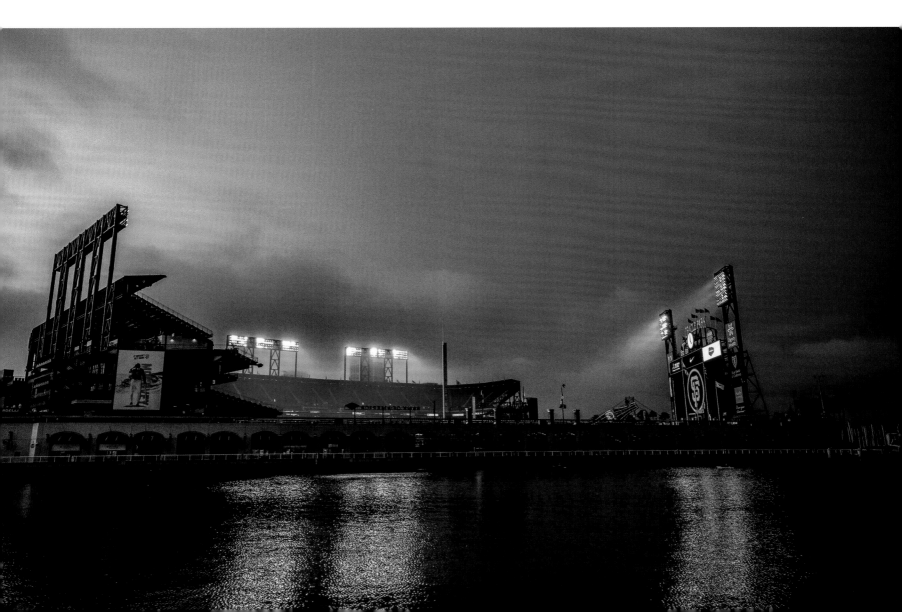

"But when it's time, if I get to heaven, I'm going to say what every San Franciscan says when they get to heaven: 'It ain't bad, but it ain't San Francisco.'"

„*Aber wenn es so weit ist, falls ich in den Himmel komme, werde ich sagen, was jeder aus San Francisco sagt, wenn er in den Himmel kommt: ‚Es ist nicht schlecht, aber es ist nicht San Francisco.'"*

«*Mais le moment venu, si je vais au paradis, je dirai ce que disent tous les San-Franciscains quand ils arrivent au paradis : "C'est pas mal, mais c'est pas San Francisco".*»

HERB CAEN, 1996

→
Christian Delfino

This was taken from the former Hunters View housing project in Bayview, built in the mid-1950s as temporary housing above the Hunters Point Naval Shipyard, and redeveloped in the 21st century after falling into disrepair, 2020.

Dieses Foto entstand von den ehemaligen Hunters-View-Sozialwohnungsbauten in Bayview aus, die Mitte der 1950er-Jahre als temporäre Wohnungen oberhalb der Marinewerft Hunters Point gebaut wurden. Die heruntergekommenen Häuser wurden im 21. Jahrhundert saniert, 2020.

Cette photo a été prise à Bayview, à l'emplacement de l'ancien projet immobilier de Hunters View, construit au milieu des années 1950 pour héberger temporairement les nouveaux travailleurs du chantier naval de Hunters Point, et réaménagé au XXIe siècle après être tombé en ruine. 2020.

p. 434
Imogen Cunningham

Self-portrait of Imogen Cunningham downtown around Market and Sixth Streets, near the Paramount Theater, c. 1950.

Selbstporträt von Imogen Cunningham in der Gegen um Market und Sixth Street, nahe des Paramount Theaters in Downtown, ca. 1950.

Autoportrait d'Imogen Cunningham dans le centre-ville de San Francisco, à l'angle de Market Street et de la 6e Rue, près du cinéma Paramount. Vers 1950.

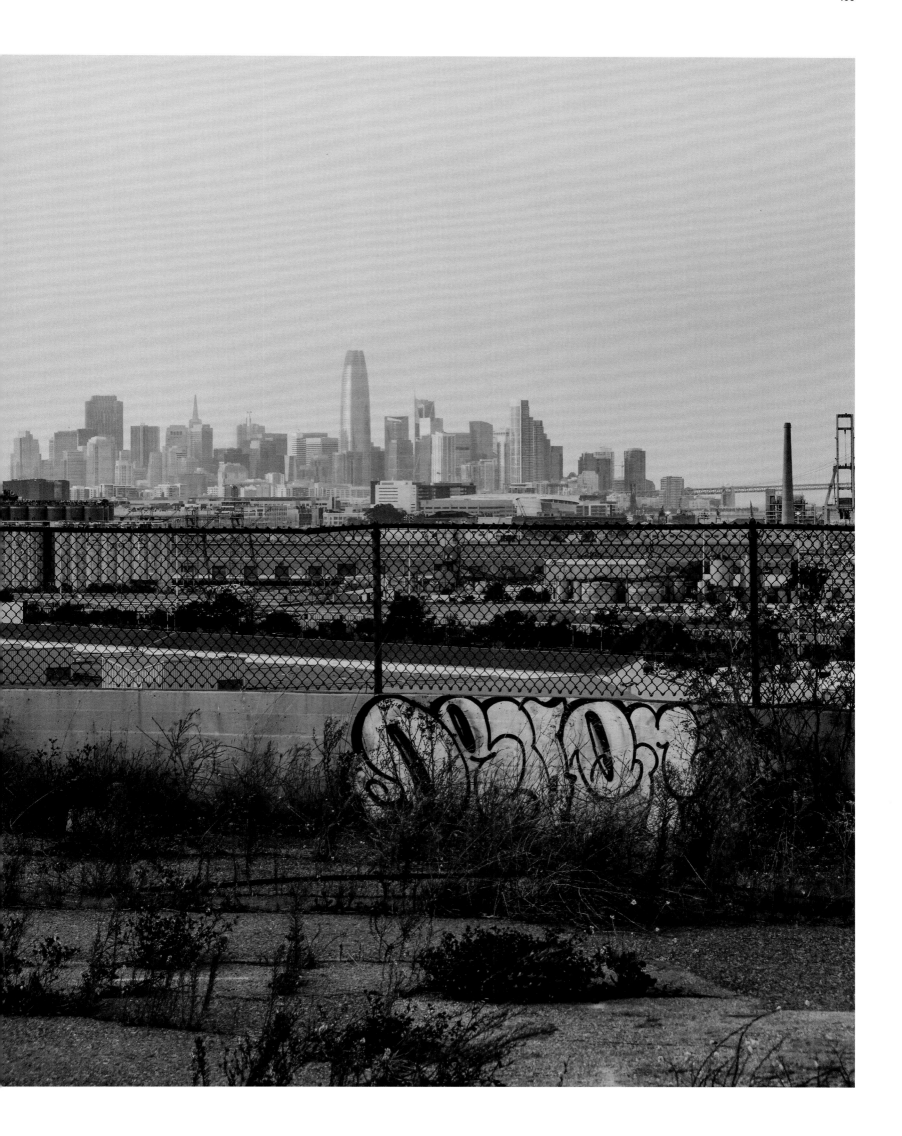

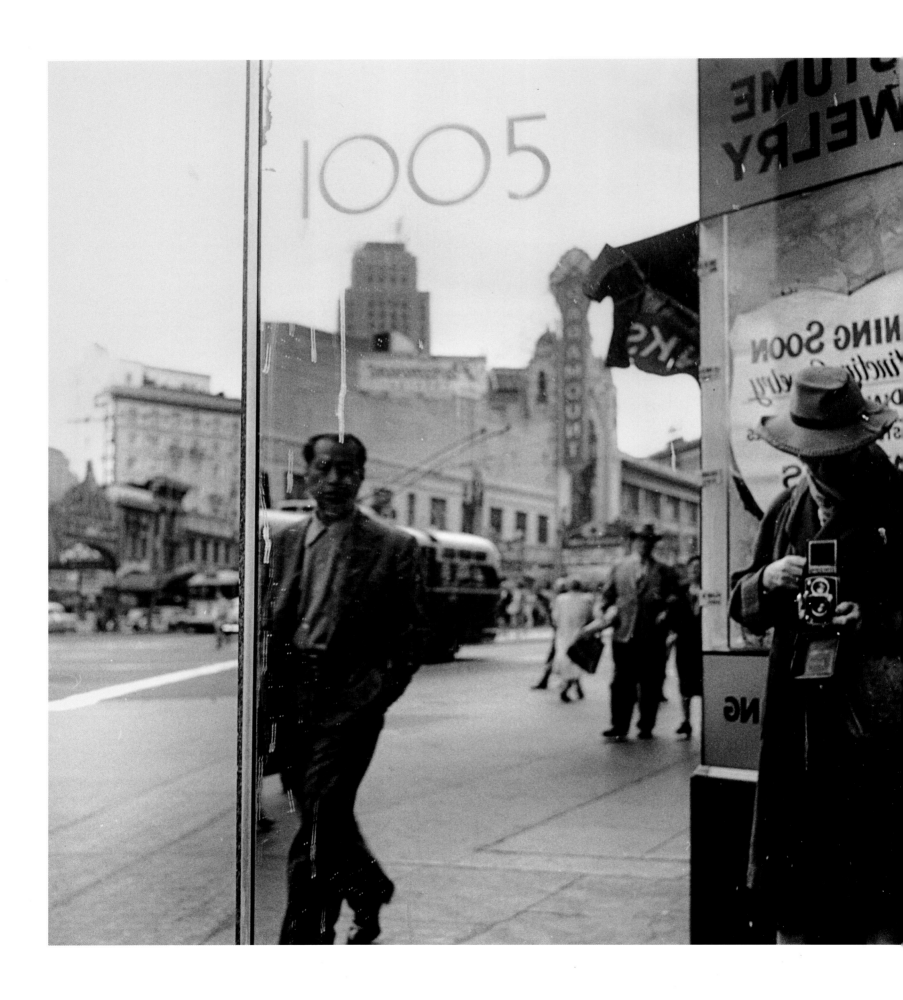

Selected Biographies of the Photographers by Jean Dykstra
Ausgewählte Biografien der Fotografen von Jean Dykstra
Biographies choisies des photographes par Jean Dykstra

Aarons, Slim *(1916–2006)*
Born George Allen Aarons, Slim Aarons was an American photographer best known for his pictures of celebrities and socialites, or what he liked to call "attractive people doing attractive things in attractive places." He began his career as a combat photographer in the Second World War, after which he moved to California, where he made a name for himself photographing Hollywood stars such as Clark Gable, Van Heflin, Gary Cooper and James Stewart. Aarons was a frequent contributor to *Life*, *Harper's Bazaar*, *Holiday* and *Town and Country Magazine*. In 1974, he published *A Wonderful Time: An Intimate Portrait of the Good Life*. In 1997, Getty Images acquired the Slim Aarons Collection.

Der amerikanische Fotograf Slim Aarons, geboren als George Allen Aarons, wurde vor allem mit seinen Aufnahmen von Prominenten und Mitgliedern der Schickeria berühmt – mit Porträts von „attraktiven Menschen, die an attraktiven Orten attraktive Dinge tun", wie er das nannte. Aarons seine Karriere als Kriegsfotograf im Zweiten Weltkrieg; nach Kriegsende zog er nach Kalifornien, wo er sich mit Aufnahmen von Hollywoodstars wie Clark Gable, Van Heflin, Gary Cooper und James Stewart einen Namen machte. Aarons fotografierte oft für *Life*, *Harper's Bazaar*, *Holiday* und *Town and Country*. 1974 veröffentlichte er *A Wonderful Time: An Intimate Portrait of the Good Life*. 1997 kaufte Getty Images die Slim Aarons Collection.

Né George Allen Aarons, Slim Aarons restera dans l'histoire de la photo pour ses images de célébrités et de figures de la haute société, cette jet-set constituée à ses yeux de « gens séduisants faisant des choses séduisantes dans des lieux séduisants ». Il débuta sa carrière comme photographe de guerre pendant le second conflit mondial, après quoi il s'installa en Californie où il se fit un nom en photographiant des stars d'Hollywood comme Clark Gable, Van Heflin, Gary Cooper et James Stewart. Il travailla régulièrement pour *Life*, *Harper's Bazaar*, *Holiday*, *Town and Country Magazine* et publia en 1974 *A Wonderful Time: An Intimate Portrait of the Good Life*. Le fonds Slim Aarons a été acquis en 1997 par Getty Images.

Adams, Ansel *(1902–1984)*
Possibly the most well-known American photographer, Adams was an environmental activist, a longtime director of the Sierra Club, as well as a photographer famous for his black-and-white images of Western landscapes and the natural world. Born and raised in San Francisco, Adams was a master printer who took iconic images of Yosemite National Park and the American western landscape, in which precision and sharp focus were primary. Along with Edward Weston and Imogen Cunningham, he founded the influential Group f/64, the Bay Area group that promoted the aesthetic of "straight photography." He cofounded the department of photography at the Museum of Modern Art, and he founded the Center for Creative Photography in Tucson. His photographs have been published in more than 35 books and appeared in hundreds of exhibitions.

Adams, der wohl bekannteste amerikanische Fotograf, war ein Umweltaktivist, langjähriger Direktor des Sierra Club und als Fotograf für seine Schwarz-Weiß-Bilder von Landschaften des amerikanischen Westens und der Natur berühmt. Der in San Francisco geborene und aufgewachsene Adams fertigte meisterhafte Abzüge an, bei seinen ikonischen Bildern des Yosemite-Nationalparks und der Landschaften des Westens stehen Präzision und Schärfe im Vordergrund. Zusammen mit Edward Weston und Imogen Cunningham gründete er die einflussreiche Gruppe f/64, die in der San Francisco Bay Area die Ästhetik der „Straight Photography" propagierte. Er war Mitbegründer der Abteilung für Fotografie am Museum of Modern Art und gründete das Center for Creative Photography in Tucson. Seine Fotografien wurden in mehr als 35 Büchern veröffentlicht und in Hunderten von Ausstellungen gezeigt.

Né et ayant grandi à San Francisco, Adams aura sans doute été le photographe américain le plus illustre, lui qui fut aussi militant écologiste avant l'heure, longtemps directeur du Sierra Club au sein duquel il joua de la plume comme du déclencheur pour célébrer la beauté de la nature : ses images en noir et blanc du parc national de Yosemite et des paysages de l'Ouest parviennent à en sublimer le moindre détail. Son attachement farouche à l'absolue netteté et sa maîtrise du tirage caractérisent cet artiste exigeant qui créera à San Francisco, aux côtés d'Edward Weston et d'Imogen Cunningham, l'influent collectif f/64, promoteur d'une esthétique de la « photographie pure ». Il cofonda le département photo du Museum of Modern Art à New York et fonda à Tucson (Arizona) le Center for Creative Photography. Ses clichés ont été publiés dans plus de trente-cinq livres et ont fait l'objet de centaines d'expositions.

Baril, Tom *(1952–)*
Baril earned his BFA from the School of Visual Arts in New York City and worked for more than 15 years as Robert Mapplethorpe's master printer. He is known for his seascapes, botanical studies, landscapes, and photographs of urban structures and for the unique toning process that he developed, resulting in rich, velvety prints. Numerous spots in San Francisco have been the subject of his photographs, including the Golden Gate Bridge, the Transamerica Pyramid, Telegraph Hill, and the Palace of the Legion of Honor.

Baril erwarb seinen Bachelor of Fine Arts an der School of Visual Arts in New York City und arbeitete mehr als 15 Jahre für Robert Mapplethorpe in der Dunkelkammer. Er ist bekannt für seine Seelandschaften, botanischen Studien, Landschaften und Fotografien von städtischen Umgebungen sowie für das von ihm entwickelte einzigartige Tönungsverfahren, das prächtige, samtige Abzüge hervorbringt. Zahlreiche Orte in San Francisco wurden Motiv seiner Fotografien, darunter die Golden Gate Bridge, die Transamerica Pyramid, Telegraph Hill und das Museum Legion of Honor.

Diplômé de la School of Visual Arts de New York, Tom Baril a secondé quinze ans durant Robert Mapplethorpe dont il développait les images. Il est connu pour ses paysages marins, ses études botaniques, ses paysages et ses photos d'espaces urbains, ainsi que pour la technique originale de virage (« toning ») qu'il a mise au point : le traitement chimique auquel il les soumet confère à ses tirages une densité et un velouté exceptionnels. Il a souvent choisi ses sujets à San Francisco, notamment le Golden Gate Bridge, la Transamerica Pyramid, Telegraph Hill et le Museum Legion of Honor.

Baruch, Ruth-Marion *(1922–1997)*
Born in Berlin, Baruch immigrated to the United States with her parents in 1927. A poet and a photographer, she studied at the California School of Fine Arts along with her future husband, Pirkle Jones. In 1968, Baruch and Jones made a photographic study of the Black Panther Party, photographs that drew more than 100,000 visitors when they were exhibited at San Francisco's de Young Museum. She photographed Haight-Ashbury during the Summer of Love, among other subjects, and did a series on women shopping in the city's Union Square that was exhibited at the San Francisco Museum of Modern Art.

Die in Berlin geborene Baruch emigrierte 1927 mit ihren Eltern in die USA. Die Dichterin und Fotografin studierte zusammen mit ihrem späteren Ehemann Pirkle Jones an der California School of Fine Arts. 1968 stellten Baruch und Jones eine fotografische Studie über die Black Panther Party zusammen, die bei ihrer Ausstellung im de Young Museum in San Francisco mehr als 100 000 Besucher anzog. Sie fotografierte unter anderem Haight-Ashbury während des Summer of Love und erstellte eine Serie über Frauen beim Einkaufen am Union Square, die im San Francisco Museum of Modern Art ausgestellt wurde.

Née à Berlin, Baruch émigra aux États-Unis avec ses parents en 1927. Poète et photographe, elle étudia à la California School of Fine Arts aux côtés de son futur mari, Pirkle Jones. En 1968, elle réalisa avec lui une étude photographique consacrée au parti des Black Panthers, qui attira plus de 100 000 visiteurs lors de l'exposition dédiée organisée au musée De Young. Entre autres sujets, elle a photographié Haight-Ashbury pendant le « Summer of Love » et exploré le consumérisme dans une série d'anonymes clientes saisies au cours de leur shopping à Union Square qui sera exposée au San Francisco Museum of Modern Art.

Bischof, Werner *(1916–1954)*
Swiss-born photojournalist Bischof began his career with a photography and advertising studio in Zurich in 1936. In 1941, he began contributing regularly to the Swiss magazine *Du*. He travelled all over Europe between 1945 and 1949 photographing the devastation of war. In 1949, he was invited to join the Magnum Photos agency and spent the next year taking pictures in Great Britain and Italy. He subsequently photographed in India, Japan, Korea, Vietnam, the United States, Panama, Mexico, and Peru for the international press, including publications such as *Life*, *Paris Match*, *Picture Post* and *The Observer*. In 1954, Bischof died at the age of 38 when a car in which he was riding went off a cliff in the Peruvian Andes.

Der in der Schweiz geborene Fotojournalist betrieb zunächst ein Atelier für Fotografie und Grafik in Zürich. Ab 1941 versorgte er das Schweizer Magazin *Du* regelmäßig mit Bildreportagen. Er reiste zwischen 1945 und 1949 durch Europa und dokumentierte die Zerstörung, die der Krieg angerichtet hatte. 1949 wurde ihm eine Mitgliedschaft bei Magnum Photos angeboten, und in den nächsten Jahren fotografierte er in Großbritannien und Italien, anschließend in Indien, Japan, Korea, Vietnam, den Vereinigten Staaten, Panama, Mexiko und Peru für die internationale Presse, darunter für *Life*, *Paris Match*, *Picture Post* und *The Observer*. 1954 starb Werner Bischof im Alter von 38 Jahren, als das Auto, in dem er saß, in den peruanischen Anden in einen Abgrund stürzte.

D'origine helvétique, Bischof démarra sa carrière en 1936 dans un studio de photo et de publicité de Zurich. En 1941, il entama une collaboration régulière avec le magazine suisse *Du* avant de parcourir l'Europe entre 1945 et 1949 pour témoigner des dévastations causées par la guerre. Invité en 1949 à rejoindre l'agence Magnum, il passera l'année suivante en reportage au Royaume-Uni et en Italie puis voyagera en Inde (où il couvrira la famine de 1951), au Japon, en Corée, au Vietnam, aux États-Unis, au Panama, au Mexique et au Pérou pour le compte de la presse internationale, notamment *Life*, *Paris Match*, *Picture Post* et *The Observer*. Il trouva la mort à l'âge de 38 ans lorsque la voiture à bord de laquelle il avait pris place dévala une falaise dans les Andes péruviennes.

Braun, Ernest *(1921–2010)*
Braun grew up in San Diego and was working as a staff photographer for Consolidated Aircraft when he was drafted and went to serve as a combat photographer in Europe. He settled in San Anselmo in 1948 and was the chief photographer for real estate developer Joseph Eichler, known for his mid-century modern homes in the Bay Area, from 1954 to 1968. In the 1960s, Braun began photographing nature and people in the Bay Area and throughout the West, photographing cable cars, the Golden Gate Bridge being painted, and other city landmarks.

Braun wuchs in San Diego auf und arbeitete als angestellter Fotograf für Consolidated Aircraft, als er eingezogen wurde und nach Europa ging, um seinen Militärdienst als Kriegsfotograf zu leisten. Er ließ sich 1948 in San Anselmo nieder und war von 1954 bis 1968 Cheffotograf des Immobilienunternehmers Joseph Eichler, der Mitte des Jahrhunderts für seine modernen Wohnhäuser in der San Francisco Bay Area bekannt war. In den 1960er-Jahren begann Braun, Natur und Menschen in der Bay Area und im gesamten Westen der USA zu fotografieren, wobei er Aufnahmen von Cable Cars, der Golden Gate Bridge, die gerade gestrichen wurde, und anderen Wahrzeichen der Stadt anfertigte.

Après avoir grandi à San Diego, Ernest Braun travaillait comme photographe pour le constructeur aéronautique Consolidated Aircraft lorsqu'il fut mobilisé et alla servir comme photographe de guerre en Europe. Installé à San Anselmo à partir de 1948, il deviendra en 1954, jusqu'en 1968, le photographe attitré du promoteur immobilier Joseph Eichler, dont les maisons de style « mid-century modern » ont laissé une empreinte durable dans la « Bay Area ». Au cours des années 1960, Braun commença aussi à photographier la nature et les habitants de tout l'Ouest américain et plus particulièrement autour de San Francisco, où il immortalisa le *cable cars* et le Golden Gate Bridge en phase de peinture, entre autres jalons emblématiques de la ville.

Braverman, Jeffrey *(1966–)*
Braverman is a San Francisco–based photographer and filmmaker whose series *David, In Brief* explores the struggles of older gay and transgender men. His portraits and photographs have appeared in *Wired*, *Esquire*, and *Newsweek*, among other publications.

Jeffrey Braverman ist ein in San Francisco ansässiger Fotograf und Filmemacher, der in seiner Serie *David, In Brief* die Probleme älterer schwuler Männer und Transmänner zeigt. Seine Porträts und Fotografien sind unter anderem in *Wired*, *Esquire* und *Newsweek* erschienen.

Photographe et cinéaste basé à San Francisco, Braverman a réalisé une série intitulée *David, In Brief* qui évoque les difficultés rencontrées par les hommes gays et transgenres d'un certain âge. Ses portraits et photos ont paru dans *Wired*, *Esquire* et *Newsweek*, entre autres publications.

Bristol, Horace *(1908–1997)*
After studying at the Art Center of Los Angeles, Bristol moved to San Francisco and became friends with Ansel Adams, Edward Weston, Dorothea Lange, and Imogen Cunningham. He became a staff photographer for *Life*, where he proposed a story about migrant workers in California's Central Valley, to be accompanied by a text by John Steinbeck. *Life* turned the story down, Steinbeck went on to write *The Grapes of Wrath*, and Bristol photographed the Central Valley on his own.

Nach seinem Studium am Art Center of Los Angeles zog Bristol nach San Francisco und freundete sich mit Ansel Adams, Edward Weston, Dorothea Lange und Imogen Cunningham an. Er wurde Fotograf bei *Life*, wo er eine Reportage über Wanderarbeiter im kalifornischen Central Valley vorschlug, die von einem Text von John Steinbeck begleitet werden sollte. *Life* lehnte die Geschichte ab, Steinbeck schrieb daraufhin *Die Früchte des Zorns*, und Bristol fotografierte das Central Valley auf eigene Faust.

Après une formation à l'Art Center de Los Angeles, Horace Bristol s'installa à San Francisco où il se lia d'amitié avec Ansel Adams, Edward Weston, Dorothea Lange et Imogen Cunningham. Au lendemain de la Grande Dépression, devenu photographe pour *Life*, il proposa à sa direction un reportage consacré aux travailleurs migrants de la Central Valley californienne, travail qui devait être accompagné d'un texte de John Steinbeck. *Life* refusa le sujet, Steinbeck écrivit *Les Raisins de la colère* et Bristol alla en solitaire photographier la vallée et ses occupants.

Claxton, William *(1927–2008)*
While studying psychology at University of California, Los Angeles, Claxton would take photographs at downtown L.A. jazz clubs with a 4 x 5 Speed Graphic camera (also used by Weegee). In 1952, Pacific Jazz Records hired him as art director, photographer, and partner. It was during this period that he shot some of his most iconic photos, including the trumpeter Chet Baker. In 1960, he went on a mammoth journey across America, photographing the music scene coast-to-coast. The results were published in *Jazz Life* (TASCHEN, 2006). TASCHEN has also published two other books of Claxton's work: *New Orleans 1960* (2006) and *Steve McQueen* (2004). In addition to jazz, Claxton shot fashion, most memorably with his wife, the model Peggy Moffitt, and numerous entertainers and actors.

Während seines Psychologiestudiums an der University of California, Los Angeles, fotografierte Claxton mit einer 4-x-5-Speed-Graphic-Kamera (die auch von Weegee verwendet wurde) in Jazzclubs in Downtown Los Angeles. 1952 engagierte ihn die Plattenfirma Pacific Jazz als Artdirector, Fotograf und Teilhaber. In dieser Zeit nahm er einige Fotos auf, die später Kultstatus erlangten, zum Beispiel von dem Trompeter Chet Baker. 1960 fotografierte er die amerikanische Musikszene auf einer Reise quer durch das ganze Land. Die Ergebnisse sind in dem Buch *Jazzlife* (TASCHEN, 2006) zu sehen. TASCHEN veröffentlichte auch zwei weitere Bücher mit Claxtons Arbeiten: *New Orleans 1960 (2006)* und *Steve McQueen* (2004). Neben Jazzmusikern nahm Claxton, auch Modefotos auf, besonders mit seiner Frau Peggy Moffitt, und fotografierte viele Entertainer und Schauspieler.

Pendant ses études de psychologie à l'Université de Californie à Los Angeles, Claxton allait le soir photographier les concerts donnés dans les clubs de jazz de la ville, son Graflex 4 x 5 Speed Graphic en main (le même appareil que Weegee). Engagé en 1952 par Pacific Jazz Records comme directeur artistique, photographe et associé, il réalisa à cette époque certains de ses clichés les plus emblématiques, parmi lesquels un célèbre portrait du trompettiste Chet Baker. En 1960, il entreprit un extraordinaire périple à travers l'Amérique, photographiant la scène musicale d'un bout à l'autre du pays. Le voyage donnera lieu en 2006 à un livre, *Jazz Life*, publié par TASCHEN qui consacrera deux autres ouvrages à ses photos : *New Orleans 1960* (2006) et *Steve McQueen* (2004). Claxton travailla également pour le monde de la mode, avec surtout sa femme, le mannequin Peggy Moffitt, mais aussi nombre d'artistes et d'acteurs.

Corbijn, Anton *(1955–)*
Corbijn is a Dutch photographer, videographer, and film director best known for his work with rock bands, having created music videos, album covers and sleeve photography for Joy Division, Depeche Mode, U2, Nirvana and The Rolling Stones. His photographs, usually black and white, often resemble motion picture stills. In 2010, Corbijn's recent portraits of people from the worlds of music, art, and fashion were assembled in an exhibition and a book entitled *Inwards and Outwards*. Corbijn now lives in Amsterdam. His book on Depeche Mode was published by TASCHEN in 2020.

Der niederländische Fotograf, Videograf und Filmregisseur wurde vor allem mit seinen Aufnahmen von Rockbands bekannt: Er schuf Musikvideos und Fotos für Plattenhüllen, beispielsweise für Joy Division, Depeche Mode, U2, Nirvana und die Rolling Stones. Seine Fotos – in der Regel in Schwarzweiß – erinnern häufig an Standbilder aus Filmen. 2010 wurden Corbijns jüngste Porträts von Menschen aus der Musik-, Kunst- und Modebranche auf einer Ausstellung und in einem Buch mit dem Titel *Inwards and Outwards* präsentiert. Corbijn wohnt heute in Amsterdam. 2020 erschien bei TASCHEN sein Buch über Depeche Mode.

Photographe, vidéaste et réalisateur néerlandais, connu avant tout pour le travail qu'il a réalisé dans le monde du rock, Corbijn a créé des clips, des photos de pochettes et de livrets d'albums pour Joy Division, Depeche Mode, U2, Nirvana et les Rolling Stones. Le plus souvent en noir et blanc, ses photos donnent l'impression d'être tirées d'un tournage de film. Ses portraits récents consacrés à des personnalités du monde de la musique, de l'art et de la mode ont été rassemblés en 2010 dans une exposition et un livre intitulés *Inwards and Outwards*. Son ouvrage sur Depeche Mode a été publié par TASCHEN en 2020. Corbijn vit aujourd'hui à Amsterdam.

Crane, Ralph *(1913–1988)*
Born in Germany, a son and grandson of physicians, it was expected that Crane would enter the "family business," but he got the photography bug from his amateur enthusiast father at a young age and never looked back. He moved to the United States in 1941, and started shooting for the Black Star agency, with many of his pictures ending up in *Life* magazine. He became a *Life* staffer in 1951 and for the next several decades established a reputation as one of the magazine's most technically adept and versatile photographers. He was especially skilled at capturing post-war American society and as an immigrant had a unique perspective on his adopted country.

Von dem in Deutschland geborenen Sohn und Enkel von Ärzten wurde eigentlich erwartet, dass er in das „Familiengeschäft" einsteigen würde, aber sein Vater, ein begeisterter Amateurfotograf, steckte ihn schon in jungen Jahren mit seiner Leidenschaft an, die ihn nie mehr losließ. Er zog 1941 in die USA und begann, für die Agentur Black Star zu fotografieren, wobei viele seiner Bilder in der Zeitschrift *Life* erschienen. 1951 wurde er Mitarbeiter von *Life* und erwarb sich in den folgenden Jahrzehnten den Ruf eines der vielseitigsten und technisch versiertesten Fotografen der Zeitschrift. Besonders gut gelang es ihm, die amerikanische Nachkriegsgesellschaft einzufangen. Auf seine Wahlheimat hatte er als Einwanderer eine einzigartige Perspektive.

Né en Allemagne, fils et petit-fils de médecins, Ralph Crane était voué à suivre leurs traces mais son père, amateur passionné, lui a transmis très tôt le virus de la photographie, dont il ne guérira jamais. Installé aux États-Unis en 1941, il commence à travailler pour l'agence Black Star et voit le magazine *Life* publier régulièrement ses photos. Il rejoint *Life* en 1951 se forge, au fil des décennies, une réputation de photographe éclectique et techniquement surdoué. Rares sont ceux à avoir su comme lui saisir les subtilités de la société américaine de l'après-guerre. Le singulier regard qu'il posait sur son pays d'adoption doit beaucoup à son histoire personnelle, celle d'un immigrant porté par une énergie exceptionnelle.

Cunningham, Imogen *(1883–1976)*
Cunningham was a founding member of the Group f/64, a group of West Coast photographers that included Ansel Adams, Edward Weston, and Sonya Noskowiak. They rejected sentimental, soft-focus images and insisted on greater sharpness and detail. Cunningham was born in Portland, OR and grew up in Seattle, WA. She was an assistant at the Edward Curtis studio and subsequently opened her own studio, making portraits of well-known artists such as Frida Kahlo, Edward Weston, and Ruth Asawa, among many others. She moved to San Francisco in 1917 and is known for her close-up, minimalist botanical studies, including a multiyear study of the magnolia and calla lillies, both common in her Bay Area neighborhood. Modernist photographic experiments included nudes, still lifes, and photographs exploring the city's vibrant street life.

Cunningham war Gründungsmitglied der Gruppe f/64, einer Gruppe von Fotografen von der Westküste, zu der auch Ansel Adams, Edward Weston und Sonya Noskowiak gehörten. Sie lehnten sentimentale Bilder mit Weichzeichnung zugunsten größerer Schärfe und mehr

Details ab. Cunningham wurde in Portland, Oregon, geboren und wuchs in Seattle, im Bundesstaat Washington, auf. Sie war Assistentin im Studio von Edward Curtis und eröffnete später ihr eigenes Atelier, in dem sie unter anderem Porträts von so bekannten Künstlern wie Frida Kahlo, Edward Weston und Ruth Asawa anfertigte. 1917 zog sie nach San Francisco. Sie ist für ihre minimalistischen Fotografien von Pflanzen bekannt, darunter über mehrere Jahre angefertigte Aufnahmen von Magnolien und Calla-Lilien, die in ihrer Nachbarschaft in der San Francisco Bay Area häufig vorkommen. Zu ihren modernistischen fotografischen Experimenten gehören Aktaufnahmen, Stillleben und Fotografien, die das pulsierende Leben der Stadt zeigen.

Audacieuse et éclectique, elle est l'une des fondatrices du groupe f/64, un collectif de photographes de la côte Ouest composé notamment d'Ansel Adams, Edward Weston et Sonya Noskowiak. Attachés à la netteté et donc à la précision du détail, ils partageaient un même rejet du sentimentalisme graphique et des effets de flou. Née à Portland, élevée à Seattle, Imogen Cunningham fit son apprentissage auprès d'Edward Curtis avant d'ouvrir son propre studio et de tirer le portrait d'artistes aussi illustres que Edward Weston, Frida Kahlo ou Ruth Asawa. Partie pour San Francisco en 1917, elle y fera apprécier le minimalisme de ses études botaniques en gros plan, et plus particulièrement le travail qu'elle consacra longtemps au magnolia et au lis calla, courants dans la « Bay Area ». Nus et natures mortes entreront également dans le cadre de ses expérimentations modernistes, ainsi que les sujets des rues de la ville.

Cushman, Charles W. *(1896–1972)*

Cushman was a prolific amateur photographer and traveler, who left a legacy of just under 15,000 Kodachrome color slides that are now housed at Indiana University, where he studied commercial law in 1914. The man himself is something of an enigma; he held a variety of jobs, including technical editor and liquidator, but we do know for certain that the images were taken between 1938 and 1969. In addition to traveling all over the United States, he went to Europe, Mexico, Canada, the Bahamas, and parts of the Middle East.

Cushman war ein produktiver Amateurfotograf und Reisender und hinterließ knapp 15 000 Kodachrome-Farbdias, die an der Indiana University aufbewahrt werden. Dort hatte er 1914 Wirtschaftsrecht studiert. Der Fotograf selbst ist ein Rätsel: Er hatte viele Berufe, zum Beispiel technischer Redakteur und Konkursverwalter, aber zumindest weiß man genau, dass seine Bilder zwischen 1938 und 1969 entstanden sind. Er bereiste nicht nur die gesamten Vereinigten Staaten, sondern auch Europa, Mexiko, Kanada, die Bahamas und Teile des Nahen Ostens.

Infatigable voyageur et prolifique photographe amateur, Cushman a laissé un héritage d'un peu moins de 15 000 diapositives Kodachrome, conservées à l'Université de l'Indiana. L'homme lui-même s'apparente à une énigme. Après avoir étudié le droit commercial en 1914, il occupa toutes sortes d'emplois (rédacteur en chef technique, liquidateur...). On sait cependant avec certitude que ses photos ont été prises entre 1938 et 1969. Il ne fit pas que sillonner les États-Unis mais visita aussi, appareil en main, l'Europe, le Mexique, le Canada, les Bahamas et certaines régions du Moyen-Orient.

Dahl-Wolfe, Louise *(1895–1989)*

Born in Alameda, CA, Dahl-Wolfe studied at the San Francisco Institute of Art. After her photograph of a Tennessee mountain woman was published in *Vanity Fair* in 1933, her career was jump-started, and she opened a photography studio in New York City. She was a staff fashion photographer for *Harper's Bazaar* from 1936 until 1958 and shot 86 covers for the magazine. Her photographs championed the sophisticated look of the "New Woman" in the 1940s and '50s. While at *Harper's*, she also photographed cultural icons such as Orson Welles, Carson McCullers, Christian Dior, and Edward R. Murrow.

Geboren in Alameda, Kalifornien, studierte Dahl-Wolfe am San Francisco Institute of Art. Nachdem ihr Foto einer Frau aus den Bergen von Tennessee 1933 in *Vanity Fair* veröffentlicht worden war, kam ihre Karriere in Schwung, und sie eröffnete ein Fotostudio in New York City. Von 1936 bis 1958 arbeitete sie als Modefotografin für *Harper's Bazaar* und ihre Fotos erschienen auf 86 Titelseiten der Zeitschrift. Ihre Fotografien setzten den eleganten Look der „Neuen Frau" in den 1940er- und 50er-Jahren in Szene. In ihrer Zeit bei *Harper's* fotografierte sie auch Berühmtheiten wie Orson Welles, Carson McCullers, Christian Dior und Edward R. Murrow.

Née à Alameda, en Californie, Louise Dahl-Wolfe a été formée au San Francisco Institute of Art. Sa carrière démarrera en flèche après la publication en 1933 dans *Vanity Fair* de la photo d'une montagnarde du Tennessee, qui lui permettra d'ouvrir son propre studio à New York. Photographe de mode pour *Harper's Bazaar* de 1936 à 1958, elle y signera 86 couvertures. Son travail plaidera avec ardeur pour le look sophistiqué de la « nouvelle femme » des années 1940 et 1950. Son passage au *Harper's* lui vaudra également de fixer sur sa pellicule des icônes du monde culturel telles qu'Orson Welles, Carson McCullers, Christian Dior et Edward R. Murrow.

Davidson, Bruce *(1933–)*

A graduate of Yale and the Rochester Institute of Technology, Davidson started working as a freelance photographer for *Life* in 1957 and joined Magnum Photos in 1958. He had previously met Henri Cartier-Bresson during his U.S. military service in Paris. In 1963, Davidson had his first solo show at the Museum of Modern Art. In 1970, his work on Spanish Harlem was published in a book, *East 100th Street*, and in 1986, his project on the New York transit system, *Subway*, was published. Between 1991 and 1995, he photographed extensively in Central Park. His images are in the collections of many of the world's leading museums, and have appeared in numerous international publications.

Der Absolvent von Yale und dem Rochester Institute of Technology begann 1957, freiberuflich für *Life* zu arbeiten. 1958 wurde Davidson Mitglied von Magnum Photos. Er hatte während seines Militärdienstes für die US-Armee in Paris Henri Cartier-Bresson kennengelernt. 1963 fand Davidsons erste Einzelausstellung im Museum of Modern Art statt, und 1970 wurden seine Fotos von Spanish Harlem im Buch *East 100th Street* veröffentlicht; 1986 wurde auch *Subway*, sein Projekt über die New Yorker U-Bahn, publiziert. Von 1991 bis 1995 nahm er viele Bilder im Central Park auf. Seine Fotos sind Bestandteil der Sammlungen von vielen großen Museen weltweit und wurden in unzähligen internationalen Publikationen veröffentlicht.

Diplômé de Yale et du Rochester Institute of Technology, Davidson commença à travailler comme photographe indépendant pour *Life* en 1957. Un an plus tard, il rejoignait l'agence Magnum, fondée par Henri Cartier-Bresson qu'il avait rencontré pendant son service militaire à Paris. En 1963, le Museum of Modern Art de New York lui consacra sa première exposition solo et en 1970, son travail sur Spanish Harlem, le quartier à majorité latino de Manhattan, trouvera une traduction éditoriale avec le livre *East 100th Street*. Son exploration de l'univers du métro new-yorkais connaîtra le même couronnement éditorial (*Subway*, 1986). Entre 1991 et 1995, il prendra énormément de photos à Central Park. Ses images ont rejoint les collections de nombreux musées importants à travers le monde et ont paru dans de multiples publications internationales.

Delaney, Janet *(1952–)*

A 2020 Guggenheim fellow and a faculty member at the University of California, Berkeley, Delaney is known for her long-term photographic project documenting cities in transition. She is best known for her series *South of Market* (1978–1986), focusing on the gentrification of a working-class neighborhood in San Francisco, and she is currently at work on a project documenting San Francisco's evolution into a center of

technology. Her photographs, which combine elements of documentary and fine-art photography, are in the collections of SFMOMA, the Pilara Foundation, and the de Young Museum, among other places.

Delaney, Guggenheim-Stipendiatin 2020 und Fakultätsmitglied an der University of California, Berkeley, ist bekannt für ihre Langzeit-Fotoprojekte, mit denen sie den Wandel in Städten dokumentiert. Am berühmtesten ist ihre Serie *South of Market* (1978–86), die sich mit der Gentrifizierung eines Arbeiterviertels in San Francisco befasst. Derzeit arbeitet sie an einem Projekt, das die Entwicklung San Franciscos zum Technologiezentrum dokumentiert. Ihre Fotografien, die Elemente der Dokumentar- und Kunstfotografie vereinen, befinden sich unter anderem in den Sammlungen des SFMOMA, der Pilara Foundation und des de Young Museum.

Enseignante à l'Université de Californie (Berkeley) et lauréate en 2020 d'une bourse Guggenheim, Janet Delaney s'est fait un nom avec le projet photographique de longue haleine qu'elle a décidé de consacrer aux processus de transition urbaine. Ainsi sa série *South of Market* (1978–1986) est-elle dédiée à la gentrification de ce quartier ouvrier de San Francisco, et elle étudie actuellement la transformation de San Francisco en capitale technologique. On peut admirer son œuvre à la fois artistique et documentaire au sein des collections du San Francisco Museum of Modern Art (SFMOMA), de la Fondation Pilara et du musée De Young, pour ne citer qu'elles.

Delfino, Christian *(1987–)*

Originally from Sarasota, FL, Delfino is a Brooklyn-based documentary photographer whose series *Disconnected* explores the urban experience, comparing similarities and differences in cities worldwide, including a photograph showing the San Francisco skyline in the distance and a grafitti-tagged wall in the foreground. More recently, he's been photographing at a Chinese-owned scrap heap, where his father works in Tampa, FL, documenting the process of sorting and compacting.

Der ursprünglich aus Sarasota, Florida, stammende Delfino ist ein in Brooklyn ansässiger Dokumentarfotograf, der sich in seiner Serie *Disconnected* mit dem Stadtleben befasst, indem er Ähnlichkeiten und Unterschiede von Städten auf der ganzen Welt untersucht, darunter eine Fotografie, die die Skyline von San Francisco in der Ferne und eine mit Grafitti überzogene Wand im Vordergrund zeigt. Seit kurzer Zeit fotografiert er an einer Schrotthalde in Tampa, Florida, die Chinesen gehört und auf der sein Vater arbeitet, und dokumentiert den Prozess des Sortierens und Pressens von Schrott.

Originaire de Sarasota, en Floride, et désormais basé à Brooklyn, Christian Delfino s'est spécialisé dans la photographie documentaire. Sa série *Disconnected* ausculte l'expérience de la vie urbaine en comparant ce qui rapproche et distingue les villes du monde entier où il a voyagé. Ainsi, à San Francisco, cette photo des gratte-ciel qui forment l'horizon de la ville et une autre de façade taguée, placée au premier plan. Plus récemment, il a photographié à Tampa le lieu de travail de son père : une entreprise chinoise de recyclage des ferrailles, documentant le processus de tri, compactage, recyclage.

Dobbin, Hamilton Henry *(1856–1930)*

Dobbin was an Irish-born police officer in San Francisco for 35 years whose hobby was the theater. He took photographs of actors, actresses, and boxers in the early 20th century, and he also photographed residents of San Francisco during the 1918 Spanish flu epidemic, including workers wearing flu masks covering their mouths and noses. Dobbin assembled two volumes of photographs titled *Album of San Francisco*, which are in the holdings of the California State Library.

Der irischstämmige Dobbin arbeitete 35 Jahre lang als Polizist in San Francisco und ging nebenbei seinem Hobby, dem Theater, nach. Zu Beginn des 20. Jahrhunderts fotografierte er Schauspieler, Schauspielerinnen und Boxer und 1918, während die Spanische Grippe wütete, auch die Einwohner von San Francisco, darunter Arbeiter mit Mundschutz. Dobbin

stellte zwei Fotobände mit dem Titel *Album of San Francisco* zusammen, die sich in den Beständen der California State Library befinden.

D'origine irlandaise, Hamilton Dobbin travailla trente-cinq ans durant au sein de la police de San Francisco. Son hobby, le théâtre, lui donna l'occasion de photographier de nombreux acteurs et actrices du début du xxᵉ siècle, ainsi que des boxeurs. Il photographia également les habitants de San Francisco pendant l'épidémie de grippe espagnole de 1918, dont des ouvriers équipés d'un masque de protection. Dobbin a rassemblé ses meilleurs clichés dans deux volumes intitulés *Album of San Francisco* et conservés à la Bibliothèque d'État de Californie.

Eppridge, Bill *(1938–2013)*

Eppridge worked for *National Geographic* and *Life*, where he became a staff photographer, photographing the Civil Rights Movement and political campaigns, heroin addicts in New York City, and patrons at gay bars in San Francisco, among other subjects. Eppridge shot the Beatles' first US tour, and took the famous photograph of Juan Romero, the busboy at the Ambassador Hotel in Los Angeles, kneeling to help Robert F. Kennedy after he was fatally shot by Sirhan Sirhan.

Eppridge arbeitete als angestellter Fotograf für *National Geographic* und *Life*, für die er unter anderem die Bürgerrechtsbewegung und politische Kampagnen, Heroinabhängige in New York City und Besucher von Schwulenbars in San Francisco fotografierte. Eppridge fotografierte die erste US-Tournee der Beatles und machte das berühmte Foto von Juan Romero, dem Hilfskellner, der neben Robert F. Kennedy kniete, nachdem dieser von Sirhan Sirhan im Ambassador Hotel in Los Angeles erschossen wurde.

Bill Eppridge a travaillé pour *National Geographic* et *Life*, dont il a rejoint l'équipe de photographes au sein de laquelle il couvrira le mouvement des droits civiques, diverses campagnes politiques, la situation des héroïnomanes de New York et l'univers des bars gays de San Francisco, entre autres sujets. Il suivra la première tournée américaine des Beatles et prendra en 1968 la célèbre photo de Juan Romero, le serveur de l'hôtel Ambassador, à Los Angeles, agenouillé pour tenter de venir en aide à Robert Kennedy qui vient de tomber sous les balles de son assassin Sirhan Sirhan.

Espada, Frank *(1930–2014)*

Born in Puerto Rico, Espada moved to New York City in 1939 and is known for documenting Puerto Rican communities across the United States, a series that became known as the Puerto Rican Diaspora Project. A photojournalist and community activist, he became involved in the Civil Rights Movement in the 1960s and worked for the Puerto Rican Community Development Project. Espada moved to San Francisco in 1985 and taught at the University of California, Berkeley Extension Program, and he is also known for documenting AIDS outreach efforts in San Francisco.

Der in Puerto Rico geborene Espada zog 1939 nach New York City und ist bekannt für seine fotografischen Dokumentationen puerto-ricanischer Communitys in den Vereinigten Staaten, die als Puerto Rican Diaspora Project bekannt wurden. Als Fotojournalist und Communityaktivist engagierte er sich in den 1960er-Jahren in der Bürgerrechtsbewegung und arbeitete für das Puerto Rican Community Development Project. Espada zog 1985 nach San Francisco und unterrichtete im Extension Program der University of California, Berkeley und ist auch für seine Dokumentation von Kampagnen zur Aids-Bekämpfung in San Francisco bekannt.

Né à Porto Rico et installé à New York à partir de 1939, Frank Espada s'est fait connaître par le travail qu'il a consacré aux communautés portoricaines présentes aux États-Unis, et que rassemble une série intitulée *Puerto Rican Diaspora Project*. Son métier de photojournaliste et son engagement communautaire l'ont conduit à participer au mouvement des droits civiques dans les années 1960 et à contribuer

directement à un important programme de développement de la communauté portoricaine. Après son déménagement à San Francisco en 1985, il donnera des cours de photo dans le cadre de la formation continue à l'Université de Californie (Berkeley) et racontera par l'image les campagnes de sensibilisation au sida menées à San Francisco.

Farbman, Nat *(1907–1988)*

Farbman was born in Poland and migrated to the United States when he was four years old. He began working as a freelance photographer while studying electrical engineering at the University of Santa Clara and became a staff photographer for *Life*, a position he held for 15 years. In 1956, the magazine ran a feature called "What I Like about Living in San Francisco," written by Farbman and accompanied by his photographs. The magazine also assigned him to photograph the nightlife of San Francisco in the 1950s, and he took a series of color images of the vibrant club and restaurant scene. After he and photographer and fashion model Pat English married, they became a photographic team for the magazine. Farbman's photographs from Botswana were included in the Museum of Modern Art's legendary *Family of Man* exhibition in 1955.

Farbman wurde in Polen geboren und wanderte im Alter von vier Jahren in die Vereinigten Staaten aus. Während seines Studiums der Elektrotechnik an der University of Santa Clara begann er als freiberuflicher Fotograf zu arbeiten und wurde schließlich fest angestellter Fotograf für *Life*, eine Position, die er 15 Jahre lang innehatte. 1956 veröffentlichte das Magazin eine Reportage mit dem Titel „What I Like about Living in San Francisco", die von Farbman geschrieben und von seinen Fotos begleitet wurde. Die Zeitschrift beauftragte ihn auch damit, das Nachtleben von San Francisco in den 1950er-Jahren zu fotografieren, und er machte eine Reihe von Farbbildern von der pulsierenden Club- und Restaurantszene. Nachdem er und Fotografin und Fotomodell Pat English geheiratet hatten, arbeiteten sie gemeinsam für das Magazin. Farbmans Fotografien aus Botswana waren 1955 Teil der legendären Ausstellung *Family of Man* des Museum of Modern Art.

Né en Pologne, Farbman avait quatre ans lorsqu'il arriva aux États-Unis. Il débuta la photo à titre indépendant en même temps qu'il étudiait le génie électrique à l'Université de Santa Clara, puis rejoindra la bande de *Life* où il restera quinze années, l'œil et la plume éveillés: il y signera ainsi, en 1956, un article intitulé « What I Like about Living in San Francisco », accompagné de ses clichés. Dans ces mêmes années 1950, le magazine l'enverra couvrir la vie nocturne de la ville dont il restituera abondamment, et en couleurs, l'effervescence des clubs et restaurants à la mode. Son mariage avec Pat English, photographe et mannequin, leur permettra de faire équipe, toujours pour le compte de *Life*. La fameuse exposition *The Family of Man*, organisée par le Museum of Modern Art de New York en 1955, a accueilli les images de son reportage au Botswana.

Fink, Larry *(1941–)*

Fink studied photography at the New School for Social Research with Lisette Model and Alexey Brodovitch. He had his first solo show at the Museum of Modern Art in 1979. A prolific editorial photographer, his images have appeared in *GQ*, *The New Yorker*, *Vanity Fair*, and *The New York Times Magazine*. His commercial clients include Smirnoff and Cunard Line. He has produced monographs on boxing, the fashion industry, and social functions. He has taught at Yale, and is now a professor at Bard College in upstate New York.

Fink studierte bei Lisette Model und Alexey Brodovitch Fotografie an der New School for Social Research. Seine erste Einzelausstellung hatte er 1979 im Museum of Modern Art. Der produktive redaktionelle Fotograf, dessen Bilder in *GQ*, *The New Yorker*, *Vanity Fair* und dem *New York Times Magazine* erschienen sind, hat auch Monografien zum Thema Boxen, Modebranche und Gesellschaft produziert. Zu seinen Firmenkunden

gehören Smirnoff und Cunard. Er war in Yale als Dozent tätig und lehrt zurzeit als Professor am Bard College im Bundesstaat New York.

Né à Brooklyn, Larry Fink étudia la photographie dans une université privée new-yorkaise, la New School for Social Research, auprès d'Alexey Brodovitch et de Lisette Model. Le MoMA lui offrira en 1979 sa première exposition solo. Photographe de presse fécond, il publia ses clichés dans *GQ*, *The New Yorker*, *Vanity Fair* et le *New York Times Magazine* mais compta aussi de nombreux clients commerciaux parmi lesquels Smirnoff et la compagnie maritime Cunard Line. Il consacra plusieurs monographies à la boxe, à l'industrie de la mode et à la manière dont se forgent les statuts sociaux. Après avoir enseigné à Yale, il est désormais professeur au Bard College, au nord de l'État de New York.

Flynn, Homer *(1945–)*

For nearly 40 years, Flynn has been involved with the murky aesthetics of San Francisco's music, performance, and video group, The Residents, as their chief visual designer and co-owner of The Cryptic Corporation, The Residents' business and public relations interface. Constantly defying classification, The Residents have been regarded as pioneers in the world of experimental music including trance, world fusion, electronica, punk, industrial, and lounge music. The group has also been credited with being among the originators of performance art and music video, with their videos included in the permanent collection of New York's Museum of Modern Art.

Seit fast 40 Jahren ist Flynn an der düsteren Ästhetik der Musik-, Performance- und Videogruppe The Residents aus San Francisco beteiligt. Er ist ihr leitender visueller Designer und Miteigentümer von The Cryptic Corporation, der Geschäfts- und PR-Schnittstelle der Gruppe. Die Residents, die sich jeder Klassifizierung entziehen, gelten als Pioniere experimenteller Musik, darunter Trance, World Fusion, Electronica, Punk, Industrial und Lounge-Musik. Sie gehören auch zu den Begründern der Performance-Kunst und des Musikvideos. Ihre Videos sind in der ständigen Sammlung des New Yorker Museum of Modern Art vertreten.

Pendant près de quarante ans, Flynn a pris une part active à l'esthétique parfois obscure de The Residents, ce collectif masqué de San Francisco dont la production alterne entre musique, vidéo et performances artistiques en tout genre, qu'ils furent parmi les premiers à initier. Copropriétaire de The Cryptic Corporation, l'interface qui assure les relations publiques et commerciales du groupe, Flynn est aussi en charge de son identité visuelle. Défiant toute tentative de catégorisation, The Residents est classé parmi les pionniers de la musique expérimentale – transe, world fusion, electronica, punk, musique industrielle, lounge… Ses vidéos font partie de la collection permanente du MoMA.

Fong, Gary *(1960–)*

The former director of photography at the *San Francisco Chronicle*, Fong is the founder of the Genesis Photo Agency, a group of professional photographers dedicated to "elevating the effectiveness of photography in evangelical publications around the world." Fong has been named the San Francisco Bay Area Photographer of the Year five times and the California Press Photographer of the Year twice. His work has appeared in *Time*, *Newsweek*, *Life*, *The New York Times*, and the *Wall Street Journal*, among other publications. He has photographed celebrities and covered conflicts around the world. Fong has taught photojournalism at San Francisco State University and the University of California, Berkeley.

Der ehemalige Cheffotograf des *San Francisco Chronicle* ist der Gründer der Genesis Photo Agency, einer Gruppe professioneller Fotografen, die sich der „Steigerung der Effektivität der Fotografie in evangelikalen Publikationen auf der ganzen Welt" verschrieben hat. Fong wurde fünfmal zum Fotografen des Jahres in der San Francisco Bay Area und zweimal zum Pressefotografen des Jahres in Kalifornien gewählt.

Seine Arbeiten sind unter anderem in *Time, Newsweek, Life,* der *New York Times* und dem *Wall Street Journal* erschienen. Er hat Prominente fotografiert und über Konflikte in aller Welt berichtet. Fong lehrt Fotojournalismus an der San Francisco State University und der University of California, Berkeley.

Ancien directeur de la photo au *San Francisco Chronicle,* Gary Fong est le fondateur de la Genesis Photo Agency, qui rassemble des professionnels résolus à «élever l'efficience de la photographie dans les publications évangéliques du monde entier». Fong a été élu à cinq reprises photographe de l'année pour la région de San Francisco et deux fois pour la Californie. Son travail, où les portraits de stars alternent avec le reportage de guerre, a notamment été publié dans *Time, Newsweek, Life,* le *New York Times* et le *Wall Street Journal.* Il a enseigné le photojournalisme à l'Université de San Francisco et à Berkeley.

Frank, Robert *(1924–2019)*

One of the most influential photographers of the 20th century, Frank is best known for *The Americans,* a book of black-and-white photographs he made over several cross-country trips in the 1950s. His grainy, cinematic photographs challenged the presiding aesthetics of photography and influenced many subsequent generations of photographers. Frank was also a filmmaker, and his 1959 film *Pull My Daisy* featured Allen Ginsberg, Gregory Corso, and Larry Rivers, among others, and was narrated by Jack Kerouac. Frank's photograph "San Francisco (1956)," of a Black couple in Alamo Square Park looking back at (or possibly glaring at) the photographer, was reportedly one of his favorite pictures.

Frank, einer der einflussreichsten Fotografen des 20. Jahrhunderts, ist vor allem für *Die Amerikaner* bekannt, ein Buch mit Schwarz-Weiß-Fotografien, die er in den 1950er-Jahren auf mehreren Reisen quer durchs Land machte. Seine körnigen Aufnahmen wandten sich gegen die vorherrschende Ästhetik der Fotografie und beeinflussten spätere Generationen von Fotografen. Frank war auch Filmemacher, und in seinem 1959 gedrehten Film *Pull My Daisy,* in dem unter anderem Allen Ginsberg, Gregory Corso und Larry Rivers mitwirkten, trat Jack Kerouac als Erzähler auf. Franks Foto „San Francisco (1956)", das ein schwarzes Paar im Alamo Square Park zeigt, das den Fotografen über die Schulter hinweg anschaut (oder ihn möglicherweise anstarrt), soll eines seiner Lieblingsbilder gewesen sein.

Du xxᵉ siècle, Robert Frank restera comme l'un des photographes les plus influents, dont la sensibilité irradie *Les Américains* (1958), le livre de photos en noir et blanc qu'il publia après avoir sillonné tout le pays dans les années 1950. Ses images granuleuses, prises sur le vif, bousculaient l'esthétique photographique alors dominante et inspireront ses pairs et successeurs sur plusieurs générations. Leur rythme quasi cinématographique annonçait son passage à la caméra et son court métrage *Pull My Daisy* (1959), qui réunit écrivains et peintres de la Beat Generation parmi lesquels Allen Ginsberg, Gregory Corso et Larry Rivers, sur un texte lu par Jack Kerouac en voix off. La photo intitulée *San Francisco, 1956,* où un couple de Noirs assis dans le parc d'Alamo Square se retourne vers lui, serait l'une des préférées du photographe.

Friedlander, Lee *(1934–)*

In 1956, after studying photography at the Art Center College of Design in Pasadena, Friedlander moved to New York. He worked for Atlantic Records, shooting album covers for recording artists such as Aretha Franklin and Ray Charles. He was a key figure in the 1967 New Documents exhibition at the Museum of Modern Art in New York, which also featured Garry Winogrand and Diane Arbus. He was the recipient of three Guggenheim Memorial Foundation grants in 1960, 1962, and 1977. In 1979, he paid the then-unknown Madonna $25 to model nude for him—one image from the sitting sold for $37,000 at auction in 2009. Friedlander has published more than 20 books, including *The American Monument* (1976).

Nach seinem Studium am Art Center College of Design in Pasadena zog Friedlander 1956 nach New York City. Er arbeitete für Atlantic Records und fotografierte Plattencover für Künstler wie Aretha Franklin und Ray Charles. Er spielte eine Schlüsselrolle bei der Ausstellung *New Documents* von 1967 im Museum of Modern Art in New York, wo auch die Arbeiten von Garry Winogrand und Diane Arbus gezeigt wurden. Er erhielt 1960, 1962 und 1977 Stipendien der Guggenheim Memorial Foundation. 1979 zahlte er der damals noch unbekannten Madonna 25 Dollar, damit sie ihm nackt Modell stand; auf einer Auktion wurde ein Bild dieses Shootings 2009 für 37000 Dollar versteigert. Friedlander hat über 20 Bücher veröffentlicht, darunter *The American Monument* (1976).

Lee Friedlander s'installe à New York en 1956, après une formation en photographie à l'Art Center College of Design de Pasadena. Il travaille pour Atlantic Records et réalise des pochettes d'album pour des artistes tels qu'Aretha Franklin et Ray Charles. Il est l'une des têtes d'affiche de l'exposition *New Documents* organisée en 1967 au MoMA, à laquelle participent également Garry Winogrand et Diane Arbus. Trois bourses de la Fondation Guggenheim lui seront attribuées, en 1960, 1962 et 1977. En 1979, il propose 25 dollars à une Madonna alors inconnue pour pouvoir la photographier nue ; dix ans plus tard, une image tirée de cette séance se vendra aux enchères 37000 dollars. Il a publié plus de vingt livres, dont *The American Monument* (1976).

Fruth, Jean *(1968–)*

Fruth is a sports photographer who has shot the San Francisco Giants, the Oakland A's, and the 49ers for many years. She got into sports photography by taking pictures at her son's baseball games, and is currently a traveling photographer for La Vida Baseball. Her nonprofit organization, Grassroots Baseball, promotes the amateur game of baseball around the world.

Jean Fruth ist eine Sportfotografin, die seit vielen Jahren die San Francisco Giants, die Oakland A's und die 49ers fotografiert. Zur Sportfotografie kam sie, als sie Aufnahmen von den Baseballspielen ihres Sohnes machte. Derzeit ist sie als Fotografin für La Vida Baseball unterwegs. Ihre gemeinnützige Organisation Grassroots Baseball fördert Amateurbaseball auf der ganzen Welt.

C'est à force de prendre en photo les matchs de base-ball disputés par son fils que Jean Fruth a fini par se spécialiser dans l'image sportive. Elle a eu ainsi l'occasion, pendant de nombreuses années, d'immortaliser les exploits et déboires des San Francisco Giants, des Oakland A's et des 49ᵉʳˢ. Actuellement photographe itinérante pour le média numérique *La Vida Baseball,* elle est à l'origine de l'initiative Grassroots Baseball, dédiée à la promotion du base-ball amateur dans le monde entier.

Fusco, Paul *(1930–2020)*

Fusco was a photographer with the U.S. Army Signal Corps in Korea before moving to New York City to become a staff photographer for *Look.* He became a member of Magnum in the mid-1970s; he had moved to Mill Valley, CA, in the 1970s and began photographing people living with AIDS, and other dispossessed groups. In the 1980s, he photographed San Francisco's Ambassador Hotel, where many of the city's poorest residents lived. His also known for his images of a nation in mourning: *Funeral Train* is a series of photographs taken of bystanders who came out to see the train carrying Robert F. Kennedy's body after he was assassinated.

Fusco war Fotograf beim US Army Signal Corps in Korea, bevor er nach New York City zog, um Fotograf bei *Look* zu werden. Mitte der 1970er-Jahre wurde er Mitglied von Magnum. In den 1970ern war er nach Mill Valley, Kalifornien, gezogen und begann, Aids-Kranke und andere benachteiligte Gruppen zu fotografieren. In den 1980er-Jahren machte er Bilder im Ambassador Hotel in San Francisco, in dem viele der ärmsten Bewohner der Stadt lebten. Bekannt ist er auch für seine Bilder von einer trauernden Nation: *Funeral Train* ist

eine Serie von Fotografien von Menschen, die den Zug mit dem Leichnam von Robert F. Kennedy nach dessen Ermordung sehen wollten.

Photographe pour l'US Army pendant la guerre de Corée, Paul Fusco s'installera quelques années plus tard à New York, où il est recruté par *Look.* Au milieu des années 1970, il rejoint l'agence Magnum. Installé à Mill Valley, en Californie, pendant cette décennie 1970, il se penche avec une attention extrême sur la condition des malades du sida et des couches les plus défavorisées de la société américaine. Au début des années 1980, il réalisera notamment une série marquante à l'hôtel Ambassador de San Francisco, qui avait ouvert ses portes à de nombreux habitants parmi les plus pauvres de la ville. Il s'était fait également l'historiographe exceptionnel d'une nation en deuil : présent à bord du convoi funéraire transportant la dépouille de Robert Kennedy, sa série *Funeral Train* a immortalisé les foules de citoyens venus au bord des rails saluer le candidat assassiné.

Gedney, William *(1932–1989)*

Gedney grew up in upstate New York and moved to New York City to attend Pratt Institute. He worked for a time at Condé Nast and at *Time* magazine, then traveled to a coal-mining town in Eastern Kentucky, where he met the Cornett family, whom he photographed over the subsequent 12 years. Gedney received a Guggenheim Fellowship and a Fulbright Award, which enabled him to take a cross-country trip through the Midwest to California, where he photographed drifters in the Haight-Ashbury neighborhood of San Francisco, a communal house near the Grateful Dead's house, and a Be-In at Golden Gate Park in San Francisco, among other subjects. A faculty member at both Pratt and Cooper Union, he also traveled to India, a trip that had a lasting impact on his work.

Gedney wuchs im Bundesstaat New York auf und zog nach New York City, um das Pratt Institute zu besuchen. Er arbeitete eine Zeit lang bei Condé Nast und beim *Time Magazine* und reiste dann in eine Bergbaustadt im Osten Kentuckys, wo er die Familie Cornett kennenlernte, die er über die folgenden zwölf Jahre hinweg fotografierte. Gedney erhielt ein Guggenheim-Stipendium und den Fulbright Award, die ihm eine Reise quer durch den Mittleren Westen nach Kalifornien ermöglichten, wo er unter anderem Drifter im Haight-Ashbury-Viertel von San Francisco, ein Gemeinschaftshaus in der Nähe des Hauses der Band Grateful Dead und ein Treffen von Hippies im Golden Gate Park in San Francisco fotografierte. Als Dozent am Pratt Institute und des Cooper Union College reiste er auch nach Indien, ein Aufenthalt, der seine Arbeit nachhaltig beeinflusste.

Après avoir grandi au nord de l'État de New York, Gedney a rejoint la mégapole pour y poursuivre des études d'art au Pratt Institute. Il travailla un temps pour le groupe de presse Condé Nast et au magazine *Time* avant de partir à la découverte d'une cité minière du Kentucky où il rencontra la famille Cornett, qu'il photographia régulièrement, douze ans durant. Bénéficiaire d'une bourse Guggenheim et d'une bourse Fulbright, il entreprit un autre périple à travers le Midwest et jusqu'en Californie, saisissant notamment le quotidien d'une communauté hippie du quartier de Haight-Ashbury, à quelques rues de la résidence des Grateful Dead. Il fixa aussi sur la pellicule le «Human Be-In», ce *happening* géant organisé en 1967 dans le parc du Golden Gate. Enseignant au Pratt Institute et à la prestigieuse Cooper Union, il a effectué un voyage en Inde qui eut un impact durable sur son travail.

Genthe, Arnold *(1869–1942)*

Genthe moved to the United States from Germany in 1895 to work as a tutor after receiving a PhD in classical philology. He began photographing in San Francisco's Chinatown and eventually opened his own portrait studio, specializing in the soft-focus pictorialist style of that time. He made portraits of local celebrities and prominent citizens, most of which were destroyed in the 1906 San Francisco earthquake

and fire. He also took famous photographs of the earthquake itself. The Chinatown images, however, had been stored in a vault and survived, and he published them in the book *Pictures of Old Chinatown* in 1911.

Genthe zog 1895 von Deutschland in die Vereinigten Staaten, um nach seiner Promotion in klassischer Philologie als Tutor zu arbeiten. Er begann in San Franciscos Chinatown zu fotografieren und eröffnete sein eigenes Porträtstudio, das auf den weichgezeichneten piktorialistischen Stil der damaligen Zeit spezialisiert war. Er fertigte Porträts von lokalen Berühmtheiten und prominenten Bürgern an, von denen die meisten 1906 bei dem Erdbeben und Brand von San Francisco zerstört wurden. Auch vom Erdbeben selbst hat er berühmte Fotos gemacht. Die Bilder von Chinatown waren jedoch in einem Tresor aufbewahrt worden und überstanden die Katastrophe. Er veröffentlichte sie 1911 in dem Buch *Pictures of Old Chinatown*.

Genthe quitta l'Allemagne en 1895 pour s'installer aux États-Unis où il travailla comme précepteur après avoir décroché un doctorat en philologie classique. Le quartier chinois de San Francisco accueillit ses premiers pas dans la photo avant qu'il ne crée son propre studio dédié aux portraits et surtout aux effets de flou et de clair-obscur alors caractéristiques de l'esthétique pictorialiste. La plupart de ses clichés consacrés aux vedettes et personnalités locales seront détruits en 1906 lors du séisme et de l'incendie de San Francisco, dont il réalisa de mémorables images. Les clichés de Chinatown, à l'abri dans un coffre, ont quant à eux survécu et été publiés, en 1911, dans un livre (*Pictures of Old Chinatown*).

Gerdes, Ingeborg L. *(1938–2020)*
Born in Germany, Gerdes immigrated to the US in 1965, first to Philadelphia, moving a few years later to San Francisco, where she earned an MFA at the San Francisco Art Institute. She is known for black-and-white street photography of San Francisco from the 1970s and later color photographs, including images of people attending, and betting on, the horse races at Golden Gate Fields and urban landscapes of the East Bay.

Die in Deutschland geborene Ingeborg Gerdes wanderte 1965 in die USA aus, zunächst nach Philadelphia, bevor sie einige Jahre später nach San Francisco weiterzog, wo sie am San Francisco Art Institute einen Master of Fine Arts erwarb. Sie ist bekannt für ihre schwarz-weißen Straßenfotografien von San Francisco aus den 1970er-Jahren und spätere Farbfotografien, darunter Bilder von Menschen, die Pferderennen auf den Golden Gate Fields besuchten und dort auf die Pferde wetteten, sowie Stadtlandschaften der East Bay.

Née en Allemagne et arrivée aux États-Unis en 1965, Ingeborg Gerdes s'est d'abord installée à Philadelphie puis quelques années plus tard à San Francisco où elle décrochera une maîtrise en beaux-arts au San Francisco Art Institute. Son œuvre photographique s'attachera successivement aux rues de San Francisco, saisies en noir et blanc dans les années 1970, au public et aux parieurs de l'hippodrome de Golden Gate Fields, en couleurs cette fois, ainsi qu'aux paysages urbains de l'East Bay, entre autres thèmes.

Gibson, Ralph *(1939–)*
Between 1956 and 1962, Gibson studied photography, both in the Navy and at the San Francisco Art Institute, before going on to assist Dorothea Lange (1961–62) and Robert Frank (1967–68). He worked as a cameraman on two of Frank's films. In 1969, he opened a studio in New York. He received National Endowment for the Arts fellowships in 1973 and 1975, and was made an Officier de l'Ordre des Arts et des Lettres by the French government in 1986. He has had almost 200 solo shows, and his work is in more than 150 museum permanent collections. Gibson has published 26 books, including *Nude* (TASCHEN, 2009).

Gibson studierte von 1956 bis 1962 sowohl bei der Marine als auch am San Francisco Art Institute Fotografie und arbeitete dann als Assistent für Dorothea Lange (1961/62) und Robert Frank (1967/68). Bei zwei

von Franks Filmen war er Kameramann. 1969 eröffnete er ein Studio in New York. Er erhielt Stipendien von der staatlichen Stiftung National Endowment for the Arts (1973 und 1975) und wurde von der französischen Regierung zum Officier de l'Ordre des Arts et des Lettres ernannt (1986). Er hatte fast 200 Einzelausstellungen, und seine Arbeiten befinden sich in über 150 ständigen Sammlungen von Museen. Gibson hat 26 Bücher veröffentlicht, darunter *Nude* (TASCHEN, 2009).

C'est entre 1956 et 1962 que Gibson s'est formé à la photo, au cours de son passage dans la marine américaine puis au San Francisco Art Institute. Il sera aussi l'assistant de Dorothea Lange (1961-62) et de Robert Frank (1967-68) – tenant la caméra dans deux de ses films. Il ouvrira un studio à New York en 1969, recevra deux bourses du National Endowment for the Arts et sera fait officier des Arts et Lettres par le gouvernement français (1986). Près de 200 expositions solo lui seront consacrées et ses œuvres figurent dans plus de 150 collections permanentes de musées. Il a publié vingt-six livres, dont *Nude* (TASCHEN, 2009).

Ginsberg, Allen *(1926–1997)*
Ginsberg studied political economy at Columbia University between 1943 and 1948. In 1944, he met like-minded souls Jack Kerouac and William Burroughs. He moved to San Francisco in 1954, and wrote his famous poem *Howl*, which ignited interest in the Beat Generation. He traveled throughout Europe and Morocco during the 1950s. In 1961, he took part in Timothy Leary's experiments with mind-expanding drugs. In 1974, he was elected a member of the American Academy of Arts and Letters. He published *Collected Poems 1947–1980* in 1984, and *Allen Ginsberg Photographs* in 1989.

Ginsberg studierte von 1943 bis 1948 Wirtschaftspolitik an der Columbia University. 1944 lernte er Gleichgesinnte kennen: Jack Kerouac und William Burroughs. Er zog 1954 nach San Francisco und schrieb sein berühmtes Gedicht *Das Geheul*, das das Interesse an der Beat Generation weckte. In den 1950er-Jahren reiste er durch Europa und Marokko. 1961 nahm er an den Experimenten von Timothy Leary mit bewusstseinserweiternden Drogen teil. 1974 wurde er in die American Academy of Arts und Letters aufgenommen. 1984 erschien *Collected Poems 1947–1980* und 1989 *Allen Ginsberg Photographs*.

Entre 1943 et 1948, Ginsberg étudia l'économie politique à l'Université de Columbia. C'est en 1944 qu'il fit la connaissance de Jack Kerouac et de William Burroughs. Installé à San Francisco en 1954, il y écrivit son célèbre poème « Howl » qui mit en lumière la Beat Generation naissante. Au cours de ces mêmes années 1950, il voyagea à travers l'Europe et le Maroc. En 1961, il participa aux expériences psychédéliques conduites par Timothy Leary autour de divers psychotropes. En 1974, il sera élu membre de l'Académie américaine des arts et lettres. Il a notamment publié *Collected Poems 1947–1980* (en 1984) et *Allen Ginsberg Photographs* (1989).

Glinn, Burt *(1925–2008)*
A member of Magnum who served two stints as president of the organization, Glinn took photographs for *Esquire, Life, Travel and Leisure,* and *Paris-Match,* among other publications. His subjects included the Little Rock Nine, who integrated Little Rock Central High School in Arkansas in 1957. Known for his pioneering work in color, he received many awards for his editorial and commercial photography. Well-known projects include his photographs of Cuba during Fidel Castro's takeover as well as his photographs of the Beat scene in New York and San Francisco.

Als Mitglied und zweimaliger Präsident der unabhängigen Fotoagentur Magnum fotografierte Glinn unter anderem für *Esquire, LIFE, Travel and Leisure* und *Paris-Match*. Zu seinen Motiven gehörten die Little Rock Nine, die ab 1957 als erste afroamerikanischen Schüler die bis dato Weißen vorbehaltene Little Rock Central High School in Arkansas besuchten. Er war bekannt für

seine Pionierarbeit in der Farbfotografie und erhielt zahlreiche Auszeichnungen für seine kommerziellen und journalistischen Fotos. Zu seinen bekanntesten Projekten gehören seine Fotos von Kuba während der Machtübernahme durch Fidel Castro sowie seine Aufnahmen der Beat-Szene in New York und San Francisco.

Membre de l'agence Magnum qu'il présida à deux reprises, Glinn a travaillé pour *Esquire, Life, Travel and Leisure* et *Paris-Match,* entre autres publications. Il a notamment suivi l'affaire des neuf de Little Rock, ces lycéens afro-américains empêchés d'étudier par le gouverneur de l'Arkansas en 1957. Réputé pour son traitement novateur de la couleur, il vu ses images publicitaires et éditoriales fréquemment récompensées. Sa couverture de la révolution cubaine et de l'arrivée au pouvoir de Fidel Castro, vécues en première ligne, reste dans les mémoires, de même que son observation de la Beat Generation à New York et San Francisco.

Greene, Stanley *(1949–2017)*
A photojournalist who worked for such publications as *The New York Times Magazine* and *Newsweek,* Greene was a New York City native who joined the Black Panthers and became an anti–Vietnam War activist. He moved to San Francisco and immersed himself in the punk scene, photographing the Dead Kennedys and other bands in the 1970s and '80s. He moved to Paris in 1986 and eventually began covering wars and conflicts including those in Sudan, Rwanda, Chechnya, and Iraq. Greene founded the documentary collective Noor, which established the Stanley Greene Legacy Prize & Fellowship in his name.

Der Fotojournalist, der für Publikationen wie das *New York Times Magazine* und *Newsweek* arbeitete, stammte aus New York City, schloss sich den Black Panthers an und wurde zu einem Aktivisten gegen den Vietnamkrieg. Er zog nach San Francisco und tauchte in die Punkszene ein, wo er in den 1970er-und 80er-Jahren die Dead Kennedys und andere Bands fotografierte. 1986 zog er nach Paris und begann, über Kriege und Konflikte zu berichten, darunter im Sudan, in Ruanda, Tschetschenien und im Irak. Greene gründete das Dokumentarfilmkollektiv Noor, das in seinem Namen den Stanley Greene Legacy Prize & Fellowship ins Leben gerufen hat.

Né à New York, ce photojournaliste a collaboré à des publications telles que le *New York Times Magazine* et *Newsweek* après avoir été membre des Black Panthers et milité activement contre la guerre du Vietnam. Installé à San Francisco, il s'immergea dans la scène punk, photographiant les Dead Kennedys et d'autres groupes des années 1970 et 1980. Il prit ses quartiers à Paris en 1986 et plongea alors corps et âme dans le reportage de guerre, qui le conduira notamment au Soudan, au Rwanda, en Tchétchénie et en Irak. Le collectif documentaire Noor, qu'il fondait, lui rendra hommage en créant une bourse portant son nom, le Stanley Greene Legacy Prize & Fellowship.

Gutmann, John *(1905–1998)*
Gutmann trained as an artist and art teacher in Germany before fleeing the Nazis in 1933 and settling in San Francisco, where he became a photojournalist with a modernist sensibility. In 1937, he began teaching at San Francisco College (later San Francisco State University), where he founded one of the first photography programs in the country. Gutmann worked for the agency Pix, Inc., and his photographs were published in *Time, Life, Look,* and the *Saturday Evening Post,* among other publications. He retired in 1973, when he began to reassess his work from the 1930s, making new prints of select images. In 1989, a retrospective of his work, *Beyond the Document,* traveled from the San Francisco Museum of Modern Art to the Museum of Modern Art in New York and the Los Angeles County Museum of Art.

Gutmann machte in Deutschland eine Ausbildung zum Künstler und Kunstlehrer, bevor er 1933 vor den Nazis nach San Francisco floh, wo er als Fotojournalist

modernistisch inspirierte Arbeiten anfertigte. Ab 1937 lehrte er am San Francisco College (der späteren San Francisco State University), wo er einen der landesweit ersten Studiengänge für Fotografie begründete. Gutmann arbeitete für die Agentur Pix, Inc. und seine Fotografien wurden unter anderem in *Time, Life, Look* und der *Saturday Evening Post* veröffentlicht. Als er 1973 in den Ruhestand ging, begann er, sein Werk aus den 1930er-Jahren neu zu bewerten und von ausgewählten Bildern neue Abzüge anzufertigen. 1989 war eine Retrospektive seines Werks, *Beyond the Document*, nacheinander im San Francisco Museum of Modern Art, dem Museum of Modern Art in New York und dem Los Angeles County Museum of Art zu sehen.

Gutmann suivait un enseignement artistique lorsqu'il dut fuir le nazisme en 1933. Il s'installa à San Francisco, où il deviendra photojournaliste, très influencé par l'esthétique moderniste. En 1937, il commence à donner des cours au San Francisco College, future Université d'État de San Francisco, et crée l'un des premiers cursus de photographie du pays. Membre de l'agence Pix, Inc. à partir de 1936, il voit ses photos publiées par *Time*, *Life*, *Look* et le *Saturday Evening Post*, parmi d'autres publications. Admis à la retraite en 1973, il en profite pour se retourner sur son travail des années 1930 et procéder à de nouveaux tirages de certaines images. À partir de 1989, le San Francisco Museum of Modern Art, le MoMA de New York et le Los Angeles County Museum of Art accueilleront tour à tour une rétrospective de son œuvre intitulée *Beyond the Document*.

Haas, Ernst *(1921–1986)*

In 1941, Haas enrolled at the Graphic Arts Institute in Vienna to study photography, and from 1943 to 1945, he worked at a commercial studio in Vienna. In 1949, a story on returning prisoners of war brought him to the attention of the U.S. market, and he joined Magnum Photos. In 1953, *Life* magazine published his 24-page color spread on New York City. He became president of Magnum in 1959, and in 1960 he moved to New York. That same year, he shot movie stills for *The Misfits*. In 1963, he got his first major commercial job, working on a Volkswagen ad campaign. From 1972 to 1974, he worked on his first Marlboro campaign, a relationship that lasted 12 years.

Haas begann 1941 das Studium der Fotografie an der Grafischen Lehr- und Versuchsanstalt in Wien. Zwischen 1943 und 1945 arbeitete er bei einem kommerziellen Fotostudio in Wien. 1949 wurde er mit einer Geschichte über die Rückkehr von Kriegsgefangenen in den USA bekannt und schloss sich Magnum Photos an. Das Magazin *LIFE* veröffentlichte 1953 seine 24-seitige Farbreportage über New York. 1959 wurde er Präsident von Magnum und zog 1960 nach New York. Im selben Jahr machte er die Standfotos für den Film *Misfits – Nicht gesellschaftsfähig*. 1963 erhielt er seinen ersten großen kommerziellen Auftrag für eine Werbekampagne für Volkswagen. 1972 bis 1974 arbeitete er an seiner ersten Kampagne für Marlboro, daraus entstand eine Verbindung, die zwölf Jahre dauerte.

Ernst Haas s'inscrit en 1941 au Grafischen Lehr- und Versuchsanstalt (Institut des arts graphiques) de Vienne pour y étudier la photographie. De 1943 à 1945, il travaillera dans un studio photographique viennois. En 1949, ses images du retour des prisonniers de guerre éveillent l'intérêt du marché américain et il rejoint l'agence Magnum. En 1953, le magazine *Life* consacre 24 pages à ses premiers travaux en couleurs, dédiés à New York. Devenu président de Magnum en 1959, il s'installe un an plus tard à New York. La même année, il réalise des photos de plateau sur le tournage des *Désaxés (The Misfits)*. En 1963, il décroche son premier grand contrat commercial avec une campagne de publicité pour Volkswagen. De 1972 à 1974, il entame avec Marlboro une collaboration appelée à durer douze ans.

Harding, John *(1940–)*

Born in Granite City, IL, Harding moved to San Francisco and attended graduate school at the San Francisco Art Institute, where he studied with Henry Wessel. He is known for his kinetic color street photographs of San Francisco. Harding was among the photographers in the 1970s and '80s known for their vivid color work, including Joel Sternfeld and Richard Misrach. His photographs focus on everyday people in public places—street fairs, business districts, concerts, and parades. His photographs have appeared in the *Los Angeles Times Magazine* and *Wired*, among other publications.

Der in Granite City, Illinois, geborene Harding zog nach San Francisco, wo er das San Francisco Art Institute besuchte und bei Henry Wessel studierte. Er ist für seine dynamischen Farbfotografien der Straßen San Franciscos bekannt. Harding war in den 1970er- und 80er-Jahren gemeinsam mit anderen Fotografen, unter anderem Joel Sternfeld und Richard Misrach, für seine lebendigen Farbfotografien bekannt. Seine Fotografien konzentrieren sich auf gewöhnliche Menschen an öffentlichen Orten – Straßenfeste, Geschäftsviertel, Konzerte und Paraden. Seine Bilder wurden unter anderem im *Los Angeles Times Magazine* und in *Wired* veröffentlicht.

Originaire de Granite City, dans l'Illinois, Harding s'est installé à San Francisco et a fait des études supérieures au San Francisco Art Institute où il a étudié avec Henry Wessel. Où qu'elle se déploie – marchés, concerts, défilés, quartiers d'affaires –, l'humanité qu'il croise dans les rues est à chaque fois pour lui l'occasion d'appuyer sur le déclencheur et de réaliser les images éclatantes de couleurs comme de dynamisme qui feront sa réputation, à l'exemple de Joel Sternfeld et de Richard Misrach, pour ne citer qu'eux. *Newsweek*, le *Los Angeles Times Magazine* et *Wired*, entre autres publications, ont publié son travail.

Harvey, Stewart *(1943–)*

Harvey attended the last Ansel Adams Yosemite Workshop and his photographs of Burning Man—which was founded by his brother, Larry, and originated on Baker Beach in San Francisco—have appeared in *Life*, *Wired*, and other magazines.

Harvey nahm am letzten Yosemite-Workshop von Ansel Adams teil, und seine Fotografien vom Burning Man – das von seinem Bruder Larry gegründet wurde und seinen Ursprung am Baker Beach in San Francisco hat – sind in *LIFE*, *Wired* und anderen Zeitschriften erschienen.

Harvey Stewart a participé au dernier atelier dirigé par Ansel Adams à Yosemite. Ses photographies de Burning Man, le grand rassemblement de la contre-culture alors organisé par son frère Larry sur Baker Beach, à San Francisco, ont paru dans *Life* et *Wired*, entre autres publications.

Heick, William *(1916–2012)*

After serving as a Naval intelligence officer during World War II, Heick attended San Francisco State University and then the California School of Fine Arts (now the San Francisco Art Institute), where he studied with Ansel Adams and Minor White. Heick was known for his enthnographic photographs and documentary films. He had a solo exhibition in 1949 at the San Francisco Museum of Art followed by an exhibition at the de Young Museum. During the 1950s and '60s, he was a producer-director and cinematographer for the Bechtel Corporation, an engineering firm, a job that took him all over the world. He was also the director and chief cinematographer for the anthropology department at the University of California, Berkeley, and for the National Science Foundation's American Indian film project.

Nachdem er während des Zweiten Weltkriegs als Nachrichtenoffizier in der Marine gedient hatte, besuchte Heick die San Francisco State University und anschließend die California School of Fine Arts (heute das San Francisco Art Institute), wo er unter anderem bei Ansel Adams und Minor White studierte. Heick war bekannt für seine ethnografischen Fotografien und Dokumentarfilme. 1949 hatte er eine Einzelausstellung im San Francisco Museum of Art, gefolgt von einer Ausstellung im de Young Museum. In den 1950er- und 60er-Jahren war er als Produzent, Regisseur und Kameramann für die Bechtel Corporation tätig, ein Job, der ihn in die ganze Welt führte. Außerdem war er Regisseur und Chefkameramann für die anthropologische Abteilung der University of California, Berkeley, und für das Filmprojekt der National Science Foundation über die indigene Bevölkerung Nordamerikas.

Après la Seconde Guerre mondiale, qui lui permit de déployer ses talents de photographe comme agent de renseignement pour l'US Navy, « Bill » Heick fréquenta l'Université d'État de San Francisco puis la California School of Fine Arts (aujourd'hui San Francisco Art Institute) où il eut pour professeurs Ansel Adams et Minor White. Ses photos ethnographiques et ses films documentaires constituent son héritage le plus marquant. Le San Francisco Museum of Art lui consacrera ainsi une exposition monographique en 1949, bientôt imité par le musée De Young. Dans les années 1950 et 1960, il occupera les fonctions de producteur, réalisateur et directeur de la photographie au sein de la Bechtel Corporation, géant de l'ingénierie et des travaux publics basé à San Francisco, et voyagera à ce titre dans le monde entier. Il a exercé les mêmes fonctions au sein du département d'anthropologie de l'Université de Californie, à Berkeley, et dans le cadre d'un projet cinématographique de la National Science Foundation sur les Amérindiens.

Henry, Jason *(1985–)*

Henry's photographs have been featured in the *Wall Street Journal*, the *New York Times*, and *Vice*, among other places. Born and raised in Florida, he began his career as a skateboard photographer. He moved to San Francisco, where he is currently based, and is known for his multi-layered street photographs that are often tinged with humor. He's photographed the Black Lives Matter protest on the Golden Gate Bridge, and on assignment, he's taken photographs at a nudist resort in Florida and made photographs for a piece about San Francisco chef Dominique Crenn for the *New York Times*.

Henrys Fotografien wurden unter anderem im *Wall Street Journal*, in der *New York Times* und bei *Vice* veröffentlicht. Geboren und aufgewachsen in Florida, begann er seine Karriere als Skateboard-Fotograf. Er zog nach San Francisco, wo er derzeit lebt, und ist bekannt für seine vielschichtigen und oft humoristischen Straßenfotografien. Er hat die Black-Lives-Matter-Proteste auf der Golden Gate Bridge dokumentiert und im Auftrag der *New York Times* sowohl ein Nudisten-Resort in Florida fotografiert als auch eine Reportage über den Koch Dominique Crenn aus San Francisco gemacht.

Les photographies de Jason Henry ont été publiées par le *Wall Street Journal*, le *New York Times* et *Vice*, pour ne citer qu'eux. Né et élevé en Floride, il a découvert la photographie à travers le skate-board. Une fois installé à San Francisco, où il réside actuellement, il a développé une forme de «street photography» à plusieurs niveaux de lecture, souvent teintée d'humour. Il s'est révélé tout aussi habile à couvrir la marche dédiée au mouvement «Black Lives Matter» sur le Golden Gate Bridge que le quotidien d'un village naturiste en Floride ou le travail d'une cheffe cuisinière de San Francisco (la Française Dominique Crenn), pour le compte du *New York Times*.

Herzog, Fred *(1930–2019)*

Herzog moved from Germany to Vancouver, British Columbia, in 1953. He was a medical photographer by day and a street photographer during the evenings and weekends, focusing on neon signs, billboards, storefronts, and urban scenes in his photographs. He used Kodachrome slide film, which produced exceptionally vivid color photographs like this book's front cover, at a time when serious photography meant black-and-white prints. He remained fairly unknown until technological advances allowed him to make archival pigment prints that matched the intensity of the film slides, and he was belatedly recognized as a pioneer in color photography.

Herzog zog 1953 von Deutschland nach Vancouver in Kanada. Tagsüber arbeitete er als medizinischer Fotograf, abends und an den Wochenenden als Straßenfotograf, wobei er sich auf Leuchtreklamen, Werbetafeln, Schaufenster und Stadtszenen konzentrierte. Er verwendete Kodachrome-Diafilme, mit denen er, zu einer Zeit, als ernsthafte Fotografie noch mit Schwarz-Weiß-Fotografie gleichgesetzt wurde, außergewöhnlich lebendige Farbfotografien produzierte – wie zum Beispiel das Foto auf der Umschlagvorderseite dieses Buches. Er blieb weitestgehend unbekannt, bis der technologische Fortschritt es ihm ermöglichte, archivierbare Pigmentabzüge seiner Bilder herzustellen, die die Intensität der Diafilme einfingen, wodurch er nachträglich als Pionier der Farbfotografie Anerkennung fand.

Fred Herzog a quitté l'Allemagne en 1953 pour s'installer à Vancouver, au Canada. Photographe médical le jour, «street photographer» le soir et le week-end, il concentre l'essentiel de son attention sur les néons, les panneaux d'affichage, les devantures de magasin, en somme, le paysage urbain. La prédilection de l'époque pour le noir et blanc ne le dissuade pas d'utiliser surtout le Kodachrome, qui confère à ses images don't l'une est reproduite en couverture de l'ouvrage, l'éclat exceptionnel propre aux diapositives. Pour être vraiment reconnu, il lui faudra attendre que le progrès et la technique de l'impression pigmentaire lui permettent de réaliser des tirages restituant l'intensité originelle de ses diapos. Il est aujourd'hui considéré comme un pionnier de la photographie couleur.

Holmes, Burton (1870–1958)

Elias Burton Holmes was an American traveler, photographer and filmmaker. He accompanied his grandmother on a trip to Europe in 1890 and returned home to show slides and lecture at the Chicago Camera Club. Burton Holmes Travelogues went on to become a hugely successful travel lecture business, Holmes himself presenting some 8,000 slide lectures before his retirement in 1952. The term "travelogue" was reportedly coined for a series of lectures Holmes gave in London in 1902. He made a great many short documentary films, among them *Motoring in England* (1916) and *London Plays Ball*, *War Women of England* and *American YMCA in London* (all 1919). TASCHEN published *Burton Holmes: Travelogues, The Greatest Traveler of his Time, 1892–1952* in 2006.

Elias Burton Holmes war ein amerikanischer Reisender, Fotograf und Filmemacher. Er begleitete 1890 seine Großmutter auf eine Reise nach Europa; nach seiner Rückkehr hielt er darüber einen Diavortrag im Chicago Camera Club. Burton Holmes Travelogues wurde zu einem sehr erfolgreichen Unternehmen. Holmes selbst hatte bis zu seinem Rückzug aus dem Berufsleben im Jahr 1952 etwa 8 000 Diavorträge gehalten. Der Begriff „travelogue" zur Beschreibung seiner Reiseberichte entstand angeblich bei einer Vortragsreihe von Holmes in London im Jahr 1902. Außerdem drehte er auch viele dokumentarische Kurzfilme, darunter *Motoring in England* (1916) sowie *London Plays Ball*, *War Women of England* und *American YMCA in London* (alle aus dem Jahr 1919). 2006 erschien bei TASCHEN *Burton Holmes: Reiseberichte. Der größte Reisende seiner Zeit, 1892–1952*.

Voyageur, photographe et cinéaste américain, Elias Burton Holmes débuta sa carrière en 1890 à l'occasion d'un tour d'Europe dans lequel il accompagnait sa grand-mère. Une fois rentré chez lui, il alla donner une conférence et montrer ses diapositives au Chicago Camera Club. Ainsi naîtront une vocation et Burton Holmes Travelogues, entreprise spécialisée dans les événements de ce type, qui rencontrera un formidable succès. À ses auditoires successifs, Holmes projettera lui-même quelque 8 000 diapositives avant de prendre sa retraite en 1952. Il réalisa aussi de nombreux courts métrages documentaires, parmi lesquels *Motoring in England* (1916) et *London Plays Ball*, *War Women of England* et *American YMCA in London* (tous en 1919). TASCHEN lui a consacré un livre en 2006, *Travelogues : le plus grand voyageur de son temps, 1892-1952*.

Jang, Michael (1951–)

Based in San Francisco, Jang is a portrait photographer whose subjects have included Jimi Hendrix, Robin Williams, and William Burroughs, as well as celebrities in Beverly Hills, the punk rock scene in the late 1970s, and the garage bands of San Francisco in the early 2000s. His photographs have been described as capturing the essence of California in the 1970s and '80s. His retrospective, *Michael Jang's California*, was held at San Francisco's McEvoy Foundation for the Arts in 2019, and he is best known for his series *The Jangs*, a portrait of his extended Chinese American family made up of images he took in the 1970s and '80s.

Der in San Francisco lebende Jang fotografierte als Porträtfotograf unter anderem Jimi Hendrix, Robin Williams und William Burroughs sowie Prominente in Beverly Hills, die Punkrock-Szene in den späten 1970er-Jahren und die Garagenbands von San Francisco in den frühen 2000er-Jahren. Seine Fotografien fingen das Wesen Kaliforniens in den 1970er- und 80er-Jahren ein. Seine Retrospektive *Michael Jang's California* war 2019 in der McEvoy Foundation for the Arts in San Francisco zu sehen. Er ist vor allem für seine Serie *The Jangs* bekannt, einem Porträt seiner chinesisch-amerikanischen Großfamilie aus Bildern, die er in den 1970er- und 80er-Jahren aufgenommen hat.

Basé à San Francisco, Michael Jang est longtemps demeuré dans le relatif anonymat d'un portraitiste commercial prospère qui prenait sur son temps libre pour aller photographier Jimi Hendrix, Robin Williams, William Burroughs, la scène punk rock à la fin des seventies ou les groupes de garage au début du nouveau siècle. On dira de lui qu'il a su saisir l'essence de la Californie des années 1970 et 1980. Il aura ainsi droit en 2019 à une rétrospective organisée à la McEvoy Foundation for the Arts, intitulée *Michael Jang's California*. La série *The Jangs*, consacrée à l'assimilation progressive de sa famille sino-américaine dans les années 1970 et 1980, a particulièrement marqué les esprits.

Johnson, David (1926–)

Johnson grew up in Jacksonville, FL, and moved to San Francisco to study with Ansel Adams in 1946, becoming the first Black photographer to study with Adams at the California School of Fine Arts. Johnson has photographed Black life for more than seven decades, including the Civil Rights Movement as well as politicians and cultural figures, including Paul Robeson, Eartha Kitt, and Nat King Cole, among others. He is known for photographing jazz clubs and nightlife in San Francisco's Fillmore District, where Ella Fitzgerald, Billie Holiday, Louis Armstrong, and Duke Ellington regularly performed, but he also photographed everyday residents of the neighborhood over the years, from girls playing hopscotch to a young boy sitting on a fence or a couple dancing.

Johnson wuchs in Jacksonville, Florida, auf und zog 1946 nach San Francisco, um bei Ansel Adams zu studieren. Er war der erste afroamerikanische Fotograf, der bei Adams an der California School of Fine Arts studierte. Johnson hat mehr als sieben Jahrzehnte lang afroamerikanisches Leben fotografiert, darunter die Bürgerrechtsbewegung sowie Politiker und kulturelle Persönlichkeiten wie Paul Robeson, Eartha Kitt und Nat King Cole. Er ist für seine Fotografien der Jazzclubs und des Nachtlebens in San Franciscos Fillmore District bekannt, wo Ella Fitzgerald, Billie Holiday, Louis Armstrong und Duke Ellington regelmäßig auftraten, aber er hat im Laufe der Jahre auch gewöhnliche Bewohner des Viertels fotografiert, von Mädchen, die Himmel und Hölle spielen, bis hin zu einem auf einem Zaun sitzenden Jungen oder einem tanzenden Pärchen.

David Johnson a grandi à Jacksonville (Floride) avant de s'installer à San Francisco afin d'y suivre l'enseignement d'Ansel Adams à la California School of Fine Arts en 1946, une première pour un apprenti photographe afro-américain. Il consacrera plus de sept décennies à l'observation de la réalité noire, à travers notamment le mouvement des droits civiques et la destinée de

différentes personnalités politiques ou culturelles dont Paul Robeson, Eartha Kitt et Nat King Cole. S'il a beaucoup photographié les clubs de jazz et la vie nocturne du Fillmore District, où se produisaient régulièrement Ella Fitzgerald, Billie Holiday, Louis Armstrong et Duke Ellington, il n'a pas oublié les habitants du quartier – petites filles qui jouent à la marelle, garçonnet songeur adossé à une palissade, couple dansant… – dont il s'est attaché, au fil des ans, à restituer le quotidien.

Jones, Pirkle (1914–2009)

Jones was one of the earliest students in the first department of photography that Ansel Adams started, which was at the California School of Fine Arts, now the San Francisco Art Institute. He grew up in the Midwest and moved to California in the mid-1940s. As a photographer, his primary interest was San Francisco, with its steep streets, colorful houses, and dense fog, though he also photographed migrant farmers and a houseboat community in Sausalito. In 1968, Jones and his wife, photographer Ruth-Marion Baruch, made a photographic study of the Black Panther Party, photographs that drew more than 100,000 visitors when they were exhibited at San Francisco's de Young Museum.

Jones war einer der ersten Studenten der von Ansel Adams gegründeten Seminars für Fotografie an der California School of Fine Arts, dem heutigen San Francisco Art Institute. Er wuchs im Mittleren Westen auf und zog Mitte der 1940er-Jahre nach Kalifornien. Als Fotograf interessierte er sich vor allem für San Francisco mit seinen steilen Straßen, bunten Häusern und dem dichten Nebel, aber er fotografierte auch zugewanderte Bauern und eine Hausbootgemeinschaft in Sausalito. 1968 erstellten Jones und seine Frau, die Fotografin Ruth-Marion Baruch, eine Fotostudie über die Black Panther Party, die bei ihrer Ausstellung im de Young Museum in San Francisco mehr als 100 000 Besucher anlockte.

Pirkle Jones fut l'un des premiers étudiants du département de photographie lancé par Ansel Adams, pionnier du genre, à la California School of Fine Arts, aujourd'hui San Francisco Art Institute. Il grandit dans le Midwest avant de s'installer dans le «Golden State» au milieu des années 1940. Le photographe qu'il était s'intéressa surtout à San Francisco – pour ses rues escarpées, ses maisons aux couleurs vives, son épais brouillard – mais il sut également honorer la dignité de paysans migrants ou l'anticonformisme d'une communauté installée à bord de *houseboats* à Sausalito. Avec sa femme, la photographe Ruth-Marion Baruch, il consacra en 1968 au parti des Black Panthers une étude photographique qui draina plus de 100 000 visiteurs vers le musée De Young lorsqu'elle y fut exposée.

Kashi, Ed (1957–)

Kashi is a photojournalist and filmmaker and a member of the VII Photo Agency. In partnership with his wife, writer and filmmaker Julie Winokur, he founded Talking Eyes Media, which has produced a number of award-winning short films and multimedia projects that focus on social issues. His immersive installation, *Enigma Room*, premiered at the 2019 Photoville festival in Brooklyn. Kashi, who lived in San Francisco for 25 years before moving to the East Coast in 2004, has created social media projects for *National Geographic*, *The New Yorker*, and MSNBC, among other organizations.

Kashi ist ein Fotojournalist, Filmemacher und Mitglied der VII Photo Agency. Gemeinsam mit seiner Frau, der Schriftstellerin und Filmemacherin Julie Winokur, gründete er Talking Eyes Media, das eine Reihe preisgekrönter Kurzfilme und Multimediaprojekte produziert hat, die sich mit sozialen Fragen befassen. Seine immersive Installation „Enigma Room" hatte ihre Premiere auf der Photoville 2019 in Brooklyn, New York. Kashi, der 25 Jahre lang in San Francisco lebte, bevor er 2004 an die Ostküste zog, hat Social-Media-Projekte unter anderem für *National Geographic*, *The New Yorker* und MSNBC geschaffen.

Photojournaliste et cinéaste, Kasti a vécu à San Francisco pendant vingt-cinq ans avant de s'installer sur

la côte Est en 2004. Il est membre de la VII Photo Agency, lancée par sept grands reporters à New York en 2001. En partenariat avec son épouse, la journaliste et documentariste Julie Winokur, il a fondé la société de production Talking Eyes Media dont plusieurs courts métrages et projets multimédias axés sur les questions sociales ont à ce jour été primés. *Enigma Room*, une installation immersive, a été présentée lors du festival Photoville 2019 de Brooklin, à New York. *National Geographic*, *The New Yorker* et MSNBC, pour ne citer qu'eux, lui ont également commandé diverses créations destinées au Web.

Keenan, Larry *(1943–2012)*

A San Francisco native, Keenan is known for his photographs of members of the Beat Generation in San Francisco. He was just 22 when the poet Michael McClure invited him to the City Lights Bookstore in San Francisco to shoot a portrait of Bob Dylan. Keenan photographed the counterculture in the San Francisco area for the next 40 years while he also built a successful commercial practice.

Der aus San Francisco stammende Keenan ist für seine Fotografien von Mitgliedern der Beat Generation in San Francisco bekannt. Er war gerade 22 Jahre alt, als der Dichter Michael McClure ihn in den City Lights Bookstore in San Francisco einlud, um ein Porträt von Bob Dylan zu machen. In den nächsten 40 Jahren fotografierte Keenan die Gegenkultur in der Gegend von San Francisco, während er gleichzeitig ein erfolgreiches Geschäft aufbaute.

Né à San Francisco, Larry Keenan s'est fait un nom grâce au travail photographique qu'il a consacré à la Beat Generation. Il avait juste 22 ans lorsque le poète Michael McClure l'invita à venir prendre Bob Dylan en photo à la librairie City Lights. Au cours des quarante années suivantes, il s'évertua à restituer les heurs et malheurs de la contre-culture de San Francisco, tout en déployant ses talents avec succès dans un registre plus commercial.

Lange, Dorothea *(1895–1965)*

Lange studied photography at Columbia University and worked in a New York portrait studio until 1918, when she moved to San Francisco. There, she opened her own portrait business. But when the Great Depression began in 1929, she started shooting documentary pictures. Her images of the poor and dispossessed led to a long professional relationship with the Resettlement Administration, later called the Farm Security Administration. Between 1935 and 1939, she relentlessly documented the rural poor and migrant workers. Her 1936 photograph "Migrant Mother" is one of the most famous images in the history of photography. During World War II, she photographed the plight of Japanese Americans. In 1945, she began teaching at the California School of Fine Arts while also working on assignment for *Life* magazine.

Lange studierte Fotografie an der Columbia University und arbeitete bis zu ihrem Umzug nach San Francisco 1918 in einem Porträtatelier in New York. In San Francisco eröffnete sie ihr eigenes Porträtstudio, aber nach Beginn der Weltwirtschaftskrise 1929 arbeitete sie als Dokumentarfotografin. Ihre Bilder von Armen und Mittellosen führten zu einer engen beruflichen Beziehung zur Resettlement Administration, der späteren Farm Security Administration. Zwischen 1935 und 1939 dokumentierte sie rastlos Arme und Wanderarbeiter auf dem Land. Das Foto *Migrant Mother* aus dem Jahr 1936 ist eines der berühmtesten Fotos in der Geschichte der Fotografie. Während des Zweiten Weltkriegs fotografierte Lange Not und Elend der japanischstämmigen Amerikaner. 1945 nahm sie eine Lehrtätigkeit an der California School of Fine Arts auf, arbeitete aber weiterhin für die Zeitschrift *Life*.

Formée à la photo à l'Université de Columbia, Dorothea Lange travailla dans un studio de portrait à New York jusqu'en 1918, date à laquelle elle s'installa à San Francisco. Elle se lança à son tour dans le portrait mais le début de la Grande Dépression, en 1929, l'orienta vers la photo documentaire. Les clichés

qu'elle réalisa alors des populations les plus démunies l'amèneront à entretenir une longue relation professionnelle avec la Resettlement Administration, future Farm Security Administration, l'organisme chargé d'aider les agriculteurs les plus durement frappés par la crise. Entre 1935 et 1939, elle restitua sans relâche la misère des campagnes et des travailleurs migrants; sa *Migrant Mother* de 1936 est l'une des images les plus célèbres de l'histoire de la photo. Pendant la Seconde Guerre mondiale, elle photographiera avec la même empathie la détresse des citoyens américains d'origine japonaise. À partir de 1945, elle enseignera à la California School of Fine Arts tout en collaborant régulièrement au magazine *Life*.

Lawrence, George R. *(1868–1938)*

An innovator and inventor, Lawrence opened a studio in Chicago that produced crayon enlargements, large portraits that were enhanced by pastels or charcoal. Subsequently, he developed his own large-format cameras and specialized in aerial views. He used a series of kites to hoist his camera into the air and photograph the city of San Francisco after the 1906 earthquake, most famously *San Francisco in Ruins*, a panoramic image shot from 2,000 feet up.

Der innovative und erfinderische Lawrence eröffnete in Chicago ein Studio, das Vergrößerungen mit Kreidestiften herstellte, große Porträts, die mit Pastellkreide oder Kohle retuschiert wurden. Später entwickelte er seine eigenen großformatigen Kameras und spezialisierte sich auf Luftaufnahmen. Er benutzte eine Reihe von Flugdrachen, um seine Kamera in die Luft zu heben und die Stadt San Francisco nach dem Erdbeben von 1906 zu fotografieren. Am berühmtesten ist „San Francisco in Ruins", ein Panoramabild, das aus einer Höhe von 600 m aufgenommen wurde.

George Lawrence ouvrit à Chicago un studio qui produisait des agrandissements de photos, le plus souvent des portraits, parachevés au crayon, au pastel ou au fusain. Par la suite, il développa ses propres appareils photo grand format et s'est spécialisé dans les vues aériennes. Il fixa ainsi un appareil photo à plusieurs cerfs-volants pour photographier San Francisco après le séisme de 1906 – l'image la plus célèbre, *San Francisco in Ruins*, sera prise à 600 mètres d'altitude.

Lyon, Fred *(1927–)*

Known as "San Francisco's Brassaï," Lyon is a San Francisco native whose photographs have appeared in magazines such as *Life*, *Look*, *Sports Illustrated*, and *Vogue*. Lyon studied with Ansel Adams, and his photographs over the years have included news, fashion, advertising, and jazz. He's photographed Billie Holiday and Sonny Rollins as well as dock workers, kids playing on the city's famously steep Kearny Street, and fishermen in Sausalito. He has explored every corner of his hometown over the years, including photographing bridge painters touching up the Golden Gate Bridge, graphic black-and-white photographs of the city's neighborhoods and architecture, and images of San Francisco at night.

Der als „Brassaï von San Francisco" bekannte Lyon stammt aus San Francisco und seine Fotos sind in Zeitschriften wie *Life*, *Look*, *Sports Illustrated* und *Vogue* erschienen. Lyon studierte bei Ansel Adams und fotografierte im Laufe der Jahre unter anderem für die Nachrichten, Mode, Werbung und Jazz. Er hat Billie Holiday und Sonny Rollins ebenso fotografiert wie Hafenarbeiter, spielende Kinder auf der berühmten, steilen Kearny Street und Fischer in Sausalito. Im Laufe der Jahre hat er jeden Winkel seiner Heimatstadt erkundet und unter anderem Brückenmaler fotografiert, die die Golden Gate Bridge ausbesserten, und grafische Schwarzweißfotografien der Stadtviertel und Architektur sowie Bilder von San Francisco bei Nacht erstellt.

Surnommé « le Brassaï de San Francisco », Fred Lyon a vu son travail publié par les plus grands magazines, parmi lesquels *Life*, *Look*, *Sports Illustrated* et *Vogue*. Natif de la ville où il apprit son métier auprès d'Ansel Adams, il en explora au fil des ans les moindres recoins,

surtout la nuit: il savait capter aussi bien l'application des peintres occupés à refaire une beauté au Golden Gate Bridge que le potentiel graphique des différents quartiers et de leur architecture, restitués dans un noir et blanc intensément contrasté. L'actualité, la mode, la publicité, le jazz n'échappèrent pas davantage à ce regard qui se posait sur Billie Holiday et Sonny Rollins avec la même sensibilité que sur les dockers de l'Embarcadero, les pêcheurs de Sausalito ou les gamins prêts à dévaler la vertigineuse Kearny Street.

Marshall, Jim *(1936–2010)*

A legendary rock photographer who began his career shooting the music and art scene in San Francisco in 1959, Marshall was said to be the favourite photographer of Jimi Hendrix, Janis Joplin and The Rolling Stones, and was the official photographer at Woodstock. Granted unprecedented access to many of the world's best musicians and bands, he photographed The Beatles' last concert in 1966. Marshall's photographs have been featured in books such as *Not Fade Away: The Rock & Roll Photography of Jim Marshall* (1997), *Trust: Photographs of Jim Marshall* (2009) and *The Rolling Stones 1972* (2012).

Marshall war ein legendärer Rockfotograf, der seine Karriere 1959 in der Musik- und Kunstszene von San Francisco begann. Er galt als Lieblingsfotograf von Jimi Hendrix, Janis Joplin und den Rolling Stones, war der offizielle Fotograf in Woodstock und dokumentierte das letzte Konzert der Beatles 1966. Marshalls Aufnahmen erschienen in Büchern wie *Not Fade Away: The Rock & Roll Photography of Jim Marshall* (1997), *Trust: Photographs of Jim Marshall* (2009) und *The Rolling Stones* (2012).

Photographe de rock légendaire, Marshall fit ses premières armes en 1959 en mitraillant la scène musicale et artistique de San Francisco. Il aurait été, dit-on, le photographe favori de Jimi Hendrix, Janis Joplin et des Rolling Stones. Il ne laissa en tout cas à nul autre le titre de photographe officiel de Woodstock. Bénéficiant d'un accès privilégié à la plupart des meilleurs musiciens et groupes de la planète, il photographia notamment le dernier concert des Beatles en 1966. Ses images sont visibles dans plusieurs livres tels *Not Fade Away: The Rock & Roll Photography of Jim Marshall* (1997), *Trust: Photographs of Jim Marshall* (2009) et *The Rolling Stones* (2012).

McCartney, Linda *(1941–1998)*

McCartney was an American photographer and animal-rights activist. Born Linda Louise Eastman, she married Beatle Paul McCartney in 1969. She got her start as a photographer when she took unofficial photographs of the Rolling Stones at a party on a yacht in New York's Hudson River. She subsequently became the house photographer for the Fillmore East concert hall, photographing recording artists such as Aretha Franklin, Jimi Hendrix, Bob Dylan, Eric Clapton, The Who, The Doors and Neil Young. TASCHEN published *Linda McCartney: Life in Photographs* in 2011 and *The Polaroid Diaries* in 2019.

Linda McCartney, mit Geburtsnamen Linda Louise Eastman, war eine amerikanische Fotografin und Tierrechtlerin. 1969 heiratete sie Paul McCartney von den Beatles. Ihren Durchbruch als Fotografin hatte sie mit den inoffiziellen Bildern, die sie bei einer Party auf einer Jacht auf dem Hudson River in New York von den Rolling Stones schoss. Anschließend fotografierte sie als offizielle Fotografin der Konzerthalle Fillmore East Künstler wie Aretha Franklin, Jimi Hendrix, Bob Dylan, Eric Clapton, The Who, The Doors und Neil Young. Bei TASCHEN erschien 2011 *Linda McCartney: Life in Photographs* und 2019 *The Polaroid Diaries*.

Née aux États-Unis, Linda Louise Eastman était une photographe américaine et une militante engagée dans la cause animale. Elle a épousé Paul McCartney, membre des Beatles, en 1969. Sa carrière photographique avait décollé un an plus tôt grâce aux images des Rolling Stones fort peu officielles réalisées à l'occasion d'une fête donnée sur un yacht amarré à New York. Devenue rapidement la photographe attitrée

du Fillmore East, elle y immortalisera quantité d'artistes, d'Aretha Franklin aux Who en passant par Jimi Hendrix, Bob Dylan, Eric Clapton, les Doors ou Neil Young. TASCHEN a publié en 2011 *Linda McCartney: Life in Photographs*, puis en 2019 *The Polaroid Diaries*.

McCombe, Leonard *(1923–)*

McCombe was born in England and became a member of the Royal Photographic Society at the age of 21. By 22, he was working for *Life*. He moved to the US in 1945, and his assignments included photographing cowboys in Texas. After his images were published in *Life*, one of his photographs became the symbol of the Marlboro Man.

McCombe wurde in England geboren und im Alter von 21 Jahren Mitglied der Royal Photographic Society. Mit 22 Jahren arbeitete er bereits für *LIFE*. 1945 zog er in die USA und fotografierte unter anderem Cowboys in Texas. Nachdem seine Bilder in LIFE veröffentlicht worden waren, kam eines von ihnen als Marlboro Mann zum Einsatz.

Né en Angleterre, Leonard McCombe était déjà membre de la Royal Photographic Society à l'âge de 21 ans, et un an plus tard, il rejoignait l'équipe du magazine *Life*. Ses reportages, une fois qu'il sera installé aux États-Unis en 1945, le conduiront au Texas et plus précisément dans un ranch emblématique. Après la publication des photos, l'un de ses portraits sera choisi pour incarner officiellement le «cow-boy Marlboro».

Mieth, Hansel *(1909–1998)*

A social documentary photographer committed to recording workers and labor struggles, Mieth came to the United States from Germany in the midst of the Great Depression. She joined Otto Hagel, who eventually became her husband. They became agricultural workers, and Mieth photographed their experiences for a series that was eventually published in *Life* magazine as *The Great Hunger* in 1934. In the 1930s, while working as a seamstress for the Works Progress Administration in San Francisco, Mieth photographed the city's Chinatown as well as freightyard and waterfront workers. She worked for a time at *Life*'s New York office, but she and Hagel eventually bought a sheep farm in Santa Rosa, CA, and published a series called *A Simple Life* in *Life*, about their farm.

Die sozialkritische Dokumentarfotografin, die sich der fotografischen Begleitung von Arbeitern und Arbeitskämpfen verschrieben hatte, kam während der Weltwirtschaftskrise aus Deutschland in die Vereinigten Staaten. Sie schloss sich Otto Hagel an, der schließlich ihr Ehemann wurde. Sie arbeiteten in der Landwirtschaft, und Mieth fotografierte ihre Erlebnisse für eine Serie, die schließlich 1934 im *Life*-Magazin unter dem Titel „The Great Hunger" veröffentlicht wurde. In den 1930er-Jahren arbeitete Mieth als Näherin für die Works Progress Administration in San Francisco und fotografierte Chinatown sowie Arbeiter in Güterbahnhöfen und Häfen. Sie arbeitete eine Zeit lang im New Yorker Büro von *Life*, kaufte aber schließlich zusammen mit Hagel eine Schaffarm in Santa Rosa, Kalifornien, über die sie in *Life* eine Serie mit dem Titel „A Simple Life" veröffentlichte.

Venue d'Allemagne, Hansel Mieth avait 15 ans quand elle débarqua aux États-Unis au beau milieu de la Grande Dépression en compagnie d'Otto Hagel, son futur mari. Ensemble ils vivront une expérience d'ouvriers agricoles qu'elle relatera en images dans une série publiée en 1934 par le magazine *Life* sous le titre *The Great Hunger* («La grande faim»). Alors qu'elle travaillait comme couturière à San Francisco pour la Works Progress Administration, elle consacra son temps libre au quartier chinois de la ville ainsi qu'à la rudesse ordinaire des activités portuaires. Elle travailla un moment au bureau new-yorkais de *Life* mais choisit alors d'aller reprendre avec son époux un élevage de moutons en Californie, à Santa Rosa. Sa nouvelle vie donna lieu à la publication dans *Life* d'une série de photos intitulée *A Simple Life*.

Mili, Gjon *(1904–1984)*

Mili immigrated to the US from Albania in 1923 and studied electrical engineering at the Massachusetts

Institute of Technology, where he worked with Harold Edgerton. He developed technology related to stroboscopic and stop-action photography and photographed action shots of dancers, athletes, musicians, and actors, many of which were published in *Life*. Mili was also the official photographer for the San Francisco Conference in 1945, when delegates from 50 nations met and created the United Nations.

Mili wanderte 1923 aus Albanien in die USA ein und studierte Elektrotechnik am Massachussets Institute of Technology, wo er mit Harold Edgerton zusammenarbeitete. Er entwickelte die Technik der Stroboskop- und Stop-Action-Fotografie und machte Actionfotos von Tänzern, Sportlern, Musikern und Schauspielern, von denen viele in *Life* veröffentlicht wurden. Mili war auch der offizielle Fotograf der Konferenz von San Francisco im Jahr 1945, als Delegierte aus 50 Nationen zusammenkamen und die Vereinten Nationen gründeten.

Né en Albanie, Gjon Mili a émigré aux États-Unis en 1923. Il étudie l'ingénierie électrique au Massachusetts Institute of Technology, à Cambridge, où il collabore avec Harold Edgerton. Mili va mettre au point une technologie photographique originale reposant sur la lumière stroboscopique et la décomposition du mouvement. Le magazine *Life* publiera régulièrement ses photos de danseurs, athlètes, musiciens et acteurs saisis en pleine action. Mili sera également en 1945 le photographe officiel de la Conférence de San Francisco, qui rassembla les délégués de 50 nations venus créer l'ONU.

Morse, Ralph *(1917–2014)*

A photojournalist who captured world events for *Life* and *Time*, among other publications, Morse photographed the D-Day landings in World War II, the preparations for the earliest American missions into space, Babe Ruth's farewell at Yankee Stadium, and several members of the San Francisco Giants in action. Morse took so many photographs in so many locations that George P. Hunt, the managing editor of *Life*, once said, "If *Life* could afford only one photographer, it would have to be Ralph Morse."

Morse war ein Fotojournalist, der unter anderem für *Life* und *Time* Weltgeschehnisse festhielt. Er fotografierte die D-Day-Landungen im Zweiten Weltkrieg, die Vorbereitungen für die ersten amerikanischen Weltraummissionen, den Abschied von Babe Ruth im Yankee-Stadion und mehrere Baseballspieler der San Francisco Giants in Aktion. Morse machte so viele Fotos an so vielen Orten, dass George P. Hunt, der leitende Redakteur von *Life*, einmal sagte: „Wenn *Life* nur einen Fotografen haben könnte, müsste es Ralph Morse sein."

Photojournaliste, Morse a été recruté par *Life* et *Time*, entre autres publications, pour couvrir des événements mondiaux. Il a photographié les débarquements du jour J pendant la Seconde Guerre mondiale. Très proche des astronautes du programme spatial Mercury, il immortalisera aussi au Yankee Stadium les adieux de Babe Ruth, la légende du base-ball, ainsi que plusieurs joueurs des San Francisco Giants en action. «Si *Life* ne pouvait se payer qu'un seul photographe, il faudrait que ce soit Ralph Morse», dira de lui George Hunt, le rédacteur en chef du magazine, fasciné par son ubiquité professionnelle.

Newman, Marvin *(1927–)*

Newman studied photography at Brooklyn College and, in 1948, joined the Photo League. In 1949, he enrolled at Chicago's Institute of Design, where his teachers included Aaron Siskind and Harry Callahan. He started working for *Sports Illustrated* in 1953, and his images also appeared in *Life*, *Look*, and *Newsweek*. He had his first solo show at Roy DeCarava's A Photographer's Gallery in 1956, and from 1982 to 1987, he worked as a commercial photographer for J.P. Morgan Bank. He is a past national president of the American Society of Magazine Photographers. In 2017, TASCHEN published a definitive monograph of his work mainly shot in NY.

Newman studierte Fotografie am Brooklyn College und wurde 1948 Mitglied der Photo League. 1949

schrieb er sich am Institute of Design in Chicago ein, wo er unter anderem bei Aaron Siskind und Harry Callahan studierte. Er begann 1953 für *Sports Illustrated* zu arbeiten, und seine Fotos erschienen auch in *Life*, *Look* und *Newsweek*. Seine erste Einzelausstellung hatte er in A Photographer's Gallery von Roy DeCarava (1956). Von 1982 bis 1987 arbeitete er als Werbefotograf für die J.P. Morgan Bank. Er war auch Präsident der American Society of Magazine Photographers. 2017 veröffentlichte TASCHEN die definitive Monografie über das Werk von Marvin Newman, das hauptsächlich in New York entstanden ist.

Newman a étudié la photographie au Brooklyn College avant de rejoindre en 1948 la Photo League, un collectif progressiste. Inscrit en 1949 à l'Institute of Design de Chicago, il y aura notamment pour professeurs Aaron Siskind et Harry Callahan. En 1953, il commence à travailler pour *Sports Illustrated*, et collabore également à *Life*, *Look* et *Newsweek*. A Photographer's Gallery, la galerie du photographe Roy DeCarava, lui consacre en 1956 une première exposition solo. De 1982 à 1987, il travaillera comme photographe publicitaire pour la banque J.P. Morgan. Il présidera également l'American Society of Magazine Photographers. En 2017, TASCHEN a publié une monographie définitive de son travail, essentiellement dédiée à New York.

Nicoletta, Daniel *(1954–)*

Known for his photographs of LGBTQ life in San Francisco, Nicoletta began his career as an intern to Crawford Barton, who was a staff photographer for *The Advocate*. He was involved in Harvey Milk's election as one of the first openly LGBTQ elected officials in the United States, and he went on to document the making of Gus Van Sant's 2008 film, *Milk*, starring Sean Penn. Nicoletta's photographs of LGBTQ folks in the Bay Area have appeared at SF Camerawork, the San Francisco Public Library, and the SF Art Commission Gallery, among many other Bay Area venues. He was awarded the 2003 Pride Creativity Award for outstanding artistic contributions to the LGBTQ community.

Nicoletta, der für seine Fotografien der LGBTQ-Szene in San Francisco bekannt ist, begann seine Karriere als Praktikant bei Crawford Barton, der als angestellter Fotograf für *The Advocate* tätig war. Er war an der Wahl von Harvey Milk beteiligt, einem der ersten offen der LGBTQ-Community angehörigen Abgeordneten in den Vereinigten Staaten, und dokumentierte die Dreharbeiten zu Gus Van Sants Film *Milk* aus dem Jahr 2008, in dem Sean Penn die Hauptrolle spielt. Nicolettas Fotografien von LGBTQ-Personen in der San Francisco Bay Area wurden unter anderem bei SF Camerawork, in der San Francisco Public Library und in der SF Art Commission Gallery ausgestellt. Er wurde 2003 mit dem Pride Creativity Award für herausragende künstlerische Leistungen für die LGBTQ-Community ausgezeichnet.

Son travail photographique a fait de lui le témoin privilégié de quarante ans d'histoire de la communauté LGBTQ à San Francisco. Daniel Nicoletta démarra sa carrière par un stage auprès de Crawford Barton, alors photographe au magazine militant *The Advocate*. Après avoir participé à l'une des premières élections d'un candidat ouvertement gay, Harvey Milk, à une responsabilité politique aux États-Unis, il couvrira en 2008 le tournage du biopic *Milk* de Gus Van Sant, avec Sean Penn dans le rôle de l'activiste assassiné. Les photos que Nicoletta a consacrées à la population LGBTQ de la «Bay Area» ont suscité de nombreuses expositions, notamment à la SF Art Commission Gallery, à la bibliothèque publique de San Francisco et à la San Francisco Art Commission Gallery. Sa «contribution artistique exceptionnelle à la communauté LGBTQ» a été saluée en 2003 par un Pride Creativity Award.

O'Connor, Jeannie *(1945–)*

A San Francisco native, O'Connor graduated from the University of California, Berkeley with an MA in painting, and her work combines photography, painting, pastel, and collage. Also an architectural photographer known

for her Bay Area industrial series—images of industrial buildings covered in layers of graffiti and paint—she has taught at UC Berkeley and the San Francisco Art Institute. O'Connor was presented with the SECA Art Award (the Society for the Encouragement of Contemporary Art) by SFMOMA in 1982. Her works include painted film collages, photographic assemblages, and portrait projects, including a number of portraits of Imogen Cunningham, who was a friend and mentor.

Die aus San Francisco stammende Jeannie O'Connor schloss ihr Studium der Malerei an der University of California, Berkeley, mit einem Master ab. Ihre Arbeit kombiniert Fotografie, Malerei, Pastellmalerei und Collagetechnik. Sie arbeitet auch als Architekturfotografin, die für ihre Bilder von Industriegebäuden in der San Francisco Bay Area, die mit Graffiti und Farbe überzogen sind, bekannt ist. Sie unterrichtet außerdem in Berkeley und am San Francisco Art Institute. 1982 wurde O'Connor vom SFMOMA mit dem Kunstpreis der Society for the Encouragement of Contemporary Art ausgezeichnet. Zu ihren Werken gehören gemalte Filmcollagen, Fotomontagen und Porträtprojekte, darunter eine Reihe von Porträts ihrer Freundin und Mentorin Imogen Cunningham.

Née à San Francisco, Jeannie O'Connor est sortie de l'Université de Californie avec en poche un master de beaux-arts. Sa palette combine peinture, pastel, collage et une pratique photographique teintée de sensibilité architecturale, comme l'a montré la série qu'elle a consacrée à des sites industriels couverts de tags et de fresques. Le SECA (Society for the Encouragement of Contemporary Art) Art Award lui a été attribué en 1982 par le SFMOMA ; elle a aussi enseigné à Berkeley et au San Francisco Art Institute. Son catalogue artistique accueille à la fois des fragments de pellicule peints réunis sous forme de collages, des assemblages photographiques et de nombreux portraits, avec pour modèle récurrent son amie et mentor Imogen Cunningham.

Owens, Bill (1938–)

Born in San Jose, CA, Owens is best known for his 1973 book *Suburbia*. Comprised of photographs of the suburban community of Livermore, CA, a portrait of middle class life in black-and-white photographs, it is considered one of the most important photography books of the 20th century. Owens was introduced to photography while serving in the Peace Corps in Jamaica, after which he studied visual anthropology at San Francisco State College. He was hired as a staff photographer for the local paper in Livermore, an East Bay suburb of San Francisco. After publishing *Suburbia*, he produced *Our Kind of People* (1975) and *Working: I Do It for the Money* (1977).

Der in San Jose, Kalifornien, geborene Owens ist vor allem für sein 1973 erschienenes Buch *Suburbia* bekannt. Dessen Fotografien der Vorstadtgemeinde Livermore, Kalifornien, ein Porträt des Mittelstandslebens in Schwarz-Weiß-Fotos, gilt als eines der wichtigsten Fotobücher des 20. Jahrhunderts. Owens kam während seiner Zeit im Friedenscorps in Jamaika mit der Fotografie in Berührung und studierte anschließend visuelle Anthropologie am San Francisco State College. Er wurde als Fotograf für die Lokalzeitung in Livermore, einem Vorort der East Bay von San Francisco, angestellt. Nach der Veröffentlichung von *Suburbia* produzierte er weitere Bücher, *Our Kind of People* (1975) und *Working: I Do It for the Money* (1977).

C'est la publication de sa monographie *Suburbia*, en 1973, qui révéla Bill Owens, natif de San José, en Californie. Engagé comme photographe par le journal local de Livermore, en Californie, il en profita pour s'inviter dans le quotidien de centaines de familles de la classe moyenne dont *Suburbia*, considéré comme l'un des ouvrages de photo les plus importants du xxᵉ siècle, livre un extraordinaire portrait en noir et blanc. Il s'était initié à son art alors qu'il servait au sein du Peace Corps en Jamaïque, avant d'étudier l'anthropologie visuelle à l'Université d'État de San Francisco. Il publiera *Our Kind of People* (1975) et *Working: I Do It for the Money* (1977).

Parks, Gordon (1912–2006)

Parks bought his first camera at age 21 and moved around the United States doing a variety of jobs while moonlighting by shooting fashion and society portraits. In 1941, he started training under Roy Stryker at the Farm Security Administration. After the war, he started photographing fashion for *Vogue*, and followed Stryker to the Standard Oil Company of New Jersey. In 1948, he became a staff photographer at *Life*, working there for more than 20 years. In 1947, he wrote the technical book *Flash Photography*. Also a skilled poet, writer, and musician, Parks directed the classic New York movie, *Shaft*, in 1971. In 1970, he founded *Essence* magazine and was editorial director until 1973.

Parks kaufte seine erste Kamera im Alter von 21 Jahren, reiste durch die USA und nahm alle möglichen Jobs an; nebenher machte er Modefotos und Porträts von Mitgliedern der feinen Gesellschaft. 1941 begann er eine Ausbildung bei Roy Stryker von der Farm Security Administration. Nach dem Krieg fotografierte er Mode für *Vogue* und folgte Stryker zu Standard Oil of New Jersey. 1948 ging er als Stammfotograf zu *Life* und arbeitete über 20 Jahre lang für die Zeitschrift. 1947 schrieb er ein Fachbuch mit dem Titel *Flash Photography*. Als ebenso talentierter Dichter, Schriftsteller und Musiker führte er 1971 Regie bei dem New-York-Klassiker *Shaft*. 1970 gründete er die Zeitschrift *Essence,* deren Redaktionsleiter er bis 1973 war.

Gordon Parks s'est offert son premier appareil photo à 21 ans avant de sillonner les États-Unis en enchaînant les petits boulots et en arrondissant ses fins de mois grâce à des photos de mode et de *people*. En 1941, il commence à suivre la formation délivrée par Roy Stryker au sein de la Farm Security Administration. Après la guerre, il revient dans la mode pour *Vogue* puis suit Stryker à la Standard Oil Company du New Jersey. En 1948, il rejoint l'équipe de *Life* où il restera plus de 20 ans. Poète, écrivain, musicien, Parks réalisera en 1971 un classique de la blaxploitation au cinéma, *Les Nuits rouges de Harlem* (*Shaft*). En 1970, il créera le magazine *Essence* dont il dirigera la rédaction jusqu'en 1973.

Plumb, Mimi (1953–)

Plumb was born in Berkeley, CA and received her MFA from the San Francisco Art Institute. She is known for her photographs of the Bay Area suburbs, such as Walnut Creek, where she was raised. Her photographs include affectionate images of teenagers sneaking cigarettes, but also the sprawl of suburbia, tract homes and strip malls, the relentless sun and persistent wildfires and droughts, and other effects of climate change in the region.

Mimi Plumb wurde in Berkeley, Kalifornien, geboren und studierte am San Francisco Art Institute. Sie ist bekannt für ihre Fotografien der Vororte der San Francisco Bay Area, wie Walnut Creek, wo sie aufgewachsen ist. Zu ihren Fotografien gehören liebevolle Bilder von Teenagern, die heimlich Zigaretten rauchen, aber auch von der Ausbreitung der Vorstädte, Reihenhäusern und Einkaufszentren sowie von der unerbittlichen Sonne, anhaltenden Waldbränden, Dürren und andere Auswirkungen des Klimawandels in der Region.

Née à Berkeley, Mimi Plumb est sortie du San Francisco Art Institute titulaire d'une maîtrise en beaux-arts. Elle est connue pour son travail photographique mené dans les banlieues de la région de San Francisco, et notamment autour de Walnut Creek, où elle a grandi, documentant les adolescents fumant en cachette, l'extension sans fin des *suburbs*, les lotissements standardisés et les centres commerciaux linéaires, l'implacable soleil californien, les sécheresses et feux de forêt répétés, entre autres conséquences locales du changement climatique.

Ramos, Alex (1989–)

Ramos is an Oakland-based photographer and the director of Leica Gallery San Francisco. Ramos studied photography at City College of San Francisco, and his photographs of railroads were on view at the SFO Museum, a division of the San Francisco International Airport.

Ramos ist ein in Oakland ansässiger Fotograf und Leiter der Leica Gallery San Francisco. Ramos studierte Fotografie am City College of San Francisco. Seine Fotografien von Eisenbahnen waren im SFO Museum, einem Bereich des San Francisco International Airport, zu sehen.

Basé à Oakland, Ramos dirige la Leica Gallery à San Francisco. Il a étudié la photographie au City College of San Francisco et ses photos des chemins de fer américains ont été exposé au SFO Museum, qui fait partie de l'aéroport international de San Francisco.

Ratto, Gerald (1933–)

Born in Richmond, CA and raised in Sonoma, Ratto attended the University of California, Berkeley to study architecture. He transferred to the California School of Fine Arts (now the San Francisco Art Institute), where he studied photography with Minor White, Imogen Cunningham, Dorothea Lange, and Edward Weston. As an architectural photographer, his clients have included I. M. Pei, Buckminster Fuller, and major architecture and design publications, but he is also known for his poignant 1952 series *Children of the Fillmore* and for his images of the city's Chinatown neighborhood.

Geboren in Richmond, Kalifornien, und aufgewachsen in Sonoma, besuchte Ratto die University of California, Berkeley, um Architektur zu studieren. Er wechselte an die California School of Fine Arts (das heutige San Francisco Art Institute), wo er Fotografie bei Minor White, Imogen Cunningham, Dorothea Lange und Edward Weston studierte. Zu seinen Kunden als Architekturfotograf gehörten I.M. Pei, Buckminster Fuller und große Architektur- und Designpublikationen. Bekannt ist er aber auch für seine ergreifende Serie *Children of the Fillmore* von 1952, sowie für seine Bilder aus der Chinatown der Stadt.

Né à Richmond et après avoir grandi à Sonoma, le Californien Gerald Ratto commença des études d'architecture à Berkeley avant de rallier la California School of Fine Arts (aujourd'hui San Francisco Art Institute). Il y apprit la photo auprès de Minor White, Imogen Cunningham, Dorothea Lange et Edward Weston pour devenir photographe d'architecture. Parmi ses clients, il comptera I. M. Pei, Buckminster Fuller et les principales publications spécialisées, design compris. Il consacra également en 1952 une poignante série à un quartier promis à une transformation profonde (*Children of the Fillmore*), et posera par ailleurs un regard artistique empreint d'empathie sur les habitants de Chinatown.

Rougier, Michael (1925–2012)

A staff photographer for *Life* magazine for more than two decades, Rougier reportedly got hired at the magazine after he'd taken photographs of the camera-shy Eva Perón in Argentina and smuggled them out. He went on to cover the Korean War and the Hungarian revolution of 1956, as well as horse racing and the Boy Scouts. One of his best-known series focused on a South Korean orphan named Kang: Rougier's photographs of him, which he sent back to *Life* along with pleas for assistance, prompted people to send supplies and money to his orphanage.

Rougier, der mehr als zwei Jahrzehnte lang als Fotograf für das *Life*-Magazin tätig war, wurde Berichten zufolge bei der Zeitschrift angestellt, nachdem er die kamerascheue Eva Perón in Argentinien fotografiert und die Bilder aus dem Land hinausgeschmuggelte. Später fotografierte er den Koreakrieg, den Ungarischen Volksaufstand von 1956 sowie Pferderennsport und Pfadfinder. Eine seiner bekanntesten Serien befasste sich mit einem südkoreanischen Waisenkind namens Kang: Rougiers Fotos von ihm, die er zusammen mit Bitten um Unterstützung an *Life* schickte, bewegten Menschen dazu, Kangs Waisenhaus Hilfsgüter und Geld zu schicken.

Michael Rougier a travaillé pendant plus de vingt ans pour le magazine *Life*, à titre de photoreporter. Ses clichés de l'actrice et femme politique Eva Perón puis leur sortie clandestine d'Argentine auraient beaucoup fait pour son embauche initiale. Il couvrira la guerre

de Corée, la révolution hongroise de 1956 et des sujets a priori moins violents tels que l'hippisme et la vie des scouts. Il a consacré l'un de ses plus célèbres reportages à un orphelin sud-coréen du nom de Kang. Les images envoyées à *Life* et l'appel à l'aide lancé à cette occasion permettront à l'orphelinat de recevoir subsides et fournitures alors indispensables.

Russell, Ethan A. *(1945–)*

Russell photographed The Rolling Stones' 1969 American tour and the making of The Beatles' *Let It Be* album. Born in New York and raised in California, Russell became interested in photography at the University of California, Santa Cruz, but did not take it up professionally until he moved to London in 1968. He met Mick Jagger in London and from 1968 to 1972 was the Stones' main photographer. He subsequently photographed rock stars including The Who, Janis Joplin, Jim Morrison, and Eric Clapton. Russell's work has been published in several books including *Dear Mr. Fantasy: Diary of a Decade: Our Time and Rock and Roll* (1985), *Let It Bleed: The Rolling Stones, Altamont and the End of the Sixties* (2009) and *Ethan Russell: An American Story* (2012).

Russel fotografierte die Amerika-Tournee der Rolling Stones 1969 und die Produktion des Albums *Let It Be* der Beatles. Geboren in New York und aufgewachsen in Kalifornien, beschäftigte sich Russell schon während des Studiums mit der Fotografie, machte sie aber erst zur Profession, als er 1968 nach London zog, wo er Mick Jagger kennenlernte. Von 1968 bis 1972 fotografierte er vornehmlich die Stones, bald auch Größen wie The Who, Janis Joplin, Jim Morrison und Eric Clapton. Zu seinen Veröffentlichungen gehören unter anderem *Dear Mr. Fantasy – Diary of a Decade: Our Time and Rock and Roll* (1985), *Let It Bleed: The Rolling Stones, Altamont and the End of the Sixties* (2009) und *Ethan Russell: An American Story* (2012).

Russell a photographié la tournée américaine des Rolling Stones en 1969 ainsi que la conception du dernier album des Beatles, *Let It Be*, la même année. Né à New York, il a grandi en Californie et prit goût à la photographie pendant ses études à l'Université de Californie, à Santa Cruz, mais n'en fit son métier qu'à son arrivée à Londres, en 1968. C'est là qu'il rencontra Mick Jagger et devint le photographe principal du groupe de 1968 à 1972. Il photographiera aussi les Who, Janis Joplin, Jim Morrison et Eric Clapton. Son travail a été publié dans plusieurs livres, parmi lesquels *Dear Mr. Fantasy/Diary of a Decade: Our Time and Rock and Roll* (1985), *Let It Bleed: The Rolling Stones, Altamont et la fin des Sixties* (2009) et *Ethan Russell: An American Story* (2012).

Salomon, Erich *(1886–1944)*

Born in Germany and known as the father of modern photojournalism, Salomon was drafted into the German Army in 1913 and spent the war years in a prisoner of war camp in France. After the war, he worked in a publishing house, where he discovered photography. He purchased a miniature camera that allowed him to inconspicuously photograph a famous murder trial in 1928 with his camera concealed in his hat. He spent time in the United States in 1930, photographing well-known figures including William Randolph Hearst at his San Simeon estate in California as well as the San Francisco Stock Exchange. He fled Germany for the Netherlands in 1933, but he was deported in 1943 and died at Auschwitz.

Der in Deutschland geborene und als Vater des modernen Fotojournalismus bekannte Salomon wurde 1913 ins Deutsche Heer eingezogen und verbrachte die Kriegsjahre in einem Kriegsgefangenenlager in Frankreich. Nach dem Krieg arbeitete er in einem Verlagshaus, wo er die Fotografie für sich entdeckte. Er kaufte eine Miniaturkamera, mit der er unauffällig fotografieren konnte, und verfolgte 1928 einen berühmten Mordprozess, bei dem er die Kamera in seinem Hut versteckte. 1930 hielt er sich in den Vereinigten Staaten auf und fotografierte bekannte Persönlichkeiten wie William Randolph Hearst auf seinem Anwesen in San Simeon, Kalifornien, und die Börse von San Francisco.

1933 floh er aus Deutschland in die Niederlande, wurde aber 1943 deportiert und starb in Auschwitz.

Né en Allemagne et connu comme le père du photojournalisme moderne, Salomon fut enrôlé dans l'armée impériale en 1913 et passa les années de guerre dans un camp de prisonniers en France. Le conflit terminé, il travailla dans une maison d'édition berlinoise où il découvrit la photographie. Il s'acheta un appareil photo miniature qu'il pouvait déclencher discrètement, ce qui lui permit de prendre des photos d'un fameux procès pour meurtre en 1928, la petite Ermanox dissimulée dans son chapeau melon. Séjournant aux États-Unis en 1930, il y photographia plusieurs personnages célèbres dont William Randolph Hearst dans son domaine de San Simeon, en Californie, ainsi que la Bourse de San Francisco. Après avoir fui l'Allemagne pour les Pays-Bas en 1933, il n'échappera pas à la déportation en 1943 et périra à Auschwitz.

Schapiro, Steve *(1934–)*

Schapiro's career as a freelance photojournalist started with a story on Arkansas migrant workers that made the cover of the *The New York Times Magazine* in 1961. Since then, his images have appeared in *Life*, *Look*, *Time*, *Newsweek*, *Rolling Stone*, *Vanity Fair*, and many other publications. In the 1970s, he began a second career as a successful publicity stills and movie poster photographer, working on classic films such as *Taxi Driver*, *The Way We Were*, and *The Godfather*—which can be seen in *The Godfather Family Album* (TASCHEN, 2008). In 2016, he collaborated with Lawrence Schiller on a Barbra Streisand book (TASCHEN) and in 2017, his Civil Rights photographs were combined with the text of James Baldwin in *The Fire Next Time* (TASCHEN).

Schapiros Karriere als Fotojournalist begann mit einem Artikel über Wanderarbeiter in Arkansas, der es 1961 auf den Titel des Magazins der *New York Times* schaffte. Seitdem erschienen seine Fotos in *LIFE*, *Look*, *Time*, *Newsweek*, *Rolling Stone*, *Vanity Fair* und vielen anderen Publikationen. In den 1970er-Jahren baute er sich eine zweite, höchst erfolgreiche Karriere als Standbild- und Plakatfotograf fürs Kino auf und fotografierte Klassiker wie *Taxi Driver*, *So wie wir waren* und *Der Pate*; die Ergebnisse sind in *The Godfather Family Album* (TASCHEN, 2008) zu sehen. Schapiro lebt und arbeitet zurzeit in Chicago. 2016 arbeitete er zusammen mit Lawrence Schiller an einem Buch über Barbra Streisand (TASCHEN), und 2017 wurden seine Bürgerrechtsfotografien dem Text von James Baldwin in *The Fire Next Time* (TASCHEN) hinzugefügt.

Steve Schapiro démarra sa carrière de photojournaliste free-lance par un reportage sur les travailleurs migrants de l'Arkansas qui fit la une du *New York Times Magazine* en 1961. Depuis lors, ses images ont paru dans *Life*, *Look*, *Time*, *Newsweek*, *Rolling Stone*, *Vanity Fair*, entre autres publications. Dans les années 1970, il entama une seconde carrière à travers photos publicitaires et affiches de films – sur des classiques tels que *Taxi Driver*, *Nos plus belles années* et *Le Parrain* (*Le Parrain – L'album de famille*, TASCHEN, 2008). En 2016, il signa avec Lawrence Schiller un ouvrage consacré à Barbra Streisand (TASCHEN) et en 2017, ses photos sur le mouvement des droits civiques accompagneront le texte de James Baldwin dans la réédition de *The Fire Next Time* par TASCHEN.

Schiller, Lawrence *(1936–)*

Schiller was a college student at Pepperdine University when he began getting his photographs published in *Life*, *Playboy*, and the *Saturday Evening Post*. Later, as a photojournalist, he photographed politicians and celebrities such as John F. Kennedy, Barbra Streisand, Marilyn Monroe, and Richard Nixon for *Newsweek* and *Time*, among others. His book *Marilyn & Me* (TASCHEN, 2012) is a memoir in words and pictures of his time photographing and getting to know Monroe, and photographs by Schiller and Steve Schapiro were published in the Taschen book *Barbra Streisand*. His photographs of Ken Kesey and the Merry Pranksters were included in a collector's edition of Tom Wolfe's

The Electric Kool-Aid Acid Test (TASCHEN). Schiller, who collaborated over the years with his longtime friend Norman Mailer, is also the president and co-founder of the Norman Mailer Center and Writer's Colony in Provincetown, MA.

Schiller war Student an der Pepperdine University, als er begann, seine Fotos in *Life*, *Playboy* und der *Saturday Evening Post* zu veröffentlichen. Als Fotojournalist fotografierte er später Politiker und Prominente wie John F. Kennedy, Barbra Streisand, Marilyn Monroe und Richard Nixon, unter anderem für *Newsweek* und *Time*. Sein Buch *Marilyn & Me* (TASCHEN, 2012) ist eine Erinnerung in Wort und Bild an die Zeit, in der er Monroe fotografierte und kennenlernte. Außerdem sind Fotografien von Schiller und Steve Shapiro in dem TASCHEN-Buch *Barbra Streisand* zu sehen. Seine Fotografien von Ken Kesey und den Merry Pranksters wurden in eine Sammlerausgabe von Tom Wolfes *The Electric Kool-Aid Acid Test* (TASCHEN) aufgenommen. Schiller, der über Jahre hinweg mit seinem langjährigen Freund Norman Mailer zusammenarbeitete, ist auch Präsident und Mitbegründer des Norman Mailer Center und Writer's Colony in Provincetown, Massachusetts.

Lawrence Schiller était encore étudiant à l'université privée de Pepperdine que *Life*, *Playboy* et le *Saturday Evening Post* publiaient déjà ses premières photos. Devenu photojournaliste, il fixera sur sa pellicule, pour *Newsweek* et *Time*, hommes politiques et célébrités en tout genre parmi lesquels John F. Kennedy, Richard Nixon, Barbra Streisand ou Marilyn Monroe : *Marilyn & Me*, son livre édité par TASCHEN en 2012, constitue une sorte de mémorial littéraire et pictural. Toujours pour TASCHEN, il suivra avec Steve Schapiro une autre étoile, Barbra Streisand, et publiera dans une édition collector d'*Acid Test* (*The Electric Kool-Aid Acid Test*), le roman journalistique de Tom Wolfe, les études photographiques qu'il avait consacrées à Ken Kesey et aux Merry Pranksters. Lié de longue date à Norman Mailer, avec qui il a souvent travaillé, Schiller est aussi le président et cofondateur de la Norman Mailer Center et Writer's Colony, à Provincetown, Massachusetts, dédiée à l'encouragement des écrivains et à la littérature engagée.

Scianna, Ferdinando *(1943–)*

While a student at the University of Palermo, Scianna, who was born in Sicily, began a long-term photographic study of the Sicilian people. His first book, *Religious Festivals in Sicily*, won the Prix Nadar. He moved to Milan in 1966 and began working for the weekly magazine *L'Europeo*, and he joined Magnum in 1982. In the late 1980s, he began taking fashion photographs, most famously working with the brand Dolce & Gabbana.

Während seines Studiums an der Universität Palermo begann der in Sizilien geborene Scianna mit einer fotografischen Langzeitstudie über die sizilianische Bevölkerung. Sein erstes Buch, *Feste Religiose in Sicilia*, wurde mit dem Prix Nadar ausgezeichnet. 1966 zog er nach Mailand und begann für die Wochenzeitschrift *L'Europeo* zu arbeiten. 1982 kam er zu Magnum Photos. In den späten 1980er-Jahren begann er mit Modefotografie und wurde vor allem durch seine Zusammenarbeit mit der Marke Dolce & Gabbana bekannt.

C'est au cours de ses études d'histoire de l'art et de philosophie à l'Université de Palerme que le Sicilien Ferdinando Scianna entama un projet photographique de longue haleine consacré à la population de son île natale. Son premier livre, *Feste religiose in Sicilia*, fut distingué par le prix Nadar en 1966. Cette même année il s'installait à Milan, devenait reporter pour *L'Europeo*. Il rejoindra l'agence Magnum en 1982 puis s'orientera vers la photo de mode à la fin des années 1980, notoirement pour Dolce & Gabbana.

Shames, Stephen *(1947–)*

A documentary photographer, Shames is known for his photographs of the Black Panthers. Shames was a student at the University of California, Berkeley when he met Bobby Seale and Huey Newton, founders of the Black

Panther Party in San Francisco. His photographs of that period are important documents of a movement for racial equality and justice, challenging stereotypes of the Black Panthers and showing their community activism and neighborhood initiatives. His photographs have been compared to those of Lewis Hine and Jacob Riis in their intention to promote social change. He has photographed street kids, actors, musicians, and writers, as well as the 50th anniversary of the occupation of Alcatraz by the Indians of All Tribes.

Der Dokumentarfotograf Shames ist für seine Fotografien der Black Panthers bekannt. Shames war Student an der University of California, Berkeley, als er Bobby Seale und Huey Newton, die Gründer der Black Panther Party in San Francisco, kennenlernte. Seine Fotografien aus dieser Zeit sind wichtige Dokumente einer Bewegung für Rassengleichheit und -gerechtigkeit, die Stereotypen über die Black Panthers anfechten und ihren Community-Aktivismus und Nachbarschaftsinitiativen zeigen. Da seine Fotografien für gesellschaftliche Veränderung warben, wurden sie mit denen von Lewis Hine und Jacob Riis verglichen. Er fotografierte sowohl Straßenkinder, Schauspieler, Musiker und Schriftsteller als auch den 50. Jahrestag der Besetzung der Insel Alcatraz durch die Aktivistengruppe Indians of All Tribes.

Stephen Shames était étudiant à Berkeley lorsqu'il rencontra Bobby Seale et Huey Newton, fondateurs du parti des Black Panthers à San Francisco. Le travail photographique qu'il réalisa alors constitue une précieuse somme documentaire sur un mouvement dédié à la lutte pour l'égalité raciale ; il déconstruit notamment certains stéréotypes dont il a fait l'objet, en montrant par exemple son engagement et son action concrète dans les quartiers. On a comparé les photos de Shames à celles de Lewis Hine et de Jacob Riis, pour l'attachement au changement social qu'elles partagent manifestement. Il a photographié des enfants des rues, des acteurs, des musiciens et des écrivains, ainsi que la célébration du 50ᵉ anniversaire de l'occupation d'Alcatraz par un groupe de militants amérindiens.

Shore, Stephen (1947–)

Shore is known for his pioneering use of color in the 1970s in photographs of everyday objects and scenes, most famously in his 1982 series Uncommon Places, the result of cross-country road trips. His work during the 1970s and '80s include color photographs of a nearly deserted Market Street in San Francisco and the residential neighborhood of Scott Street. His work also includes black-and-white photographs, print-on-demand books, and a prolific Instagram account. His comprehensive retrospective was on view at New York's Museum of Modern Art in 2017. Shore was a teenager when he sold his first photographs to MoMA's then-curator, Edward Steichen, and at age 16, he befriended Andy Warhol and photographed the goings-on at the Factory. Shore's work is in the collection of SFMOMA and the Pilara Foundation, among many other institutions.

Shore ist für seine bahnbrechende Verwendung von Farbe in den 1970er-Jahren in Fotografien von Alltagsgegenständen und -szenen bekannt, besonders in seiner 1982 entstandenen Serie Uncommon Places, die auf Autoreisen quer durchs Land entstand. Zu seinen Arbeiten aus den 1970er- und 80er-Jahren gehören Farbfotografien einer fast menschenleeren Market Street in San Francisco und des Wohnviertels Scott Street. Zu seinem Werk gehören auch Schwarz-Weiß-Fotografien, Print-on-Demand-Bücher und ein äußerst aktiver Instagram-Account. Seine umfassende Retrospektive war 2017 im New Yorker Museum of Modern Art zu sehen. Shore war ein Teenager, als er seine ersten Fotografien an den damaligen Kurator des MoMA, Edward Steichen, verkaufte. Mit 16 Jahren freundete er sich mit Andy Warhol an und fotografierte das Treiben in der Factory. Shores Werke befinden sich unter anderem in der Sammlung des SFMOMA und der Pilara Foundation.

Lorsqu'il vendit ses premiers tirages à Edward Steichen, alors conservateur du MoMA de New York, Stephen Shore était encore adolescent, et il avait à

peine 16 ans quand il se lia avec Andy Warhol, trouvant ainsi le moyen de décrire de l'intérieur la vie de la Factory. Décidément en avance, il marquera les années 1970 par l'usage novateur et non conformiste qu'il fera de la couleur dans sa représentation des scènes et objets du quotidien. Ses multiples road trips à travers une Amérique saisie dans l'éclat de sa banalité trouveront leur traduction éditoriale en 1982 avec la publication de la série Uncommon Places. Son travail l'amena bien sûr à San Francisco, comme en témoigne sa restitution fascinée de l'ambiance résidentielle de Scott Street en 1973 et d'une Market Street quasi déserte. Il ne négligea pas pour autant le noir et blanc, non plus que les ouvrages imprimés à la demande et Instagram où il tient un compte particulièrement prolifique. Le MoMA lui a consacré une rétrospective complète en 2017 et de nombreuses institutions accueillent aujourd'hui ses œuvres, à commencer par le SFMOMA et la Fondation Pilara.

Shulman, Julius (1910–2009)

Shulman was educated at University of California, Los Angeles and Berkeley, and his career as an architectural photographer started by chance in 1936. An acquaintance, who was a draftsman for the architect Richard Neutra, asked Shulman, a keen amateur photographer, to accompany him to a recently completed project, the Kun residence. Neutra saw Shulman's images and commissioned him to shoot more of his buildings. The two worked together until Neutra's death in 1970. Over the years, Shulman's client list reads like a who's who of modernist architecture: Frank Lloyd Wright, Charles Eames, Raphael S. Soriano, John Lautner, and Eero Saarinen. His editorial clients included Arts & Architecture, Architectural Forum, and many others. TASCHEN has published Julius Shulman: Architecture and Its Photography (1999) and Julius Shulman: Modernism Rediscovered (three volumes, 2007).

Shulman studierte sowohl an der UCLA als auch in Berkeley; seine Karriere als Architekturfotograf verdankte er einem Zufall im Jahr 1936. Ein Bekannter, der als technischer Zeichner für den Architekten Richard Neutra arbeitete, bat Shulman, einen ehrgeizigen Amateurfotografen, ihn zu einem kürzlich fertiggestellten Projekt, der Kun Residence, zu begleiten. Neutra sah die Bilder von Shulman und beauftragte ihn, weitere von ihm entworfene Gebäude zu fotografieren. Die Zusammenarbeit dauerte bis 1970. Im Lauf der Zeit erstand eine Kundenliste, die sich wie das Who's who der modernen Architektur liest: Frank Lloyd Wright, Charles Eames, Raphael S. Soriano, John Lautner und Eero Saarinen. Zu seinen Zeitschriftenkunden gehörten unter anderem Arts & Architecture und Architectural Forum. TASCHEN hat Julius Shulman: Architecture and its Photography (1999) und Julius Shulman, Modernism Rediscovered (3 Bände, 2007) herausgegeben.

Formé à l'Université de Californie, à Los Angeles et à Berkeley, Julius Shulman démarra par le plus grand des hasards sa carrière de photographe d'architecture, en 1936. Il n'était qu'un amateur passionné lorsque l'un de ses camarades, dessinateur pour l'architecte Richard Neutra, lui demanda de l'accompagner sur un projet récemment achevé : la maison de Josef Kun à Los Angeles. Au vu des clichés de Shulman, l'architecte lui demanda de continuer à photographier ses créations. Les deux hommes travailleront ensemble jusqu'à la mort de Neutra en 1970. La liste des clients de Shulman, au fil des ans, se lit comme un Who's Who de l'architecture moderniste : Frank Lloyd Wright, Charles Eames, Raphael S. Soriano, John Lautner, Eero Saarinen. Ses collaborations éditoriales incluront Arts & Architecture, Architectural Forum et bien d'autres. TASCHEN a publié Julius Shulman, Architecture and Its Photography (1999) et Julius Shulman, Modernism Rediscovered (trois volumes, 2007).

Stackpole, Peter (1913–1997)

The son of artists, Stackpole grew up in the company of Dorothea Lange, Edward Weston, and Diego Rivera, and he was included as an honorary member of the Group

f/64 after he showed photographer Willard Van Dyke his photographs of the construction of the San Francisco–Oakland Bay Bridge. Stackpole was one of the first photographers hired by Life magazine; he photographed Hollywood celebrities for the magazine as well as the everyday lives of workers. He was the magazine's chief Hollywood photographer from 1938 to 1951, when he moved to New York to work for Time, Inc.

Als Sohn von Künstlern wuchs Stackpole in der Gesellschaft von Dorothea Lange, Edward Weston und Diego Rivera auf. Er wurde als Ehrenmitglied in die Gruppe f/64 aufgenommen, nachdem er dem Fotografen Willard Van Dyke seine Fotos vom Bau der Brücke zwischen San Francisco und Oakland gezeigt hatte. Stackpole war einer der ersten Fotografen, die von der Zeitschrift Life angeheuert wurden. Er fotografierte für das Magazin Hollywood-Berühmtheiten ebenso wie den Alltag von Arbeitern. Von 1938 bis 1951 war er der leitende Hollywood-Fotograf des Magazins, dann zog er nach New York, um für Time Inc. zu arbeiten.

Élevé par deux parents artistes, Peter Stackpole eut très tôt l'occasion de fréquenter de grands noms comme Dorothea Lange, Edward Weston ou Diego Rivera. Après avoir montré au photographe Willard Van Dyke ses clichés de la construction du Bay Bridge, il rejoignit en 1934 le groupe f/64, à titre de membre honoraire. Il sera aussi l'un des premiers photographes intégrés à la rédaction du magazine Life pour lequel il couvrira avec la même empathie le quotidien des ouvriers et la geste flamboyante des célébrités d'Hollywood, dont il deviendra le grand spécialiste entre 1938 et 1951. Il quitte alors la Californie pour New York et le siège du groupe de presse Time, propriétaire de Life.

Stock, Dennis (1928–2010)

At age 17, Stock joined the U.S. Navy. After the war, he assisted Gjon Mili from 1947 to 1951. In 1951, Stock was one of ten winners in Life magazine's $15,000 Contest for Young Photographers. In 1954, he joined Magnum Photos and in 1955, took his most famous photograph James Dean in Times Square. From 1957 to 1960, Stock shot portraits of famous jazz musicians that culminated in the book Jazz Street (1960). During the 1970s and '80s, he diversified into nature and landscape color photography.

Mit 17 ging Stock zur Navy. Nach dem Krieg, von 1947 bis 1951, arbeitete er als Assistent für Gjon Mili. 1951 war Stock einer von zehn Gewinnern des mit 15 000 Dollar dotierten Wettbewerbs für Nachwuchsfotografen der Zeitschrift Life. 1954 wurde er Mitglied von Magnum Photos und nahm 1955 sein berühmtestes Foto auf: James Dean auf dem Times Square. Von 1957 bis 1960 machte Stock Porträtaufnahmen von berühmten Jazzmusikern, die in dem Buch Jazz Street (1960) veröffentlicht wurden. In den Siebziger- und Achtzigerjahren wandte er sich zusätzlich der Natur- und Landschaftsfotografie in Farbe zu.

Dennis Stock s'engage à 17 ans dans l'US Navy. Après la guerre, il met en pied à Life en devenant l'assistant de Gjon Mili entre 1947 et 1951. Cette année-là il est l'un des dix lauréats d'un concours de jeunes photographes doté de 15 000 dollars et organisé par Life. Puis il commence à travailler pour l'agence Magnum qu'il rejoindra pleinement en 1954. Sa photo la plus célèbre, James Dean à Times Square, New York, date de 1955. Ses portraits des grands du jazz aboutiront en 1960 au livre Jazz Street. Dans les années 1970 et 1980, il s'orientera vers la photographie en couleurs dédiée à la nature et au paysage.

Streshinsky, Ted (1923–2003)

A photojournalist best known for his photographs of the migrant worker strikes and anti-war protests in California in the 1960s and '70s for Time and Life, among other publications, Streshinsky also photographed the counterculture in San Francisco. With Lawrence Schiller, he photographed Ken Kesey and the Merry Pranksters, photographs that were included in a collector's edition of Tom Wolfe's The Electric Kool-Aid Acid Test (TASCHEN). Born in China to Russian

expatriate parents, he moved to the US to finish his education at the University of California, Berkeley. He went on to photograph politicians, the closing of Alcatraz, and the People's Park demonstrations on the Berkeley campus, among many other subjects.

Der Fotojournalist ist vor allem für seine Fotografien der Streiks von Wanderarbeitern und Antikriegsproteste in Kalifornien in den 1960er- und 70er-Jahren bekannt, die er unter anderem für *Time* und *Life* machte. Er fotografierte auch die Gegenkultur in San Francisco. Zusammen mit Lawrence Schiller fotografierte er Ken Kesey und die Merry Pranksters, deren Bilder in einer Sammlerausgabe von Tom Wolfes *The Electric Kool-Aid Acid Test* (TASCHEN) enthalten sind. Er wurde als Sohn russischer Auswanderer in China geboren und zog in die USA, um seine Ausbildung an der University of California, Berkeley zu beenden. Später fotografierte er unter anderem Politiker, die Schließung von Alcatraz und die People's-Park-Demonstrationen auf dem Berkeley-Campus.

Pour *Time* et *Life*, entre autres publications, Ted Streshinsky a couvert les troubles sociaux et politiques des années 1960 et 1970 en Californie, depuis les grèves des travailleurs immigrés jusqu'aux marches pacifistes. Il est également l'un des photographes attitrés de l'âge d'or de la contre-culture à San Francisco. Avec Lawrence Schiller, il a photographié Ken Kesey et les Merry Pranksters pour une édition collector de l'*Acid Test* de Tom Wolfe (*The Electric Kool-Aid Acid Test*, TASCHEN). Né en Chine de parents russes expatriés, il était venu aux États-Unis pour terminer ses études à l'Université de Californie, à Berkeley. Son activité l'a notamment amené à photographier le monde politique américain, la fermeture d'Alcatraz et les différentes manifestations dont People's Park, sur le campus de Berkeley, a été le théâtre.

Taber, Isaiah W. *(1830–1912)*

Born in Massachusetts, Taber worked on whaling ships for several years as a teenager. He became a dentist, but eventually his interest in amateur photography became his life's work. He moved to San Francisco and established a photography studio and became known for his portraits, urban views, and landscapes. Taber is known for his albumen-silver prints of San Francisco, including the Palace Hotel and the residences of then-governor Stanford and others. His entire collection of glass plates and negatives was ultimately destroyed in the 1906 earthquake and fire.

Der in Massachusetts geborene Taber arbeitete als Jugendlicher mehrere Jahre lang auf Walfangschiffen. Er entschied sich zwar, Zahnarzt zu werden, doch wurde die Amateurfotografie zu seiner Lebensaufgabe. Er zog nach San Francisco, gründete ein Fotostudio und wurde für seine Porträts, Stadtansichten und Landschaften bekannt. Insbesondere verbindet man mit seinem Namen aber seine Albumin-Abzüge von San Francisco, darunter das Palace Hotel und die Wohnhäuser des damaligen Gouverneurs Stanford und anderer Personen. Seine gesamte Sammlung von Fotoplatten und Negativen wurde bei dem Erdbeben von 1906 zerstört.

Né dans le Massachusetts, Isaiah Taber travailla pendant plusieurs années sur des baleinières alors qu'il était encore adolescent. Il avait entamé une carrière de dentiste lorsque son intérêt pour la photographie amateur finit par le rattraper et décider de son destin. Il s'installa à San Francisco où il ouvrit un studio et se fit un nom avec les portraits, les scènes urbaines et les paysages dont il réalisait des tirages albuminés. Le Palace Hotel et les résidences du gouverneur de l'époque figurent parmi les nombreux sujets qu'il a fixés sur la pellicule. Toute sa collection de plaques de verre et de négatifs sera détruite lors du tremblement de terre et de l'incendie de 1906.

Talamon, Bruce W. *(1949–)*

Talamon has photographed the music industry for many years, taking pictures of Stevie Wonder, Donna Summer, Marvin Gaye, Diana Ross, and Chaka Khan, among many other music legends. Many of these

were collected in his book *Soul R&B Funk: Photographs 1972–1982* (TASCHEN, 2018). Talamon captured rehearsals, sound checks, and recording sessions, as well as concerts and performances. He was a staff photographer for *SOUL* newspaper in the 1970s, and he was photographing an outdoor music festival on assignment when he met artist David Hammons, whom he went on to photograph extensively. Talamon is also known for his still photographs on film sets and for photographing official movie posters.

Talamon fotografiert seit vielen Jahren die Musikbranche und machte unter anderem Aufnahmen von Stevie Wonder, Donna Summer, Marvin Gaye, Diana Ross und Chaka Khan. Viele davon finden sich in seinem Buch *Soul R&B Funk: Photographs 1972–1982* (TASCHEN, 2018). Talamon hat Proben, Soundchecks und Aufnahmesessions sowie Konzerte und Auftritte fotografiert. In den 1970er-Jahren arbeitete er als Fotograf für die Zeitung *SOUL* und lernte bei einem Auftrag für ein Outdoor-Musikfestival den Künstler David Hammons kennen, den er später ausgiebig fotografierte. Talamon ist auch für seine Aufnahmen an Filmsets und für offizielle Filmplakate bekannt.

La longue carrière de Bruce W. Talamon dans le monde de la musique lui a permis de photographier les plus grandes figures de son époque, parmi lesquelles Stevie Wonder, Donna Summer, Marvin Gaye, Diana Ross ou Chaka Khan. Son ouvrage *Soul R&B Funk: Photographs 1972–1982*, publié chez TASCHEN en 2018, réunit l'essentiel de cette importante facette de son œuvre. Répétitions, balances, enregistrements en studio, concerts et performances en tout genre, rien ne lui échappait. Membre de la rédaction du journal *SOUL* dans les années 1970, il couvrait un festival lorsqu'il rencontra l'un des personnages majeurs du Black Arts Movement, David Hammons, dont il suivra au plus près et en images l'itinéraire artistique. Il rejoindra ensuite l'univers du cinéma en tant, notamment, que photographe de plateau, et verra ses clichés repris par de nombreuses affiches de film.

Tibbitts, H.C. *(1863–1937)*

A San Francisco-based photographer, Tibbitts worked for the Southern Pacific Railroad for 40 years, documenting landscapes, parks, and towns to promote the railroad. Tibbetts made prints from glass-plate negatives, and his images were published in the railroad's magazine, *Sunset*, which attempted to change the "wild west" reputation of California and Nevada.

Der Fotograf Tibbitts, der in San Francisco lebte, arbeitete 40 Jahre lang für Southern Pacific Railroad und dokumentierte Landschaften, Parks und Städte, um für die Eisenbahn zu werben. Tibbitts fertigte Abzüge von Fotoplattennegativen an, die in der Eisenbahnzeitschrift *Sunset* veröffentlicht wurden, die versuchte, die Reputation Kaliforniens und Nevadas als „Wilder Westens" zu ändern.

Basé à San Francisco, Tibbitts a travaillé quarante ans durant pour la Southern Pacific Railroad. Il photographiait paysages, parcs et cités traversés afin de promouvoir le tout jeune chemin de fer. Réalisés à partir de négatifs sur plaque de verre, ses tirages paraissaient dans *Sunset*, le magazine de la compagnie chargé de combattre les stéréotypes associant Californie et Nevada à un Far West hostile et primitif.

Tress, Arthur *(1940–)*

Tress was born in Brooklyn and as a teenager, he began photographing the dilapidated neighborhoods around Coney Island. After studying art and art history at Bard College, he moved to Paris to attend film school but left to travel around Europe, Asia, and Mexico. Tress developed and printed photographs in a communal darkroom in San Francisco's Castro district in the 1960s, and the vintage prints were stored in his sister's home until they were rediscovered in 2009. The rediscovery prompted him to revisit his early negatives, and the result was the exhibition *Arthur Tress: San Francisco 1964* at the de Young Museum in San Francisco in 2012. That

same year, Tress was presented with a Lucie Award for Fine Art Photography.

Tress wurde in Brooklyn geboren und begann schon als Teenager, die heruntergekommenen Viertel um Coney Island zu fotografieren. Nach seinem Studium der Kunst und Kunstgeschichte am Bard College zog er nach Paris, um dort eine Filmschule zu besuchen, die er aber verließ, um Europa, Asien und Mexiko zu bereisen. In den 1960er-Jahren entwickelte und druckte Tress seine Fotografien in einer Gemeinschaftsdunkelkammer im Castro-Viertel von San Francisco. Die alten Abzüge wurden im Haus seiner Schwester aufbewahrt, bis sie 2009 wiederentdeckt wurden. Die Wiederentdeckung veranlasste ihn, seine frühen Negative erneut zu betrachten. Das Ergebnis war die Ausstellung *Arthur Tress San Francisco 1964* im de Young Museum in San Francisco im Jahr 2012. Im selben Jahr wurde Tress mit dem Lucie Award for Fine Art Photography ausgezeichnet.

Né à Brooklyn, Tress commença dès l'adolescence à photographier son environnement, notamment les quartiers déshérités qui entouraient alors Coney Island et ses parcs d'attractions. Après un cursus d'art et d'histoire de l'art au prestigieux Bard College, il s'installa à Paris dans l'intention d'y suivre des études cinématographiques mais repartit voyager à travers l'Europe, en Asie et au Mexique. Au cours de cette décennie 1960, c'est dans une chambre noire communautaire du Castro, à San Francisco, qu'il développait son travail. Les tirages de l'époque sommeillaient chez sa sœur lorsqu'il les retrouva en 2009 et décida de se pencher de plus près sur ses premiers négatifs. Cette redécouverte donnera lieu en 2012 à l'exposition *Arthur Tress San Francisco 1964* au musée De Young. La même année il recevra un Lucie Award pour la dimension artistique de son œuvre.

Warhol, Andy *(1928–1987)*

Andy Warhol was a leading figure in the Pop Art movement and is now regarded as one of modern art's greats. In the 1960s, Warhol began combining advertising and celebrity culture to create artistic works that are now world famous. He employed many artistic media in his work, including photography, screen printing, painting, drawing, film, and music. TASCHEN has collaborated with the Andy Warhol Foundation on four books: *Andy Warhol. Polaroids* (2015), *Andy Warhol. Seven Illusrated Books* (2017), *Warhol on Basquiat* (2019) and *Andy Warhol. Love, Sex and Desire. Drawings 1950–1962* (2020).

Andy Warhol war eine führende Persönlichkeit in der Pop-Art und gilt heute als einer der bedeutendsten Vertreter der Mordernen Kunst. Ab den 1960er-Jahren verband er Werbung und den Kult um Prominente und machte daraus Kunstwerke, die heute weltberühmt sind. Für seine Arbeit nutzte er viele künstlerische Techniken, darunter Fotografie, Druck, Malerei, Zeichnen, Film und Musik. TASCHEN hat mit der Andy Warhol Foundation an vier Büchern gearbeitet: *Andy Warhol. Polaroids* (2015), *Andy Warhol. Seven Illusrated Books* (2017), *Warhol on Basquiat* (2019) und *Andy Warhol. Love, Sex and Desire. Drawings 1950–1962* (2020).

Figure de proue du pop art, Andy Warhol est aujourd'hui considéré comme l'un des papes de l'art contemporain. Les années 1960 l'amèneront à marier pub et culture *people* pour créer des œuvres d'art aujourd'hui mondialement célèbres. Son travail fera appel à toutes sortes de supports artistiques, notamment la photographie, la sérigraphie, la peinture, le dessin, le cinéma et la musique. TASCHEN a collaboré avec la Fondation Andy Warhol pour quatre publications : *Andy Warhol. Polaroids* (2015), *Andy Warhol. Seven Illustrated Books* (2017), *Warhol on Basquiat* (2019) et *Andy Warhol. Love, Sex and Desire. Drawings 1950-1962* (2020).

Watkins, Carleton *(1829–1916)*

Considered one of the greatest photographers of the American West, Watkins made thousands of mammoth glass-plate images of the Yosemite Valley, the Columbia River, the Pacific Coast, as well as many views of San

Francisco, including its streets and the view of Alcatraz across the San Francisco Bay. His photographs of Yosemite helped encourage Congress to establish it as a National Park in 1864. Watkins moved to California from New York as part of the gold rush, but he eventually opened his own photography studio in San Francisco. He was named the official photographer for the California State Geological Survey and opened the Yosemite Art Gallery in San Francisco.

Watkins, der als einer der größten Fotografen des amerikanischen Westens gilt, schuf Tausende von riesigen Fotoplattenaufnahmen des Yosemite Valley, des Columbia River und der Pazifikküste sowie zahlreiche Ansichten von San Francisco, darunter seine Straßen und der Blick auf Alcatraz in der Bucht von San Francisco. Seine Fotografien von Yosemite trugen dazu bei, dass der Kongress das Tal 1864 zum Nationalpark erklärte. Watkins zog während des Goldrausches von New York nach Kalifornien, eröffnete aber schließlich sein eigenes Fotostudio in San Francisco. Er wurde zum offiziellen Fotografen des California State Geological Survey ernannt und eröffnete die Yosemite Art Gallery in San Francisco.

Après avoir quitté New York pour la Californie au moment de la ruée vers l'or, Carleton Watkins s'est installé à San Francisco où il a ouvert son propre studio. Considéré comme l'un des plus grands photographes de l'Ouest américain, il a laissé de la vallée de Yosemite, du fleuve Columbia et de la côte Pacifique des milliers d'images réalisées sur plaque de verre au collodion humide, généralement dans de très grands formats. Il a aussi immortalisé sous presque tous les angles les rues de San Francisco, sans oublier l'île d'Alcatraz. Ses photos de Yosemite ont convaincu le Congrès américain d'en faire une réserve naturelle et un parc national en 1864. Nommé photographe officiel de l'Institut d'études géologiques de Californie, il a ouvert à San Francisco la Yosemite Art Gallery.

Watson, Albert (1942–)
Albert Watson has made his mark as one of the world's most successful fashion and commercial photographers during the last 40 years, while creating his own art along the way. His striking images have appeared on more than a hundred covers of *Vogue* and have been featured in countless other publications, from *Rolling Stone* to *Time*, many of the photographs iconic portraits of celebrities. Watson has also created photography for hundreds of successful ad campaigns, for companies such as Prada, Revlon, and Chanel. All the while, he has spent much of his time working on personal projects, creating stunning images from his travels and interests, from Marrakech to Las Vegas. In 2017, TASCHEN published a definitive monograph of his work, *Kaos*.

Watson ist einer der erfolgreichsten Mode- und Werbefotografen der letzten 40 Jahre und hat dabei seine eigene Handschrift entwickelt. Er hat über 100 Cover für die *Vogue* fotografiert und für zahllose andere Magazine von *Rolling Stone* bis *Time* gearbeitet. Für Firmen wie Prada, Revlon und Chanel hat er erfolgreiche Werbekampagnen realisiert. Parallel dazu hat er eigene Projekte verfolgt und auf seinen Reisen von Marrakesch bis Las Vegas atemberaubend Bilder geschaffen. 2017 veröffentlichte TASCHEN mit dem Band *Kaos* eine maßgebliche Monografie seines Werkes.

Albert Watson a marqué les quarante dernières années en s'imposant comme l'un des plus grands photographes de mode et de publicité au monde, tout en inventant son propre langage artistique. Ses clichés saisissants ont enflammé plus d'une centaine de couvertures du magazine *Vogue* et les pages d'innombrables publications, de *Rolling Stone* à *Time* ; dans la plupart des cas, il s'agissait de portraits de célébrités devenus emblématiques. Il a également contribué à des centaines de campagnes publicitaires à succès pour des marques telles que Prada, Revlon ou Chanel. Il n'en a pas moins consacré une grande partie de son temps à des projets personnels, ainsi la création d'images étonnantes à partir de ses voyages et de ses centres d'intérêt,

de Marrakech à Las Vegas. En 2017, TASCHEN a publié une monographie de son œuvre qui fait autorité, *Kaos*.

Weston, Edward (1886–1946)
One of the most influential American photographers, Weston was born in Highland Park, Illinois. He moved to California in 1906 and soon began working as an itinerant photographer. After working for other photography studios, he opened his own portrait studio in Tropico, California, and he began keeping journals that became known as his "Daybooks," chronicling his life and photographic development. He moved to Mexico City for a time, opening a photography studio with photographer Tina Modotti, but when he moved back to California, he began making the photographs for which he is best known – nudes, still lives, and landscapes, including sculptural close ups of peppers, shells, and rocks, among other natural forms. Along with Ansel Adams and Imogen Cunningham, he was a founding member of Group f/64, the Bay Area group that promoted the aesthetic of "straight photography."

Weston, einer der einflussreichsten Fotografen Amerikas, wurde in Highland Park, Illinois, geboren. Im Jahr 1906 zog er nach Kalifornien und begann bald als reisender Fotograf zu arbeiten. Nachdem er für andere Fotografen gearbeitet hatte, eröffnete er sein eigenes Porträtstudio in Tropico, Kalifornien, und begann, Tagebücher zu führen, die als „Daybooks" bekannt wurden und sein Leben und seine fotografische Entwicklung dokumentierten. Er zog für einige Zeit nach Mexiko-Stadt und eröffnete dort ein Studio mit der Fotografin Tina Modotti. Als er jedoch nach Kalifornien zurückkehrte, begann er mit den Fotografien, für die er am bekanntesten ist – Akte, Stillleben und Landschaften, darunter skulpturale Nahaufnahmen von Paprika, Muscheln und Felsen und anderen natürlichen Formen. Zusammen mit Ansel Adams und Imogen Cunningham gehörte er zu den Gründungsmitgliedern der Gruppe f/64, die in der San Francisco Bay Area die Ästhetik der „Straight Photography" propagierte.

Né à Highland Park, dans l'Illinois, Edward Weston a été l'un des photographes américains les plus influents. Installé en Californie en 1906 après que le Chicago Art Institute a déjà exposé ses clichés d'artiste précoce, il entame une carrière de photographe itinérant. Il travaille pour divers studios avant d'ouvrir le sien à Tropico, spécialisé dans le portrait. En même temps, il tient ses « Daybooks », un journal dans lequel il relatera sa vie et son évolution photographique. Parti quelque temps à Mexico lancer un studio avec la photographe Tina Modotti, il attendra de revenir en Californie pour se tourner vers les sujets qui lui permettront d'exprimer l'extraordinaire réalisme sensuel aujourd'hui attaché à son nom : nus intenses, paysages spectaculaires, natures mortes – poivrons, coquillages, rochers saisis en gros plan dans leur quintessence littéralement sculpturale. Aux côtés d'Ansel Adams et d'Imogen Cunningham, il fut l'un des fondateurs du groupe f/64, le collectif de San Francisco qui défendait une esthétique de la « photographie pure ».

White, Minor (1908–1976)
Known for his meticulous and beautifully printed black-and-white photographs, White co-founded the influential photography magazine *Aperture* in 1952, along with Ansel Adams, Dorothea Lange, Barbara Morgan, and Nancy and Beaumont Newhall, and edited it until 1975. He began his career with the Oregon Camera Club in Portland, taking assignments for the Works Progress Administration. White was influenced by Alfred Stieglitz, Ansel Adams, and Edward Weston, particularly by Stieglitz's notion of "equivalents." His interest in Zen philosophy and mysticism also shaped his images. He moved to San Francisco in 1946 and set out to photograph every part of the city, a project that grew to some 6,000 images, including photographs of an increasingly diverse population and an increasingly modernized city. An influential teacher, he founded the first fine-art photography department at the California School of Fine Arts in San Francisco.

Bekannt für seine sorgfältig und wunderschön gearbeiteten Schwarz-Weiß-Abzüge, gründete White 1952 zusammen mit Ansel Adams, Dorothea Lange, Barbara Morgan und Nancy und Beaumont Newhall die einflussreiche Fotozeitschrift *Aperture*, deren Herausgeber er bis 1975 war. Er begann seine Karriere beim Oregon Camera Club in Portland und nahm Aufträge für die Works Progress Administration an. White wurde von Alfred Stieglitz, Ansel Adams und Edward Weston beeinflusst, insbesondere von Stieglitz' Konzept der „Equivalents". Auch sein Interesse an Zen-Philosophie und Mystik prägte seine Bilder. 1946 zog er nach San Francisco und begann, jeden Teil der Stadt zu fotografieren – ein Projekt, das auf etwa 6 000 Bilder anwuchs, darunter Aufnahmen einer immer diverseren Bevölkerung und einer zunehmend modernisierten Stadt. Als einflussreicher Lehrer gründete er das landesweit erste Institut für Kunstfotografie an der California School of Fine Arts in San Francisco.

Célébré pour l'attachement minutieux au détail qui distingue ses clichés en noir et blanc et leur magnifique restitution physique, White fut avec Nancy et Beaumont Newhall, Ansel Adams, Dorothea Lange et Barbara Morgan l'un des fondateurs en 1952 d'*Aperture*, le magazine photo de référence qu'il dirigea jusqu'en 1975. Il avait débuté à Portland, à l'Oregon Camera Club puis au sein de la Works Progress Administration en tant que responsable des services photographiques. Adams et Edward Weston compteront parmi ses maîtres, ainsi qu'Alfred Stieglitz dont il contribuera à diffuser le concept d'« équivalence ». Nourri de philosophie zen et de mysticisme, son itinéraire créatif l'amènera à s'installer à San Francisco en 1946 où il se lancera dans une vaste entreprise : fixer sur sa pellicule la totalité des quartiers de la ville. Le projet donnera lieu à quelque 6 000 images qui dépeignent une diversité humaine toujours plus affirmée et une incessante modernisation urbaine. Enseignant influent, il a mis en place le premier département de photographie artistique à la California School of Fine Art à San Francisco.

Wiener, Leigh (1929–1993)
Wiener grew up in New York; his father was a newspaper reporter and Weegee was a family friend who first taught Wiener to look at pictures. A staff photographer for the *LA Times*, he went on to create the Emmy Award–winning television show *Talk about Pictures* for Channel 4 in Los Angeles. Wiener photographed U.S. presidents as well as actors, writers, and musicians, among them Johnny Cash, whom he photographed many times, and Miles Davis, whom he photographed at the Black Hawk club in San Francisco. On assignment for *Life*, he photographed the closing day of Alcatraz federal prison in 1963.

Wiener wuchs in New York auf; sein Vater war Zeitungsreporter, und ein Freund der Familie, Weegee, brachte Wiener das Betrachten von Bildern bei. Er arbeitete als angestellter Fotograf für die *LA Times* und schuf später die mit dem Emmy Award ausgezeichnete Fernsehsendung *Talk about Pictures* für Channel 4 in Los Angeles. Wiener fotografierte US-Präsidenten ebenso wie Schauspieler, Schriftsteller und Musiker, darunter Johnny Cash, den er mehrfach fotografierte, und Miles Davis, den er im Black Hawk Club in San Francisco ablichtete. Im Auftrag von *LIFE* fotografierte er 1963 den Tag der Schließung des Bundesgefängnisses Alcatraz.

Leigh Wiener a grandi à New York. Fils d'un journaliste, il a appris comment regarder et décrypter les images grâce à un ami de la famille, le photographe Weegee. Lui-même devenu photographe au *Los Angeles Times*, Wiener créera sur Channel 4 « Talk about Pictures », une émission dédiée que récompensera un Emmy Award. Devant son objectif se succéderont des présidents américains, des acteurs, des écrivains, des chanteurs comme Johnny Cash et de grands musiciens, à l'exemple de Miles Davis au Black Hawk de San Francisco. Envoyé spécial de *Life*, il était présent le jour de la fermeture du pénitencier fédéral d'Alcatraz, en 1963.

Wilkes, Stephen (1957–)

Born in New York City and based in Westport, CT, Wilkes is best known for his *Day to Night* series of photographs (published by TASCHEN in 2019), in which he digitally stitches together more than 1,000 photographs taken from a fixed position over the course of an entire day, so that the passage of a day appears to be captured in one photograph. His subjects have included Ipanema Beach in Rio de Janeiro, the Tour de France in Paris, and a view of the America's Cup race that captures the sailboats as well as the skyline of San Francisco.

Der in New York City geborene und in Westport, Connecticut, lebende Wilkes ist vor allem für seine Fotoserie *Day to Night* bekannt (die 2019 bei TASCHEN erschien), in der er mehr als 1.000 Fotos, die er im Laufe eines ganzen Tages von einem festen Standort aus aufgenommen hat, digital zusammenfügt, sodass der Verlauf eines Tages in einem einzigen Foto festgehalten zu sein scheint. Zu seinen Motiven gehören der Strand von Ipanema in Rio de Janeiro, die Tour de France in Paris und ein Blick auf die Segelregatta America's Cup, der die Segelboote und die Skyline von San Francisco einfängt.

Né à New York et basé à Westport, dans le Connecticut, Stephen Wilkes a réalisé une célèbre série intitulée *Day to Night*, publiée par TASCHEN en 2019: assemblant par le jeu du numérique plus de 1 000 photographies prises au même endroit sur une journée entière, elle restitue le passage des heures en une image unique et saisissante. Il a ainsi photographié la plage d'Ipanema à Rio de Janeiro, l'étape parisienne du Tour de France cycliste et la Coupe de l'America 2013 en baie de San Francisco, entre autres sujets.

Willoughby, Bob (1927–2009)

Known as a chronicler of Hollywood, Willoughby took photographs of actors and celebrities on film sets for *Life* and *Look*, among other magazines, as well as portraits of jazz musicians like Dave Brubeck, Chet Baker, and Gerry Mulligan in San Francisco's jazz clubs. His photograph of Judy Garland on the set of *A Star Is Born* became his first *Life* cover. His spontaneous, documentary style was a break from the tradition of the Hollywood glamour shot. He photographed Audrey Hepburn on the set of *Roman Holiday* and went on to make many more images of the actress over the years, captured in the book *Audrey Hepburn: Photographs, 1953–1966* (TASCHEN).

Bekannt als ein Chronist Hollywoods, machte Willoughby unter anderem für *Life* und *Look* Fotos von Schauspielern und Berühmtheiten an Filmsets sowie Porträts von Jazzmusikern wie Dave Brubeck, Chet Baker und Gerry Mulligan in den Jazzclubs von San Francisco. Sein Foto von Judy Garland am Set von *Ein neuer Stern am Himmel* wurde sein erstes *Life*-Titelbild. Sein spontaner, dokumentarischer Stil brach mit der Tradition glamouröser Hollywood-Aufnahmen. Er fotografierte Audrey Hepburn am Set von *Ein Herz und eine Krone* und machte im Laufe der Jahre viele weitere Bilder der Schauspielerin, die in dem Buch *Audrey Hepburn: Photographs, 1953–1966* (TASCHEN) zu sehen sind.

Chroniqueur de certaines des grandes heures d'Hollywood, Bob Willoughby a photographié acteurs et célébrités en plein travail pour *Life* et *Look*, entre autres magazines. Il a également signé dans les clubs de San Francisco des portraits de jazzmen tels que Dave Brubeck, Chet Baker et Gerry Mulligan, pour ne citer qu'eux. Sa photo de Judy Garland sur le tournage d'*Une étoile est née* lui a valu sa première couverture pour *Life*. Après avoir photographié Audrey Hepburn sur le tournage de *Vacances romaines*, il la suivra dans quantité d'autres situations qui donnera lieu au livre *Audrey Hepburn: Photographs, 1953–1966* (TASCHEN). Son style spontané et documentaire rompait avec la tradition plus glamour du traitement habituel d'Hollywood.

Winogrand, Garry (1928–1984)

Winogrand first caught the photography bug in 1948, when a fellow student at Columbia showed him the university paper's darkroom. He studied photojournalism at the New School for Social Research, under the celebrated art director Alexey Brodovitch in 1951, and was further influenced by Walker Evans, Robert Frank, and Henri Cartier-Bresson. In 1963, Winogrand's work was shown at New York's Museum of Modern Art in a group show. Throughout the 1960s and '70s, he shot editorial assignments for publications including *Life* and *Sports Illustrated*. In 1969, his book *The Animals* documented wildlife and marine life at the Bronx Zoo and the Coney Island aquarium, while his book *Women Are Beautiful* (1975) featured candid street shots of anonymous women. When he died, he left 2,500 rolls of undeveloped film and hundreds of thousands of unedited images.

Winogrand wurde 1948 vom Fotovirus infiziert, als ihm ein Kommilitone von der Columbia University die Dunkelkammer der Unizeitung zeigte. Er studierte 1951 Fotojournalismus an der New School for Social Research bei Alexey Brodovitch und wurde von Walker Evans, Robert Frank und Henri Cartier-Bresson beeinflusst. 1963 wurden seine Arbeiten im Museum of Modern Art in einer Gruppenausstellung gezeigt. In den 1960er- und 70er-Jahren machte er Pressefotos unter anderem für *LIFE* und *Sports Illustrated*. 1969 erschien sein Buch *The Animals* mit Fotos aus dem Zoo in der Bronx und dem Aquarium in Coney Island; das Buch *Women Are Beautiful* (1975) enthielt spontane Aufnahmen von anonymen Frauen auf der Straße. Als er starb, hinterließ er 2 500 noch nicht entwickelte Filme und Hunderttausende noch nicht gesichtete Fotos.

Garry Winogrand sera saisi par le virus de la photo en 1948 lorsqu'un condisciple de Columbia l'introduira dans la chambre noire du journal de l'université. Il étudiera le photojournalisme à la New School for Social Research sous la direction du célèbre directeur artistique Alexey Brodovitch en 1951 et s'ouvrira notamment à l'influence de Walker Evans, Robert Frank et Henri Cartier-Bresson. En 1963, son travail sera présenté au MoMA dans le cadre d'une exposition collective. Au fil des années 1960 et 1970, il réalisera des reportages pour des publications telles que *Life* et *Sports Illustrated*. En 1969, son livre *The Animals* restituera la vie sauvage et marine du zoo du Bronx et de l'aquarium de Coney Island, tandis que l'ouvrage *Women Are Beautiful* (1975) célébrera des femmes anonymes croisées dans la rue. Il laissera à sa mort 2 500 pellicules jamais développées et des centaines de milliers d'images inédites.

Wolman, Baron (1937–2020)

Wolman was the first director of photography for *Rolling Stone* magazine from 1967 to 1970, starting work for the music magazine from its first issue. He agreed to work for free in exchange for ownership of the copyright on photographs he took. During his three years with the magazine, he photographed Janis Joplin, Bob Dylan, The Rolling Stones, the Grateful Dead, Pink Floyd, Iggy Pop, and many other famous artists. After leaving *Rolling Stone*, Wolman went on to found *Rags*, a counterculture fashion magazine that ran for 13 issues in 1970–71. After the fall of *Rags*, Wolman learned to fly a Cessna and authored two photographic books, *California from the Air: the Golden Coast* (1981) and *The Holy Land: Israel from the Air* (1987).

Wolman war von der ersten Nummer im Jahr 1967 bis 1970 Bildredakteur des *Rolling Stone*. Wolman arbeitete unentgeltlich für das Musikmagazin, behielt jedoch die Urheberrechte an seinen gesamten Fotos. Während seiner drei Jahre bei der Zeitschrift fotografierte er Janis Joplin, Bob Dylan, die Rolling Stones, The Grateful Dead, Pink Floyd, Iggy Pop und viele mehr. Nach seiner Zeit beim *Rolling Stone* gründete er das Gegenkultur-Modemagazin *Rags*, das es 1970 bis 1971 auf 13 Ausgaben brachte. Nach dem Aus für *Rags* machte er den Pilotenschein und veröffentlichte die Bücher *California from the Air: the Golden Coast* (1981) und *The Holy Land: Israel from the Air* (1987).

Baron Wolman a été de 1967 à 1970 le premier directeur de la photographie de *Rolling Stone*, le magazine musical dont il accompagna la naissance. Il acceptait de travailler gratuitement à condition de conserver la maîtrise du copyright de ses images. Au cours de ces trois années fondatrices, il photographia Janis Joplin, Bob Dylan, les Rolling Stones, Grateful Dead, Pink Floyd, Iggy Pop, parmi beaucoup d'autres célébrités du rock. Après avoir quitté *Rolling Stone*, il fondera *Rags*, un magazine de mode ancré dans la contre-culture, dont paraîtront treize numéros en 1970-71. Une fois *Rags* fermé, Wolman apprendra à piloter un Cessna qui lui permettra de signer deux ouvrages photographiques « vus du ciel », *California from the Air: the Golden Coast* (1981) et *The Holy Land: Israel from the Air* (1987).

Wright, Gene (1916–2004)

Born in Ogden, UT, Wright moved to San Francisco in 1949 and worked as a photographer for the Southern Pacific Railroad. He eventually opened his own studio and specialized in photographs of the city, including some taken with a 140-degree panoramic camera, images that captured its character, like the curved cable car tracks or a panoramic view of the city, the Golden Gate Bridge, or the Legion of Honor.

Geboren in Ogden, Utah, zog Wright 1949 nach San Francisco und arbeitete als Fotograf für Southern Pacific Railroad. Schließlich eröffnete er sein eigenes Studio und spezialisierte sich auf Fotografien der Stadt, darunter einige, die mit einer 140-Grad-Panoramakamera aufgenommen wurden. Diese Bilder, wie von den sich wölbenden Cable-Car-Schienen oder ein Panoramablick auf die Stadt, die Golden Gate Bridge oder das Kunstmuseum Legion of Honor, fingen den Charakter der Stadt ein.

Né à Ogden, dans l'Utah, Gene Wright s'est installé à San Francisco en 1949 où il a été employé par la Southern Pacific Railroad à titre de photographe. Il finira par ouvrir son propre studio et se spécialiser dans les photos urbaines pour lesquelles il lui arrivera d'utiliser un appareil permettant de réaliser des images à 140°. Un excellent moyen de saisir la dimension exceptionnelle de la ville, à travers les rails courbes des *cable cars* ou les vues panoramiques les plus variées, du Golden Gate Bridge au musée Legion of Honor.

Wulzen, D.H. (1862–1946)

A San Francisco pharmacist and photographer, Wulzen made views of San Francisco before and after the 1906 earthquake and fire. Wulzen had built a pharmacy in the city's Castro neighborhood and added a Kodak Agency to his drugstore when he became interested in photography. He joined the California Camera Club and photographed in Yosemite, but he also made many photographs in San Francisco's Chinatown and elsewhere in the city.

Wulzen war Apotheker und Fotograf in San Francisco und fertigte Ansichten von der Stadt vor und nach dem Erdbeben und dem Brand von 1906 an. Wulzen hatte eine Apotheke im Castro-Viertel der Stadt, die er um eine Kodak-Agentur erweiterte, als er sich für Fotografie zu interessieren begann. Er trat dem California Camera Club bei und fotografierte in Yosemite, aber er machte auch viele Aufnahmen in San Franciscos Chinatown und anderen Teilen der Stadt.

Wulzen avait bâti une pharmacie dans le quartier du Castro et ajouté une agence Kodak à son commerce lorsqu'il s'est intéressé à la photographie. C'est coiffé de cette double casquette qu'il a réalisé de précieuses vues de San Francisco avant et après le séisme et l'incendie de 1906. Membre du California Camera Club, il a photographié la vallée de Yosemite et consacré de nombreux clichés à la ville elle-même et notamment à son quartier chinois.

Yavno, Max (1911–1985)

Yavno was a social documentary photographer known for his street photographs of Los Angeles, New York, and San Francisco. He photographed for the Works Progress Administration and served as the president, in the 1930s, of the Photo League, where he met Aaron Siskind, who became a lifelong friend. Yavno was a social worker during the early 1930s, and that period seems to have influenced the humanistic sensibility

of his photographs. After serving in the U.S. Army Air Force as a film and photography instructor during World War II, he relocated to San Francisco and began photographing for *Vogue* and *Harper's Bazaar*. Yavno later published *The San Francisco Book* (1948) and *The Los Angeles Book* (1950), chronicling the urban landscape of those cities and the lives of their residents.

Yavno war ein sozialkritischer Dokumentarfotograf, der für seine Straßenfotografien von Los Angeles, New York und San Francisco bekannt ist. Er fotografierte für die Works Progress Administration und war in den 1930er-Jahren Präsident der Photo League, wo er Aaron Siskind kennenlernte, mit dem ihn eine lebenslange Freundschaft verband. Yavno war in den frühen 30ern als Sozialarbeiter tätig, eine Zeit, die das humanistische Bewusstsein seiner Fotografien beeinflusst zu haben scheint. Nachdem er während des Zweiten Weltkriegs in der U.S. Army Air Force als Ausbilder für Film und Fotografie gedient hatte, zog er nach San Francisco und begann für *Vogue* und *Harper's Bazaar* zu fotografieren. Später veröffentlichte Yavno *The San Francisco Book* (1948) und *The Los Angeles Book* (1950), in denen er die urbane Landschaft dieser Städte und das Leben ihrer Bewohner dokumentierte.

Les scènes de rue que Max Yavno a signées à Los Angeles, New York et San Francisco ont forgé la renommée de ce fils d'immigrés russes dont l'expérience de travailleur social, au début des années 1930, déteindra sur son œuvre documentaire, empreinte d'humanisme. D'abord missionné par la Works Progress Administration, il assura de 1938 à 1939 la présidence de la Photo League, un collectif de photographes à vocation sociale ; il y rencontra Aaron Siskind qui restera à jamais son ami. Au cours de la Seconde Guerre mondiale il servit dans l'US Air Force en tant qu'instructeur spécialisé, avant de s'installer à San Francisco et d'entamer une collaboration avec *Vogue* et *Harper's Bazaar*. Il peindra dans *The San Francisco Book* (1948) et *The Los Angeles Book* (1950) le paysage urbain de ces deux villes et le quotidien de leurs habitants.

Zownir, Miron (1953–)

Zownir began taking photographs in the 1970s in West Berlin and London and moved to the US in 1980. He is known for his moody, grainy black-and-white photographs of urban subcultures, including his photographs of New York City's piers and gritty Los Angeles and San Francisco neighborhoods. In some of his photographs, he focused on the mistreatment of Native Americans, including a somber portrait of a Native American man wearing a feathered headdress and smoking a cigarette. He is represented by the gallerist Bene Taschen.

Zownir begann in den 1970er-Jahren in West-Berlin und London zu fotografieren und zog 1980 in die Vereinigten Staaten. Er ist bekannt für seine stimmungsvollen körnigen Schwarz-Weiß-Fotografien urbaner Subkulturen, darunter seine Aufnahmen der Piers von New York City und zwielichtiger Viertel in Los Angeles und San Francisco. In einigen seiner Fotografien konzentrierte er sich auf die Misshandlung der indigenen Bevölkerung, darunter ein düsteres Porträt eines indigenen Mannes, der einen gefiederten Kopfschmuck trägt und eine Zigarette raucht. Er wird von dem Galeristen Bene Taschen vertreten.

Miron Zownir a commencé à prendre des photos dans les années 1970 à Berlin-Ouest puis à Londres avant de s'installer aux États-Unis en 1980. La façon dont il a peint les sous-cultures urbaines, notamment dans la zone portuaire désaffectée de New York et les quartiers les plus durs de Los Angeles ou de San Francisco, atteste une forme de radicalité qui lui est souvent associée et que vient souligner l'usage d'un noir et blanc granuleux, souvent lugubre. Il s'est également intéressé aux mauvais traitements infligés aux Amérindiens, à travers par exemple le portrait en clair-obscur de l'un d'eux, coiffé de plumes, une cigarette entre index et majeur. Il est représenté par le galeriste Bene Taschen.

p. 452/453
Anonymous

A cab cruises the heart of downtown near Montgomery and Market Streets, c. 1950s.

Ein Taxi im Herzen von Dowtown, nah an Montgomery und Market Street, 1950er-Jahre.

Un taxi circule au cœur du centre-ville, à proximité de Montgomery Street et de Market Street. Vers les années 1950.

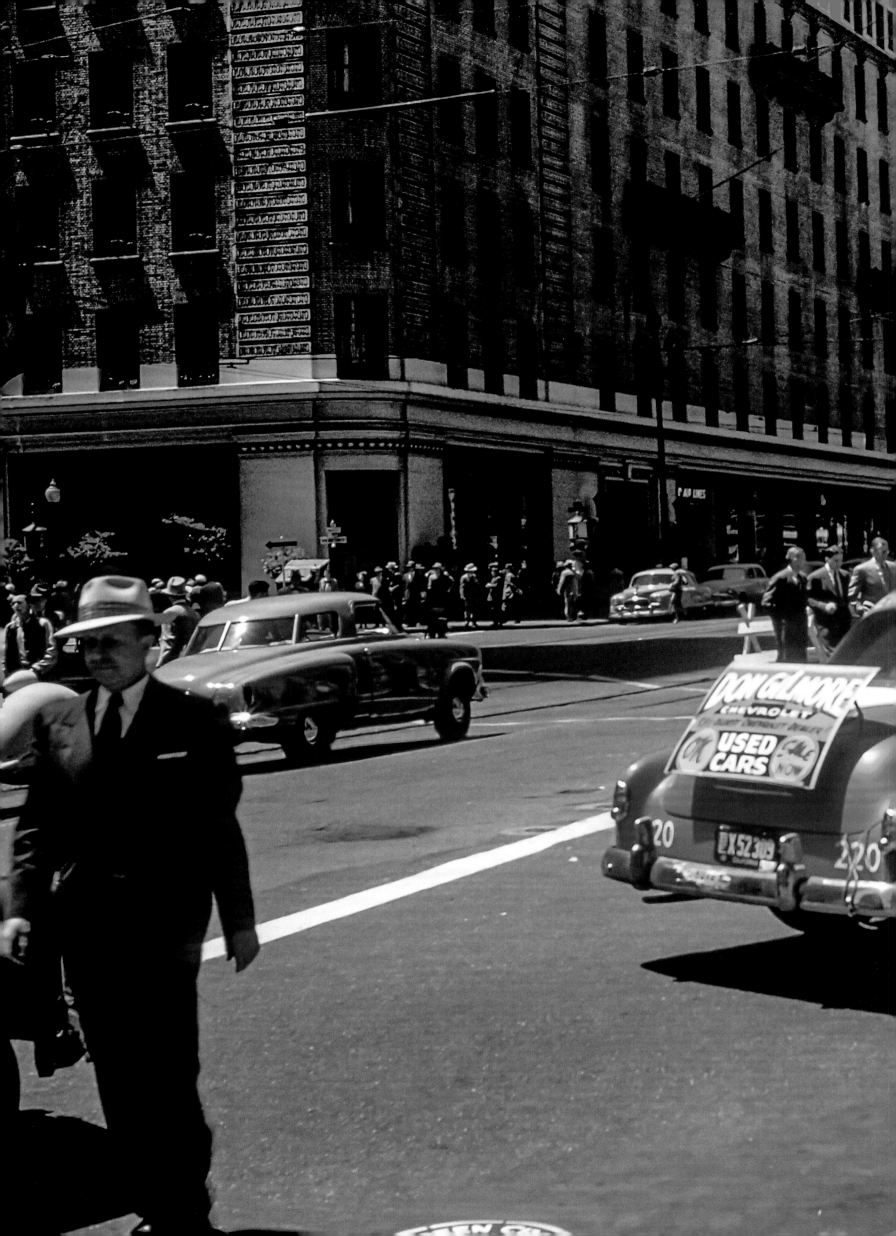

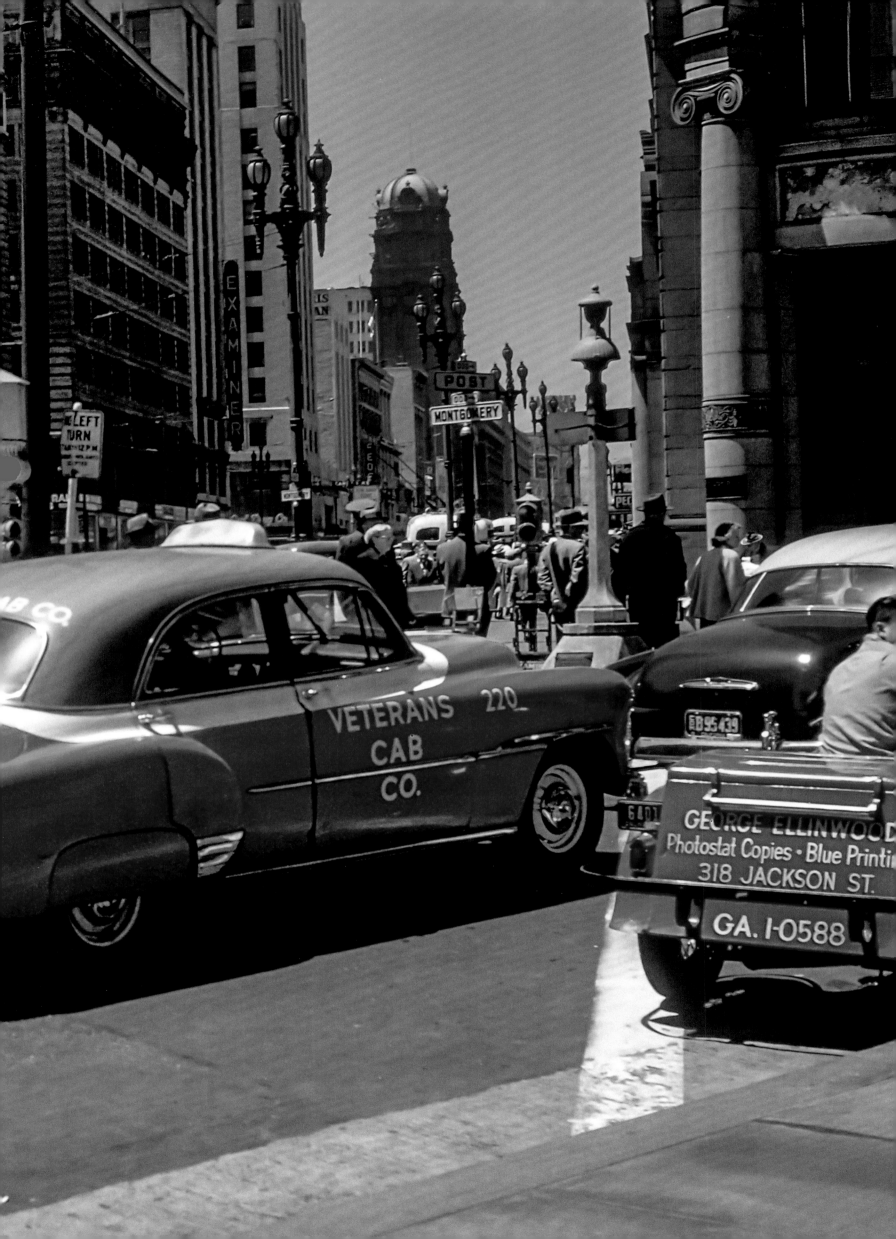

a novel
by Jack Kerouac

ON THE ROAD

Recommended Reading
Literaturempfehlungen
Les livres à lire

Two Years Before the Mast Richard Henry Dana (1840)

Dana's account of his two-year stint as a sailor in the mid-1830s includes a stop in a nearly unpopulated San Francisco, whose woods and shores he depicts in detail; his postscript from an 1859 visit in a subsequent edition remarks on the almost unrecognizably bustling city it became just a quarter of a century later.

Danas Bericht über seine zwei Jahre als Seemann Mitte der 1830er enthält auch einen Halt im fast unbewohnten San Francisco, dessen Wälder und Küste er detailliert beschreibt. Sein Postscript von einem Besuch im Jahr 1859 in späteren Auflagen bezeugt, dass die mittlerweile geschäftige Stadt nur ein Vierteljahrhundert später kaum wiederzuerkennen war.

Le narrateur relate son séjour de deux ans à bord d'un cap-hornier, entre 1834 et 1836, et son escale à San Francisco alors quasiment inhabitée, dont il décrit en détail forêts et rivages. Une nouvelle visite en 1859 lui inspirera un post-scriptum constatant l'effervescence d'une ville devenue presque méconnaissable en à peine un quart de siècle.

The Annals of San Francisco Frank Soulé, John H. Gibon, and James Nisbet (1855)

This meticulous 800-page log of San Francisco's social and political origins, especially from the mid-1840s to the mid-1850s, was written as it unfolded, if tainted by unflattering depictions of some ethnic groups.

Dieses 800 Seiten lange, akribische Protokoll über die politischen und sozialen Ursprünge San Franciscos, besonders in den 1840ern und 1850ern, wurde ohne zeitlichen Abstand geschrieben und ist geprägt von zeitgenössischem Rassismus.

Huit cents pages consacrées à la progressive édification sociale et politique de San Francisco, à partir du milieu des années 1840 et sur les dix ans suivants. Ce méticuleux journal écrit au fil des jours contient des descriptions peu flatteuses de certains groupes ethniques.

Roughing It Mark Twain (1872)

A rambling autobiographical account, likely dressed up with fanciful tale-telling, describes Twain's travels as a young man from Missouri to Nevada, San Francisco, and Hawaii, with plenty of misadventures along his way to establishing himself as a journalist.

Twains Reisen als junger Mann und Journalist von Missouri nach Nevada, San Francisco und Hawaii sind in dieser ausufernden Autobiografie festgehalten und vermutlich mit der einen oder anderen erfundenen Geschichte ausgeschmückt. Auf seinem Weg zum etablierten Journalisten geschehen ihm auch einige Missgeschicke.

Ce récit quasi autobiographique et décousu, probablement pimenté de quelques affabulations, raconte les voyages du jeune Twain de son Missouri natal jusqu'au Nevada, à San Francisco et à Hawaii, et les péripéties multiples qui jalonneront ses débuts vers une première carrière journalistique.

Picturesque California and the Region West of the Rocky Mountains John Muir (ed.) (1888)

These two dozen or so essays with early impressions of the American West include a sizable chapter on San Francisco by Joaquin Miller with a nearly starstruck description of its beauty and cosmopolitan sophistication, as well as sections on the East Bay and Marin County.

Die zwei Dutzend Essays über frühe Eindrücke vom amerikanischen Westen beinhalten auch ein längeres Kapitel über San Francisco von Joaquin Miller, der

von Schönheit und kosmopolitischer Atmosphäre der Stadt sowie Teile der East Bay und Marin County geradezu überwältigt ist.

Ce recueil d'articles illustrés qu'édita le célèbre naturaliste John Muir se présente comme une découverte impressionniste de l'Ouest américain. L'important chapitre consacré à San Francisco permet à Joaquin Miller de livrer une description presque émerveillée de sa beauté et de sa sophistication cosmopolite, ainsi qu'une évocation de l'East Bay et du comté de Marin.

McTeague Frank Norris (1899)

Best friends turn into worst enemies in a battle for the same woman and her lottery prize in this naturalist novel, much of the action taking place in the rough 'n' tumble Polk Street neighborhood of the 1890s; it was adapted into the silent film classic Greed a quarter-century later.

In diesem naturalistischen Roman werden zwei beste Freunde im Kampf um eine Frau und deren Lotteriegewinn zu erbitterten Feinden. Ein Großteil der Handlung spielt im eher härteren Viertel um die Polk Street. Das Buch kam ein Vierteljahrhundert später als Stummfilmklassiker Greed ins Kino.

Deux meilleurs amis devenus ennemis jurés pour l'amour d'une femme et de l'argent qu'elle a gagné à la loterie : l'intrigue de ce roman naturaliste, qui sera adapté au cinéma vingt-cinq ans plus tard par Erich von Stroheim, se déroule en grande partie dans le voisinage rude et agité de Polk Street, à la toute fin du xixᵉ siècle.

The Sea-Wolf Jack London (1904)

A gentleman of leisure gets rescued by a sealing schooner after nearly drowning in the Golden Gate, only to get roped into forced menial seamanship by (and battles of philosophical wits with) the vessel's captain, Sea Wolf, modeled on an actual sealing captain London met in an Oakland saloon.

Ein Müßiggänger wird nach dem Untergang eines Schiffes am Golden Gate von einem Schoner auf Robbenfang gerettet und vom Kapitän zur Arbeit als Seemann (sowie zum philosophischen Kräftemessen) gezwungen. Der Roman basiert auf dem echten Kapitän eines Robbenfängers, den London in einem Saloon in Oakland kennenlernte.

Après le naufrage de son ferry dans la baie de San Francisco, un distingué critique littéraire échappe à la noyade grâce à une goélette de chasse au phoque. Son capitaine, le brutal Loup des mers – inspiré d'un personnage réel que London rencontra dans un bar d'Oakland – lui imposera en retour les tâches les plus ingrates, ponctuées de joutes philosophiques.

San Francisco Through Earthquake and Fire Charles Keeler (1906)

This 50-page account of the 1906 earthquake and the days and weeks that followed has vivid descriptions of the fires, collapsed buildings, and displaced, disoriented residents, mixing in some firsthand experiences of the author as he tried to dispense aid, with striking vintage photos of the crumbling city.

Ein 50-seitiger Bericht über das Erdbeben von 1906 und die darauf folgenden Tage und Wochen. Enthalten sind nicht nur Erfahrungsberichte über die Feuer, einstürzende Gebäude, obdach- und orientierungslose Menschen sowie die Versuche des Autors, zu helfen, sondern auch Fotografien der zerstörten Stadt.

Ces 50 pages consacrées au séisme de 1906 ainsi qu'aux jours et semaines qui suivirent composent un tableau particulièrement vif des incendies, des

effondrements de bâtiments et de l'errance des habitants déplacés. L'auteur, qui fit son possible pour aider, livre ici un témoignage de première main qu'étayent de saisissantes photographies de la ville en ruine.

The Devil's Dictionary Ambrose Bierce (1911)

This mischievous mock-dictionary by one of San Francisco's first major literary figures dispenses a wealth of pithy definitions with acerbic wit and humor that can still bite more than a century later, despite some exasperatingly winding prose.

Bierce, einer der ersten großen Schriftsteller der Stadt, erfindet in seinem vermeintlichen Lexikon prägnante Definitionen mit beißendem Witz, der auch über 100 Jahre später noch Eindruck hinterlässt, trotz der etwas ausufernden Prosa.

Ce similidictionnaire concocté par l'une des premières grandes figures littéraires de San Francisco prodigue avec une fielleuse malice pléthore de définitions lapidaires que le temps n'a pas émoussées, même s'il arrive à la prose de l'auteur de suivre d'horripilants méandres.

The Maltese Falcon Dashiell Hammett (1930)

Hammett lived in San Francisco and worked there for the Pinkerton Detective Agency before penning this legendary novel, which follows macho sleuth Sam Spade around the city as he trails the chase for a coveted statuette and sidesteps getting framed for the murder of his business partner.

Hammet lebte in San Francisco und arbeitet für die Detektivfirma Pinkerton, bevor er diesen legendären Roman schrieb, der dem Macho-Detektiv Sam Spade durch die Stadt folgt, während er nach einer begehrten Statue forscht und zugleich versucht, sich den Mord an seinem Geschäftspartner nicht anhängen zu lassen.

Hammett vécut à San Francisco et y joua les détectives pour l'agence Pinkerton avant d'écrire ce roman légendaire. Un limier quelque peu phallocrate du nom de Sam Spade sillonne la ville afin de retrouver une statuette disparue et d'éviter au passage de se retrouver accusé du meurtre de son associé.

The Barbary Coast Herbert Asbury (1933)

An elaborate, if somewhat long-winded and sensationalistic, look at the seamier side of the city in its first seventy years, with anecdote-heavy coverage of political corruption, Chinatown's underworld, and the vices on offer in the Barbary Coast district.

Ausführlich, aber gelegentlich langatmig oder sensationslüstern bietet dieses Buch einen Blick auf die schäbigere Seite der Stadt in ihren ersten 70 Jahren. Mit vielen Anekdoten geht es hier um Korruption, die Unterwelt in Chinatown und das sündige Leben an der Barbary Coast.

Une évocation minutieuse, certes un peu prolixe et sensationnaliste, des plus sordides facettes de San Francisco au cours de ses soixante-dix premières années d'existence. Le tableau fourmille d'anecdotes qui sont autant d'illustrations de la corruption politique, de la pègre de Chinatown et du cortège de tous les vices offerts aux visiteurs du quartier de Barbary Coast.

Howl and Other Poems Allen Ginsberg (1956)

First performed in San Francisco in 1955 and published by City Lights Books, the cathartic blast of Howl launched the heyday of beat literature, accompanied here by several other lengthy notable poems from the same era.

Uraufgeführt 1955 in San Francisco und von City Lights Books veröffentlicht, ist die kathartische

Explosion von *Howl* auch der Urknall der Beatliteratur, hier zusammen mit anderen längeren Gedichten aus derselben Zeit.

Ressenti pour la première fois à San Francisco en 1955 lors d'une lecture publique, et publié par City Lights Books, le souffle cathartique du poème de Ginsberg a lancé l'âge d'or de la littérature beat. Il est ici accompagné de plusieurs autres poèmes longs et importants qui datent de la même époque.

On the Road **Jack Kerouac** *(1957)*
Epitomizing the beat movement in its celebration of a restless on-the-move lifestyle and near-breathless kinetic prose, much of this classic takes place as the core duo (based on Kerouac and pal Neal Cassady) flit in and out of San Francisco on their way to various misadventures throughout the United States.

Mit der Glorifizierung eines Lebens, das immer in Bewegung ist, sowie der Prosa, die genau das formell einzufangen versucht, ist dieser Roman ein Höhepunkt der Beat-Bewegung. San Francisco ist darin eine Art Heimatbasis für die Trips durch die USA, die die beiden Protagonisten (basierend auf Kerouac und Neal Cassady) unternehmen.

Emblématique de la Beat Generation par sa célébration d'une effervescence de chaque instant et la frénésie quasi cinétique de son écriture, ce grand classique suit les pérégrinations et mésaventures américaines de ses deux principaux personnages, Kerouac et son ami Neal Cassady, dans lesquelles San Francisco tient une place de choix.

The Electric Kool-Aid Acid Test **Tom Wolfe** *(1968)*
This hyperventilatingly stream-of-consciousness account of the LSD experimentation and wild cross-country bus rides of author Ken Kesey and his band of Merry Pranksters also covers Kesey's marijuana busts, flight to Mexico, and return to Haight-Ashbury.

In einem atemlose Bericht über den Bewusstseinsstrom, dokumentiert Wolfe hier die LSD-Experimente und wilden Busreisen durch das ganze Land, die Ken Kesey und seine Merry Pranksters unternahmen, sowie Keseys Verhaftung wegen des Besitzes von Marihuana, die folgende Flucht nach Mexiko und seine Rückkehr nach Haight-Ashburry.

Wolfe choisit la technique narrative du courant de conscience – *stream of consciousness* – pour composer cette chronique spasmophile du périple américain de l'autobus des Merry Pranksters, le groupe psychédélique emmené par l'écrivain Ken Kesey. Les expériences sous LSD, les arrestations de Kesey pour possession de marijuana, son exil au Mexique et son retour à Haight-Ashbury : tout y est.

Zap Comix **No. 0–4** *(1968–1969)*
Featuring cartoonists like R. Crumb, Rick Griffin, Victor Moscoso, Gilbert Shelton, and S. Clay Wilson, the first issues of the popular underground comic offered jaded portrayals of the hippie counterculture with taboo-breaking depictions of the sex 'n' drugs lifestyle.

Mit Comiczeichnern wie R. Crumb, Rick Griffin, Victor Moscoso, Gilbert Shelton und S. Clay Wilson boten die ersten Ausgaben dieses Undergroundcomics einen genervten Blick auf die Hippieszene, inklusive tabubrechender Darstellungen des Sex-und-Drogen-Lebensstils.

Forts des signatures alignées – Robert Crumb, Rick Griffin, Victor Moscoso, Gilbert Shelton, S. Clay Wilson… –, les premiers numéros de ce comic underground bientôt poursuivi pour « obscénité » renvoyaient un reflet à la fois fidèle et satirique de ce qu'était alors la contre-culture hippie, tous tabous ignorés, à commencer par le sexe et la drogue.

The Abortion: An Historical Romance 1966 **Richard Brautigan** *(1971)*
A bohemian hermit lives/works in a surreal library for unpublished books until his girlfriend's pregnancy nudges him into the real, chaotic world of mid-'60s San Francisco when they travel to Mexico and back for her abortion.

Ein Einsiedler und Bohemien lebt und arbeitet in einer surrealen Bibliothek für unveröffentlichte Bücher, bis die Schwangerschaft seiner Freundin ihn in die chaotische Welt des echten San Franciscos der 60er zwingt, von wo die beiden für eine Abtreibung nach Mexiko und zurück reisen.

Parce que sa petite amie tombe enceinte, un ermite bohème qui vit et travaille dans une improbable bibliothèque réservée aux manuscrits refusés par les éditeurs se retrouve précipité dans le monde réel et chaotique de la San Francisco du milieu des années 1960. Pour avorter, alors, il fallait aller au Mexique.

Kerouac: A Biography **Ann Charters** *(1973)*
The best bio of beat giant Jack Kerouac follows his erratic career in a heroically researched volume that's as interesting to read as Kerouac's own novels, adding plenty of lively context about the San Francisco beat scene in the sections discussing his time in the city.

Die beste Biografie des Beat-Giganten Jack Kerouac folgt seiner sprunghaften Karriere in einem beeindruckend tief recherchierten Buch, das genauso packend ist, wie Kerouacs Romane. Hinzu kommen viele Informationen über den Hintergrund der Beatszene in San Francisco in dem Teil des Buchs, der sich um Kerouacs Zeit in der Stadt dreht.

La meilleure biographie du géant de la Beat Generation retrace son itinéraire erratique grâce à un travail de recherche exceptionnel qui la rend aussi captivante que les romans de son sujet. Les chapitres consacrés à ses séjours à San Francisco replongent le lecteur au cœur de l'effervescence de la scène beat à la grande époque.

Hammett **Joe Gores** *(1975)*
This imaginative tale—quite different in many respects than the Wim Wenders movie adaptation—draws a reluctant Dashiell Hammett back into real-life detective work as he's struggling to start his writing career, on a 1928 murder case tangled in prostitution and government/police corruption.

Diese einfallsreiche Geschichte, die sich von Wim Wenders' Filmadaption stark unterscheidet, bringt einen zurückhaltenden Dashiell Hammet am schwierigen Start seiner Autorenkarriere wieder ins Detektivdasein zurück, um einen Mordfall im Jahr 1928, dessen Spur zu Prostitution und Korruption in Politik und Polizei führt, aufzuklären.

Ce récit imaginatif, très différent, à plus d'un titre, de l'adaptation cinématographique réalisée par Wim Wenders, campe Dashiell Hammett en ex-détective qui renâcle à reprendre du service alors qu'il peine à lancer sa carrière d'écrivain – on est en 1928. Le meurtre du vieil ami venu le solliciter, lié à des affaires de prostitution et de corruption des autorités, aura toutefois raison de ses réticences.

The Woman Warrior **Maxine Hong Kingston** *(1976)*
This genre-blending work by one of the Bay Area's most renowned authors mixes Chinese folktales with memories of her family's bumpy adjustment to American life in the years after immigrating to the US during World War II.

Dieses Werk einer der berühmtesten Autorinnen aus der Bay Area kennt in seinem Mix aus chinesischen Märchen und Erinnerungen an die schwierige Umstellung auf das Leben in Amerika nach der Immigration am Ende des Zweiten Weltkriegs keine Genregrenzen.

Essayiste et romancière parmi les plus illustres de la « Bay Area », Maxine Hong Kingston mélange les genres et emprunte aux contes populaires chinois pour retracer l'adaptation difficile de sa famille à la vie américaine dans les années qui suivirent son immigration aux États-Unis pendant la Seconde Guerre mondiale.

Tales of the City **Armistead Maupin** *(1978)*
Growing out of serialized columns for Bay Area newspapers, the first novel in Maupin's long-running saga zeroes in on the intersecting lives and romances (straight, gay, and otherwise) of the residents of a Russian Hill complex, touching on serious issues of sexuality and the ups and downs of city life amidst its oft-lighthearted comic tone.

Entstanden aus einer Kolumne für mehrere Bay-Area-Zeitungen ist Maupins erster Teil einer langen Saga eine detaillierte Aufnahme der Leben und Romanzen (hetero, schwul und andere) von Bewohnern eines Hauses auf dem Russian Hill und behandelt dabei ernste Themen rund um Sexualität und die Herausforderungen des urbanen Lebens in unbeschwert-witzigem Ton.

Issu des chroniques publiées en feuilleton dans les journaux de San Francisco, ce premier volet d'une longue saga romanesque se focalise sur l'entrelacs des vies et des amours (hétéro, gay et autres) des habitants d'une résidence de Russian Hill. Les questions de sexualité les plus sérieuses et les aléas de la vie urbaine y sont abordés sur un ton souvent empreint d'humour et de légèreté.

The Chez Panisse Menu Cookbook **Alice Waters** *(1982)*
The cookbook is a couple hundred or so recipes, suggested menus, and general homespun advocacy of a closer and healthier relationship to the food we eat from the chef and owner of Berkeley's Chez Panisse, famed the world over for its innovative California cuisine.

Geschrieben von Köchin und Besitzerin des Chez Panisse in Berkeley, weltberühmt als Mitbegründerin der kalifornischen Küche, enthält dieses Kochbuch ein paar Hundert Rezepte und Menüvorschläge, tritt aber auch generell für eine engere und gesündere Beziehung zur eigenen Ernährung ein.

Ce livre de cuisine de quelque 200 recettes et suggestions de menus participent d'un plaidoyer en faveur d'une relation plus intime et plus saine avec la nourriture. Il est l'œuvre de la restauratrice américaine à qui l'enseigne Chez Panisse, à Berkeley, doit sa notoriété internationale et la gastronomie californienne sa « révolution délicieuse ». Son *Art de la cuisine simple* a été traduit en dix-sept langues, dont le français.

The Mayor of Castro Street: The Life & Times of Harvey Milk **Randy Shilts** *(1982)*
Fine in-depth biography of the gay activist by a San Francisco television and newspaper reporter who was on the scene as events unfolded in the Castro and City Hall, drawing on interviews with more than a hundred of Milk's personal and political associates.

Eine gute und detaillierte Biografie des schwulen Aktivisten, geschrieben von einem TV- und Zeitungsreporter aus San Francisco, der den Werdegang Milks vom Castro bis ins Rathaus miterlebte und für das Buch Interviews mit mehr als 100 von Milks Freunden und politischen Verbündeten führte.

Une biographie fouillée, signée par un journaliste de San Francisco présent lorsque les événements se précipitèrent dans le quartier du Castro et à l'hôtel de ville entre 1977 et 1978, depuis l'élection de Milk au conseil municipal jusqu'à son assassinat avec le maire George Moscone. L'enquête s'appuie sur plus d'une centaine d'entretiens réalisés après coup dans l'entourage de l'activiste gay.

The Haight-Ashbury: A History **Charles Perry** *(1984)*
The best account of the neighborhood more identified with the psychedelic movement and the Summer of Love than any other, by one of the first editors at *Rolling Stone*.

Von einem der ersten Redakteure des *Rolling Stone* geschrieben, ist dies die beste Darstellung der Geschichte des Viertels, die nahezu ein Synonym für die psychedelische Bewegung und den Sommer der Liebe ist.

La meilleure étude jamais consacrée à un quartier dont l'histoire se confond avec le mouvement psychédélique et le «Summer of Love» est l'œuvre de l'un des premiers rédacteurs en chef du magazine *Rolling Stone*.

The Golden Gate Vikram Seth (1986)

Written entirely in verse, this novel follows the tangled love affairs of Reagan-era singles in the city, told from shifting perspectives of various characters (and even a cat and the author himself), building to a surprisingly somber finale despite its largely playful tone.

Dieser Roman, komplett in Versform, berichtet von den verstrickten Liebesbeziehungen einiger Singles in der Reagan-Ära aus ständig wechselnden Perspektiven (sogar aus der einer Katze und des Autors selbst), um dann trotz des weitestgehend verspielten Tons auf überraschend bedrückende Art zu enden.

Entièrement rédigé en vers, ce roman suit le parcours amoureux, imprévisible et complexe, de jeunes célibataires à l'ère Reagan. Il passe d'un personnage à l'autre – un chat et l'auteur compris – pour dérouler une intrigue qui s'achève, en dépit de sa tonalité souvent badine, sur une note étonnamment sombre.

The Joy Luck Club Amy Tan (1989)

Tan's immensely popular tale of four women who emigrate from China to San Francisco, their post-World War II daughters, and their struggles to balance their heritage with modern American life was also made into a hit film by Wayne Wang.

Tans immens beliebter Roman über vier Frauen, die aus China nach San Francisco emigrieren und ihre nach dem Zweiten Weltkrieg geborenen Töchter mit ihren eigenen Schwierigkeiten, ihre Traditionen mit dem modernen amerikanischen Leben zu vereinbaren, wurde in der Adaption von Wayne Wang zum Kinohit.

Un immense succès a accueilli ce récit qui raconte l'histoire de quatre femmes ayant émigré de Chine à San Francisco, celle de leurs filles après la Seconde Guerre mondiale puis leurs difficultés à trouver le juste équilibre entre leur héritage culturel et la vie moderne à l'américaine. L'adaptation cinématographique de Wayne Wang a connu la même réussite.

A Taste of Power: A Black Woman's Story Elaine Brown (1992)

An action-packed memoir of one of the top movers and shakers (and eventually chairperson of) the Black Panther Party both celebrates the party's gains against oppression and laments the explosive inner turmoil of its dissolution.

Diese actionreichen Memoiren eines der wichtigsten Mitglieder (und späteren Vorsitzenden) der Black Panther Party feiert die Errungenschaften der Partei und beklagt gleichzeitig ihre innere Zerrissenheit, die letztendlich zur Auflösung führt.

Les mémoires très mouvementés de l'une des personnalités phares (et *in fine* présidente) du parti des Black Panthers. L'ouvrage salue les avancées enregistrées face à l'oppression et déplore les déchirements internes explosifs qui accompagnèrent la dissolution du mouvement.

Bone Fae Myenne Ng (1993)

In 1980s San Francisco Chinatown, a family's fragile balance is upset by the mysterious suicide of their youngest daughter in a novel that deftly weaves in many nuances and quirks of their noisy and cluttered neighborhood's daily life.

In San Franciscos Chinatown der 1980er stellt der rätselhafte Selbstmord der jüngsten Tochter das fragile Gleichgewicht einer Familie auf eine harte Probe und wirft ein Licht auf die Nuancen und Eigenheiten des Lebens in der lauten, dicht bewohnten Gegend.

Le mystérieux suicide d'une jeune fille bouleverse l'équilibre fragile d'une famille du Chinatown des années 1980. Le roman se faufile avec un infini doigté entre les nuances et les étrangetés dont est tissé leur quotidien au cœur de ce quartier fiévreux et bruyant.

Summer of Love Joel Selvin (1994)

This thorough history of the birth and peak of early San Francisco rock concentrates almost exclusively on 1965–71, focusing on the era's major bands, especially Jefferson Airplane, the Grateful Dead, Big Brother & the Holding Company with Janis Joplin, and Santana.

Eine gründliche Geschichte des Anfangs und der frühen Höhepunkte des San-Francisco-Rock, vor allem im Zeitraum von 1965 bis 1971, die sich besonders mit den größten Bands der Zeit beschäftigt wie Jefferson Airplane, die Grateful Dead, Big Brother & the Holding Company mit Janis Joplin und Santana.

Cette chronique pointue de la naissance et de l'apogée du rock de San Francisco se concentre presque exclusivement sur la période 1965-71 et les principaux groupes de l'époque, de Jefferson Airplane à Santana. En 2014, une édition française, *Summer of love, Rock et révolution à San Francisco* (Huginn & Muninn), ajoutera à cet historique les clichés du célèbre photographe Jim Marshall, témoin privilégié de l'âge d'or.

Gun, with Occasional Music Jonathan Lethem (1994)

Plot and prose reminiscent of the hard-boiled noirish detective novels of Raymond Chandler and Dashiell Hammett gets shot into a gloomy future with strange drugs and scientifically "evolved" animals and babies, set in dingy corners of Berkeley and Oakland.

Erzählt und geschrieben wie die Hardboiled-Detektivromane von Raymond Chandler und Dashiell Hammett, ist dieser Roman in das düstere Berkeley und Oakland der Zukunft versetzt, voll von seltsamen Drogen und künstlich „weiterentwickelten" Tieren und Babys.

Une intrigue et un style qui rappellent le noirceur *hard-boiled* des polars de Raymond Chandler et Dashiell Hammett, qu'on aurait projetés dans un avenir sinistre où d'inquiétantes drogues voisinent avec des bêtes et des bébés scientifiquement «évolués» dans les zones les plus miteuses de Berkeley et d'Oakland.

The Rice Room Ben Fong-Torres (1995)

Longtime San Francisco media personality Ben Fong-Torres details his improbable journey from a traditional Chinese American family to becoming one of *Rolling Stone*'s first editors in his moving memoir of reaching adulthood in the Summer of Love.

Ben Fong-Torres, seit Langem eine bekannte Medienpersönlichkeit aus San Francisco, berichtet in diesen Memoiren über das Aufwachsen während des Sommers der Liebe und von seinem Weg aus einer traditionellen chinesisch-amerikanischen Familie zu einem der ersten Redakteure des *Rolling Stone*.

Il a atteint l'âge adulte en plein «Summer of Love»: Ben Fong-Torres, personnalité médiatique bien connue à San Francisco, revient en détail et avec émotion sur le parcours improbable qui a été le sien, d'une famille traditionnelle sino-américaine à la rédaction en chef du *Rolling Stone* des débuts.

The Invisible Circus Jennifer Egan (1995)

A decade after the Summer of Love, a precocious San Francisco teenager investigates her older sister's death on a trail that winds from the ashes of Haight-Ashbury to closet skeletons of the '70s European radical Left.

Ein Jahrzehnt nach dem Sommer der Liebe untersucht ein frühreifer San Francisco Teenager den Tod ihrer älteren Schwester und begibt sich so auf einen Weg, der von der Asche Haight-Ashburys zu den Leichen in den Kellern von Europas radikaler Linken in den 70ern führt.

Dix ans après le «Summer of Love», une adolescente de San Francisco part sur les traces de sa sœur aînée qui se serait suicidée lors d'un périple en Europe. Ce pèlerinage initiatique conduira la jeune fille du crépuscule de Haight-Ashbury aux inavouables secrets de la gauche radicale des années 1970.

Daughter of Fortune Isabel Allende (1999)

A young Chilean woman arrives in San Francisco in search of her prospector lover just as the Gold Rush peaks in 1849, navigating nearly unspeakable squalor as the city rises in a clamor of hopeful chaos amidst corruption, greed, disease, and prostitution.

Eine junge chilenische Frau kommt auf dem Höhepunkt des Goldrauschs 1849 nach San Francisco. Sie sucht ihren Liebhaber, einen Goldsucher, und muss mitten im hoffnungsvollen Chaos der im Aufstieg begriffenen Stadt und umgeben von Korruption, Gier, Krankheit und Prostitution fast unaussprechliches Elend durchleben.

Une jeune Chilienne arrive à San Francisco où elle espère retrouver son amant parti chercher de l'or au plus fort de la grande Ruée, en 1849. Elle devra faire face à une misère presque indicible alors même que s'éveille une ville surgie de l'espérance et du chaos entre corruption, cupidité, maladie et prostitution.

The Diary of a Teenage Girl Phoebe Gloeckner (2002)

This autobiographical novel is told in diary form and is interspersed with comics by the author, recounting a volatile adolescence in a libertine 1976–77 San Francisco replete with underage sex, dalliances with drugs, and heedlessly irresponsible parents.

Dieser autobiografische Roman enthält als Tagebuch von einer instabilen Jugend in einem zügellosen San Francisco in den Jahren 1976/77, von Sex unter Minderjährigen, Drogen und äußerst verantwortungslosen Eltern.

À la fois écrit et dessiné, ce journal intime retrace l'adolescence instable d'une jeune fille dans la San Francisco libertine des années 1976-77, quand sexualité au plus jeune âge, usage ludique des drogues et démission parentale y étaient monnaie courante.

Everybody into the Pool: True Tales Beth Lisick (2005)

Humorous wry vignettes trace the author's journey from a suburban Silicon Valley upbringing to San Francisco's turn-of-the-millennium counterculture, with ground reports on squatting in a rough Mission District neighborhood and writing for websites in the dot-com boom.

In ironischen Vignetten vollzieht die Autorin ihren Weg von einer Kindheit in einer Vorstadt im Silicon Valley zur Counterculture in San Francisco um die Jahrhundertwende nach, mit Berichten aus erster Hand über Hausbesetzungen im härteren Teil des Mission District und das Schreiben für Websites während der Dotcom-Blase.

Sous la forme de vignettes humoristiques teintées d'ironie, Beth Lisick raconte l'itinéraire qui la mena d'une enfance ordinaire dans la Silicon Valley à la contre-culture de San Francisco au tournant du siècle. Elle y revisite sa vie en squat dans un quartier rude comme peut l'être le Mission District et ses premières piges en ligne pendant le boom de l'internet.

Shortcomings Adrian Tomine (2007)

Berkeley/Oakland twentysomethings with an artsy-academic bent wiggle in and out of a bisexual tangle of stormy relationships in this graphic novel that captures regional snarky dialogue with slice-of-life accuracy.

In dieser Graphic Novel verheddern sich Menschen in ihren 20ern aus dem künstlerisch-akademischen Milieu in einem stürmischen Gewirr aus bisexuellen Beziehungen, erzählt mit einem Gespür für die regionalen Mundarten und die Feinheiten des Alltags.

Un peu artistes, un peu étudiants, ils ont la vingtaine, vont de Berkeley à Oakland et se débattent dans un méli-mélo bisexuel tissé de relations orageuses. Les dialogues de ce roman graphique restituent avec une précision empirique un usage du sarcasme propre à une génération, sinon à la région.

The Story of a Marriage Andrew Sean Greer (2008)

An African American family's placid domesticity is nearly torn apart by long-buried secrets of bisexual affairs and war traumas in a novel taking oft-surprising turns, largely set in the Sunset District during the early 1950s, in a San Francisco whose cozy post-World

War II prosperity hides an undercurrent of unease and instability.

In diesem oft überraschenden Roman wird eine afroamerikanische Familie fast von alten Geheimnissen um bisexuelle Affären und Kriegstraumata zerrissen. Der Großteil des Romans spielt im San Francisco der frühen 1950er, dessen gemütlicher Nachkriegswohlstand unterschwellige Unsicherheiten und Instabilitäten überdeckt.

Au début des années 1950, la vie sans histoire d'une famille afro-américaine tout près d'être bouleversée par la révélation de secrets longtemps enfouis, entre liaisons bisexuelles et traumatismes militaires. L'action de ce roman fertile en rebondissements se déroule surtout dans le Sunset District, quand l'instabilité de San Francisco couvait sous la prospérité douillette de l'après-guerre.

Season of the Witch David Talbot (2012)

This absorbing history of social movements, countercultural and otherwise, in San Francisco from 1967 to 1982 documents many of the major developments that were a backdrop to its music and arts scene, from Haight-Ashbury and the Black Panthers to the SLA, Jonestown, and the assassinations of George Moscone and Harvey Milk.

Die sozialen Bewegungen im Hintergrund der Kunst- und Musikszene San Franciscos von 1967 bis 1982 werden hier packend dokumentiert, von Haight-Ashbury und den Black Panthers bis zur SLA, Jonestown und der Ermordung von George Moscone und Harvey Milk.

Cette captivante histoire des mouvements sociaux à San Francisco de 1967 à 1982, et notamment de sa contre-culture, revient sur la plupart des événements importants qui formèrent la toile de fond de la scène musicale et artistique : de l'évolution du quartier de Haight-Ashbury jusqu'aux luttes des Black Panthers, en passant par l'affaire Hearst, la tuerie de Jonestown et les assassinats de George Moscone et Harvey Milk.

Collected Poems of Lenore Kandel Lenore Kandel (2012)

Kandel is most famous for the erotically explicit works in 1966's *The Love Book*, which generated obscenity charges after police raids on City Lights Books and the Psychedelic Shop, but also wrote many other poems, sexual and otherwise, that bridged the beat and hippie eras.

Am bekanntesten ist Kandel für ihr erotisch-explizites Werk *The Love Book* von 1966, das für eine Razzia im City Lights Books und eine Anklage wegen Obszönität gesorgt hat. Aber sie schrieb noch viele andere, sexuelle oder anderweitige Gedichte, die eine Brücke zwischen den Beats und den Hippies schlagen.

Lenore Kandel a connu la célébrité lorsque l'érotisme explicite de son livre *The Love Book*, paru en 1966, lui valut d'être saisi pour cause d'«obscénité» dans les librairies City Lights et The Psychedelic Book Shop. Elle a écrit beaucoup d'autres poèmes, d'inspiration sexuelle ou non, qui embrassent à la fois le mouvement beat et l'aventure hippie.

Telegraph Avenue Michael Chabon (2012)

A North Oakland record store gets threatened with extinction by encroaching early-21st century gentrification in this wordy novel, whose cluttered plot draws on ghosts from the Black Panther/blaxploitation film past, with many knowing references to Oakland/Berkeley landmarks and institutions.

In der überfrachteten Handlung dieses Romans wird ein Schallplattenladen im Norden Oaklands von der Gentrifizierung bedroht. Der Text ist voll von Bezügen auf die Black Panthers, Blaxploitation-Filme und Institutionen oder Sehenswürdigkeiten in Oakland und Berkeley.

À Oakland, comme un symbole de la gentrification à l'œuvre en ce début de XXIᵉ siècle, un magasin de disques vinyles est menacé par l'implantation d'un mégastore. L'intrigue touffue de ce roman non moins volubile invoque les fantômes cinéphiliques de la blaxploitation et multiplie les allusions aux sites et institutions emblématiques d'Oakland et de Berkeley.

Fridays at Enrico's Don Carpenter (2014)

The manic ups and downs in the intersecting lives of a dozen or so aspiring writers from the beat era through the mid-1970s are detailed in this novel largely set in San Francisco and particularly in North Beach haunts like Enrico's, published nearly twenty years after the author's death.

Diese, vor allem in den Kneipen von North Beach spielende Geschichte handelt von den Höhen und Tiefen einiger aufstrebender Autoren von der Beat-Ära bis zur Mitte der 1970er und wurde erst etwa 20 Jahre nach dem Tod des Autors veröffentlicht.

Les tribulations fiévreuses et entrelacées d'une dizaine d'aspirants écrivains, des balbutiements de la Beat Generation jusqu'au milieu des seventies. L'action de ce roman publié près de vingt ans après la mort de son auteur se déploie pour l'essentiel à San Francisco et notamment dans de légendaires hauts lieux de North Beach, tel le restaurant Enrico's.

There There Tommy Orange (2018)

The turbulent lives of a dozen Native Americans in Oakland intersect with explosive results in this episodic novel, the generation-spanning characters wrestling with their community's drug addictions, gang violence, and abuse-ridden families.

Die turbulenten Leben von einem Dutzend Native Americans in Oakland kreuzen sich mit explosiven Ergebnissen in diesem episodischen Roman, in dem die Charaktere aus mehreren Generationen mit Drogenabhängigkeit, Gang-Gewalt und Missbrauch in den Familien ihrer Community ringen.

Douze personnages de tous âges partageant de près ou de loin des racines amérindiennes se retrouvent à Oakland où leurs destins se croisent jusqu'à se fondre en un tourbillon bouillonnant. Maltraitance familiale, violence des gangs, alcoolisme et toxicomanie sont autant d'adversaires dressés face à eux au sein même de leur communauté.

p. 454
On The Road, *Jack Kerouac, Viking Press, 1957. Heritage Auctions, HA.com*

→

Zap Comix No. 4, *cover by Victor Moscoso, 1969. Print Mint, ed. Robert Crumb. Heritage Auctions, HA.com*

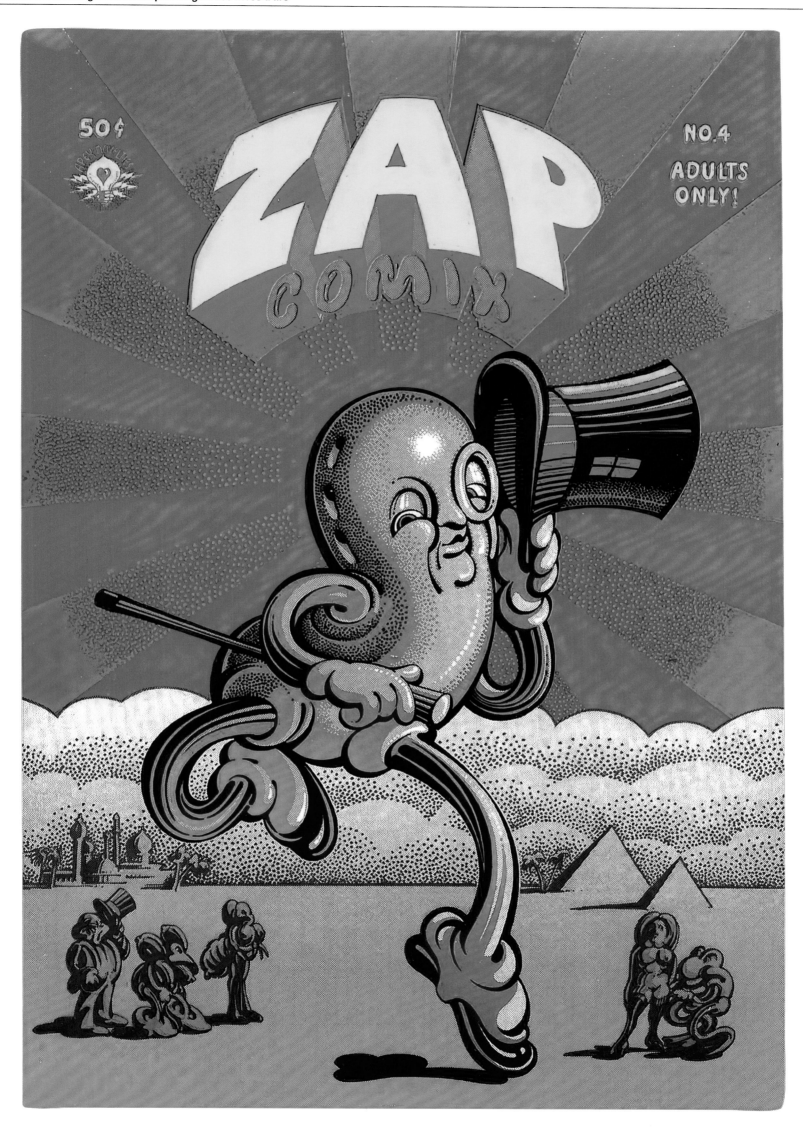

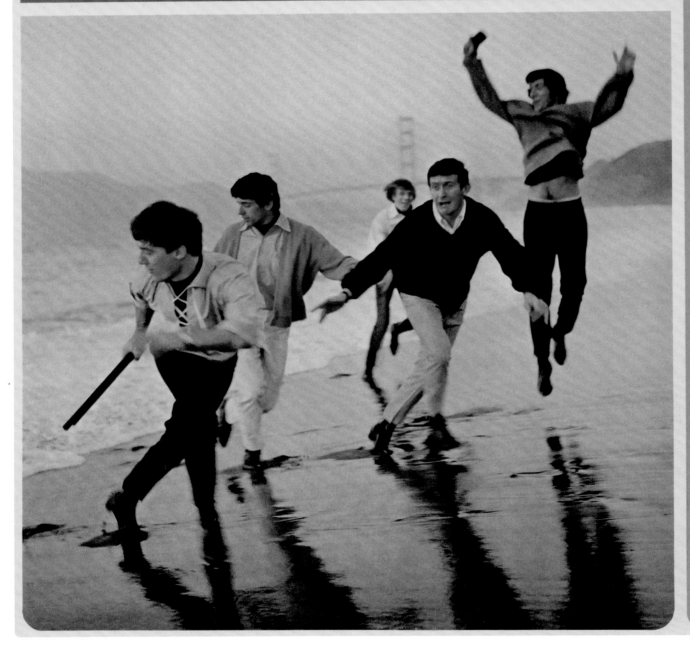

Introducing *The Beau Brummels, Autumn Records*, 1965.

Recommended Listening
Musikempfehlungen
Les chansons à écouter

Theme from San Francisco Jeanette MacDonald
(1936)
Performed by star Jeanette MacDonald in the MGM movie musical *San Francisco*, this overtly melodramatic, operatic theme was the first song in honor of the city to gain wide mass media exposure.

Dieser Song war der erste, der gleichzeitig der Stadt gewidmet war und medienweite Aufmerksamkeit erfuhr. Aufgeführt vom Star Jeanette MacDonald im MGM-Film-Musical *San Francisco*, ist der Klang offen melodramatisch und opernhaft.

Jamais une chanson écrite en l'honneur de la ville n'avait connu un succès aussi retentissant que ce thème lyrique, mélodramatique à souhait, interprété par l'actrice et cantatrice star Jeanette MacDonald dans la comédie musicale de la MGM *San Francisco*.

There's a Silver Moon on the Golden Gate
Girls of the Golden West *(1938)*
The official song marking the 1937 opening of the Golden Gate Bridge was immortalized on disc the following year by sisters Dorothy Laverne Good and Mildred Fern Good, who give the tune a doleful yodel-topped country harmony treatment.

Als offizieller Song für die Eröffnung der Golden Gate Bridge 1937 geschrieben, wurde er ein Jahr später auf Schallplatte von den Schwestern Dorothy Laverne Good und Mildred Fern Good verewigt, die ihm auch den Klang eines traurig-harmonierenden Country-Songs mit Jodler gaben.

L'hymne officiel de l'inauguration du Golden Gate Bridge, en 1937, a été immortalisé sur disque l'année suivante par deux sœurs, les « fiancées de l'Ouest » Dorothy Laverne Good et Mildred Fern Good, qui lui ont ajouté une tonalité mélancolique empruntée à la fois au country et à la technique du yodel germanique.

Cement Mixer (Put-Ti-Put-Ti) Slim Gaillard Trio
(1946)
Jazzman Gaillard coined his own language, "Voot-a-Reenee," for his delightfully nonsensical, infectious lyrics and singing, admired by (and possibly an influence on the prose of) Jack Kerouac, whose semi-autobiographical protagonist grooves to this song at a San Francisco club in *On the Road*.

Jazzmusiker Gillard schuf für diesen fröhlich sinnfreien Song eine eigene Sprache, „Voot-a-Reenee". Beeindruckt (und vielleicht inspiriert) von dem Song war auch Jack Kerouac, dessen semi-autobiografischer Protagonist in *On the Road* zu diesem Lied in einem Club in San Francisco tanzt.

Le « vout », la langue imaginaire créée par le chanteur, pianiste et guitariste de jazz Slim Gaillard, irrigue un swing et des textes aussi irrésistibles que délicieusement absurdes. Il suscitait l'admiration de Jack Kerouac dont il influença peut-être l'écriture ; le personnage quasi autobiographique de *Sur la route* se laisse gagner par le groove communicatif de ce morceau dans un club de San Francisco.

Working on the Railroad Jesse Fuller *(1955)*
Recorded just north of Berkeley at the dawn of the folk revival, this six-song, 10-inch disc has powerfully fresh folk-blues from miraculously dexterous one-man-band Fuller, most notably on the first recording of his own composition, the much-covered "San Francisco Bay Blues."

Nördlich von Berkeley zu Beginn des Folk-Revivals aufgenommen, bietet diese Zehn-Zoll-Platte mit ihren sechs Songs frischen Folk-Blues von der beeindruckend vielseitigen Ein-Mann-Band Fuller. Am

wichtigsten ist der schon oft gecoverte „San Francisco Bay Blues".

Enregistrés juste au nord de Berkeley à l'aube du renouveau folk, les six morceaux de ce 33 tours 10 pouces (25 centimètres) proposent un folk-blues d'une vivifiante fraîcheur interprété par un homme-orchestre à la dextérité miraculeuse, remarquable sur le premier enregistrement de sa propre composition, « San Francisco Bay Blues », qui générera maintes reprises.

Mambo with Tjader Cal Tjader *(1955)*
Tjader's combo of cool jazz and mambo was arguably the Bay Area's first significant original contribution to popular music, juxtaposing Tjader's glowing vibraphone with then-novel use of congas, timbales, and bongos.

Tjaders Kombination von coolem Jazz und Mambo ist wahrscheinlich der erste neuartige Impuls für die Popmusik aus der Bay Area. Tjader kombiniert sein Vibrafon mit damals noch neuartigen Congas, Bongos und Timbales.

Le combo de cool jazz et de mambo formé par Tjader constitue probablement la première contribution originale significative de la « Bay Area » à la musique populaire. Piano, contrebasse et vibraphone incandescent y épousaient congas, timbales et bongos en une communion alors novatrice.

Do You Want to Dance Bobby Freeman *(1958)*
San Francisco's first big rock 'n' roll hit, whose garage production couldn't muffle the irrepressible enthusiasm of Freeman's call to the dance floor or its hypnotic ascending piano riffs and pseudo-Latin beat.

Der erste große Rock-'n'-Roll-Hit aus San Francisco, dessen Garagenproduktion Freemans enthusiastischen Ruf auf die Tanzfläche, die hypnotischen Pianoriffs oder den pseudolatin Beat nicht dämpfen konnte.

Riffs ascendants et entêtants, piano mêlé aux bongos à la manière latino : Freeman signe le premier grand succès rock'n roll de San Francisco, un tube dont la production minimaliste, annonciatrice du garage rock, n'endigue en rien l'irrépressible énergie de cet appel à rejoindre illico le dancefloor.

The Kingston Trio The Kingston Trio *(1958)*
The threesome's chart-topping debut not only introduced their rousing if clean-cut brand of singalong folk to a national audience, but arguably did more than any other recording to ignite the folk revival, especially with their #1 single "Tom Dooley."

Das Debüt der drei landete an der Spitze der Charts und erreichte so mit seiner mitreißenden, aber unanstößigen Art von Folk nicht nur ein landesweites Publikum, sondern war auch ein großer Teil des Folk-Revivals, besonders dieNummer-1-Single „Tom Dooley".

Le renouveau du folk aux États-Unis doit tout au premier album de ce trio bon chic, bon genre, que l'immense succès de « Tom Dooley », la reprise d'une vieille chanson populaire de Caroline du Nord, propulsa au sommet des charts.

Grant Avenue Pat Suzuki *(1958)*
The sole number from Richard Rodgers and Oscar Hammerstein's musical *The Flower Drum Song* to bring a San Francisco setting to vivid life is a jubilant ode to Chinatown's main drag, sung with irresistibly hammy zest by Pat Suzuki.

Diese Nummer aus Richard Rodgers und Oscar Hammersteins Musical *The Flower Drum Song* ist eine freudestrahlende Ode an Chinatowns Hauptstraße, gesungen mit unwiderstehlichem Elan von Pat Suzuki.

Revêtue des signatures légendaires de Richard Rodgers et Oscar Hammerstein, et mise en scène par Gene Kelly, la comédie musicale *Au rythme des tambours fleuris* campe un décor de San Francisco à la fin de l'acte I : Pat Suzuki y interprète avec un entrain irrésistible et théâtral cette ode jubilatoire à la principale artère de Chinatown.

Howl and Other Poems Allen Ginsberg *(1959)*
The premier beat poet reads his most famous poem, and several others from the same era (including *America* and *Kaddish*), on this combination of live performances and studio recordings, whose occasional explicit profanity was quite groundbreaking and risky for a late-'50s LP.

Der wichtigste Beat-Dichter liest auf dieser LP seine berühmtesten Gedichte aus dieser Zeit (unter anderem *America* und *Kaddish*) in einer Kombination von Liveauftritten und Studioaufnahmen. Ginsbergs Verwendung von Obszönitäten waren in den späten 50ern sowohl bahnbrechend als auch gewagt.

Le poète attitré de la Beat Generation lit son œuvre la plus illustre ainsi que plusieurs autres créées à la même époque (dont *America* et *Kaddish*) sur cette compilation d'enregistrements *live* et studio. L'immoralisme explicite qui s'y déploie parfois était aussi audacieux que risqué pour un disque de la fin des années 1950.

I Left My Heart in San Francisco Tony Bennett
(1962)
Bennett's suave ode to the "city by the bay" is as close as San Francisco's come to an unofficial anthem, hailing its cable cars, morning fog, and windy sea as the ballad builds to a sumptuously orchestrated climax.

Bennetts sanfte Ode an die Stadt in der Bucht ist so etwas wie San Franciscos inoffizielle Hymne, handelt sie doch von Cable Cars, Morgennebel und der windigen See auf dem Weg zu ihrem prächtig inszenierten Höhepunkt.

Tout en suavité, cette ballade à la gloire de « la ville au bord de la baie » n'est pas loin de constituer l'hymne non officiel de San Francisco. Dans sa progression vers un final somptueusement orchestré, la chanson rend un hommage mêlé aux tramways que tracte un filin d'acier – les *cable cars* –, au brouillard du matin et à l'océan agité par les vents.

Jazz Impressions of "A Boy Named Charlie Brown"
The Vince Guaraldi Trio *(1964)*
Although "Cast Your Fate to the Wind" was this ebullient San Franciscan jazz pianist's big hit, he's justly most renowned for his irresistibly bouncy soundtracks for the *Peanuts* TV specials, which used several of the character-inspired themes featured here.

Obwohl „Cast Your Fate to the Wind" der größte Hit dieses gut gelaunten Jazzpianisten aus San Francisco war, kennt man ihn ganz richtig vor allem für seine unwiderstehlich lebhaften Soundtracks für die TV-Specials der *Peanuts*, wo viele der hier gesammelten, auf die Charaktere zugeschnittenen Songs verwendet wurden.

Si « Cast Your Fate to the Wind » a été son plus grand succès, ce prolifique pianiste de jazz de San Francisco est à juste titre admiré pour avoir composé la musique originale des dessins animés TV *Charlie Brown*, eux-mêmes tirés du comic strip *Peanuts* de Charles Schulz. Follement pétillante, la bande-son reprend plusieurs mélodies de cet album, créées en fonction des différents personnages de la BD.

Introducing the Beau Brummels The Beau Brummels (1965)

The first American band to convincingly emulate the British Invasion was also the first great San Francisco rock group, setting the template for the city's early folk-rock sound with haunting melodies and vocal harmonies, most memorably on their hits "Laugh Laugh" and "Just a Little."

Als erste Band, die auf glaubhafte Weise den Klang der British Invasion nachahmte, war sie auch die erste große Rockband aus San Francisco. So setzte sie die Standards für den frühen Folk-Rock-Sound der Stadt, vor allem mit eindringlichen Melodien und Vokalharmonien in Hits wie „Laugh Laugh" und „Just a Little."

À la «British Invasion» emmenée par les Beatles, il fallait une réponse américaine sinon exactement comparable, du moins convaincante, que ces cinq jeunes gens furent les premiers à formuler. À la faveur de ses mélodies et de ses harmonies vocales obsédantes – sur leurs tubes «Laugh Laugh» et «Just a Little» – le premier groupe rock important de San Francisco a formé la matrice du premier son folk rock entendu dans la ville.

Surrealistic Pillow Jefferson Airplane (1967)

The record most responsible for defining and popularizing the San Francisco psychedelic sound mixed a folk-rock base with freak flag–flying lyrics and Jorma Kaukonen's wailing distorted guitar, most memorably on the two smash hits powered by Grace Slick's ice-queen vocals, "White Rabbit" and "Somebody to Love."

Dieses Album, das wie kein anderes den Psychedelic Rock aus San Francisco definierte und beliebt machte, mischte Folk-Rock mit Freak-Texten und Jorma Kaukonens wimmernd-verzerrter Gitarre. Dazu kam der unnahbare Gesang von Grace Slick in Superhits wie „White Rabbit" oder „Somebody to Love".

L'album qui contribua le mieux à définir et à populariser le son psychédélique de San Francisco associait une base folk-rock à des textes aussi allumés qu'engagés et aux sanglots distordus de la guitare de Jorma Kaukonen, notamment sur les deux immenses succès portés par la voix de Grace Slick, « White Rabbit » et « Somebody to Love ».

San Francisco (Be Sure to Wear Flowers in Your Hair) Scott McKenzie (1967)

Loved and loathed in equal measures (in part because it was written by Los Angeles pop star John Phillips and sung by a non–San Franciscan to boot), this advisory to wear flowers in your hair on your visit to the city became a Summer of Love anthem in spite of its suspected bandwagon-jumping.

Gleichermaßen geliebt und gehasst (vor allem, weil er vom Popstar John Phillips aus Los Angeles geschrieben wurde und auch McKenzie nicht aus San Francisco stammt), wurde dieser Song mit seiner Empfehlung, bei einem Besuch in der Stadt Blumen im Haar zu tragen, doch zu einer Hymne des Sommers der Liebe, trotz aller Vorwürfe der Trittbrettfahrerei.

Aussi chérie que honnie, notamment parce qu'elle était l'œuvre d'une pop star de Los Angeles, John Phillips, et chantée par un artiste étranger à la ville, cette invitation à se nouer des fleurs dans les cheveux quand on visite San Francisco est devenue l'un des hymnes du « Summer of Love », en dépit des soupçons d'opportunisme qu'elle suscita.

Conspicuous Only in Its Absence The Great Society with Grace Slick (1968)

Recorded live at the Matrix club in 1966, this document of Grace Slick's pre–Jefferson Airplane group captures San Francisco psychedelia at its birth with its intoxicating blend of bittersweet rock with Indian ragas and free jazz–influenced improvisation, including early versions of "Somebody to Love" and "White Rabbit."

1966 im Club Matrix live aufgenommen, dokumentiert das Album nicht nur Grace Slick vor ihrer Zeit mit Jefferson Airplane, sondern auch die Geburt des San-Francisco-Psychedelic-Rocks mit seiner Mischung aus bittersüßer Rockmusik, indischen Ragas und der Improvisation des Free Jazz. Außerdem enthalten sind auch frühe Versionen von „Somebody to Love" und „White Rabbit".

Réalisé lors d'un concert organisé au club Matrix en 1966, cet enregistrement du groupe où évolua Grace Slick avant Jefferson Airplane saisit le psychédélisme de San Francisco à sa naissance : un mélange enivrant de rock doux-amer, de ragas indiens et d'improvisations inspirées du free jazz, notamment les versions originelles de « Somebody to Love » et de « White Rabbit ».

(Sittin' On) The Dock of the Bay Otis Redding (1968)

The soul great started writing this wistful classic on a houseboat in Sausalito, but died in a plane crash shortly after it was recorded in late 1967 (in Memphis, with help from guitarist and cowriter Steve Cropper), never seeing it soar to #1 a few months later.

Redding, ein Gigant des Soul, begann, diesen wehmütigen Klassiker auf einem Hausboot in Sausalito zu schreiben, starb aber bei einem Flugzeugabsturz kurz nachdem das Lied 1967 in Memphis (mit der Hilfe des Gitarristen und Co-Autors Steve Cropper) aufgenommen wurde. So konnte er den Nummer-1-Erfolg seines Stücks ein paar Monate später nicht miterleben.

Le premier couplet de ce classique mélancolique a été écrit sur l'une des houseboats de Sausalito, des maisons-bateaux qui y forment un village flottant. Peu après son enregistrement, fin 1967 à Memphis avec l'aide du guitariste et co-auteur Steve Cropper, Otis Redding, immense artiste de soul, s'est tué dans un accident d'avion. Il ne verra pas sa création atteindre le sommet des charts quelques mois plus tard.

Who Needs the Peace Corps The Mothers of Invention (1968)

On their psychedelic parody album We're Only in It for the Money, Frank Zappa's group included this savage but brilliant swipe at Haight-Ashbury flower power, ending with an aspiring rock roadie loving the police as they beat the crap out of him on the street.

Die Gruppe von Frank Zappa veröffentlichte diesen brutalen, aber brillanten Seitenhieb gegen die Haight-Ashbury-Flower-Power als Teil ihres Psychedelic-Parodiealbums We're Only in It for the Money.

L'album We're Only in It for the Money, satire assumée et brillante du mouvement psychédélique, est l'occasion pour Frank Zappa et son groupe de brocarder l'idéologie Flower Power de Haight-Ashbury. Dans ce morceau, un aspirant hippie promet de continuer à aimer la police y compris lorsqu'elle lui cassera la figure en pleine rue.

Cheap Thrills, Big Brother & the Holding Company (1968)

The second and last LP by Big Brother to feature the explosive lead vocals of Janis Joplin, delivering rough 'n' ready psychedelia with wailing guitars by Sam Andrew and James Gurley on the exquisite soul-rock hit "Piece of My Heart" and the epic pained blues ballad "Ball and Chain."

Die zweite und letzte Big-Brother-LP mit Janis Joplin lieferte rohen Psychedelic Rock mit Sam Andrew und James Gurley an der Gitarre beim Soul-Rock-Hit „Piece of my Heart" und der episch-schmerzerfüllten Blues-Ballade „Ball and Chain".

Cet album de Big Brother est le deuxième et le dernier à s'appuyer sur la voix rauque et puissante de Janis Joplin. Il s'y déploie un psychédélisme brut de décoffrage, marqué par les arabesques gémissantes des guitaristes Sam Andrew et James Gurley sur le blues lancinant de « Ball and Chain » et sur le magnifique « Piece of my Heart », à la fois plus rock et plus soul, qui fera de Joplin une star.

Oar Alexander Spence (1969)

The ex–Jefferson Airplane drummer and Moby Grape guitarist was just out of an acid-spurred stay at a mental hospital when he cut this riveting blues-country-folk outing, sounding as if a Delta bluesman had been infused with the spirit of Haight-Ashbury at its most addled.

Der ehemalige Schlagzeuger von Jefferson Airplane und Gitarrist von Moby Grape hatte gerade einen von LSD verursachten Aufenthalt in einer Nervenklinik hinter sich, als er diesen Mix aus Blues, Country und Folk veröffentlichte. Das Resultat klingt, als hätte ein Bluessänger den verwirrtesten Teil des Geistes von Haight-Ashbury in sich aufgenommen.

L'ex-batteur de Jefferson Airplane et guitariste de Moby Grape sortait à peine d'un séjour en hôpital psychiatrique, LSD oblige, lorsqu'il enregistra ce fascinant album où résonne un folk nimbé de psychédélisme dépouillé, comme si un bluesman du delta s'était laissé hanter par l'esprit de Haight-Ashbury au plus fort de son potentiel addictif.

Stand! Sly & the Family Stone (1969)

Soul, rock, and psychedelic spirit come to an exultant head with the jubilant chart-topper "Everyday People" and the "I Want to Take You Higher," though the troubled underside of the late '60s surfaces with a vengeance on "Don't Call Me Nigger, Whitey."

Hier kommen Soul, Rock und Psychedelic Rock zusammen. Alles ist in diesem Album vertreten, vom Chart-Spitzenreiter „Everyday People" über die baldige Woodstock-Hymne „I Want to Take You Higher" bis hin zur Rückkehr der dunklen Seite der späten 60er auf „Don't Call Me Nigger, Whitey".

La soul, le rock et l'esprit du psychédélisme touchent à leur paroxysme avec le jubilatoire « Everyday People », bientôt numéro 1, et « I Want to Take You Higher » que le film consacré à Woodstock fera passer à la postérité. Le titre « Don't Call Me Nigger, Whitey » éclaire quant à lui on ne peut plus crûment le visage moins allègre des sixties.

Santana Santana (1969)

By mixing San Francisco psychedelic blues with Latin music, guitarist Carlos Santana's band came up with an entirely new form of rock, his sustain-laden guitar meshing with effervescent organ and multi-layered polyrhythms, reaching an exhilarating peak on the soon-to-be-immortalized-at-Woodstock "Soul Sacrifice."

Die Band des Gitarristen Carlos Santana mischte San Francisco-Psychedelic-Blues mit Latin und schuf so eine neue Form des Rocks, dessen gehaltene Gitarre gemischt mit brausendem Orgelspiel und Polyrhythmik ihren Höhepunkt mit „Soul Sacrifice" erreichte, das bald darauf in Woodstock unsterblich wurde.

En mélangeant le blues psychédélique de San Francisco aux rythmes latino, le groupe de Carlos Santana a inventé une forme de rock totalement inédite. La légendaire longueur de son de sa guitare – le sustain – coalisée avec l'orgue fiévreux et une maîtrise parfaite de la polyrythmie atteint des sommets sur le morceau « Soul Sacrifice », lui aussi immortalisé à Woodstock.

Cosmo's Factory Creedence Clearwater Revival (1970)

This East Bay outfit crafted a characteristically potent blast of roots rock grounded in swampy rockabilly, but updated with a 1970 mindset, both on this LP's smashes ("Travelin' Band," "Lookin' Out My Back Door," "Who'll Stop the Rain," "Up Around the Bend") and its marathon cover of "I Heard It Through the Grapevine."

Die Gruppe aus der East Bay schuf ein charakteristisch starkes Stück ursprünglicher Rockmusik auf Rockabilly-Basis, das sie aber mit der Mentalität der 1970er-Jahre verbanden – sowohl bei den Hits dieser LP („Travelin' Band", „Lookin' Out My Back Door", „Who'll Stop the Rain", „Up Around the Bend") als auch mit ihrer Marathoncoverversion von „I Heard it Through the Grapevine".

La puissance de l'onde de choc déclenchée par les frères Fogerty et leurs compères, tous issus de

l'East Bay, est emblématique de ce roots rock ancré dans le rockabilly et le swamp pop des marécages de Louisiane, remis au goût du jour. Les tubes (« Travelin' Band », « Lookin' Out My Back Door », « Who'll Stop the Rain », « Up Around the Bend ») voisinent ici avec une reprise marathon – plus de onze minutes – de « I Heard It Through the Grapevine ».

American Beauty The Grateful Dead *(1970)*
If more subdued than the acid jams filling their concert sets on the likes of 1969's *Live/Dead*, this was their strongest studio album, focused on concise, country-rock flavored tunes like "Friend of the Devil" and "Sugar Magnolia" spotlighting their best vocal harmonies.

Wenn auch etwas gedämpfter als der LSD-Sound ihrer Konzerte wie *Live/Dead* 1969, war dies ihr stärkstes Studioalbum, konzentriert auf kurze, an Country-Rock angelehnte Songs wie „Friends of the Devil" und „Sugar Magnolia", die die besten Vokalharmonien der Band hervorhoben.

S'il est plus feutré que les jams défoncées qui prenaient presque tout l'espace de leurs prestations publiques, comme l'atteste la compilation *Live/Dead* (1969), cet album studio des « défunts reconnaissants », leur cinquième, est aussi leur meilleur. Il marque le retour à un certain dépouillement aux parfums de country rock, dans « Friend of the Devil » et « Sugar Magnolia », par exemple, semés de grandioses harmonies vocales.

East Bay Grease Tower of Power *(1970)*
Although Tower of Power's debut showcased a slightly raw-at-the-edges Oakland funk band with brass, there were traces of the San Francisco sound in their long and loose songs and some lyrical reflections of the social changes rocking the area, especially in "Social Lubrication."

Obwohl das Debüt von Tower of Power eine noch nicht ganz ausgegorene Oakland-Funkband zeigte, enthält es doch Spuren des San-Francisco-Sounds in ihren langen, lockeren Songs, in denen sie lyrisch über die sozialen Veränderungen in der Gegend nachdenken, vor allem in dem Song „Social Lubrication".

Apprécié à ses débuts pour son funk un peu brut de fonderie et la flamboyance de sa section de cuivres, ce groupe né à Oakland s'est laissé imprégner çà et là par le son de San Francisco, ainsi qu'en témoignent ici ses longues compositions débridées. Certains textes (« Social Lubrication ») n'oublient pas d'évoquer les bouleversements sociaux qui secouent la région.

Free Bobby Now The Lumpen *(1970)*
Rare both in its limited pressing and pointedly political message, this blistering slab of jubilant soul-funk-rock demanded freedom for imprisoned Black Panther co-founder Bobby Seale, on a Black Panther Party–distributed single recorded by Bay Area Panthers.

Diese Soul-Funk-Rock-Platte ist aus zwei Gründen eine Seltenheit, zum einen wegen ihrer geringen Auflage und zum anderen wegen der klaren politischen Botschaft, nämlich Freiheit für den inhaftierten Mitgründer der Black Panthers, Bobby Seal zu erkämpfen. Aufgenommen und verkauft wurde die Single von den Panthers selbst.

Aussi rare par son pressage limité que par le message politique qu'il véhicule, ce bloc enjoué et vigoureux de funk rock mêlé de soul réclamait la libération du cofondateur incarcéré des Black Panthers, Bobby Seale. Les membres du groupe appartenaient eux-mêmes au mouvement révolutionnaire afro-américain, qui distribuait très officiellement leur single.

Malo Malo *(1972)*
With Carlos Santana's brother Jorge on lead guitar, Malo also fused rock and Latin music, but were considerably more tilted toward the Latin part than Santana, and less toward blues and psychedelia, though they also incorporated jazz influences, as well as pure pop on the hit single "Suavecito."

Mit Carlos Santanas Bruder Jorge an der Gitarre spielt Malo auch eine Fusion aus Rock und Latin, neigt dabei aber wesentlich mehr in Richtung Latin als Santana und ist gleichzeitig weniger interessiert an Blues oder Psychedelic Rock. Trotzdem gibt es auch hier Elemente aus Jazz oder reinem Pop, Letzteres auf der Hitsingle „Suavecito."

Avec à la guitare solo Jorge Santana, frère de Carlos, Malo mène à bien lui aussi la fusion du rock et des rythmes latinos, lesquels occupent toutefois ici une place prépondérante. Blues et psychédélisme sont moins présents que chez Santana mais on retrouve des influences jazz et de la pop pure et suave sur le single et futur tube… « Suavecito ».

The Pointer Sisters The Pointer Sisters *(1973)*
The debut by this Oakland group featured their eclectic, slick, and snazzy brand of harmony soul, including the Allen Toussaint–written people-power hit "Yes We Can Can" and their jazzy take on Howlin' Wolf/Koko Taylor's blues classic "Wang Dang Doodle."

Das Debüt dieser Gruppe aus Oakland zeigt ihre clever eklektische Version von Harmony-Soul, inklusive des Hits „Yes We Can Can", geschrieben von Allen Toussaint, und ihre jazzige Version des Bluesklassikers von Howlin' Wolf und Koko Taylor, „Wang Dang Doodle".

Le charme de leurs harmonies vocales irradie le premier album de ce groupe féminin originaire d'Oakland, interprète d'une soul éclectique, chic et léchée. On y découvre notamment, signées Allen Toussaint, « Yes We Can Can », qui va cartonner, et une version jazzy de « Wang Dang Doodle », un classique du blues qu'avaient chanté Howlin' Wolf et Koko Taylor.

The Third Reich 'N Roll The Residents *(1976)*
As if reflecting the darkening mood of the city as the last remnants of the Summer of Love died and punk loomed just around the corner, this goofy, anonymous ensemble devoted an entire album to oldies medleys replacing the sunny optimism of the originals with gloomy, at times ghastly deconstructions.

Das anonyme und fast alberne Ensemble greift die dunkler werdende Stimmung in der Stadt auf, die aus den letzten Resten des sterbenden Sommers der Liebe entsteht, während sich am Horizont schon Punk abzeichnet. Dazu widmet es ein ganzes Album Medleys, in denen der sonnige Optimismus der Originale durch trübsinnig, manchmal scheußliche Dekonstruktionen ersetzt wird.

Comme s'il reflétait l'humeur assombrie d'une ville où fanent les derniers pétales du « Summer of Love » tandis que la vague punk s'apprête à déferler, cet ensemble loufoque, dont l'identité des membres était cachée au public, consacre tout un album à deux longs medleys enchaînant de vieux standards du rock dépouillés de leur optimisme originel au profit de déconstructions lugubres, parfois même effrayantes.

Step II Sylvester *(1978)*
As an iconic hero to the gay community, Sylvester's falsetto graced some of the era's most propulsive disco, most famously on the space-age-effect-driven "You Make Me Feel (Mighty Real)," a soundtrack for the Castro at its most euphoric.

Als eine Ikone der schwulen Community war Sylvesters Falsetto in einigen der dynamischsten Discostücke dieser Zeit zu hören, vor allem in seinem vom Space-Age beeinflussten Hit „You Make Me Feel (Mighty Real)", ein euphorischer Soundtrack für das Castro.

Le falsetto suraigu de Sylvester, héros emblématique de la communauté gay, exalta certains des tubes les plus énergisants de l'ère disco, à commencer par l'illustre « You Make Me Feel (Mighty Real) » ; presque du « space disco » avec inventions électro, déjà, pour porter à son paroxysme l'euphorie festive du Castro.

Fresh Fruit for Rotting Vegetables The Dead Kennedys *(1980)*
One of the most notorious punk bands, the DKs were crucial instigators of the confrontational harder-faster-louder variant of punk that became known as hardcore, venting bilious ironic social commentary in "Kill the Poor," "Holiday in Cambodia," and "California Über Alles."

Als eine der berüchtigtsten Punkbands zählten die DKs zu den wichtigsten Anstiftern der konfrontationsfreudigen, härter-schneller-lauter Variante des Punks, später als Hardcore bekannt, mit giftig-ironischen Tracks wie „Kill the Poor", „Holiday in Cambodia" oder „California Über Alles".

S'ils formaient l'un des groupes les plus célèbres de la vague punk, les « Kennedy morts » ont aussi été à l'origine du sous-genre volontiers conflictuel connu sous le nom de hardcore : plus dur, plus bruyant, tempo accéléré. Sarcastique et rageuse, la critique sociale s'y excrète en particulier dans « Kill the Poor », « Holiday in Cambodia » et « California Über Alles ».

Avengers Avengers *(1983)*
The most significant San Francisco punk band never released an album in their original incarnation, but this collected late-'70s singles, EPs, live, and unreleased material by a group that combined raw punk with leftist politics, and opened for the Sex Pistols' last (pre-reunion) show in early 1978.

Die wichtigste Punkgruppe aus San Francisco veröffentlichte nie ein Album mit ihrer ursprünglichen Besetzung, sondern nur diese Sammlung aus Singles der späten 70er, EPs, Live- oder unveröffentlichtem Material der Gruppe, die rohen Punksound mit linker Politik kombinierte und die Vorgruppe bei der letzten Show der Sex Pistols 1978 (vor deren Wiedervereinigung) war.

Le groupe punk le plus important de San Francisco n'a jamais sorti d'album dans la composition qui était la sienne à ses débuts mais celui-ci réunit les singles diffusés à la fin des années 1970 : maxis (EP), concerts et enregistrements inédits d'un collectif qui combinait punk à l'état brut et engagement politique à gauche. Il assura début 1978 la première partie du dernier concert (avant leur reformation) des Sex Pistols.

Heart Shaped World Chris Isaak *(1989)*
Isaak's most popular album brought his brand of modified rockabilly-roots rock to the Top Ten, sparked by the huge hit "Wicked Game," whose spooky backup female vocals complemented eerie wavering, reverberating guitar and Roy Orbison–like vocals.

Isaaks beliebtestes Album brachte seine Art des Rockabilly-Rock in die Top Ten, ausgelöst vom Riesenhit „Wicked Game", dessen gespenstischer Hintergrundchor wunderbar zur gruselig nachhallenden Gitarre und dem Roy-Orbison-ähnlichen Gesang passte.

L'album le plus populaire de Chris Isaak a permis à son rock teinté de blues traditionnel et de rockabilly revu et corrigé d'accéder au top 10 des charts, grâce au succès colossal de « Wicked Game ». Des chœurs féminins à donner le frisson y enveloppent l'étrangeté des effets d'ondulation et de réverbération prodigués à la guitare et le timbre d'une voix qui n'est pas sans rappeler Roy Orbison.

Sex Packets Digital Underground *(1990)*
This Oakland group offers a sort of comic twist on the spacey funk of George Clinton on their debut, ostensibly a concept album about Genetic Suppression Relief Antidotes, drawing plenty of jazz and soul into their humorous, sample-heavy hip-hop.

In ihrem Debütalbum bietet die Gruppe aus Oakland einen humoristischen Twist des spacigen Funk von George Clinton. Eigentlich ein Konzeptalbum über „Genetic Suppression Relief Antidotes", bringt es Einflüsse von Jazz und Soul in den stark mit Samples arbeitenden Hip-Hop der Gruppe.

Pour ses débuts, ce groupe d'Oakland proposait une sorte de variation comique du funk spatial de

George Clinton sur un album conceptuel dédié au GSRA (*Genetic Suppression Relief Antidote*) : une pilule magique censée assurer l'épanouissement sexuel aux astronautes. Leur hip-hop loufoque farci de samples intègre au passage une bonne dose de jazz et de soul.

2Pacalypse Now 2Pac (1991)

The debut by this Marin City rapper seemed extreme to many at the time, like then–vice president Dan Quayle, for its blunt critiques of police brutality and vivid portrayal of racism, crime, and other ills in the African American community, though now it seems more realism than exaggeration.

Das erste Album des Rappers aus Marin County wirkte auf viele extrem, auch auf den damaligen Vizepräsidenten Dan Quayle, weil es unverblümt Kritik an Polizeigewalt übte und Rassismus, Kriminalität und andere Missstände in der afroamerikanischen Community schonungslos benannte. Heute klingt es eher realistisch als übertrieben.

Si l'on en croit certains commentateurs, comme le vice-président de l'époque, Dan Quayle, la percée de ce rappeur issu de Marin City relevait de l'extrémisme. Tupac ne prenait certes pas de gants pour dénoncer les brutalités policières ou évoquer racisme, criminalité et autres maux affligeant la communauté afro-américaine, mais c'était plus réaliste qu'excessif, à en juger aujourd'hui.

Dookie Green Day (1994)

Rooted in the early-'90s punk scene at Berkeley's 924 Gilman Street club, Green Day reached international superstardom by putting more pop into their punk on this massive hit, which offered a sort of more all-ages, accessible Ramones for the 1990s.

Mit Wurzeln in der Punkszene der frühen 90er des 924 Gilman Street Clubs in Berkeley erreichte Green Day Superstarstatus, indem sie auf diesem Album mehr Pop in ihren Punk mischten wie eine Art Ramones der 1990er-Jahre für alle Altersgruppen.

Enracinés dans la scène punk rock du début des années 1990 et piliers du 924 Gilman Street, fameux club de Berkeley, les Californiens de Green Day accéderont au statut de superstars internationales avec cet album. Leur punk mâtiné de pop accrocheuse et mélodique évoque le son des Ramones, remis pour l'occasion au goût du jour et de tous les âges.

Punk in Drublic NOFX (1994)

Rawer in their pop-punk attack than Green Day, and laced with liberal doses of sardonic humor, this long-lived group reached their widest audience with this collection of short sharp shocks, dotted with bits of reggae and mock opera.

Mit roherem Pop-Punk als Green Day und einer guten Dosis sardonischen Humors erreichte die lange bestehende Gruppe ihr größtes Publikum mit dieser Sammlung von kurzen, aber harten Schocks, gemischt mit etwas Reggae und Opernsound.

D'une agressivité punk rock plus franche que Green Day, coupée néanmoins de généreuses doses d'humour sardonique, ce groupe à la rare longévité connut son plus grand succès public avec cet album-contrepet (lire *drunk in public*, ivre en public) qui enchaîne une succession de secousses brèves et tranchantes émaillées de reggae et d'opéra parodique.

Demolition Pumpkin Squeeze Musik DJ Q-Bert (1994)

This widely distributed mixtape by one of the earliest and foremost turntablists has an hour of unpredictably shifting samples of funk, jazz, and rock spanning several decades, blended with snippets of video games, soundtrack music and dialogue, and scratching.

Dieses weit verbreitete Mixtape eines der ersten und wegweisendsten Turntable-Künstlern besteht aus einer Stunde mit unvorhersehbaren Samples aus Funk, Jazz und Rock aus mehreren Dekaden zusammen mit Schnipseln aus Videospielen, Soundtracks, Dialogen und Scratching.

Cette mixtape largement distribuée par l'un des tout premiers DJ platinistes (*turntablists*, créateurs de son à partir de platines vinyls) balaie plusieurs décennies en une heure de samples funk, jazz et rock aux placements imprévisibles, entrecoupés de fragments de jeux vidéo, de dialogues ou musiques de film et d'effets de scratch.

Bing, Bing, Bing! Charlie Hunter Trio (1995)

Cool soul-jazz with eight-string guitarist Hunter, tenor sax, and drums that you would have heard them play at one of the Mission District's most popular clubs of the late 20th and early 21st centuries, the now-closed Elbo Room; this album's closing track is titled in its honor.

Cooler Soul-Jazz mit Hunter an der achtseitigen Gitarre, Tenorsaxophon und Schlagzeug, wie man ihn im heute geschlossenen Elbo Room, einem der beliebtesten Clubs im Mission District des späten 20. und frühen 21. Jahrhunderts, gehört hätte. Das letzte Lied des Albums ist zu Ehren eben dieses Clubs benannt.

Le soul-jazz cool interprété notamment par Hunter et sa guitare à huit cordes, Dave Ellis au saxo ténor et Jay Lane à la batterie pouvait s'écouter à l'Elbo Room, l'un des clubs les plus courus du Mission District à la fin du xxᵉ et au début du xxiᵉ siècles, aujourd'hui fermé. Le titre du dernier morceau lui est dédié.

Howl, USA Kronos Quartet (1996)

San Francisco's world-renowned contemporary string quartet backed an Allen Ginsberg reading of *Howl* with classical composer Lee Hyla's music on this ambitious album, which also features similar treatments of Cold War texts by I. F. Stone and J. Edgar Hoover.

San Franciscos weltbekanntes zeitgenössisches Streichquartett hinterlegt eine Allen-Ginsberg-Lesung von *Howl* mit der Musik des Komponisten Lee Hyla auf diesem ambitionierten Album, das andere Texte aus der Zeit des Kalten Krieges in ähnlichen Versionen enthält, zum Beispiel von I.F. Stone oder J. Edgar Hoover.

Mondialement célèbre, le quatuor à cordes contemporain de San Francisco accompagne ici une lecture de « Howl » par son auteur Allen Ginsberg. Le compositeur classique Lee Hyla signe la musique de cet album où sont par ailleurs samplés des extraits de textes liés à la guerre froide signés par le journaliste I.F. Stone et le directeur du FBI Edgar Hoover.

Island — Immigrant Suite No. 1 Jon Jang featuring Genny Lim (1997)

Avant-garde, sometimes free jazz is woven with Chinese melodies on this intricate conceptual work documenting the trials of Chinese immigrants detained at Angel Island in the early 20th century, juxtaposing pianist Jang's "arkestra" with singing and recitation by poet Genny Lim.

In diesem komplexen Konzeptwerk des Pianisten Jang werden Avantgarde- und manchmal Free Jazz mit klassischen chinesischen Melodien kombiniert, um die Strapazen von chinesischen Immigranten auf Angel Island im frühen 20. Jahrhundert zu dokumentieren. Dabei steht das „Arktestra" des Pianisten Jang dem Gesang und der Rezitation der Dichterin Genny Lim gegenüber.

Le jazz avant-gardiste du pianiste et compositeur Jon Jang, qui flirte parfois avec le free jazz, épouse des mélodies chinoises dans cette œuvre conceptuelle très élaborée qui retrace les épreuves subies au début du xxᵉ siècle par les immigrants asiatiques détenus à Angel Island. Le Pan Asian Arkestra de Jang accompagne le récitatif déclamé par la poétesse Genny Lim.

Spend the Night The Donnas (2002)

The Bay Area has generated more all-women rock bands than almost any other region, none more popular than these pop-punkers, who delivered brash odes to young adult love and rowdy good times with both hard rock and garage rock overtones.

Aus der Bay Area kommen mehr reine Frauenrockbands als aus irgendeiner anderen Region, und keine davon ist beliebter als diese Pop-Punkerinnen mit ihren frechen Oden an jugendliche Liebe und die guten Zeiten der Jugend, alles mit Andeutungen von von Garage und Hardrock.

La région de San Francisco a engendré plus de groupes de rock 100 % féminins qu'aucune autre, ou presque. Aucun, en tout cas, n'a connu davantage de succès que ce quatuor de pop-punkettes culottées dont les hymnes aux amours adolescentes et aux bringues d'antan prennent à l'occasion des accents de garage et de hard rock.

Temple Beautiful Chuck Prophet (2012)

A staple of the San Francisco alternative rock scene for decades, singer-songwriter Prophet crafted a song cycle of sorts paying homage to the city, whether in its general mood or specific subjects like "Castro Halloween," "Willie Mays Is Up at Bat," and "Emperor Norton in the Last Year of His Life (1880)."

Als seit Jahrzehnten fester Bestandteil der alternativen Rockszene San Franciscos erstellte Singer-Songwriter Prophet einen Liederzyklus als Hommage an die Stadt, sowohl an ihre allgemeine Atmosphäre als auch an speziellere Aspekte, wie „Castro Halloween", „Willie Mays Is Up at Bat" und „Emperor Norton in the Last Year of His Life (1880)."

Figure incontournable et chevronnée de la scène du rock alternatif à San Francisco, le songwriter et chanteur Chuck Prophet a ciselé ici une série de morceaux dédiés à sa ville. Ils y célèbrent tant son atmosphère globale que des sujets plus spécifiques dans « Castro Halloween », « Willie Mays Is Up at Bat » et « Emperor Norton in the Last Year of His Life (1880) ».

Sorry to Bother You Tune-Yards (2019)

The Oakland-set dark sci-fi film comedy *Sorry to Bother You* features, appropriately enough, a score by one of that city's top alternative acts, who devise an atmospheric, oft-spooky mash-up of rap, rock, dialogue, operatic instrumentals, and experimental noise pop.

Die dunkle, in Oakland spielende, Sci-Fi-Comedy *Sorry to Bother You* hat einen passenden Soundtrack von einem der besten alternativen Musiker der Stadt und ist eine atmosphärische, fast unheimliche Mischung aus Rap, Rock, Dialog, opernhafter Instrumentalmusik und experimentellem Noise-Pop.

L'onirisme noir et satirique du film *Sorry to Bother You*, situé à Oakland, s'accompagne à bon escient d'une musique composée par l'un des meilleurs groupes alternatifs de la ville. Résultat : un mélange souvent saisissant de rap, de rock, de dialogues, d'instrumentaux lyriques et de noise pop expérimentale.

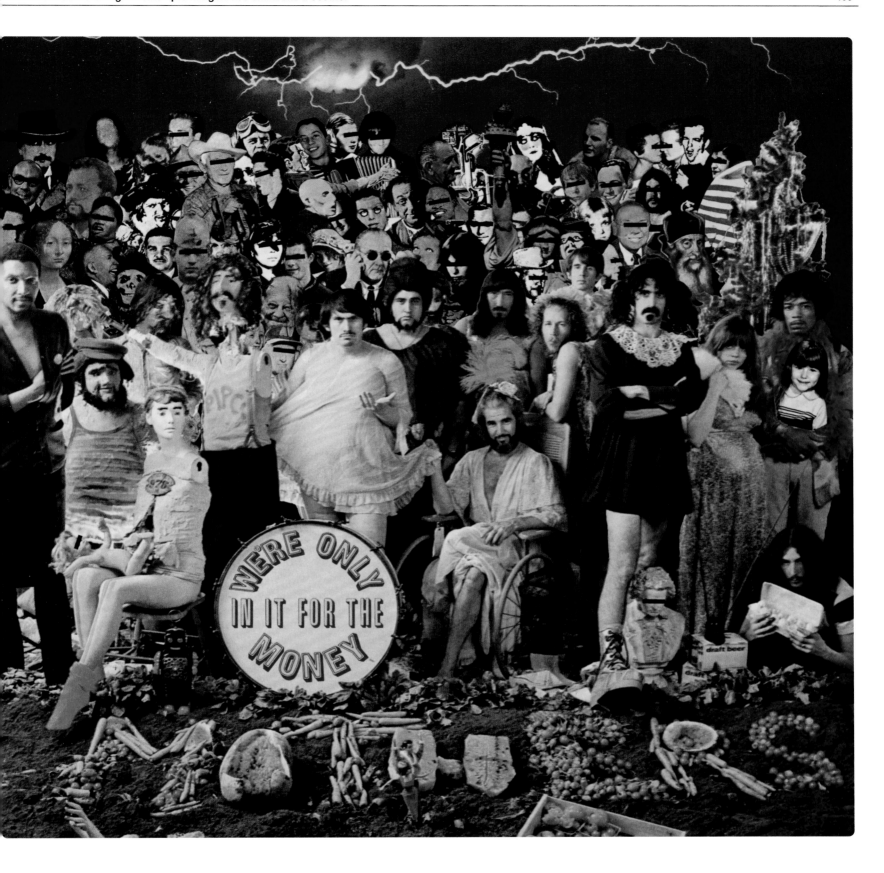

We're Only In It For The Money, *The Mothers of Invention, Verve Records, 1968.*

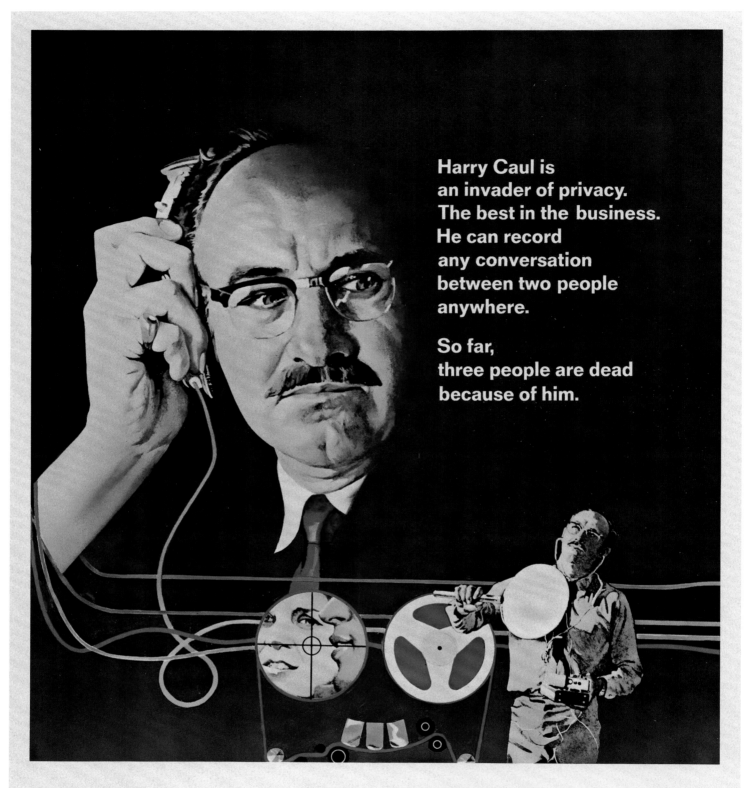

Harry Caul is
an invader of privacy.
The best in the business.
He can record
any conversation
between two people
anywhere.

So far,
three people are dead
because of him.

The Directors Company presents

GENE HACKMAN

in

"THE CONVERSATION"

Co-starring JOHN CAZALE · ALLEN GARFIELD · CINDY WILLIAMS · FREDERIC FORREST
Music scored by Co-producer Written, Produced and Directed by
DAVID SHIRE · FRED ROOS · FRANCIS FORD COPPOLA

 PG PARENTAL GUIDANCE SUGGESTED
SOME MATERIAL MAY NOT BE
SUITABLE FOR PRE-TEENAGERS Color by TECHNICOLOR® · A Paramount Pictures Release

Recommended Viewing
Filmempfehlungen
Les films à voir

The Penalty Wallace Worsley (1920)

Silent film superstar Lon Chaney turns in a bravura performance as an underworld madman bent on exacting revenge for a boyhood operation that left him legless, dotted by periodic shots of a rapidly developing (and motorizing) San Francisco.

Stummfilm-Superstar Lon Chaney ist hier in einer seiner besten Rollen als rachsüchtiger verrückter Gangster zu sehen, den eine Operation im Kindesalter beide Beine gekostet hat. Nun sucht er nach dem Verantwortlichen. Dazu gibt es immer wieder Ansichten des immer städtischer und motorisierter werdenden San Francisco. Dazu kommen noch regelmäßige Blicke auf das sich rapide urbanisierende San Francisco.

Lon Chaney, superstar du cinéma muet, réalise une impressionnante performance artistique dans la peau d'un gangster sadique résolu à se venger du chirurgien qui l'a à tort amputé des deux jambes quand il était encore un enfant. Le film est parsemé çà et là de plans de San Francisco, alors en pleine croissance urbaine et automobile.

Greed Erich von Stroheim (1924)

ZaSu Pitts centers a doomed love triangle in this grim silent film classic where lives fall apart with romantic jealousy and squabbling over an accidental fortune, with many exterior and interior scenes filmed on location in 1923 San Francisco.

ZaSu Pitts steht in diesem dunklen Stummfilmklassiker im Zentrum eines Liebesdreiecks, das die Leben aller Beteiligten durch Eifersucht und die Gier nach Reichtum zerstört. Viele der Innen- und Außenszenen wurden vor Ort gedreht.

Un triangle amoureux voué à l'échec et la brune Zasu Pitts en son cœur dans ce classique du cinéma muet inspiré par le roman *McTeague* de Frank Norris. Sous l'effet de la jalousie et des cupidités rivales, les vies se désagrègent dans cette fresque au sombre naturalisme dont de nombreuses scènes d'extérieur et d'intérieur ont été tournées à San Francisco.

Old San Francisco Alan Crosland (1927)

Descendants of Spanish settlers defend their ranch from takeover by a villain who's built his fortune in the underworlds of Chinatown and the Barbary Coast in this silent movie, the 1906 earthquake striking in the middle of the climactic showdown.

Nachfahren von spanischen Siedlern verteidigen ihre Ranch gegen die Übernahme durch einen Bösewicht, der seinen Reichtum in der Unterwelt Chinatowns und der Barbary Coast gemacht hat. Das Erdbeben von 1906 trifft die Stadt während des Showdowns.

Des descendants de colons espagnols défendent leur ranch contre la convoitise d'un méchant spéculateur qui a bâti sa fortune dans les bas-fonds de Chinatown et de Barbary Coast. Le tremblement de terre de 1906 frappe au point culminant de la confrontation et de ce film muet.

San Francisco W.S. Van Dyke (1936)

Singer Jeanette MacDonald falls for rogue Barbary Coast club owner Clark Gable, mediated by priest Spencer Tracy, in this 1906-set romance that ends with lengthy reenactments of the earthquake and its immediate aftermath.

Die Sängerin Jeanette MacDonald verliebt sich in den schurkischen Clark Gable, einen Clubbesitzer an der Barbary Coast, orchestriert vom Priester Spencer Tracy. Die im Jahr 1906 spielende Liebesgeschichte endet mit einer langen Darstellung des Erdbebens und seiner Folgen.

La chanteuse Jeanette MacDonald tombe amoureuse de l'ambigu gérant d'un cabaret de Barbary Coast – Clark Gable – avec l'aide du prêtre Spencer Tracy. Cette romance située en 1906 s'achève par de longues reconstitutions du tremblement de terre et de ses répercussions immédiates.

The Maltese Falcon John Huston (1941)

Early film noir classic based on a Dashiell Hammett murder-cum-smuggler mystery actually doesn't make too much of its San Francisco setting, but features some great establishing shots of the bay and waterfront neighborhoods, plus superb performances by Humphrey Bogart as Sam Spade and a sleazy, clumsily villainous Peter Lorre.

Dieser frühe Film-noir-Klassiker, basierend auf Dashiell Hammetts Mord-und-Schmuggel-Mystery, macht tatsächlich nicht viel aus dem San-Francisco-Setting, zeigt aber einige großartige Aufnahmen von der Bay und den am Ufer gelegenen Vierteln, zusammen mit einem grandiosen Humphrey Bogart als Sam Spade und dem etwas ungelenken Bösewicht Peter Lorre.

Emblématique des premiers classiques du film noir, cette adaptation du roman de Dashiell Hammett, une histoire de meurtre et de statuette volée, ne fait pas grand cas de San Francisco, où elle se déroule, mais comprend tout de même quelques plans essentiels de la baie et des quartiers proches du front de mer. Humphrey Bogart y est superbe en détective désabusé et Peter Lorre génial dans son personnage d'escroc maniéré.

This Gun for Hire Frank Tuttle (1942)

Hitman Alan Ladd goes on the run to Los Angeles after getting set up to knock off a San Franciscan chemist in this adaptation of a Graham Greene novel, dragging showgirl Veronica Lake into a complex web of espionage and corrupt tycoons.

In dieser Adaption eines Romans von Graham Greene flieht der Auftragskiller Alan Ladd nach Los Angeles, nachdem sein Auftrag, einen Chemiker in San Francisco auszuschalten, sich als Falle herausstellt. Er zieht dabei das Showgirl Veronica Lake in ein kompliziertes Netz aus Spionage und Korruption hinein.

Alan Ladd, tueur traqué, vient d'abattre un industriel de San Francisco. Il entraîne dans sa fuite à Los Angeles Veronica Lake en chanteuse de cabaret, résolu à se venger des commanditaires qui l'ont manipulé. Espions et nababs véreux s'agitent en une intrigue tortueuse tirée d'un roman de Graham Greene.

Dark Passage Delmer Daves (1947)

Lauren Bacall rescues San Quentin Prison fugitive Humphrey Bogart in this underrated, unusual film noir, with plenty of imaginative daytime and evening scenes on the Golden Gate Bridge and some of San Francisco's steepest blocks.

In diesem ungewöhnlichen, unterschätzten Film noir rettet Lauren Bacall den aus dem Gefängnis San Quentin geflohenen Humphrey Bogart. Es gibt viele einfallsreiche Tag- und Nachtszenen an der Golden Gate Bridge und in einigen der steilsten Straßen von San Francisco.

Évadé du pénitencier de San Quentin, Humphrey Bogart franchit un barrage de police avec l'aide de Lauren Bacall dans ce film noir sous-estimé et singulier, riche en vues non moins originales, notamment panoramiques, du Golden Gate et des zones parmi les plus escarpées de San Francisco, saisis de jour comme de nuit.

The Lady from Shanghai Orson Welles (1947)

Welles directed and starred as a seaman framed for murder by Rita Hayworth, with key location scenes on the Sausalito waterfront, Chinatown, and most famously a climactic hall-of-mirrors shootout whose exteriors were shot at the Playland at the Beach amusement park.

Welles führt Regie und spielt gleichzeitig einen Fischer, demRita Hayworth einen Mord angehängt. Schlüsselszenen wurden in Chinatown, am Ufer von Sausalito und (die berühmteste von allen) in einem Spiegelkabinett gedreht, für die die Außenansichten im Vergnügungspark Playland at the Beach gefilmt wurden.

Welles assure la mise en scène et interprète le rôle d'un marin accusé de meurtre par Rita Hayworth. Plusieurs scènes clés se déroulent sur le front de mer de Sausalito et à Chinatown, sans oublier la célébrissime fusillade finale du labyrinthe de miroirs, dont les extérieurs ont été tournés au parc d'attractions Playland-at-the-Beach.

D.O.A. Rudolph Maté (1950)

Only about half of this terrifying film noir of a poisoned man using his final hours to avenge his death takes place in San Francisco, but that's enough time for some memorable city settings, especially in the fictional "The Fisherman" bop jazz club by the waterfront.

Nur die Hälfte dieses angsteinflößenden Film noir, in dem ein vergifteter Mann seine letzten Stunden nutzt, um seinen Tod zu rächen, spielt in San Francisco. Doch das genügt vollkommen für erinnerungswürde Schauplätze in der Stadt, vor allem der erfundene Bop-Jazz-Club „The Fisherman" an der Bay.

San Francisco n'abrite qu'une moitié seulement de cet angoissant film noir qui voit un homme empoisonné employer à ourdir sa vengeance les heures qui lui restent. C'est assez toutefois pour y admirer quelques mémorables tableaux urbains, notamment dans un club de be-bop fictif, « The Fisherman », installé sur le front de mer.

It Came from Beneath the Sea Robert Gordon (1955)

A giant radioactive sea monster terrorizes the city's waterfront in this grim sci-fi flick, tearing down the Golden Gate Bridge and the Ferry Building; mass panic ensues along the Embarcadero before the navy destroys the creature.

Ein gigantisches radioaktives Seemonster sucht in diesem düsteren Sci-Fi-Streifen die Ufer von San Francisco heim und zerstört die Golden Gate Bridge und das Ferry Building. Es folgt eine Massenpanik, und die Navy erledigt das Monster.

Un monstre marin géant et radioactif terrorise le front de mer de San Francisco, pulvérisant au passage le Golden Gate Bridge et le Ferry Building dans cette lugubre série B de science-fiction. Une panique générale s'emparera de l'Embarcadero avant que la marine ne réussisse à anéantir la créature.

Vertigo Alfred Hitchcock (1958)

James Stewart stars as a fear-of-heights cop who gets obsessed with Kim Novak in the most critically acclaimed San Francisco-set film, with plenty of striking color location scenes, most famously when Stewart fishes Novak out of the water underneath the Golden Gate Bridge.

James Stewart spielt in dem berühmtesten San-Francisco-Film einen Polizisten mit Höhenangst, für den Kim Novak zur Besessenheit wird. Der Film ist voll

von beeindruckenden vor Ort gedrehten Farbszenen, in deren berühmtester Stewart Novak aus den Wassern unter der Golden Gate Bridge fischt.

James Stewart joue un ancien flic phobique des hauteurs et hanté par la blonde Kim Novak dans ce chef-d'œuvre qui est aussi le plus illustre des films situés à San Francisco. L'intensité du Technicolor éclate dans de nombreuses scènes tournées en décor réel, à l'exemple du repêchage de « Madeleine » sous le Golden Gate Bridge.

The Lineup Don Siegel (1958)
A narcotics smuggling operation using innocent travelers as carriers breaks down into violent murders in this late film noir, notable for lengthy scenes in now-gone San Francisco landmarks like the Steinhart Aquarium and the Sutro Baths ice skating rink, and a car chase that terminates on the under-construction Embarcadero Freeway.

Ein Drogenschmuggelring, der unschuldige Reisende als Kuriere verwendet, endet in diesem späten Noir Film in brutalen Morden. Der Film ist besonders wegen der langen Szenen in mittlerweile verschwundenen Wahrzeichen der Stadt bemerkenswert, wie dem Steinhart Aquarium oder der Eisbahn in den Sutro Baths, und einer Verfolgungsjagd auf dem sich noch im Bau befindenden Embarcadero Freeway.

Un trafic d'héroïne reposant sur l'utilisation de simples voyageurs comme « mules » involontaires tourne à la violence et au bain de sang. Ce classique tardif du polar vaut notamment par la course-poursuite achevée au bout de l'Embarcadero Freeway en construction et les repères emblématiques aujourd'hui disparus qu'on y revisite en longueur, tels l'aquarium Steinhart alors situé dans le parc du Golden Gate et la patinoire des Sutro Baths.

Days of Wine and Roses Blake Edwards (1962)
Jack Lemmon and Lee Remick star as an also-ran power couple, whose excruciatingly drawn-out descent into alcoholism mirrors the film's shift from cheery San Francisco Bay/Fisherman's Wharf backdrops to seedy apartments and hotels.

Jack Lemmon und Lee Remick spielen ein erfolgloses Paar, dessen quälend langsamer Absturz in die Alkoholsucht dem Kontrast zwischen der fröhlichen Szenerie der Bucht und der Fisherman's Wharf und immer schmierigeren Apartments und Hotels gegenübergestellt wird.

À mesure qu'elle abandonne le décor enjoué de la baie de San Francisco et de Fisherman's Wharf pour le papier peint d'hôtels et d'appartements de plus en plus miteux, cette romance tragicomique traduit l'inexorable plongée dans l'alcoolisme du couple splendide formé par Jack Lemmon et Lee Remick.

Monterey Pop D. A. Pennebaker (1968)
Exhilarating documentary of the first great rock festival, featuring footage of top Bay Area psychedelic groups Jefferson Airplane, Big Brother & the Holding Company, and Country Joe and the Fish, as well as breakout performances by Jimi Hendrix, Otis Redding, and the Who.

Eine aufregende Dokumentation über das erste große Rockfestival, mit Aufnahmen von Psychedelic-Gruppen wie Jefferson Airplane, Big Brother & the Holding Company und Country Joe and the Fish sowie Auftritten von Jimi Hendrix, Otis Redding und The Who.

Un documentaire euphorisant sur l'un des tout premiers festivals de rock, organisé en Californie en juin 1967. On y voit en particulier les meilleurs groupes psychédéliques de la « Bay Area » comme Big Brother & the Holding Company, Jefferson Airplane, ou Country Joe & The Fish, ainsi que les performances éruptives des Who, de Jimi Hendrix et d'Otis Redding.

San Francisco Anthony Stern (1968)
With its dazzling if disorienting collage of rapid-fire cityscapes and special effects, this fifteen-minute short is one of the few cinematic works to capture the psychedelic frenzy of San Francisco in the mid-to-late 1960s, soundtracked by a rare early version of Pink Floyd's "Interstellar Overdrive."

Dieser 15-minütige Kurzfilm ist eine überwältigende und desorientierende Collage aus Aufnahmen der Stadtlandschaft und Spezialeffekten. Mit einer frühen Version von Pink Floyds „Interstellar Overdrive" als Soundtrack ist es einer der wenigen Filme, der den psychedelischen Rausch San Franciscos Mitte bis Ende der 60er-Jahre einfangen kann.

Sur une version rare et précoce du « Interstellar Overdrive » de Pink Floyd, un montage kaléidoscopique aussi éblouissant que déroutant qui enchaîne en rafale saynètes urbaines et effets spéciaux : ce court métrage impressionniste d'un quart d'heure est l'une des rares œuvres cinématographiques à avoir su saisir la frénésie psychédélique de San Francisco, du milieu à la fin des années 1960.

Bullitt Peter Yates (1968)
Detective Steve McQueen stops at nothing to bring organized criminals to justice in this tense if occasionally turgid thriller, highlighted by the most extensive steep hill–heavy San Francisco car chase in cinema history.

Der Polizist Steve McQueen macht vor nichts Halt, um das organisierte Verbrechen zur Strecke zu bringen. Highlight dieses spannenden, wenn auch gelegentlich etwas schwülstigen Thrillers ist die längste und hügeligste Verfolgungsjagd der Kinogeschichte in San Francisco.

Pour faire traduire en justice des membres du crime organisé, Steve McQueen en lieutenant de police ne recula devant rien. Le point d'orgue de ce thriller haletant quoiqu'un peu boursouflé par moments reste la plus longue et la plus folle course-poursuite jamais tournée dans les rues vertigineuses de San Francisco.

Gimme Shelter Albert and David Maysles and Charlotte Zwerin (1970)
After following the Rolling Stones' 1969 US tour, Gimme Shelter turns into a gripping and at times horrific document of their violence-scarred Altamont concert, capturing the fatal stabbing of a teenager in the audience on film.

Erst folgt Gimme Shelter der Rolling-Stones-Tour 1969 durch die USA, dann wird der Film zu einem packenden und teilweise erschreckenden Dokument des von Gewalt gezeichneten Altamont-Konzerts, bei dem im Teenager erstochen wird.

Le point de départ de ce film consistait à suivre la tournée américaine des Rolling Stones, fin 1969. La captation du concert d'Altamont et de sa violence ambiante, qui entraîna le meurtre au couteau d'un adolescent noir, en fait un document effrayant et captivant sur la fin d'une époque mythique.

Dirty Harry Don Siegel (1971)
Clint Eastwood stars as a verging-on-vigilante cop in this massively successful, and massively violent, tale inspired by the Zodiac serial killer, making effective use of many San Francisco locations and aerial shots.

Clint Eastwood spielt einen zur Selbstjustiz neigenden Polizisten in diesem äußerst erfolgreichen und äußerst brutalen Film, inspiriert vom Zodiac-Serienmörder und mit vielen Originalschauplätzen und Luftaufnahmen von San Francisco.

Plus proche du justicier sauvage que du flic assermenté, Clint Eastwood traque un criminel inspiré du tueur du Zodiaque, qui terrorisa San Francisco à la fin des années 1960. La ville est très présente, surtout à travers des plans aériens, dans ce vigilante movie qui rencontra un succès aussi vif qu'il est violent.

What's Up, Doc? Peter Bogdanovich (1972)
The top San Francisco-set screwball comedy finds Barbra Streisand wreaking havoc on the once-orderly life of uptight music professor Ryan O'Neal, most famously on a wild multi-car chase that winds through Lombard Street, Chinatown, and ultra-steep hills before splashing into the bay.

Diese schräge, in San Francisco spielende Komödie handelt vor allem davon, wie Barbra Streisand das zuvor ordentliche Leben des Musikprofessors Ryan O'Neal über den Haufen wirft, bis hin zu einer Verfolgungsjagd mit mehreren Wagen, die sich durch die steilen Hügel, Lombard Street und Chinatown windet, bevor sie im Wasser der Bucht endet.

Loufoque à souhait, la meilleure screwball comedy que San Francisco ait jamais accueillie envoie Barbra Streisand bouleverser l'existence bien rangée de Ryan O'Neal en musicologue coincé. Une folle course-poursuite en voiture traverse Lombard Street, Chinatown et les hauteurs les plus escarpées de la ville avant de s'achever au beau milieu de la baie.

Play It Again Sam Herbert Ross (1972)
Woody Allen and Diane Keaton back into a brief but torrid affair in the generally successful, sometimes uproarious movie adaptation of Allen's Broadway comedy, with subtle but deft use of San Francisco locations, most memorably in a scene of the star-crossed couple riding a cable car.

Woody Allen und Diane Keaton haben eine kurze, aber stürmische Affäre in der erfolgreichen und manchmal zum Schreien komischen Adaption von Allens Broadway-Komödie, die subtil, aber nachdrücklich San Francisco in Szene setzt, besonders als die Verliebten mit dem Cable Car fahren.

La brève et néanmoins torride aventure amoureuse de Diane Keaton et de Woody Allen enfièvre cette adaptation cinématographique globalement réussie, parfois hilarante, de la pièce de théâtre du susdit. Le décor de San Francisco y est subtilement et habilement exploité, en particulier dans la scène où le couple loser emprunte un cable car.

The Conversation Francis Ford Coppola (1974)
Uptight surveillance expert Gene Hackman uncovers a murky murder plot in this anxious suspense drama, built around an extended scene of two lovers walking around Union Square that's shot and repeatedly played over from several different angles.

Der verklemmte Überwachungsexperte Gene Hackman deckt in diesem spannungsvollen Drama ein Mordkomplott auf. Das Herzstück des Films ist eine lange Szene, in der zwei Liebende um den Union Square gehen und dabei immer wieder aus unterschiedlichen Perspektiven gezeigt werden.

L'introverti Gene Hackman, expert ès surveillance, découvre un angoissant projet d'assassinat dans ce thriller psychologique qui s'articule autour d'une longue scène de déambulation d'un couple sur Union Square, filmée et répétée sous plusieurs angles.

High Anxiety Mel Brooks (1977)
Mel Brooks both directs and stars as a vertigo-challenged psychiatrist in an uneven Hitchcock parody that puts much of the action in San Francisco's swanky Hyatt Regency hotel, with other key scenes at the Golden Gate Bridge and city parks.

Mel Brooks spielt die Hauptrolle eines unter Höhenangst leidenden Psychiaters und führt Regie bei dieser etwas unausgewogenen Hitchcook-Parodie, bei der ein Großteil der Handlung entweder im protzigen Hyatt Regency Hotel oder um die Golden Gate Bridge und die Parks der Stadt herum spielt.

À la fois réalisateur et acteur, Mel Brooks joue un psychiatre sujet au vertige dans ce pastiche assez inégal des thrillers hitchcockiens, et plus spécifiquement de Sueurs froides. Si l'essentiel de l'action se déroule au très chic hôtel Hyatt Regency de San Francisco, d'autres scènes importantes prennent pour cadre le Golden Gate Bridge et les parcs de la ville.

Invasion of the Body Snatchers Philip Kaufman (1978)
Respectable remake of the '50s horror classic shifts the setting from a fictional California small town to a very

urban San Francisco, Donald Sutherland leading a losing fight against aliens set on taking over the bodies of an entire population.

Das Remake des Horrorklassikers aus den 50ern spielt statt in einer kalifornischen Kleinstadt mitten in San Francisco, wo Donald Sutherland auf verlorenem Posten gegen Aliens kämpft, die darauf aus sind, die Körper der gesamten Bevölkerung zu übernehmen.

Ce respectable remake d'un classique de l'horreur des années 1950 substitue au décor original – une petite ville fictive de Californie – le cœur on ne peut plus urbain de San Francisco. Donald Sutherland y livre un combat désespéré à des spores extra-terrestres résolues à déposséder les habitants de leur identité.

Escape from Alcatraz Don Siegel (1979)
Dirty Harry star–director combo Don Siegel and Clint Eastwood team up again for this dramatization of the 1962 escape of three inmates (never subsequently found) from the prison, much of it actually filmed on the former prison grounds.

Das Star-Regisseur-Team aus *Dirty Harry*, Don Siegel und Clint Eastwood, hat wieder zusammengearbeitet und zeigt die Flucht von drei Insassen (die nie wieder fand) von der Gefängnisinsel Alcatraz im Jahr 1962; ein Großteil des Films wurde vor Ort gedreht.

Don Siegel-Clint Eastwood : le duo gagnant de *L'Inspecteur Harry* se reconstitue pour raconter la célèbre évasion en 1962 de trois détenus de la prison d'Alcatraz – qui ne seront jamais repris. Le film est en grande partie tourné sur le site de l'ancien pénitencier.

Time After Time Nicholas Meyer (1979)
As H.G. Wells, Malcolm McDowell time-travels from 1893 to late-'70s San Francisco to stop a transplanted Jack the Ripper, hitting many top city landmarks (most prominently the Palace of Fine Arts) along the way.

Malcolm McDowell reist als H.G. Wells von 1893 ins San Francisco der späten 70er. Er muss eine ebenfalls zeitgereisten Jack the Ripper aufhalten, und nimmt auf dem Weg viele Sehenswürdigkeiten (vor allem den Palace of Fine Arts) mit.

Malcolm McDowell dans le rôle du romancier et inventeur H.G. Wells voyage à travers le temps, de 1893 jusqu'à la San Francisco des années 1970, afin de mettre la main sur un Jack l'Éventreur délocalisé en Californie. Il croise en chemin des hauts lieux de la ville, parmi lesquels, très en vue, le Palace of Fine Arts.

Serial Bill Persky (1980)
Silly, overly broad satire of '70s Marin County life lampoons open marriages, new age spirituality, cults, and gay motorcycle gangs, with a few zingers and plenty of lush location shots of Marin landmarks and ferry rides on the bay.

Eine blödelnde, etwas zu allgemeine Satire über das Leben der 70er in Marin County, die es vor allem auf offene Ehen, New-Age-Spiritualität, Kulte und schwule Motorradgangs abgesehen hat. Zu ein paar guten Sprüchen kommen satte Aufnahmen aus Marin County und von Fährfahrten über die Bucht.

Cette satire niaise et assez nébuleuse de la vie du comté de Marin dans les années 1970 brocarde pêle-mêle libération sexuelle, spiritualité New Age, sectes en tout genre et bikers gays. Les bonnes blagues s'y font plus rares que les traversées de la baie en ferry et les cartes postales emblématiques de Marin.

Chan Is Missing Wayne Wang (1982)
This rambling tale of a cab driver looking for a friend who vanishes after taking cash in a business deal is far more notable for its gritty, black-and-white scenes of everyday life in working-class Chinatown than for its anticlimactic story.

Diese ausschweifende Geschichte über einen Taxifahrer, der einen Freund sucht, der nach einem schmutzigen Deal verschwunden ist, bleibt eher wegen ihrer Schwarz-Weiß-Szenen aus dem Alltag der Arbeiterklasse in Chinatown in Erinnerung als wegen ihres enttäuschenden Endes.

L'histoire d'un chauffeur de taxi lancé à la recherche d'un ami disparu avec l'argent qui lui avait été confié. En dépit d'un scénario un peu plat et décousu, le deuxième film de Wayne Wang vaut surtout pour le réalisme du quotidien qui caractérise cette exploration en noir et blanc du Chinatown ouvrier.

Hammett Wim Wenders (1982)
Dashiell Hammett, played by Frederic Forrest, gets snagged into acting as an intermediary between high-powered late-'20s politicians and the Chinatown underworld in this brooding, arty film noir, though much of it was reshot on a soundstage after Francis Ford Coppola's production company was dissatisfied with the original version.

In diesem nachdenklichen Film noir muss Dashiell Hammet, gespielt von Frederic Forrest, als Vermittler zwischen mächtigen Politikern der späten 1920er-Jahre und der Unterwelt von Chinatown dienen. Ein Großteil des Films wurde im Studio noch einmal aufgenommen, weil die Produktionsform von Francis Ford Coppola nicht mit der ersten Fassung zufrieden war.

Un exercice de style oppressant et nocturne qui voit le romancier Dashiell Hammett (Frederic Forrest) entraîné à jouer les intermédiaires entre la pègre de Chinatown et de puissants politiciens de la fin des années 1920. La majeure partie du film a été retournée en studio selon les directives du producteur Francis Ford Coppola, insatisfait de la première version.

Star Trek IV: The Voyage Home Leonard Nimoy (1986)
The *Enterprise* crew time-travels to mid-1980s San Francisco to save Earth's future by rescuing a pair of Sausalito whales, justifying the ludicrous premise with a good deal of lighthearted comedy as they charm and connive bewildered locals.

Die Besatzung der *Enterprise* begibt sich auf eine Zeitreise zurück in das San Francisco Mitte der 80er, um die Zukunft der Erde zu vor dem Untergang zu bewahren, indem sie ein Walpaar in Sausalito rettet. Dieses aberwitzige Szenario wird mit jeder Menge Humor gerechtfertigt, vor allem in den Begegnungen zwischen den Zeitreisenden und der lokalen Bevölkerung.

L'équipage de l'*Enterprise* voyage dans le temps pour atterrir au milieu des années 1980 à San Francisco et sauver la planète en venant à l'aide d'un couple de baleines de Sausalito. Si saugrenu soit-il, ce pitch est relevé par une bonne dose d'humour qui repose sur la difficile intégration des visiteurs venus de l'avenir à une population éberluée.

The Wash Michael Toshiyuki Uno (1988)
A longtime marriage between former internment camp inmates slowly crumbles in a rare and realistic film set in the Bay Area's Japanese American community, also touching upon intergenerational conflict and assimilation.

Eine lange Ehe zwischen ehemaligen Insassen der Internierungslager zerfällt langsam in diesem realistischen Film, der in der japanisch-amerikanischen Gemeinschaft der Bay Area spielt und dabei auch Generationskonflikte und das Thema Assimilation berührt.

Ils se sont connus quarante ans plus tôt dans un camp d'internement mais leur amour aujourd'hui s'éteint peu à peu… Cette œuvre singulière pose un regard réaliste et délicat sur la communauté nippo-américaine de la « Bay Area », non sans aborder le conflit entre les générations et la question de l'assimilation.

Mrs. Doubtfire Chris Columbus (1993)
In the wake of a divorce, Robin Williams impersonates a matronly housekeeper in order to see his kids more in this somewhat saccharine, extremely popular family comedy-drama, largely set in the opulent Pacific Heights neighborhood.

Nach seiner Scheidung gibt sich Robin Williams als mütterliche Haushälterin aus, um seine Kinder öfter sehen zu können. Diese süßliche und äußerst beliebte Familien-Tragikomödie spielt größtenteils in dem wohlhabenden Viertel Pacific Heights.

Pour voir davantage ses enfants dont il a perdu la garde après son divorce, Robin Williams se grime en vénérable gouvernante. Tournée en grande partie dans le quartier cossu de Pacific Heights, cette comédie familiale un rien sirupeuse a reçu du public un accueil triomphal.

Following Sean Ralph Arlyck (2005)
Nearly three decades after filming four-year-old Sean Farrell for a student short in late-'60s Haight-Ashbury, the director finds out what happened to this offspring of hippie parents, who emerged surprisingly normal considering his unconventional upbringing.

Fast 30 Jahre nachdem er als Student den damals vierjährigen Sean Farrel für einen Kurzfilm im Haight-Ashbury der 60er gefilmt hat, ermittelt der Regisseur, was aus dem Sohn von Hippie-Eltern geworden ist. Er stellt sich als überraschend normal heraus, in Anbetracht seiner ungewöhnlichen Kindheit.

Près de trente ans après avoir filmé Sean Farrell, alors âgé de quatre ans, pour un court métrage de fin d'études, le réalisateur part à la recherche du garçonnet. Il découvre l'évolution étonnamment banale d'un enfant pourtant élevé loin des conventions par des parents hippies et libertaires, dans le Haight-Ashbury de la fin des sixties.

The Bridge Eric Steel (2006)
This documentary mixes harrowing footage of suicide attempts (successful and failed) on the Golden Gate Bridge and moving interviews with family and friends of those who fell to their deaths, as well as many beautiful shots of the bridge from dawn to dusk.

Diese Dokumentation mischt erschütternde Aufnahmen von Suizidversuchen (gescheiterten wie geglückten) auf der Golden Gate Bridge und bewegenden Interviews mit Angehörigen und Freunden von Menschen, die sich das Leben genommen haben, sowie vielen herrlichen Aufnahmen von der Brücke zu allen Tageszeiten.

Ce documentaire mêle des images déchirantes de tentatives de suicide (abouties ou non) sur le Golden Gate Bridge, des entretiens poignants avec les proches des victimes et de nombreux plans magnifiques du pont, filmé de l'aube au crépuscule.

The Pursuit of Happyness Gabriele Muccino (2006)
Based on the true story of Chris Gardner, Will Smith stars as a struggling salesman and aspiring stockbroker who descends into homelessness with his preschool son in this sober, at times maudlin biopic, whose location scenes and situations straddle several layers of the city's social and economic classes.

Basierend auf der wahren Geschichte von Chris Gardner, spielt Will Smith einen wenig erfolgreichen Verkäufer und angehenden Börsenmakler, der mit seinem jungen Sohn in die Obdachlosigkeit gerät. Die Drehorte und Situationen dieser ernsten und manchmal rührseligen Filmbiografie umfassen verschiedene ökonomische und soziale Schichten der Stadt.

Will Smith joue le rôle d'un représentant de commerce impécunieux qui se rêve un avenir d'agent de change mais se retrouve SDF avec son fils de cinq ans. Inspiré de la véridique histoire de Chris Gardner, ce biopic alterne sobriété et mélo de même qu'il scanne toute une ville à travers des lieux et des situations caractéristiques de sa diversité sociale et économique.

Zodiac David Fincher (2007)
A hit docudrama on the hunt for the late-'60s Zodiac serial killer responsible for several murders in San Francisco and Northern California, much of the film's action takes place in the city's seedier corners and journalist/law enforcement offices/hangouts.

Der Dokudrama-Hit über die Jagd auf den für mehrere Morde in San Francisco und Nordkalifornien verantwortlichen Zodiac in den späten 60ern spielt in den dreckigeren Ecken der Stadt sowie in den Büros und Absteigen von Journalisten und Polizisten.

Ce thriller à succès inspiré de la traque du tueur du Zodiaque, auteur d'une série de meurtres à San Francisco et dans le nord de la Californie à la fin des années 1960, se déroule pour l'essentiel dans les recoins les plus glauques de la ville. Les bureaux et repaires favoris des principaux enquêteurs – journalistes et policiers – ne sont pas oubliés.

Medicine for Melancholy **Barry Jenkins** (2008)

A young Black couple gradually open up to each other on the day following a one-night stand in this realistic, mostly black-and-white indie, with plenty of San Francisco neighborhood street scenes and observations on Bay Area race relations and gentrification.

Ein junges schwarzes Paar kommt sich in diesem realistischen, mehrheitlich schwarz-weißen Indiefilm nach einem One-Night-Stand langsam näher. Dazu gibt es viele Straßenszenen aus den Vierteln von San Francisco und Beobachtungen über die Beziehungen zwischen den Ethnien und über die Gentrifizierung.

Au lendemain d'une aventure d'un soir, deux jeunes Noirs se découvrent pas à pas. Tourné principalement dans un noir et blanc qui en conforte le réalisme, ce film indépendant à petit budget foisonne de scènes de rue typiques des quartiers de San Francisco et propose une fine observation des relations interraciales et de la gentrification à l'œuvre dans la « Bay Area ».

Milk **Gus Van Sant** (2008)

Sean Penn brings Harvey Milk to reverent life in this witty and poignant portrait of his rise to political power in the Castro and 1978 assassination, though the documentary *The Times of Harvey Milk* is more accurate than this biopic.

Sean Penn verkörpert Harvey Milk in diesem witzigen und ergreifenden Porträt seines Wegs in die Politik bis zu seiner Ermordung 1978, auch wenn die Dokumentation *The Times of Harvey Milk* näher an den Fakten bleibt.

À travers Sean Penn, Gus Van Sant dresse un tableau tout en révérence, à la fois fin et poignant, de la vie d'Harvey Milk, de son ascension vers le pouvoir politique dans le quartier du Castro et de son assassinat en 1978, bien que le documentaire *The Times of*

Harvey Milk soit d'une plus grande précision historique que ce biopic.

Blue Jasmine **Woody Allen** (2013)

After her marriage to a wealthy New York tycoon fails, Cate Blanchett crash-lands with ditzy sister Sally Hawkins in a dizzying fall from grace that contrasts glimpses of the San Francisco good life with the harsh reality of tawdry local neighborhoods and lowlifes.

Nachdem ihre Ehe mit einem New Yorker Tycoon scheitert, landet Cate Blanchett nach ihrem schwindelerregenden sozialen Absturz bei ihrer schusseligen Schwester Sally Hawkins. Der Film kontrastiert das gehobene Leben in San Francisco mit der harten Realität von schäbigen Vierteln und Gesindel.

Après l'échec de son mariage avec un riche homme d'affaires new-yorkais, Cate Blanchett débarque chez sa sœur écervelée en une vertigineuse dégringolade qui confronte la vie des *beautiful people* de San Francisco à la dure réalité des quartiers pauvres et de leurs petits voyous.

Blindspotting **Carlos López Estrada** (2018)

Bay Area gentrification, police brutality, and social inequity jam together in this alternately comic and scathing Oakland-set drama, which follows a struggling working-class youngster's attempt to stay out of trouble in his last few days of probation.

Gentrifizierung in der Bay Area, Polizeigewalt und soziale Ungleichheit stoßen in diesem teils lustigen, teils gnadenlos kritischen Oakland-Drama aufeinander, das einem Jugendlichen aus der Arbeiterklasse folgt, der versucht, die letzten Tage seiner Bewährungszeit hinter sich zu bringen, ohne in Schwierigkeiten zu geraten.

La gentrification de la « Bay Area », la brutalité des forces de l'ordre et la fracture sociale s'enchevêtrent dans ce drame tour à tour comique et mordant qui raconte le dilemme d'un jeune prolétaire d'Oakland pendant ses derniers jours de liberté conditionnelle : témoin clé d'une bavure policière, il doit choisir entre se taire et risquer de tout perdre…

Sorry to Bother You **Boots Riley** (2018)

This comic yet dystopian tale of an African American Oakland telemarketer who stumbles upon a terrifying corporate plan to boost productivity by genetic mutation is a kind of science fiction/futurist-colored counterpoint to the same year's *Blindspotting*.

Diese komödiantische Dystopie erzählt von einem afroamerikanischen Telefonverkäufer, der auf den schrecklichen Plan seiner Firma, Produktivität durch genetische Mutation zu steigern, stößt. Der Film ist eine Art futuristischer Sci-Fi-Kontrapunkt zu *Blindspotting* aus demselben Jahr.

L'histoire comique et néanmoins dystopique d'un télévendeur afro-américain d'Oakland – « désolé de vous déranger » – qui découvre que son entreprise de télémarketing prépare un terrifiant projet visant à augmenter la productivité des salariés par mutation génétique. Une sorte de contrepoint futuriste au film *Blindspotting*, sorti la même année.

The Last Black Man in San Francisco **Joe Talbot** (2019)

A young African American tries to reclaim his family home against impossible odds in a drama with trenchant commentary on San Francisco gentrification and discrimination, set mostly in low-income neighborhoods that even many residents of the city rarely visit.

Ein junger Afroamerikaner versucht in diesem Drama, das Haus seiner Familie entgegen aller Wahrscheinlichkeit zurückzubekommen. Ein messerscharfer Kommentar zu Gentrifizierung und Diskriminierung, der vor allem in armen Vierteln spielt, in die selbst langjährige Bewohner San Franciscos selten kommen.

« Le dernier homme noir de San Francisco » est un jeune Afro-Américain confronté à des obstacles insurmontables alors qu'il tente de récupérer la maison de son enfance. Gentrification et discrimination sont au cœur de cette fresque sociale acerbe, située principalement dans des quartiers pauvres qu'ignorent encore souvent la plupart des habitants de la ville.

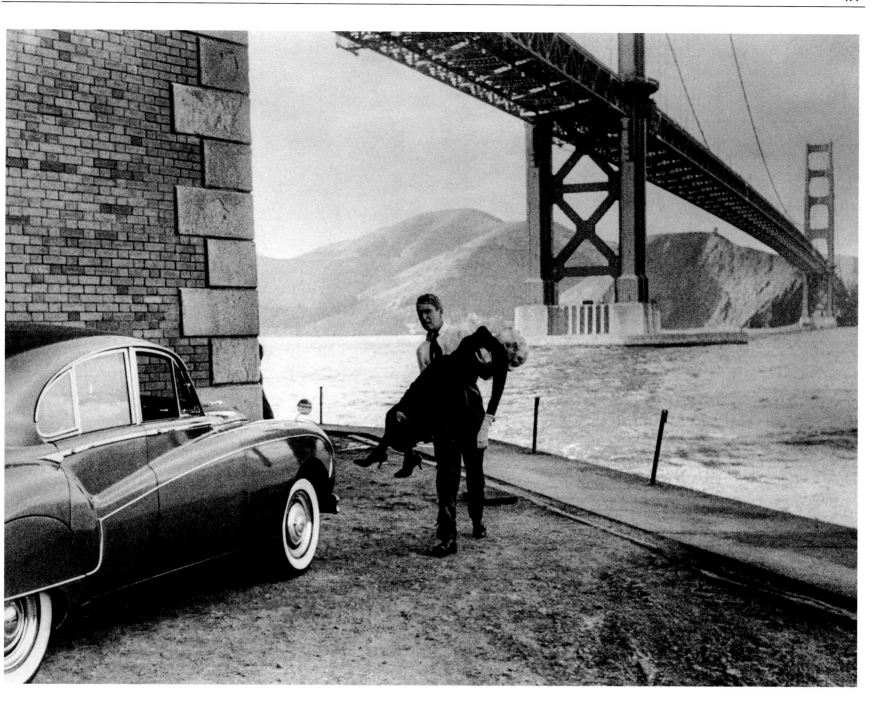

Quotation credits
Zitatnachweis
Sources des citations

28 University of Virgina, Miller Center, *Presidential Speeches*, Fourth Annual Message to Congress, 1848

36 California Department of Parks and Recreation, *The Civil War in California*, Abraham Lincoln, speaking to his friend Charles Maltby, Superintendent of Indian Affairs for California, on March 25, 1865

42 "The Story of an Eyewitness," *The Call-Chronicle Examiner*, April 19, 1906

59 *Great Speeches by Mark Twain*, Dover Publications, 2013

64 Oscar Wilde, *The Picture of Dorian Gray*, First published in *Lippincott's Monthly Magazine*, 1890

68 *San Francisco Stories: Great Writers on the City*, edited by John Miller, Chronicle Books, 2004

74 Frank Norris, *McTeague: A Story of San Francisco*, Doubleday & McClure, 1899

105 Music by Bronislaw Kaper and Walter Jurmann with lyrics by Gus Kahn, 1936

106 Dashiell Hammett, *The Maltese Falcon*, Arthur A. Knopf, 1930

121 William Saroyan, *The Daring Young Man on the Flying Trapeze and other Stories*, Random House, 1934

130 *San Francisco Chronicle*, "Stanton Delaplane," April 25, 1945

155 *The Love Letters of Dylan Thomas*, Orion Publishing Company, 2003

165 Jesse Fuller, "San Francisco Bay Blues," 1954

170 Alfred Hitchcock, *Vertigo*, 1958

182 Douglass Cross and George Cory, 1953

190 John Steinbeck, *Travels with Charley: In Search of America*, Viking Press, 1962

202 Jack Kerouac, *On the Road*, Viking Press, 1957

211 *I Greet You at the Beginning of a Great Career: The Selected Correspondence of Lawrence Ferlinghetti and Allen Ginsberg*. Edited by Bill Morgan 1955–1997, City Lights Publishers, 2015

214 *San Francisco Chronicle*, "While San Francisco Sleeps," June 1, 1958

225 Joseph Eichler, *American Builder*, August 1963

234 *Life*, "Big Day for Bards at Bay," September, 9, 1957

308 Jann Wenner, *Rolling Stone*, 1968

312 Joan Didion, *Slouching Towards Bethlehem*, Farrar Straus and Giroux, 1968

323 Norman Mailer, *Miami and the Siege of Chicago: An Informal History of the Republican and Democratic Conventions*, World Publishing Co., 1968

343 Harvey Milk, *The Hope Speech*, 1978

378 Dead Kennedys, "Let's Lynch the Landlord," 1980, from: Raymond Pepperelle / Geoffrey Lyall / Darren Henley / Eric Boucher "Let's Lynch the Landlord," 1980

384 Vikram Seth, *The Golden Gate*, Random House, 1986

392 Tad Friend, "Jumpers: The Fatal Grandeur of the Golden Gate Bridge," *The New Yorker*, 2003

405 Chris Isaak, "San Francisco Nights", 1993

410 San Quinn, "San Francisco Anthem," 2008, lyrics by Big & Rich feat. Boo Banga & San Quinn

416 Alexis C. Madriga, "Who's Really Buying Property in San Francisco?," *The Atlantic*, April 19, 2019

428 "Herb Caen's Big Day: San Francisco Gets Down to Party," *SFGate*, June 14, 1996

Photo credits
Bildnachweis
Crédits photographiques

Any omissions for copy or credit are unintentional and appropriate credit will be given in future editions if such copyright holders contact the publisher. The publisher gratefully acknowledges the use of photographs provided courtesy of the following individuals and institutions:

Photo by Ansel Adams. Collection Center for Creative Photography © 2016 The Ansel Adams Publishing Rights Trust 109

© Andrea Frank Foundation, from The Americans 235

© 2021 The Andy Warhol Foundation for the Visual Arts, Inc/Licensed by Artist Rights Society (ARS) New York 376

Photo by Arnold Genthe/Alamy Stock Photo 20–21, 46–47

Bob Kreisel/Alamy Stock Photo 329

Dorothea Lange/Alamy Stock Photo 110

Carleton E. Watkins/Alamy Stock Photo 12–13

Granamour Weems Collection/Alamy Stock Photo 460

Anne T. Kent California Room, Marin County Free Library 36

Photo by Nancy Kittle, Marin County Free Library, Anne T. Kent California Room 410

Arthur Tress Archive LLC 280, 281, 286, 287

Associated Press Photo 276–277

Associated Press Photo/Noah Berger 430–431

Associated Press/File Photo 115

© Photo by Tom Baril. Courtesy of the Robert Koch Gallery 415

Photo by Ruth-Marion Baruch. The Regents of the University of California. Courtesy Special Collections, University Library, University of California, Santa Cruz, Ruth-Marion Baruch and Pirkle Jones Photographs 314–315

© Photograph by Ernest Braun 246, 380, 381

© Jeffrey Braverman 417

Courtesy, California Historical Society 29 (DAG-9G_01), 68 (1906 PC-SF_00014/CHS2017_2264), 114 (PC-SF_Golden-Gate-Bridge_019/CHS.Huggins.019)

Photo by H.H. Dobbin. Courtesy of the California History Room, California State Library, Sacramento, California 76, 77, 79

Photo by I.W. Taber. Courtesy of the California History Room, California State Library, Sacramento, California 50–51

Charles W. Cushman Collection: Indiana University Archives 90–91, 126, 202–203, 427

© Estate of William Claxton 216, 218–219

© Photo Anton Corbijn 418–419

© Photo by Louise Dahl-Wolfe, Center for Creative Photography, Arizona Board of Regents 166–167

© Janet Delaney 387, 388, 420

Christian Delfino 427, 433

© Frank Espada Photography 395

Photograph by Bill Eppridge © Estate of Bill Eppridge 284–285

© Larry Fink 304

© Homer Flynn 352–353

© Lee Friedlander, courtesy Fraenkel Gallery, San Francisco; Collection Center for Creative Photography, The University of Arizona 340

© Jean Fruth 429

William Gedney Photographs and Writings, Duke University David M. Rubenstein Rare Book & Manuscript Library 288, 303

© Ingeborg L. Gerdes Trust 394

Photo by Arnold Genthe. Courtesy Fine Arts Museums of San Francisco 40–41, 65 (courtesy of ƒ/Ø Project)

Photo by Arnold Genthe. The Huntington Library, Jack London papers, 1866–1977 43

Photo by Arnold Genthe. Courtesy of the J. Paul Getty Trust Open Content Program. 60–61

Slim Aarons/Hulton Archive/Getty Images 194

American Stock Archive/Getty Images 62–63

Archive Farms/Getty Images 58, 74, 75

Bettmann/Getty Images 48, 107, 305, 342

Jon Brenneis/Getty Images 212

Bob Campbell/San Francisco Chronicle via Getty Images 213

Gary Fong/San Francisco Chronicle via Getty Images 397

Janet Fries/Getty Images 325

GHI/Universal History Archive via Getty Images 230, 231

Ernst Haas/Getty Images 245, 246

Bromberger Hoover Photography/Getty Images 409

Interim Archives/Getty Images 482–483

Walter Iooss Jr./Sports Illustrated via Getty Images 392–393

MediaNews Group/The Mercury News via Getty Images 406

Morse Collection/Gado/Getty Images 124

Tom Munnecke/Getty Images 343

Steve Ringman/San Francisco Chronicle via Getty Images 396

Steve Schapiro/Corbis via Getty Images 248–249, 302, 308, 316

Silver Screen Collection/Getty Images 471

Ted Streshinsky/Corbis via Getty Images 256–257, 289, 290, 295, 299, 310

Jim Sugar/Corbis via Getty Images 407

ullstein bild Dtl./Getty Images 105

Bob Willoughby/Redferns via Getty Images 266–267

Baron Wolman/Getty Images 293, 312

WW Swadley/Library of Congress/Corbis/VCG via Getty Images 80–81

Bibliography
Bibliografie
Bibliographie

Ackley, Laura A. *San Francisco's Jewel City: The Panama-Pacific International Exposition of 1915.* Berkeley, CA: Heyday, 2015.

Alinder, Mary Street. *Group F.64: Edward Weston, Ansel Adams, Imogen Cunningham and the Community of Artists Who Revolutionized American Photography.* New York: Bloomsbury, 2014.

Asbury, Herbert. *The Barbary Coast.* New York: Alfred A. Knopf, 1933.

Boulware, Jack and Silke Tudor. *Gimme Something Better.* New York: Penguin, 2009.

Brechin, Gray. *Imperial San Francisco.* Berkeley, CA: University of California Press, 1999.

Brook, James and Chris Carlsson and Nancy J. Peters (eds.). *Reclaiming San Francisco.* San Francisco: City Lights, 1998.

Brown, Elaine. *A Taste of Power: A Black Woman's Story.* New York: Pantheon, 1992.

Burnham, Daniel. *Report on a Plan for San Francisco.* San Francisco: Sunset Press, 1905.

Cahan, Richard and Michael Williams. *Un-American: The Incarceration of Japanese Americans During World War II.* Chicago: CityFiles Press, 2016.

Carlsson, Chris. *Hidden San Francisco.* London: Pluto Press, 2020.

Carpenter, Patricia F. and Paul Totah (eds.). *The San Francisco Fair: Treasure Island, 1939-1940.* San Francisco: Scottwall Associates, 1989.

Charters, Ann. *Kerouac: A Biography.* San Francisco: Straight Arrow, 1973.

Chase, Marilyn. *Everything She Touched: The Life of Ruth Asawa.* San Francisco: Chronicle, 2020.

Clavin, Tom. *The DiMaggios.* New York: Ecco, 2013.

Cole, Tom. *A Short History of San Francisco (3rd edition).* Berkeley, CA: Heyday, 2015.

Cramer, Richard Ben. *Joe DiMaggio: A Hero's Life.* New York: Simon & Schuster, 2000.

Dalzell, Tom. *The Battle for People's Park, Berkeley 1969.* Berkeley, CA: Heyday, 2019.

Davis, Amelia. *Jim Marshall: Show Me the Picture.* San Francisco: Chronicle, 2019.

Draper, Robert. *Rolling Stone Magazine.* New York: Doubleday, 1990.

Fardon, G.R. *San Francisco Album: Photographs 1854-1856.* San Francisco: Chronicle, 1999.

Ferlinghetti, Lawrence and Nancy J. Peters. *Literary San Francisco: A Pictorial History, From Its Beginnings to the Present Day.* San Francisco: City Lights, 1980.

Fitzgerald, Frances. *Cities on a Hill.* New York: Simon & Schuster, 1986.

Fortunate Eagle, Adam with Tim Findley. *Heart of the Rock: The Indian Invasion of Alcatraz.* Norman, OK: University of Oklahoma Press, 2002.

Fracchia, Charles A. *Fire & Gold: The San Francisco Story.* Encinitas, CA: Heritage Media Corp., 1996.

George-Warren, Holly. *Janis: Her Life and Music.* New York: Simon & Schuster, 2019.

Graham, Bill and Robert Greenfield. *Bill Graham Presents.* New York: Doubleday, 1992.

Guinn, Jeff. *The Road to Jonestown: Jim Jones and Peoples Temple.* New York: Simon & Schuster, 2017.

Green, Tyler. *Carleton Watkins: Making the West American.* Oakland: University of California Press, 2018.

Groth, Gary (ed.) *The Complete Zap Comix.* Seattle: Fantagraphics, 2014.

Hagan, Joe. *Sticky Fingers: The Life and Times of Jann Wenner and Rolling Stone Magazine.* New York: Alfred A. Knopf, 2017.

Harris, Scott Jordan. *World Film Locations: San Francisco.* Chicago: Chicago Press, 2013.

Hilliard, David and Keith and Kent Zimmerman. *Huey: Spirit of the Panther.* New York: Thunder's Mouth Press, 2006.

Hirsch, James S. *Willie Mays: The Life, the Legend.* New York: Scribner, 2010.

Isenberg, Alison. *Designing San Francisco: Art, Land, and Urban Renewal in the City by the Bay.* Princeton, NJ: Princeton University Press, 2017.

Jacoby, Annice (ed.). *Street Art San Francisco: Mission Muralismo.* New York: Abrams, 2009.

Johnson, Diane. *Dashiell Hammett: A Life.* New York: Random House, 1983.

Johnson, Troy R. *The American Indian Occupation of Alcatraz Island: Red Power and Self-Determination.* Lincoln, NE: University of Nebraska Press, 2008.

Keil, Rob. *Little Boxes: The Architecture of a Classic Midcentury Suburb.* Daly City, CA: Advection Media, 2006.

Kubernik, Harvey and Kenneth Kubernik. *A Perfect Haze: The Illustrated History of the Monterey Pop Festival.* Solana Beach, CA: Santa Monica Press, 2011.

Lasar, Matthew. *Uneasy Listening: Pacifica Radio's Civil War.* Cambridge, UK: Black Apollo Press, 2000.

Lippert, Amy K. DeFalco. *Consuming Identities: Visual Culture in Nineteenth-Century San Francisco.* New York: Oxford University Press, 2018.

McKenna, Kristine and David Hollander (eds.). *Notes from a Revolution: Com/Co, The Diggers & The Haight.* Santa Monica, CA: Foggy Notion, 2012.

McNally, Dennis. *A Long Strange Trip: The Inside History of the Grateful Dead.* New York: Broadway, 2002.

Meltzer, David (ed.). *San Francisco Beat: Talking with the Poets.* San Francisco: City Lights, 2001.

Murphy, Brian. *San Francisco Giants: 50 Years.* San Rafael, CA: Insight Editions, 2008.

Perry, Charles. *The Haight-Ashbury: A History.* New York: Random House, 1984.

Quin, Mike. *The Big Strike.* Olema, CA: Olema Publishing Co., 1949.

Santana, Carlos. *The Universal Tone.* New York: Little Brown & Co., 2014.

Selvin, Joel. *Altamont.* New York: Dey St., 2016.

——— *Summer of Love.* New York: Dutton, 1994.

Sherwood, Susan P. and Catherine Powell (eds.). *The San Francisco Labor Landmarks Guide Book.* San Francisco: The Labor Archives and Research Center, San Francisco State University, 2008.

Shilts, Randy. *And the Band Played On: Politics, People, and the AIDS Epidemic.* New York: St. Martin's Press, 1987.

——— *The Mayor of Castro Street: The Life & Times of Harvey Milk.* New York: St. Martin's Press, 1982.

Silva, Elizabeth Pepin and Lewis Watts. *Harlem of the West: The San Francisco Fillmore Jazz Era.* Berkeley, CA: Heyday, 2020.

Spencer, Keith A. *A People's History of Silicon Valley.* London: Eyewear Publishing, 2018.

Strauss, Ethan Sherwood. *The Victory Machine: The Making and Unmaking of the Warriors Dynasty.* New York: PublicAffairs, 2020.

Talbot, David. *Season of the Witch.* New York: Free Press, 2012.

Tamarkin, Jeff. *Got a Revolution: The Turbulent Flight of Jefferson Airplane.* New York: Atria, 2003.

Thomas, Pat. *Listen Whitey! The Sounds of Black Power 1965-1975.* Seattle: Fantagraphics, 2012.

Thompson, Hunter S. *Hell's Angels.* New York: Random House, 1967.

Toobin, Jeffrey. *American Heiress: The Wild Saga of the Kidnapping, Crimes and Trial of Patty Hearst.* New York: Doubleday, 2016.

Van der Zee, John. *The Gate: The True Story of the Design and Construction of the Golden Gate Bridge.* New York: Simon and Schuster, 1986.

Index

Acknowledgments
Dank
Remerciements

Thanks to Publisher Benedikt Taschen for the opportunity to add this book to TASCHEN's compelling *Portrait of a City* series. Thanks also to everyone who was essential in the creation of this volume, including Editor Reuel Golden, Art Director Josh Baker, Daniela Asmuth, for production, Kathrin Murr, Jörg Schwellnus and Alexi Alario; Holly Stuart Hughes, for additional photo research and Jean Dykstra, for writing the photographers' biographies.

Staff from several major San Francisco Bay Area libraries and archives gave many hours of generous assistance. Thanks to Susan Goldstein, Christina Moretta, and Jeff Thomas of the San Francisco History Center; Jaime Henderson, Frances Kaplan, and Debra Kaufman of the San Francisco branch of the California Historical Society; Shana Lopes, Assistant Curator of Photography at the San Francisco Museum of Modern Art; Peggy Tran-Le, Archivist/Records Manager of the San Francisco Museum of Modern Art; Gina Bardi of the San Francisco Maritime Research Center; Amanda Williford of the Golden Gate National Recreation Area Park Archives; Jack von Euw, Curator of the Bancroft Library Pictorial Collection at the University of California at Berkeley; James Eason, Archivist for Pictorial Collections at the University of California at Berkeley; Nicole Meldahl of Open SFHistory; Jeff Gunderson of the San Francisco Art Institute; Jason Gibbs of the San Francisco Public Library; Catherine Powell of San Francisco State University's Labor Archives and Research Center, Special Collections and Archives; John Hawk, Head of Special Collections and University Archives at the University of San Francisco; Rick Prelinger of the Prelinger Archives; Grisson Leigh of the Center For Creative Photography; and Bradley D. Cooke of the Charles W. Cushman Archive at Indiana University.

San Francisco historians John Freeman and David Gallagher were enormously helpful in pinning down locations and background information for numerous photos. Carrie Ludwig, Ron Ludwig, Rodney Paul, Sarah Paul, Elizabeth Pepin Silva, Robert Tat, Pat Thomas, and Lewis Watts also supplied essential aid in researching and confirming details for pictures within their fields of expertise. Chris Carlsson generated a fountain of useful suggestions and additional information for the book's historical essays. David Hellman, Kevin Jones, Lisa McElroy, Sudha Putnam, and Anneli Rufus did the same for the lists of recommended reading, listening, and viewing.

The support and creative input of the following people is also very much appreciated: Fred Lyon, Ralph Gibson, Peter Fetterman, Alex Ramos, Neil Leifer, Lawrence Schiller, Steve Schapiro, Dimitri Levas, William Raaum, Meg Partridge, Marvin Newman, Pierluigi Serraino, Chantelle Fawcett, and the Estate of Fred Herzog.

Richie Unterberger, Bay Area, 2022

p. 480
Fred Lyon

Riding the California Street cable car line near the Fairmount Hotel's Tonga Room on Nob Hill, 1946.

Eine Fahrt mit der Cable-Car-Linie California Street nahe am Tonga Room des Fairmount Hotels in Nob Hill, 1946.

Sur la ligne de cable car California Street, qui passe ici devant le restaurant de l'hôtel Fairmount à Nob Hill, le célèbre Tonga Room. 1946.

Endpapers

A bird's eye view of the city, 1878.

Blick auf die Stadt aus der Vogelperspektive, 1878.

Vue aérienne de la ville. 1878.

German translation: Alexander Rüter and Marlene Mück (biographies), Cologne

French translation: François Dirdans, Paris

© 2022 TASCHEN GmbH
Hohenzollernring 53, D–50672 Köln
www.taschen.com

Printed in Italy
ISBN 978–3–8365–7485–3

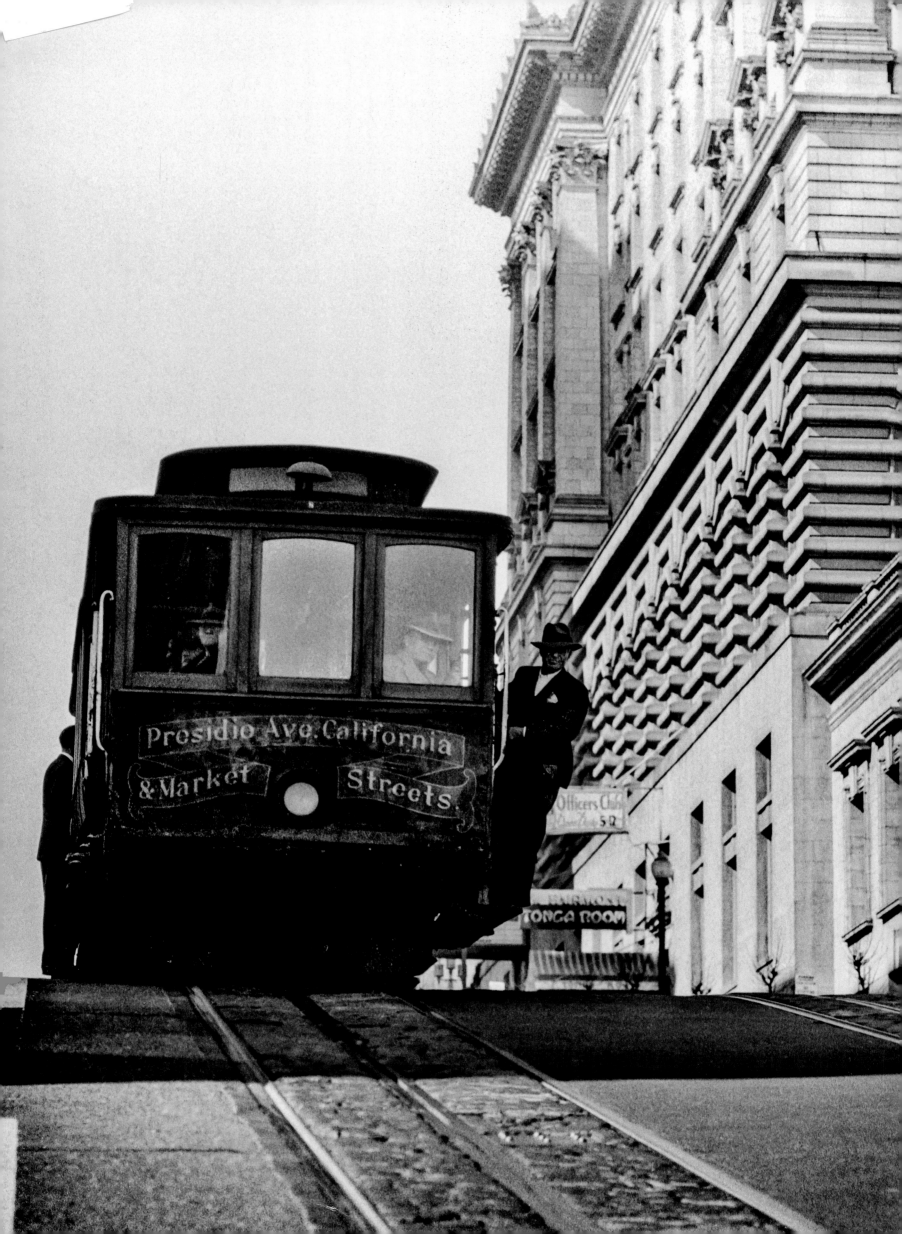